Oil Paintings in Public Ownership in Surrey

D1340131

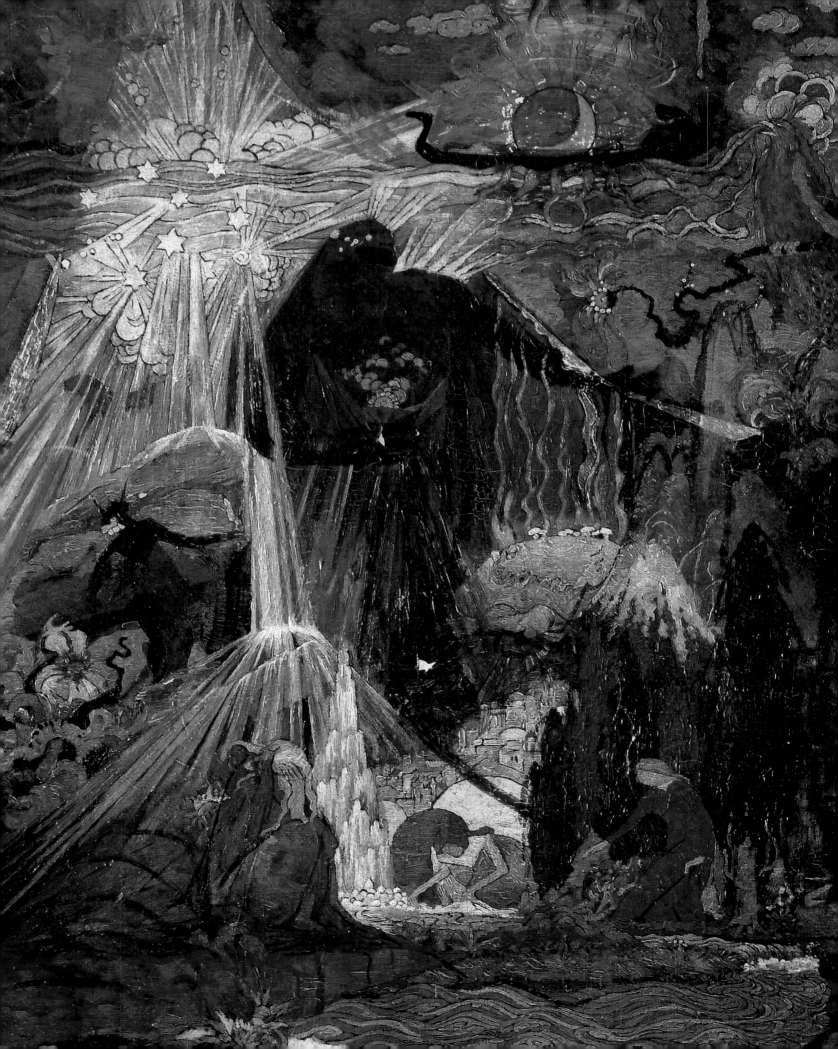

Oil Paintings in Public Ownership in Surrey

The Public Catalogue Foundation

Andrew Ellis, Director
Sonia Roe, Editor
Stella Sharp, Surrey Coordinator
Andy Johnson, Photographer

First published in 2006 by the Public Catalogue
Foundation, St Vincent House, 30 Orange Street,
London, WC2H 7HH

ISBN 1-904931-24-3 (hardback)
ISBN 1-904931-25-1 (paperback)

Surrey photography: Andy Johnson

Designed by Jeffery Design, London

Distributed by the Public Catalogue Foundation,
St Vincent House, 30 Orange Street,
London, WC2H 7HH
Telephone 020 7747 5936

**Printed and bound in the UK by Butler & Tanner
Ltd, Frome, Somerset**

Cover image:

Landseer, Edwin Henry 1802–1873
Man Proposes, God Disposes (detail), 1864
Royal Holloway, University of London (see p.49)

Image opposite title page:

Sime, Sidney Herbert 1867–1941
Illustrative Design of Fountain and Figures (detail)
Sidney H. Sime Memorial Gallery, (see p.216)

Back cover images (from top to bottom):

Clamp, Laura b.1980
Lips and Blue Straw
University College for the Creative Arts at the
Farnham Campus (see p.74)

Elmer, Stephen 1714–1796
Dead Hare and Wild Fowl
Museum of Farnham (see p.66)

Gere, Margaret 1878–1965
The Garden of the Slothful c.1901
Royal Holloway, University of London (see p. 45)

Contents

ix Foreword
x The Public Catalogue Foundation
xi Financial Supporters
xii Acknowledgements
xiii Catalogue Scope and Organisation
xiv Key to Painting Information

THE PAINTINGS

Ash
3 Ash Museum

Ash Vale
3 The Army Medical Services Museum

Byfleet
4 Byfleet Heritage Society
5 Byfleet Village Hall

Camberley
5 Surrey Heath Borough Council
6 Surrey Heath Museum
14 The Royal Logistic Corps Museum

Caterham
15 Caterham Valley Library
16 East Surrey Museum

Chertsey
17 Chertsey Museum

Dorking
23 Dorking and District Museum
32 Mole Valley District Council

Egham
33 Egham Museum
35 Royal Holloway, University of London

Epsom
58 Epsom & Ewell Borough Council

Esher
59 Esher Library

Ewell
59 Bourne Hall Museum
62 Ewell Court Library

Farnham

62 Crafts Study Centre, University College for the Creative Arts
62 Farnham Maltings Association Limited
64 Museum of Farnham
74 University College for the Creative Arts at the Farnham Campus

Godalming

75 Godalming Library
76 Godalming Museum
82 Godalming Town Council
83 Waverley Borough Council

Godstone

84 The White Hart Barn, Godstone Village Hall

Guildford

85 Guildford House Gallery
96 Guildford Museum
97 Queen's Royal Surrey Regimental Museum
99 Surrey Archaeological Society
108 The Guildford Institute of the University of Surrey
108 The Guildhall
111 University of Surrey
129 Watts Gallery
162 Watts Mortuary Chapel
163 Yvonne Arnaud Theatre

Haslemere

163 Haslemere Educational Museum

Kingston-upon -Thames*

174 Surrey County Council

Leatherhead

177 Leatherhead and District Local History Society

Lingfield

178 The Guest House, Lingfield Library

Oxted

178 Oxted Library
179 Tandridge District Council

Redhill

179 East Surrey Hospital

Reigate

182 Holmsdale Natural History Club
183 Reigate & Banstead Borough Council
184 Reigate Priory Museum

Ripley

184 Send and Ripley Museum

Staines**
184 Spelthorne Borough Council
185 Spelthorne Museum

Sunbury-on-Thames**
185 Sunbury Library

Thames Ditton
186 Dittons Library

Warlingham
187 Warlingham Library, Lockton Collection

West Molesey
194 Molesey Library

Weybridge
195 Brooklands Museum
202 Elmbridge Museum

Woking
208 Surrey History Centre

Worplesdon
209 Sidney H. Sime Memorial Gallery

235 Paintings Without Reproductions
236 Further Information
253 Collection Addresses
256 Index
261 Supporters of the Public Catalogue Foundation

* Kingston-upon-Thames forms part of the Ceremonial County of Greater London, and as such will be covered in full in
 a future volume. However, an exception was made in the case of Surrey County Council, as their head office is located in
 Kingston-upon-Thames. Hence its inclusion in this catalogue.
** Staines and Sunbury-on-Thames, forming part of Spelthorne, became part of the Ceremonial County of Surrey under
 the 1965 local government reforms.

Foreword

It has to be said. Surrey is distinctly odd.

Most counties will have a key gallery – at Leeds in West Yorkshire, at Ipswich in Suffolk, or at York in North Yorkshire.

Surrey is the home of the local collection – and of the improbably glorious one-off of which there are two: Watts Gallery in Compton and Royal Holloway in Egham, both utterly distinct from one another yet linked by county, period and didactic intent and by the very richness of their idiosyncratic collections.

For the rest, one can only be amused or amazed – or both. The county's collections range from the Brooklands Collection of aviation and motor racing paintings to that of a gentleman's outfitter in Egham, the Oliver Collection; from a Joseph Wright portrait of Peter Labilliere who was buried upside down on Box Hill in Dorking to the portrait of Louisa Egerton in Weybridge, found in an air raid shelter and bought by the donor for a penny; from the portrait in Godalming of Jack Phillips, chief telegraphist on the Titanic who was still transmitting as he drowned, to John Russell's *Micoc and Tootac*, from the Sydney H. Sime Collection in Worplesdon to the Lockton Collection in Warlingham; 58 unique creations in total.

Yet if you want to revert to the mainstream, wander back to the Royal Holloway and admire a grand Landseer or a Herkomer, a Bratby or a Pollock. But try not to miss the collection in Farnham, not least for the paintings there by Sir John Verney who has also given this country one of the finest Second World War army memoirs, *Going to the Wars*.

Perhaps a county that lies within such easy reach of the great London museums has a powerful need to heed itself. Proudly local, Surrey does heed itself, as this catalogue vividly shows. We are all the better for that.

As usual, our Foundation is grateful to all those whose contributions have made this volume possible. In particular, I would like to thank Pat Grayburn, our Master Patron, for all her help raising funds for this catalogue. We are particularly grateful to the Peter Harrison Foundation, the first and largest donor behind this volume. I would also like to thank the collections for all their assistance, in particular Julia Dudkiewicz at Watts Gallery who spent considerable time ensuring the Watts painting information was complete. Finally, a big thank you to our co-ordinator on this catalogue Stella Sharp.

Fred Hohler, Chairman

Facing page: Bratby, John Randall, 1928–1992, *Washline, Little Bridge* (detail), 1989, Royal Holloway, University of London, (p. 39) ix

The Public Catalogue Foundation

The United Kingdom holds in its galleries and civic buildings arguably the greatest publicly owned collection of oil paintings in the world. However, an alarming four in five of these paintings are not on view. Whilst many galleries make strenuous efforts to display their collections, too many paintings across the country are held in storage, usually because there are insufficient funds and space to show them. Furthermore, very few galleries have created a complete photographic record of their paintings, let alone a comprehensive illustrated catalogue of their collections. In short, what is publicly owned is not publicly accessible.

The Public Catalogue Foundation, a registered charity, has three aims. First, it intends to create a complete record of the nation's collection of oil, tempera and acrylic paintings in public ownership. Second, it intends to make this accessible to the public through a series of affordable catalogues and, after a suitable delay, through a free Internet website. Finally, it aims to raise funds through the sale of catalogues in gallery shops for the conservation and restoration of oil paintings in these collections and for gallery education.

The initial focus of the project is on collections outside London. Highlighting the richness and diversity of collections outside the capital should bring major benefits to regional collections around the country. The benefits also include a revenue stream for conservation, restoration, gallery education and the digitisation of collections' paintings, thereby allowing them to put the images on the Internet if they so desire. These substantial benefits to galleries around the country come at no financial cost to the collections themselves.

The project should be of enormous benefit and inspiration to students of art and to members of the general public with an interest in art. It will also provide a major source of material for scholarly research into art history.

Financial Supporters

The Public Catalogue Foundation would like to express its profound appreciation to the following organisations and individuals who have made the publication of this catalogue possible.

Donations of £10,000 or more

The Peter Harrison Foundation

Donations of £5,000 or more

Hiscox plc
Stavros S. Niarchos Foundation
The Manifold Trust

The Monument Trust
Garfield Weston Foundation

Donations of £1,000 or more

Barlow Robbins LLP
C. J. R. & Mrs C. L. Calderwood
The John S. Cohen Foundation
Professor Patrick & Dr Grace
 Dowling
Mrs M. A. G. Fenston

Mrs Patricia Grayburn, MBE DL
The Keatley Trust
Sir Idris Pearce
Stuart M. Southall
Surrey County Council
University of Surrey

Other Donations

Peter & Ruth Bareau
Mr & Mrs Gordon Bates
Mrs Handa Bray, MBE DL
H. J. C. Browne
Mr & Mrs Mervyn Charlton
Lewis & Mary Elton
Olga & Claude Fielding
Sarah Goad, Lord Lieutenant of
 Surrey
Guildford Borough Council

Howell & Susanna Harris Hughes
Sir Brian Hill
Mr & Mrs David Hypher
Lord Lane of Horsell
Mr M. J. Moss
Leszek & Pat Muszynski
Mr & Mrs A. O'Hea
Mrs Jennifer Powell
Sir Alfred & Lady Shepperd

National Supporters

The Bulldog Trust
The John S. Cohen Foundation
Hiscox plc
The Manifold Trust

The Monument Trust
Stavros S. Niarchos Foundation
Garfield Weston Foundation

National Sponsor

Christie's

Acknowledgements

The Public Catalogue Foundation would like to thank the individual artists and copyright holders for their permission to reproduce for free the paintings in this catalogue. Exhaustive efforts have been made to locate the copyright owners of all the images included within this catalogue and to meet their requirements. Copyright credit lines for copyright owners who have been traced are listed in the Further Information section.

The Public Catalogue Foundation would like to express its great appreciation to the following organisations for their great assistance in the preparation of this catalogue:

Bridgeman Art Library
Flowers East
Marlborough Fine Art
National Association of Decorative and Fine Art Societies (NADFAS)
National Gallery, London
National Portrait Gallery, London
Royal Academy of Arts, London
Tate

The participating collections included in the catalogue would like to express their thanks to the following organisations which have so generously enabled them to acquire paintings featured in this catalogue:

Alfred McAlpine Donation
Dorking and District Preservation Society
The Friends of Guildford House
The Friends of the Museum of Farnham
The Friends of Surrey Heath Museum
G. Jarvis and Co.
MLA/ V & A Purchase Grant Fund
National Art Collections Fund (The Art Fund)
Potter, Kempson and White, Solicitors
R. C. Sherriff Rosebriars Trust
Royal County Surrey Hospital
Shell Research
Sunbury Art Group
Surrey Heath Borough Council
The Contemporary Art Society
The Esmée Fairbairn Foundation
The Legrew Trust, Chaldon
The Museum and Galleries Commission
The S. A. Oliver Charitable Settlement
The Wheen family of Chobham
West Ewell Social Club

Catalogue Scope and Organisation

Medium and Support

The principal focus of this series is oil paintings. However, tempera and acrylic are also included as well as mixed media, where oil is the predominant constituent. Paintings on all forms of support (e.g. canvas, panel etc) are included as long as the support is portable. The principal exclusions are miniatures, hatchments or other purely heraldic paintings and wall paintings *in situ*.

Public Ownership

Public ownership has been taken to mean any paintings that are directly owned by the public purse, made accessible to the public by means of public subsidy or generally perceived to be in public ownership. The term 'public' refers to both central government and local government. Paintings held by national museums, local authority museums, English Heritage and independent museums, where there is at least some form of public subsidy, are included. Paintings held in civic buildings such as local government offices, town halls, guildhalls, public libraries, universities, hospitals, crematoria, fire stations and police stations are also included. Paintings held in central government buildings as part of the Government Art Collection and MoD collections are not included in the county-by-county series but should be included later in the series on a national basis.

Geographical Boundaries of Catalogues

The geographical boundary of each county is the 'ceremonial county' boundary. This county definition includes all unitary authorities. Counties that have a particularly large number of paintings are divided between two or more catalogues on a geographical basis.

Criteria for Inclusion

As long as paintings meet the requirements above, all paintings are included irrespective of their condition and perceived quality. However, painting reproductions can only be included with the agreement of the participating collections and, where appropriate, the relevant copyright owner. It is rare that a collection forbids the inclusion of its paintings. Where this is the case and it is possible to obtain a list of paintings, this list is given in the Paintings Without Reproductions section. Where copyright consent is refused, the paintings are also listed in the Paintings Without Reproductions section. All paintings

in collections' stacks and stores are included, as well as those on display. Paintings which have been lent to other institutions, whether for short-term exhibition or long-term loan, are listed under the owner collection. In addition, paintings on long-term loan are also included under the borrowing institution when they are likely to remain there for at least another five years from the date of publication of this catalogue. Information relating to owners and borrowers is listed in the Further Information section.

Layout

Collections are grouped together under their home town. These locations are listed in alphabetical order. In some cases collections that are spread over a number of locations are included under a single owner collection. A number of collections, principally the larger ones, are preceded by curatorial forewords. Within each collection paintings are listed in order of artist surname. Where there is more than one painting by the same artist, the paintings are listed chronologically, according to their execution date.

The few paintings that are not accompanied by photographs are listed in the Paintings Without Reproductions section.

There is additional reference material in the Further Information section at the back of the catalogue. This gives the full names of artists, titles and media if it has not been possible to include these in full in the main section. It also provides acquisition credit lines and information about loans in and out, as well as copyright and photographic credits for each painting. Finally, there is an index of artists' surnames.

Key to Painting Information

Almost all paintings are reproduced in the catalogue. Where this is not the case they are listed in the Paintings Without Reproductions section. Where paintings are missing or have been stolen, the best possible photograph on record has been reproduced. In some cases this may be black and white. Paintings that have been stolen are highlighted with a red border. Some paintings are shown with conservation tissue attached to parts of the painting surface.

Adam, Patrick William 1854–1929
Interior, Rutland Lodge: Vista through Open Doors 1920
oil on canvas 67.3 × 45.7
LEEAG.PA.1925.0671.LACF

Artist name This is shown as surname first. Where the artist is listed on the Getty Union List of Artist Names (ULAN), ULAN's preferred presentation of the name is always given. In a number of cases the name may not be a firm attribution and this is made clear. Where the artist name is not known, a school may be given instead. Where the school is not known, the painter name is listed as *unknown artist*. If the artist name is too long for the space, as much of the name is given as possible followed by (…). This indicates the full name is given at the rear of the catalogue in the Further Information section.

Painting title A painting followed by *(?)* indicates that the title is in doubt. Where the alternative title to the painting is considered to be better known than the original, the alternative title is given in parentheses. Where the collection has not given a painting a title, the publisher does so instead and marks this with an asterisk. If the title is too long for the space, as much of the title is given as possible followed by *(…)* and the full title is given in the Further Information section.

Medium and support Where the precise material used in the support is known, this is given.

Artist dates Where known, the years of birth and death of the artist are given. In some cases one or both dates may not be known with certainty, and this is marked. No date indicates that even an approximate date is not known. Where only the period in which the artist was active is known, these dates are given and preceded with the word *active*.

Execution date In some cases the precise year of execution may not be known for certain. Instead an approximate date will be given or no date at all.

Dimensions All measurements refer to the unframed painting and are given in cm with up to one decimal point. In all cases the height is shown before the width. Where the painting has been measured in its frame, the dimensions are estimates and are marked with (E). If the painting is circular, the single dimension is the diameter. If the painting is oval, the dimensions are height and width.

Collection inventory number In the case of paintings owned by museums, this number will always be the accession number. In all other cases it will be a unique inventory number of the owner institution. (P) indicates that a painting is a private loan. Details can be found in the Further Information section. The symbol indicates that the reproduction is based on a Bridgeman Art Library transparency (go to www.bridgeman.co.uk) or that the Bridgeman administers the copyright for that artist.

Facing page: Leighton, Edmund Blair, 1853 –1922, *A Flaw in the Title* (detail), 1878, Royal Holloway, University of London, (p. 51)

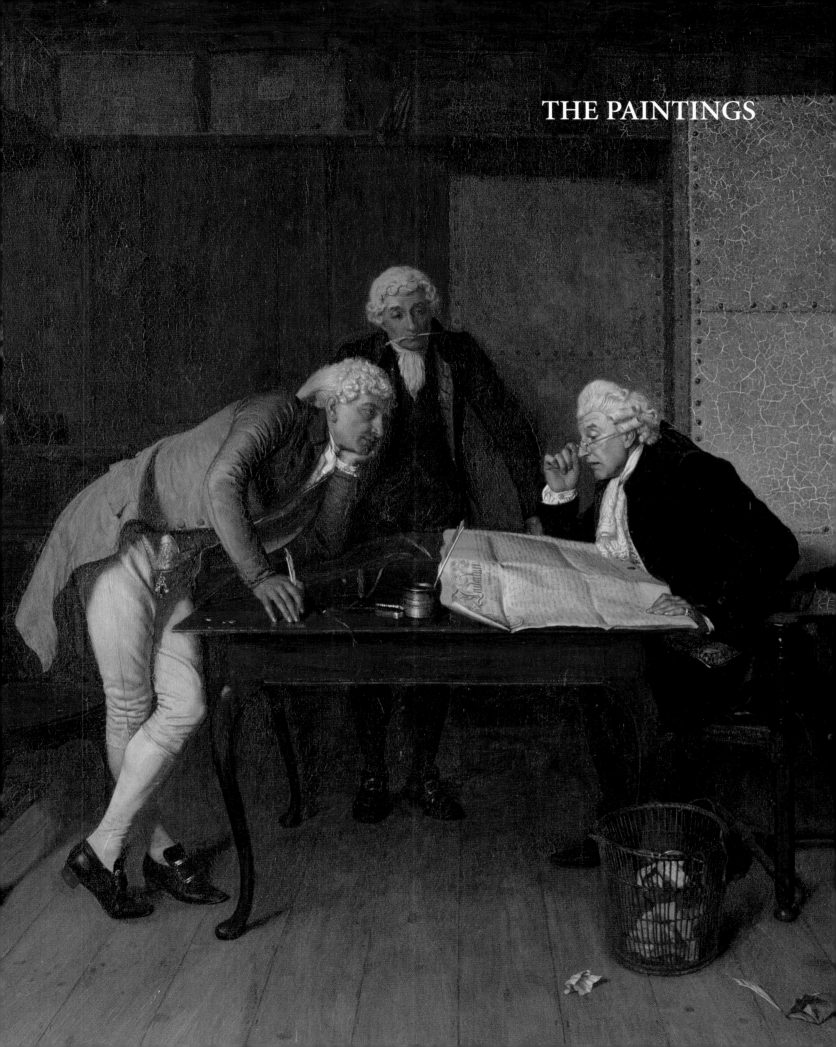

THE PAINTINGS

Ash Museum

Miles, John James active c.1906–c.1920
St Peter's Church, Ash c.1906
oil on cardboard 19.5 x 26.1
210

Miles, John James active c.1906–c.1920
Battleship c.1920
oil on cardboard 13.3 x 22.9
302

The Army Medical Services Museum

Bentos, Achille b.1882
Queen Alexandra's Imperial Military Nursing Service (QAIMNS) Sister, Second World War 1945
oil on canvas 60 x 40
Aldms A04

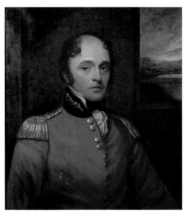

Brown, Mather 1761–1831
Purveyor, Army Medical Department 1800s
oil on canvas 29 x 24
448

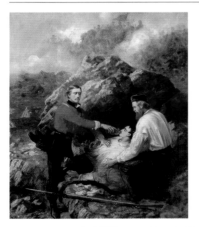

Desanges, Louis William 1822–c.1887
Assistant Surgeon H. Sylvester 1856
oil on canvas 47 x 39
725

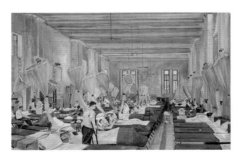

Frankewitz, Bruno 1897–1982
B Ward, 64th British General Hospital, Second World War 1942
oil on canvas 78 x 118
Aldms A06

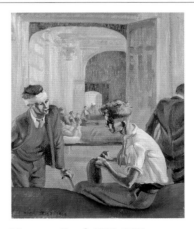

Newman, Beryl 1906–1991
Soldiers in Morton Hampstead Hospital, Second World War 1946
oil on canvas 75 x 62
2674

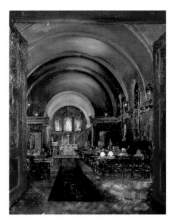

Robinson active 20th C
Queen Alexandra Military Hospital Chapel
oil on canvas 68 x 50
Aldms A05

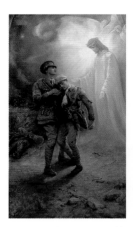

Swinstead, George Hillyard 1860–1926
White Comrade 1916
oil on canvas 74 x 41
Aldms A01

unknown artist
Hampton Massey mid-1800s
oil on canvas 29 x 24
1129

unknown artist
Arthur Martin Leake, VC 1920
oil on canvas 25 x 21
Aldms A02

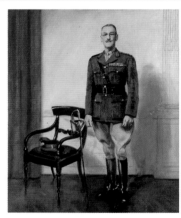

unknown artist
Colonel Alfred L. Robertson 1920s
oil on canvas 60 x 50
Aldms A03

Byfleet Heritage Society

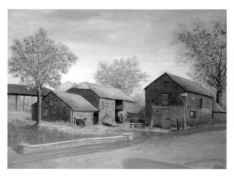

Bridgman, Marjorie
Foxlake Farm 1970
oil on hardboard 58 x 75.6
BHS742P

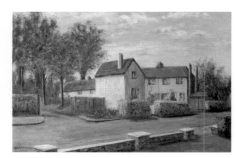

Henderson, H. B.
Stream Cottages 1970s
oil on hardboard 50 x 76.2
BHS743P

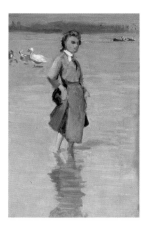

Fisher, Percy Harland 1867–1944
Paddling 1903–1944
oil on board 28.5 x 18.3
SHM/1996.34/3

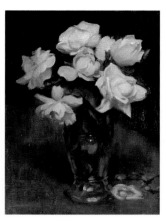

Fisher, Percy Harland 1867–1944
Roses in a Vase 1903–1944
oil on canvas 44.4 x 33
SHM/1992.43

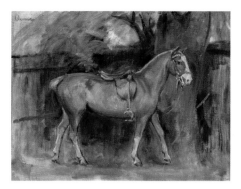

Fisher, Percy Harland 1867–1944
The Chestnut Hunter 1903–1944
oil on board 28 x 34.9
SHM/1996.34/4

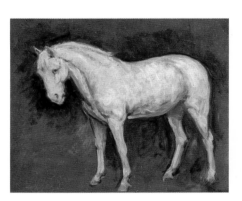

Fisher, Percy Harland 1867–1944
The Grey Horse (recto) 1903–1944
oil on board 31.2 x 37.8
SHM/1996.34/9

Fisher, Percy Harland 1867–1944
Lion Standing on Rock (verso)
oil or tempera on board 30.4 x 22
SHM/1996.34/1/b

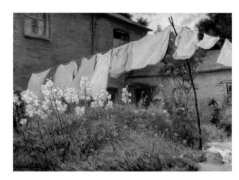

Fisher, Percy Harland 1867–1944
Washing on the Line 1903–1944
oil on canvas 49 x 65.8
SHM/1991.6

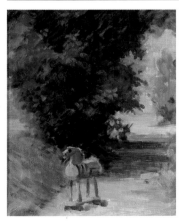

Fisher, Percy Harland 1867–1944
Dobbin on the Path (The Wooden Horse)
1910–1920
oil on panel 27.9 x 23.2
SHM/1996.34/66

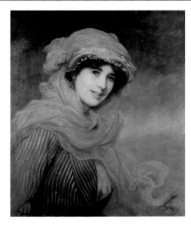

Fisher, Percy Harland 1867–1944
The Blue Veil 1911
oil on canvas 75 x 62.5
SHM/2000.24/2

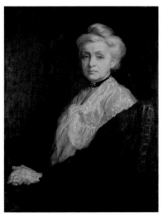

Fisher, Percy Harland 1867–1944
Mrs Hudson c.1911
oil on canvas 96 x 70.5
SHM/2000.24/1

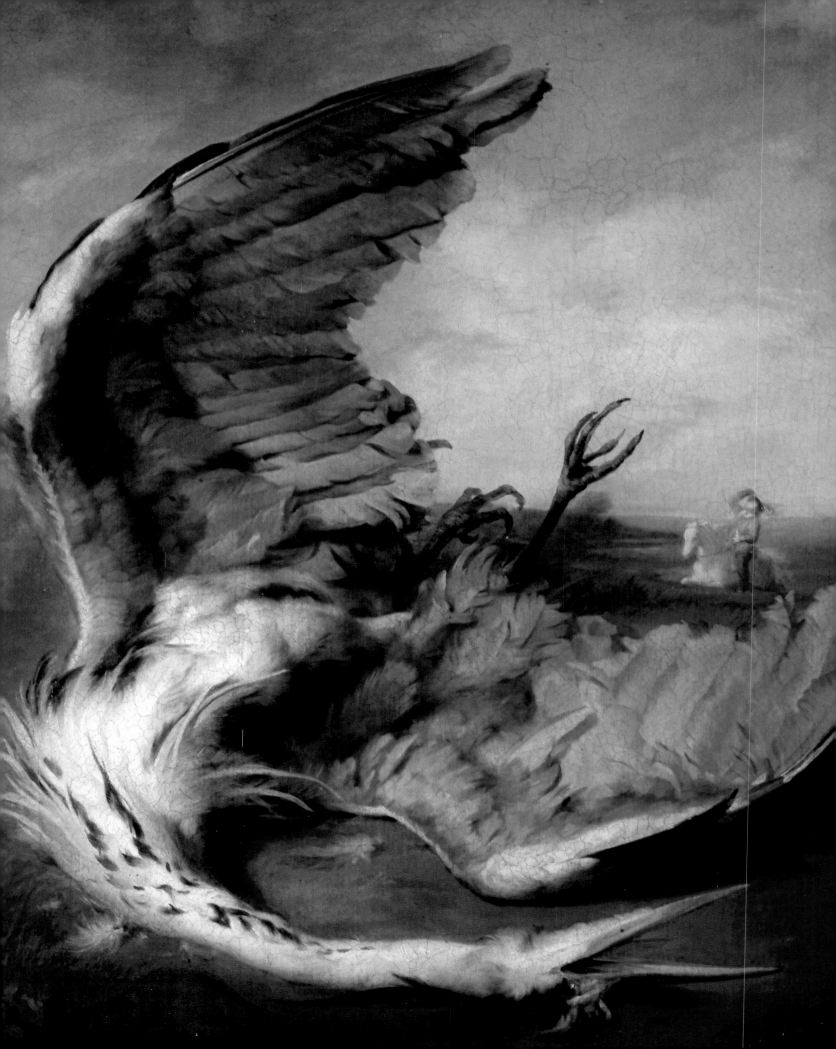

Fisher, Percy Harland 1867–1944
Anthony on a Swing (Boy on a Swing) (recto)
1915–1920
oil on board 30 x 22
SHM/1992.26/1

Fisher, Percy Harland 1867–1944
Leaves (verso)
oil on board 16.3 x 25.5
SHM/1992.26/1/b

Fisher, Percy Harland 1867–1944
Temptation (The Gypsy Girl) 1930s
oil on canvas 69.5 x 54
SHM/1992.14

Fisher, Percy Harland 1867–1944
Italian Fruit Stall
oil on canvas 25 x 16.4
SHM/1996.34/2

Fisher, Percy Harland 1867–1944
Porch, Side of House and Tree
oil on board 35.2 x 28.8
SHM/1992.9/b

Fisher, Percy Harland 1867–1944
Rushes (recto)
oil on board 27 x 36.2
SHM/1996.34/1

Fisher, Percy Harland 1867–1944
Study of Female Head: Grisaille (verso)
oil on board 33.2 x 27
SHM/1996.34/9/b

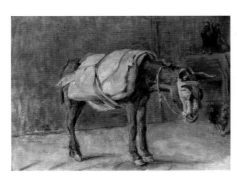

Fisher, Percy Harland 1867–1944
The Italian Donkey
oil on board 18.5 x 25.8
SHM/1996.34/5

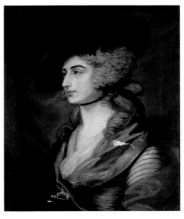

Gainsborough, Thomas (after) 1727–1788
Mrs Siddons
oil on canvas 74.5 x 62
SHM.1985.6/2

Facing page: Watts, George Frederick, 1817–1904, *The Wounded Heron* (detail), 1837, Watts Gallery, (p. 136)

Graham, Nora active 1990s
Basingstoke Canal 1994
oil on canvas 39.5 x 49.5
SHM/1994.18/2

Green, Phillip active 1980s–1990s
Graduations 1989
acrylic on board 62.2 x 75
SHM/989.18

Hadlow, Pauline
Puppet Magic 1989
mixed media 19 x 16
SHM 1989/22

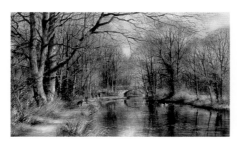

Harrison, Terry b.1947
King's Head Bridge, Basingstoke Canal 1989
acrylic on paper? 42.5 x 70.8
SHM/1989.70

Hill, O. F.
Civic Hall 1965
oil on board 38.2 x 53.5
RC 83

Holmes, Betty
Newstead, Camberley Museum 1971
oil on board 23 x 45
RC 82

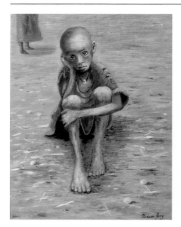

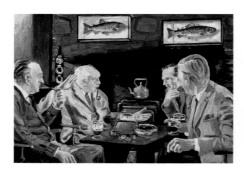

Jory, Miriam b.1933
Despair (A Boy in Somalia, 1993) 1994
acrylic on board 44 x 34
SHM/1994.5

Lomas, Rod active 1970s–1980s
Fisherman's Tale 1989
oil on canvas 23 x 33
SHM/1989.8

Perry, Roy 1935–1993
Camberley Library late 1960s–1970s
acrylic on paper 37.4 x 54.2
CM 2

Perry, Roy 1935–1993
Chobham Churchyard 1970–1980
acrylic on canvas 49.5 x 75
CM 3

Perry, Roy 1935–1993
Wells Bakery 1970–1980
acrylic? on paper? 37.5 x 54
CM4

Perry, Roy 1935–1993
High Street, Camberley c.1970
acrylic on board 24 x 29.2
IR 288

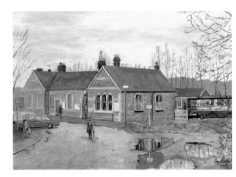

Perry, Roy 1935–1993
Chobham Church from the Cricket Field
c.1980
acrylic? 44.2 x 64.5
CM 1

Rice, B. A.
Chobham Common c.1990
acrylic on board 14.3 x 26.5
SHM/1990.53

Sams, Ian b.1945
Frimley Station c.1989
oil on canvas 29 x 39.5
SHM/1989.31

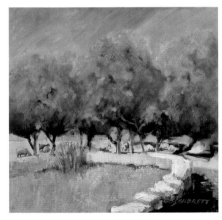

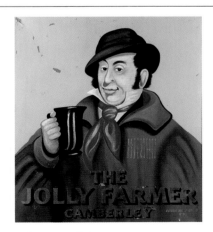

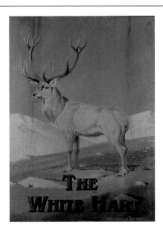

Scandrett, Graham active 1960s–2006
Olive Grove with Goats, Crete 1990–1995
oil on board 29 x 29
SHM 1995.5/2

unknown artist
Signboard from 'The Jolly Farmer' Pub, Side 1
1875–1944
enamel? mix on metal 89 x 79
SHM/1996.59

unknown artist
Signboard from 'The White Hart' Pub: Front
1875–1944
oil? on metal 115 x 80
SHM/1997.76

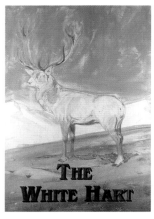

unknown artist
Signboard from 'The White Hart' Pub: Back
1875–1944
oil? on metal 115 x 80
SHM/1997.76/b

unknown artist mid-19th C
Frimley Heath
oil on canvas 104.5 x 195
SHM/1985.6/1

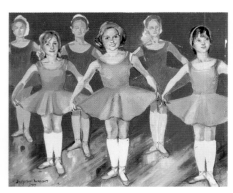

Wright, Dorothy 1910–1996
Elmhurst Ballet School 1977
oil on board 25.2 x 30.4
SHM/1989.29

The Royal Logistic Corps Museum

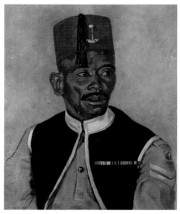

Archdale, W. M.
Audu Doso of the Nigeria Military Forces 1957
oil on canvas 53 x 43
CAYLC:RCT:1522.01

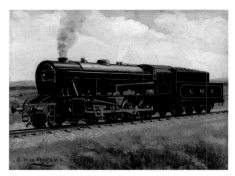

Ellis, Cuthbert Hamilton 1909–1987
McMullen Steam Engine c.1950
oil on wood 28 x 37
CAYLC:RCT:0624.23

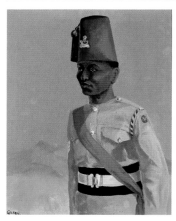

Gilson, J.
*Soldier of the King's African Rifles, Ceremonial
Dress* 1962
oil on canvas 53 x 45
CAYLC:RCT:1522.02

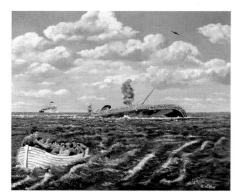

May, Robert W.
The 'Lancastria', 17 June 1940 1968
oil on canvas 53 x 62
CAYLC:RCT:0731

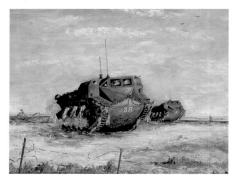

Nicoll, John
*Tracked Amphibian Neptunes, Kabrit, Little
Bitter Lake, 1947* c.1950
oil on canvas 34 x 42
CAYLC:T:0883

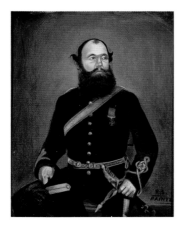

Painter, R. S.
John Buckley, VC (1813–1876), Deputy Assistant Commissary of Ordnance, Bengal
oil on paper 19.5 x 15
CAYLC:RAOC:0211

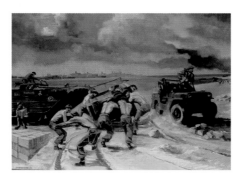

Redgrove
DUKWs Unloading Supplies, D-Day, 6 June 1944 1955
oil on canvas 92 x 122
CAYLC:RCT:1833.01

Reynolds, Joshua (after) 1723–1792
John Manners, Marquis of Granby
oil on canvas 84 x 72.5
CAYLC:RAOC: 2013

Shotter, R.
Portrait of an Unknown Gentleman
oil on canvas 50.5 x 40.5
CAYLC:NN0354

Summerville, D.
Diamond 'T' Recovering Tank on Battlefield, North Africa 1985
oil on canvas 72 x 84
CAYLC:RCT:1764

Wanklyn, Joan active 1956–1994
Horse of the Year Show, 1966 1966
oil on canvas 53.5 x 94
CAYLC:T:2213

Caterham Valley Library

Christie, Ernest C. 1863–1937
Sundials in Gardens 1927
oil on canvas 38 x 30
2 (P)

Christie, Ernest C. 1863–1937
Chaldon Church
oil on canvas 30 x 40
1 (P)

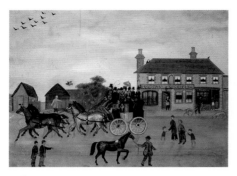

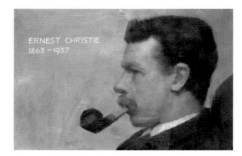

unknown artist
The Greyhound Public House, Caterham
c.1872
oil on canvas 44 x 57
4

unknown artist
Ernest Christie (1863–1937) c.1937
oil on board 16 x 23
3 (P)

East Surrey Museum

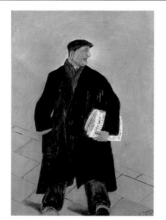

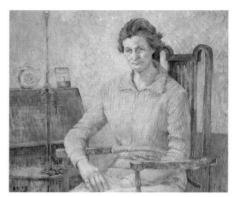

Adams, D.
Old Fred 1970
oil on board 41.5 x 29
CATES:3965

Curzon-Price, Paddy
Ruth Chaplin, OBE, in Retirement 1973
oil on board 52 x 61

MacLeod, Fay
The Clock in Queen's Park, Caterham 1955
oil on canvas 50 x 40.5
CATES:4279

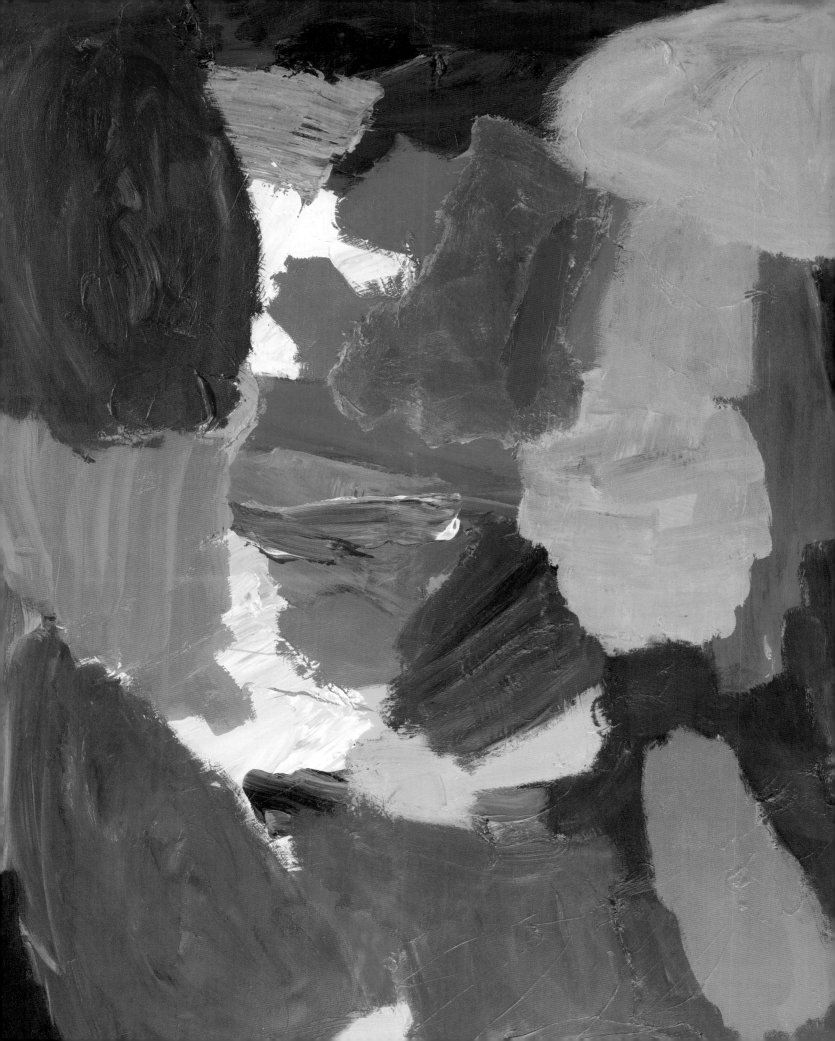

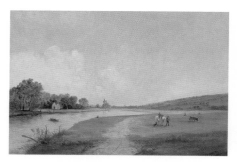

Pettitt, Charles 1831–1885
Magna Carta Island, Runnymede 1876
oil on canvas 35 x 55.5
Oa.018 (P)

Popesco, George b.1962
Mr Ron Taylor, Greengrocer, in His Shop at 8 Windsor Street, Chertsey 1990
oil on canvas 85.5 x 65
CHYMS.3231

Potter, Frank Huddlestone 1845–1887
Egham from Long Mede, Runnymede 1880
oil on canvas 59.3 x 82.5
Oa.158 (P)

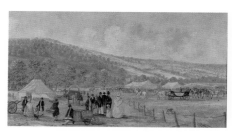

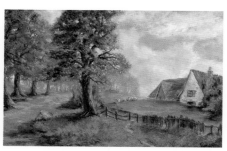

Robinson, Margaret J.
Self Portrait 1946
oil on canvas 69 x 58
CHYMS.2001.186

Spoade, John
William IV Arriving at Long Mede, Runnymede at the Point of the One Mile Winning Post
oil on canvas 42.5 x 73.5
O.1991.03 (P)

Tolles, W.
Cooper's Hill Farm, Priest Hill 1907
oil on canvas 31 x 47
O.1991.05 (P)

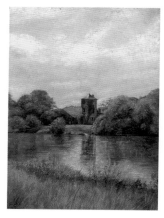

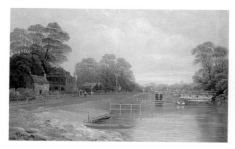

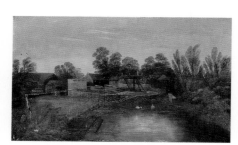

unknown artist
Cooper's Company Fishing Temple, Staines Lane c.1851
oil on canvas 61.5 x 46
Oa.013 (P)

unknown artist
'Angler's Rest' and Bell Weir c.1880
oil on canvas 40.5 x 61
O.064 (P)

unknown artist
William Gardan's Timber Wharf on the Western End of Church Island, Staines
oil on canvas 46 x 76
Oa.097 (P)

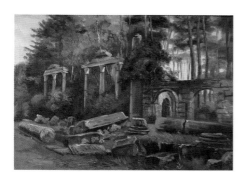

Vingoe, Francis b.1880
Ruins at Virginia Water 1905
oil on canvas 26 x 36
O.1986.22 (P)

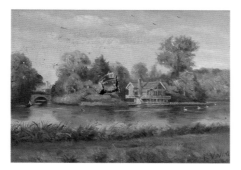

Vingoe, Francis b.1880
Virginia Water Tea House 1905
oil on canvas 26 x 36
O.1986.15 (P)

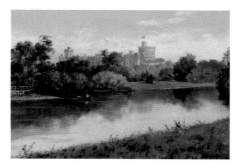

J. C. W.
View of Windsor Castle c.1900
oil on canvas 25.5 x 36
O.1986.14 (P)

Dorking and District Museum

Dorking Museum's collection of paintings in all mediums reflects the beautiful countryside which attracted artists to the area, and comprises the work of professional and amateur artists who have lived and worked in Dorking, even for a short period, and painted local scenes. Professional artists with their pupils would take up residence in the summer, returning to London to work in their studios during the winter months.

The actual collection of oil paintings, together with other artefacts, began soon after the Second World War when the idea of a museum was first proposed and donations began to be stored in cellars and attics all over the town. Numerous attempts were made to find suitable premises, but it was only in 1975 when the Mole Valley and District Council offered a small building consisting of two rooms (once part of the Old Foundry in West Street, Dorking) that the Museum came into existence. Owing to limited space very few of our paintings were hung, but in March 1983 and June 2001 a further two rooms were opened when a nearby building erected during the Second World War for the collection of waste paper became available, and these two expansions enabled us to more than treble the hanging space. Many of the oils painted in the nineteenth century had been badly stored and were in need of cleaning and restoration. In the millennium year, thanks to Mole Valley Council providing grants to commemorate the occasion, and the South Eastern Museums Service, we were able to have conservation work carried out on 22 of our oils. Fortunately, private donations enabled a further five paintings to be treated. It is our policy to hang all oils and we have only 14 smaller items stored in acid free boxes.

The two main artists represented in our Collection are John Beckett (1799–1864) and Alfred Charles Jerome Collins RBA, RCA (known as Charles Collins) (1851–1921). John Beckett was born in Dorking and began as a house painter and decorator, but was soon supporting himself by selling his paintings. His compositions were mostly landscapes of the area in the neighbourhood of

Dorking, and his legacy of depicting the town as it was in his day is very much appreciated by our visitors, as are his three pictures of the Medieval Church demolished in 1835.

Charles Collins came from a family of several generations of professional artists. He studied at the West London School of Art and first exhibited at the Royal Academy at the age of 16 when his family was living in Camden. He moved to Dorking in 1875 and was Art Master for many years at Dorking High School. He was very prolific, and as well as painting in oils, he produced works in a variety of media, including watercolour, etching and dry point. He also illustrated books and created a number of postcards for the publisher Ernest Nister. He exhibited at the Royal Academy, the Royal Society of Artists, the Royal Institute of Oil Painters and many other galleries in London and the provinces. He was also a very fine model engineer.

Two of the portraits in our Collection are some of our oldest works, the first being a small portrait of Major Peter Labilliere painted in 1780 by Joseph Wright (1756–1793). Labilliere was an eccentric character who lived in Dorking and when he died in 1800 was famously buried upside down on Box Hill because of his belief that the world was topsy-turvy and when the end came he would be the correct way up! He is also believed to have been involved in espionage with an American lady, Patience Wright, the mother of Joseph. In the same year that he painted this portrait, Joseph Wright finished one of the then Prince of Wales and on returning to America in 1782 had George Washington sit for him several times.

The second portrait is of William Broad (1759–1862), the well known Dorking coachman known as 'Hold Hard' because of his familiar cry as the horses took the strain of the coach as it departed on its daily return journey of 12 hours, from the 'Bulls' Head Inn', Dorking, to the 'Spread Eagle', Gracechurch Street, London. The Charles Dickens character Samuel Weller is said to be based on him. This portrait by an unknown artist hung for several years over the open fireplace of the 'Bulls' Head Inn' which still flourishes in South Street.

We look forward to a challenging future with the promise of a new larger museum and the exciting prospect of increasing our Collection.

Barbara Turnbull, Curator of Paintings

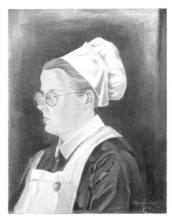

Assadourigil, H.
Sister Still 1938
oil on board 44.5 x 34
1794

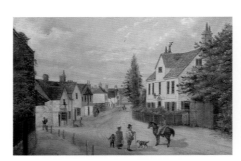

Beckett, John 1799–1864
Clarendon House, West Street, Dorking 1820
oil on wood panel 24.3 x 37
283

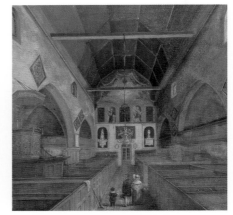

Beckett, John 1799–1864
St Martin's Medieval Nave, Dorking 1830
oil on cardboard panel 29.5 x 30.3
912

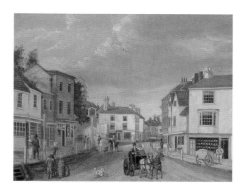

Beckett, John 1799–1864
South Street from Pump Corner, Dorking 1830
oil on canvas 36 x 45
277

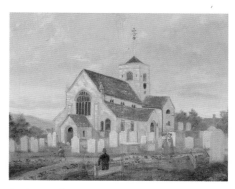

Beckett, John 1799–1864
St Martin's Medieval Church, Dorking 1835
oil on cardboard panel 24 x 30
279

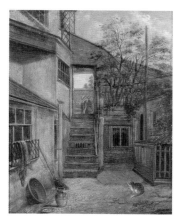

Beckett, John 1799–1864
Courtyard with Cat and Robin, South Street, Dorking 1852
oil on canvas 39 x 30
196

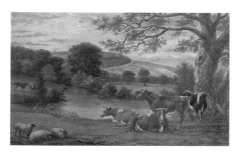

Beckett, John 1799–1864
Boxhill, River Mole and Cows, Dorking 1861
oil on wood panel 34.8 x 53.4
1617

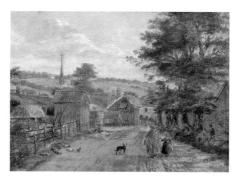

Beckett, John 1799–1864
Dene Street, Dorking 1863
oil on cardboard panel 24 x 32.4
278

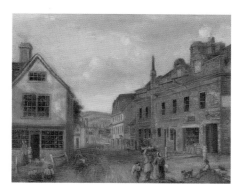

Beckett, John 1799–1864
Pump Corner, 'Queen's Arms', West Street, Dorking
oil on wooden panel 20.3 x 25
281

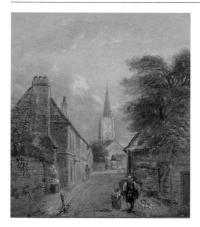

Beckett, John 1799–1864
St Martin's Intermediate Church, Dorking
oil on wood panel 17.5 x 15
1613

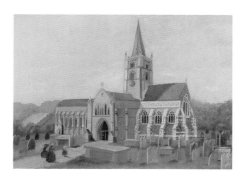

Beckett, John 1799–1864
St Martin's Intermediate Church Exterior, Dorking
oil on canvas 26.5 x 36.8
913

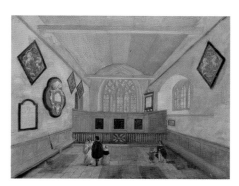

Beckett, John 1799–1864
St Martin's Medieval Chancel, Dorking
oil on wooden panel 26.3 x 34.4
911

Beckett, John 1799–1864
South Street, Dorking
oil on canvas 36.5 x 52
282

Beckett, John 1799–1864
'The Bull's Head', South Street, Dorking
oil on wooden panel 33.5 x 46
280

Beckett, John 1799–1864
Westcott Sandpits, Westcott, Surrey
oil on canvas 34.5 x 45
284

Box, Helena d.1914
Boxhill Mill, Dorking
oil on wood 19 x 36.5
380

Boxall, William 1862–1937
The Mill Pond, Dorking c.1880
oil on canvas covered board panel 27.5 x 44.5
285

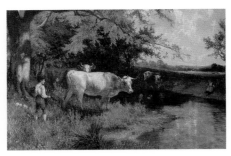

Collins, Charles II 1851–1921
*River Mole, Dorking with Cows and Two
Figures, Son Robert and Daughter Margaret*
c.1900
oil on canvas 59.5 x 90
302

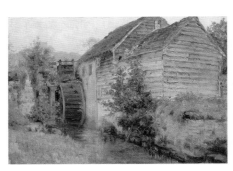

Collins, Charles II 1851–1921
Abinger Mill, Abinger, Surrey
oil on cardboard panel 29 x 42
303

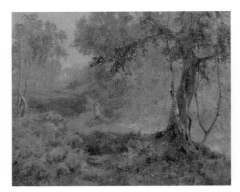

Collins, Charles II 1851–1921
'Autumn Gold', the Nower, Dorking
oil on canvas 62 x 76
1609

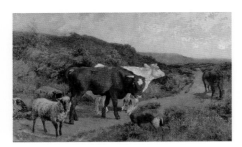

Collins, Charles II 1851–1921
Cattle and Dog on Common
oil on canvas 76 x 126.7
1023

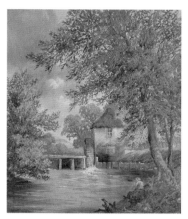

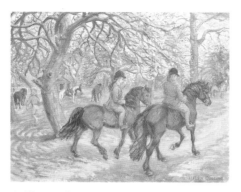

Collins, Charles II 1851–1921
*Old Castle Mill Pumping Station, Betchworth
Castle Gardens, Dorking*
oil on canvas 24 x 20
1458

Collins, Helen 1921–1990
Horses at a Riding School
oil on canvas 40.5 x 50.5
1025

Collins, Samuel William 1849–1892
*The Old Rest House, Hampstead Lane,
Dorking*
oil on wood 14 x 21.5
1646

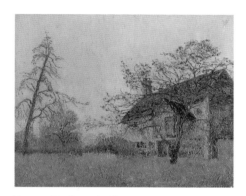

Daws, Philip b.1845
The Old Mill Pond, Netley, Shere, Surrey
oil on canvas 62 x 85
589

Drane, Herbert Cecil 1860–1932
*Garretts Ghyll (Shophouse Farm), Forest
Green, Surrey*
oil on canvas 29 x 44.5
985

Drane, Herbert Cecil 1860–1932
Waterlands Farm, Forest Green, Surrey
oil on canvas 34 x 42
984

C. F. G.
*Gate to Camilla Lacey, Mrs Ball's Cottage and
Barn Mission Room*
oil on wood 22 x 28
1787

Gibbs, Charles 1834–1910
Abinger Mill, Abinger, Surrey
oil on board 29.5 x 36.3
304

Harris, Alfred John 1835–1916
*Ranmore Common, Dorking, with Post Office
and Dispensary*
oil on canvas 25 x 35
1393

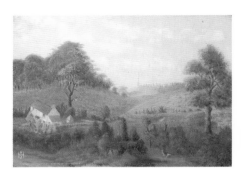

Harris, Alfred John 1835–1916
Shepherd's Cottage, Dunley Hill near Dorking
oil on canvas 25 x 35
1392

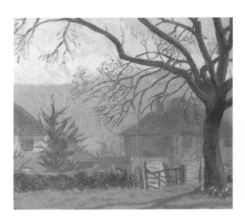

Harvey, Michael Anthony 1921–2000
Spring in Westhumble 1952
oil on wood panel 23.5 x 25
1760

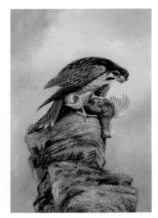

Jordan, Denham 1836–1920
Birds of Prey, Falcon and Dead Bird 1881
oil on canvas 77 x 51
169

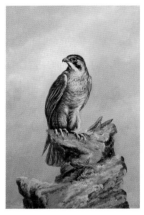

Jordan, Denham 1836–1920
Birds of Prey, Kestrel 1881
oil on canvas 77 x 51
180

Jordan, Denham 1836–1920
Exotic Bird 1912
oil on board 20.5 x 20.5
1837/98/D

Jordan, Denham 1836–1920
Exotic Bird on Branch and Flowers 1912
oil on board 20.5 x 20.5
1837/98/C

Jordan, Denham 1836–1920
Boar 1919
oil on board 19 x 19
1837/98/B

Jordan, Denham 1836–1920
Marsh Scene 1919
oil on board 16 x 19
1837/98/A

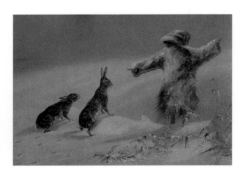

Jordan, Denham 1836–1920
Scarecrow and Two Hares
oil on board 40.5 x 57
460

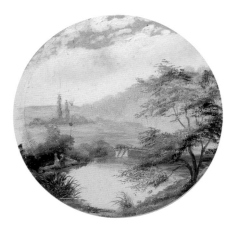

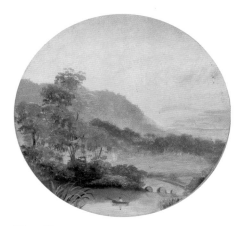

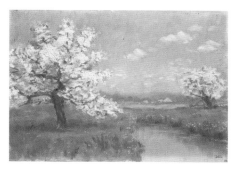

Kiste, Hans
Floodgate, Castle Mill, Dorking
oil on wood 15

1615

Kiste, Hans
The River Mole, Dorking
oil on wood 15

1614

Langdon, Dorothy b.1886
Flowering Tree on Water
oil on board 22 x 31

1427

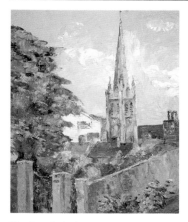

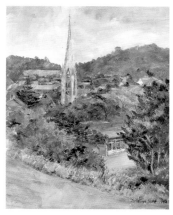

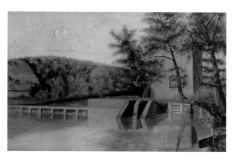

Neale, Christine active 1989–1992
St Martin's Church, Dorking 1989
oil on board 50 x 40

1612

Neale, Christine active 1989–1992
St Martin's Church, Dorking 1992
oil on board 50 x 40

1789

Rose, Walter John 1857–1954
*The Weir and Pump House at Betchworth
Castle Gardens (sometimes known as Boxhill
Mill)*
oil on board 19.3 x 29

1611

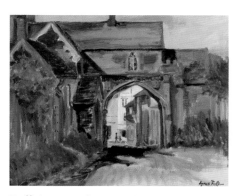

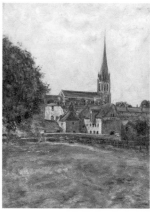

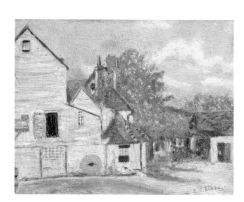

Ruff, Agnes active 1958–2001
Rose Hill Arch, Dorking 1971
oil on board 38 x 47

1768

Stokoe, Elizabeth Calvert active 1933–1937
St Martin's Church, Dorking 1933
oil on board 35 x 25

1610

Stokoe, Elizabeth Calvert active 1933–1937
Attlee Mill, Station Road, Dorking 1937
oil on board 22.5 x 27.5

1780

'Sunny', Batchelor
George Baker (Pompey) 1972
oil on board 50.5 x 40
1608

Todman
Young Girl in Punchbowl Lane (The Hollows)
oil on board 24 x 16.5
1123

unknown artist 19th C
Thomas Huggins, Aged 9, with Hoop and Dog,
Great Grandfather of William Huggins
oil on wood 22.5 x 14.5
1825/97

unknown artist 19th C
William Broad (1759–1862), Dorking
Coachman
oil on canvas 72 x 60.8
596

unknown artist late 19th C
Castle Mill, Dorking
oil on canvas 25.5 x 35
192

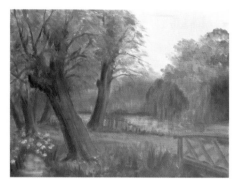

unknown artist
Willow Walk Painted from Garden of 10 Rothes
Road, Dorking 1965
oil on board 40.8 x 50.5
1643

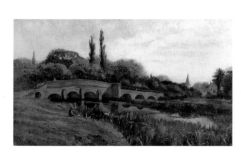

unknown artist
Brockham Bridge, Brockham, Surrey
oil on canvas 45 x 75
711

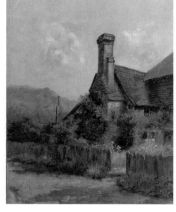

unknown artist
Granny Washington's Cottage, Junction Road,
Dorking
oil on canvas 44.5 x 34.8
1616

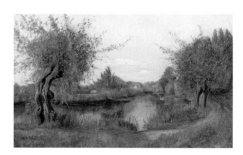

unknown artist
Willow Walk and Millpond, Dorking
oil on canvas 37.3 x 60.3
710

Facing page: Watts, George Frederick, 1817 –1904, *Self Portrait, Aged 17* (detail), 1834, Watts Gallery, (p. 135)

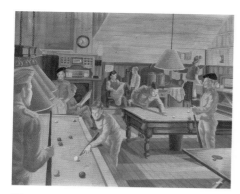

Warrenne, Joan (attributed to)
Canadian TOC H Social Club c.1939–1945
oil on canvas 45.5 x 55.5
199

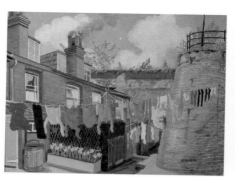

Watson, Stella d.1980s
Washing Day at Lyons Cottages, Dorking
1970s
oil on wood panel 38 x 49.8
1694

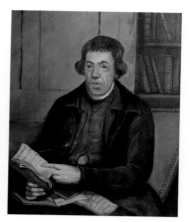

Wright, Joseph 1756–1793
Major Peter Labilliere (d.1800) 1780
oil on wood panel 25.4 x 21.6
115

Mole Valley District Council

Caffyn, Walter Wallor 1845–1898
In the Garden of the Grove, Boxhill
oil on canvas 90 x 70
20062

Hulk, Abraham 1813–1897
On the Mole 1886
oil on canvas 40 x 110 (E)
20063

Waite, Edward Wilkins 1854–1924
Shepherd and Flock in Wooded Landscape
1895
oil on canvas 135 x 113.5
20061

Egham Museum

Arnold, Harriet Gouldsmith c.1787–1863
River Thames with Fish Weir 1840
oil on canvas 20 x 35
PR77a

Arnold, Harriet Gouldsmith c.1787–1863
Magna Carta Island 1845
oil on canvas 20 x 35
PR87a

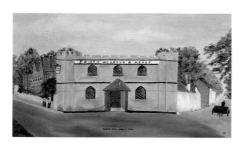

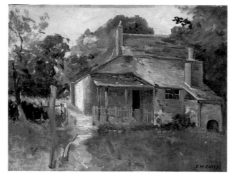

Body, A. M. active 1975–1982
'Castle Inn', 1910 1975
oil on board 29.7 x 48.2
PR108

Carey, Charles William 1862–1943
Mount Lee Farm
oil on canvas 39 x 49
PR42

Cleaver, James 1911–2003
Horse and Trap, Egham Show
oil on canvas 60 x 83
PR339

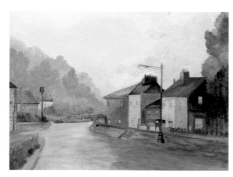

Cleaver, James 1911–2003
'King's Arms', Egham
oil on board 60 x 83
PR338

Cowdrey
Glanty Cottages
oil on board 39.5 x 53
PR48

Harris, Alfred John 1835–1916
Expecting the Grand Master 1894
oil on canvas 62.7 x 85.5
PR223

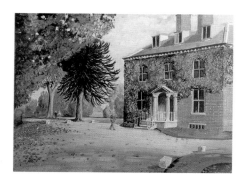

Hayward, J. F.
Rusham House 1958
oil on canvas 40 x 51.1
PR36

Holland, Doreen
Sunset at Longside Lake, Thorpe 1990
oil on canvas 50 x 39
PR323

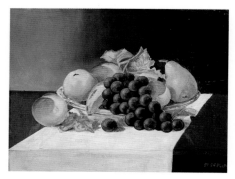

King, N. H.
Still Life: Fruit c.1950
oil on canvas 36.7 x 46.6
PR273

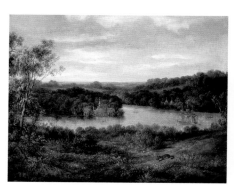

Nasmyth, Patrick 1787–1831
Virginia Water 1819
oil on board 14.5 x 18
PR306

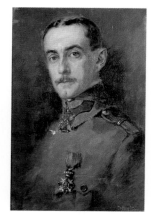

unknown artist
Baron Octave George Lecca
oil on canvas 74 x 51
PR142

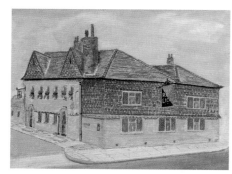

unknown artist
'Red Lion Inn', Egham
oil on board 33 x 40
PR95

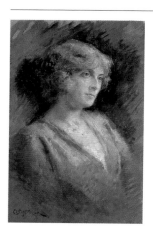

unknown artist
Vera Katherine Blackett
oil on canvas 65 x 41
PR141

Royal Holloway, University of London

The spectacular facade of Royal Holloway is a familiar sight to motorists on the A30 between Egham and Sunningdale. Financed by the patent medicine millionaire, Thomas Holloway, it was designed by William Henry Crossland, who took the sixteenth-century Château de Chambord as his model, and opened as a college for women in 1886. No expense was spared. Solid, extravagant and richly decorated with sculpture, it stands as a monument to the wealth, optimism and spirit of philanthropy which so characterized the Victorian age. More famous even than the unique building is the collection of paintings which hangs in the College gallery in authentic High Victorian style, almost frame to frame and regardless of subject. It was assembled by Holloway in the last two years of his life, as the final educative touch to his generous endowment.

Heedless of cost, Holloway spent the equivalent, in today's terms, of several million on his collection. The importance he placed on it illustrates the Victorians' belief in art as the ultimate civilizing influence. Like literature, art could teach; not only in the obvious sense of portraying a moral lesson or illustrating an edifying text; but, in its own unique and inimitable way, through the medium of visual beauty. A picture collection of the first quality would provide the ultimate refining influence in Holloway's College for young ladies.

Virtually all the paintings were bought at Christie's, and the vast majority were modern. Holloway made his choice from the catalogues in consultation with his brother-in-law, George Martin, who did the bidding on his behalf. Amongst Holloway's purchases were some of the most important paintings of the period, including William Powell Frith's *The Railway Station* (1862), a panoramic view of the busy crowd at Paddington with the artist and his family in the centre-foreground. It is the most potent and revealing image ever painted of Victorian urban life; and no painting has been more admired or vilified. For the modernist critic Roger Fry, its mundane realism marked the lowest point to which Victorian art ever sunk: 'an artistic Sodom and Gomorrah', he called it. Frith, who expressed a healthy disdain for aesthetes, would have scorned such criticism. He knew that he was painting history in the making, and posterity has proved him right. As a visual social document and a repository of contemporary ideas, *The Railway Station* has few equals. It provides a stark contrast with another significant portrayal of contemporary life: Luke Fildes's *Casual Ward* (1874) – the toughest pictorial statement ever made on Victorian urban poverty and homelessness. It caused a sensation at the Royal Academy of 1874 and was voted picture of the year by popular assent. Fildes was the acknowledged leader of a group of artists who emerged independently in the 1870s, and whose direct engagement with the problems of the day earned them the title of the Social Realists. Frank Holl's *Newgate* (1878) is another masterpiece in this category. Painted from studies made in Newgate itself, it demonstrates the tenuous hold of the poor on respectability and the means of survival, both of which are instantly under threat when the breadwinner turns to crime.

Most Victorians preferred historical subjects to portrayals of their own time. Supreme amongst those at Royal Holloway is John Millais's *Princes in the*

Tower (1878); a masterly exercise in psychological drama which once adorned every child's history book. Daniel Maclise's *Peter the Great at Deptford Dockyard* (1857) is far more elaborate. It was based on contemporary accounts, and depends on an accumulation of historical detail to illustrate an episode from the period when the Russian Emperor visited England in order to learn how to construct his own navy. The contrast between the energetic figure of Peter, engaged in carpentry, and the refined and elegant form of William III, is the dramatic point of the picture. The largest painting in the Collection – Edwin Long's *Babylonian Marriage Market* (1875) is a meticulous archaeological reconstruction of the ancient world. Every detail was supplied by the Assyrian Galleries at the British Museum, and by published books by Austen Henry Layard and others on the excavations at Nineveh and other sites. The subject – young girls being auctioned in the market place, in order of beauty – may seem an odd choice for a college for well-bred young ladies; but critics agreed that the artist had handled the subject with irreproachable delicacy.

Holloway also secured two of the most celebrated animal paintings of the period. Briton Riviere unashamedly played to the gallery with *Sympathy* (1877); which shows his woeful little daughter being comforted by her pet bull terrier. Landseer, on the other hand, courted controversy with *Man Proposes - God Disposes* (1864) – a bleak portrayal of polar bears tearing at the remnants of an abandoned ship: a scarcely veiled reference to Sir John Franklin's ill-fated expedition to the Northern Arctic some 20 years previously. It may also be read as an image of the helplessness of man, and the ultimate decline and wreckage of all civilizations.

The cherished notion of an unspoiled countryside, and the continuity of traditional peasant and Highland life, is celebrated in landscape and figurative works by artists as distinguished as John Brett, Thomas Creswick, Thomas Faed, Benjamin W. Leader, John Linnell and John McWhirter. The much travelled Holloway, whose patent medicines reached the remotest corners of the world, also acquired scenes of favourite Continental destinations including Cairo, Venice, the Austrian Alps, Switzerland, the Pyrenees and Turkey. James Holland's view of Verona (1844), William J. Muller's *Tomb in the Water, Telmessus, Lycia* and Ludwig Munthe's Norwegian *Snow Scene* (1873) are particularly fine examples in this category.

Pride in Britain's naval and trading prowess is evident in numerous depictions of ships, harbours and dockyards; and the more negative aspect of native bull-dog pugnacity is celebrated in George Morland's portrayal of a press-gang in action. Clarkson Stanfield, whose contributions to the collection include a battle scene from the Napoleonic Wars, was himself press-ganged into the Royal Navy in 1812. Stanfield's ability to cover huge canvases at speed was aided by his time as a scene painter at Drury Lane Theatre – a task he shared with another great artist, David Roberts, whose *Pilgrims Approaching Jerusalem* (1841) is among Holloway's most inspired purchases.

The College also has a distinguished and varied secondary collection. This includes a large and impressive landscape by Sir David Murray, *Spring in the Alps*, which was exhibited as *Spring Blossoms to the Mountain Snows* at the RA in 1910. There is also a small number of paintings in tempera, dating from the turn of the twentieth century when the medium underwent a major revival in England. Most are high quality copies of early Renaissance paintings by Lady

Christiana Herringham, an expert in the field, and founder member of the Tempera Society in 1901. Another of her copies, in oils, of Gherardo di Giovanni's *Battle of Love and Chastity* (circa late fifteenth century, National Gallery, London), is perhaps the finest of all. *The Garden of the Slothful* (c.1901) by Margaret Gere, who was also active in the tempera revival, is a highly personal and charming interpretation of two verses from Proverbs.

The Herringham Collection, some portraits and other artworks, came with the merger of Bedford College with Royal Holloway in 1985. The College owns a number of outstanding portraits, including two by one of the most celebrated of all early-twentieth-century portrait painters, Philip De Laszlo. There are other major examples by Sir William Orpen, Sir Hubert von Herkomer (renowned as a Social Realist as well as a portrait painter), Sir James Shannon, David Jagger and Sir Herbert James Gunn. The tradition of commissioning portraits continues, and more recent examples include works by Sir Lawrence Gowing, Peter Greenham, Paul Brason and Louise Riley-Smith.

In 2001 the College was the recipient of an anonymous donation of ten contemporary paintings dating from the 1980s. These hang in the award-winning International Building, which was completed in 1999. They include John Bratby's *Washline, Little Bridge* (1989), Jon Groom's *Moorish House V*, and abstracts by Jeremy Annear, Fred Pollock and Gary Wragg. Other benefactors have enabled the College to acquire contemporary works which range from the representational to installations and other conceptual works. The former include particularly fine examples by Louise Courtnell, Steven Hubbard and Clive Wilkins.

In current values, Holloway spent at least £50,000,000 on the building and the collection. He appreciated the civilizing effects of art and architecture and their role in education, and through them he created a fitting memorial to himself and his wife. Holloway died rightly confident that his generous gift would inspire generations of students and teachers; and that inspiration has also been shared by the numerous visitors who have flocked to the College since it first opened. Holloway would have approved that the College buildings – and the contemporary art collection – continue to expand; for the enterprising spirit and generosity which make this possible are very much in the tradition of the College's original founder.

Mary Cowling, Curator & Lecturer in History of Art

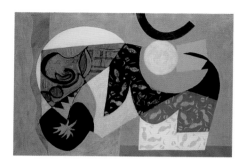

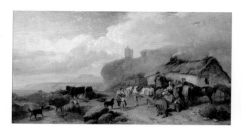

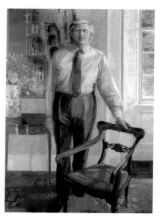

Annear, Jeremy b.1949
Untitled Abstract in Blue and Grey
oil on canvas 76.3 x 91.5
P1675

Ansdell, Richard 1815–1885
The Drover's Halt, Island of Mull in the Distance 1845
oil on canvas 96 x 181.5
THC001

Atherton, Linda b.1952
Professor Drummond Bone 2002
oil on canvas 137.1 x 96
P1694

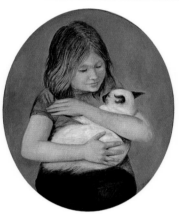

Atroshenko, Viacheslav 1935–1994
Musical Moment 1972
acrylic on canvas 152.4 x 182.8
P1695

Atroshenko, Viacheslav 1935–1994
New York I (of a series of six) 1978
acrylic on canvas 182.8 x 243.8
P1696

Backer
Girl with Siamese Cat c.1970
oil on canvas 58.5 x 48.3
P0443

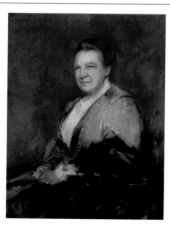

Bernhardt, Sarah 1844–1923
Le retour de l'église 1879
oil on board 38 x 22.8
P0492

Bigland, Percy 1858–1926
Henrietta Busk 1884?
oil on canvas 101.6 x 76.2
P0459

Brason, Paul b.1952
Professor Dorothy Wedderburn 1991
oil on canvas 91.5 x 76.2
P1551

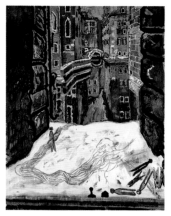

Bratby, John Randall 1928–1992
Washline, Little Bridge 1989
oil on canvas 122 x 91.5
P1672 🐝

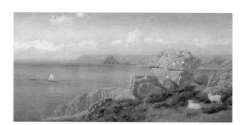

Brett, John 1830–1902
Carthillon Cliffs 1878
oil on canvas 45.7 x 91.4
THC002

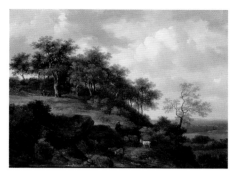

British School early 19th C
Wooded Landscape with Goat and Figures
oil on panel 35.5 x 47.8
P1010

British School 19th C
Thomas Holloway Senior (d.1836)
oil on canvas 81.3 x 63.5
P0460

British School late 19th C
Dame Emily Penrose (1858–1942)
oil on canvas 111.2 x 86.5
P0471

British School late 19th C
Mrs Louise d'Este Oliver (1850–1919)
oil on canvas 91.5 x 76.2
P0078

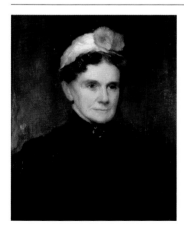

British School late 19th C
Mrs Maria Louisa Carlile (1826–1908)
oil on canvas 61.1 x 52
P0023

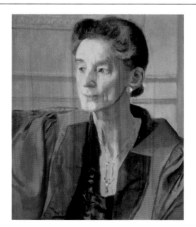

British School
Dr Nora L. Penston c.1964
oil on canvas 61 x 50.8
P1608

British School
Abstract Composition 1970s
acrylic on canvas 202.5 x 202.5
P1640

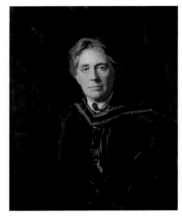

British School 20th C
Dame Margaret Janson Tuke (1862–1947)
oil on canvas 75.5 x 62.5
P0019

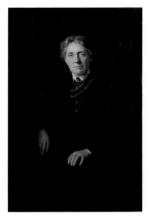

British School 20th C
Dame Margaret Janson Tuke (1862–1947)
oil on canvas 122 x 78
P0019A

British School late 20th C
Harbour
oil on canvas 50.8 x 40.6
P0405

British School late 20th C
Winter Landscape with Lake
oil on canvas 45 x 35
P1684

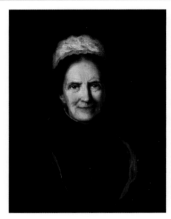

Bruce, H. A.
Miss Anna Swanwick (1813–1899)
oil on canvas 59.5 x 50
P0064

Bruce, H. A.
Miss Anna Swanwick (1813–1899)
oil on canvas 59.5 x 50 (E)
P1626

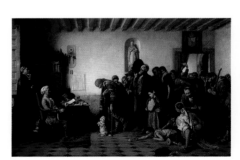

Burgess, John Bagnold 1830–1897
Licensing the Beggars in Spain 1877
oil on canvas 121.8 x 192.9
THC003

Butler, H. C.
Boats
oil on board 35 x 45
P0194

Butler, H. C.
Lakeside Landscape
oil on canvas 33 x 47
P0206

Facing page: Swedish School, *The Three Kings and the Wise and Foolish Virgins* (detail), c.1801–1828, Haslemere Educational Museum, (p. 171)

Carey, Charles William 1862–1943
Farm House, Mount Lee 1886
oil on canvas 34.2 x 44.4
P0210

Carey, Charles William 1862–1943
South East Corner of Royal Holloway College
1890
oil on canvas 22.8 x 35.5
P0787

Carey, Charles William 1862–1943
*South West Terrace Steps, Royal
Holloway* 1896
oil on canvas 50.8 x 61
P0205

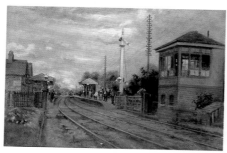

Carey, Charles William 1862–1943
Egham Station
oil on canvas 89 x 130
P0401 (P)

Chamberlain, Brenda 1912–1971
Seascape in Red 1959
oil on canvas 30.5 x 35.5
P1561

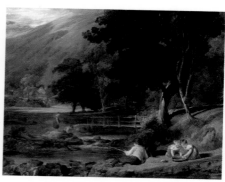

Collins, William 1788–1847
*Borrowdale, Cumberland, with Children
Playing by the Banks of a Brook* 1823
oil on canvas 86.3 x 111.7
THC004

Conti, Tito 1842–1924
Goodbye 1877
oil on canvas 63.4 x 45.7
THC007

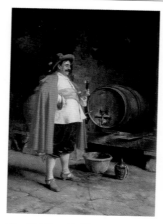

Conti, Tito 1842–1924
Approved
oil on panel 38 x 27.9
THC006

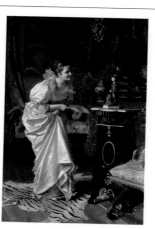

Conti, Tito 1842–1924
Paying Her Respects to His High Mightiness
oil on panel 44.4 x 31.7
THC005

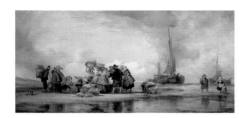

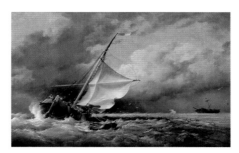

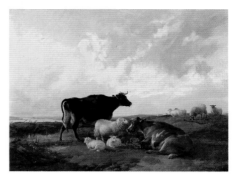

Cooke, Edward William 1811–1880
Scheveningen Beach 1839
oil on canvas 45.7 x 91.4
THC008

Cooke, Edward William 1811–1880
*A Dutch Beurtman Aground on the
Terschelling Sands, in the North Sea after a
Snowstorm* 1865
oil on canvas 106.6 x 167.5
THC009

Cooper, Thomas Sidney 1803–1902
Landscape with Cows and Sheep 1850
oil on canvas 63.4 x 81.2
THC0010

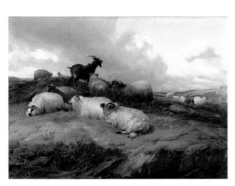

Cooper, Thomas Sidney 1803–1902
Landscape with Sheep and Goats 1856
oil on canvas 96.4 x 126.9
THC0011

Courtnell, Louise b.1963
Mr Shoa the Younger 1992
oil on canvas 68.5 x 53.3
P1622

Covey, Molly Sale 1880–1917
Portrait of an Elderly Gentleman
oil on canvas 50.8 x 35.5
P0457

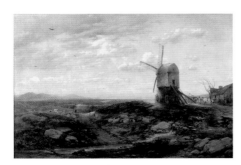

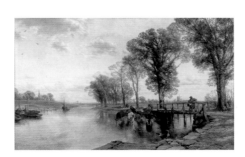

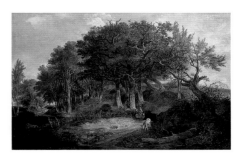

Creswick, Thomas 1811–1869
The First Glimpse of the Sea 1850
oil on canvas 101.5 x 152.3
THC0012

Creswick, Thomas 1811–1869
Trentside 1861
oil on canvas 114.2 x 182.8
THC0013

Crome, John (follower of) 1768–1821
A Woodland Scene 1813
oil on panel 78.7 x 121.9
THC0014

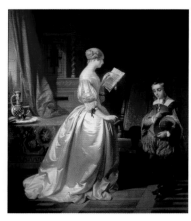

Daele, Charles van den d.1873
The Letter 1850
oil on panel 50.8 x 43.3
P1577

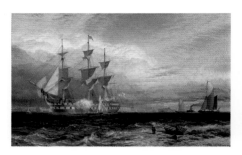

Dawson, Henry 1811–1878
Sheerness, Guardship Saluting 1875
oil on canvas 81.2 x 126.9
THC0015

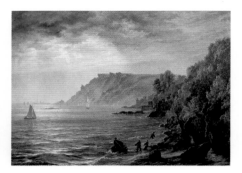

Dawson, Henry Thomas
1841/1842–after 1896
Salcombe Estuary, South Devon 1882
oil on canvas 76.1 x 106.6
THC0016

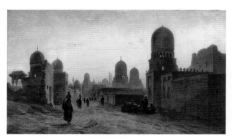

Dillon, Frank 1823–1909
Tombs of the Khedives in Old Cairo
oil on canvas 66 x 112
P0456

Dixon, G.
Seascape with Cliffs 1971
oil on board 28.5 x 39.5
P1688

Dodd, Francis 1874–1949
Dame Margaret Janson Tuke
(1862–1947) 1934
oil on canvas 63.5 x 50.8
P0020

Ellis, Edwin 1841–1895
The Harbour Bar
oil on canvas 40.6 x 76.1
THC0017

Elmore, Alfred 1815–1881
The Emperor Charles V at the Convent of St
Yuste 1856
oil on canvas 121.8 x 167.5
THC0018

Faed, Thomas 1826–1900
Taking Rest 1858
oil on canvas 83.7 x 63.4
THC0019

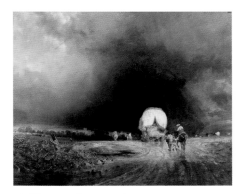

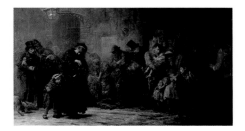

Fielding, Anthony V. C. 1787–1855
Travellers in a Storm, Approach to Winchester
1829
oil on canvas 101.5 x 126.9
THC0020

Fildes, Luke 1844–1927
Applicants for Admission to a Casual Ward
1874
oil on canvas 137.1 x 243.7
THC0021

Frith, William Powell 1819–1909
Sketch for 'The Railway Station' c.1860
oil on canvas 17.7 x 25.4
P0068

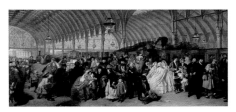

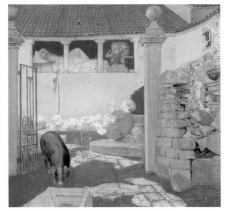

Frith, William Powell 1819–1909
The Railway Station 1862
oil on canvas 116.7 x 256.4
THC0022

Gere, Margaret 1878–1965
The Garden of the Slothful c.1901
tempera on silk mounted on panel 26 x 26
P1280

Girardot, Ernest Gustave 1840–1904
Jane Holloway (posthumous) 1882
oil on canvas 213.5 x 152.5
P1602

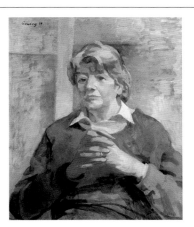

Girardot, Ernest Gustave 1840–1904
Thomas Holloway 1882
oil on canvas 213.5 x 152.5
P1601

Glindoni, Henry Gillard 1852–1913
The Musician 1876
oil on panel 45.8 x 35.8
P1578

Gowing, Lawrence 1918–1991
Mrs E. M. Chilvers 1984
oil on canvas 76.2 x 63.5
P1606

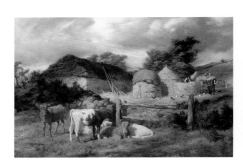

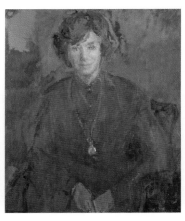

Graham, Peter 1836–1921
A Highland Croft 1873
oil on canvas 121.8 x 182.8
THC0023

Greenham, Peter 1909–1992
Professor Dorothy Wedderburn 1985
oil on canvas 76.2 x 63.5
P0063 🐝

Groom, Jon b.1953
The Moorish House, V
oil on canvas 157.5 x 152.5
P1678

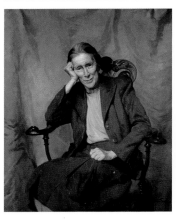

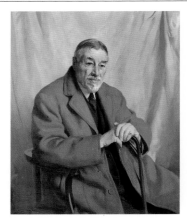

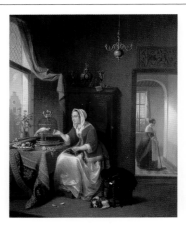

Gunn, Herbert James 1893–1964
Miss Geraldine E. M. Jebb, CBE 1952
oil on canvas 111.8 x 91.5
P1604

Gunn, Herbert James 1893–1964
*Sir Wilmot Herringham KCMG, CB, MD
(1855–1936)*
oil on canvas 132.1 x 91.5
P0079

Hamme, Alexis van 1818–1875
Feeding the Parrot 1860
oil on panel 53.3 x 44.4
P1579

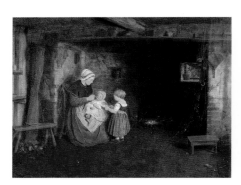

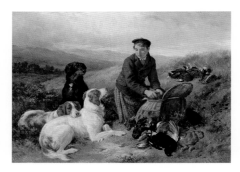

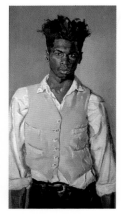

Hardy, Frederick Daniel 1826–1911
*Expectation: Interior of Cottage with Mother
and Children* 1854
oil on panel 22.8 x 30.4
THC0024

Hardy, James II 1832–1889
A Young Gillie, with Setters and Dead Game
1877
oil on canvas 71 x 99
THC0025

Haughton, Desmond b.1968
Self Portrait in a Yellow Waistcoat 1993
oil on canvas 81.3 x 45.7
P1620

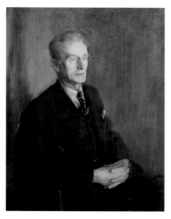

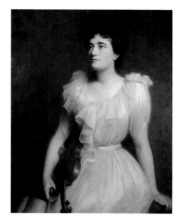

Hazelwood, David B. 1932–1994
Fluttering 1966
oil on canvas 83.5 x 22
P1697

Hepple, Norman 1908–1994
Sir Charles Tennyson, 1954
oil on canvas 101.6 x 76.2
P0080 🐝

Herkomer, Hubert von 1849–1914
Marie Douglas (Mrs Arthur Stothert)
oil on canvas 111.8 x 86.5
P0824

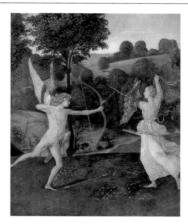

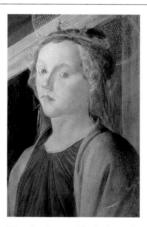

Herringham, Christiana Jane 1852–1929
Asphodel
oil on canvas 91.5 x 61
P0453

Herringham, Christiana Jane 1852–1929
Battle of Love and Chastity (after Gherardo di Giovanni del Fora)
oil on canvas 45.8 x 38
P1279

Herringham, Christiana Jane 1852–1929
Head of St Catherine (after Sandro Botticelli)
tempera on panel 45 x 28.5
P0145

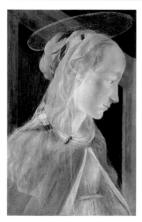

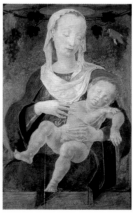

Herringham, Christiana Jane 1852–1929
Head of the Magdalene (after Sandro Botticelli)
tempera on panel 45 x 28.5
P0746

Herringham, Christiana Jane 1852–1929
Landscape with Farm
tempera on card 25 x 76.5
P15633

Herringham, Christiana Jane 1852–1929
Madonna and Child (after Cosmè Tura)
tempera on panel 62.5 x 42.5
P069A

Herringham, Christiana Jane 1852–1929
Pink Aquilegia, Yellow Foxgloves, Cow Parsley
oil on canvas 78.8 x 68.5
P1267

Herringham, Christiana Jane 1852–1929
Red Lilies on Blue Ground
oil on canvas 50.8 x 76.2
P1250

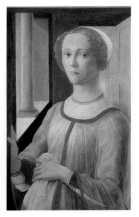

Herringham, Christiana Jane 1852–1929
Smeralda Bandinelli (after Sandro Botticelli)
tempera on panel 64.3 x 40.8
P0451

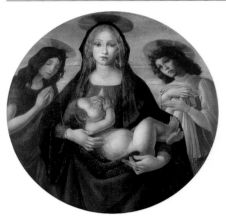

Herringham, Christiana Jane 1852–1929
Virgin and Child (after Sandro Botticelli)
oil on canvas 76.2
P1104

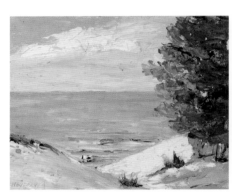

Heydorn, S.
Seascape
oil on card 20.3 x 24.8
P1687

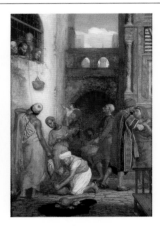

Hodgson, John Evan 1831–1895
Relatives in Bond 1877
oil on panel 93.9 x 66
THC0026

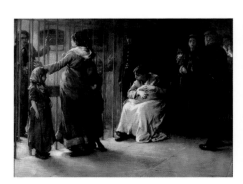

Holl, Frank 1845–1888
Newgate: Committed for Trial 1878
oil on canvas 152.3 x 210.7
THC0027

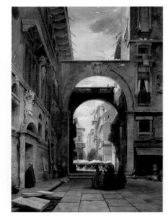

Holland, James 1800–1870
Piazza dei Signori, Verona, with the Market Place 1844
oil on canvas 101.5 x 76.1
THC0028

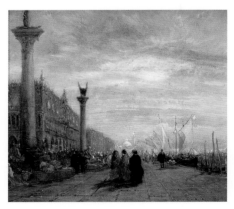

Holland, James 1800–1870
Venice, Piazza di San Marco 1850
oil on panel 22.8 x 27.9
THC0029

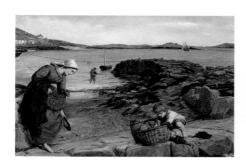

Hook, James Clarke 1819–1907
Leaving at Low Water 1863
oil on canvas 68.5 x 106.6
THC0030

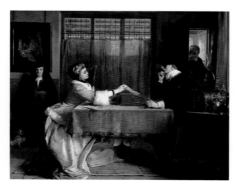

Horsley, John Callcott 1817–1903
The Banker's Private Room, Negotiating a Loan 1870
oil on canvas 101.5 x 126.9
THC0031

Hubbard, Steven b.1954
Self Portrait with Objects 1993
oil on canvas 91.5 x 61
P1623

Jagger, David 1891–1958
Miss Janet Ruth Bacon 1946
oil on canvas 76.2 x 63.5
P1612

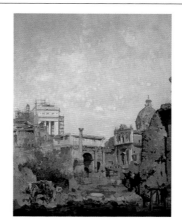

Kerr-Lawson, James 1865–1939
The Forum with the Arch of Constantine, Rome
oil on canvas 122 x 91.5
P0996

Kerr-Lawson, James 1865–1939
The Forum with Trajan's Column, Rome
oil on canvas 122 x 91.5
P0995

Koike, Masahiro
La fontaine 2003
oil on canvas 59 x 45.3
P1693

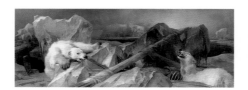

Landseer, Edwin Henry 1802–1873
Man Proposes, God Disposes 1864
oil on canvas 91.4 x 243.7
THC0032

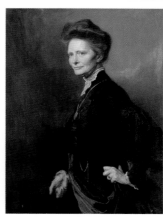

László, Philip Alexius de 1869–1937
Dame Emily Penrose (1858–1942) 1907
oil on canvas 116.8 x 91.5
P0471

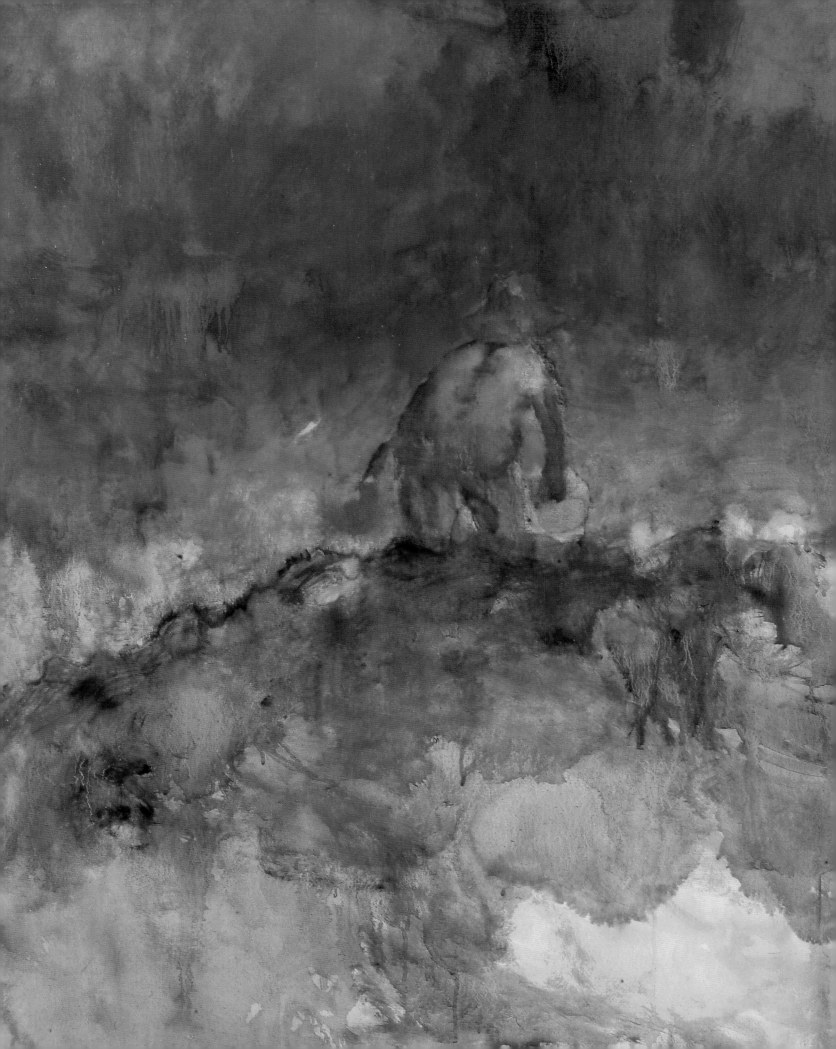

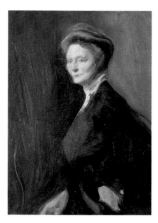

László, Philip Alexius de 1869–1937
Sketch for 'Dame Emily Penrose (1858–1942)'
1907
oil on canvas 34 x 24.3
P1683

László, Philip Alexius de 1869–1937
Elizabeth Maude Guinness 1910
oil on canvas 101.6 x 76.2
P1600

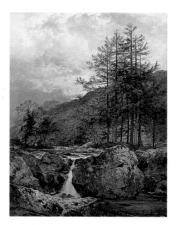

Leader, Benjamin Williams 1831–1923
The Rocky Bed of a Welsh River 1874
oil on canvas 121.8 x 91.4
THC0033

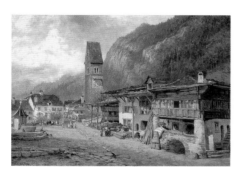

Leader, Benjamin Williams 1831–1923
Unterseen, Interlaken, Autumn in Switzerland
1878
oil on canvas 86.3 x 121.8
THC0034

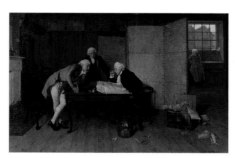

Leighton, Edmund Blair 1853–1922
A Flaw in the Title 1878
oil on canvas 60.9 x 91.4
THC0035

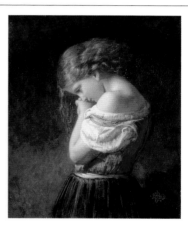

Lejeune, Henry 1820–1904
Early Sorrow 1869
oil on panel 30.4 x 25.3
THC0036

Leslie, Charles 1835–1890
Loch Katrine, Ellen's Isle 1879
oil on canvas 76.2 x 125.7
P1615

Linnell, John 1792–1882
Wayfarers 1849 & 1866
oil on canvas 71 x 91.4
THC0037

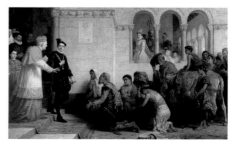

Long, Edwin 1829–1891
The Suppliants: Expulsion of the Gypsies from Spain 1872
oil on canvas 182.8 x 286.9
THC0038

Facing page: Muszynski, Leszek, b.1923, *Sunrise (triptych)* (detail), 1989, University of Surrey, (p. 123)

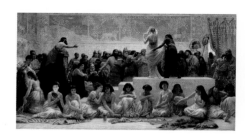

Long, Edwin 1829–1891
The Babylonian Marriage Market 1875
oil on canvas 172.6 x 304.6
THC0039

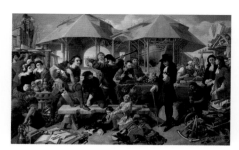

Maclise, Daniel 1806–1870
Peter the Great at Deptford Dockyard 1857
oil on canvas 152.3 x 243.7
THC0040

MacWhirter, John 1839–1911
'Night, most glorious night, thou wert not made for slumber' 1874
oil on canvas 99 x 165
THC0041

MacWhirter, John 1839–1911
Spindrift 1876
oil on canvas 81.2 x 142.1
THC0042

Mann, Joshua Hargrave Sams
active 1849–1884
The Cauld Blast 1876
oil on canvas 91.4 x 60.9
THC0043

Millais, John Everett 1829–1896
The Princes in the Tower 1878
oil on canvas 147.2 x 91.4
THC0044

Millais, John Everett 1829–1896
Princess Elizabeth in Prison at St James's 1879
oil on canvas 144.7 x 101.5
THC0045

Morland, George 1763–1804
The Cottage Door 1790
oil on panel 35.5 x 45.7
THC0046

Morland, George 1763–1804
The Press-Gang 1790
oil on panel 35.5 x 45.7
THC0047

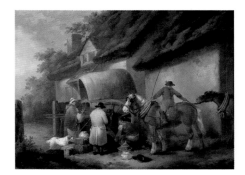

Morland, George 1763–1804
The Carrier Preparing to Set Out 1793
oil on canvas 86.3 x 116.7
THC0048

Morpurgo, Simonetta
Senigallia
oil on canvas 35.5 x 57
P0435

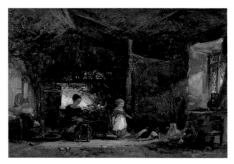

Müller, William James 1812–1845
Interior of a Cottage in Wales 1841
oil on panel 25.3 x 35.5
THC0049

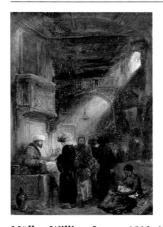

Müller, William James 1812–1845
Opium Stall 1841
oil on panel 40.6 x 27.9
THC0050

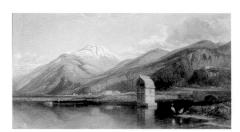

Müller, William James 1812–1845
Tomb in the Water, Telmessos, Lycia 1845
oil on canvas 76.1 x 137.1
THC0051

Munthe, Ludwig 1841–1896
Snow Scene 1873
oil on canvas 126.9 x 205.6
THC0052

Murray, David 1849–1933
Spring in the Alps (Spring Blossoms to the Mountain Snows) 1910
oil on canvas 137.1 x 167.8
P1614

Nash, John Northcote 1893–1977
Mountain Landscape with Distant Lake 1939
oil on canvas 61 x 76.2
P1029

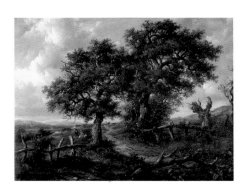

Nasmyth, Patrick 1787–1831
Landscape with Trees and Figures in the Foreground, a Church in the Distance 1830
oil on panel 30.4 x 40.6
THC0053

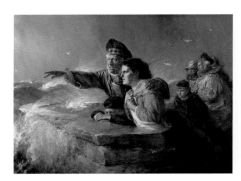

Nicol, Erskine 1825–1904
The Missing Boat 1876
oil on canvas 86.3 x 116.7
THC0054

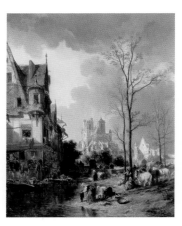

Noël, Jules Achille 1815–1881
Abbeville, with Peasants and Horses in the Foreground 1857
oil on panel 53.3 x 45.7
THC0055

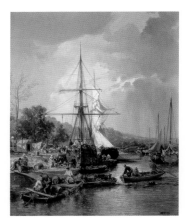

Noël, Jules Achille 1815–1881
The Quay, Hennebont, with Boats and Figures 1857
oil on panel 53.3 x 45.7
THC0056

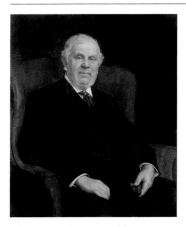

Olivier, Herbert Arnold 1861–1952
William James Russell (1830–1909)
oil on canvas 101.6 x 81.2
P0081

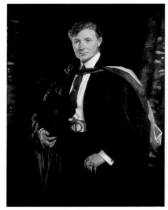

Orpen, William 1878–1931
Miss Ellen Charlotte Higgins 1926
oil on canvas 125.7 x 101.6
P1610

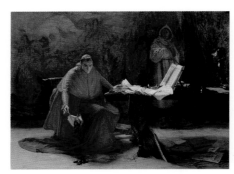

Pettie, John 1839–1893
A State Secret 1874
oil on panel 121.8 x 162.4
THC0057

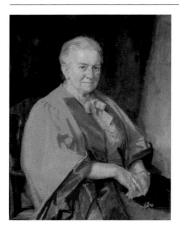

Phillips, Patrick Edward 1907–1976
Dr Edith Batho 1961
oil on canvas 91.5 x 71
P1611

Pollock, Fred b.1937
Trossachs Blossom 1996
oil on canvas 205 x 160
P1674

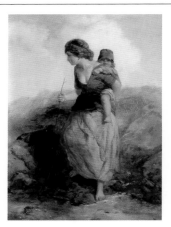

Poole, Paul Falconer 1807–1879
Crossing the Stream 1844
oil on panel 49.5 x 38
THC0058

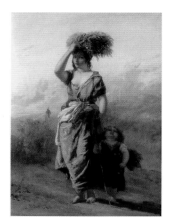

Poole, Paul Falconer 1807–1879
The Gleaner 1845
oil on canvas 48.2 x 38
THC0059

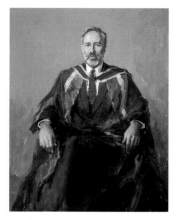

Poole, R. F.
Dr Roy Frank Miller c.1985
oil on canvas 122 x 91.5
P1553

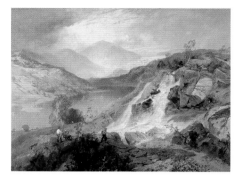

Pyne, James Baker 1800–1870
Haweswater from Waller Gill Force 1850
oil on canvas 83.7 x 111.7
THC0060

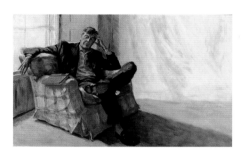

Riley-Smith, Louise b.1946
Norman Gowar 1999
oil on canvas 101.6 x 162.6
P1616

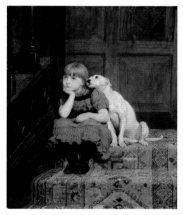

Riviere, Briton 1840–1920
Sympathy 1877
oil on canvas 121.8 x 101.5
THC0061

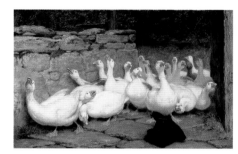

Riviere, Briton 1840–1920
An Anxious Moment 1878
oil on canvas 66 x 101.5
THC0062

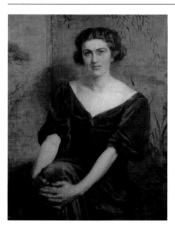

Riviere, Hugh Goldwin 1869–1956
Miss Peggy Wood 1935
oil on canvas 76.2 x 63.5
P1619

Roberts, David 1796–1864
Pilgrims Approaching Jerusalem 1841
oil on canvas 119.3 x 210.7
THC0063

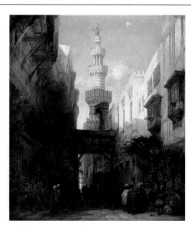

Roberts, David 1796–1864
A Street in Cairo 1846
oil on canvas 76.1 x 63.4
THC0064

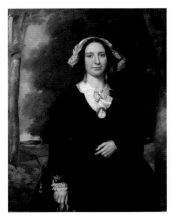

Scott, William Wallace 1795–1883
Jane Holloway 1845
oil on canvas 113 x 86.4
THC0066

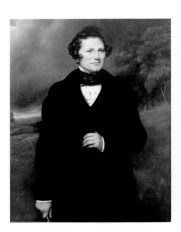

Scott, William Wallace 1795–1883
Thomas Holloway 1845
oil on canvas 115.6 x 83.8
THC0065

Scott-Moore, Elizabeth 1904–1993
Sir John Cameron (1903–1968) 1971
oil on canvas 76.2 x 61
P0065

Shannon, James Jebusa 1862–1923
Miss Matilda Ellen Bishop 1897
oil on canvas 125.7 x 101.6
P1609

Shephard, Rupert 1909–1992
Professor Lionel Butler 1983
oil on canvas 91.5 x 71
P1552

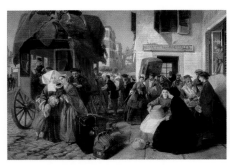

Solomon, Abraham 1824–1862
Departure of the Diligence 'Biarritz' 1862
oil on canvas 88.8 x 126.9
THC0067

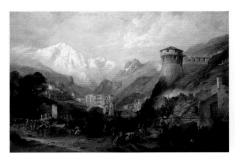

Stanfield, Clarkson 1793–1867
The Battle of Roveredo, 1796 1846
oil on canvas 182.8 x 274.2
THC0069

Stanfield, Clarkson 1793–1867
View of the Pic du Midi d'Ossau in the Pyrenees, with Brigands 1854
oil on canvas 213.2 x 152.3
THC0070

Stanfield, Clarkson 1793–1867
After a Storm
oil on millboard 21.5 x 33
THC0068

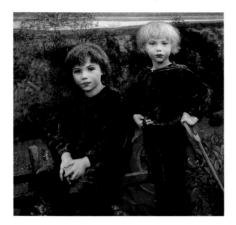

Swynnerton, Annie Louisa 1844–1933
Geoffrey and Christopher Herringham 1889
oil on canvas 91.5 x 91.5
P1367

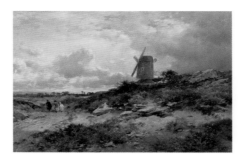

Syer, John 1815–1885
The Windmill 1878
oil on canvas 54.5 x 81.2
THC0071

Syer, John 1815–1885
Welsh Drovers 1878
oil on canvas 81.2 x 121.8
THC0072

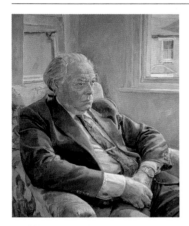

Todd, Daphne b.1947
Dr John Nicholson Black
oil on canvas 76.2 x 63.5
P1607

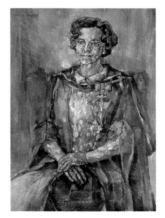

Tolansky, Ottilie 1912–1977
Dame Marjorie Williamson 1973
oil on canvas 106.8 x 76.2
P1613

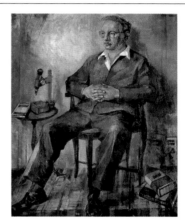

Tolansky, Ottilie 1912–1977
Professor Samuel Tolansky (d.1973)
oil on canvas 137.1 x 111.8
P1268

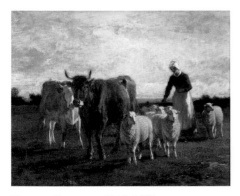

Troyon, Constant 1810–1865
Evening, Driving Cattle 1859
oil on canvas 66 x 88
THC0073

Webb, James c.1825–1895
Dordrecht before 1865
oil on canvas 22.8 x 35.5
THC0074

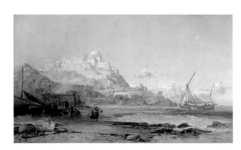

Webb, James c.1825–1895
Cartagena, Spain 1874
oil on canvas 76.1 x 126.9
THC0075

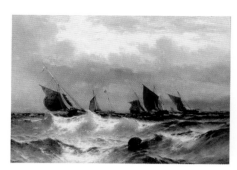

Weber, Theodor Alexander 1838–1907
Dover Pilot and Fishing Boats before 1882
oil on canvas 60 x 91.4
THC0076

Wells, Henry Tanworth 1828–1903
William Shaen 1877
oil on canvas 125.7 x 101.6
P0077

Wilkins, Clive
Woman with a Shielded Candle 1993
oil on board 20.3 x 17.7
P1621

Wragg, Gary b.1946
Medusa 1982
oil on canvas 253.5 x 176
P1671

Wragg, Gary b.1946
Blue Dragon 1984
oil on canvas 68.5 x 99
P1670

Epsom & Ewell
Borough Council

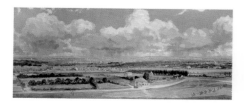

Birch, William Henry David 1895–1968
Epsom and Ewell from the Grandstand 1954
oil on canvas 54 x 125
2

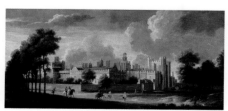

Danckerts, Hendrick (attributed to) 1625–
1680
Nonsuch Palace from the North East c.1666–
1679
oil on canvas 50 x 105
1

Esher Library

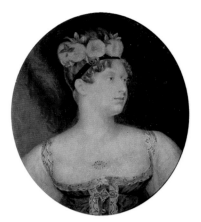

Dawe, George (copy of) 1781–1829
*Princess Charlotte Augusta of Wales
(1796–1817)* after 1816
oil on card 21 x 18
3

L. E. S.
Ember Lane, with a Woman and a Child
1890–1900
oil on canvas 29 x 44
1

H. W.
Preacher at Christchurch, Esher, Surrey
oil on canvas 30 x 25
2

Bourne Hall Museum

Cullerne, Rennie
Mill Lane, Ewell 1960s
oil on wood 30 x 36 (E)
1998.105

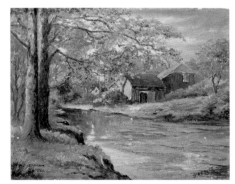

Pettit, D.
Lower Mill 1930s
oil on board 20 x 26
1990.140

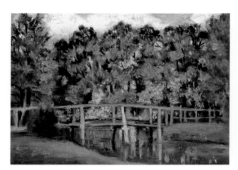

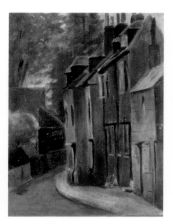

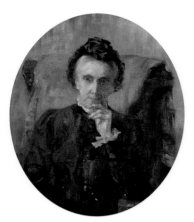

Stone, Helen C. 1884–1947
Bridge over the Hogsmill River, West Ewell
oil on canvas 27 x 36 (E)
1970.005

Stone, Helen C. 1884–1947
Old Cottages in West Ewell, Ewell
oil on canvas 40 x 26 (E)
1970.006

unknown artist
Mary Williams 1880s
oil on canvas 92 x 78 (E)
2002.017/002

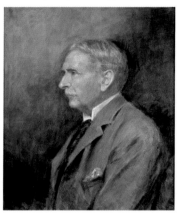

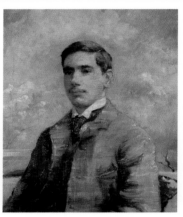

unknown artist
Sir Arthur Glyn 1880s
oil on canvas 82 x 72 (E)
2002.017/001

unknown artist
The Amato Inn c.1880s
oil on canvas 21 x 28
2005.040/014

unknown artist
Gervas Powell Glyn 1890s
oil on canvas 77 x 65 (E)
1990.135/005

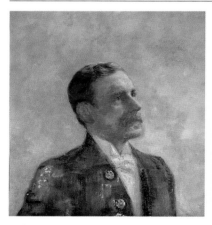

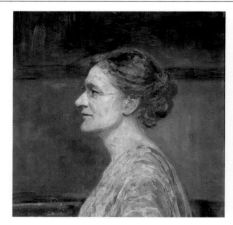

unknown artist
Gervas Powell Glyn 1900s
oil on canvas 57 x 53
1990.135/004

unknown artist
Margaret Glyn 1900s
oil on canvas 85 x 65
1990.135/006

unknown artist
Arthur Glyn 1910s
oil on canvas 60 x 46
1990.135/007

Facing page: Sime, Sidney Herbert, 1867–1941, *Woods and Dark Animals* (detail), Sidney H. Sime Memorial Gallery, (p. 233)

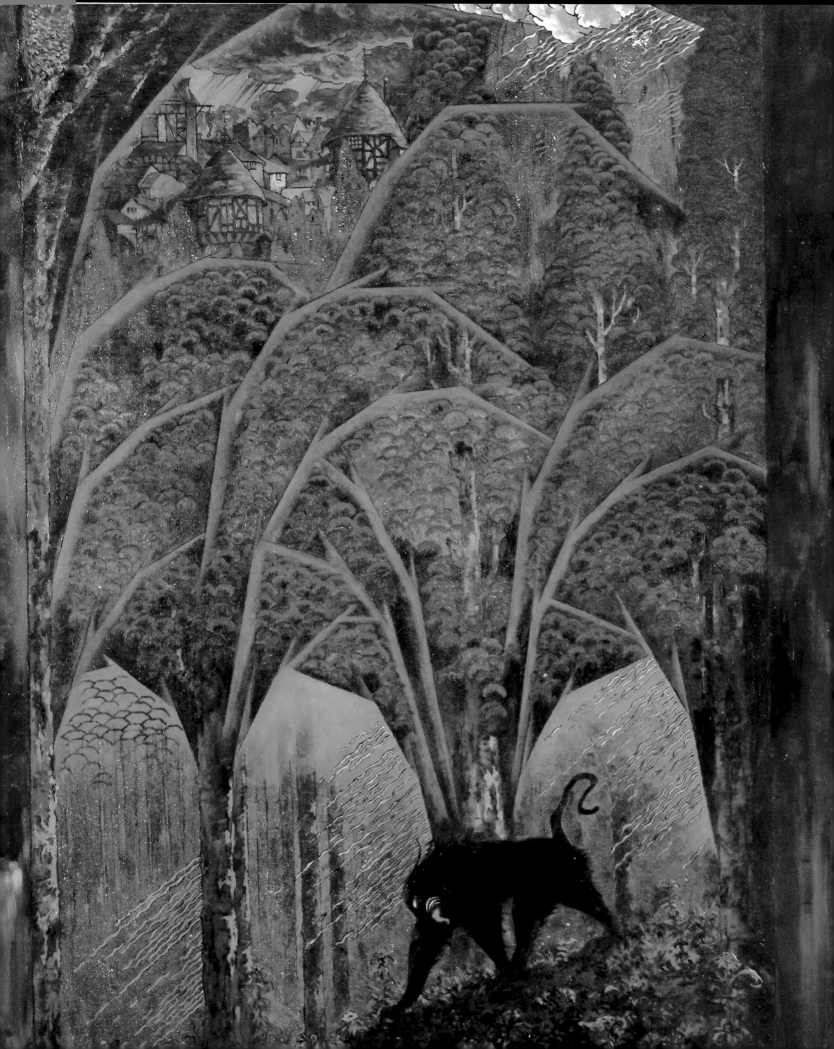

Ewell Court Library

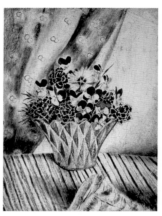

Langer, D.
As I Remembered, Ewell Court Grounds 1980s
oil on board 47 x 60
1

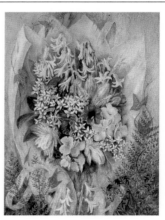

Langer, D.
As I Remembered, Hogsmill River 1980s
oil on board 49 x 60 (E)
2

Crafts Study Centre, University College for the Creative Arts

Larcher, Dorothy 1884–1952
Black Prince and Jackanapes c.1920–1930
oil on artboard 38 x 28
CSC.2006.19

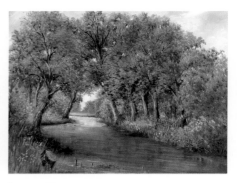

Larcher, Dorothy 1884–1952
Bunch for a Birthday 1945
tempera on gesso ground 40 x 29
CSC.2003.44

Farnham Maltings Association Limited

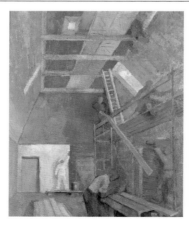

Anderson, Will
Kiln Conversion by DIY 1995
oil on board 59 x 49
FM3

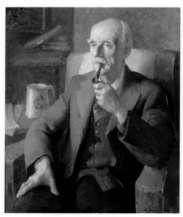

Bryson, Frank
Mr C. Biles 1950
oil on board 75 x 66
FM1

Krish, Raymond
The Philospher 1999
oil on board 91 x 34
FM2

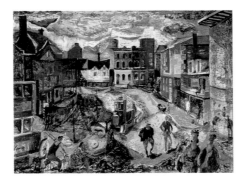

Verney, John 1913–1993
Castle Street, Farnham
oil on board 85 x 110
FM6

Verney, John 1913–1993
Pictures of Farnham
oil on board 43 x 73
FM4

Verney, John 1913–1993
Pictures of Farnham
oil on board 50 x 59
FM5

Museum of Farnham

The fine art Collection at the Museum of Farnham was started in 1961, when the Museum was first established. The Collection reflects the artistic heritage of Farnham, and its surrounding villages.

The fine art Collection contains works by prominent local artists, such as the eighteenth-century painter Stephen Elmer (c.1714–1796) who owned the building now occupied by the museum, but who lived and had his studio at a neighbouring property. Elmer was renowned in the eighteenth century for his skilful depiction of dead game. He was an Associate of the Royal Academy and exhibited there regularly from 1772 until his death. One contemporary critic favourably compared him with Stubbs, and his work adorned the walls of aristocratic homes throughout the country. The Museum of Farnham is thought to have one of the largest and finest collections of works by Elmer.

Another key figure in the artistic life of Farnham was William Herbert Allen (1863–1943). For many years he was Director of Farnham Art School, the forerunner of the University College for the Creative Arts at the Farnham Campus, which today enjoys an international reputation. Allen was strongly influenced by William Morris and was saddened by the rapid urbanisation at the turn of the twentieth century that was changing the face and character of the local landscape. He did his best to preserve the traditional local crafts and farming methods on paper and canvas, and he left a rich legacy of paintings, drawings and watercolours depicting the landscape of the Surrey and North Hampshire borders.

More recent works include a collection of paintings by John Verney (1913–1993). Born in London, Verney spent part of his childhood in India and served abroad with the SAS during the Second World War. He and his family settled in Farnham after the war, and for 30 years he was a familiar figure, tirelessly defending the town's heritage. Although he considered himself to be primarily an artist, Verney was also an accomplished author and illustrator. The Museum has been fortunate to acquire a number of his watercolours in recent years, most of which are on permanent display.

The Museum also owns four large murals by the New Zealand artist John Hutton (1906–1978) depicting women carrying out war work at the Crosby factory in Farnham. Hutton is probably better known for his engraved glass Great West Screen at Coventry Cathedral, but during the Second World War he was head of the Army School of Camouflage that was based at Farnham Castle. Hutton became friends with Basil Crosby who was in charge of the local bomb disposal squad and was invited to sketch the war work in progress at Crosby's factory. These sketches led Hutton to paint four heroic murals of the mainly female workforce making ammunition boxes, radio vans for use during the invasion of France and components for detonator boxes. The paintings were presented to Crosby's by the artist in 1946 and hung there in the staff canteen until the factory's closure in 1991. In that year, the owners of Crosby Sarek Ltd gave the paintings to the Museum in order to safeguard their long-term safety and ensure that they stay within the community. Because of the size of the murals the Museum was unable to display them, so they are on public display at the nearby Farnham Public Library.

Anne Jones, Curator

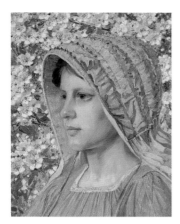

Allen, William Herbert 1863–1943
Bertha Clapshaw c.1900
oil on canvas 34 x 25.5
A980.5285

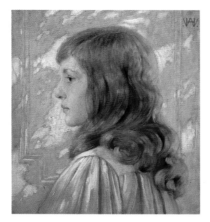

Allen, William Herbert 1863–1943
Winifred Clapshaw c.1900
oil on canvas 40 x 35
A980.5066

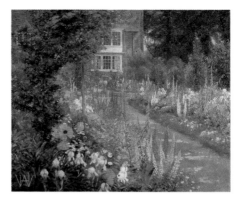

Allen, William Herbert 1863–1943
Stranger's Corner 1903
oil on canvas 102 x 120
A980.5158

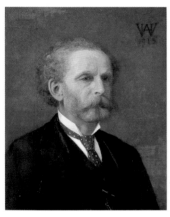

Allen, William Herbert 1863–1943
James Sydney Longhurst (d.1921) 1915
oil on canvas 57 x 44
609.2

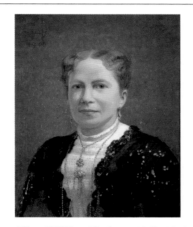

Allen, William Herbert 1863–1943
Phoebe Ellen Longhurst (d.1914) 1915
oil on canvas 58 x 44
609.1

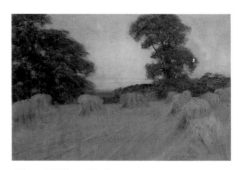

Allen, William Herbert 1863–1943
Harvest Field with Elms
oil on canvas 26.5 x 36.5
A979.710

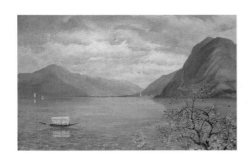

Allen, William Herbert 1863–1943
Italian Lake Scene
oil on canvas 35 x 52.5
A979.718

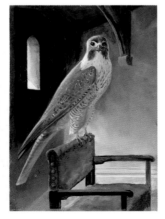

Booth, Ashton b.c.1925
Hawk 1971
oil on hardboard 34.5 x 23.5
A987.32

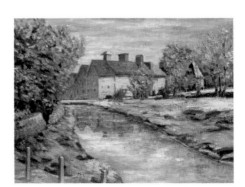

Brockman, Dale
The Maltings 1974
oil on hardboard 39.5 x 49.5
A991.29

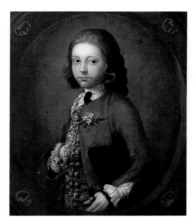

Elmer, Stephen c.1714–1796
Thomas Ashburne, Aged 11 Years 1735
oil on canvas 75 x 62.5
A996.25

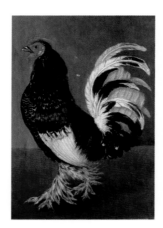

Elmer, Stephen c.1714–1796
A Cockerel Facing Left
oil on canvas 35 x 25
229-61

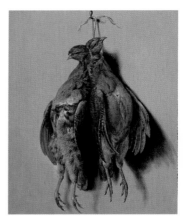

Elmer, Stephen c.1714–1796
Brace of Pheasant
oil on canvas 42 x 36
230-61

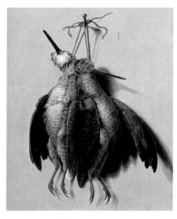

Elmer, Stephen c.1714–1796
Brace of Woodcock
oil on canvas 43 x 36
A979.2171

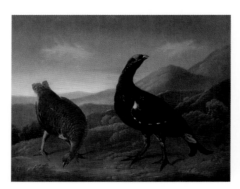

Elmer, Stephen c.1714–1796
Cock and Hen Black Grouse in Landscape
oil on canvas 61 x 74.5
A979.2111

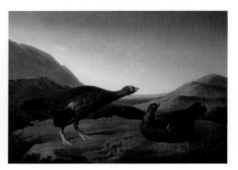

Elmer, Stephen c.1714–1796
Cock and Hen Red Grouse in Landscape
oil on canvas 62 x 75.5
A979.2115

Elmer, Stephen c.1714–1796
Dead Cock Pheasant
oil on canvas 80 x 61 (E)
227-61

Elmer, Stephen c.1714–1796
Dead Game with Pheasant
oil on canvas 62 x 74
A979.2175

Elmer, Stephen c.1714–1796
Dead Hare and Wild Fowl
oil on canvas 69.5 x 91
A980.5065

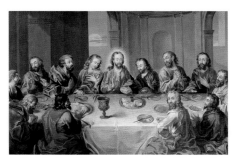

Elmer, Stephen c.1714–1796
Still Life with Pineapple and Other Fruit
oil on canvas 37 x 119
A979.2073

Elmer, Stephen c.1714–1796
The Last Supper
oil on canvas 150 x 191 (E)
A980.5619

Elmer, Stephen c.1714–1796
William Elmer, Nephew of Artist
oil on canvas 64 x 52.5
A980.5063

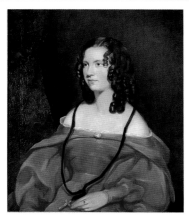

Grace, James Edward 1851–1908
Windmill
oil on canvas 34 x 24.5
A979.716

Harris, William E. 1860–1930
Cows Grazing in a Meadow 1891
oil on canvas 30 x 60.5
A979.616

Hunter, Thomas Sr b.1771
Harriet Harding (d.1880) c.1835
oil on canvas 76 x 64
A002.29

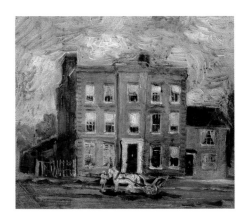

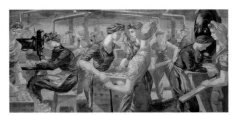

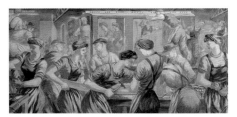

Hunter, Thomas Jr b.1821
Willmer House, Farnham c.1855
oil on board 16.5 x 18.7
A979.694

Hutton, John Campbell 1906–1978
Making Ammunition Boxes 1946
oil on panel 90 x 181
A991.41

Hutton, John Campbell 1906–1978
Railway Carriages 1946
oil on panel 90 x 181
A991.41

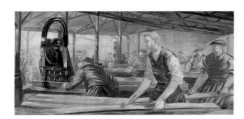

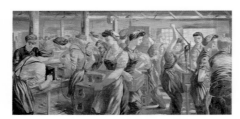

Hutton, John Campbell 1906–1978
Wartime Wood Machining 1946
oil on panel 90 x 181
A991.41

Hutton, John Campbell 1906–1978
Women Making Munitions Boxes 1946
oil on panel 90 x 181
A991.41

Loutherbourg, Philip James de 1740–1812
Sea Battle c.1790
oil on glass 12 x 12
A980.5369.1

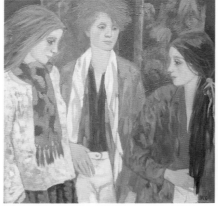

Loutherbourg, Philip James de 1740–1812
Seascape
oil on glass 12 x 12
A980.5369.2

McCannell, Ursula Vivian b.1923
'We don't know' c.1998
oil on hardboard 75 x 75
674

McCannell, William Otway 1883–1969
Colour 1966
oil on canvas 54 x 77
A980.5479

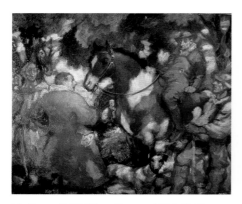

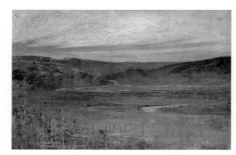

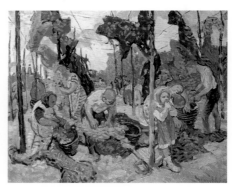

McCannell, William Otway 1883–1969
The Farmers
oil on canvas 53.5 x 64
A980.5480

Morley, Robert 1857–1941
River at Twilight
oil on canvas 50 x 76
A980.5616

Murphy, Clara Joan 1900–1986
The Last Hop-Picking in the Chantries, Farnham c.1970
oil on canvas 61.5 x 74.5
A980.5326P

Newyin, R. Graham
View Looking from Mr Borelli's Courtyard
1949
oil on board 39 x 46
A991.28.88

Peacock, Ralph 1868–1946
Eileen Fox 1908
oil on canvas 136 x 89.5
A979.2119

Ransom, George 1843–1935
Coastal Landscape with Castle 1892
oil on canvas 40 x 60.5
A979.1089

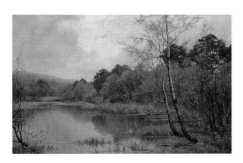

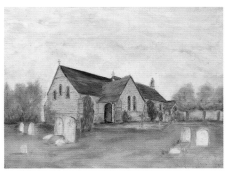

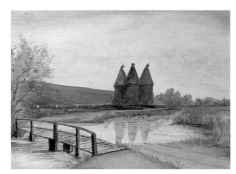

Ransom, George 1843–1935
Black Lake, Waverley
oil on canvas 59.5 x 90.5
3-74

Reeves, Sidney b.c.1925
Old Bourne Church 1970s
oil on hardboard 26 x 34
A979.682

Reeves, Sidney b.c.1925
Landscape with Oasthouses
oil on hardboard 29 x 40.5
A979.684

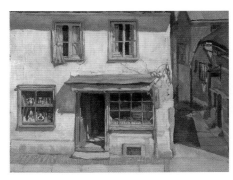

Russell, H. M. active mid-20th C
The Old Book Shop
oil on canvas 29 x 39
A979.714

Seaby, Allan William 1867–1953
The Wakes from the Park 1912
oil on canvas 20 x 25 (E)
A979.634

Turk, W.
Farnham Castle c.1920
oil on hardboard 23.5 x 14.5
A996.17

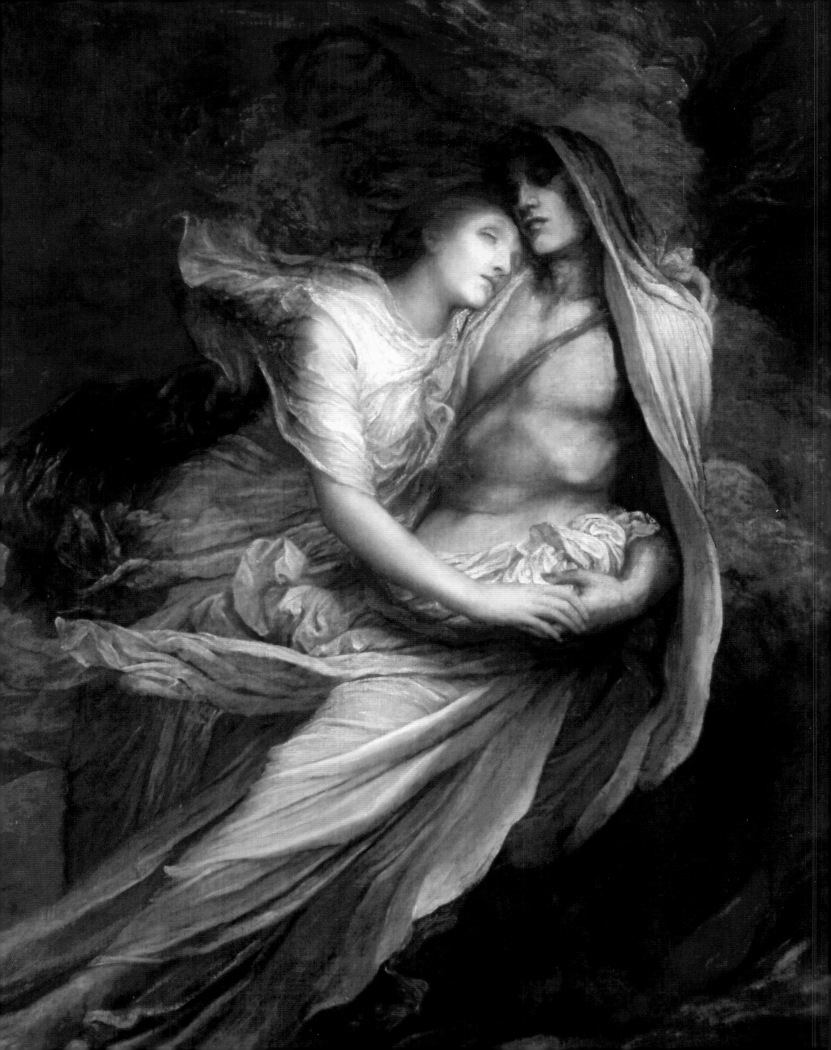

Turk, W.
Farnham Park Castle Approach c.1920
oil on hardboard 23.5 x 14.5
A996.16

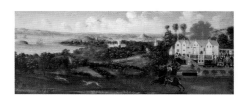

unknown artist
View over Bridgewater Bay c.1678
oil on wooden panel 57 x 142
A980.5522

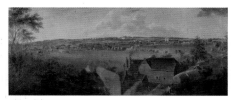

unknown artist
Panorama of Farnham c.1770
oil on canvas 56 x 148
A980.5280

unknown artist 18th C
Mr Cranston
oil on board 27 x 21
A979.2683

unknown artist 18th C
Portrait of a Lady
oil on canvas 34 x 25.5
A979.2313

unknown artist
View of Farnham c.1830
oil on canvas 23 x 33
A991.27

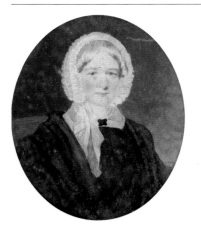

unknown artist early 19th C
Portrait of a Member of the Duncan Family
oil on board 9.5 x 7.5
A979.5010.CAT.NO.68

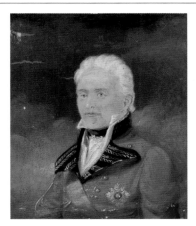

unknown artist early 19th C
Sir David Ochterlony (1758–1825)
oil on board 9.5 x 8
A979.5010

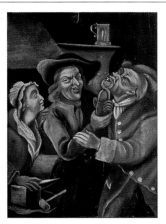

unknown artist 19th C
Blacksmith Pulling Teeth
oil on wooden panel 28 x 20.5
A980.5053

Facing page: Watts, George Frederick, 1817–1904, *Paolo and Francesca* (detail), 1872–1875, Watts Gallery (see p.147)

unknown artist 19th C
Landscape at Night
oil on board 14 x 22.5
A979.696

unknown artist 19th C
Poet Reading to a Seated Muse
oil on glass 21.5 x 16
A979.4406

unknown artist 19th C
Riverscape with Windmill and Fishermen
oil on glass 15 x 20
A980.5366.2

unknown artist 19th C
Seascape with Castle and Fisherman
oil on glass 15 x 20
A980.5366.1

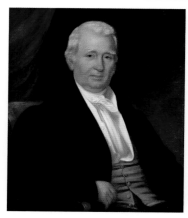

unknown artist 19th C
William Cobbett (1763–1835)
oil on canvas 74 x 61
A980.5185 (P)

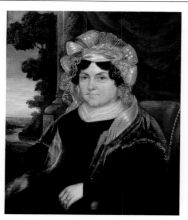

unknown artist 19th C
Mrs William Cobbett (1774–1848)
oil on canvas 74.5 x 62
A980.5186 (P)

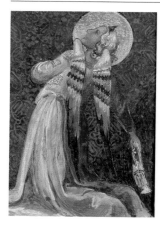

unknown artist late 19th C
Angel
oil on wood 12 x 8.5
A979.4489

unknown artist
The Maltings c.1960
oil on hardboard 39 x 49
A994.23

unknown artist
Abstract c.1970
oil on hardboard 86.5 x 66.5
0670

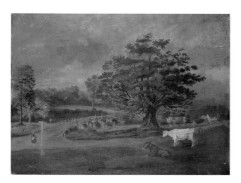

unknown artist early 20th C
Tilford Green and Cobbett's Oak
oil on canvas 101 x 130
A979.2121

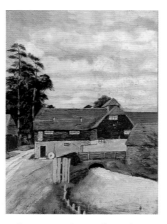

unknown artist early 20th C
Weydon Mill
oil on board 20.5 x 15
A982.59.2

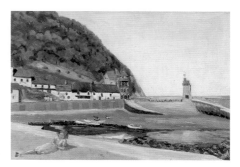

unknown artist 20th C
Shore Scene with Lighthouse
oil on card 25 x 35
A986.45

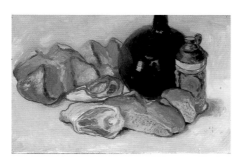

unknown artist
Still Life with Bread and Meat
oil on canvas 30 x 45.5
A979.608

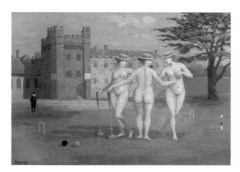

Verney, John 1913–1993
The Three Graces c.1965
oil on wood 25 x 34
A999.17

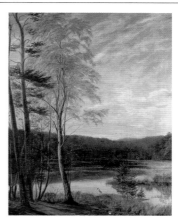

Wonnacott, Thomas 1835–1918
Black Lake, Waverley 1882
oil on canvas 90 x 69.5
A987.53

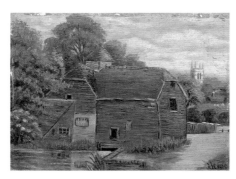

Wonnacott, Thomas 1835–1918
Weydon Mill 1910
oil on hardboard 14.5 x 19.5
A982.59.1

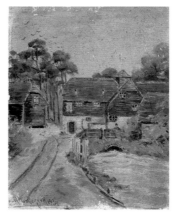

Wooderson, J.
Evening at Weydon Mill 1934
oil on hardboard 20.5 x 15.5
A979.2053

University College for the Creative Arts at the Farnham Campus

Ball, Robin 1910–1979
The Lovers
oil & collage 128 x 122.5
9

Butler, Paul b.1947
Bus Stop 1995
oil on board 120 x 120
1

Butler, Paul b.1947
City Night II 1999
oil on board 69.5 x 137
8

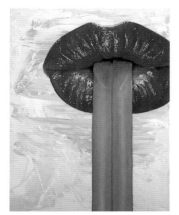

Clamp, Laura b.1980
Lips and Blue Straw
acrylic on canvas 66 x 51.5
11

Edmonds, Frances b.1953
Blue Room 1993
oil on paper 93 x 130
2

Hockey, James 1904–1990
A Cyclamen 1930
oil on board 39 x 30
5

Hossain, Zahura Sultana
Where Am I? 2001
oil on board 140 x 140
6

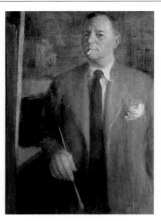

Muszynski, Leszek b.1923
James Hockey, RBA (1904–1990) 1954
oil on canvas 65 x 52
3

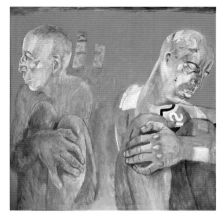

Northwood, Sally b.1935
Two Figures 1994
oil on canvas 105.5 x 105.5
4

unknown artist late 20th C
Untitled
oil on canvas 16 x 117
10

Whamond, Andrew b.1947
Leaning Figure 2002–2004
oil on linen 85 x 110
7

Godalming
Library

Wondrausch, Mary b.1923
Dead Magpie c.1956
mixed media on board 180 x 120.4
1

Godalming Museum

Godalming Museum was established in 1920 to preserve and share the story of the town and the surrounding area. Founded by the Town Council, it has always benefited from volunteer involvement and is now run in partnership by an independent charitable trust, Godalming Museum Trust, and Waverley Borough Council.

Originally set up in the Old Town Hall, the Museum is a friendly, welcoming place housed in a fascinating medieval building on the High Street. As well as displays on the geology, archaeology and history of the area, there is a gallery dedicated to the work of Gertrude Jekyll and Sir Edwin Lutyens and an exhibition space which shows the work of local artists and craftworkers. The garden, which is a living exhibit, is a copy of a border designed by Gertrude Jekyll for a house at Bramley. The Museum's local studies library offers access to published works on Godalming and the surrounding area, as well as photographs, ephemera and documents. The collections include many works about and by Gertrude Jekyll, as well as her planting notebooks and copies of her garden plans (the originals of which are held by the University of California).

The Museum collects art primarily for its local history interest. The Collection includes local views, portraits of individuals associated with the area and the work of local artists, both amateur and professional.

The more significant oil paintings in the Collection include *Thomas in the Character of Puss in Boots* (1869) and *The Sun of Venice Going to Sea (after Joseph Mallord William Turner)* (c.1870), both by Gertrude Jekyll.

Born in 1843, Gertrude Jekyll spent her childhood in Bramley. In later life, she was to become famous as a garden designer, especially for the commissions on which she worked with Arts and Crafts architect Sir Edwin Lutyens, but she originally trained as an artist. Always fond of cats, she was 26 when she painted her cat Thomas as Puss in Boots. She is thought to have painted the copy of Turner's *The Sun of Venice* at around the same time. She is known to have admired the artist's work and to have spent time at the National Gallery copying his paintings. In the early 1880s, Jekyll commissioned a house, Munstead Wood, just outside Godalming, from Lutyens. Here she created a garden which is still greatly admired, and established a nursery to supply plants for the gardens she designed. She was fascinated by the traditional life of the countryside, which she recorded in her book *South West Surrey* (1904). In Godalming she campaigned to preserve the Old Town Hall and the Museum archive includes correspondence between her and the curator. Jekyll died in 1932 and is buried in Busbridge churchyard, where her memorial stone, designed by Lutyens, simply states 'Artist, Gardener, Craftswoman'.

Another painting of note is *Jack Phillips* (1912) by Ellis Martin. John George 'Jack' Phillips would never have expected to have his portrait painted. Born in 1887 above the drapers' shop which his parents managed, his first job was in the Post Office in Godalming High Street. Here he learned Morse code and began a career which was to lead to a prestigious posting as Chief Telegraphist on the 'Titanic'. As the great liner went down, Jack stayed at his post, sending the messages which guided the 'Carpathia' to rescue the survivors. He lost his

life in the disaster and became a national hero. This portrait, painted from a photograph after his death, was commissioned by the students of Godalming Grammar School, where Jack had been a pupil.

Ellis Martin was to become well known as the Ordnance Survey artist between the wars, designing many evocative map covers. Born in Plymouth in 1881, he was educated at King's College, Wimbledon and later studied art at the Slade. Two years before this portrait was painted he had married Mabel Verstage of Godalming. The couple lived in Southampton but maintained links with the Godalming area and Martin produced many attractive watercolours of the local countryside.

T. H. Huxley's portrait, painted by his artist son-in-law John Collier in 1883, is in the National Portrait Gallery. Thomas Henry Huxley, the great Victorian scientist and supporter of Darwin, began the family's connection with the Godalming area when he rented a house in Milford for the summer of 1883. His son Leonard was appointed a master at Charterhouse two years later, a post which gave him the means to get married. His wife, Julia Arnold, granddaughter of the headmaster of Rugby, went on to establish her own school in Godalming, Priors Field, which celebrated its centenary in 2002. Their son Aldous was one of its first pupils and indeed is believed to be the only boy ever to attend the school.

Towards the end of his life, Collier, by then living in Egypt, told the *Egyptian Gazette* that he was making a series of replicas of his most important pictures and it may well be that he painted this small version of the work in the National Portrait Gallery at this time. It is not known how the portrait entered the Museum Collections. It is described in the 1950s catalogue as 'colour picture of an unknown man'. The Museum is indebted to conservator Sarah Cove who recognised the subject and to Jill Springall of the National Portrait Gallery who confirmed the identification and found the newspaper reference to Collier's plan to produce replicas of his paintings.

Alison Pattison, Curator

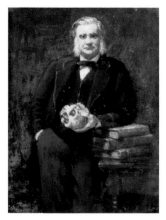

Collier, John 1850–1934
Thomas Henry Huxley (1825–1895)
oil on board 24.4 x 18.4
2195

Duff, Pamela b.1920
Miss Jekyll's Boots (after William Nicholson)
1991
oil on canvas 31 x 40
B991.50

Duff, Pamela b.1920
Gertrude Jekyll (after William Nicholson)
1999
oil on canvas 30 x 40.4
B999.67

Harwood Eve
Great Pond, Frensham
oil on board 26.5 x 35.5
B980.783

Jekyll, Gertrude 1843–1932
Thomas in the Character of Puss in Boots 1869
oil on canvas 76.2 x 63.5
B999.60

Jekyll, Gertrude 1843–1932
The Sun of Venice Going to Sea (after Joseph Mallord William Turner) c.1870
oil on canvas 150.1 x 227.8
B989.32

Lewis, J. active early 20th C
Godalming: A Bit of the Old Town
oil on canvas 50.7 x 76
B006.6

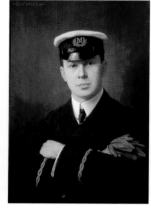

Martin, Ellis 1881–1977
Jack Phillips (1887–1912) 1912
oil on canvas 85 x 61
B004.34

O'Brian, Henry active 1950s
Low Tide at Maldon, Essex 1953
oil on canvas 40.5 x 54.5
B980.623

O'Brian, Henry active 1950s
Berkshire Downs
oil on board 41 x 62
B980.775

O'Brian, Henry active 1950s
Brixham Harbour
oil on canvas 47 x 36
B986.22

O'Brian, Henry active 1950s
Country Scene
oil on canvas 36 x 51
B980.627

O'Brian, Henry active 1950s
Glengarriff, Kerry
oil on board 41 x 61
B980.625

O'Brian, Henry active 1950s
Hastings Beach
oil on board 30.6 x 50.7
B980.626

O'Brian, Henry active 1950s
Killarney from Muckross House Terrace, Co. Kerry
oil on board 30 x 39.5
B980.780

O'Brian, Henry active 1950s
Lake Geneva, Montreux
oil on board 32 x 51.5
B980.620

O'Brian, Henry active 1950s
Lakeside
oil on board 49.5 x 28.5
B980.621

O'Brian, Henry active 1950s
Nocturne
oil on board 44.5 x 59.5
B980.624

O'Brian, Henry active 1950s
River Glaslyn, Wales
oil on board 30.5 x 40.5
B980.629

O'Brian, Henry active 1950s
Rolling Breakers at Evening
oil on board 35 x 46
B980.630

O'Brian, Henry active 1950s
Sea View with a Boat
oil on board 37 x 44
B980.631

O'Brian, Henry active 1950s
Self Portrait
oil on canvas 35.7 x 25.5
B986.21

O'Brian, Henry active 1950s
Studland Bay, Dorset
oil on board 30 x 40.5
B980.628

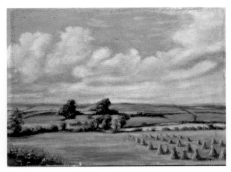

O'Brian, Henry active 1950s
Sussex Harvest
oil on board 32 x 43
B980.632

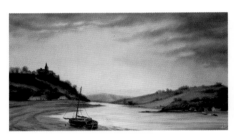

O'Brian, Henry active 1950s
The Church on the Hill
oil on board 38 x 68.3
B980.778

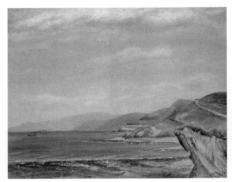

O'Brian, Henry active 1950s
Welsh Coast
oil on board 51 x 61.6
B980.622

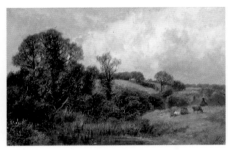

Peel, James 1811–1906
Roke Farm, Witley, Surrey
oil on canvas 20.5 x 31
B986.9

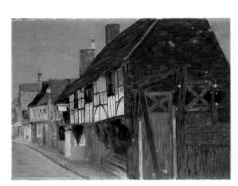

Smallman-Tew, F. active 20th C
Church Street, Godalming
oil on board 24 x 32
B980.758

Smallman-Tew, F. active 20th C
Church Street, Godalming
oil on canvas board 35.5 x 25.3
2133

Smallman-Tew, F. active 20th C
Old Godalming by Moonlight
oil on canvas, laid onto board 35.2 x 24.5
B980.15

Facing page: Watts, George Frederick, 1817–1904, *Time, Death and Judgement* (detail), 1884, Watts Gallery, (p. 151)

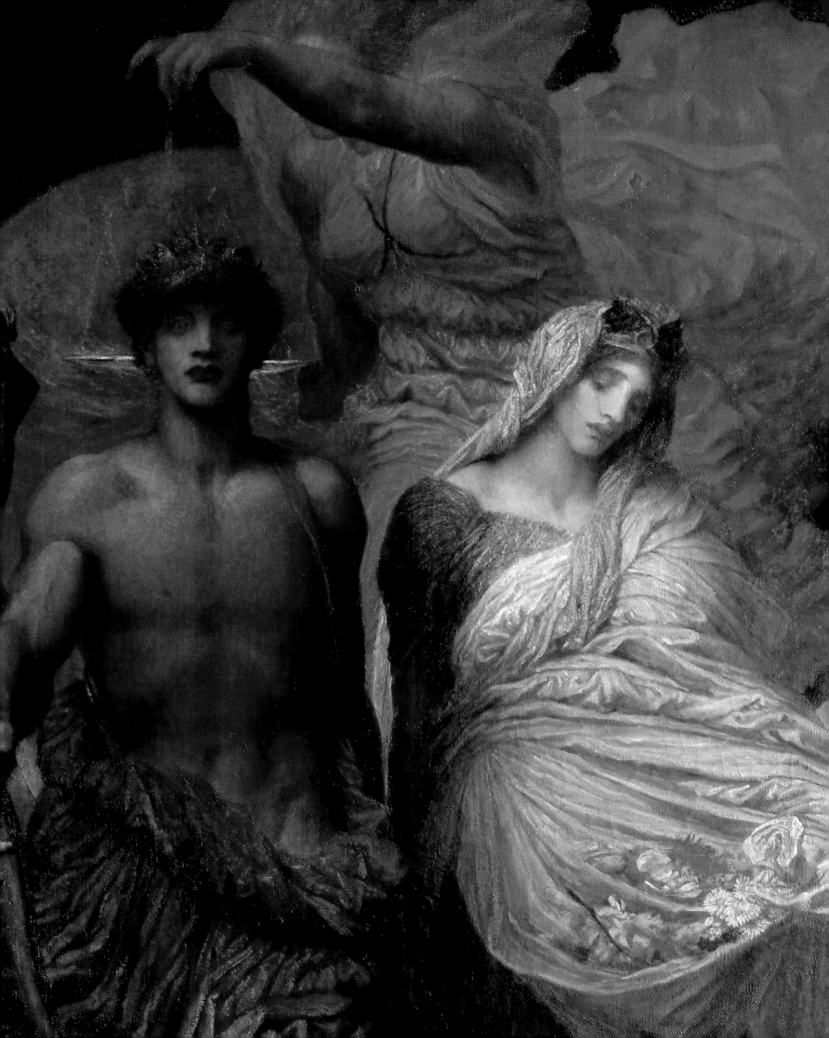

Smallman-Tew, F. active 20th C
The Millstream at Godalming
oil on board 25.5 x 35.5
2131

Smart, W. H. active mid-20th C
Godalming Church
oil on board 47 x 60.5
B000.18

unknown artist
Dr Owen Manning 1758
oil on canvas 76.5 x 63.5
NN217

unknown artist 19th C
Ironstone Bridge, Tilthams Green
oil on canvas 30.8 x 45.8
NN097

unknown artist 20th C
Old Borden Bridge
oil on canvas 25.4 x 35.5
B980.600

Godalming Town Council

British (English) School mid-19th C
Sir Richard Balchin, Surgeon, Mayor of Godalming
oil on canvas 61 x 50.8
5

Donne, Walter J. 1867–1930
Alderman Thomas Rea 1907
oil on canvas 127 x 101.6
7

Kneller, Godfrey (style of) 1646–1723
Vice Admiral Sir John Balchin
oil on canvas 114.3 x 88.9
6

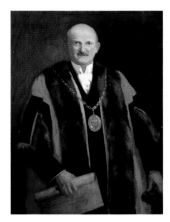

Schumacher, Vera active 1911–1913
Joseph E. Sparkes, Mayor of Godalming (1890–1892) 1911
oil on canvas 129.5 x 94
1

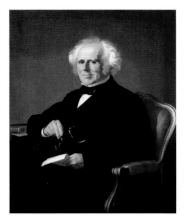

unknown artist 19th C
Henry Marshall, First Mayor of Godalming, 1836
oil on canvas 114.3 x 88.9
8

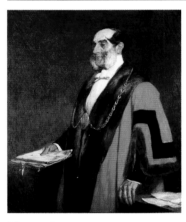

Watson, D.
John Simmonds, Mayor (1871 & 1875) 1876
oil on canvas 127 x 99.1
4

Waverley Borough Council

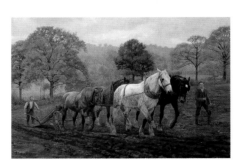

Hollams, F. Mabel 1877–1963
Horses Ploughing a Field 1904
oil on canvas 79 x 120
1

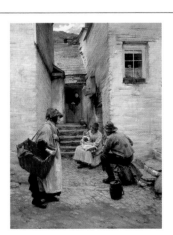

Langley, Walter 1852–1922
Cornish Village Scene
oil on canvas 135 x 98
2

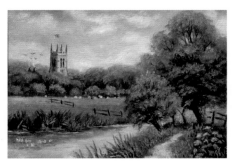

unknown artist
Farnham Church from the Meadows c.1869
oil on canvas 13.5 x 19
A979.2005

The White Hart Barn, Godstone Village Hall

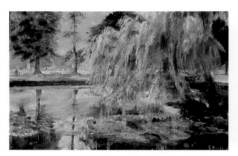

Burford, Eva active 1970–1985
Godstone Pond c.1980
oil on board 29.5 x 44
2

Butcher, Fred
Godstone High Street with the Clayton Arms
1902
oil on paper with board support 59.5 x 87.5
4

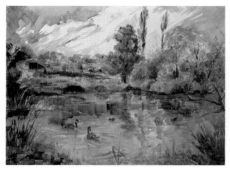

Hayner, D. (attributed to)
The Bay Pond, Godstone c.1980
oil on canvas 34 x 44.6
3

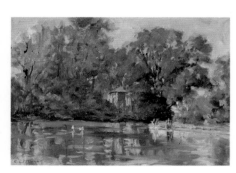

unknown artist
Ivy Mill Pond, Godstone c.1932
oil on canvas 24.5 x 30.5
1

Guildford House Gallery

Guildford Borough's Art Collection contains many fascinating artworks, despite its relatively compact size. Its home is Guildford House Gallery, an intriguing seventeenth-century townhouse in Guildford High Street. The Borough Council acquired the gallery building in 1957, and after restoration to much of its original appearance, the building opened as Guildford Borough Art Gallery in 1959. Today, Guildford House Gallery is well-known in Surrey and beyond for the Borough Collection and its exciting programme of temporary exhibitions. In 2005/2006, annual visitor numbers exceeded 120,000, which makes it one of the most popular cultural destinations in Surrey.

The Gallery was built as a private house for John Child, a London attorney and three times Mayor of Guildford, in about 1660. Built in an early Neo-Classical style, it contains many fine original architectural period features, including wooden wall-panelling, fine seventeenth-century plaster ceilings, rare espagnolette iron window bolts and an ornately carved Restoration staircase with fruit, flower and acanthus-leaf carving. The fine fittings of the house often surprise visitors and serve as a backdrop to the Borough Collection.

Guildford Borough's Collection comprises more than 550 pieces and small collections; many objects consist of multiple parts so the number of works comes close to 800. They span over 250 years and include a plethora of media – oil paintings, watercolours, pastels, etchings, engravings, prints, textiles, ceramics, sculpture and glass. In addition, there are interesting period furniture pieces on display within the Gallery, including a seventeenth-century court cupboard and a number of seventeenth- and eighteenth-century vernacular sideboards and chests-of-drawers. Guildford Borough's oil paintings thus form only one facet of this exciting and varied collection.

The Borough Collection has been built up through gifts, bequests and purchases over the past 50 years, and many of its historically most significant works have been acquired with assistance from national and local grant aid. New works are added to the Collection every year. Most of the Collection is not on continuous display; instead, the works are integrated carefully into the Gallery's varied exhibition programme. This temporary gallery display aids the preservation of the Collection and allows the Gallery to show as many objects as possible every year.

Many of the works in the Collection are by local artists and those with a strong Guildford connection; other pieces have associations with the Guildford area and Surrey. Guildford House Gallery is thus particularly well-known for the many works it owns by Guildford's most famous son, John Russell RA (1745–1806), who was pastel painter to King George III and his son, the Prince of Wales (later George IV). Guildford Borough's Collection of paintings by the artist is one of the largest in the country; as well as the three oil paintings depicted in this catalogue, the Russell Collection comprises 27 pastel portraits and numerous pen drawings, engravings and prints.

One of the most interesting and famous works is the oil painting of *Micoc and Tootac*. Micoc and her son Tootac were Inuit Indians from Labrador and were brought to England in the 1760s by Admiral Sir Hugh Palliser, Governor of Newfoundland between 1764 and 1766. Micoc and her son caused a

sensation in London and were presented at court, where George III presented Micoc with the medal she is depicted wearing in Russell's portrait. Interestingly, and fascinating from a historical perspective, the portrait was the first of 322 portraits Russell was to exhibit at the Royal Academy between 1769 and his death in 1806, and Robert Walpole described this picture as 'very natural'.

Graeme Highet (1905–1966), Edward Wesson (1910–1983) and Ronald Smoothey (1914–1996) are among many twentieth-century and contemporary painters represented in the Collection. Visitors enjoy their highly individual paintings and the eclectic mixture of pictorial and abstract works.

Currently, the Gallery is in the process of making all of its Collection available on its website on the Internet. Photographs of the works and short descriptions will become a valuable resource for study and enjoyment for those unable to visit the Gallery in person. The project will help overcome the access limitations of Guildford House Gallery's grade I listed gallery premises and will make the Gallery and its collections accessible for everyone for the first time in its history.

Now in its 47th year at Guildford House, the Gallery and the Borough Art Collection are flourishing; their future will, no doubt, be a vibrant and exciting one.

Christian Dettlaff, Gallery and Exhibitions Manager

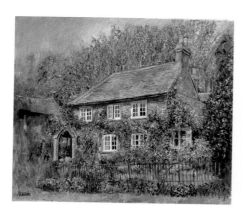

Allison, Jane b.1959
Rose Cottage, Pockford Road, Chiddingfold
2004
oil on canvas 31 x 36
1113

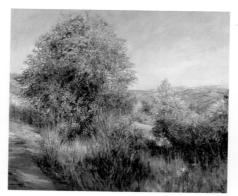

Allison, Jane b.1959
View from the Chantries with Hawthorn Tree
2004
oil on canvas 50 x 59.5
1112

Boughton, Thomas 1812–1893
Guildford High Street c.1856–1858
oil on canvas 53.5 x 43.2
895

Caffyn, Walter Wallor 1845–1898
The Weald of Surrey 1887
oil on canvas 76.2 x 127
894

Carter, William 1863–1939
Mayor Ferdinand Smallpeice 1905
oil on canvas 74.5 x 61.5
730

Charlton, Mervyn b.1945
Moon Glow 1983
oil on board 90 x 95
780

Cheesman, Harold 1915–1983
Landscape 1948
oil on canvas 71 x 90
927

Collins, Helen 1921–1990
North Street, Guildford 1940s
oil on canvas 91.5 x 71.2
923

Collins, Helen 1921–1990
George Edward Collins
oil on canvas 35.8 x 30.6
972

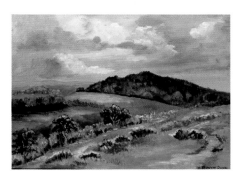

Cracknell, Jennifer active 1960s–1970s
Rockfall 1971
oil on board 50.8 x 61
435

Cripps, Clara
Narrow Lane, Guildford c.1910
oil on canvas 40.7 x 15.2
1010

Dunn, John Selwyn 1895–1978
St Martha's c.1960
oil on board 58.5 x 74
1033

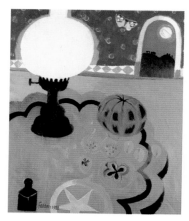

Fedden, Mary b.1915
The Lamp 1988
oil on canvas 64 x 51
798

Harris Hughes, Susanna b.1947
St Catherine's, February 1997
oil on canvas 92 x 92
999

Harrison, Christopher b.1935
Below Coldharbour 1971
oil on canvas 51 x 91.5
363

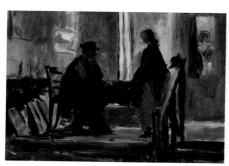

Harwood Eve
Old Guildford House c.1962
oil on canvas board 25.2 x 34
231

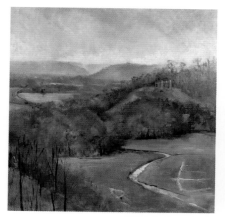

Herringham, Christiana Jane 1852–1929
Madonna and Child (after Sandro Botticelli)
c.1900
tempera on board 58 x 39
480

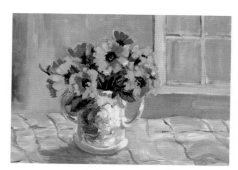

Hoyt Desmond, Charlotte d.1971
Pot of Marigolds c.1970
oil on board 30.8 x 40.4
617

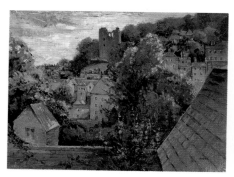

Huston active mid-20th C
View of Guildford Castle
oil on canvas 30 x 40.5
1058

Hyde, William 1859–1925
Landscape towards Peaslake c.1900
oil on canvas 71.2 x 107
648

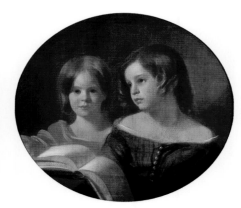

Laurence, Samuel 1812–1884
The Fletcher Children c.1850
oil on canvas 71 x 83
865

Le Mare, Frederick b.1846
Landscape Millmead 1890
oil on canvas 50 x 76
738

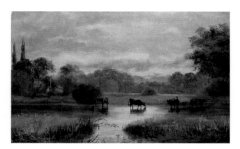

Lee, Ada
Cows and Boy in Landscape 1890
oil on canvas 35.7 x 53.6
755

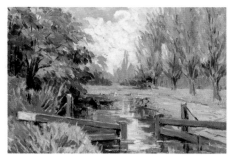

Marsham, Cara
Millmead Lock 1953
oil on board 28 x 38
116

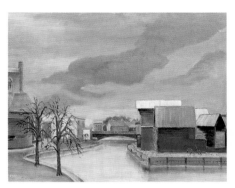

May, F. T. active c.1957–1968
River Wey in Winter 1959
oil on board 41 x 51
751

McCannell, Ursula Vivian b.1923
Birches and Hollies 1979
oil on canvas 35.5 x 25.5
913

Morris, Mali b.1945
In Apple Blossom Time c.1985
acrylic on canvas 58 x 181
767

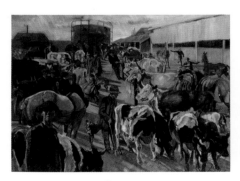

Morshead, Arminell 1889–1966
Guildford Cattle Market 1920
oil on canvas 90 x 119
746

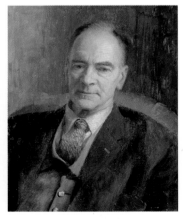

Narraway, William Edward 1915–1979
Alderman Lawrence Powell 1967
oil on canvas 61 x 51
692

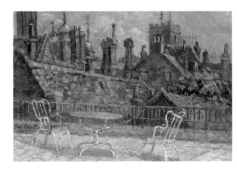

Parfitt, Ida 1910–1977
Guildford Old and New 1962
oil on board 30.5 x 40.7
241

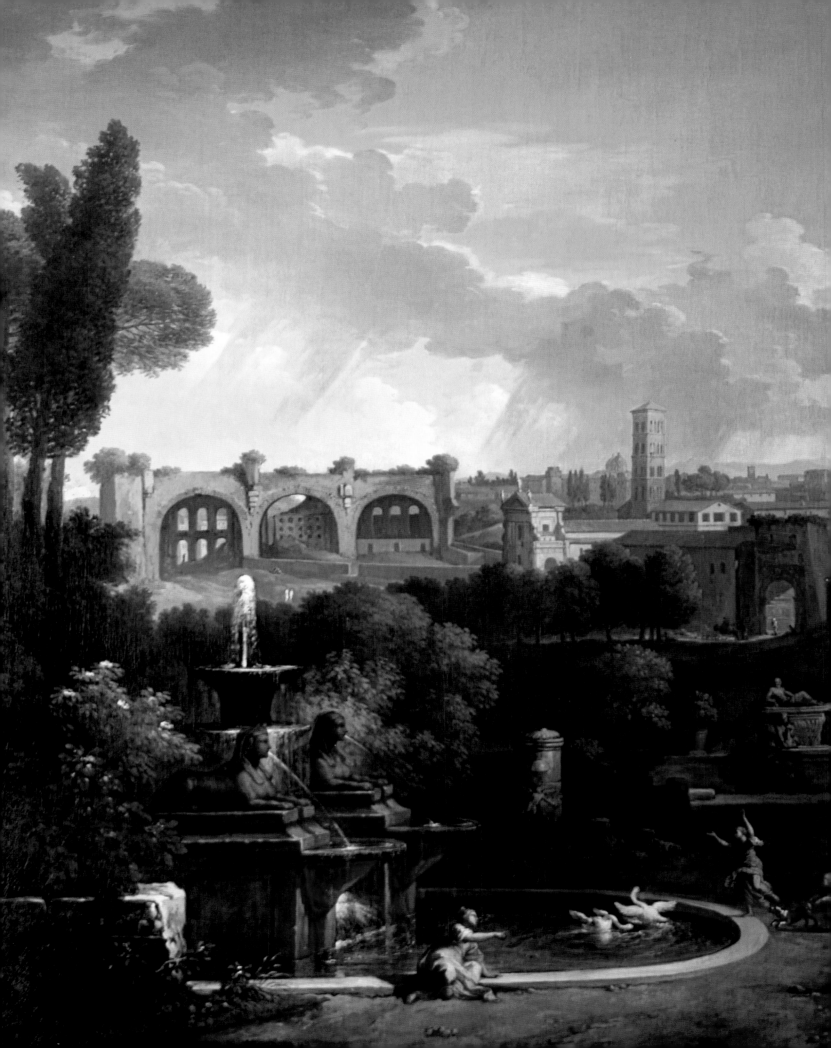

Passey, Charles Henry active 1870–c.1894
A Lane at Albury, Surrey c.1880
oil on canvas 60.5 x 50
896

Penycate, Dorothy 1910–1969
Roses c.1962
oil on canvas 34.3 x 44.5
969

Perraudin, Wilfrid b.1912
Black Forest Landscape and Farm Buildings
1989
oil on canvas 75 x 100
897

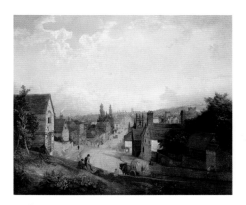

Pether, Henry active 1828–1865
Old Guildford 1849
oil on canvas 90 x 105
658

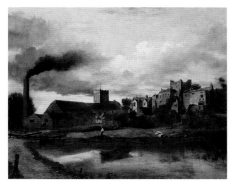

Pether, Henry (circle of) active 1828–1865
St Mary's, Guildford
oil on canvas 62.8 x 76.5
966

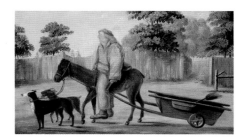

Randoll, F.
The Eccentric Billy Hicks, Shere 1854
oil on canvas 32.2 x 51.8
744

Ranken, Marguerite 1897–1973
The Estuary c.1960
oil & gouache on canvas board 39.2 x 29.2
589

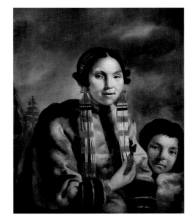

Russell, John 1745–1806
Micoc and Tootac 1769
oil on canvas 75 x 60
1003

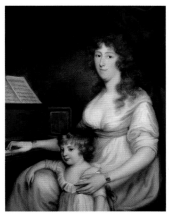

Russell, John 1745–1806
Portrait of a Lady with Her Child 1798
oil on canvas 99 x 76
915

Facing page: Bloemen, Jan Frans van, 1662 –1749, *View of Rome from the Baberini Palace* (detail), Surrey County Council, (p. 175)

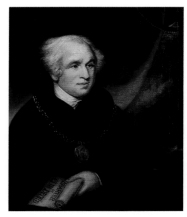

Russell, William 1780–1870
Samuel Russell, Mayor of Guildford 1805
oil on board 93.5 x 76
863

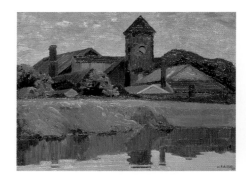

Schofield, Winifred d.2000
The Oil Mills, Thames Lock 1928–1929
oil on canvas 31 x 41.2
757

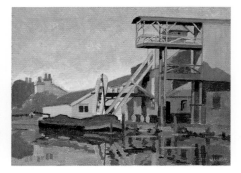

Schofield, Winifred d.2000
The Oil Mills, Weybridge, Surrey 1930s
oil on canvas 30.8 x 40.8
739

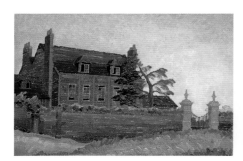

Schofield, Winifred d.2000
The Lone Manor House 1975
oil on canvas 32 x 44.8
742

Scholfield, Margaret active 1922–1932
Impression: Wey Navigation Canal 1922
oil on canvas 38 x 27
694

Smoothey, Ronald 1913–1996
Winter Landscape 1960
oil on board 50.5 x 70.8
818

Smoothey, Ronald 1913–1996
Headlamps c.1970
oil on board 39.5 x 57
916

Smoothey, Ronald 1913–1996
Mutation c.1970
oil on board 56 x 76.6
1109

Smoothey, Ronald 1913–1996
Stress Forms c.1970
acrylic on board 81 x 53
335

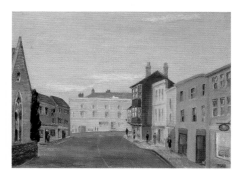

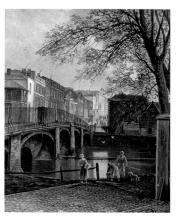

May, F. T. active c.1957–1968
View of Park Street
oil on canvas laid on board 30.1 x 40.3
TG 323

May, F. T. active c.1957–1968
View of 'The Old White Lion'
oil on canvas laid on board 30.1 x 40.3
TG 322

unknown artist
View of Guildford Town Bridge c.1850?
oil? on wood panel 30.3 x 24.6
G 3804

Van Jones active 1917–1941
Artwork for Friary Ales Poster c.1939
oil on hardboard 81 x 58
RB 2431

Queen's Royal Surrey Regimental Museum

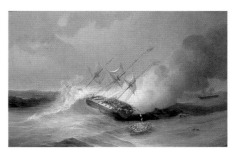

Bennett, John active 20th C
Salerno 43
oil on canvas 55 x 70.5
HH45

Daniell, William 1769–1837
Burning of 'The Kent' 1st March 1825 c.1827
oil on canvas 47 x 71
DS45

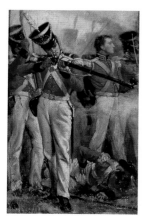

Davidson, Thomas
*The Queen's (Second) Royal Regiment of Foot,
c.1830* c.1830
oil on canvas 25 x 15
DS27

Deayton-Groom, (Major) active 20th C
*The East Surrey Regiment Passing through
Cassino, 18th May 1944*
oil on canvas 25 x 38
DS116

Grant, Henry active 1950–1980
Sergeant Major Lynch (d.1917)
oil on canvas 38 x 25
DS34

Rocke, R. Hill (Major)
*The Queen's (Second) Royal Regiment of Foot
in South Africa* c.1853
oil on canvas 20 x 30
DS29

Surrey Archaeological Society

The Surrey Archaeological Society was founded in 1854, and since the early years of the twentieth century has had its headquarters in Guildford. Its library has been in existence since the Society's earliest days, and as well as purchasing material of local archaeological and historical interest, has, over the years, received a number of bequests and donations from members and friends. This means that it now represents probably the finest source of material on Surrey history and archaeology. Although the library is maintained primarily for the benefit of members of the Society, it is open by appointment to the general public, and the catalogue can be viewed on the Society's website.

The Collection includes books, drawings, prints, journals, photographs, scrapbooks and maps. Apart from two items – *Study of a Castle on a Hill* by an unknown artist, and a copy of a portrait of John Evelyn, after Godfrey Kneller, donated by Mr C. J. A. Evelyn in 1948 – the collection of oil paintings is a series of 59 views, mainly of East Surrey buildings and landscapes, by Ernest C. Christie.

Ernest Christie was born in Redhill in 1863 into an artistic family and lived his life in East Surrey. He began painting at the age of six, and won a prize at the age of ten for a painting of Brays Farm in Nutfield. He studied under Linnell in Reigate, and Charles Davidson at Reigate Grammar School, both very competent local artists. He spent two and a half years at South Kensington School of Art, but was not to make painting his main career, as he joined his father's firm, the Commercial Assurance Company Country Department.

In the 1920s Christie exhibited at the Royal Academy. As well as art, he had a lifelong interest in archaeology and local history, which is why the Surrey Archaeological Society was fortunate enough to receive some of his paintings. He produced wash drawings and sketches in addition to oil paintings. Like the paintings, the sketches detail the exterior and interior of buildings in Limpsfield, Oxted, Godstone, Bletchingley, Dorking and, Ockley and a few further afield, providing an invaluable record of architectural detail and bygones such as firebacks, hearths and pumps. There are views of gardens, and landscapes from War Coppice Hill, Whitehill and Leith Hill, among others, and studies of separate parts of buildings and machinery.

Christie took enormous care over his work, and would go back many times to make sure that he had left nothing out of his pictures. The story is told of how an admirer criticised the colouring in his painting of Brewer Street Farm. 'Would you have seen it at five o'clock this morning?', Christie asked, and on being told no, he replied, 'Then you had better go then.' He displayed a sensitive eye for reflected light and stone texture, a love for trees, which figure largely in his paintings, and a genuine affection for the Surrey buildings he portrayed.

He appears to have been a rather withdrawn, private person who never married. His niece remembered how, as a child, she was not allowed in his studio while he was working, and when they went for walks, he would often be thinking, during which time she was not supposed to talk!

He remained a very competent amateur artist until his death, with a tremendous love for his corner of Surrey. 'He had the usual look of the Christies – they were thinking and working it out, but they all had nice manners, and shook hands very warmly.'

Gillian Drew, Honorary Librarian

Christie, Ernest C. 1863–1937
Interior View of Unidentified Cottage in East Surrey 1897
oil on board 35.6 x 53.3
RR PD1 / 30 / 30

Christie, Ernest C. 1863–1937
Interior of Room in a Cottage at Chaldon, with Fireplace c.1900
oil on board 30.5 x 45.7
RR PD1 / 30 / 51

Christie, Ernest C. 1863–1937
Wall with Arched Gateway Opening on to a Field with Trees, Identified as the Entrance to Oxted Church 1906
oil on board 30.5 x 40.6
RR PD1 / 30 / 49

Christie, Ernest C. 1863–1937
Staircase in Cottage at Limpsfield 1911
oil on board 40.6 x 30.5
RR PD1 / 30 / 15

Christie, Ernest C. 1863–1937
Barn at Godstone 1912
oil on board 30.5 x 40.6
RR PD1 / 30 / 10

Christie, Ernest C. 1863–1937
Exterior of Cottage near Oxted 1914
oil on board 40.6 x 30.5
RR PD1 / 30 / 22

Christie, Ernest C. 1863–1937
Doorway between Two Rooms in Cottage at Godstone 1916
oil on board 40.6 x 30.5
RR PD1 / 30 / 5

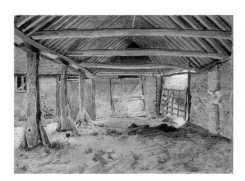

Christie, Ernest C. 1863–1937
Interior View of a Cart Shed in East Surrey 1916
oil on board 30.5 x 40.6
RR PD1 / 30 / 53

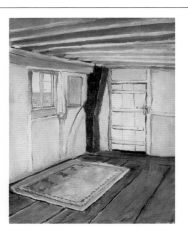

Christie, Ernest C. 1863–1937
Room in Cottage at Godstone c.1916
oil on board 38.1 x 30.5
RR PD1 / 30 / 7

Facing page: Russell, John, 1745–1806, *Micoc and Tootac* (detail), 1769, Guildford House Gallery, (p. 91)

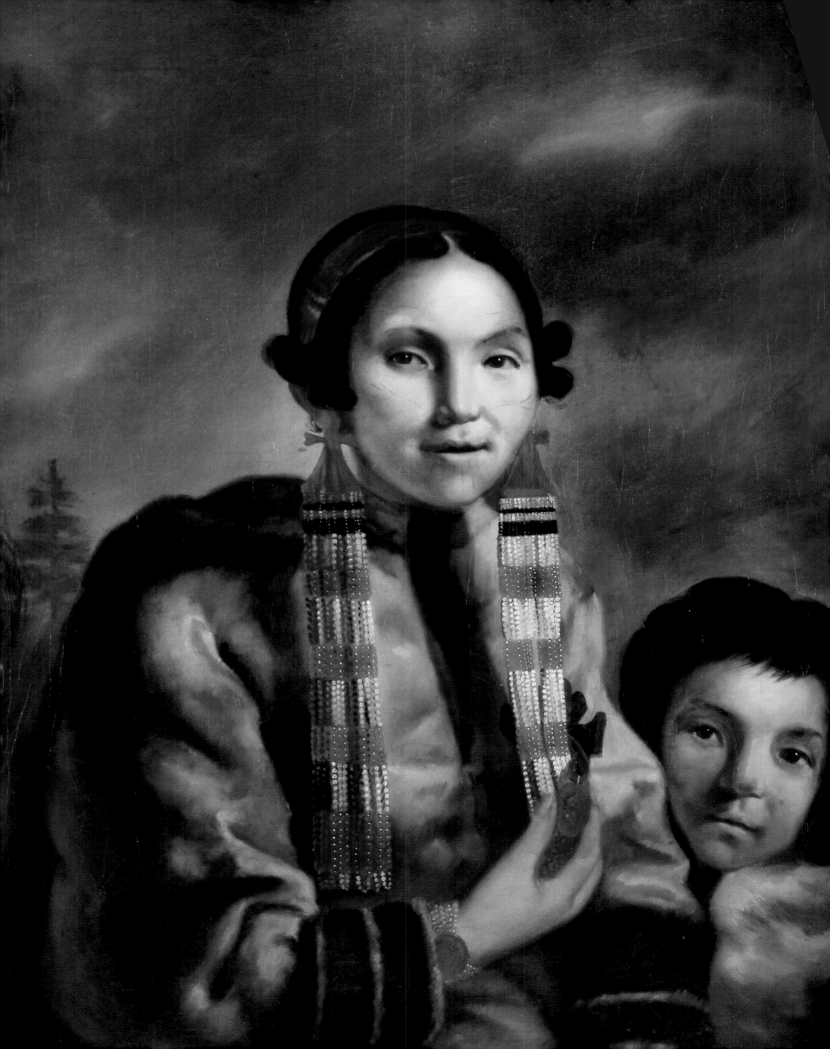

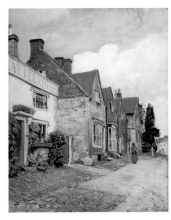

Christie, Ernest C. 1863–1937
High Street, Bletchingley 1917
oil on board 40.6 x 30.5
RR PD1 / 30 / 27

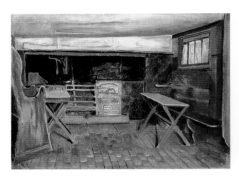

Christie, Ernest C. 1863–1937
Kitchen Range at the Hare and Hounds, Godstone 1917
oil on board 30.5 x 40.6
RR PD1 / 30 / 9

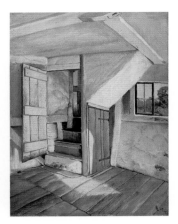

Christie, Ernest C. 1863–1937
Staircase in Cottage at Godstone 1917
oil on board 40.6 x 30.5
RR PD1 / 30 / 8

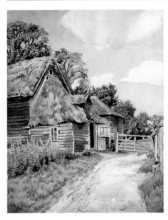

Christie, Ernest C. 1863–1937
Exterior View of Unidentified Barn at Bletchingley or Godstone 1918
oil on board 40.6 x 30.5
RR PD1 / 30 / 29

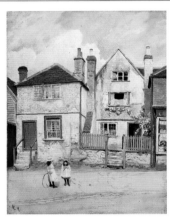

Christie, Ernest C. 1863–1937
1 and 2 Needles Bank, Godstone 1919
oil on board 40.6 x 30.5
RR PD1 / 30 / 12

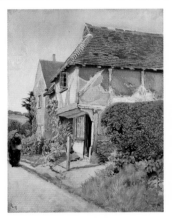

Christie, Ernest C. 1863–1937
Exterior View of Unidentified Cottage in East Surrey 1919
oil on board 40.6 x 30.5
RR PD1 / 30 / 25

Christie, Ernest C. 1863–1937
Exterior View of Unidentified Cottage near Bletchingley 1919
oil on board 40.6 x 30.5
RR PD1 / 30 / 28

Christie, Ernest C. 1863–1937
Fireplace and Post in Centre of Room in Cottage at Godstone 1919
oil on board 40.6 x 30.5
RR PD1 / 30 / 6

Christie, Ernest C. 1863–1937
Rear of Cottage at Godstone (probably Forge Cottage) 1919
oil on board 45.7 x 30.5
RR PD1 / 30 / 14

Christie, Ernest C. 1863–1937
Staircase in Cottage at Godstone 1919
oil on board 40.6 x 30.5
RR PD1 / 30 / 13

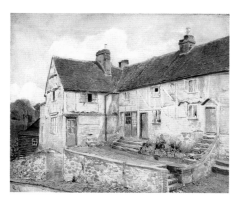

Christie, Ernest C. 1863–1937
Streeters, Terrace and Huddle Cottages, High Street, Oxted 1919
oil on board 30.5 x 35.6
RR PD1 / 30 / 21

Christie, Ernest C. 1863–1937
Bonet's Farm, Capel c.1919
oil on board 45.7 x 30.5
RR PD1 / 30 / 36

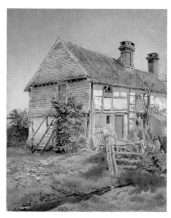

Christie, Ernest C. 1863–1937
Exterior View of Cottage at Oakwood c.1919
oil on board 40.6 x 30.5
RR PD1 / 30 / 38

Christie, Ernest C. 1863–1937
Exterior View of Cottage at Ockley c.1919
oil on board 30.5 x 40.6
RR PD1 / 30 / 39

Christie, Ernest C. 1863–1937
Exterior View of Cottage at Outwood c.1919
oil on board 40.6 x 30.5
RR PD1 / 30 / 33

Christie, Ernest C. 1863–1937
Exterior View of Cottage at Outwood c.1919
oil on board 30.5 x 40.6
RR PD1 / 30 / 44

Christie, Ernest C. 1863–1937
Exterior View of Cottages at Ockley c.1919
oil on board 30.5 x 40.6
RR PD1 / 30 / 46

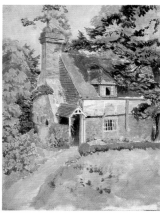

Christie, Ernest C. 1863–1937
Exterior View of Unidentified Cottage in East Surrey, with Prominent Chimney and Porch c.1919
oil on board 40.6 x 30.5
RR PD1 / 30 / 31

Christie, Ernest C. 1863–1937
Exterior View of Unidentified House in East Surrey c.1919
oil on board 40.6 x 30.5
RR PD1 / 30 / 41

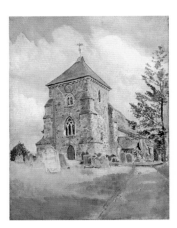

Christie, Ernest C. 1863–1937
Exterior View of West End of Unidentified Church in East Surrey c.1919
oil on board 40.6 x 30.5
RR PD1 / 30 / 37

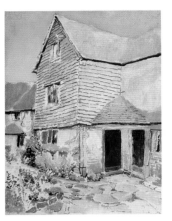

Christie, Ernest C. 1863–1937
Part of 'The Barracks', Oakwood Hill, Ockley, near Dorking c.1919
oil on board 40.6 x 30.5
RR PD1 / 30 / 40

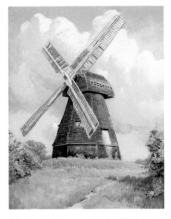

Christie, Ernest C. 1863–1937
Shiremark Windmill, Capel c.1919
oil on board 40.6 x 30.5
RR PD1 / 30 / 34

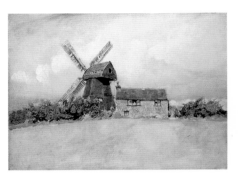

Christie, Ernest C. 1863–1937
Shiremark Windmill, with Mill Cottage on Bonet's Farm, Capel c.1919
oil on board 30.5 x 40.6
RR PD1 / 30 / 35

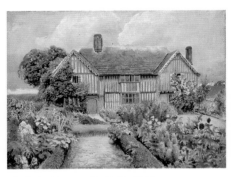

Christie, Ernest C. 1863–1937
Brewer Street Farm, Bletchingley c.1920
oil on board 30.5 x 40.6
RR PD1 / 30 / 48

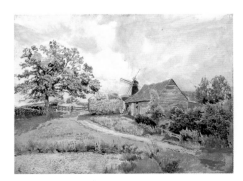

Christie, Ernest C. 1863–1937
Ockley Windmill c.1920
oil on board 30.5 x 40.6
RR PD1 / 30 / 43

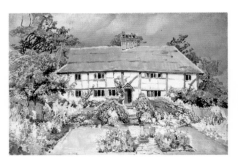

Christie, Ernest C. 1863–1937
Pollingfold, Abinger (front view) c.1920
oil on board 30.5 x 45.7
RR PD1 / 30 / 56

Christie, Ernest C. 1863–1937
View of North Downs in East Surrey c.1920
oil on board 30.5 x 45.7
RR PD1 / 30 / 50

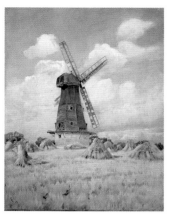
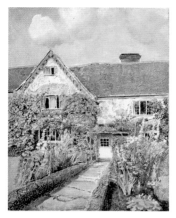

Christie, Ernest C. 1863–1937
Walton Heath Windmill c.1920
oil on board 30.5 x 45.7
RR PD1 / 30 / 45

Christie, Ernest C. 1863–1937
Ockley Windmill 1923
oil on board 40.6 x 30.5
RR PD1 / 30 / 47

Christie, Ernest C. 1863–1937
School House, Ockley 1923
oil on board 40.6 x 30.5
RR PD1 / 30 / 24

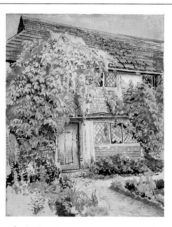

Christie, Ernest C. 1863–1937
Interior of Cottage, Ockley 1924
oil on board 40.6 x 30.5
RR PD1 / 30 / 23

Christie, Ernest C. 1863–1937
*St John the Baptist Church, Okewood, near
Ockley* 1924
oil on board 30.5 x 40.6
RR PD1 / 30 / 32

Christie, Ernest C. 1863–1937
Exterior of Cottage at Forest Green 1925
oil on board 40.6 x 30.5
RR PD1 / 30 / 4

Christie, Ernest C. 1863–1937
Exterior of House at Dorking 1925
oil on board 40.6 x 30.5
RR PD1 / 30 / 2

Christie, Ernest C. 1863–1937
Pinkhurst, Oakwood Hill 1925
oil on board 40.6 x 30.5
RR PD1 / 30 / 3

Christie, Ernest C. 1863–1937
Distant View of Leith Hill, with Tower c.1925
oil on board 30.5 x 45.7
RR PD1 / 30 / 54

Christie, Ernest C. 1863–1937
Farm Buildings at Dorking 1926
oil on board 30.5 x 45.7
RR PD1 / 30 / 1

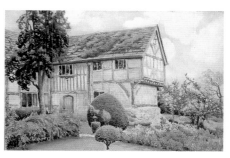

Christie, Ernest C. 1863–1937
Gosterwood Manor, Forest Green 1926
oil on board 30.5 x 45.7
RR PD1 / 30 / 26

Christie, Ernest C. 1863–1937
Pollingfold, Abinger (rear view) 1926
oil on board 30.5 x 45.7
RR PD1 / 30 / 57

Christie, Ernest C. 1863–1937
Tudor Barn at Standen Farm, Ockley 1926
oil on board 30.5 x 40.6
RR PD1 / 30 / 20

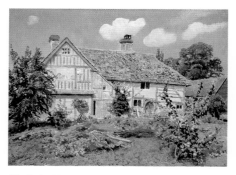

Christie, Ernest C. 1863–1937
Gosterwood Manor Farm, Forest Green c.1926
oil on board 30.5 x 40.6
RR PD1 / 30 / 52

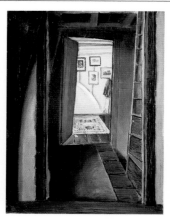

Christie, Ernest C. 1863–1937
Pollingfold, Abinger (view towards a landing)
1927
oil on board 40.6 x 30.5
RR PD1 / 30 / 58

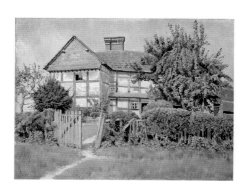

Christie, Ernest C. 1863–1937
Volvens Farm, Forest Green 1927
oil on board 30.5 x 40.6
RR PD1 / 30 / 55

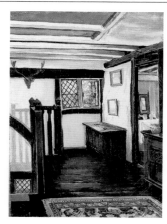

Christie, Ernest C. 1863–1937
Pollingfold, Abinger (view of a landing) c.1927
oil on board 40.6 x 30.5
RR PD1 / 30 / 59

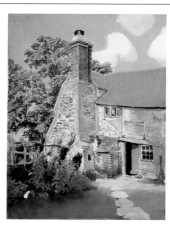

Christie, Ernest C. 1863–1937
Exterior Chimney of Cottage at Mayes Green
1928
oil on board 40.6 x 30.5
RR PD1 / 30 / 17

Christie, Ernest C. 1863–1937
Exterior Chimney of Cottage at Mayes Green
1928
oil on board 45.7 x 30.5
RR PD1 / 30 / 18

Christie, Ernest C. 1863–1937
Exterior Chimney of Cottage at Mayes Green
1928
oil on board 38.1 x 30.5
RR PD1 / 30 / 19

Christie, Ernest C. 1863–1937
Fireplace in Cottage at Mayes Green 1928
oil on board 30.5 x 40.6
RR PD1 / 30 / 16

Christie, Ernest C. 1863–1937
Interior of Olde Bell Inn, Oxted 1928
oil on board 40.6 x 30.5
RR PD1 / 30 / 11

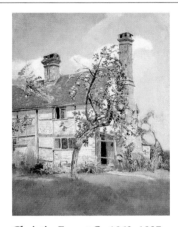

Christie, Ernest C. 1863–1937
Exterior View of Cottage at Mayes Green
c.1928
oil on board 40.6 x 30.5
RR PD1 / 30 / 42

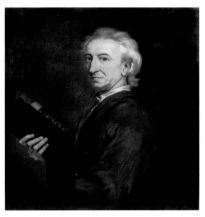

Kneller, Godfrey (after) 1646–1723
John Evelyn, 1687
oil on canvas 76.2 x 66
PD/EV

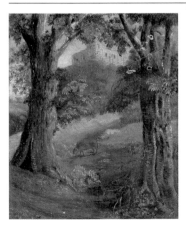

unknown artist
Study of a Castle on a Hill
oil on canvas 48.9 x 35.6
RR PD1 / 30 / 63

The Guildford Institute of the University of Surrey

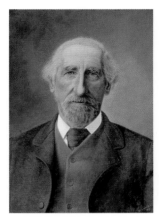

Harris, W. J.
George William Downes (1831–1915) 1916
oil on canvas board 50 x 35.5
G.I. 5

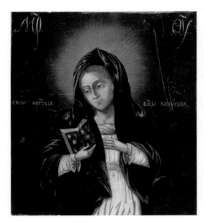

Russian School
Three-Quarter Length Portrait of a Female Saint
oil on panel 35.5 x 30.7
G.I. 6

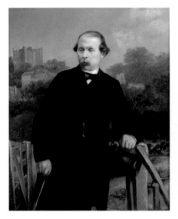

unknown artist
James Macnab by the River Wey, with a View of Guildford Castle c.1866
oil on panel 47 x 37
G.I. 1

Willis-Pryce, George 1866–1949
High Street, Guildford, Looking West, with a View of Holy Trinity Church c.1892
oil on canvas board 52 x 87
G.I. 4

The Guildhall

Halliday, Edward Irvine 1902–1984
Elizabeth II (b.1926) 1957
oil on canvas 99.1 x 73.7
584

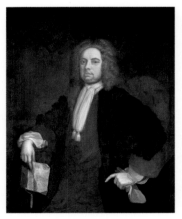

Highmore, Joseph (circle of) 1692–1780
Portrait of a Gentleman, Wearing a Brown Coat, White Glove and an Academic Gown, Holding a Letter
oil on canvas 124.5 x 99.1
582

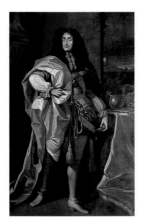

Lely, Peter (circle of) 1618–1680
Charles II (1630–1685)
oil on canvas 259.1 x 134.6
575

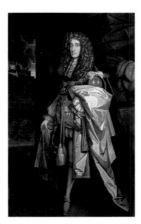

Lely, Peter (circle of) 1618–1680
James II (1633–1701)
oil on canvas 259.1 x 137.2
576

Lewis
Queen's Regiment Parade before the Mayor of Guildford
oil on canvas 125 x 99
574

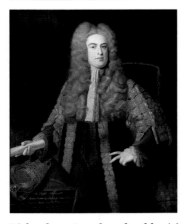

Richardson, Jonathan the elder (circle of) 1665–1745
The Right Honourable Arthur Onslow (1691–1768)
oil on canvas 124.5 x 99.1
579

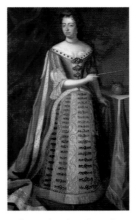

Riley, John (studio of) 1646–1691
Mary II (1662–1694)
oil on canvas 177.8 x 104.1

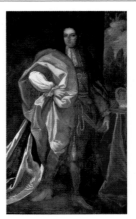

Riley, John (studio of) 1646–1691
William III (1650–1702)
oil on canvas 177.8 x 104.1

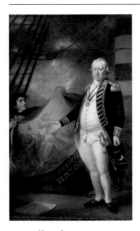

Russell, John 1745–1806
Sir Richard Onslow, Bt (1741–1817)
oil on canvas 231.1 x 142.2
580

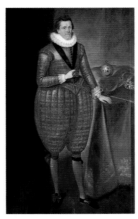

Somer, Paulus van I (circle of) 1576–1621
James I (1566–1625)
oil on canvas 205.7 x 137.2
583

University of Surrey

The University of Surrey was granted its Charter on the 9th September 1966. It had its origins in Battersea College of Technology, which, by the early 1960s, was a potential university in search of a campus, just as Guildford was beginning to be a town in search of a university. The College had been primarily a teaching institution, albeit with increasingly strong research in some disciplines. The University's Charter defined its objectives as, 'The pursuit of learning, the advancement and dissemination of knowledge in Science and Technology and all that pertains to a fuller understanding of humanity, in close co-operation with the industrial life of the country and with commerce and the professions.'

The designated site was on Stag Hill, below the recently completed Cathedral, and building was concentrated on three bands of activity – residential, social and academic – and the move from Battersea to Guildford was completed by 1970. A wide range of cultural activities was planned to draw the local community on to the campus.

The first Vice-Chancellor, Dr Peter Leggett, placed a high value on the arts and humanities, and the college had been starting to develop degree courses in these areas and to offer General Studies courses to all students. Today there is a School of Arts which comprises Dance Studies; Law; Culture, Media and Communication Studies; Translation Studies; Music and Sound Recording; and Political, International and Policy Studies.

At Battersea, Professor Lewis Elton (who had arrived in England in 1939 as a refugee from Prague) had started a project in 1963 to show real art in the Physics Department, of which he was Head. In 1978 Lewis suggested an exhibition *Then and Now* to show the work of some artists who had exhibited, contrasting what they were doing at that time with current work. Those represented included local artists Charles Bone, Brian Dunce, Sir George Pollock, Ronald Smoothey, James Winterbottom and even David Hockney. The exhibitions continue to this date, at first they were located in the Library Gallery, and since 1997 they have been displayed in the Lewis Elton Gallery.

The Gallery continues to flourish and there is a queue of people waiting to exhibit. The policy is to show the work of artists of international and national repute, local professional artists, student work from affiliated institutions and sculpture, ceramics, photography and jewellery.

Apart from Professor Elton's exhibitions in the corridors, there was not much art in the new buildings at Guildford. The Library received the portraits of the Principals of Battersea Polytechnic and in 1983 a number of pictures in the General Studies Department were discovered, of which the provenance and in many cases the names of the artists, were unknown. There had been two artists-in-residence, Oleg Prokofiev (son of the composer) and Andrzej Jackowski, some of whose pictures now adorn our walls.

Over the last 23 years the collection has steadily grown, over and above those works which fall within the scope of this catalogue, particularly pastels and watercolours. Eilean Pearcey, a friend of Professor Elton, donated a collection of drawings she had made of the great Indian dancer Uday Shankar, (brother of Ravi Shankar) now housed in the National Resource Dance Centre.

Facing page: Watts, George Frederick, 1817 –1904, *Sower of the Systems* (detail), 1902, Watts Gallery, (p. 157)

Professor Carola Grindea offered us a selection of paintings by her brother-in-law, Arnold Daghani, a survivor of the holocaust, many of them in unusual media, on sacking, cupboard doors and the like. There is also a collection of his work at the University of Sussex, under the care of the Centre for Anglo-Jewish Studies. An artist called Wendy Spooner (also known as Sparks), donated a number of large pieces to the University before moving abroad, but sadly we have lost touch with her (can anybody help?). There have of course been portraits of Chancellors and Vice-Chancellors by distinguished artists, and even pictures donated by our very eminent late Pro-Chancellor, Sir George Edwards OM, CBE, FRS, DL, who was a talented painter himself.

In 1966–1967 Professor Elton had received £50 for the purchase of works from the exhibitions, this was increased to £500 in the early 1980s and subsequently money was used from the unspent surplus from the arts budget. Now there is a 'Per Cent for Art' budget, as a result of which 1% of the contract price for new buildings and .1% for refurbishments can be used to purchase works of art. This has resulted in some major sculpture commissions, again alas outside the present remit. Another source has been the yearly Vice-Chancellor's Prize for a final year student at Wimbledon School of Art, and the opportunity has been seized to buy other works from their degree shows, also from the Department of Fine Art at the former Roehampton Institute, now Roehampton University, whose students created a mural inspired by the 1987 hurricane for the vegetarian restaurant.

When Professor Dowling – a great supporter of the arts and a discerning collector himself – became Vice-Chancellor in 1994, he moved into a new official residence, Blackwell House, created from an old farmhouse with the addition of a similar-sized new block with an atrium in between. It became a showcase for the University's Collection and acquisitions from exhibitions often found their way there. Professor Christopher Snowden, who became Vice-Chancellor on the 1st July 2005, paints himself and is keen to maintain the tradition of support for the visual arts.

Another source was tapped by the European Institute of Health and Medical Sciences, which entered into an agreement with a comprehensive school in Farnham to acquire paintings by their sixth form pupils. This has been a great success.

The Collection is displayed around the campus for the benefit of staff and students. It has become widely known that pictures can be borrowed from the Arts Office, and lack of storage space means that all are actually on view, and of course are adequately insured!

Patricia Grayburn, Curator

Allen, Michael b.1976
Barriers 1999
oil on canvas 150 x 292 (E)
306

Allison, Jane b.1959
Lord Nugent 1989
oil on canvas 76.2 x 61
148

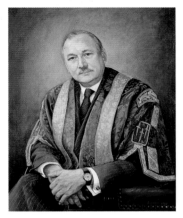

Allison, Jane b.1959
Lord Robens of Woldingham 1989
oil on canvas 100 x 74.6
294

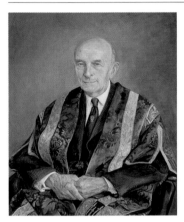

Allison, Jane b.1959
Sir George Edwards 1989
oil on canvas 76.2 x 61
149

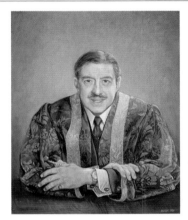

Allison, Jane b.1959
Sir William Mullens 1989
oil on canvas 76.2 x 61
151

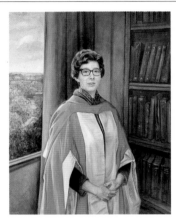

Allison, Jane b.1959
Daphne Jackson (1936–1991) 2001
oil on canvas 89.5 x 69.5
276

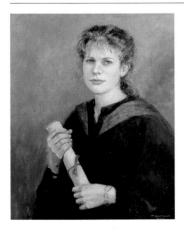

Anderson, Freda b.1942
Emma Jerman 2005
oil on canvas 48 x 38.5
316

Bachba, Emma & Powell, Alex
The Storm, October 1987 1987
acrylic on board 137.5 x 122
202a

Bachba, Emma & Powell, Alex
The Storm, October 1987 1987
acrylic on board 234 x 122
202b

Bachba, Emma & Powell, Alex
The Storm, October 1987 1987
acrylic on board 234 x 86.5
202c

Bachba, Emma & Powell, Alex
The Storm, October 1987 1987
acrylic on board 234 x 86.5
202d

Bachba, Emma & Powell, Alex
The Storm, October 1987 1987
acrylic on board 234 x 96
202e

Bachba, Emma & Powell, Alex
The Storm, October 1987 1987
acrylic on board 234 x 121.5
202f

Bachba, Emma & Powell, Alex
The Storm, October 1987 1987
acrylic on board 234 x 122
202g

Bachba, Emma & Powell, Alex
The Storm, October 1987 1987
acrylic on board 234 x 122
202h

Bachba, Emma & Powell, Alex
The Storm, October 1987 1987
acrylic on board 234 x 105
202i

Bachba, Emma & Powell, Alex
The Storm, October 1987 1987
acrylic on board 234 x 122
202j

Bachba, Emma & Powell, Alex
The Storm, October 1987 1987
acrylic on board 137.5 x 86
202k

Bachba, Emma & Powell, Alex
The Storm, October 1987 1987
acrylic on board 234 x 122
202l

Bachba, Emma & Powell, Alex
The Storm, October 1987 1987
acrylic on board 137.5 x 122
202m

Bachba, Emma & Powell, Alex
The Storm, October 1987 1987
acrylic on board 234 x 122.4
202n

Bachba, Emma & Powell, Alex
The Storm, October 1987 1987
acrylic on board 137.5 x 122
202o

Bachba, Emma & Powell, Alex
The Storm, October 1987 1987
acrylic on board 234 x 121.5
202p

Barratt, Krome 1924–1990
Cadmium and Compliments before 1983
oil on board behind ribbed glass 170 x 59.6
134

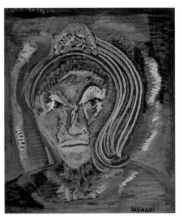

Barter, Paul b.1945
130204
mixed media on board 65 x 122
344

Cuthbert, Alan 1931–1995
Abstract: Yellow Series 3/13
oil on canvas 152 x 152
170

Daghani, Arnold 1909–1985
Abstract: Portrait 1956
acrylic on paper 35.5 x 28.8
326

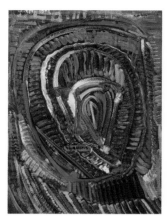

Daghani, Arnold 1909–1985
Abstract 1958
oil on paper 42.4 x 30.6
327

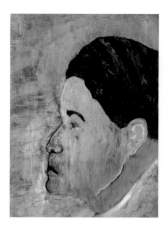

Daghani, Arnold 1909–1985
Portrait in Profile 1963
oil & gouache on paper 58.5 x 40.6
117

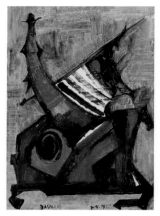

Daghani, Arnold 1909–1985
Musical Abstract No.2 1974–1977
acrylic on paper 59.8 x 49.5
225

Daghani, Arnold 1909–1985
Décaméron: Studies of a Female in Metamorphosis 1979
oil on door panels 31 x 58.5
209

Daghani, Arnold 1909–1985
Abstract: House c.1970s
oil on paper 49.5 x 34.5
325

Daghani, Arnold 1909–1985
Abstract
acrylic? on canvas 37 x 32.7
229

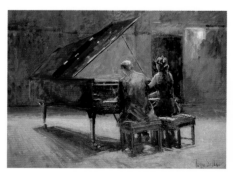

Dellar, Roger b.1949
One Piano, Four Hands (Guildford International Music Festival) 2005
oil on canvas 95 x 120
318

Devitt, Margaret b.1944
Mirabib, Namibia 1995
oil on canvas 61 x 137
277

Devitt, Margaret b.1944
Red Desert 2004
oil on canvas 69.6 x 97.5
329

Di Duca, Adrian b.1966
Big Red 1997
gloss paint, acrylic, pigment on canvas
286 x 286
345

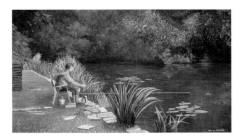

Edwards, George 1908–2003
Boy Fishing 1981
oil on board 29 x 48.5
281

Edwards, George 1908–2003
Balloons over Longdown
oil on board 39.5 x 49.5
D280

Edwards, George 1908–2003
Newlands Corner
oil on board 62 x 60.3
278

Edwards, George 1908–2003
St Martha's Hill
oil on board 58.5 x 59.5
D354

Edwards, George 1908–2003
Tyting Farm
oil on board 40.5 x 34.5
D279

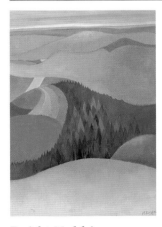

Enright, Madeleine
Mont Pilat
oil on canvas 70 x 49.5
193

Farthing, Stephen b.1950
The Eye of Information 1999–2000
oil on canvas 207.5 x 303.5
282

Fitzgerald, Paul b.1922
HRH the Duke of Kent 1999
oil on canvas 95 x 69.5
283

Fitzgerald, Paul b.1922
HRH the Duke of Kent 1999
oil on canvas 120 x 84 (E)
305

Ganley, Brogan b.1971
Cuenca Recollection 2002
oil on canvas 193 x 117
284

Gildea, Paul b.1956
White Cups and Shell
oil on canvas 55.3 x 90
110

Gotlib, Henryk 1890–1966
Sketch for 'Knossos'
mixed media on paper 96.5 x 59.8
119

Grant, Keith b.1930
Launch of the Ariane Rocket Carrying UOSAT 1983–1984
oil on canvas 127 x 100.5; 127 x 100.5;
127 x 100.5
161a; 161b; 161c

Grant, Keith b.1930
Design for a Mural on the Leggett Building of UOSAT in the Night Sky 1985
mixed media on paper 55.5 x 78.5 (E)
323a

Grant, Keith b.1930
Design for a Mural on the Leggett Building of UOSAT in the Night Sky 1985
mixed media on paper 55.5 x 78.5 (E)
323b

Grant, Keith b.1930
Design for a Mural on the Leggett Building of UOSAT in the Night Sky 1985
mixed media on paper 55.5 x 78.5 (E)
323c

Hardy, Anne
Blue Abstract c.2003
oil or acrylic on canvas 91.2 x 122
307

Hepple, Norman 1908–1994
Dr Peter Leggett 1973
oil on canvas 75 x 62
172 🐝

Hornsby-Smith, Stephen b.1969
Man outside a Nightclub in San Francisco
1991
oil on chipboard 89 x 66

Hornsby-Smith, Stephen b.1969
Seascape II 1995
oil on canvas 59.5 x 49.5
D286

Jackowski, Andrzej b.1947
The Way (Falmouth): Lovers II 1973
mixed media on paper 19.7 x 21.6
235

Jackowski, Andrzej b.1947
Dinner Party for Four 1976
mixed media on paper 20.3 x 25.5
114

Jackowski, Andrzej b.1947
Room at Midday 1976
mixed media on paper 22 x 29
107

Jackowski, Andrzej b.1947
Room with Blinds 1976
mixed media on paper 23.3 x 28
105

Jackowski, Andrzej b.1947
Room with Surprised Guest 1976
mixed media on paper 23.5 x 28
106

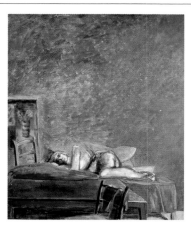

Jackowski, Andrzej b.1947
Reclining Nude
oil on canvas 121 x 103 (E)
230

Jackowski, Andrzej b.1947
Room with a View of the Road
mixed media on paper 23 x 28
108

Jackowski, Andrzej b.1947
The Room (A Lady Seated at a Table)
oil on canvas 122 x 110.5 (E)
231

Jordan, Valerie
I Wish Bonnard Could Come to Tea c.2002
oil on canvas 152.5 x 122
287

Jordan, Valerie
Kurdistan Garden c.2002
oil on canvas 153 x 122
353

Kannreuther, Caroline b.1964
Movement in Four Colours: Large Pink (panel 1 of 4) 2005
oil & acrylic on canvas 150 x 200
317a

Kannreuther, Caroline b.1964
Movement in Four Colours: Red (panel 2 of 4) 2005
oil, enamel & alkyd on board 48 x 58.5
317b

Kannreuther, Caroline b.1964
Movement in Four Colours: Green (panel 3 of 4) 2005
oil, enamel & alkyd on board 66.5 x 46
317c

Kannreuther, Caroline b.1964
Movement in Four Colours: Yellow (panel 4 of 4) 2005
acrylic & alkyd on board 100 x 100
317d

Kilpatrick, Alan b.1963
Beijing Opera 1991
oil & acrylic on canvas 143.5 x 183
104

Facing page: Millais, John Everett, 1829 –1896, *The Princes in the Tower* (detail), 1878, Royal Holloway, University of London, (p. 52)

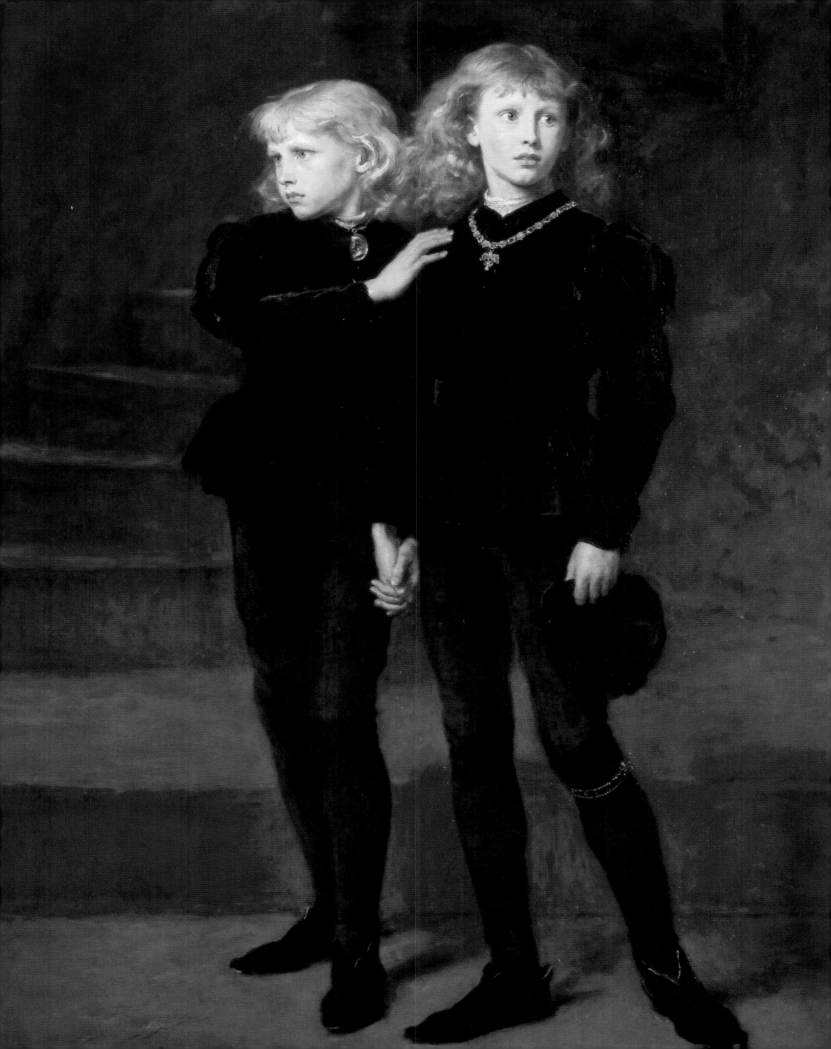

Lang, Kathryn b.1979
Motion Pictures (panel 1 of 3) 2001
oil on canvas 90 x 240 (E)
288a

Lang, Kathryn b.1979
Motion Pictures (panel 2 of 3) 2001
oil on canvas 90 x 240 (E)
288b

Lang, Kathryn b.1979
Motion Pictures (panel 3 of 3) 2001
oil on canvas 90 x 240 (E)
288c

Lawrence, William b.1957
The Painting Studio c.1980
acrylic on canvas 55 x 76
347

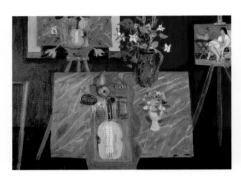

McClure, David 1926–1998
Between Two Easels 1965
oil on canvas 75 x 100
165

McLynn, Rebecca b.1966
Perspectives on the Wey (triptych) 2001
oil on paper 118 x 93
319a; 319b; 319c

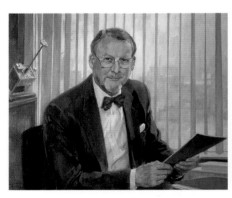

Mendoza, June active 1960–2006
Professor Anthony Kelly 1994
oil on canvas 62.3 x 75
171

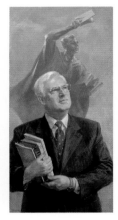

Mendoza, June active 1960–2006
Professor Patrick Dowling 2005
oil on canvas 110 x 55
289

Mohanty, Michael
Abstract c.2000
mixed media on canvas 152 x 101
308

Mohanty, Michael
Abstract c.2000
mixed media on canvas 152 x 101
309

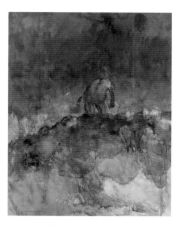

Muszynski, Leszek b.1923
Sunrise (triptych) 1989
oil on canvas 89 x 69
343a

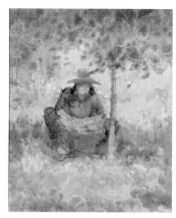

Muszynski, Leszek b.1923
Heat of the Day (triptych) 1989
oil on canvas 89 x 69
343b

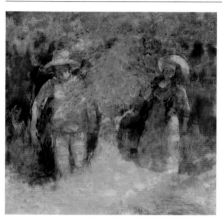

Muszynski, Leszek b.1923
Twilight (triptych) 1989
oil on canvas 89 x 89
343c

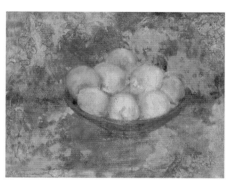

Muszynski, Leszek b.1923
Lemons
oil on canvas 39.5 x 49.5
348

Newbolt, Thomas b.1951
Battersea Power Station 1980
oil on canvas 141 x 152.3
159

Oki, Yuji b.1949
Dancing Tree 1997
oil on canvas 86 x 111
290 ✿

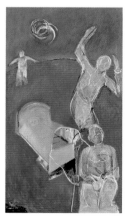

Paxson, Pat b.1939
The Broken Dream (triptych) 1998
oil on canvas 200 x 110.7 (E)
291a

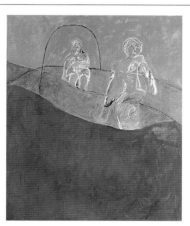

Paxson, Pat b.1939
The Broken Dream (triptych) 1998
oil on canvas 200 x 166 (E)
291b

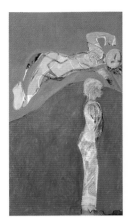

Paxson, Pat b.1939
The Broken Dream (triptych) 1998
oil on canvas 200 x 110 (E)
291c

Penn, William Charles 1877–1968
Major F. H. Johnson, VC 1916
oil on canvas 71 x 58.4
167

Penn, William Charles 1877–1968
*Sidney G. Rawson, DC, Principal of Battersea
Polytechnic (1907–1915)* 1916
oil on canvas 102.5 x 87.2
168

Prokofiev, Oleg 1928–1998
Belle-Ile 1975
oil on canvas 170 x 255 (E)
136

Prokofiev, Oleg 1928–1998
Bodies 1975
oil on canvas 173 x 272
292

Prokofiev, Oleg 1928–1998
The Tree of Life 1975
oil on canvas 200 x 178
135

Prokofiev, Oleg 1928–1998
Allegory of Calumny
oil on canvas 178 x 130
189

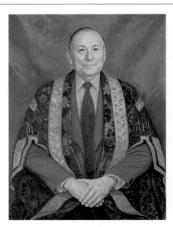

Ramos, Theodore b.1928
Lord Robens 1989
oil on canvas 100 x 74.6
294

Reason, Cyril b.1931
Salome
oil on canvas 213 x 166.5
156

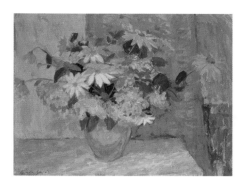

Sajó, Gyula 1918–1979
Yellow Flowers 1965
oil on board 48.2 x 63.5
166

Satchel, Hannah b.1980
South Africa (pair) 2003
oil on canvas 134 x 270
295a

Satchel, Hannah b.1980
South Africa III (pair) 2003
oil on canvas 134 x 270
295b

Spooner, Wendy
A New Moon and a Vortex (The Wave)
mixed media on board 105.5 x 122
267

Spooner, Wendy
Abstract Design: The Blue Tree
acrylic on board 98.5 x 109
270

Spooner, Wendy
Abstract: Street Light
acrylic on board 102 x 72
269

Spooner, Wendy
Christ in Gethsemane
mixed media on board 122 x 135.5
268

Spooner, Wendy
Flower Rocks
acrylic & textiles on board 122.2 x 54.3
275

Spooner, Wendy
Summer Wind
acrylic on board 121.5 x 91.5
271

Spooner, Wendy
The Annunciation
mixed media on board 108.2 x 98.5
266

Spooner, Wendy
The Garden
mixed media on board 90 x 121
265

Spooner, Wendy
The Hand
mixed media on board 79 x 122
264

Spooner, Wendy
Winter Wind
acrylic on board 90 x 121.2
272

Spooner, Wendy
Wooden Collage
acrylic & wooden collage on board 150 x 102
273

Stockbridge, Gill b.1938
Populoso 2004
oil on canvas 90.6 x 72
296

Stokoe, Jack b.1980
Two Figures 2003
oil on canvas 250 x 200 (E)
297

Swann, Marilyn b.1932
Galloping Horse
oil on canvas, laid on board 102.2 x 77
131

Swift, Richard b.1918
Manor House Hall of Residence 1983
oil on canvas 110.5 x 137
139

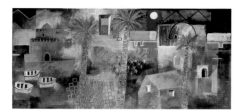

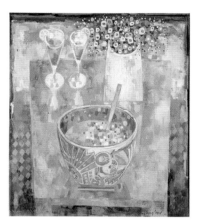

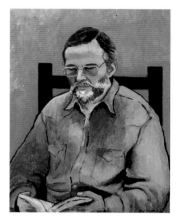

Taylor, Frank b.1946
Methoni, Greece 1999
acrylic & watercolour on paper 36.5 x 75.5
349

Taylor, Frank b.1946
Punch 1999
acrylic & watercolour on paper 28.5 x 24.5
328

Tipton, Heather b.1941
Colin Tipton
oil or acrylic 50 x 39
D299

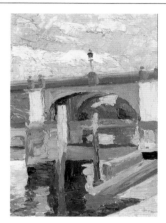

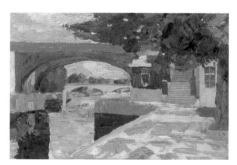

Tipton, Heather b.1941
Still Life: Plant
acrylic on paper? 49.5 x 42
D298

unknown artist late 20th C
View of a Bridge in Richmond
oil on board 34.5 x 24.5
303

unknown artist late 20th C
View of a Bridge in Richmond
oil on board 24.5 x 34.5
304

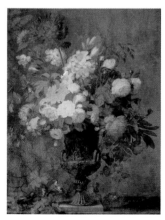

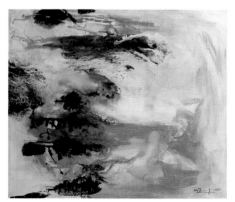

unknown artist
Jardinière of Flowers
oil on board 126.8 x 92
321

Verrall, Nicholas b.1945
Cerisiers dans le jardin
oil on canvas 62 x 94
352

Wei, Feng
The Transfiguration of Landscape 1985
oil on canvas 79 x 90.2
111

Whishaw, Anthony b.1930
Green Landscape c.1972
acrylic on canvas 175 x 305
L300 (P)

Windsor, Alan b.1931
Stars, Fields and Trees 1998–1999
acrylic on canvas 107 x 107
302

Windsor, Alan b.1931
Gem II 2002
acrylic on canvas 38 x 70.3
301

Wolf, Tim
Abstract
oil on canvas 122 x 90
350

Wright, Peter active 20th C
East Coast
oil on canvas 132 x 172.2
181

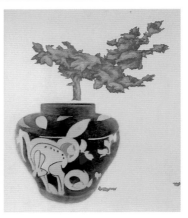

Wright, Steve b.1975
Bonsai 1 (panel 1 of 2) 1998
oil on canvas 95.5 x 79.5
351a

Wright, Steve b.1975
Bonsai 2 (panel 2 of 2) 1998
oil on canvas 95.5 x 79.5
351b

Watts Gallery

Watts Gallery in Compton (near Guildford) was the first purpose-built gallery dedicated to the work of a single artist in England, and opened on Good Friday, 1st April 1904, three months before George Frederick Watts's death.

In his day G. F. Watts (1817–1904) was one of the most famous and internationally renowned living artists. He was the first living artist to be invited to have a solo exhibition at the recently opened Metropolitan Museum of Art in New York. Due to public demand, the show was extended and culminated in Watts's controversial gift of his allegorical painting *Love and Life* to the American people. Watts was awarded two gold medals at the Paris Universal Exhibitions in 1878 and 1889 and won the high regard of the European avant-garde artistic community, including that of the Belgian Symbolist painter and art critic Fernand Khnopff. Watts was also greatly admired by some of the most original thinkers of his day, including Henry James and Oscar Wilde. Such recognition was due to Watts's strong artistic autonomy and deliberate independence of any of the schools or movements of the time. He not only rejected an invitation from the Pre-Raphaelites to decorate the Oxford Union walls with Arthurian murals, but was also reluctant to join the prestigious Royal Academy, despite Lord Leighton's encouragement (though he was eventually convinced in 1867, when the election procedure was especially reformed for him).

Watts had a deep belief in 'art for all' and considered himself a public artist aiming to 'stimulate the mind and awaken large thoughts' in the viewers. Consequently, he donated large parts of his prolific output to public collections and institutions across the UK. Watts was one of the four original founders of the Tate in 1897 (alongside Henry Tate, and two public transfers from the Royal Academy and the National Gallery), having donated 18 of his most accomplished symbolical paintings for the benefit of the nation. This generous gift was received with well-deserved appreciation and was prominently displayed in two dedicated Watts Rooms on the Gallery's opening (and subsequently transferred to a larger room where it remained on permanent display until Mary Seton Watts's death in 1938, when the Watts Room was converted into a special exhibition space).[1] 'The Hall of Fame', Watts's vital gift of over 50 portraits of his distinguished contemporaries to the National Portrait Gallery, still forms the core of its nineteenth-century collection. The series comprises likenesses of eminent Victorians from the world of culture, politics, religion and philosophy, including William Morris, Lord Alfred Tennyson, Josephine Butler, Thomas Carlyle, Cardinal Manning and John Stuart Mill. As a result of his philosophy, Watts is probably the best represented artist in national collections.

However, since its foundation in 1904, Watts Gallery has continued to be the chief repository of G. F. Watts's work. Its rural location might have been partly dictated by convenience, since the Wattses spent their winters at 'Limnerslease', their country house in Compton from the 1890s, where Mary moved permanently after her husband's death. However, it appears that Watts's decision to display the contents of his Kensington studio in the heart of Surrey stemmed primarily from his belief in 'art for all' and his urge to improve the

[1] Smith, A. (2004), 'Watts and the National Gallery of British Art', in C. Trodd and S. Brown (eds), *Representations of G. F. Watts. Art Making in Victorian Culture*, Ashgate.

lives of the working class.

When the Arts and Crafts Movement building designed by Christopher Turnor first opened it served a double purpose. It became an exhibition space for the display of Watts's studio collection, as well as a hostel for Mary Seton Watts's apprentice potters working for her Potters' Arts Guild, later known as the Compton Pottery. The Wattses transformed Compton into a model Arts and Crafts Movement village by involving the local community in a number of artistic undertakings, including clay-modelling classes at Limnerslease (launched in 1895), the building of the Mortuary Chapel (consecrated in 1898) and the foundation of the pottery (c.1900). Indeed, Mary's support for the building of the Compton Village Hall (completed in 1934) demonstrated her continuing dedication and devotion to the local people.

The Gallery houses over 1,000 diverse exhibits including oil paintings, drawings, sculptures and pottery. The artworks range from finished masterpieces (*Paolo and Francesca*, c.1872–1884, or the bronze bust *Clytie*, 1875) to sketches, studies, sculptural maquettes and purely experimental works never intended for public display. The nature and scope of the Watts Gallery collection makes it a fascinating resource for the study of Watts's working methods and techniques. It also demonstrates Watts's remarkable evolution as an artist in terms of style and subject matter over the seven decades of his active career, as well as his responses and contribution to the development of British and European art of the nineteenth and early twentieth century.

Throughout the reign of Queen Victoria, G. F. Watts's style moves from History Painting through Social Realism, Aestheticism and Symbolism to works anticipating Expressionism and Abstraction. The young Watts set out to emulate the achievement of Italian artists in the fresco technique and become England's most famous history painter. This early ambition is represented by two major oils on permanent display at Watts Gallery (*Echo*, 1844–1846 and *Guelphs and Ghibellines*,1846).

However, Watts's aspiration to 'invite reflection' through his art soon took different forms. In the late 1840s, on his return from a carefree four-year stay in Italy with Lord and Lady Holland, Watts was so moved by the miserable poverty of the working classes in England and Ireland that he produced a series of large-scale paintings representing the plight of the unprivileged in very sympathetic terms. These oppressive scenes of modern life (as opposed to grand history) were pioneering works of English Social Realism. Having been exhibited only once during Watts's lifetime at his solo exhibition at the avant-garde Grosvenor Gallery in 1881, *Found Drowned, Under the Dry Arch, Song of the Shirt* and *Irish Famine* (all 1848–1850) remain on permanent display at Watts Gallery.

Throughout his career, Watts innovated within Victorian art and unconsciously foreshadowed developments in the late nineteenth-and early twentieth-century European avant-garde. His Venetian classical paintings of the 1860s, such as *Rhodopis* (c.1868) and *Clytie* (late 1860s), reveal him as a pioneer of Aestheticism along with his friends Dante Gabriel Rossetti, Edward Burne-Jones and Frederic Leighton. [2] He helped re-introduce the depiction of the nude into Victorian art in the 1860s through works like *Thetis* (1866–1893) and later developed a heroic and deliberately non-sexual depiction of the nude in grand public works such as *Eve Repentant* (1868–1903). [3] His monumental allegories such as *Love and Death* (1871–1887) and *Mammon* (1885) were

[2] Underwood, H. (2004), 'Watts and the Symbolist Art in the Nineteenth Century', pp.30-31 in V. Franklin Gould (ed.), *The Vision of G.F. Watts*, Watts Gallery.

[3] Smith, A. (1996), *The Victorian Nude: Sexuality, Morality and Art*, Manchester University Press.

admired by the European Symbolists, as were his aesthetic portraits (*Violet Lindsay*, 1879) and symbolist landscapes (*After the Deluge*, 1885–1886).[4] Some of his paintings (*Sower of the Systems*, 1902) even seem to presage Abstraction.

In addition to diverse works by G. F. Watts, Watts Gallery also owns a number of works by other Victorian and early Edwardian artists, including Val Prinsep, Arthur Hughes, Charles Shannon, Lord Leighton, John Singer Sargent and Graham Robertson. These works come primarily from two major bequests made after Mary Seton Watts's death in 1938. The Graham Robertson Bequest (1951) consists of a collection of Victorian and Edwardian portraiture. The Cecil French Bequest (1954) comprises primarily imaginative works from the Aesthetic Movement and Pre-Raphaelite traditions. The nature of the two bequests reflects the main tendencies within Watts's oeuvre – subject pictures and portraits.

However, when Watts Gallery first opened, the Collection included 109 core works by G. F. Watts exclusively. These largely finished subject pictures comprised the original Memorial Collection listed in the Trust Deed signed by Mary Seton Watts and the executors and trustees of G. F. Watts's will on the 24th May 1905. Only 13 of these pictures were recorded as studies, sketches or unfinished works, and only four were drawings. The core Collection was subsequently enriched by gifts from Mary Seton Watts and Lilian Chapman (née Macintosh), Watts's adopted daughter, and has been expanding through other bequests and donations as well as acquisitions made with the generous support of the NACF and Heritage Lottery Fund (the significant portrait of the Ionides family, *Alexander Constantine Ionides and His Wife Euterpe*, c.1841–1842, being the most recent addition to the Collection purchased through Sotheby's in 2005).

There have been only four curators in the gallery's first century. Mr Thompson, the first, left the gallery in 1914 and Mrs Watts dispensed with an official curator until 1931, when Roland Alston was appointed and confirmed as curator in 1938. Wilfrid Blunt (artist, writer and, formerly, drawing and calligraphy master at Eton) took over in 1959 and wrote the first contemporary biography of G. F. Watts, *England's Michelangelo* (1975). Blunt's curatorship lasted for 26 years and, following his retirement in 1985, his assistant Richard Jefferies was appointed as his successor. At the beginning of his term of office, Richard was able to refurbish and reopen the Sculpture Gallery, which had been closed for over 40 years, and which remains one of the favourite aspects of our Collection. In 2004 Perdita Hunt joined Watts Gallery as its Director and launched the *Hope Appeal* – a restoration and education project aimed at rescuing the Gallery for future generations. Mark Bills was appointed the new curator following Richard's retirement earlier this year.

Watts Gallery is undergoing a dynamic period of development, which started with the Watts Centenary in 2004. The Centenary celebrations were marked with special temporary exhibitions and the publication of several significant books on Watts, including the most recent and comprehensive biography of the artist, *G. F. Watts: The Last Great Victorian* by Veronica Franklin Gould (2004). The reinstatement of Watts's reputation is underway and we are delighted to be able to promote Watts's output through the work of the Public Catalogue Foundation.

Julia Dudkiewicz, Assistant Curator

[4] For a comprehensive discussion of Watts's symbolist works see: A. Wilton and R. Upstone (eds) (1997). *The Age of Rossetti, Burne-Jones & Watts. Symbolism in Britain 1860-1910*, Tate Gallery Publishing.

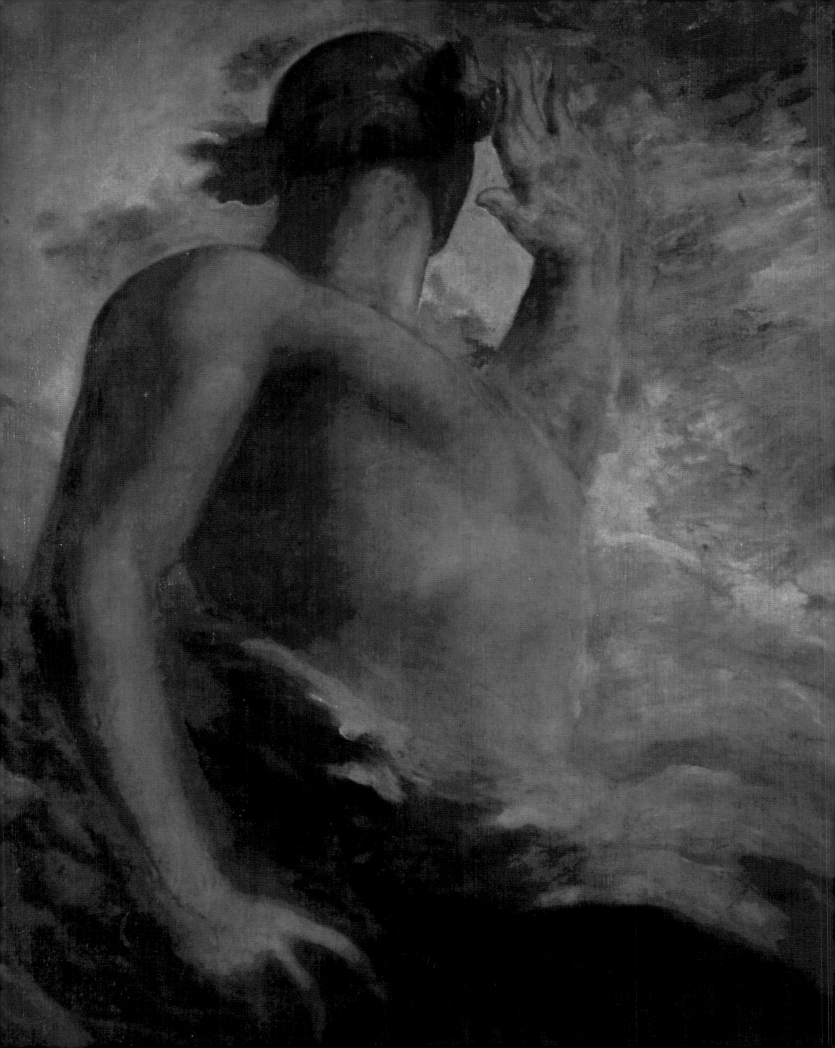

Alston, Rowland Wright 1895–1958
Lough Conn, Ireland 1935
oil on paper 21.5 x 31.8

Alston, Rowland Wright 1895–1958
Dead Bird (Sheldrake)
oil on canvas 45.7 x 30.5
COMWG 580

Bauerle, Karl Wilhelm Friedrich 1831–1912
Graham Robertson as a Boy 1871
oil on canvas 140.8 x 110
COMWG 572

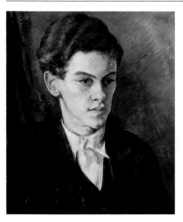

Blunt, Wilfrid 1901–1987
Michael Severne 1939
oil on canvas 49.6 x 39.5
COMWG NC 25

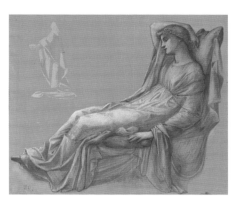

Burne-Jones, Edward 1833–1898
Laus Veneris c.1873
mixed media heightened with gold on board
34 x 40
COMWG 560

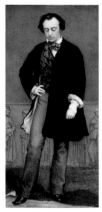

Couzens, Charles active 1838–1875
G. F. Watts 1849
oil on canvas 41 x 21.4
COMWG 501

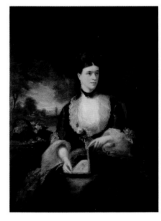

Graves, Henry Richard (attributed to)
1818–1882
Mrs Graham Robertson, in Her Youth 1873
oil on canvas 140.5 x 99.7
COMWG 573

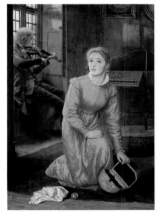

Hughes, Arthur 1832–1915
Memories c.1882–1883
oil on canvas 84 x 59.9
COMWG 579

**Leighton, Frederic, 1st Baron Leighton of
Stretton** 1830–1896
Female Head
oil on canvas 18 x 13
COMWG 555

Facing page: Watts, George Frederick, 1817–1904, *Satan* (detail), 1847, Watts Gallery, (p. 138)

Melville, Arthur 1855–1904
Mrs Graham Robertson 1900
oil on canvas 201 x 165
COMWG 571

Prinsep, Valentine Cameron 1838–1904
Nancy Hitchens c.1880s
oil on canvas 65.2 x 50.3
COMWG 577

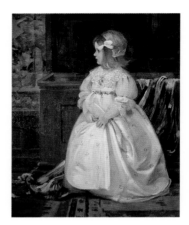

Robertson, Walford Graham 1866–1948
Binkie 1899
oil on canvas 124 x 100.1
COMWG 570

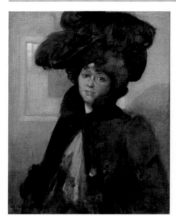

Robertson, Walford Graham 1866–1948
Olga Brandon 1901
oil on canvas 76.5 x 58.5
COMWG 569

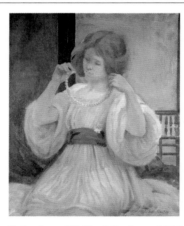

Robertson, Walford Graham 1866–1948
The Amber Necklace
oil on canvas 77.6 x 64.7
COMWG NC 7

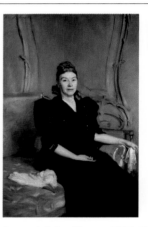

Sargent, John Singer 1856–1925
Mrs Graham Robertson 1880
oil on canvas 159 x 102.5
COMWG 568

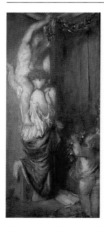

Shannon, Charles Haslewood 1863–1937
The Garland 1895–1902
oil on canvas 88.2 x 40.8
COMWG 575

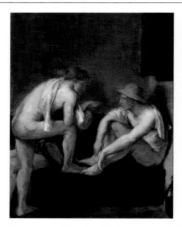

Shannon, Charles Haslewood 1863–1937
The Bathers 1900
oil on board 45.8 x 35.2
COMWG 563

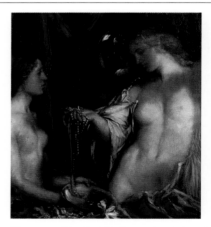

Shannon, Charles Haslewood 1863–1937
The Toilet 1903
oil on canvas 85 x 76.4
COMWG 553

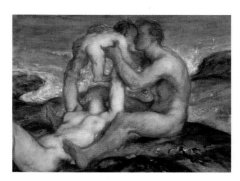

Shannon, Charles Haslewood 1863–1937
An Idyll 1904
oil on canvas 35.8 x 46.2
COMWG 564

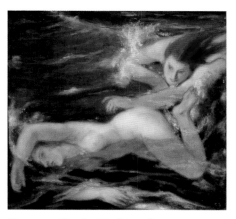

Shannon, Charles Haslewood 1863–1937
The Pursuit
oil on canvas 38.6 x 40.8
COMWG 554

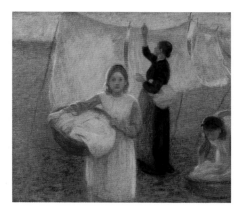

Stott, William 1857–1900
Washing Day
oil on canvas 46.7 x 51.9
COMWG 550

unknown artist
Group Portrait
oil on board 33.8 x 53.5
COMWG NC36

Watts, George Frederick 1817–1904
Early Copy from an Unidentified Baroque Portrait c.1830
oil on canvas 29.8 x 21.6
COMWG 259

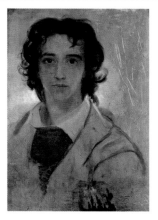

Watts, George Frederick 1817–1904
Self Portrait, Aged 17 1834
oil on canvas 53.3 x 38.1
COMWG 10

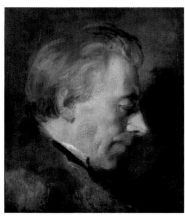

Watts, George Frederick 1817–1904
The Artist's Father 1834–1836
oil on canvas 38 x 32
COMWG 119

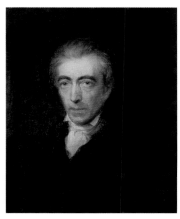

Watts, George Frederick 1817–1904
The Artist's Father, Half-Length 1834–1836
oil on canvas 61 x 51
COMWG 3

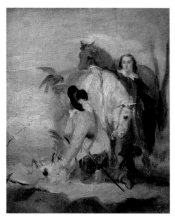

Watts, George Frederick 1817–1904
The Falconer c.1834–1836
oil on canvas 25.4 x 20.3
COMWG 236

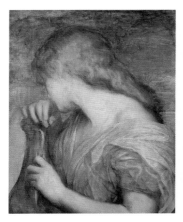

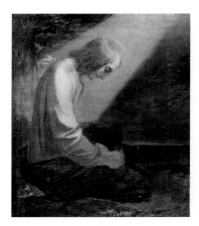

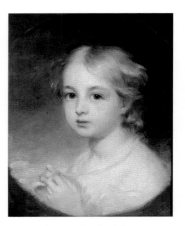

Watts, George Frederick 1817–1904
Undine 1835 & 1870
oil on canvas 61 x 48.3
COMWG 62

Watts, George Frederick 1817–1904
A Kneeling Figure (A Man of Sorrows)
c.1835–1836
oil on canvas 34.5 x 30.1
COMWG NC 23

Watts, George Frederick 1817–1904
Little Miss Hopkins 1836
oil on canvas 25.4 x 20.3
COMWG 58

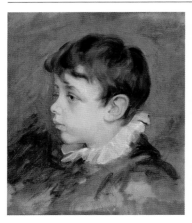

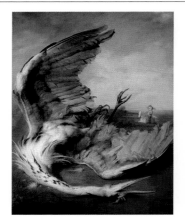

Watts, George Frederick 1817–1904
Portrait of a Boy's Head (Cornellius) 1836
oil on canvas 40.6 x 35.6
COMWG 173

Watts, George Frederick 1817–1904
The Wounded Heron 1837
oil on canvas 91.4 x 71.1
COMWG 64

Watts, George Frederick 1817–1904
Reverend A. Wellsted 1838–1839
oil on canvas 25.4 x 20.3
COMWG 189

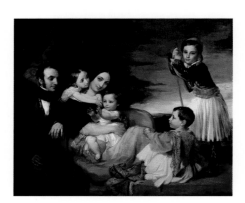

Watts, George Frederick 1817–1904
Gerald Hamilton as an Infant 1839
oil on canvas 50.8 x 63.5
COMWG NC 24

Watts, George Frederick 1817–1904
Blondel 1841
oil on canvas 29.7 x 24.7
COMWG NC 13

Watts, George Frederick 1817–1904
*Alexander Constantine Ionides and His Wife
Euterpe, with Their Children Constantine,
Alexander, Aglaia and Alecco* c.1841–1842
oil on canvas 150 x 183
COMWG NC 26

Watts, George Frederick 1817–1904
Lady Holland on Daybed 1844
oil on canvas 38.1 x 45.7
COMWG 16

Watts, George Frederick 1817–1904
Lady Augusta Holland c.1844
oil on canvas 68.5 x 56
COMWG 55

Watts, George Frederick 1817–1904
Drowning of the Doctor 1844–1845
oil on canvas 20.3 x 25.4
COMWG 253

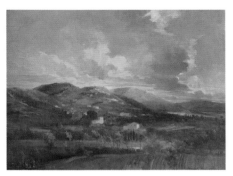

Watts, George Frederick 1817–1904
Fiesole, Tuscany 1844–1845
oil on canvas 66 x 86.4
COMWG 12

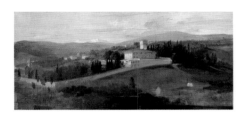

Watts, George Frederick 1817–1904
Villa Petraia 1844–1845
oil on canvas 30.5 x 63.3
COMWG NC 22

Watts, George Frederick 1817–1904
Echo 1844–1846
oil on canvas 388.6 x 198.1
COMWG LN 1

Watts, George Frederick 1817–1904
Miss Marietta Lockhart 1845
oil on canvas 76.2 x 63.5
COMWG NC 10

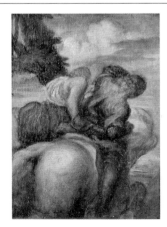

Watts, George Frederick 1817–1904
Orderic and the Witch 1845–1868
oil on panel 35.6 x 27.9
COMWG 24

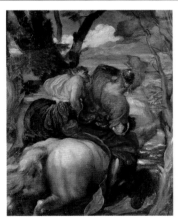

Watts, George Frederick 1817–1904
Orderic and the Witch (Large version in colour) 1845–1868
oil on canvas 71.1 x 58.4
COMWG 4

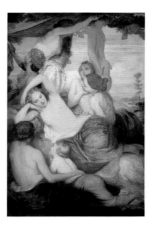

Watts, George Frederick 1817–1904
Diana's Nymphs 1846
oil on canvas 195.6 x 137.2
COMWG 32

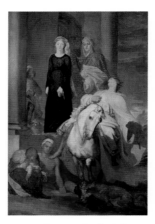

Watts, George Frederick 1817–1904
Guelphs and Ghibellines 1846
oil on canvas 320 x 259.1
COMWG 45

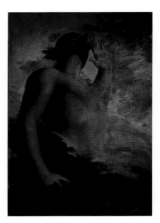

Watts, George Frederick 1817–1904
Satan 1847
oil on canvas 198.1 x 132.1
COMWG 117

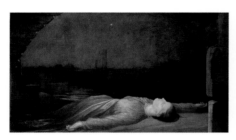

Watts, George Frederick 1817–1904
Found Drowned 1848–1850
oil on canvas 119.4 x 213.4
COMWG 161

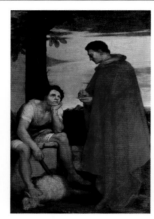

Watts, George Frederick 1817–1904
Aristides and the Shepherd 1848–1852
oil on canvas 305 x 213
COMWG 33

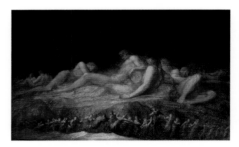

Watts, George Frederick 1817–1904
The Titans 1848–1873
oil on panel 71.1 x 111.8
COMWG 109

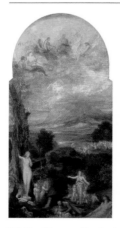

Watts, George Frederick 1817–1904
Olympus 1849
oil on canvas 129.5 x 53.5
COMWG 74

Watts, George Frederick 1817–1904
Under the Dry Arch 1849–1850
oil on canvas 137 x 101.5
COMWG 171

Watts, George Frederick 1817–1904
The Good Samaritan 1849–1904
oil on canvas 243.8 x 154.9
COMWG 140

Watts, George Frederick 1817–1904
Irish Famine 1850
oil on canvas 180.3 x 198.1
COMWG 132

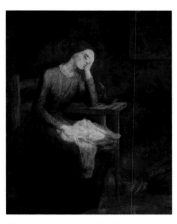

Watts, George Frederick 1817–1904
Song of the Shirt 1850
oil on canvas 144.8 x 127
COMWG 128

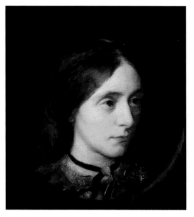

Watts, George Frederick 1817–1904
Mrs Morris 1850s
oil on panel 40.6 x 35.6
COMWG 181

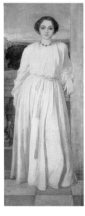

Watts, George Frederick 1817–1904
Lady Dalrymple c.1851–1853
oil on canvas 198 x 78.7
COMWG 200

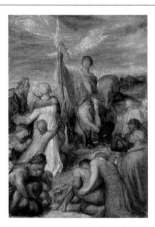

Watts, George Frederick 1817–1904
St George 1852
oil on canvas 55.9 x 38.1
COMWG 20

Watts, George Frederick 1817–1904
Study for Carlton House Terrace Frescoes
1853–1854
oil on canvas 14 x 61
COMWG NC 1

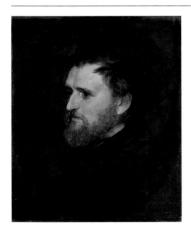

Watts, George Frederick 1817–1904
James Barr Mitchell 1855–1856
oil on canvas 46.6 x 56.2
COMWG NC 6

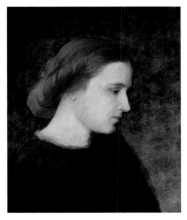

Watts, George Frederick 1817–1904
Miss Mildmay 1855–1856
oil on canvas 55.9 x 45.7
COMWG 65

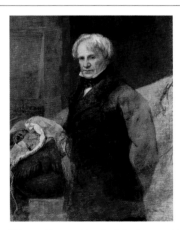

Watts, George Frederick 1817–1904
Admiral Lord Lyons 1856
oil on canvas 121.9 x 99.1
COMWG 170

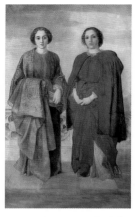

Watts, George Frederick 1817–1904
The Sisters 1856
oil on canvas 231.1 x 144.8
COMWG 137

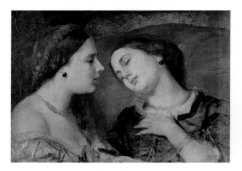

Watts, George Frederick 1817–1904
Georgina Treherne 1856–1858
oil on canvas 50.8 x 69.9
COMWG NC 19

Watts, George Frederick 1817–1904
Bodrum, Asia Minor 1857
oil on canvas 20.3 x 58.4
COMWG 174

Watts, George Frederick 1817–1904
In Asia Minor 1857
oil on canvas 30.5 x 61
COMWG 85

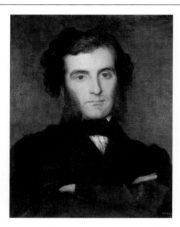

Watts, George Frederick 1817–1904
Dr Zambaco 1858
oil on panel 50.8 x 40.6
COMWG NC 20

Watts, George Frederick 1817–1904
Study for Fresco of Corialanus for Bowood House 1858–1860
mixed media on paper laid on canvas
134 x 109.5
COMWG NC 2

Watts, George Frederick 1817–1904
Study for Fresco of Corialanus for Bowood House 1858–1860
mixed media on paper laid on canvas
134 x 105.5
COMWG NC 3

Watts, George Frederick 1817–1904
Study for Fresco of Corialanus for Bowood House 1858–1860
mixed media on paper laid on canvas
134 x 77.5
COMWG NC 4

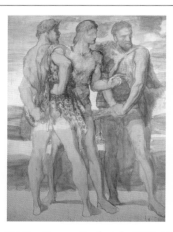

Watts, George Frederick 1817–1904
Study for Fresco of Corialanus for Bowood House 1858–1860
mixed media on paper laid on canvas
98.5 x 86
COMWG NC 5

Facing page: Holland, James, 1800–1870, *Piazza dei Signori, Verona, with the Market Place* (detail), 1844,
Royal Holloway, University of London, (p. 48)

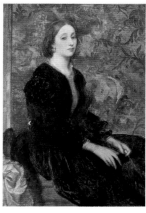

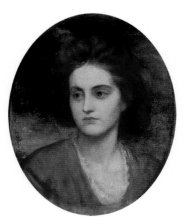

Watts, George Frederick 1817–1904
Achilles and Briseis c.1858–1860
fresco, mixed media & oil on plaster
122 x 518.5
COMWG 94

Watts, George Frederick 1817–1904
Aileen Spring-Rice 1859
oil on canvas 40.6 x 33
COMWG 27

Watts, George Frederick 1817–1904
Lady Lilford 1860
oil on canvas 50.8 x 40.6
COMWG 31

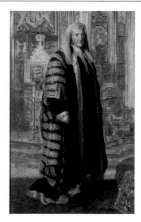

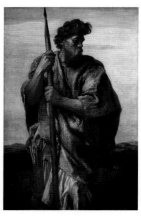

Watts, George Frederick 1817–1904
Lady Somers 1860
oil on panel 121.9 x 89
COMWG 71

Watts, George Frederick 1817–1904
Lord Campbell 1860
oil on panel 63.5 x 38
COMWG 18

Watts, George Frederick 1817–1904
Esau 1860–1865
oil on canvas 165.1 x 111.8
COMWG 129

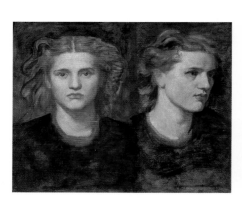

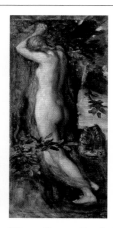

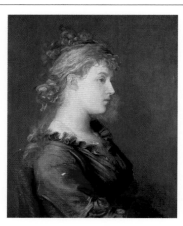

Watts, George Frederick 1817–1904
'Long Mary' c.1860
oil on panel 53.3 x 66
COMWG 180

Watts, George Frederick 1817–1904
Eve Repentant 1860s
oil on canvas 61 x 28
COMWG 26

Watts, George Frederick 1817–1904
Lady Archibald Campbell 1860s
oil on canvas 66 x 53.3
COMWG 108

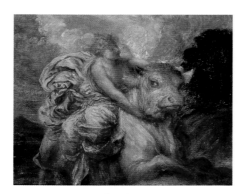

Watts, George Frederick 1817–1904
Europa 1860s & late 1890s
oil on canvas 53.3 x 66
COMWG 14

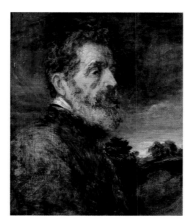

Watts, George Frederick 1817–1904
Earl of Shrewsbury 1862
oil on panel 61 x 53.3
COMWG 52

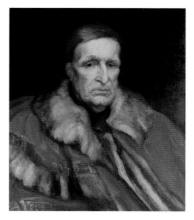

Watts, George Frederick 1817–1904
Lord Lyndhurst 1862
oil on canvas 61 x 50.8
COMWG 50

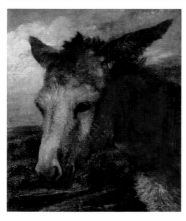

Watts, George Frederick 1817–1904
Head of an Ass 1862–1863
oil on panel 61 x 51
COMWG 155

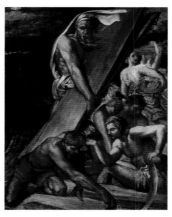

Watts, George Frederick 1817–1904
The Building of the Ark 1862–1863
oil on canvas 94 x 73.7
COMWG 111

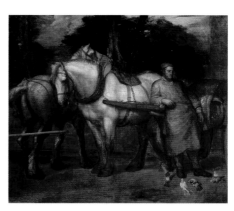

Watts, George Frederick 1817–1904
The Midday Rest (Dray Horses) 1862–1863
oil on canvas 137.2 x 154.9
COMWG 82

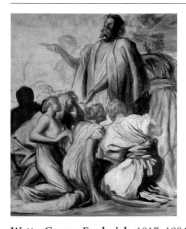

Watts, George Frederick 1817–1904
Preaching of Jonah (or Noah) c.1863
oil on canvas 70 x 58
COMWG 165

Watts, George Frederick 1817–1904
*Ganymede (Son of Dr Zambaco and Miss
Mary Cassavetti)* 1864
oil on canvas 58.4 x 45.7
COMWG 110

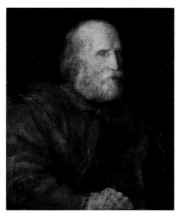

Watts, George Frederick 1817–1904
Giuseppe Garibaldi (1807–1882) 1864
oil on canvas 68.6 x 55.9
COMWG 51

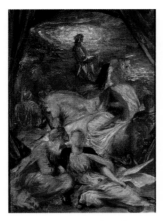

Watts, George Frederick 1817–1904
Britomart 1865
oil on canvas 56 x 38
COMWG 29

Watts, George Frederick 1817–1904
Dr J. Joachim 1865–1866
oil on canvas 91.4 x 66.6
COMWG 34

Watts, George Frederick 1817–1904
Sir Henry Taylor (unfinished) 1865–1870
oil on canvas 66 x 53.3
COMWG 96

Watts, George Frederick 1817–1904
The Standard-Bearer 1866
oil on canvas 66 x 53.3
COMWG 19

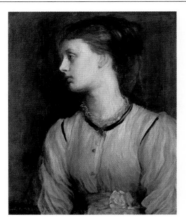

Watts, George Frederick 1817–1904
Miss May Prinsep 1867–1869
oil on canvas 66 x 53.3
COMWG 88

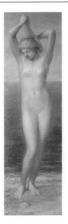

Watts, George Frederick 1817–1904
Thetis 1867–1869
oil on canvas 193 x 53.3
COMWG 42

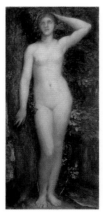

Watts, George Frederick 1817–1904
Thetis 1867–1869
oil on canvas 66.5 x 30.5
COMWG 93

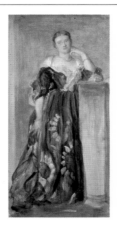

Watts, George Frederick 1817–1904
Mrs Percy Wyndham 1867–1871
oil on canvas 53.3 x 27.9
COMWG 56

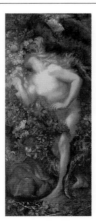

Watts, George Frederick 1817–1904
Eve Tempted 1868
oil on canvas 251.5 x 109.2
COMWG 142

Watts, George Frederick 1817–1904
Florence Nightingale (1820–1910) 1868
oil on canvas 66 x 53.3
COMWG 152

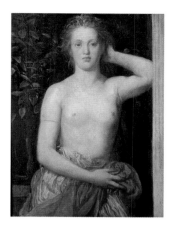

Watts, George Frederick 1817–1904
Rhodopis c.1868
oil on canvas 91.4 x 71.1
COMWG 114

Watts, George Frederick 1817–1904
Cedar Tree 1868–1869
oil on panel 45.7 x 29.2
COMWG 160

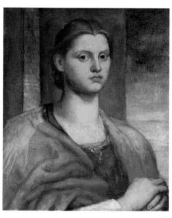

Watts, George Frederick 1817–1904
A Fair Saxon 1868–1870
oil on canvas 66 x 53.3
COMWG 91

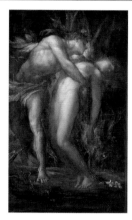

Watts, George Frederick 1817–1904
Orpheus and Euridice (small version)
1868–1872
oil on canvas 66 x 38.1
COMWG 79

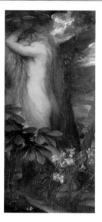

Watts, George Frederick 1817–1904
Eve Repentant 1868–1903
oil on canvas 251.5 x 114.3
COMWG 141

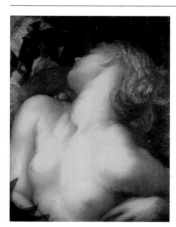

Watts, George Frederick 1817–1904
Clytie late 1860s
oil on panel 61 x 51
COMWG 73

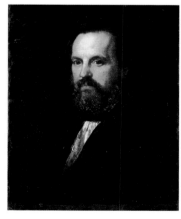

Watts, George Frederick 1817–1904
Donders Frans late 1860s
oil on canvas 66 x 53.3
COMWG 179

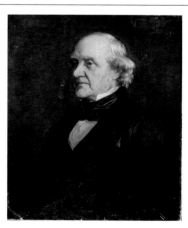

Watts, George Frederick 1817–1904
George Peabody late 1860s
oil on canvas 94 x 71.1
COMWG 121

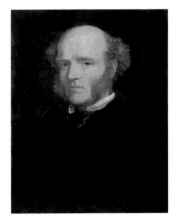

Watts, George Frederick 1817–1904
Thomas Hughes c.1870s
oil on canvas 66 x 48.3
COMWG 5

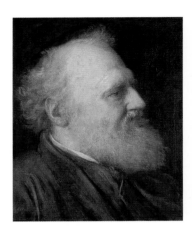

Watts, George Frederick 1817–1904
H. Toby Prinsep 1871
oil on canvas 50.8 x 40.6
COMWG 153

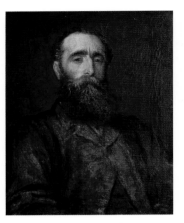

Watts, George Frederick 1817–1904
P. H. Calderon 1871
oil on canvas 63.5 x 51
COMWG 40

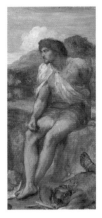

Watts, George Frederick 1817–1904
Samson 1871
oil on panel 55.9 x 25.4
COMWG 75

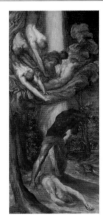

Watts, George Frederick 1817–1904
The Denunciation of Cain 1871–1872
oil on canvas 147 x 68.6
COMWG 76

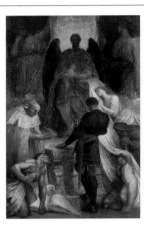

Watts, George Frederick 1817–1904
The Court of Death 1871–1902
oil on canvas 94 x 61
COMWG 81

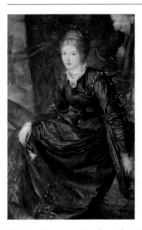

Watts, George Frederick 1817–1904
Miss Virginia Julian Dalrymple (Mrs Francis Champneys) 1872
oil on canvas 132 x 84
COMWG 200A

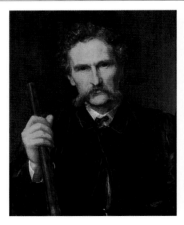

Watts, George Frederick 1817–1904
Rith H. Wallis-Dunlop 1872
oil on canvas 64.8 x 52.1
COMWG LN 2 (P)

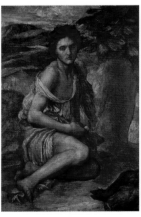

Watts, George Frederick 1817–1904
The Prodigal Son 1872–1873
oil on canvas 109.2 x 78.7
COMWG 192

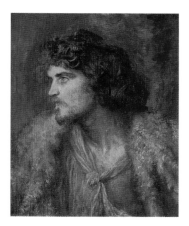

Watts, George Frederick 1817–1904
The Prodigal Son (bust-length figure)
1872–1873
oil on canvas 61 x 50.8
COMWG 44

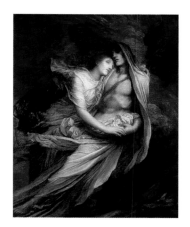

Watts, George Frederick 1817–1904
Paolo and Francesca 1872–1875
oil on canvas 152.4 x 129.5
COMWG 83

Watts, George Frederick 1817–1904
The Spirit of Christianity 1872–1875
oil on canvas 91.4 x 53.3
COMWG 122

Watts, George Frederick 1817–1904
John Stuart Mill (1806–1873) 1873
oil on canvas 66 x 53.3
COMWG 86

Watts, George Frederick 1817–1904
The Denunciation of Adam and Eve 1873
oil on panel 61 x 25.4
COMWG 59

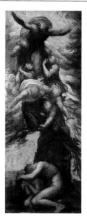

Watts, George Frederick 1817–1904
The Denunciation of Adam and Eve 1873
oil on canvas 117 x 44
COMWG 162

Watts, George Frederick 1817–1904
Chaos 1873–1875
oil on canvas 104 x 317.5
COMWG 143

Watts, George Frederick 1817–1904
King Edward VII (1841–1910) 1874
oil on canvas 235 x 118.1
COMWG 138

Watts, George Frederick 1817–1904
Lady Garvagh 1874
oil on canvas 66 x 48.3
COMWG 57

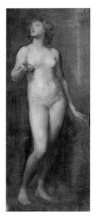

Watts, George Frederick 1817–1904
Study of Nude (Standing Figure) 1874
oil on canvas 52 x 21.5
COMWG 17

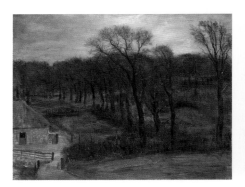

Watts, George Frederick 1817–1904
Freshwater, near Farringford 1874–1875
oil on canvas 53.3 x 66
COMWG 163

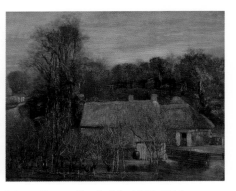

Watts, George Frederick 1817–1904
Freshwater Farm Buildings 1875
oil on canvas 53.3 x 66
COMWG 166

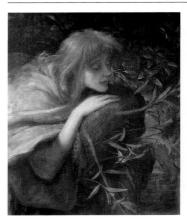

Watts, George Frederick 1817–1904
Ophelia 1875–1880
oil on canvas 76.2 x 63.5
COMWG 89

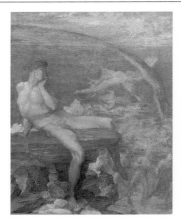

Watts, George Frederick 1817–1904
Genius of Greek Poetry 1878
oil on canvas 66 x 53.3
COMWG 22

Watts, George Frederick 1817–1904
Jacob and Esau 1878
oil on canvas 106.7 x 99.1
COMWG 25

Watts, George Frederick 1817–1904
King Edward VII (1841–1910) 1878
oil on canvas 66 x 56
COMWG 154

Watts, George Frederick 1817–1904
Arcadia 1878–1880
oil on canvas 193 x 61
COMWG 39

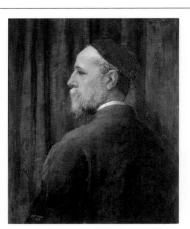

Watts, George Frederick 1817–1904
Self Portrait 1879
oil on canvas 66 x 53.3
COMWG 9

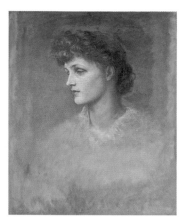

Watts, George Frederick 1817–1904
Violet Lindsay 1879
oil on canvas 66 x 53.3
COMWG 148

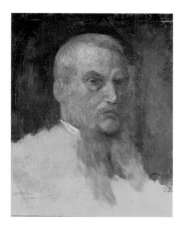

Watts, George Frederick 1817–1904
Sir Richard Burton 1879–1880
oil on canvas 66 x 53.3
COMWG 176

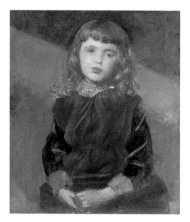

Watts, George Frederick 1817–1904
Lucy Bond 1880
oil on canvas 66 x 53.3
COMWG 177

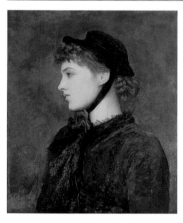

Watts, George Frederick 1817–1904
Mrs Lillie Langtry 1880
oil on canvas 66 x 53.3
COMWG 43

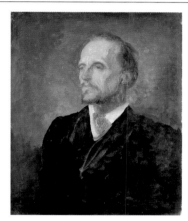

Watts, George Frederick 1817–1904
Sketch of Lord Dufferin 1880
oil on canvas 66.4 x 53.2
COMWG NC 11

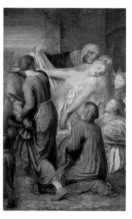

Watts, George Frederick 1817–1904
Lady Godiva 1880–1890
oil on canvas 185.4 x 109.2
COMWG 136

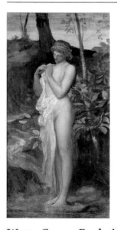

Watts, George Frederick 1817–1904
Daphne's Bath 1880s
oil on canvas 56 x 28
COMWG 77

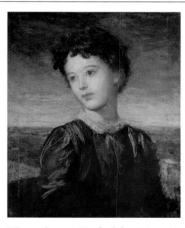

Watts, George Frederick 1817–1904
Laura Gurney (later Lady Troubridge) 1880s
oil on canvas 61 x 50.8
COMWG 54

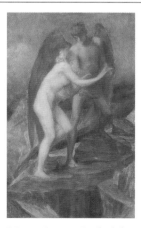

Watts, George Frederick 1817–1904
Love and Life 1880s
oil on canvas 66 x 43.2
COMWG 175

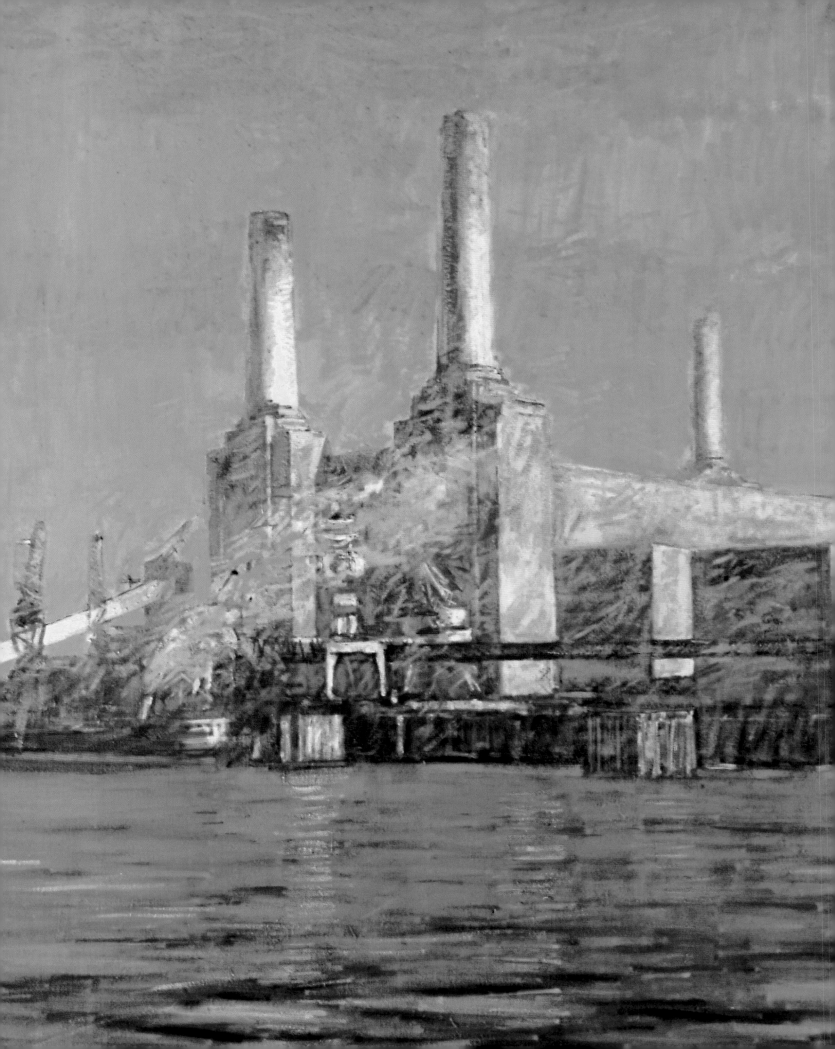

Watts, George Frederick 1817–1904
Miss Blanche Maynard 1881–1882
oil on canvas 63.5 x 53.3
COMWG 149

Watts, George Frederick 1817–1904
The Creation of Eve 1881–1882
oil on canvas 117 x 43.2
COMWG 11

Watts, George Frederick 1817–1904
The Creation of Eve (unfinished) 1881–1882
oil on canvas 117 x 43.2
COMWG 13

Watts, George Frederick 1817–1904
G. F. Watts 1882
oil on canvas 66 x 53.3
COMWG 105 (P)

Watts, George Frederick 1817–1904
Tasting the First Oyster 1882–1883
oil on canvas 104.1 x 165.1
COMWG 92

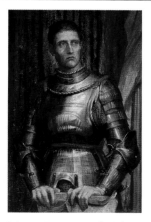

Watts, George Frederick 1817–1904
The Condottiere 1883
oil on canvas 99.1 x 61
COMWG 168

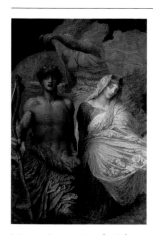

Watts, George Frederick 1817–1904
Time, Death and Judgement 1884
oil on canvas 243.8 x 168.9
COMWG LN 3

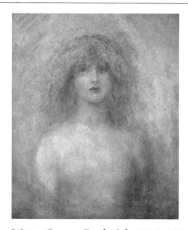

Watts, George Frederick 1817–1904
Uldra 1884
oil on canvas 66 x 53.3
COMWG NC 21

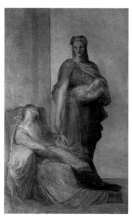

Watts, George Frederick 1817–1904
The Messenger 1884–1885
oil on canvas 111.8 x 66
COMWG 37

Facing page: Newbolt, Thomas, b.1951, *Battersea Power Station* (detail), 1980, University of Surrey, (p. 123)

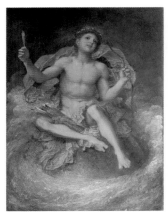

Watts, George Frederick 1817–1904
Idle Child of Fancy 1885
oil on canvas 147.3 x 106.7
COMWG 147

Watts, George Frederick 1817–1904
Mammon 1885
oil on canvas 53.3 x 30.5
COMWG 49

Watts, George Frederick 1817–1904
Near Brighton 1885
oil on canvas 50.8 x 61
COMWG 125

Watts, George Frederick 1817–1904
Olympus on Ida 1885
oil on canvas 66 x 55.9
COMWG 30

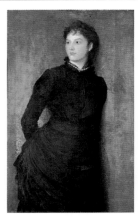

Watts, George Frederick 1817–1904
Rachel Gurney 1885
oil on canvas 111.8 x 66.6
COMWG 38

Watts, George Frederick 1817–1904
After the Deluge 1885–1886
oil on canvas 104 x 178
COMWG 145

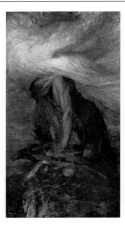

Watts, George Frederick 1817–1904
Study for 'Achilles and Briseis' 1885–1886
mixed media on paper 13 x 51
COMWG 258

Watts, George Frederick 1817–1904
Study for 'Corialanus' 1885–1886
mixed media on paper 13 x 51
COMWG 258

Watts, George Frederick 1817–1904
The Death of Cain 1885–1886
oil on canvas 63.5 x 35.6
COMWG 66

Watts, George Frederick 1817–1904
A Sea Ghost 1887
oil on canvas 45.7 x 71.1
COMWG 100

Watts, George Frederick 1817–1904
Egyptian Landscape 1887
oil on paper laid on canvas 78.7 x 55.9
COMWG 127

Watts, George Frederick 1817–1904
Mrs G. F. Watts 1887
oil on canvas 50.8 x 25.4
COMWG 1

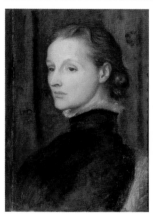

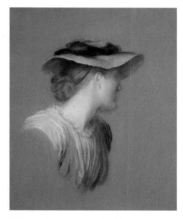

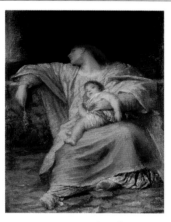

Watts, George Frederick 1817–1904
Mrs G. F. Watts 1887
oil on canvas 48.3 x 35.6
COMWG 7

Watts, George Frederick 1817–1904
Mrs G. F. Watts in a Straw Hat 1887
oil on paper 64.6 x 51.8
COMWG NC 15

Watts, George Frederick 1817–1904
Peace and Goodwill 1887
oil on canvas 66 x 53.3
COMWG 2

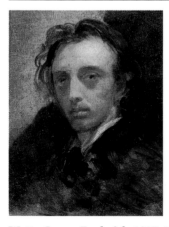

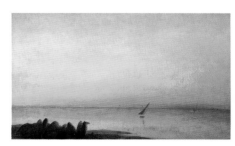

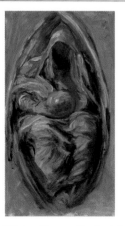

Watts, George Frederick 1817–1904
Self Portrait, Aged 24 1887
oil on copper 12.7 x 10.2
COMWG 184

Watts, George Frederick 1817–1904
Sunset on the Nile 1887
oil on canvas 62.2 x 102
COMWG NC 16

Watts, George Frederick 1817–1904
The All-Pervading 1887
oil on paper 26.5 x 16
COMWG NC 30

Watts, George Frederick 1817–1904
The Sphinx 1887
oil on canvas 40.6 x 50.8
COMWG 126

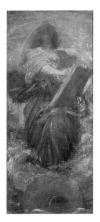

Watts, George Frederick 1817–1904
Recording Angel 1888
oil on canvas 58.4 x 25.4
COMWG 61

Watts, George Frederick 1817–1904
Sunset on the Alps 1888
oil on canvas 142.2 x 109.2
COMWG 113

Watts, George Frederick 1817–1904
The Alps near Monnetier 1888
oil on canvas 48 x 107
COMWG 80

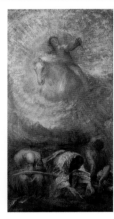

Watts, George Frederick 1817–1904
Progress 1888–1904
oil on canvas 281.9 x 142.2
COMWG 139

Watts, George Frederick 1817–1904
Naples 1889
oil on canvas 27.9 x 45.7
COMWG 172

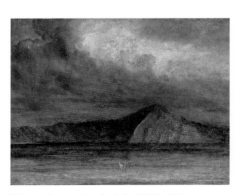

Watts, George Frederick 1817–1904
The Bay of Naples 1889
oil on canvas 96.5 x 121.9
COMWG 124

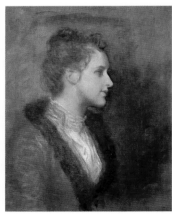

Watts, George Frederick 1817–1904
Lila Prinsep 1890
oil on canvas 65 x 52.2
COMWG LN 4 (P)

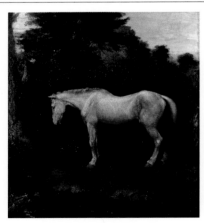

Watts, George Frederick 1817–1904
Patient Life of Unrequited Toil 1890–1891
oil on canvas 182.9 x 167.6
COMWG 130

Watts, George Frederick 1817–1904
Evening Landscape 1890s
oil on canvas 40.6 x 30.5
COMWG 178

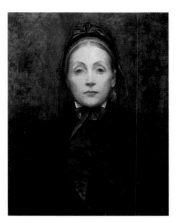

Watts, George Frederick 1817–1904
Sympathy 1892
oil on canvas 66 x 53.3
COMWG 95

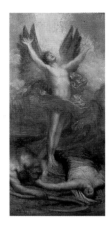

Watts, George Frederick 1817–1904
Love Triumphant 1893–1898
oil on canvas 132.1 x 50.8
COMWG 90

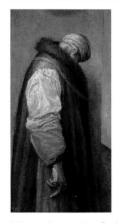

Watts, George Frederick 1817–1904
'For he had great possessions' 1894
oil on canvas 94 x 45.7
COMWG 36

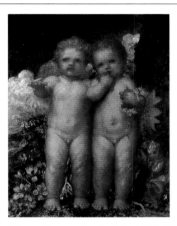

Watts, George Frederick 1817–1904
In the Land of Weissnichtwo 1894
oil on canvas 91.4 x 71.1
COMWG 46

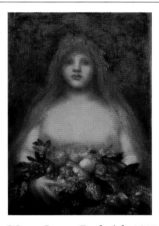

Watts, George Frederick 1817–1904
Earth 1894–1895
oil on canvas 86.4 x 61
COMWG 167

Watts, George Frederick 1817–1904
Outcast Goodwill 1895
oil on canvas 99.1 x 66
COMWG 118

Watts, George Frederick 1817–1904
John Burns 1897
oil on canvas 66 x 53.3
COMWG 84

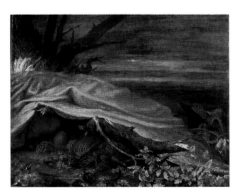

Watts, George Frederick 1817–1904
Can These Bones Live? 1897–1898
oil on canvas 152.4 x 190.5
COMWG 15

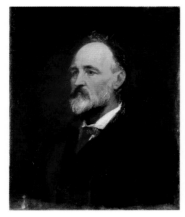

Watts, George Frederick 1817–1904
George Andrews 1898
oil on canvas 63.5 x 51
COMWG 103

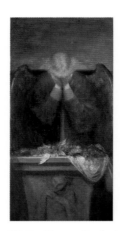

Watts, George Frederick 1817–1904
A Dedication 1898–1899
oil on canvas 137.2 x 71
COMWG 157

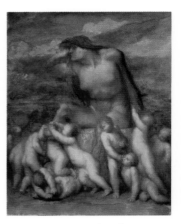

Watts, George Frederick 1817–1904
Evolution 1898–1904
oil on canvas 167.6 x 134.6
COMWG 35

Watts, George Frederick 1817–1904
Invernesshire Landscape (Loch Ruthven) 1899
oil on canvas 35.6 x 88.9
COMWG 21

Watts, George Frederick 1817–1904
Seen from the Train 1899
oil on canvas 39.5 x 76.3
COMWG 112

Watts, George Frederick 1817–1904
Study of Moorland, Invernesshire 1899
oil on canvas 20.3 x 45.7
COMWG NC 9

Watts, George Frederick 1817–1904
The Right Honourable Gerald Balfour 1899
oil on canvas 76.2 x 63.5
COMWG 120

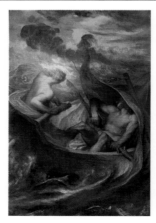

Watts, George Frederick 1817–1904
Love Steering the Boat of Humanity
1899–1901
oil on canvas 198.1 x 137.2
COMWG 131

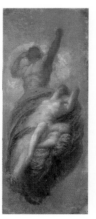

Watts, George Frederick 1817–1904
Sun, Earth and Their Daughter Moon
1899–1902
oil on canvas 61 x 25.4
COMWG 70

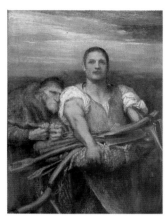

Watts, George Frederick 1817–1904
Industry and Greed 1900
oil on canvas 114.3 x 104.1
COMWG 159

Watts, George Frederick 1817–1904
Orpheus and Euridice 1900–1903
oil on canvas 185.4 x 104.1
COMWG 134

Watts, George Frederick 1817–1904
Fugue 1900–1904
oil on canvas 198 x 106.7
COMWG 158

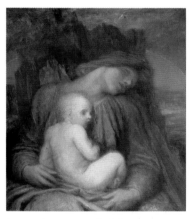

Watts, George Frederick 1817–1904
The Slumber of the Ages 1901
oil on canvas 106.7 x 94
COMWG 53

Watts, George Frederick 1817–1904
Autumn 1901–1903
oil on canvas 134.6 x 73.7
COMWG 78

Watts, George Frederick 1817–1904
Sower of the Systems 1902
oil on canvas 66 x 53.3
COMWG 101

Watts, George Frederick 1817–1904
End of the Day (Surrey Woodland) 1902–1903
oil on canvas 76.2 x 63.5
COMWG 68A

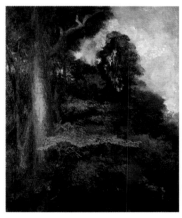

Watts, George Frederick 1817–1904
Surrey Woodland 1902–1903
oil on canvas 76.2 x 63.5
COMWG 68

Watts, George Frederick 1817–1904
A Parasite 1903
oil on canvas 198.1 x 106.7
COMWG 135

Watts, George Frederick 1817–1904
C. J. G. Montefiore 1903
oil on canvas 76.2 x 63.5
COMWG 98

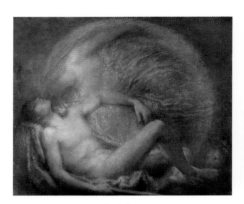

Watts, George Frederick 1817–1904
Endymion 1903
oil on canvas 104.1 x 121.9
COMWG 150

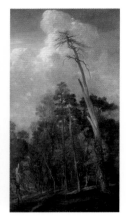

Watts, George Frederick 1817–1904
Green Summer 1903
oil on canvas 167.6 x 88.9
COMWG 47

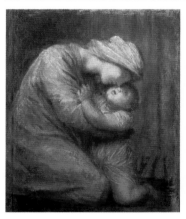

Watts, George Frederick 1817–1904
Mother and Child 1903–1904
oil on canvas 76.2 x 63.5
COMWG 69

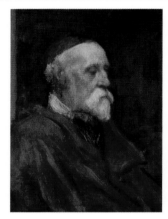

Watts, George Frederick 1817–1904
Self Portrait in Old Age 1903–1904
oil on canvas 63.5 x 45.7
COMWG 6

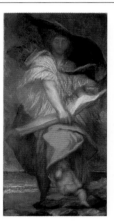

Watts, George Frederick 1817–1904
Destiny 1904
oil on canvas 213.4 x 104
COMWG 133

Watts, George Frederick 1817–1904
Iris 1904
oil on canvas 53.3 x 20.3
COMWG 48

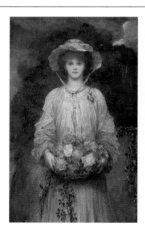

Watts, George Frederick 1817–1904
Lilian 1904
oil on canvas 152.4 x 101.6
COMWG 123

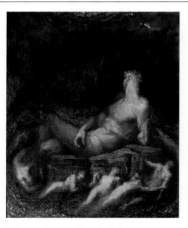

Watts, George Frederick 1817–1904
Prometheus 1904
oil on canvas 66 x 53.3
COMWG 28

Watts, George Frederick 1817–1904
A Fragment
oil on canvas 38.1 x 81.3
COMWG 164

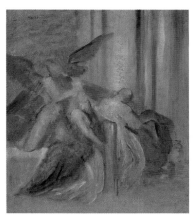

Watts, George Frederick 1817–1904
Death with Two Angels
oil on paper 28 x 23
COMWG 254

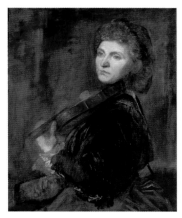

Watts, George Frederick 1817–1904
Lady Halle
oil on canvas 73.7 x 61
COMWG 41

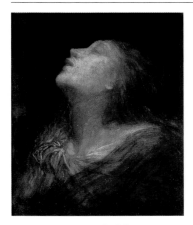

Watts, George Frederick 1817–1904
Magdalen
oil on canvas 36.2 x 30.5
COMWG 191

Watts, George Frederick 1817–1904
Malta
oil on paper 17 x 35
COMWG NC33

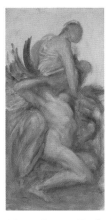

Watts, George Frederick 1817–1904
Monochrome Study
oil on canvas 41.2 x 19.8
COMWG NC35

Watts, George Frederick 1817–1904
Nude Standing (The Pool)
oil on canvas 52 x 21
COMWG 107

Watts, George Frederick 1817–1904
Portrait of a Small Girl with Fair Hair and Full Face
oil on canvas 66 x 53.5
COMWG 104

Watts, George Frederick 1817–1904
Portrait of an Unknown Lady (possibly Lilian Macintosh)
oil on canvas 51 x 41
COMWG 116

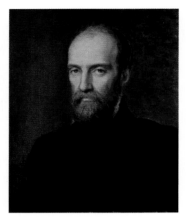

Watts, George Frederick 1817–1904
Prince de Joinville (1818–1900)
oil on panel 61 x 50.8
COMWG 67

Watts, George Frederick 1817–1904
Psyche
oil on canvas 54.5 x 28.5
COMWG 182

Watts, George Frederick 1817–1904
St George
oil on canvas 58.5 x 41
COMWG 20A

Watts, George Frederick 1817–1904
Study for 'Lady Godiva'
oil on canvas 66 x 53.3
COMWG 151

Watts, George Frederick 1817–1904
Study for 'The Messenger'
oil on panel 111 x 88
COMWG NC 14

Watts, George Frederick 1817–1904
Study of Armour
oil on canvas 48 x 35.6
COMWG 146

Watts, George Frederick 1817–1904
Study of Armour
oil on canvas 51 x 23
COMWG 156

Watts, George Frederick 1817–1904
The Countess of Kenmare (My Lady Peacock)
oil on canvas 132.1 x 116.8
COMWG 97

Watts, George Frederick 1817–1904
The Wine-Bearer
oil on canvas 53.3 x 22.9
COMWG 63

Facing page: Sime, Sidney Herbert, 1867 –1941, *Illustrative* (detail), Sidney H. Sime Memorial Gallery, (p. 216)

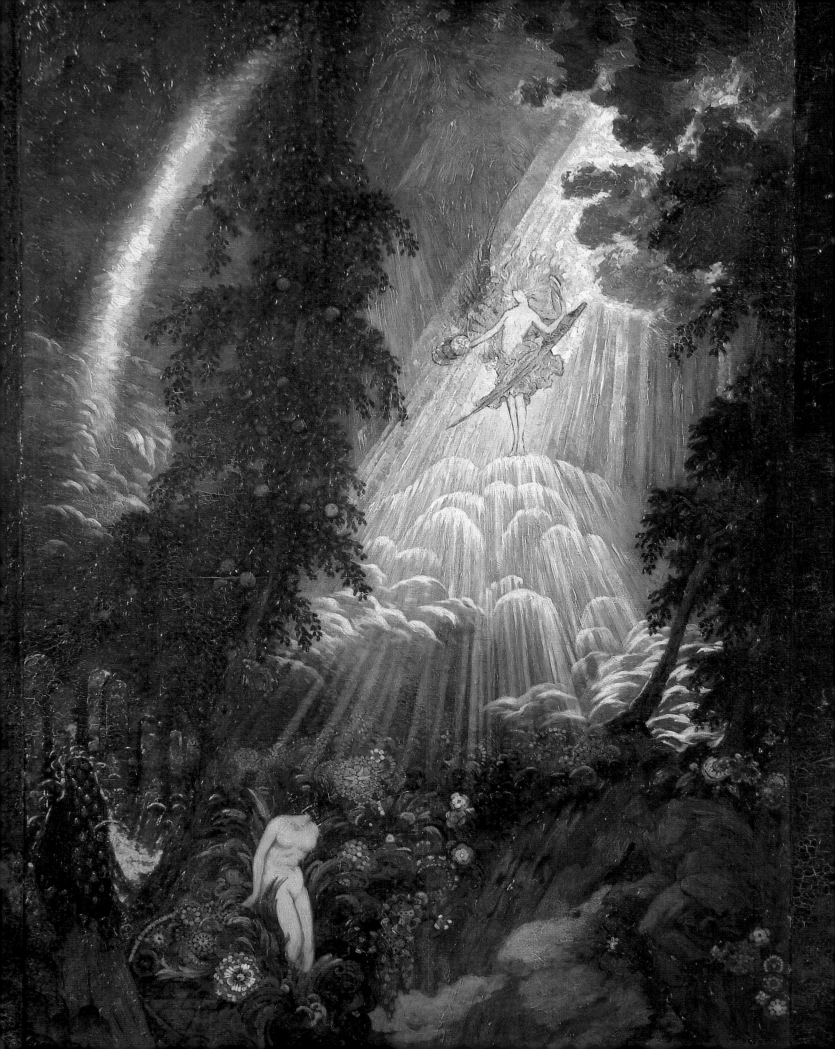

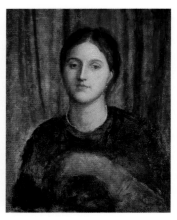

Watts, George Frederick 1817–1904
Unknown Landscape
oil on paper 17.5 x 25.2
COMWG NC32

Watts, George Frederick 1817–1904
Unknown Landscape, possibly Ireland
oil on paper 16.7 x 22.7
COMWG NC31

Watts, George Frederick 1817–1904
Unknown Portrait (possibly Lady Somers or Lady Lothian)
oil on canvas 72 x 53
COMWG 205

Watts, George Frederick 1817–1904
View from Monkshatch, Compton
oil on paper 17.1 x 35.5
COMWG NC29

Watts Mortuary Chapel

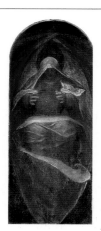

Watts, George Frederick 1817–1904
The All-Pervading 1904
oil on canvas 137.5 x 55.5
1

Cooper, Byron 1850–1933
Brook, May Morning 1895
oil on canvas 45 x 60.5
FP.2.2

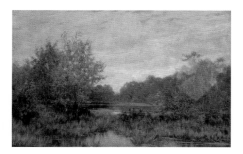

Cooper, Byron 1850–1933
A Quiet Pool, near Haslemere 1900
oil on canvas 60 x 90
FP.2.15

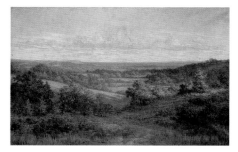

Cooper, Byron 1850–-933
Sussex Weald 1904
oil on canvas 100 x 149
FP.2.139

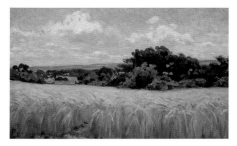

Cooper, Byron 1850–1933
Barley Field
oil on wooden board 22 x 35
FP.2.164

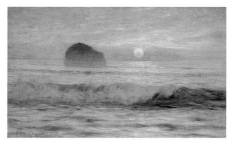

Cooper, Byron 1850–1933
Gull Rock, Tintagel
oil on wooden board 22 x 35
FP.2.22

Cooper, Byron 1850–1933
In the Woods
oil on wooden board 22.5 x 35.5
FP.2.157

Cooper, Byron 1850–1933
Maple Tree
oil on canvas 90 x 60
FP.2.23

Cooper, Byron 1850–1933
Moonlit Atlantic from Tintagel
oil on canvas 101 x 153
FP.2.138

Cooper, Byron 1850–1933
Near Haslemere, Sunset
oil on canvas 102 x 153.5
FP.2.144

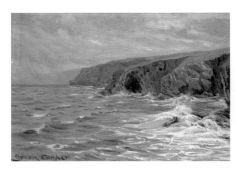

Cooper, Byron 1850–1933
On the Cliffs, Tintagel
oil on wooden board 25 x 35.5
FP.2.154

Cooper, Byron 1850–1933
Solent from Farringford
oil on canvas 60 x 91
FP.2.21

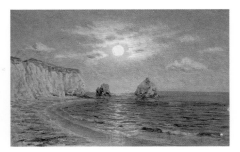

Cooper, Byron 1850–1933
Summer Moonlight
oil on wooden panel 24 x 34.5
FP.2.155

Cooper, Byron 1850–1933
The Birches
oil on canvas 61 x 91
FP.2.26

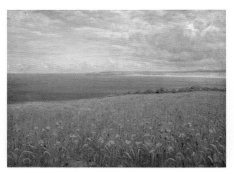

Cooper, Byron 1850–1933
The Poppy Field
oil on canvas 45.6 x 61
FP.2.3

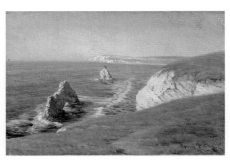

Cooper, Byron 1850–1933
Tintagel Coast
oil on canvas 33 x 48
FP.2.1

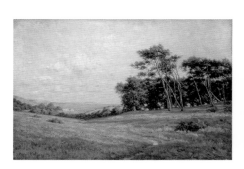

Cooper, Byron 1850–1933
View from Farringford
oil on canvas 60 x 91
FP.2.19

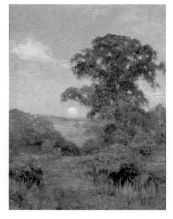

Cooper, Byron 1850–1933
View of a Sunset over Water by a Tree
oil on canvas 60 x 45
FP.2.7

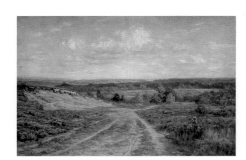

Cooper, Byron 1850–1933
View of Countryside Hills
oil on canvas 60 x 90
FP.2.20

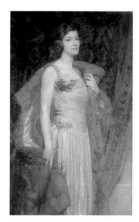

Cooper, Byron 1850–1933
View over a Pool
oil on canvas 60 x 90
FP.2.18

Cummings, Vera 1891–1949
Portrait of a Maori Woman
oil on canvas 19 x 14
FP.2.43

Dicksee, Frank 1853–1928
Miss Edith Fitton 1926
oil on canvas 140 x 85
FP.2.179

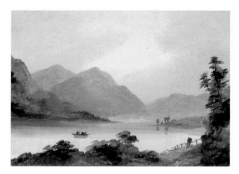

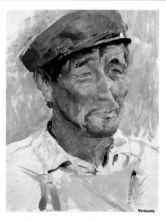

Dobie, Joan
Waggoners Wells
oil on canvas 46 x 62
FP.2005.2

Ewbank, S.
Pass of Elsinore
oil on paper 11.5 x 15.5
FP.01.2.14

Gridnev, Valery b.1956
Fisherman
oil on hardboard 39 x 30
FP.2005.1

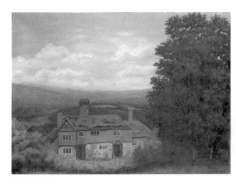

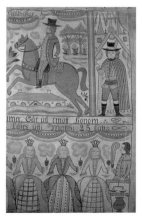

Hill, J. R.
View of Cottage Surrounded by Woodland
1929
oil on canvas 50.5 x 66
FP.2.5

Leizle, Eric
The Devil's Punchbowl
oil on canvas 57 x 155
FP.1998.1

Nilsson, Johannes 1757–1827
*The Three Kings and the Wise and Foolish
Virgins* c.1801–1827
oil on canvas 124 x 80
FP.7.270

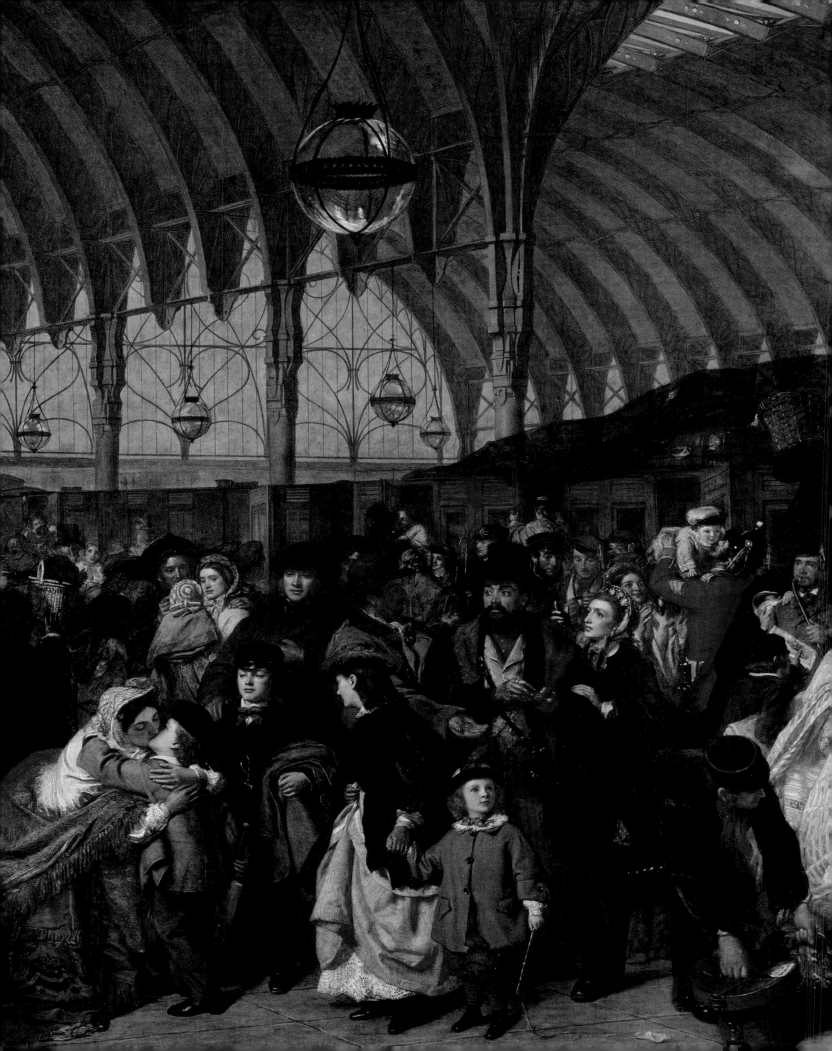

Potter, Violet
Potter (after George Romney)
oil on canvas 63 x 63
FP.1998.2

Prossen, Henry
Killinghurst, Haslemere 1878
oil on canvas 40 x 55
FP.2.11

Storr, Milton active 1888–1891
Cottage with a Man, Woman and a Dog 1888
oil on canvas 60 x 91
FP.2.17

Swedish School
*The Three Kings and the Wise and Foolish
Virgins* c.1801–1828
oil on canvas 123 x 276
FP.7.267

Swedish School
*The Three Kings and the Wise and Foolish
Virgins* c.1801–1828
oil on canvas 114 x 200
FP.7.268

Swedish School
*The Three Kings and the Wise and Foolish
Virgins* c.1801–1828
oil on canvas 95 x 207
FP.7.269

Swedish School
*The Three Kings and the Wise and Foolish
Virgins* c.1801–1828
oil on canvas 116 x 160
FP.7.271

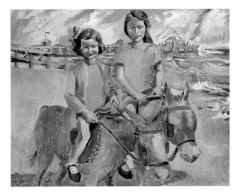

Tomes, Marjorie
On the Beach
oil on artboard 50 x 61
FP.2001.3.1

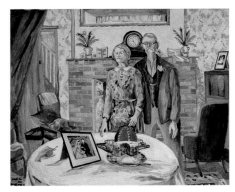

Tomes, Marjorie
The Anniversary
oil on artboard 63 x 76
FP.2001.3.2

Facing page: Frith, William Powell, 1819–1909, *The Railway Station* (detail), 1862, Royal Holloway, University of London, (p. 45)

Tomes, Marjorie
*Two Men and Two Women Sitting in
Deckchairs*
oil on artboard 51 x 61
FP.2001.3.3

unknown artist
*The London to Chichester Coach on Shepherd's
Hill, Haslemere* c.1760–1826
oil on canvas 86 x 134
FP.6.444.1

unknown artist
New Mill c.1890s
oil on canvas 26 x 42
FP.2.162

unknown artist late 19th C
Beach Scene
oil on paper 9.5 x 17
FP.01.2.5

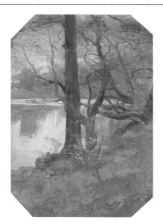

unknown artist late 19th C
Woodland Scene by a Lake
oil on paper 24 x 16
FP.01.2.6

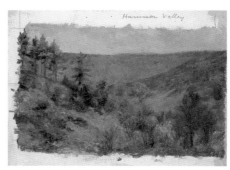

unknown artist
Hammer Valley
oil on cardboard 26.5 x 35.5
FP.2.153

unknown artist
*Haslemere Society of Artists Exhibition:
Landscape*
oil on canvas 68 x 45.5
FP.7.358

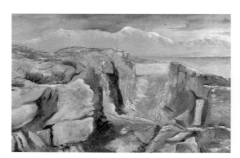

unknown artist
Landscape of Iceland
oil on wood 30 x 46
FP.06.3.1

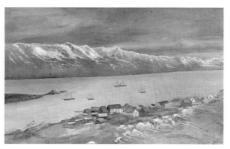

unknown artist
Landscape of Iceland
oil on wood 30 x 46
FP.06.3.2

unknown artist
Portrait of a Man
oil on canvas on hardboard 29.5 x 24.5
FP.7.1

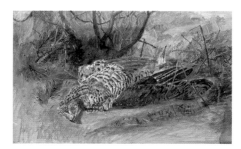

unknown artist
Study of Dead Game Bird
oil on artboard 43 x 68
FP.7.261

unknown artist
The Pigsties, Inval
oil on canvas 31 x 40
FP.2.161

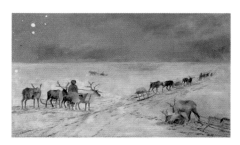

unknown artist
Winter Landscape with Reindeer and Sledges
oil on artboard 30 x 50
FP.8.3

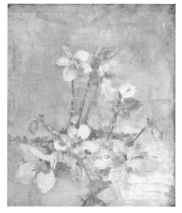

Whymper, Emily 1833–1886
Still Life
oil on canvas 45 x 36.5
FP.2.160

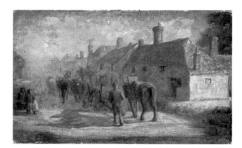

Williams, Juliet Nora d.1937
Winter Morning c.1900
oil on canvas 26 x 40
FP.2.4

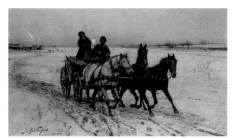

Wolski, Stanislaw Polian 1859–1894
Winter Landscape with Horse Drawn Carriage
1884
oil on canvas 54 x 89
FP.2.30

Surrey County Council

County Hall in Penrhyn Road, Kingston-upon-Thames is a fine 1893 Portland-stone construction of a scale which lends itself to the display of many full-length portraits, typical of nineteenth-and early twentieth-century commemoration of county dignitaries. Often gifts or works raised by public subscription, the paintings reflect the warmth in which local worthies were held, at a time when individuals who held office usually came from a relatively small number of families and were gentlemen of means who had the leisure time to represent the people of Surrey. These men (and apart from royalty there are no oil paintings of women in the Collection) were often in post for decades and had huge influence over the development of services in the county, directly affecting people's lives.

An excellent example is the portrait by the American artist Herman Herkomer of Edward Hugh Leycester Penrhyn, the first Chairman of the County Council. Although he served the usual three-year term, he had already led the county as Chairman of Quarter Sessions since 1862, so he gave a continuity to Surrey's government. As well as being remembered in the road name, he appears in this delightful, relaxed portrait as an approachable and lively man.

Of the later paintings, Michael Noakes' three-quarter length portrait *The Right Honourable James Chuter Ede*, painted in 1961, is worthy of note. James Chuter Ede of Epsom was an active member of the council (1914–1949), as well as being a Labour MP and Home Secretary (1945–1951). Remembered for his love for education, he was greatly involved in the 1944 Education Act. Noakes, the internationally famous portrait painter, was educated in Surrey at Reigate School of Art.

The earliest painting in the County Collection is probably that of Sir Richard Onslow, 1st Lord Onslow (1654–1717). A rather pinched face in a heavy wig, painted in the manner of Sir Godfrey Kneller, depicts one of the more contentious Speakers of the House of Commons, known for his lack of neutrality and pedantic demeanour. Quite a contrast from the other sitters!

The County Council is delighted that through the Public Catalogue Foundation a wider audience will be able to share our fondness for these local treasures.

Maggie Vaughan-Lewis, County Archivist

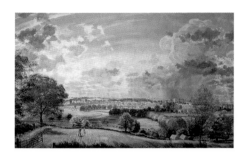

Birch, David 1895–1968
Morning in June, the Vale of Dedham
oil on canvas 129.5 x 203.2
10

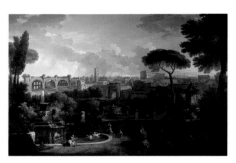

Bloemen, Jan Frans van 1662–1749
View of Rome from the Baberini Palace
oil on canvas 167.6 x 245.1
15b

Bone, Charles b.1926
Oxenford Grange, Peper Harow
oil on canvas 90.2 x 90.2
G15 🐝

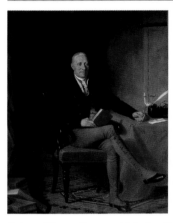

Briggs, Henry Perronet (circle of)
1791/1793–1844
John Leech
oil on canvas 198.1 x 137.2
23

Brooks, Henry Jamyn 1865–1925
Sir William Vincent, Bt 1897
oil on canvas 111.8 x 86.4
24

Carter, William 1863–1939
Henry Yool Esq. 1895
oil on canvas 127 x 101.6
17

Carter, William 1863–1939
Edward Joseph Halsey 1908
oil on canvas 215.9 x 128.3
13

Carter, William 1863–1939
*The Right Honourable St John Broderick, 9th
Viscount Midleton* 1908
oil on canvas 212.1 x 111.8
3

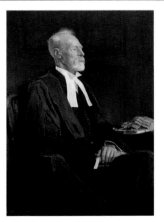

Carter, William 1863–1939
Thomas Weeding Weeding (1847–1929) 1928
oil on canvas 147.3 x 101.6
9

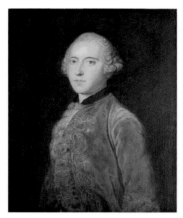

Chamberlin, Mason the elder (circle of) 1727–1787
Richard, 3rd Earl of Onslow
oil on canvas 71.8 x 56.5
21

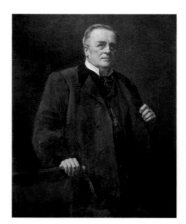

Clay, Arthur 1842–1928
Sir William Hardman, QC 1889
oil on canvas 127 x 101.6
19

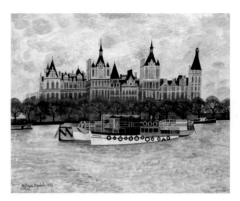

Daniels, Alfred b.1924
Boats Moored on the River Thames 1968
oil on canvas 61 x 71.1
2

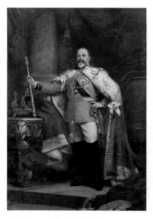

Fildes, Luke (after) 1844–1927
King Edward VII (1841–1910)
oil on canvas 269.2 x 177.8
6

Gunn, Herbert James 1893–1964
Sir Lawrence Edward Halsey, KBE, JP 1945
oil on canvas 90.2 x 69.9
15a

Herkomer, Herman 1863–1935
Edward Hugh Leycester Penrhyn, First Chairman of Surrey County Council (1889–1893) 1889
oil on canvas 127 x 101.6
18

Jervas, Charles (style of) c.1675–1739
Thomas Onslow, 2nd Lord Onslow (1680–1740)
oil on canvas 71.8 x 56.5
22

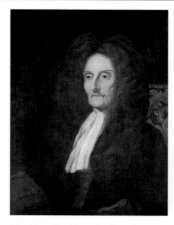

Kneller, Godfrey (style of) 1646–1723
Sir Richard Onslow, 1st Lord Onslow (1654–1717)
oil on canvas 72.4 x 56.5
20

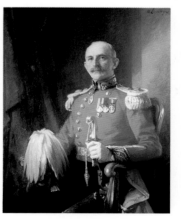

Llewellyn, William Samuel Henry 1854–1941
The Right Honourable Lord Ashcombe, CB, TD c.1939
oil on canvas 124.5 x 97.8
12

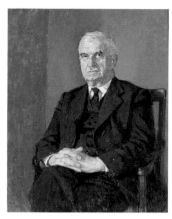

Noakes, Michael b.1933
The Right Honourable James Chuter Ede, CH, JP, DL 1961
oil on board 88.9 x 68.6
11

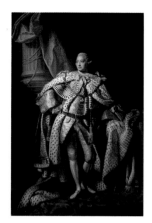

Phillips, Thomas 1770–1845
Florance Young Esq. 1824
oil on canvas 127 x 101.6
14

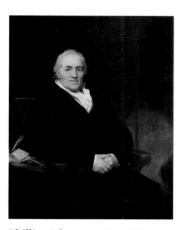

Ramsay, Allan (studio of) 1713–1784
King George III (1738–1820) c.1775
oil on canvas 254 x 157.5
7

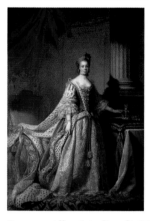

Ramsay, Allan (studio of) 1713–1784
Queen Charlotte (1744–1818) c.1775
oil on canvas 254 x 157.5
8

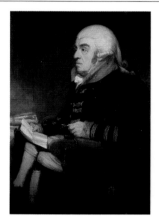

Stewardson, Thomas 1781–1859
The Right Honourable George, 4th Baron and 1st Earl of Onslow
oil on canvas 180.3 x 125.7
5

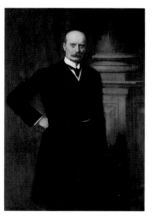

Symonds, William Robert 1851–1934
The Right Honourable George Viscount Cave, CC, MC 1911
oil on canvas 152.4 x 101.6
4

Leatherhead and District Local History Society

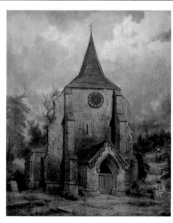

unknown artist
Mickleham Church
oil on canvas 74.6 x 61.7 (E)
LP 1082

unknown artist
Mr S. Maw
oil on canvas 76.2 x 63.5 (E)
LP 1185

The Guest House, Lingfield Library

Akehurst, R. D.
Lingfield Coronation Decorations 1953
oil on board 35 x 24
2

Oxted Library

Christie, Ernest C. (attributed to)
1863–1937
Kentish Farm, E. Christie War Coppice
oil on canvas 39.5 x 30 (E)
2 (P)

Christie, Ernest C. (attributed to)
1863–1937
Prucks Works at Links Corner, Limpsfield (now demolished)
oil on canvas 30 x 44
1 (P)

Christie, Ernest C. (attributed to) 1863–1937
View of Pond Gate and Farm
oil on canvas 38 x 30 (E)
3 (P)

Tandridge District Council

Collier, John 1850–1934
Colonel Arthur Stuart Daniel, Chairman of Godstone Rural District Council (1900–1935)
1928
oil on board 122 x 91.4
5

Curzon-Price, Paddy
Councillor Mrs M. D. Wilks, First Lady Chair of Tandridge District Council (1977–1978)
1980
oil on canvas 91.4 x 76.2 (E)
3

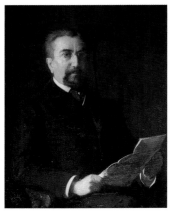

Grace, Harriet Edith active 1877–1909
William Garland Soper, First Chairman of Caterham & Warlingham Urban District Council (1899–1908) 1909
oil on board 91.4 x 76.2
4

unknown artist
Marjory Pease, JP (1911–1947)
oil on canvas 91.4 x 76.2
1

unknown artist
Old Oxted
oil on board 61 x 91.4
2

East Surrey Hospital

Dorman, Ernest A. b.1928
Darkness on Face of the Deep 1999
oil on MDF board 78 x 122
11

Dorman, Ernest A. b.1928
Earth without Form and Void 1999
oil on MDF board 91 x 61
12

Dorman, Ernest A. b.1928
Gathering of the Waters unto One Place and Dry Land Appearing 1999
oil on MDF board 91 x 61
15

Dorman, Ernest A. b.1928
God Created Lights to Rule the Day and Night 1999
oil on MDF board 91 x 61
14

Dorman, Ernest A. b.1928
Let There Be Light 1999
oil on MDF board 91 x 61
13

Dorman, Ernest A. b.1928
Produce of the Earth by Nature and Creation of Every Living Creature 1999
oil on MDF board 91 x 61
16

Dorman, Ernest A. b.1928
The Four Seasons, Winter 1999
oil on MDF board 102 x 91
10

Dorman, Ernest A. b.1928
The Four Seasons, Spring 1999
oil on MDF board 102 x 91
7

Dorman, Ernest A. b.1928
The Four Seasons, Summer 1999
oil on MDF board 102 x 91
8

Dorman, Ernest A. b.1928
The Four Seasons, Autumn 1999
oil on MDF board 102 x 91
9

Dorman, Ernest A. b.1928
Winter Tree 1999
oil on MDF board 78 x 91
6

Facing page: Sargent, John Singer, 1856–1925, *Mrs Graham Robertson* (detail), 1880, Watts Gallery, (p. 134)

Moosajee, Mariya
A Not So Funny Bone 2004
oil on wood 120 x 80
3

Moosajee, Mariya
High Heels and Fashion Fractures 2004
oil on wood 120 x 80
2

Moosajee, Mariya
Rugby Kicks and Patella Nicks 2004
oil on wood 100 x 120
4

Shepherd, Frank
Pastoral Scene via Open Window 2003
oil on MDF board 107 x 122
5

Stevens active mid-20th C
Seascape
oil on canvas 61 x 122
1

Holmsdale Natural History Club

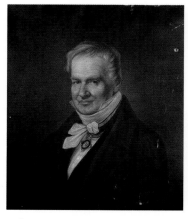

unknown artist early 19th C
Portrait of a Man (possibly Baron von Humbolt)
oil on canvas 71.2 x 60.6
2

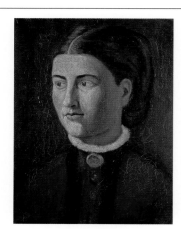

unknown artist 19th C
Portrait of an Unknown Victorian Lady
oil on canvas 49.5 x 38.3
1

Reigate & Banstead Borough Council

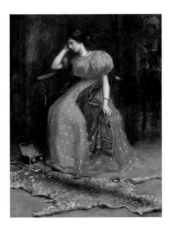

Gogin, Alma 1854–1948
Regrets
oil on canvas 89.5 x 64
2

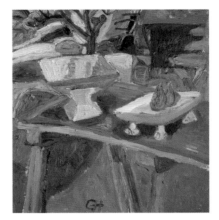

Hooper, George 1910–1994
The Garden at Loxwood, Redhill
acrylic on board 60 x 55
6

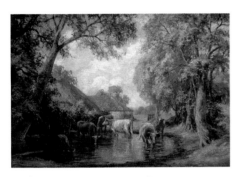

Little, George Leon 1862–1941
Cows in a Landscape
oil on canvas 87 x 118
4

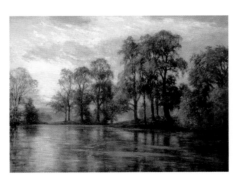

Little, George Leon 1862–1941
Evening Lake Scene
oil on canvas 89.5 x 120.5
1

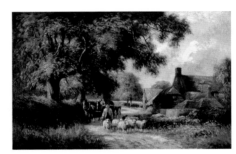

Little, George Leon 1862–1941
Sheep in a Landscape
oil on canvas 59 x 90
3

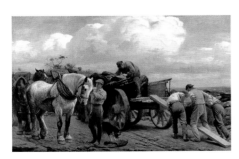

Wells, Henry Tanworth 1828–1903
Loading at the Quarry, Holmbury Hill
oil on canvas 134.5 x 211
5

Reigate Priory Museum

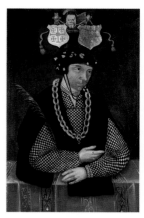

British (English) School early 16th C
*John Lymden (elected 1530, surrendered 1536),
the Last Prior of Reigate*
oil on wood panel 57 x 36
2

Noakes, Michael b.1933
F. E. Claytor, Headmaster (1948–1957) 1957
oil on canvas 75.5 x 62.5
1

Send and Ripley Museum

Baigent, R. active c.1920–c.1940
Newark Mill, Ripley, Surrey
oil on canvas 21 x 35
P2

Brown, Frank active 1950s–1970s
Ripley Village 1973
oil on canvas 51 x 62
P1

Spelthorne Borough Council

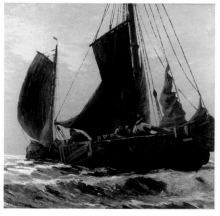

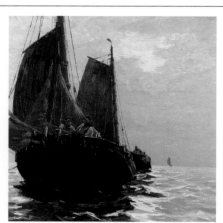

Marion
At Sea 1
oil on canvas 191.2 x 192.4 (E)
2005:01

Marion
At Sea 2
oil on canvas 191.2 x 192.4 (E)
2005:02

Spelthorne Museum

unknown artist
Cottages in Thames Street
oil on canvas 20 x 25
SMXSP:1995.289

Vasey, M.
A Mother's Rosary
oil on canvas 11 x 16
SMXSP:1980.239

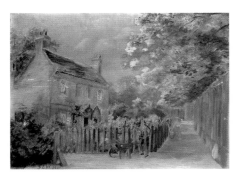

Winfield, G. E.
A Cottage on the Corner of Manygate Lane and Rope Walk, Shepperton 1901
oil on canvas 30 x 41
SMXSP:2006.106

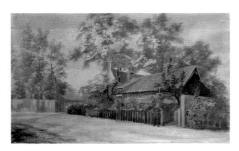

Winfield, G. E.
A Cottage on the Corner of Manygate Lane and Rope Walk, Shepperton 1901
oil on canvas 26 x 41
SMXSP:2006.107

Sunbury Library

The Sunbury Art Group
The Thames at Sunbury 1960s
oil on canvas 61 x 213.4
1

Dittons Library

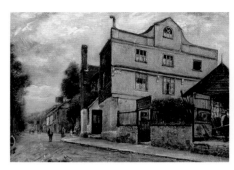

Freeman, William c.1838–1918
Thames Villa 1905
oil on canvas 30.5 x 40.6
3

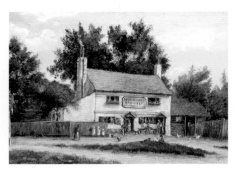

Freeman, William c.1838–1918
'The Swan' at Claygate 1905
oil on board 21.6 x 29.2
7

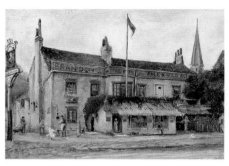

Freeman, William c.1838–1918
'The White Lion', Esher 1905
oil on canvas 19.1 x 29.2
2

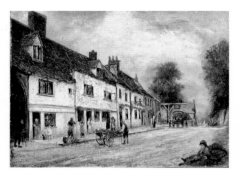

Freeman, William c.1838–1918
High Street, Thames Ditton?
oil on canvas 30.5 x 40.6
4

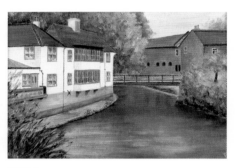

P. W. J.
'Ye Olde Swan', Thames Ditton? mid-20th C
oil on board 29.5 x 45
1

Stevens, Thomas active 1889–1893
Cottage at Weston Green 1889
oil on canvas 25.4 x 35.6
5

Stevens, Thomas active 1889–1893
Weston Green Pond 1890
oil on canvas 24.1 x 34.3
6

Warlingham Library, Lockton Collection

In All Saints' Church, Warlingham, there is a simple alabaster tablet inscribed to the memory of Charles Langton Lockton (1856–1932). Few remember him now, but some may know of the collection of his paintings of local scenes which he gave to the Parish, and which can be seen in the library. Many depict a rural community now long gone.

Charles Langton Lockton was born in Tasmania on the 2nd July 1856. He was the second son of the Reverend Philip Langton Lockton. In 1864 the family returned to England, and the eldest son, Philip, became a pupil at Merchant Taylors' School in London. Charles joined him there in 1866.

Charles did not achieve any exceptional scholastic success but did develop into a fine natural athlete, outstanding at school and in nationwide competition. In 1873 and again in 1875 he won the National Long Jump Championship, and at 16 he became the youngest English Champion on record. Charles retained his connection with sport by qualifying as an official starter, a position he filled at most athletic championships between 1890 and 1911, including the 1908 Olympic Games in London. From 1877 to 1881 he worked in the library of the India Office, moving on to a position as a Clerk in the House of Commons, where he remained until retirement in 1921.

He married Jane Emma Seale of Croydon and they had two children, Noel and Dorothy. In 1894 they moved to live in Warlingham, Surrey, then still a very rural village. Charles purchased a plot of land and a house was built to his requirements. Completed in 1898, he named it 'Teeton'.

Now settled in Warlingham, Charles built himself a studio in his garden. During the 30 years that followed, he passed many happy hours there painting, a hobby he found relaxing. His grandsons, Philip and Tom, recalled the studio as friendly and untidy, glass jam pots full of brushes, jars of turpentine and tubes of oil paints everywhere. They were allowed to sit and watch, enthralled. Charles did not sell his paintings but gave them away, either to local people or for village fundraising purposes. He was a prolific artist, and most of his works are on board as canvas was expensive. The Parish Collection, which since 1970 has been displayed in the local library, provides a glimpse of rural life long gone. These paintings are mostly of uniform size but larger paintings do exist. Few people appear in the paintings and any animals are usually sheep at a distance.

Charles soon became much involved in village activities, including sport, of course. He became a sidesman at All Saints' Church, and in 1901 was appointed Vicar's Warden, a position he held until his death. During the 1920s he served five years on the Parish Council, and due to his involvement in many local affairs he was very well-liked and respected in the village.

In 1921 his wife, Jane, died, and his son Noel and his wife came to live with him at 'Teeton'. Following his retirement later that year he was made a Justice of the Peace.

Charles was a sincere, straightforward man, always willing to help others with his kindness and generosity. In 1932 his health began to fail, and he was often unable to attend to his many duties and interests as diligently as he would have wished. He died peacefully on the 30th October 1932, aged 76.

Dorothy Tutt, Vice-President, The Bourne Society

Lockton, Charles Langton 1856–1932
*All Saints' Church, North-West, before
Enlargement* early 1890s
oil on card 15 x 23
6

Lockton, Charles Langton 1856–1932
*All Saints' Church, South Side, before
Enlargement* early 1890s
oil on wood 15.5 x 24
31

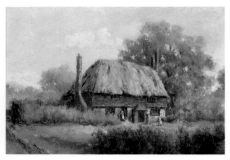

Lockton, Charles Langton 1856–1932
*Cottage on the Corner of Westhall Road and
Ridley Road (demolished in 1898), Site of
'Teeton', the Artist's Home* c.1895
oil on wood 17 x 24
9

Lockton, Charles Langton 1856–1932
*Westhall Road, Corner of Workhouse Lane
(now Hillbury Road)* c.1895
oil on wood 18.5 x 22
4

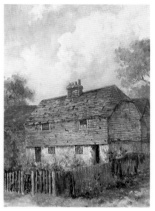

Lockton, Charles Langton 1856–1932
*Cottage between 'The Leather Bottle' and Mill
House* 1900
oil on wood 29 x 21.5
16

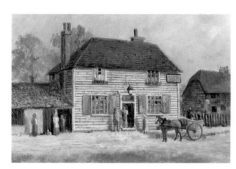

Lockton, Charles Langton 1856–1932
*'The Leather Bottle', with Butcher's Shop on the
Left as it was in the 1880s* 1900
oil on wood 17 x 25
21

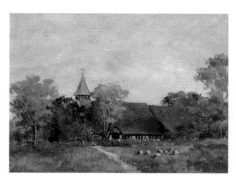

Lockton, Charles Langton 1856–1932
All Saints' Church c.1900
oil on card 9.5 x 15
30

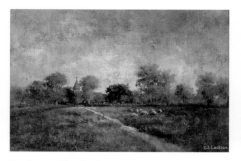

Lockton, Charles Langton 1856–1932
All Saints' Church, Footpath from Village
c.1900
oil on wood 20 x 30
26

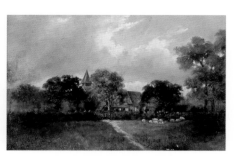

Lockton, Charles Langton 1856–1932
All Saints' Church, Footpath from Village
c.1900
oil on wood 27 x 41
27

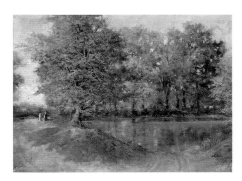

Lockton, Charles Langton 1856–1932
Hamsey Green Pond c.1900
oil on board 19 x 22
32

Lockton, Charles Langton 1856–1932
'The White Lion' as it was in the 1880s c.1900
oil on wood 24 x 33
10

Lockton, Charles Langton 1856–1932
Village Green, South-East Corner c.1900
oil on wood 24 x 34
5

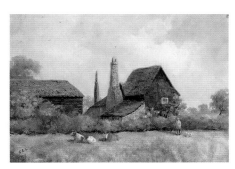

Lockton, Charles Langton 1856–1932
Westhall Road, Warlingham (near Searchwood Road) 1901
oil on wood 24 x 30
19

Lockton, Charles Langton 1856–1932
Tydcombe Farm 1902
oil on wood 10 x 22
12

Lockton, Charles Langton 1856–1932
Blanchman's Farm from the South-East 1913
oil on wood 24 x 34
7

Lockton, Charles Langton 1856–1932
Shops on the Village Green early 1920s
oil on canvas 24 x 51
2

Lockton, Charles Langton 1856–1932
Warlingham Vicarage mid-1920s
oil on wood 22 x 33
35

Lockton, Charles Langton 1856–1932
All Saints' Church
oil on card 15 x 22
28

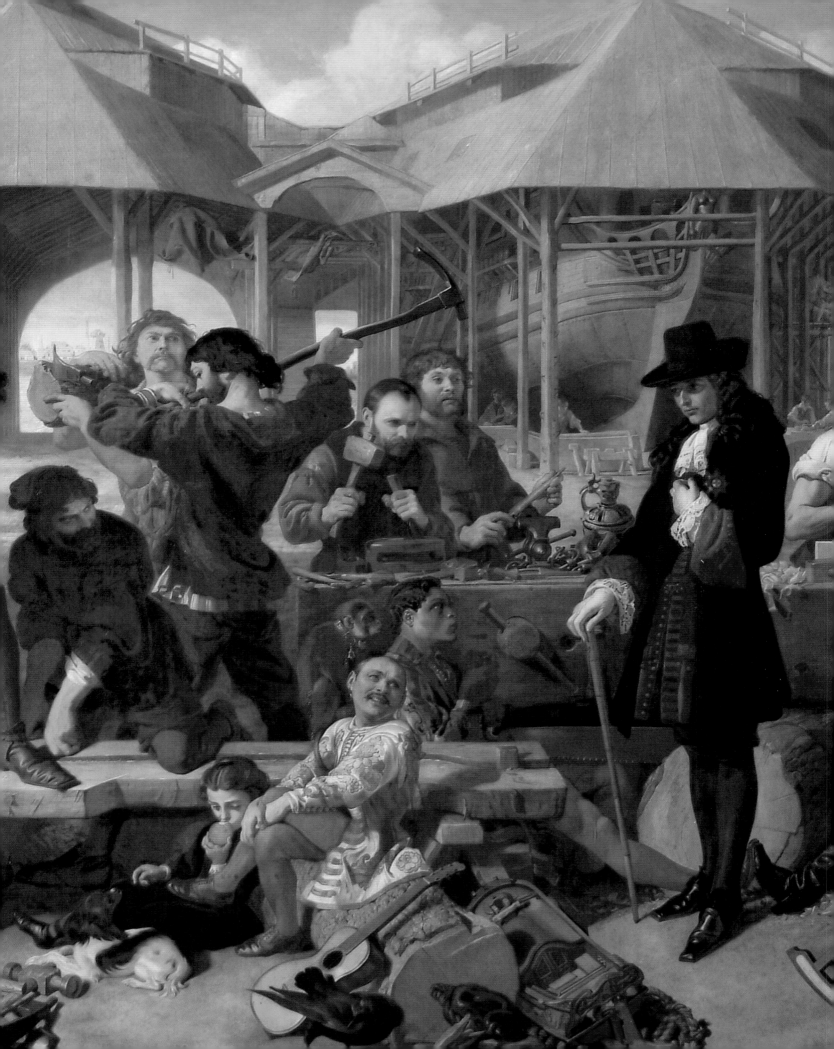

Lockton, Charles Langton 1856–1932
All Saints' Church, before Enlargement
oil on card 15 x 12.5
28

Lockton, Charles Langton 1856–1932
Alms Houses, Leas Road
oil on card 9.5 x 13
28

Lockton, Charles Langton 1856–1932
Baker's Wheelwrights Shop on Farleigh Road
oil on wood 10 x 22
13

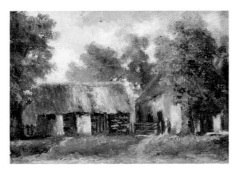

Lockton, Charles Langton 1856–1932
Barn and Post Office Cottage by 'The White Lion'
oil on card 9.5 x 13
28

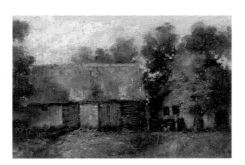

Lockton, Charles Langton 1856–1932
Barn between Glebe Road and 'The White Lion' (long since demolished)
oil on wood 13 x 20
20

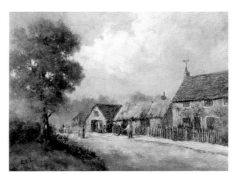

Lockton, Charles Langton 1856–1932
Blanchard's Smithy, Farleigh Road
oil on wood 18.5 x 22
3

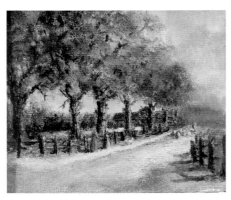

Lockton, Charles Langton 1856–1932
Bug Hill Road (Now Leas Road)
oil on card 10 x 11.5
28

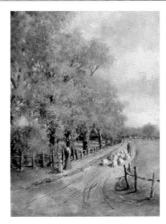

Lockton, Charles Langton 1856–1932
Bug Hill Road from the Village (Leas Road)
oil on wood 30.5 x 21
17

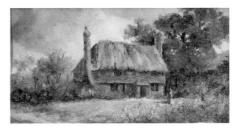

Lockton, Charles Langton 1856–1932
Cottage, Westhall Road, Demolished 1898 (The site of the artist's house 'Teeton')
oil on card 11.5 x 21
28

Facing page: Maclise, Daniel, 1806–1870, *Peter the Great at Deptford Dockyard* (detail), 1857, Royal Holloway, University of London, (p. 52)

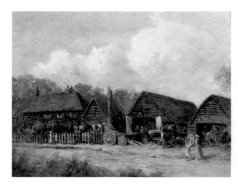

Lockton, Charles Langton 1856–1932
Cottages and Baker's Wheelwrights, Farleigh Road
oil on wood 24 x 31
22

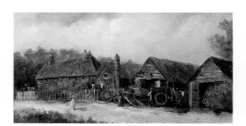

Lockton, Charles Langton 1856–1932
Cottages and Baker's Wheelwrights, Farleigh Road
oil on card 11.5 x 21
28

Lockton, Charles Langton 1856–1932
Cottages between 'The Leather Bottle' and Mill House
oil on card 15 x 12
28

Lockton, Charles Langton 1856–1932
Court Cottage, North Side (front view), Hamsey Green
oil on wood 19.5 x 34
23

Lockton, Charles Langton 1856–1932
Court Cottage, South Side (rear view), Hamsey Green
oil on wood 19 x 34
18

Lockton, Charles Langton 1856–1932
Crewes Cottages, opposite 'The Leather Bottle'
oil on card 9 x 13
28

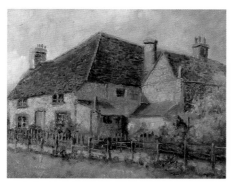

Lockton, Charles Langton 1856–1932
Horseshoe Cottages, Side/Rear View from Mint Walk, Farleigh Road
oil on board 16.5 x 20
34

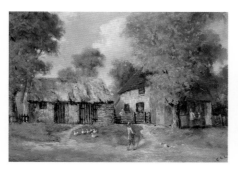

Lockton, Charles Langton 1856–1932
Post Office on North-East Side of the Green next to 'The White Lion' Cottage
oil on wood 21 x 28
8

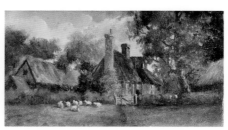

Lockton, Charles Langton 1856–1932
Side/Rear view of Horseshoe Cottages from Mint Walk
oil on card 9 x 12.5
28

Lockton, Charles Langton 1856–1932
The Font, All Saints' Church
oil on board 20 x 15
29

Lockton, Charles Langton 1856–1932
The Forge, Farleigh Road
oil on card 11.5 x 21
28

Lockton, Charles Langton 1856–1932
'The Leather Bottle' as it was in the 1880s
oil on card 10 x 12
28

Lockton, Charles Langton 1856–1932
'The White Lion' as it was in the 1880s
oil on card 11.5 x 21
28

Lockton, Charles Langton 1856–1932
Tydcombe Farm
oil on wood 19 x 29
14

Lockton, Charles Langton 1856–1932
Tydcombe Farm
oil on card 11.5 x 21
28

Lockton, Charles Langton 1856–1932
Tydcombe Farm from the North-West
oil on wood 22 x 30
15

Lockton, Charles Langton 1856–1932
Unidentified Farm Buildings (possibly Crewes Farm)
oil on wood 10 x 22
11

Lockton, Charles Langton 1856–1932
Village Green, South-East Corner
oil on card 11.5 x 21
28

Lockton, Charles Langton 1856–1932
Webbs Cottage, Farleigh Road
oil on card 10 x 12
28

Lockton, Charles Langton 1856–1932
Westhall Cottage
oil on board 19 x 23
33

Lockton, Charles Langton 1856–1932
Westhall Road (Narrow Lane to Right)
oil on card 10 x 12
28

Lockton, Charles Langton 1856–1932
Woodland Scene
oil on canvas 16 x 23
24

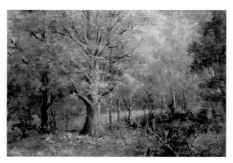

Lockton, Charles Langton 1856–1932
Woodland Scene
oil on canvas 16 x 23
25

Molesey Library

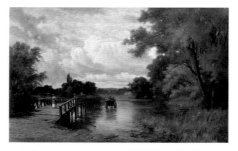

Helcke, Arnold active 1880–1911
The Bridge over the Mole 1905
oil on canvas 92 x 145

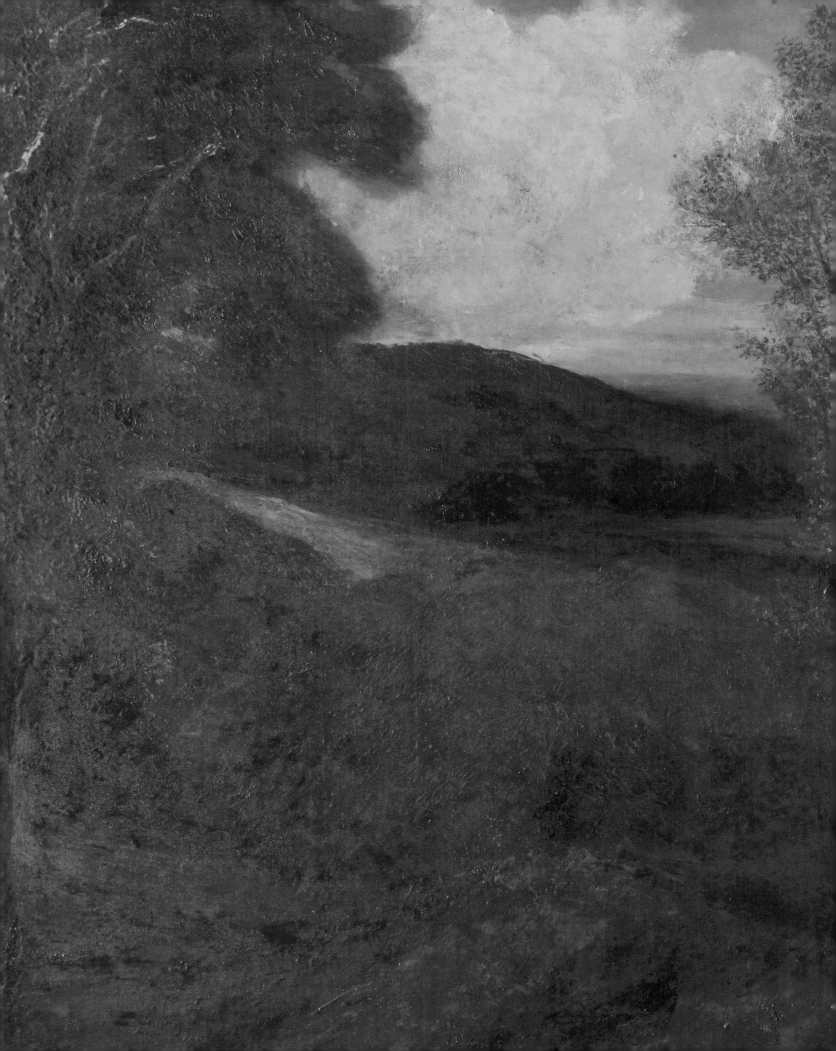

Waller, Claude b.c.1920
Tiger Moth over Brooklands c.1996
oil on canvas 51 x 77
D2273

Weekley, Barry active 1993–2006
Wellington 'R' for 'Robert' in Flight 1993
oil on canvas 51 x 71
D2562

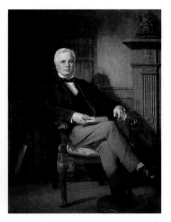

Wells, Henry Tanworth 1828–1903
Peter Locke King 1874
oil on canvas 187 x 140
L512

Wilson, Colin b.1949
Hurricane Landing 1985
oil on canvas 60 x 77
D248

Wootton, Frank 1914–1998
BOAC Shorts S45A Solent Seaplane, 'Salisbury'
oil on canvas 56 x 63
D1920

Elmbridge Museum

Elmbridge Museum, located in the heart of Weybridge, is a fascinating source of local knowledge which illustrates the rich history of our beautiful Borough in the North-West of Surrey.

Weybridge Museum opened on the 23rd June 1909, though there had been a long tradition of exhibitions of 'Art, Industries and Manufactures' in the town, going back to 1874. From the outset, the Museum was part of the local council but it was not until 1967, when it moved to its current location above Weybridge Library, that it had paid, rather than voluntary, staff. Following the Local Government reorganisation, the name changed to Elmbridge Museum, to show that it served the Borough as a whole.

As a service provided by Elmbridge Borough Council, the Museum is not just about the past, it also deals with contemporary issues and supports the

arts, community, health, youth and sports services provided by the Council. In addition to the permanent exhibitions, there is an exciting programme of temporary displays as well as workshops and children's activities. For more information visit the museum website at www.elmbridgemuseum.org.uk.

As a local history museum, the art collection is linked to the local area and communities. As a result, the collection contains landscapes of Elmbridge and the surrounding areas, as well as portraits of individuals connected with the Borough. Many paintings in the Collection are by local artists, and a number of oil paintings are on loan from various local individuals and organisations.

Due to space constraints, very few paintings are on display. One of the few is a large oil painting on a wooden board representing a group of people in eighteenth-century costume dancing around a maypole on Monument Green in Weybridge. It was found in 'Lavender Cottage' on Monument Green and is currently on display in the museum reception.

Amongst those paintings not on display are a number with interesting backgrounds. One of these, by an unknown artist from c.1895, represents Lady Louisa Egerton, the wife of Admiral Francis Egerton, in a black evening dress with large pink puff sleeves. Initially it was thought to depict the sitter's mother-in-law, the Countess of Ellesmere. The painting was found in an old air-raid shelter in 1970 in Walton-on-Thames (no one knows how it came to be there). Originally, it was substantially larger than it is today. However, after its discovery the damaged areas of the painting were removed and the painting was remounted. The picture eventually ended up in a jumble sale in 1972, where the donor purchased it for the princely sum of one penny.

Another painting with an interesting background is *HM Torpedo Boat 2015* by Charles David Cobb, which illustrates the long, and possibly surprising history connecting the Borough of Elmbridge and the Royal Navy, which dates back to the eighteenth century. During the Second World War different towns adopted various warships and Walton and Weybridge adopted 'HM Torpedo Boat 2015'. As a sign of gratitude, the crew of the ship presented a painting of their boat to the two towns during Thanksgiving Week in November 1945.

The Collection at Elmbridge Museum also includes contemporary paintings. To celebrate the millennium, the Museum organised the 'Painting for Prosperity' arts project (funded by the R. C. Sherriff Rosebriars Trust), in order to acquire contemporary landscapes by local artists. These included the three oil paintings, *Oxshott Station, The Wey Bridge* and *Cedar House, Cobham*.

Given its space constraints, Elmbridge Museum is dedicated to finding new and different ways to make its collections accessible to the public and is delighted to have had the opportunity to be involved with the Public Catalogue Foundation's exciting project.

Jason Finch, Temporary Assistant Manager

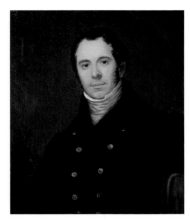

Bradley
Robert Gill, Railway Pioneer (1796–1871)
c.1805
oil on canvas 73 x 60
16.1986.44

Brewer, Derek
Cedar House, Cobham 1999
oil on board 24 x 34.5
72.2000.4

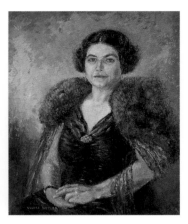

Butler, Villers
Amy Gentry, OBE 1952
oil on canvas 75 x 62
L.290.1976.41 (P)

Cobb, Charles David b.1921
HM Torpedo Boat 2015 1945
oil on canvas 44.5 x 59
23.1985

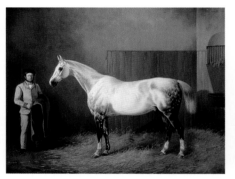

Dalby, John 1810–1865
A White Horse with Dappled Legs Standing in a Stable 1849
oil on board 44 x 56
16.1986.48

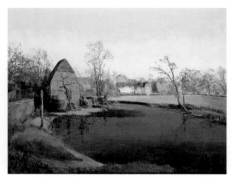

Dawson, M.
Cobham Mill with Houses on Right Bank of a River in the Distance 1974
oil 39 x 49
366.1974

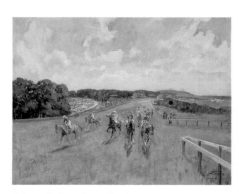

Edwards (attributed to)
Going to the Post, Goodwood 1955
oil 49 x 59.5
L.346.1989.5 (P)

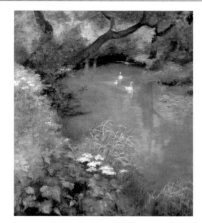

Ewan, Eileen
Swans on the River Wey
oil on canvas 104.5 x 90.5
317.1994

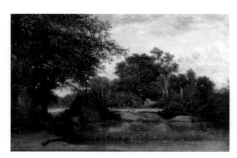

Godfrey, J.
A View of St George's Hill, with Dead Man's Pool in the Foreground 1886
oil 49.5 x 75
270.1989 (P)

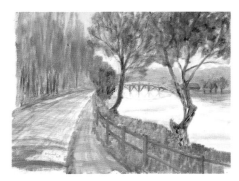

Gray, M.
Esher Road, Showing a Rustic Bridge (now demolished) 1950
oil 37.5 x 49
43.1982

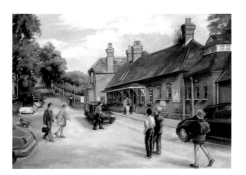

Grosvenor, Jennifer b.1931
Oxshott Station
oil 44.5 x 60
72.2000.7

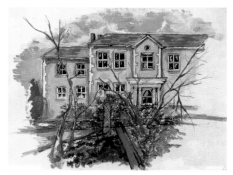

Hobbes, Ian b.1969
Cardinal Godfrey School, Sunbury
oil on canvas 39 x 49
318.1994

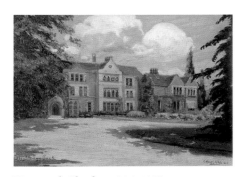

Houssard, Charles 1884–1958
Weybridge Park College 1915
oil 38 x 46 (E)
29.1996

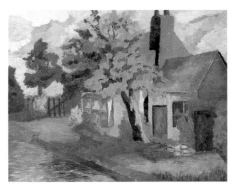

Lefevre, M.
The Lock-Keeper's Cottage by the Oil Mills on the River Wey 1959
oil 39 x 49
239.1969.1

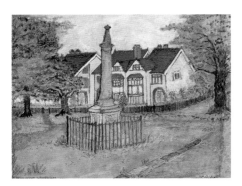

Lock, Edwin active 1929–1961
The Duchess of York's Monument at Monument Green, Weybridge 1929
oil 16 x 20.5
L.30.1982.5 (P)

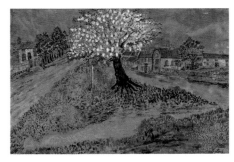

Lock, Edwin active 1929–1961
An Old Chestnut Tree, Which Stood near the 'Ship Inn', High Street, Weybridge 1960
oil on board 25 x 36
L.30.1982.7 (P)

Lock, Edwin active 1929–1961
Shops in the High Street: 'Sough & Son' 1960
oil on board 24 x 35
L.30.1982.1 (P)

Lock, Edwin active 1929–1961
The Entrance to Springfield Lane, Weybridge 1961
oil 29.5 x 39
L.30.1982.4 (P)

Outram, Lance
Robert John Brook Gill, Aged Two 1913
oil on canvas? 75.8 x 62.7
16.1986/47

Saunders, Jutta
The Wey Bridge 1970
oil 48 x 65
218.1970.1

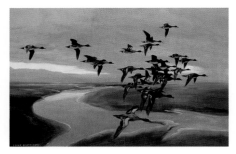

Scott, Peter Markham 1909–1989
Flying Geese 1935
oil 50 x 75
L.346.1989.6 (P)

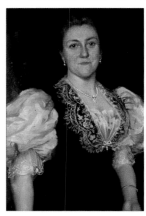

unknown artist
Lady Louisa Egerton, Wife of Admiral Francis Egerton c.1895
oil on canvas 74.5 x 49
203.1973

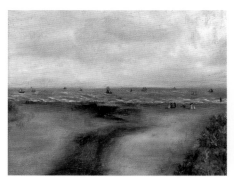

unknown artist
Beach and Seascape 1987
oil on canvas 18.5 x 24

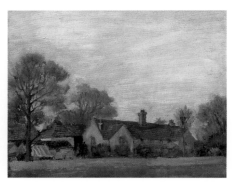

unknown artist
Hamm Court Farm, Weybridge
oil 20.5 x 25
L.254.1971 (P)

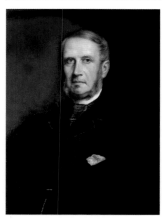

unknown artist
John Phillip Fletcher, Son of Sir Henry Fletcher, of Ashley House, Walton
oil on canvas 81 x 58.4
1.1936

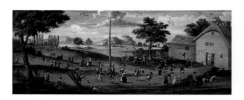

unknown artist
Maypole on Monument Green, with Figures in 18th Century Costume
oil on wooden board 87.6 x 188 (E)
6.1914

unknown artist
Portion of Fresco from East Wall of Old St James' Church
oil fresco 57 x 45
13.1910

Sime, Sidney Herbert 1867–1941
Autumn Trees
oil on board 21.6 x 15.2
77/12

Sime, Sidney Herbert 1867–1941
Autumn Trees
oil on board 8.9 x 18.4
77/15

Sime, Sidney Herbert 1867–1941
Bare Tree
oil on panel board 10.2 x 15.2
D10/A26

Sime, Sidney Herbert 1867–1941
Cloud over Hill
oil on panel board 8.9 x 18.4
D10/A22

Sime, Sidney Herbert 1867–1941
Clouds
oil on canvas 22.9 x 24.1
D6/28

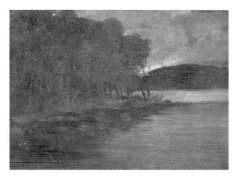

Sime, Sidney Herbert 1867–1941
Dark Lakeside
oil on panel board 15.9 x 20.3
D10/A10

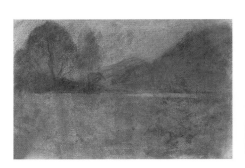

Sime, Sidney Herbert 1867–1941
Dark Landscape
oil on canvas 18.4 x 27.9
D6/54

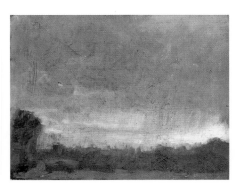

Sime, Sidney Herbert 1867–1941
Dark Landscape
oil on canvas 20.3 x 26
D6/61

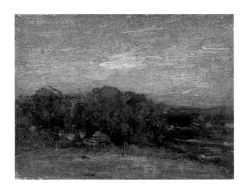

Sime, Sidney Herbert 1867–1941
Dark Landscape
oil on panel board 21 x 26.7
D8/S

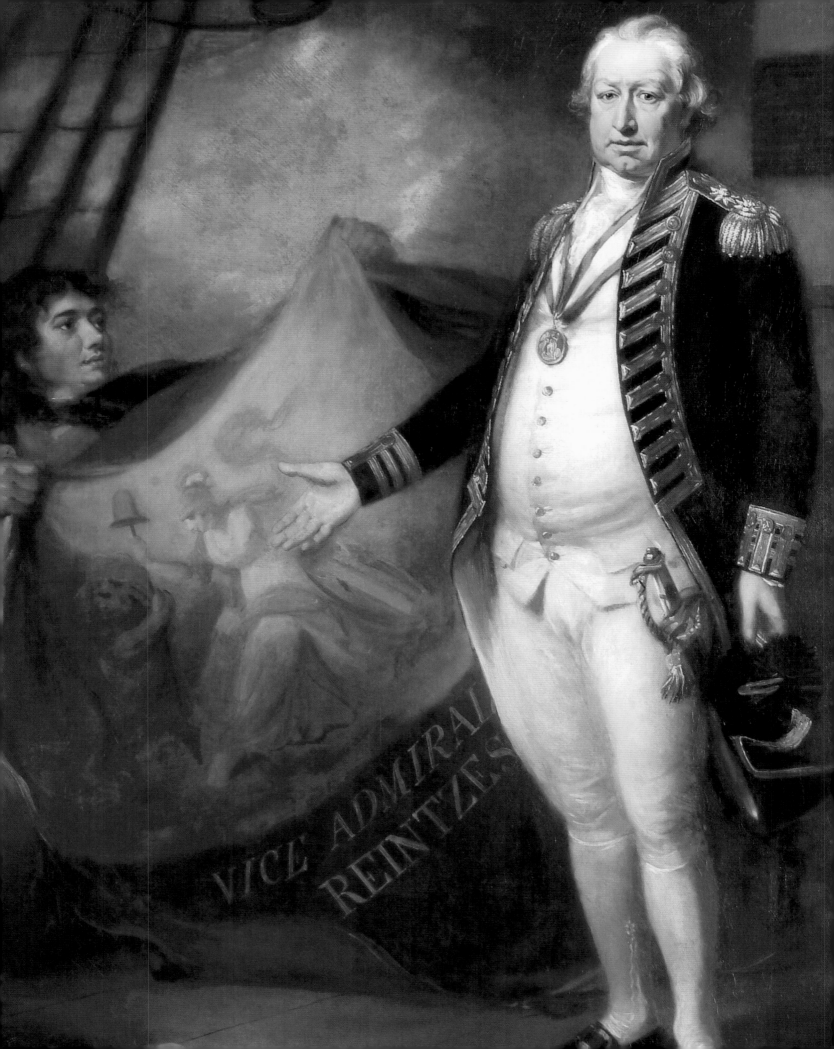

Sime, Sidney Herbert 1867–1941
Dark Landscape
oil on panel board 15.2 x 21.6
D9/A7

Sime, Sidney Herbert 1867–1941
Dark Mountains and Boat
oil on panel board 10.2 x 15.2
D8/V

Sime, Sidney Herbert 1867–1941
Dark Mountains and Water
oil on panel board 18.4 x 8.9
D10/A33

Sime, Sidney Herbert 1867–1941
Dark Pine Trees
oil on board 15.2 x 21.6
77/9

Sime, Sidney Herbert 1867–1941
Dark Sky
oil on canvas 19.7 x 19.1
D6/57

Sime, Sidney Herbert 1867–1941
Dark Sky Tinged White
oil on canvas 23.5 x 27.9
D6/62

Sime, Sidney Herbert 1867–1941
Dark Sky with White Clouds
oil on canvas 19.1 x 27.9
D6/31

Sime, Sidney Herbert 1867–1941
Dark Trees
oil on board 21.6 x 15.2
77/6

Sime, Sidney Herbert 1867–1941
Dark Trees
oil on board 25.4 x 21
77/20

Facing page: Russell, John, 1745–1806, *Sir Richard Onslow, Bt (1741–1817)* (detail), The Guildhall, (p 109)

Sime, Sidney Herbert 1867–1941
Dark Trees
oil on panel 21 x 26.7
D9/W

Sime, Sidney Herbert 1867–1941
Dark Trees and Blue Sky
oil on canvas 19.1 x 21
D6/73

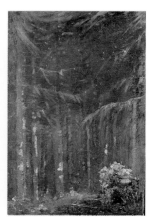

Sime, Sidney Herbert 1867–1941
Dark Trees and Floral Urn
oil on panel board 40.6 x 26.7
D7/A

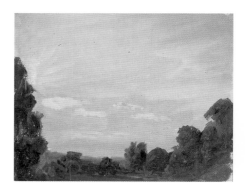

Sime, Sidney Herbert 1867–1941
Dark Trees and Light Sky
oil on canvas 27.3 x 32.4
D6/45

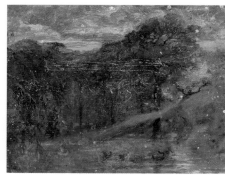

Sime, Sidney Herbert 1867–1941
Dark Trees and Mist
oil on panel board 21.6 x 26.7
D8/P

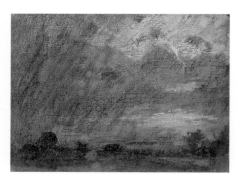

Sime, Sidney Herbert 1867–1941
Dark Trees and Sky
oil on canvas 27.3 x 34.9
D6/41

Sime, Sidney Herbert 1867–1941
Dark Trees and Sky
oil on canvas 24.1 x 26.7
D6/43

Sime, Sidney Herbert 1867–1941
Dark Trees and White Houses
oil on panel board 21 x 26.7
D8/R

Sime, Sidney Herbert 1867–1941
Dark Trees and White-Tip Clouds
oil on canvas 23.5 x 25.4
D6/42

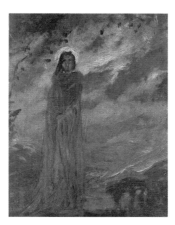

Sime, Sidney Herbert 1867–1941
Figure of a Man with Book
oil on panel board 18.4 x 8.9
D10/A20

Sime, Sidney Herbert 1867–1941
Figure of a Woman
oil on panel board 20.3 x 15.9
D10/A19

Sime, Sidney Herbert 1867–1941
Figure of Lady in Grey
oil on board 18.4 x 8.9
77/22

Sime, Sidney Herbert 1867–1941
Figure of Lady in White
oil on board 18.4 x 8.9
77/21

Sime, Sidney Herbert 1867–1941
Fir Trees
oil on panel board 26.7 x 21
D8/I

Sime, Sidney Herbert 1867–1941
Flower Painting
oil on canvas 35.6 x 52.7
12

Sime, Sidney Herbert 1867–1941
Flying Creatures
oil on panel board 22.9 x 30.5
D7/F

Sime, Sidney Herbert 1867–1941
Forest and Lake
oil on canvas 17.1 x 25.4
D6/74

Sime, Sidney Herbert 1867–1941
Hills
oil on panel board 8.9 x 18.4
D10/A32

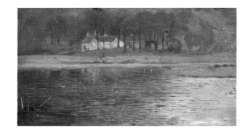

Sime, Sidney Herbert 1867–1941
House by a Lake
oil on board 12.7 x 21.6
77/4

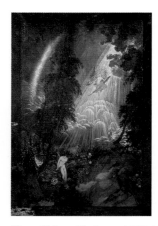

Sime, Sidney Herbert 1867–1941
Illustrative
oil on canvas 139.7 x 91.4
3

Sime, Sidney Herbert 1867–1941
Illustrative
oil on canvas 106.7 x 70.5
7

Sime, Sidney Herbert 1867–1941
Illustrative Design of Fountain and Figures
oil on canvas 109.2 x 83.8
5

Sime, Sidney Herbert 1867–1941
Imaginary
oil on canvas 106.7 x 80
1

Sime, Sidney Herbert 1867–1941
Lady
oil on panel board 18.4 x 8.9
D10/A21

Sime, Sidney Herbert 1867–1941
Lake, House and Trees
oil on canvas 13.3 x 14
D6/33

Sime, Sidney Herbert 1867–1941
Landscape
oil on panel board 15.9 x 21.6
D10/A11

Sime, Sidney Herbert 1867–1941
Landscape and Dark Sky
oil on canvas 21 x 22.9
D6/59

Sime, Sidney Herbert 1867–1941
Landscape and Patterned Sky
oil on canvas 21 x 21.6
D6/52

Sime, Sidney Herbert 1867–1941
Landscape and Red Sky
oil on canvas 14 x 25.4
D6/19

Sime, Sidney Herbert 1867–1941
Landscape and Sky
oil on canvas 21 x 30.5
D6/4

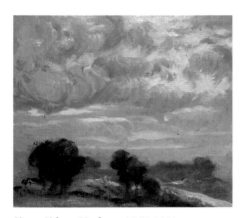

Sime, Sidney Herbert 1867–1941
Landscape and Sky
oil on canvas 22.9 x 24.8
D6/5

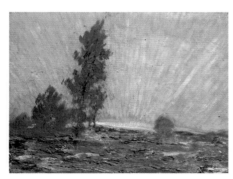

Sime, Sidney Herbert 1867–1941
Landscape and Sky
oil on canvas 19.7 x 24.1
D6/24

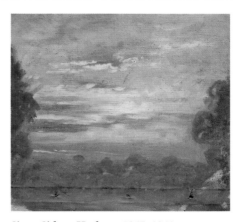

Sime, Sidney Herbert 1867–1941
Landscape and Sunset
oil on canvas 26 x 27.3
D6/7

Sime, Sidney Herbert 1867–1941
Landscape Decoration
oil on canvas 69.2 x 104.8
16

Sime, Sidney Herbert 1867–1941
Landscape Decoration
oil on canvas 66.7 x 79.4
25

Sime, Sidney Herbert 1867–1941
Landscape, Mountain and Lake
oil on board 8.9 x 18.4
77/1

Sime, Sidney Herbert 1867–1941
Landscape, Mountains
oil on board 15.2 x 21.6
77/17

Sime, Sidney Herbert 1867–1941
Landscape of Fields and Bay of Water
oil on canvas 17.8 x 43.8
P537

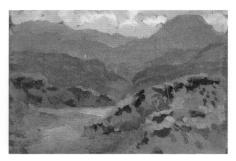

Sime, Sidney Herbert 1867–1941
Landscape, Scottish Mountains
oil on board 15.2 x 21.6
77/16

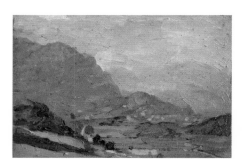

Sime, Sidney Herbert 1867–1941
Landscape, Scottish Mountains
oil on board 15.2 x 21.6
77/18

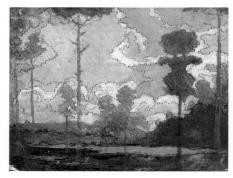

Sime, Sidney Herbert 1867–1941
Landscape, Trees and Green Field
oil on board 21 x 26.7
77/11

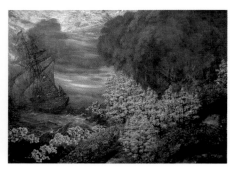

Sime, Sidney Herbert 1867–1941
Landscape with Ship
oil on canvas 82.6 x 107.3
13

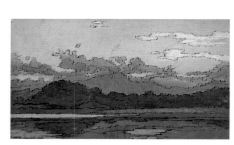

Sime, Sidney Herbert 1867–1941
Landscape with Trees
oil on board 12.7 x 21.6
77/2

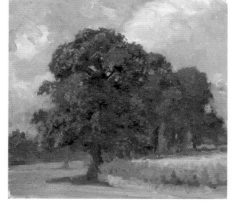

Sime, Sidney Herbert 1867–1941
Large Trees
oil on canvas 23.5 x 25.4
D6/18

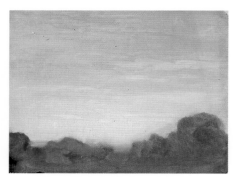

Sime, Sidney Herbert 1867–1941
Light Sky and Trees
oil on canvas 24.1 x 30.5
D6/46

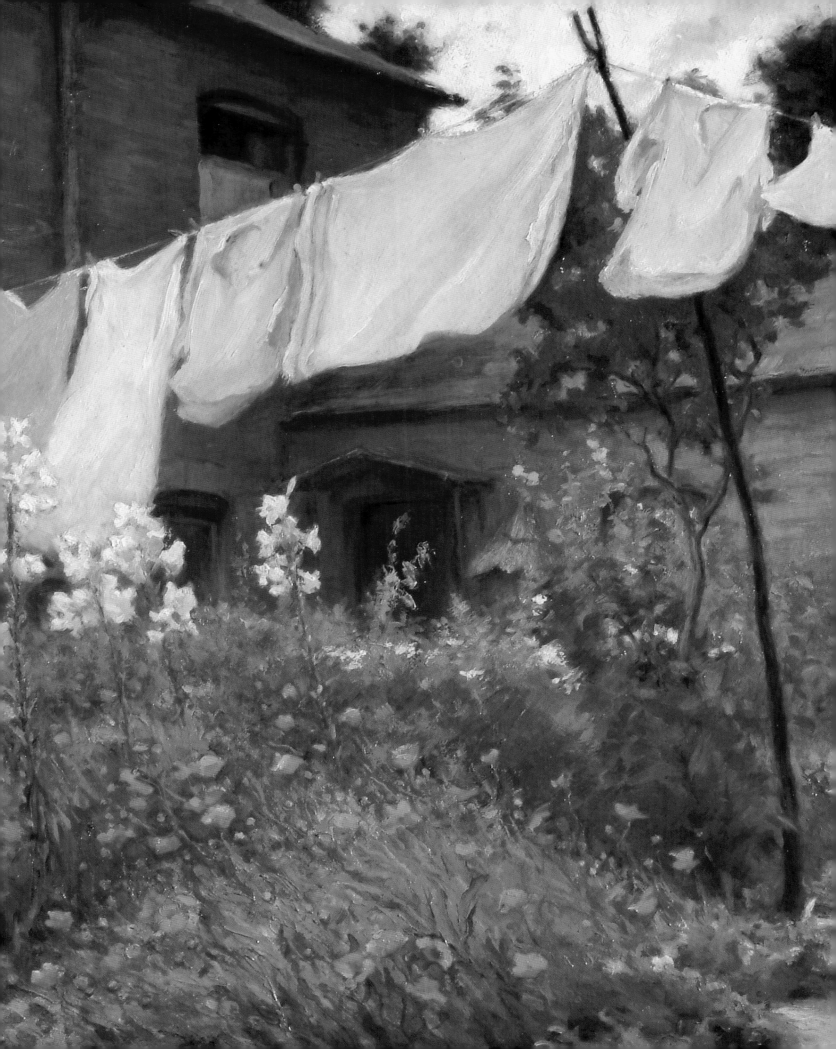

Sime, Sidney Herbert 1867–1941
Patterned Trees
oil on panel board 15.2 x 20.3
D9/Z

Sime, Sidney Herbert 1867–1941
Patterned Trees
oil on panel board 12.7 x 20.3
D10/A18

Sime, Sidney Herbert 1867–1941
Patterned Trees and Sky
oil on canvas 21 x 30.5
D6/58

Sime, Sidney Herbert 1867–1941
Patterned Trees and Sky
oil on canvas 21 x 24.8
D6/72

Sime, Sidney Herbert 1867–1941
Patterned Waves
oil on canvas 25.4 x 30.5
D6/36

Sime, Sidney Herbert 1867–1941
Patterned Winter Tree
oil on panel board 15.9 x 21.6
D10/A13

Sime, Sidney Herbert 1867–1941
Purple Iris and White Pansies
oil on canvas 39.4 x 52.1
82

Sime, Sidney Herbert 1867–1941
Reclining Female
oil on panel board 29.2 x 26.7
D7/C

Sime, Sidney Herbert 1867–1941
Red Sky
oil on canvas 19.1 x 22.2
D6/10

Sime, Sidney Herbert 1867–1941
Red Sky
oil on canvas 24.1 x 24.1
D6/12

Sime, Sidney Herbert 1867–1941
Scottish Landscape, Mountains with Moon
oil on board 15.2 x 21.6
77/19

Sime, Sidney Herbert 1867–1941
Scottish River and Trees
oil on board 21 x 26.7
77/13

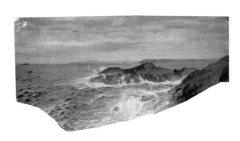

Sime, Sidney Herbert 1867–1941
Sea and Rocks
oil on canvas 25.4 x 45.7
D6/11

Sime, Sidney Herbert 1867–1941
Self Portrait
oil on panel board 16.5 x 7
D10/A40

Sime, Sidney Herbert 1867–1941
Sky and Bushes
oil on canvas 21 x 22.9
D6/25

Sime, Sidney Herbert 1867–1941
Skyscape
oil on canvas 21 x 22.9
D6/21

Sime, Sidney Herbert 1867–1941
Skyscape
oil on canvas 24.8 x 25.4
D6/39

Sime, Sidney Herbert 1867–1941
Skyscape
oil on panel board 21.6 x 26.7
D8/H

Sime, Sidney Herbert 1867–1941
Skyscape
oil on panel board 21.6 x 26.7
D8/N

Sime, Sidney Herbert 1867–1941
Snow-Capped Mountain
oil on panel board 10.2 x 15.2
D10/A28

Sime, Sidney Herbert 1867–1941
Storm
oil on canvas 94 x 63.5
9

Sime, Sidney Herbert 1867–1941
Storm
oil on panel board 15.9 x 21.6
D10/A8

Sime, Sidney Herbert 1867–1941
Storm Clouds and Water
oil on canvas 20.3 x 19.1
D6/50

Sime, Sidney Herbert 1867–1941
Storm Scene
oil on canvas 22.2 x 31.8
D6/49

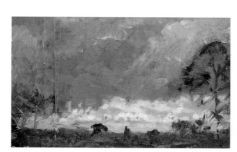

Sime, Sidney Herbert 1867–1941
Stormy Sky
oil on canvas 20.3 x 33
D6/27

Sime, Sidney Herbert 1867–1941
Sun through Clouds
oil on canvas 21.6 x 29.8
D6/14

Sime, Sidney Herbert 1867–1941
Sunflower (recto)
oil on panel board 26.7 x 21
D8/Q

Sime, Sidney Herbert 1867–1941
Across the Field (verso)
oil on panel board 21 x 26.7
D81Q2

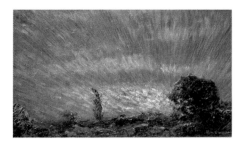

Sime, Sidney Herbert 1867–1941
Sunset Landscape
oil on canvas 33.8 x 43.2
68

Sime, Sidney Herbert 1867–1941
Sunset Sketch
oil on canvas 15.2 x 21.6
69

Sime, Sidney Herbert 1867–1941
Swirling Sky
oil on panel board 24.1 x 30.5
D8/O

Sime, Sidney Herbert 1867–1941
Swirling Sky
oil on panel board 21 x 26.7
D8/T

Sime, Sidney Herbert 1867–1941
The Fountain
oil on canvas 89.5 x 72.4
8

Sime, Sidney Herbert 1867–1941
The Waterfall
oil on canvas 97.8 x 97.8
11

Sime, Sidney Herbert 1867–1941
Tree and Billowing Sky
oil on canvas 20.3 x 20.3
D6/63

Sime, Sidney Herbert 1867–1941
Tree and Heaped Clouds
oil on canvas 17.1 x 30.5
D6/44

Sime, Sidney Herbert 1867–1941
Tree Reflections
oil on panel board 15.2 x 21.6
D9/A4

Sime, Sidney Herbert 1867–1941
Tree Reflections
oil on panel board 12.7 x 20.3
D10/A9

Sime, Sidney Herbert 1867–1941
Tree-Like Scrolls
oil on panel board 25.4 x 38.1
D7/B

Sime, Sidney Herbert 1867–1941
Trees
oil on board 15.2 x 21.6
77/3

Sime, Sidney Herbert 1867–1941
Trees
oil on board 27.9 x 21
77/5

Sime, Sidney Herbert 1867–1941
Trees
oil on canvas 24.8 x 32.4
D6/6

Sime, Sidney Herbert 1867–1941
Trees
oil on canvas 22.9 x 31.8
D6/17

Sime, Sidney Herbert 1867–1941
Trees and Birds in Pool
oil on panel board 26.7 x 21
D7/E

Sime, Sidney Herbert 1867–1941
Trees and Bracken
oil on board 15.2 x 21.6
77/14

Sime, Sidney Herbert 1867–1941
Trees and Calm Sky
oil on canvas 24.1 x 32.4
D6/35

Sime, Sidney Herbert 1867–1941
Trees and Clouds
oil on canvas 22.2 x 29.8
D6/48

Sime, Sidney Herbert 1867–1941
Trees and Dark Sky
oil on canvas 17.8 x 27.3
D6/30

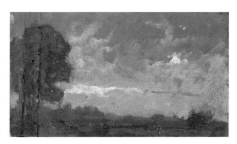

Sime, Sidney Herbert 1867–1941
Trees and Dark Sky
oil on canvas 19.1 x 31.8
D6/65

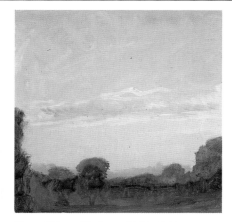

Sime, Sidney Herbert 1867–1941
Trees and Golden Sky
oil on canvas 21 x 21
D6/23

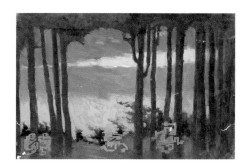

Sime, Sidney Herbert 1867–1941
Trees and Imps
oil on canvas 31.8 x 39.4
D6/1

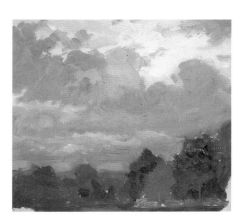

Sime, Sidney Herbert 1867–1941
Trees and Light Clouds
oil on canvas 23.5 x 25.4
D6/67

Sime, Sidney Herbert 1867–1941
Trees and Light Clouds
oil on panel board 14 x 26.7
D9/Y

Sime, Sidney Herbert 1867–1941
Trees and Light Sky
oil on canvas 22.9 x 22.9
D6/56

Sime, Sidney Herbert 1867–1941
Trees and Light Sky
oil on canvas 17.8 x 22.9
D6/60

Sime, Sidney Herbert 1867–1941
Trees and Light Sky
oil on canvas 20.3 x 22.9
D6/68

Sime, Sidney Herbert 1867–1941
Trees and Pink Sky
oil on canvas 22.2 x 22.2
D6/29

Sime, Sidney Herbert 1867–1941
Trees and Red-Tinged Hills
oil on panel board 15.9 x 21.6
D10/A12

Sime, Sidney Herbert 1867–1941
Trees and Red-Tinged Sky
oil on panel board 21 x 26.7
D8/K

Sime, Sidney Herbert 1867–1941
Trees and Sky
oil on canvas 19.1 x 22.9
D6/55

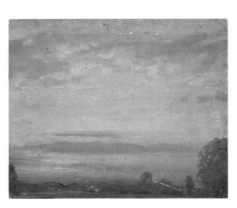

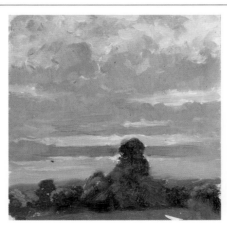

Sime, Sidney Herbert 1867–1941
Trees and Sky
oil on canvas 22.9 x 27.3
D6/70

Sime, Sidney Herbert 1867–1941
Trees and Skyscape
oil on canvas 21.6 x 21.6
D6/15

Sime, Sidney Herbert 1867–1941
Trees and Sun
oil on canvas 21.6 x 26.7
D6/9

Paintings Without Reproductions

This section lists all the paintings that have not been included in the main pages of the catalogue. They were excluded as it was not possible to photograph them for this project. Additional information relating to acquisition credit lines or loan details is also included. For this reason the information below is not repeated in the Further Information section.

Watts Gallery

Alston, Rowland Wright 1895–1958, *Kestrel*, 46 x 31, oil on canvas, COMWG 582, acquired from the Rowland Alston Estate, 1958, missing at the time of photography

Watts, George Frederick 1817–1904, *Scotch Landscape (Loch Ruthven)*, 1899, 17.8 x 53.3, oil on canvas, COMWG 8, gift from Mrs Michael Chapman (née Lilian Macintosh), 1946, missing at the time of photography

Watts, George Frederick 1817–1904, *Nude Study*, 61 x 23, oil on canvas, COMWG 72, missing at the time of photography

Surrey County Council

Carter, William 1863–1939, *William Brodrick, 8th Viscount Midleton*, 1901, 149.9 x 110.5, oil on canvas, 16, not available on the day of photography

University of Surrey

Graham, Jane *Triangular Form*, oil on canvas, 134.2 x 200.7, 204, donated to the University by the artist after an exhibition, 1986, missing at the time of photography

Facing page: Jekyll, Gertrude, 1843–1932, *Thomas in the Character of Puss in Boots* (detail), 1869, Godalming Museum, (p. 78)

Further Information

The paintings listed in this section have additional information relating to one or more of the five categories outlined below. This extra information is only provided where it is applicable and where it exists. Paintings listed in this section follow the same order as in the illustrated pages of the catalogue.

I The full name of the artist if this was too long to display in the illustrated pages of the catalogue. Such cases are marked in the catalogue with a (…).

II The full title of the painting if this was too long to display in the illustrated pages of the catalogue. Such cases are marked in the catalogue with a (…).

III Acquisition information or acquisition credit lines as well as information about loans, copied from the records of the owner collection.

IV Artist copyright credit lines where the copyright owner has been traced. Exhaustive efforts have been made to locate the copyright owners of all the images included within this catalogue and to meet their requirements. Any omissions or mistakes brought to our attention will be duly attended to and corrected in future publications.

V The credit line of the lender of the transparency if the transparency has been borrowed. Bridgeman images are available subject to any relevant copyright approvals from the Bridgeman Art Library at www.bridgeman.co.uk

Ash Museum

Miles, John James active c.1906–c.1920, *St Peter's Church, Ash*, gift
Miles, John James active c.1906–c.1920, *Battleship*, gift

The Army Medical Services Museum

Bentos, Achille b.1882, *Queen Alexandra's Imperial Military Nursing Service (QAIMNS) Sister, Second World War*
Brown, Mather 1761–1831, *Purveyor, Army Medical Department*, gift from Major General R. Barnsley, 1957
Desanges, Louis William 1822–c.1887, *Assistant Surgeon H. Sylvester*, gift from Mrs H. Silver-Ley, 1964
Frankewitz, Bruno 1897–1982, *B Ward, 64th British General Hospital, Second World War*
Newman, Beryl 1906–1991, *Soldiers in Morton Hampstead Hospital, Second World War*, gift from the artist, 1984
Robinson active 20th C, *Queen Alexandra Military Hospital Chapel*
Swinstead, George Hillyard 1860–1926, *White Comrade*
unknown artist *Hampton Massey*, gift from Colonel G. M. McClavity, 1973
unknown artist *Arthur Martin Leake, VC*
unknown artist *Colonel Alfred L. Robertson*

Byfleet Heritage Society

Bridgman, Marjorie *Foxlake Farm*,

bequeathed by Mr Robinson
Henderson, H. B. *Stream Cottages*, bequeathed

Byfleet Village Hall

Lockhart, William Ewart 1846–1900, *Sketch of Queen Victoria Attending Her Diamond Jubilee*

Surrey Heath Borough Council

unknown artist *Bietigheim, the Rathaus*, donated
unknown artist *Bietigheim, Old Town Gate*, donated

Surrey Heath Museum

Biggs, R. Henry active c.1960–1970, *Outdoor Studio*, donated
Biggs, R. Henry active c.1960–1970, *Mill*, donated
Billington, Neville active 1990s, *Camberley Heath Golf Club*, purchased
Cooper, A. L. *Old Pear Tree Cottage*
Cooper, A. L. *The Obelisk*
Fisher, Percy Harland 1867–1944, *Amongst the Reeds*, purchased with the assistance of the Friends of Surrey Heath Museum
Fisher, Percy Harland 1867–1944, *Barossa Common*, purchased with the assistance of the Friends of Surrey Heath Museum
Fisher, Percy Harland 1867–1944, *Chestnut Horse (Cookie the Hunter) (recto)*, purchased with the assistance of Surrey Heath Museum

Fisher, Percy Harland 1867–1944, *Chestnut Horse (verso)*, purchased with the assistance of the Friends of Surrey Heath Museum
Fisher, Percy Harland 1867–1944, *Paddling*, purchased with the assistance of the Friends of Surrey Heath Museum
Fisher, Percy Harland 1867–1944, *Roses in a Vase*, purchased with the assistance of the Friends of Surrey Heath Museum
Fisher, Percy Harland 1867–1944, *The Chestnut Hunter*, purchased with the assistance of the Friends of Surrey Heath Museum
Fisher, Percy Harland 1867–1944, *The Grey Horse (recto)*, purchased with the assistance of the Friends of Surrey Heath Museum
Fisher, Percy Harland 1867–1944, *Lion Standing on Rock (verso)*, purchased with the assistance of the Friends of Surrey Heath Museum
Fisher, Percy Harland 1867–1944, *Washing on the Line*, purchased with the assistance of the Victoria & Albert Museum Purchase Grant Fund and the Friends of Surrey Heath Museum
Fisher, Percy Harland 1867–1944, *Dobbin on the Path (The Wooden Horse)*, purchased with the assistance of the Friends of Surrey Heath Museum
Fisher, Percy Harland 1867–1944, *The Blue Veil*, purchased with the assistance of the Friends of Surrey Heath Museum
Fisher, Percy Harland 1867–1944, *Mrs Hudson*, purchased with the assistance of the Friends of Surrey Heath Museum

Fisher, Percy Harland 1867–1944, *Anthony on a Swing (Boy on a Swing) (recto)*, purchased with the assistance of the Friends of Surrey Heath Museum
Fisher, Percy Harland 1867–1944, *Leaves (verso)*, purchased with the assistance of the Friends of Surrey Heath Museum
Fisher, Percy Harland 1867–1944, *Temptation (The Gypsy Girl)*, purchased with the assistance of the Victoria & Albert Museum Purchase Grant Fund and the Friends of Surrey Heath Museum
Fisher, Percy Harland 1867–1944, *Italian Fruit Stall*, purchased with the assistance of the Friends of Surrey Heath Museum
Fisher, Percy Harland 1867–1944, *Porch, Side of House and Tree*, purchased with the assistance of the Friends of Surrey Heath Museum
Fisher, Percy Harland 1867–1944, *Rushes (recto)*, purchased with the assistance of the Friends of Surrey Heath Museum
Fisher, Percy Harland 1867–1944, *Study of Female Head: Grisaille (verso)*, purchased with the assistance of the Friends of Surrey Heath Museum
Fisher, Percy Harland 1867–1944, *The Italian Donkey*, purchased with the assistance of the Friends of Surrey Heath Museum
Gainsborough, Thomas (after) 1727–1788, *Mrs Siddons*, transferred to Surrey Heath Museum, 1986
Graham, Nora active 1990s, *Basingstoke Canal*, purchased
Green, Phillip active 1980s–1990s,

Graduations, donated by a former mayor
Hadlow, Pauline *Puppet Magic*, purchased
Harrison, Terry b.1947, *King's Head Bridge, Basingstoke Canal*, commissioned by Surrey Heath Borough Council for Surrey Heath Museum
Hill, O. F. *Civic Hall*
Holmes, Betty *Newstead, Camberley Museum*
Jory, Miriam b.1933, *Despair (A Boy in Somalia, 1993)*, purchased, © the artist
Lomas, Rod active 1970s–1980s, *Fisherman's Tale*
Perry, Roy 1935–1993, *Camberley Library*
Perry, Roy 1935–1993, *Chobham Churchyard*
Perry, Roy 1935–1993, *Wells Bakery*
Perry, Roy 1935–1993, *High Street, Camberley*
Perry, Roy 1935–1993, *Chobham Church from the Cricket Field*
Rice, B. A. *Chobham Common*, purchased by the Friends of Surrey Heath Museum
Sams, Ian b.1945, *Frimley Station*, donated, © the artist
Scandrett, Graham active 1960s–2006, *Olive Grove with Goats, Crete*, purchased, © the artist
unknown artist *Signboard from 'The Jolly Farmer' Pub, Side 1*, donated by brewery
unknown artist *Signboard from 'The White Hart' Pub: Front*, donated by brewery
unknown artist *Signboard from 'The White Hart' Pub: Back*, donated by brewery

unknown artist mid-19th C, *Frimley Heath*, donated to Surrey Heath Borough Council by the Wheen family of Chobham, then transferred to Surrey Heath Museum
Wright, Dorothy 1910–1996, *Elmhurst Ballet School*, purchased

The Royal Logistic Corps Museum

Archdale, W. M. *Audu Doso of the Nigeria Military Forces*, transferred from the Royal Corps of Transport Mess, 1983
Ellis, Cuthbert Hamilton 1909–1987, *McMullen Steam Engine*, transferred from the Royal Corps of Transport Mess, 1970
Gilson, J. *Soldier of the King's African Rifles, Ceremonial Dress*, transferred from the Royal Corps of Transport Mess, 1983
May, Robert W. *The 'Lancastria', 17 June 1940*, gift, 1972
Nicoll, John *Tracked Amphibian Neptunes, Kabrit, Little Bitter Lake, 1947*
Painter, R. S. *John Buckley, VC (1813–1876), Deputy Assistant Commissary of Ordnance, Bengal*, acquired, 1953
Redgrove *DUKWs Unloading Supplies, D-Day, 6 June 1944*, transferred from the Royal Corps of Transport Mess, 1987
Reynolds, Joshua (after) 1723–1792, *John Manners, Marquis of Granby*, purchased from Phillips auction, 1991
Shotter, R. *Portrait of an Unknown Gentleman*
Summerville, D. *Diamond 'T' Recovering Tank on Battlefield, North Africa*, gift, 1985
Wanklyn, Joan active 1956–1994, *Horse of the Year Show, 1966*, commissioned by the Royal Corps of Transport, 1966

Caterham Valley Library

Christie, Ernest C. 1863–1937, *Sundials in Gardens*, on loan from the Legrew Trust, Chaldon, Surrey
Christie, Ernest C. 1863–1937, *Chaldon Church*, on loan from the Legrew Trust, Chaldon, Surrey
unknown artist *The Greyhound Public House, Caterham*
unknown artist *Ernest Christie (1863–1937)*, on loan from James Batley

East Surrey Museum

Adams, D. *Old Fred*, gift from Mrs M. Scott of Chaldon Road, Caterham, 2000
Curzon-Price, Paddy *Ruth Chaplin, OBE, in Retirement*
MacLeod, Fay *The Clock in Queen's Park, Caterham*, gift from Mrs E. M. Wilson

Chertsey Museum

Allam active 1878–1880, *Egham Races*, on loan from the S. A. Oliver Charitable Settlement
Allam active 1878–1880, *Egham Races*, on loan from the S. A. Oliver Charitable Settlement
Allam active 1878–1880, *Bells of Ouzeley*, on loan from the S. A. Oliver Charitable Settlement
Allam active 1878–1880, *Windsor Castle from Bishopsgate*, on loan from the S. A. Oliver Charitable Settlement
Bosher, M. A. *View from Cooper's Hill*, on loan from the S. A. Oliver Charitable Settlement
Bosher, M. A. *View from Cooper's Hill*, on loan from the S. A. Oliver Charitable Settlement
Breanski, Alfred de 1852–1928, *Milson's Point on the Thames near Runnymede*, on loan from the S. A. Oliver Charitable Settlement
Brettingham, L. (attributed to) *Almner's Priory*, gift
Carey, Charles William 1862–1943, *Aldridge's Forge*, on loan from the S. A. Oliver Charitable Settlement
Carey, Charles William 1862–1943, *In the Grounds of Royal Holloway College*, on loan from the S. A. Oliver Charitable Settlement
Daniell, William 1769–1837, *Dunford Bridge*, purchased
Earl, William Robert 1806–1880, *Chertsey Preserve*, purchased
Frowd, Thomas T. J. active 1847–1864, *The Lock, Windsor*, on loan from the S. A. Oliver Charitable Settlement
Fuller, Eugene 1889–1968, *Ottershaw School*, gift
Gallon, Robert 1845–1925, *View from Cooper's Hill over Runnymede, with Windsor Castle in Distance*, transferred from Egham Urban District Council when Runnymede Council was formed
Harris, Alfred John 1835–1916, *Cooper's Hill*, on loan from the S. A. Oliver Charitable Settlement
Harris, Alfred John 1835–1916, *View of Runnymede from Towpath with Windsor Castle in the Distance*, on loan from the S. A. Oliver Charitable Settlement
Harris, Alfred John 1835–1916, *View near Staines, Middlesex*, on loan from the S. A. Oliver Charitable Settlement
Harris, Alfred John 1835–1916, *Cooper's Hill*, on loan from the S. A. Oliver Charitable Settlement
Harris, Alfred John 1835–1916, *Cows Grazing*, on loan from the S. A. Oliver Charitable Settlement
Harris, Alfred John 1835–1916, *Cows on the Mead, Egham*, on loan from the S. A. Oliver Charitable Settlement
Harris, Alfred John 1835–1916, *Windsor Castle from Langham's, Runnymede*, on loan from the S. A. Oliver Charitable Settlement
Harris, William E. 1860–1930,

Runnymede Island, on loan from the S. A. Oliver Charitable Settlement
Howard, E. (attributed to) *Cricketer's Inn*, gift
Jutsum, Henry 1816–1869, *Egham Races, Egham*, on loan from the S. A. Oliver Charitable Settlement
Knight, A. Roland active 1810–1840, *Barbel Fishing at Chertsey*
Lyndon, Herbert active 1860–1922, *Bell Weir Lock and 'Angler's Rest', Staines*, on loan from the S. A. Oliver Charitable Settlement
Melville, Arthur 1855–1904, *Staines Bridge*, on loan from the S. A. Oliver Charitable Settlement
Niemann, Edward H. active 1863–1887, *Staines with St Mary's Church*, on loan from the S. A. Oliver Charitable Settlement
Oades, Emily W. 1836–1897, *Bell Weir and 'Angler's Rest'*, on loan from the S. A. Oliver Charitable Settlement
Pettitt, Charles 1831–1885, *Magna Carta Island, Runnymede*, on loan from the S. A. Oliver Charitable Settlement
Popesco, George b.1962, *Mr Ron Taylor, Greengrocer, in His Shop at 8 Windsor Street, Chertsey*, purchased
Potter, Frank Huddlestone 1845–1887, *Egham from Long Mede, Runnymede*, on loan from the S. A. Oliver Charitable Settlement
Robinson, Margaret J. *Self Portrait*, purchased
Spoade, John *William IV Arriving at Long Mede, Runnymede at the Point of the One Mile Winning Post*, on loan from the S. A. Oliver Charitable Settlement
Tolles, W. *Cooper's Hill Farm, Priest Hill*, on loan from the S. A. Oliver Charitable Settlement
unknown artist *Cooper's Company Fishing Temple, Staines Lane*, on loan from the S. A. Oliver Charitable Settlement
unknown artist *Angler's Rest' and Bell Weir*, on loan from the S. A. Oliver Charitable Settlement
unknown artist *William Gardan's Timber Wharf on the Western End of Church Island, Staines*, on loan from the S. A. Oliver Charitable Settlement
Vingoe, Francis b.1880, *Ruins at Virginia Water*, on loan from the S. A. Oliver Charitable Settlement
Vingoe, Francis b.1880, *Virginia Water Tea House*, on loan from the S. A. Oliver Charitable Settlement
J. C. W. *View of Windsor Castle*, on loan from the S. A. Oliver Charitable Settlement

Dorking and District Museum

Assadourigil, H. *Sister Still*, gift from Mr G. Goldsmith, 1997
Beckett, John 1799–1864, *Clarendon House, West Street, Dorking*, bequeathed by Leonard Machin via Mrs Green, 1958
Beckett, John 1799–1864, *St*

Martin's Medieval Nave, Dorking, gift from Reverend Lamb, Vicar of St Martin's Church
Beckett, John 1799–1864, *South Street from Pump Corner, Dorking*, bequeathed by Leonard Machin via Mrs Green, 1958
Beckett, John 1799–1864, *St Martin's Medieval Church, Dorking*, gift from H. L. Moore
Beckett, John 1799–1864, *Courtyard with Cat and Robin, South Street, Dorking*, bequeathed by Leonard Machin via Mrs Green, 1958
Beckett, John 1799–1864, *Boxhill, River Mole and Cows, Dorking*, gift from Mr J. Howard
Beckett, John 1799–1864, *Dene Street, Dorking*, bequeathed by Leonard Machin via Mrs Green, 1958
Beckett, John 1799–1864, *Pump Corner, 'Queen's Arms', West Street, Dorking*, gift from A. W. Eade, executor of Clara Philips, 1950
Beckett, John 1799–1864, *St Martin's Intermediate Church, Dorking*, gift from Mrs Eade
Beckett, John 1799–1864, *St Martin's Intermediate Church Exterior, Dorking*, gift from Reverend Lamb, Vicar of St Martin's Church
Beckett, John 1799–1864, *St Martin's Medieval Chancel, Dorking*, gift from Reverend Lamb, Vicar of St Martin's Church
Beckett, John 1799–1864, *South Street, Dorking*, bequeathed by Leonard Machin via Mrs Green, 1958
Beckett, John 1799–1864, *'The Bull's Head', South Street, Dorking*, bequeathed by Leonard Machin via Mrs Green, 1958
Beckett, John 1799–1864, *Westcott Sandpits, Westcott, Surrey*, bequeathed by Leonard Machin via Mrs Green, 1958
Box, Helena d.1914, *Boxhill Mill, Dorking*, gift from Miss Rose of Westcott, 1976
Boxall, William 1862–1937, *The Mill Pond, Dorking*, gift from Mr & Mrs A. W. Eade
Collins, Charles II 1851–1921, *River Mole, Dorking with Cows and Two Figures, Son Robert and Daughter Margaret*, gift from Guy Collins & his grandsons, 1976
Collins, Charles II 1851–1921, *Abinger Mill, Abinger, Surrey*, gift from Guy Collins & his grandsons, 1976
Collins, Charles II 1851–1921, *Autumn Gold', the Nower, Dorking*, gift from Mr J. Howard
Collins, Charles II 1851–1921, *Cattle and Dog on Common*, gift from the widow of R. G. Collins, 1983
Collins, Charles II 1851–1921, *Old Castle Mill Pumping Station, Betchworth Castle Gardens, Dorking*, gift from Miss M. Felgate, 1988
Collins, Helen 1921–1990, *Horses*

at a Riding School, gift from Guy Collins & his sister, 1983
Collins, Samuel William 1849–1892, *The Old Rest House, Hampstead Lane, Dorking*, gift from Guy Collins & his sister, 1982
Daws, Philip b.1845, *The Old Mill Pond, Netley, Shere, Surrey*, gift from Mrs R. Brown
Drane, Herbert Cecil 1860–1932, *Garretts Ghyll (Shophouse Farm), Forest Green, Surrey*, gift from M. R. T. of Westcott
Drane, Herbert Cecil 1860–1932, *Waterlands Farm, Forest Green, Surrey*, gift from M. R. T. of Westcott
C. F. G. *Gate to Camilla Lacey, Mrs Ball's Cottage and Barn Mission Room*, gift from T. Cooper
Gibbs, Charles 1834–1910, *Abinger Mill, Abinger, Surrey*, gift from Guy Collins
Harris, Alfred John 1835–1916, *Ranmore Common, Dorking, with Post Office and Dispensary*, bequeathed by S. A. Oliver via B. F. J. Pardoe per Surrey Record Office, 1987
Harris, Alfred John 1835–1916, *Shepherd's Cottage, Dunley Hill near Dorking*, bequeathed by S. A. Oliver via B. F. J. Pardoe per Surrey Record Office, 1987
Harvey, Michael Anthony 1921–2000, *Spring in Westhumble*, gift from Mrs Victoria Houghton, 1996
Jordan, Denham 1836–1920, *Birds of Prey, Falcon and Dead Bird*, gift from P. W. Turner
Jordan, Denham 1836–1920, *Birds of Prey, Kestrel*, gift from P. W. Turner
Jordan, Denham 1836–1920, *Exotic Bird*, gift from Mrs Scragg, 1988
Jordan, Denham 1836–1920, *Exotic Bird on Branch and Flowers*, gift from Mrs Scragg, 1998
Jordan, Denham 1836–1920, *Boar*, gift from Mrs Scragg, 1998
Jordan, Denham 1836–1920, *Marsh Scene*, gift from Mrs Scragg, 1998
Jordan, Denham 1836–1920, *Scarecrow and Two Hares*, gift from Mrs M. Pratt
Kiste, Hans *Floodgate, Castle Mill, Dorking*, gift from Mr J. Howard
Kiste, Hans *The River Mole, Dorking*, gift from Mr J. Howard
Langdon, Dorothy b.1886, *Flowering Tree on Water*, gift from Miss M. Felgate, 1987
Neale, Christine active 1989–1992, *St Martin's Church, Dorking*, gift from Miss C. Mann
Neale, Christine active 1989–1992, *St Martin's Church, Dorking*, gift from Dorking and District Preservation Society in memory of Miss Ethel Clear, 1992
Rose, Walter John 1857–1954, *The Weir and Pump House at Betchworth Castle Gardens (sometimes known as Boxhill Mill)*, gift from Miss M. Felgate
Ruff, Agnes active 1958–2001, *Rose*

Hill Arch, Dorking, gift from the artist, 1997

Stokoe, Elizabeth Calvert active 1933–1937, *St Martin's Church, Dorking*, gift from Mr J. Howard

Stokoe, Elizabeth Calvert active 1933–1937, *Attlee Mill, Station Road, Dorking*, gift from Mr J. Howard

'Sunny', Batchelor *George Baker (Pompey)*, gift from Mr J. Howard

Todman *Young Girl in Punchbowl Lane (The Hollows)*, gift from Mr J. Howard, 1984

unknown artist 19th C, *Thomas Huggins, Aged 9, with Hoop and Dog, Great Grandfather of William Huggins*, gift from unknown donor, 1997

unknown artist 19th C, *William Broad (1759–1862), Dorking Coachman*, purchased from Miss Stockton, 1952

unknown artist late 19th C, *Castle Mill, Dorking*, gift

unknown artist *Willow Walk Painted from Garden of 10 Rothes Road, Dorking*, gift from Miss C. N. Newberry

unknown artist *Brockham Bridge, Brockham, Surrey*, gift from Miss N. Simpson, 1979

unknown artist *Granny Washington's Cottage, Junction Road, Dorking*, gift from Mr J. Howard

unknown artist *Willow Walk and Millpond, Dorking*, gift from Miss N. Simpson, 1979

Warrenne, Joan (attributed to) *Canadian TOC H Social Club*, gift from the artist in memory of Sydney Ison

Watson, Stella d.1980s, *Washing Day at Lyons Cottages, Dorking*, gift from Mrs N. Cellier, 1994

Wright, Joseph 1756–1793, *Major Peter Labilliere (d.1800)*, bequeathed by Leonard Machin via Mrs Green, 1958

Mole Valley District Council

Caffyn, Walter Wallor 1845–1898, *In the Garden of the Grove, Boxhill*, on display at Dorking Library

Hulk, Abraham 1813–1897, *On the Mole*, on display at Dorking Library

Waite, Edward Wilkins 1854–1924, *Shepherd and Flock in Wooded Landscape*, on display at Dorking Library

Egham Museum

Arnold, Harriet Gouldsmith c.1787–1863, *River Thames with Fish Weir*, purchased from T. Cursine, 1985

Arnold, Harriet Gouldsmith c.1787–1863, *Magna Carta Island*, purchased from T. Cursine, 1985

Body, A. M. *'Castle Inn', 1910*, donated by the artist, 1982

Carey, Charles William 1862–

1943, *Mount Lee Farm*, donated by Miss I. M. White, 1991

Cleaver, James 1911–2003, *Horse and Trap, Egham Show*, donated by Mr Cleaver Jr, 1995

Cleaver, James 1911–2003, *'King's Arms', Egham*, donated by Mr Cleaver Jr, 1995

Cowdrey *Glanty Cottages*, donated by the artist, 1993

Harris, Alfred John 1835–1916, *Expecting the Grand Master*, anonymous donation, 1984

Hayward, J. F. *Rusham House*, donated by Shell Research, 1977

Holland, Doreen *Sunset at Longside Lake, Thorpe*, donated by Mrs J. Whitfield, 2001

King, N. H. *Still Life: Fruit*, donated by Mr Eldridge, 1987

Nasmyth, Patrick 1787–1831, *Virginia Water*, purchased from Rayner McConnell, 1991

unknown artist *Baron Octave George Lecca*, donated by R. B. C., 1984

unknown artist *'Red Lion Inn', Egham*, donated by the landlord at the Red Lion Inn, 1995

unknown artist *Vera Katherine Blackett*, donated by R. B. C., 1984

Royal Holloway, University of London

Annear, Jeremy b.1949, *Untitled Abstract in Blue and Grey*, anonymous gift, 2001

Ansdell, Richard 1815–1885, *The Drover's Halt, Island of Mull in the Distance*, purchased for Thomas Holloway, 1882

Atherton, Linda b.1952, *Professor Drummond Bone*, commissioned by Royal Holloway, University of London, 2002

Atroshenko, Viacheslav 1935–1994, *Musical Moment*, presented by the Warwick Arts Trust, London, 2005

Atroshenko, Viacheslav 1935–1994, *New York I (of a series of six)*, presented by the Warwick Arts Trust, London, 2005

Backer *Girl with Siamese Cat*

Bernhardt, Sarah 1844–1923, *Le retour a l'église*

Bigland, Percy 1858–1926, *Henrietta Busk*, acquired on the merger with Bedford College, 1985

Brason, Paul b.1952, *Professor Dorothy Wedderburn*, commissioned by Royal Holloway, University of London, 1991

Bratby, John Randall 1928–1992, *Washline, Little Bridge*, anonymous donation, 2001, © courtesy of the artist's estate/www.bridgeman. co.uk

Brett, John 1830–1902, *Carthillon Cliffs*, purchased for Thomas Holloway, 1883

British School early 19th C, *Wooded Landscape with Goat and Figures*

British School 19th C, *Thomas Holloway Senior (d.1836)*,

presented by the Misses Blanche & Grace Young, 1941

British School late 19th C, *Dame Emily Penrose (1858–1942)*

British School late 19th C, *Mrs Louise d'Este Oliver (1850–1919)*

British School late 19th C, *Mrs Maria Louisa Carlile (1826–1908)*, acquired on the merger with Bedford College, 1985

British School *Dr Nora L. Penston*, acquired on the merger with Bedford College, 1985

British School *Abstract Composition*

British School 20th C, *Dame Margaret Janson Tuke (1862–1947)*, acquired on the merger with Bedford College, 1985

British School 20th C, *Dame Margaret Janson Tuke (1862–1947)*, acquired on the merger with Bedford College, 1985

British School late 20th C, *Harbour*

British School late 20th C, *Winter Landscape with Lake*

Bruce, H. A. *Miss Anna Swanwick (1813–1899)*, acquired on the merger with Bedford College, 1985

Bruce, H. A. *Miss Anna Swanwick (1813–1899)*, acquired on the merger with Bedford College, 1985

Burgess, John Bagnold 1830–1897, *Licensing the Beggars in Spain*, purchased for Thomas Holloway, 1883

Butler, H. C. *Boats*

Butler, H. C. *Lakeside Landscape*

Carey, Charles William 1862–1943, *Farm House, Mount Lee*, donated by the artist, Curator of the Royal Holloway Collection (1887–1943)

Carey, Charles William 1862–1943, *South East Corner of Royal Holloway College*, donated by the artist, Curator of the Royal Holloway Collection (1887–1943)

Carey, Charles William 1862–1943, *South West Terrace Steps, Royal Holloway*, donated by the artist, Curator of the Royal Holloway Collection (1887–1943)

Carey, Charles William 1862–1943, *Egham Station*, on loan from the S. A. Oliver Charitable Settlement

Chamberlain, Brenda 1912–1971, *Seascape in Red*

Collins, William 1788–1847, *Borrowdale, Cumberland, with Children Playing by the Banks of a Brook*, purchased for Thomas Holloway, 1881

Conti, Tito 1842–1924, *Goodbye*, purchased for Thomas Holloway, 1883

Conti, Tito 1842–1924, *Approved*, purchased for Thomas Holloway, 1883

Conti, Tito 1842–1924, *Paying Her Respects to His High Mightiness*, purchased for Thomas Holloway, 1883

Cooke, Edward William 1811–1880, *Scheveningen Beach*, purchased for Thomas Holloway,

1882

Cooke, Edward William 1811–1880, *A Dutch Beurtman Aground on the Terschelling Sands, in the North Sea after a Snowstorm*, purchased for Thomas Holloway, 1882

Cooper, Thomas Sidney 1803–1902, *Landscape with Cows and Sheep*, purchased by Thomas Holloway, 1881

Cooper, Thomas Sidney 1803–1902, *Landscape with Sheep and Goats*, purchased by Thomas Holloway, 1881

Courtnell, Louise b.1963, *Mr Shoa the Younger*, purchased with assistance from the Esmée Fairbairn Donation, 1993, © the artist

Covey, Molly Sale 1880–1917, *Portrait of an Elderly Gentleman*

Creswick, Thomas 1811–1869, *The First Glimpse of the Sea*, purchased for Thomas Holloway, 1883

Creswick, Thomas 1811–1869, *Trentside*, purchased by Thomas Holloway, 1881

Crome, John (follower of) 1768–1821, *A Woodland Scene*, purchased by Thomas Holloway, 1881

Daele, Charles van den d.1873, *The Letter*, given through the Cranbrook Bequest

Dawson, Henry 1811–1878, *Sheerness, Guardship Saluting*, purchased for Thomas Holloway, 1882

Dawson, Henry Thomas 1841/1842–after 1896, *Salcombe Estuary, South Devon*, purchased for Thomas Holloway, 1882

Dillon, Frank 1823–1909, *Tombs of the Khedives in Old Cairo*

Dixon, G. *Seascape with Cliffs*

Dodd, Francis 1874–1949, *Dame Margaret Janson Tuke (1862–1947)*, acquired on the merger with Bedford College, 1985, © the artist's estate

Ellis, Edwin 1841–1895, *The Harbour Bar*, purchased for Thomas Holloway, 1883

Elmore, Alfred 1815–1881, *The Emperor Charles V at the Convent of St Yuste*, purchased for Thomas Holloway, 1883

Faed, Thomas 1826–1900, *Taking Rest*, purchased for Thomas Holloway, 1882

Fielding, Anthony V. C. 1787–1855, *Travellers in a Storm, Approach to Winchester*, purchased by Thomas Holloway, 1881

Fildes, Luke 1844–1927, *Applicants for Admission to a Casual Ward*, purchased for Thomas Holloway, 1883

Frith, William Powell 1819–1909, *Sketch for 'The Railway Station'*

Frith, William Powell 1819–1909, *The Railway Station*, purchased by Thomas Holloway, 1883

Gere, Margaret 1878–1965, *The Garden of the Slothful*, presented to Bedford College by Sir Wilmot Herringham, 1918

Girardot, Ernest Gustave 1840–

1904, *Jane Holloway (posthumous)*, commissioned by Thomas Holloway, 1882

Girardot, Ernest Gustave 1840–1904, *Thomas Holloway*, commissioned by Thomas Holloway, 1882

Glindoni, Henry Gillard 1852–1913, *The Musician*, given through the Cranbrook Bequest

Gowing, Lawrence 1918–1991, *Mrs E. M. Chilvers*, acquired on the merger with Bedford College, 1985, © the estate of (the late) Sir Lawrence Gowing

Graham, Peter 1836–1921, *A Highland Croft*, purchased for Thomas Holloway, 1883

Greenham, Peter 1909–1992, *Professor Dorothy Wedderburn*, acquired on the merger with Bedford College, 1985, © courtesy of the artist's estate/ www. bridgeman.co.uk

Groom, Jon b.1953, *The Moorish House, V*, anonymous gift, 2001

Gunn, Herbert James 1893–1964, *Miss Geraldine E. M. Jebb, CBE*, acquired on the merger with Bedford College, 1985, © the artist's estate

Gunn, Herbert James 1893–1964, *Sir Wilmot Herringham KCMG, CB, MD (1855–1936)*, acquired on the merger with Bedford College, 1985, © the artist's estate

Hamme, Alexis van 1818–1875, *Feeding the Parrot*

Hardy, Frederick Daniel 1826–1911, *Expectation: Interior of Cottage with Mother and Children*, purchased for Thomas Holloway, 1883

Hardy, James II 1832–1889, *A Young Gillie, with Setters and Dead Game*, purchased for Thomas Holloway, 1883

Haughton, Desmond b.1968, *Self Portrait in a Yellow Waistcoat*, purchased with assistance from the Esmée Fairbairn Donation, 1993

Hazelwood, David B. 1932–1994, *Fluttering*, © the artist's estate

Hepple, Norman 1908–1994, *Sir Charles Tennyson, 1954*, acquired on the merger with Bedford College, 1985, © courtesy of the artist's estate/ www.bridgeman. co.uk

Herkomer, Hubert von 1849–1914, *Marie Douglas (Mrs Arthur Stothert)*, presented by Miss S. M. Barker

Herringham, Christiana Jane 1852–1929, *Asphodel*, presented to Bedford College by Sir Wilmot Herringham, 1918. Acquired on the merger with Bedford College, 1985

Herringham, Christiana Jane 1852–1929, *Battle of Love and Chastity (after Gherardo di Giovanni del Fora)*, presented to Bedford College by Sir Wilmot Herringham, 1918. Acquired on the merger with Bedford College, 1985

Herringham, Christiana Jane

1852–1929, *Head of St Catherine (after Sandro Botticelli)*, presented to Bedford College by Sir Wilmot Herringham, 1918. Acquired on the merger with Bedford College, 1985

Herringham, Christiana Jane 1852–1929, *Head of the Magdalene (after Sandro Botticelli)*, presented to Bedford College by Sir Wilmot Herringham, 1918. Acquired on the merger with Bedford College, 1985

Herringham, Christiana Jane 1852–1929, *Landscape with Farm*

Herringham, Christiana Jane 1852–1929, *Madonna and Child (after Cosmè Tura)*, presented to Bedford College by Sir Wilmot Herringham, 1918. Acquired on the merger with Bedford College, 1985

Herringham, Christiana Jane 1852–1929, *Pink Aquilegia, Yellow Foxgloves, Cow Parsley*, presented to Bedford College by Sir Wilmot Herringham, 1918. Acquired on the merger with Bedford College, 1985

Herringham, Christiana Jane 1852–1929, *Red Lilies on Blue Ground*, presented to Bedford College by Sir Wilmot Herringham, 1918. Acquired on the merger with Bedford College, 1985

Herringham, Christiana Jane 1852–1929, *Smeralda Bandinelli (after Sandro Botticelli)*, presented to Bedford College by Sir Wilmot Herringham, 1918. Acquired on the merger with Bedford College, 1985

Herringham, Christiana Jane 1852–1929, *Virgin and Child (after Sandro Botticelli)*, presented to Bedford College by Sir Wilmot Herringham, 1918. Acquired on the merger with Bedford College, 1985

Heydorn, S. *Seascape*

Hodgson, John Evan 1831–1895, *Relatives in Bond*, purchased for Thomas Holloway, 1883

Holl, Frank 1845–1888, *Newgate: Committed for Trial*, purchased for Thomas Holloway, 1882

Holland, James 1800–1870, *Piazza dei Signori, Verona, with the Market Place*, purchased by Thomas Holloway, 1881

Holland, James 1800–1870, *Venice, Piazza di San Marco*, purchased for Thomas Holloway, 1883

Hook, James Clarke 1819–1907, *Leaving at Low Water*, purchased, 1883

Horsley, John Callcott 1817–1903, *The Banker's Private Room, Negotiating a Loan*, purchased for Thomas Holloway, 1883

Hubbard, Steven b.1954, *Self Portrait with Objects*, purchased through the Alfred McAlpine Donation, 1993

Jagger, David 1891–1958, *Miss Janet Ruth Bacon*, commissioned by Royal Holloway, University of

London, 1946

Kerr-Lawson, James 1865–1939, *The Forum with the Arch of Constantine, Rome*

Kerr-Lawson, James 1865–1939, *The Forum with Trajan's Column, Rome*

Koike, Masahiro *La fontaine*, purchased through Mrs Eileen Stansfield Bequest, 2004

Landseer, Edwin Henry 1802–1873, *Man Proposes, God Disposes*, purchased by Thomas Holloway, 1881

László, Philip Alexius de 1869–1937, *Dame Emily Penrose (1858–1942)*, commissioned by Royal Holloway, University of London, 1907, © courtesy of the artist's estate/www.bridgeman.co.uk

László, Philip Alexius de 1869–1937, *Sketch for 'Dame Emily Penrose (1858–1942)'*, bequeathed by Dame Marjorie Williamson, 2003, © courtesy of the artist's estate/www.bridgeman.co.uk

László, Philip Alexius de 1869–1937, *Elizabeth Maude Guinness*, presented to the College by its past and present members, 1911, © courtesy of the artist's estate/www.bridgeman.co.uk

Leader, Benjamin Williams 1831–1923, *The Rocky Bed of a Welsh River*, purchased for Thomas Holloway, 1883

Leader, Benjamin Williams 1831–1923, *Unterseen, Interlaken, Autumn in Switzerland*, purchased for Thomas Holloway, 1883

Leighton, Edmund Blair 1853–1922, *A Flaw in the Title*, purchased for Thomas Holloway, 1883

Lejeune, Henry 1820–1904, *Early Sorrow*, purchased for Thomas Holloway, 1883

Leslie, Charles 1835–1890, *Loch Katrine, Ellen's Isle*, presented by Dr Edith M. Guest

Linnell, John 1792–1882, *Wayfarers*, purchased for Thomas Holloway, 1883

Long, Edwin 1829–1891, *The Suppliants: Expulsion of the Gypsies from Spain*, purchased for Thomas Holloway, 1882

Long, Edwin 1829–1891, *The Babylonian Marriage Market*, purchased for Thomas Holloway, 1882

Maclise, Daniel 1806–1870, *Peter the Great at Deptford Dockyard*, purchased for Thomas Holloway, 1883

MacWhirter, John 1839–1911, *'Night, most glorious night, thou wert not made for slumber'*, purchased for Thomas Holloway, 1882

MacWhirter, John 1839–1911, *Spindrift*, purchased for Thomas Holloway, 1882

Mann, Joshua Hargrave Sams active 1849–1884, *The Cauld Blast*, purchased for Thomas Holloway, 1882

Millais, John Everett 1829–1896, *The Princes in the Tower*, purchased

by Thomas Holloway, 1881

Millais, John Everett 1829–1896, *Princess Elizabeth in Prison at St James's*, purchased by Thomas Holloway, 1881

Morland, George 1763–1804, *The Cottage Door*, purchased for Thomas Holloway, 1883

Morland, George 1763–1804, *The Press-Gang*, purchased for Thomas Holloway, 1883

Morland, George 1763–1804, *The Carrier Preparing to Set Out*, purchased by Thomas Holloway, 1881

Morpurgo, Simonetta *Senigallia*

Müller, William James 1812–1845, *Interior of a Cottage in Wales*, purchased for Thomas Holloway, 1883

Müller, William James 1812–1845, *Opium Stall*, purchased for Thomas Holloway, 1883

Müller, William James 1812–1845, *Tomb in the Water, Telmessos, Lycia*, purchased by Thomas Holloway, 1881

Munthe, Ludwig 1841–1896, *Snow Scene*, purchased for Thomas Holloway, 1883

Murray, David 1849–1933, *Spring in the Alps (Spring Blossoms to the Mountain Snows)*, presented to Royal Holloway, University of London, by the artist's executors

Nash, John Northcote 1893–1977, *Mountain Landscape with Distant Lake*, © artistic trustee of the estate of John Nash

Nasmyth, Patrick 1787–1831, *Landscape with Trees and Figures in the Foreground, a Church in the Distance*, purchased for Thomas Holloway, 1883

Nicol, Erskine 1825–1904, *The Missing Boat*, purchased for Thomas Holloway, 1883

Noël, Jules Achille 1815–1881, *Abbeville, with Peasants and Horses in the Foreground*, purchased for Thomas Holloway, 1883

Noël, Jules Achille 1815–1881, *The Quay, Hennebont, with Boats and Figures*, purchased for Thomas Holloway, 1883

Olivier, Herbert Arnold 1861–1952, *William James Russell (1830–1909)*, acquired on the merger with Bedford College, 1985

Orpen, William 1878–1931, *Miss Ellen Charlotte Higgins*, commissioned by Royal Holloway, University of London, 1926

Pettie, John 1839–1893, *A State Secret*, purchased for Thomas Holloway, 1882

Phillips, Patrick Edward 1907–1976, *Dr Edith Batho*, commissioned by Royal Holloway, University of London, c.1961

Pollock, Fred b.1937, *Trossachs Blossom*, anonymous gift, 2001

Poole, Paul Falconer 1807–1879, *Crossing the Stream*, purchased for Thomas Holloway, 1883

Poole, Paul Falconer 1807–1879, *The Gleaner*, purchased for Thomas Holloway, 1883

Poole, R. F. *Dr Roy Frank Miller*, commissioned by Royal Holloway, University of London, c.1985

Pyne, James Baker 1800–1870, *Haweswater from Waller Gill Force*, purchased by Thomas Holloway, 1881

Riley-Smith, Louise b.1946, *Norman Gowar*, commissioned by Royal Holloway, University of London, 1999, © the artist

Riviere, Briton 1840–1920, *Sympathy*, purchased for Thomas Holloway, 1883

Riviere, Briton 1840–1920, *An Anxious Moment*, purchased for Thomas Holloway, 1883

Riviere, Hugh Goldwin 1869–1956, *Miss Peggy Wood*

Roberts, David 1796–1864, *Pilgrims Approaching Jerusalem*, purchased, 1883

Roberts, David 1796–1864, *A Street in Cairo*, purchased for Thomas Holloway, 1883

Scott, William Wallace 1795–1883, *Jane Holloway*, commissioned by Thomas Holloway, 1845

Scott, William Wallace 1795–1883, *Thomas Holloway*, commissioned by Thomas Holloway, 1845

Scott-Moore, Elizabeth 1904–1993, *Sir John Cameron (1903–1968)*, © Royal Watercolour Society

Shannon, James Jebusa 1862–1923, *Miss Matilda Ellen Bishop*, commissioned by Royal Holloway, University of London, 1897

Shephard, Rupert 1909–1992, *Professor Lionel Butler*, commissioned by Royal Holloway, University of London, c.1982/1983

Solomon, Abraham 1824–1862, *Departure of the Diligence 'Biarritz'*, purchased for Thomas Holloway, 1883

Stanfield, Clarkson 1793–1867, *The Battle of Roveredo, 1796*, purchased by Thomas Holloway, 1881

Stanfield, Clarkson 1793–1867, *View of the Pic du Midi d'Ossau in the Pyrenees, with Brigands*, purchased by Thomas Holloway, 1881

Stanfield, Clarkson 1793–1867, *After a Storm*, purchased for Thomas Holloway, 1883

Swynnerton, Annie Louisa 1844–1933, *Geoffrey and Christopher Herringham*

Syer, John 1815–1885, *The Windmill*, purchased for Thomas Holloway, 1882

Syer, John 1815–1885, *Welsh Drovers*, purchased for Thomas Holloway, 1882

Todd, Daphne b.1947, *Dr John Nicholson Black*, acquired on the merger with Bedford College, 1985, © the artist

Tolansky, Ottilie 1912–1977, *Dame Marjorie Williamson*, commissioned by Royal Holloway, University of London, 1973

Tolansky, Ottilie 1912–1977, *Professor Samuel Tolansky (d.1973)*

Troyon, Constant 1810–1865, *Evening, Driving Cattle*, purchased for Thomas Holloway, 1883

Webb, James c.1825–1895, *Dordrecht*, purchased for Thomas Holloway, 1883

Webb, James c.1825–1895, *Cartagena, Spain*, purchased for Thomas Holloway, 1882

Weber, Theodor Alexander 1838–1907, *Dover Pilot and Fishing Boats*, purchased for Thomas Holloway, 1882

Wells, Henry Tanworth 1828–1903, *William Shaen*, acquired on the merger with Bedford College, 1985

Wilkins, Clive *Woman with a Shielded Candle*, purchased with assistance from the Esmée Fairbairn Donation, 1993

Wragg, Gary b.1946, *Medusa*, anonymous gift, 2001, © the artist

Wragg, Gary b.1946, *Blue Dragon*, anonymous gift, 2001, © the artist

Epsom & Ewell Borough Council

Birch, William Henry David 1895–1968, *Epsom and Ewell from the Grandstand*, gift from Stanley Longhurst to the Borough of Epsom & Ewell, 1954

Danckerts, Hendrick (attributed to) 1625–1680, *Nonsuch Palace from the North East*, gift to the Nonsuch Park Joint Management Committee by the Kynnersley-Browne family, 1980s

Esher Library

Dawe, George (copy of) 1781–1829, *Princess Charlotte Augusta of Wales (1796–1817)*, donated by Reverend H. Gordon French, c.1974

L. E. S. *Ember Lane, with a Woman and a Child*, donated, before 1933

H. W. *Preacher at Christchurch, Esher, Surrey*, donated, before 1974

Bourne Hall Museum

Cullerne, Rennie *Mill Lane, Ewell*, gift from the executors of Rennie Cullerne, 1998

Pettit, D. *Lower Mill*, gift from Miss Phyllis Davies, 1969–1990

Stone, Helen C. 1884–1947, *Bridge over the Hogsmill River, West Ewell*, gift from Miss Margaret Stone, 1970

Stone, Helen C. 1884–1947, *Old Cottages in West Ewell, Ewell*, gift from Miss Margaret Stone, 1970

unknown artist *Mary Williams*, gift from the management of Glyn House, 2002

unknown artist *Sir Arthur Glyn*, gift from the management of Glyn House, 2002

unknown artist *The Amato Inn*, on permanent loan from Ewell

Library

unknown artist *Gervas Powell Glyn*, gift from an unknown donor, 1969–1990

unknown artist *Gervas Powell Glyn*, gift from an unknown donor, 1969–1990

unknown artist *Margaret Glyn*, gift from an unknown donor, 1969–1990

unknown artist *Arthur Glyn*, gift from West Ewell Social Club, 1969–1990

Ewell Court Library

Langer, D. *As I Remembered, Ewell Court Grounds*, gift, 1980s

Langer, D. *As I Remembered, Hogsmill River*, gift, 1980s

Crafts Study Centre, University College for the Creative Arts

Larcher, Dorothy 1884–1952, *Black Prince and Jackanapes*

Larcher, Dorothy 1884–1952, *Bunch for a Birthday*, bequeathed by Nan Youngman, Cambridge, after 1982

Farnham Maltings Association Limited

Anderson, Will *Kiln Conversion by DIY*, donated by the artist

Bryson, Frank *Mr C. Biles*, gift from the Mr & Mrs M. O'Donnell Collection

Krish, Raymond *The Philospher*, donated

Verney, John 1913–1993, *Castle Street, Farnham*, donated, © the artist's estate

Verney, John 1913–1993, *Pictures of Farnham*, donated, © the artist's estate

Verney, John 1913–1993, *Pictures of Farnham*, donated, © the artist's estate

Museum of Farnham

Allen, William Herbert 1863–1943, *Bertha Clapshaw*, gift from Dr T. S. Allen, 1965

Allen, William Herbert 1863–1943, *Winifred Clapshaw*, gift from Dr T. S. Allen, 1965

Allen, William Herbert 1863–1943, *Stranger's Corner*, gift from Dr T. S. Allen, 1965

Allen, William Herbert 1863–1943, *James Sydney Longhurst (d.1921)*, gift from Ruth Moulton, 2005

Allen, William Herbert 1863–1943, *Phoebe Ellen Longhurst (d.1914)*, gift from Ruth Moulton, 2005

Allen, William Herbert 1863–1943, *Harvest Field with Elms*, gift from Mr & Mrs R. C. I. Mason, 1970

Allen, William Herbert 1863–1943, *Italian Lake Scene*, gift from R. C. I. Mason, 1970

Booth, Ashton b.c.1925, *Hawk*, gift from Mrs Elfreda Manning, 1986

Brockman, Dale *The Maltings*, gift from Vicky King, 1991

Elmer, Stephen c.1714–1796, *Thomas Ashburne, Aged 11 Years*, purchased from Anthony Mould Ltd, New Bond Street with grants from the MGC/Victoria & Albert Museum Purchase Grant Fund, the National Art Collections Fund, and the Friends of the Museum of Farnham, 1996

Elmer, Stephen c.1714–1796, *A Cockerel Facing Left*, bequeathed by Margaret Ida Mason, 1961

Elmer, Stephen c.1714–1796, *Brace of Pheasant*, bequeathed by Margaret Ida Mason, 1961

Elmer, Stephen c.1714–1796, *Brace of Woodcock*, bequeathed by Margaret Ida Mason, 1961

Elmer, Stephen c.1714–1796, *Cock and Hen Black Grouse in Landscape*, gift from S. A. Mason, 1961

Elmer, Stephen c.1714–1796, *Cock and Hen Red Grouse in Landscape*, gift from S. A. Mason, 1961

Elmer, Stephen c.1714–1796, *Dead Cock Pheasant*, gift from R. C. R. Mason, 1961

Elmer, Stephen c.1714–1796, *Dead Game with Pheasant*, gift from S. A. Mason, 1961

Elmer, Stephen c.1714–1796, *Dead Hare and Wild Fowl*, gift from R. C. R. Mason, 1961

Elmer, Stephen c.1714–1796, *Still Life with Pineapple and Other Fruit*, gift from Miss A. C. Mason, 1961

Elmer, Stephen c.1714–1796, *The Last Supper*, commissioned to hang above the altar in Farnham Parish Church, presumably paid for by Mr Henry Halsey who presented it to the Church in the late 18th century

Elmer, Stephen c.1714–1796, *William Elmer, Nephew of Artist*, transferred from the Council Offices, 1974

Grace, James Edward 1851–1908, *Windmill*, gift, between 1961–1979

Harris, William E. 1860–1930, *Cows Grazing in a Meadow*, gift, between 1961–1979

Hunter, Thomas Sr b.1771, *Harriet Harding (d.1880)*, gift from Geoffrey Box, 2002

Hunter, Thomas Jr b.1821, *Willmer House, Farnham*

Hutton, John Campbell 1906–1978, *Making Ammunition Boxes*, on permanent loan to Farnham Library

Hutton, John Campbell 1906–1978, *Railway Carriages*, on permanent loan to Farnham Library

Hutton, John Campbell 1906–1978, *Wartime Wood Machining*, on permanent loan to Farnham Library

Hutton, John Campbell 1906–1978, *Women Making Munitions Boxes*, on permanent loan to Farnham Library

Loutherbourg, Philip James de 1740–1812, *Sea Battle*, gift, between 1961–1979

Loutherbourg, Philip James de 1740–1812, *Seascape*, gift, between 1961–1979

McCannell, Ursula Vivian b.1923, *'We don't know'*, gift from the artist, 2006

McCannell, William Otway 1883–1969, *Colour*, gift from the McCannell family, 1970

McCannell, William Otway 1883–1969, *The Farmers*, gift from the McCannell family, 1970

Morley, Robert 1857–1941, *River at Twilight*, gift, between 1961–1979

Murphy, Clara Joan 1900–1986, *The Last Hop-Picking in the Chantries, Farnham*, on loan from the Farnham Society

Newyin, R. Graham *View Looking from Mr Borelli's Courtyard*, gift from Father Borelli, 1991

Peacock, Ralph 1868–1946, *Eileen Fox*, gift from Miss Adeley, 1978

Ransom, George 1843–1935, *Coastal Landscape with Castle*, purchased from F. W. Simmonds, 1965

Ransom, George 1843–1935, *Black Lake, Waverley*, presented to the Council by the artist on the occasion of his 90th birthday in 1933, then transferred to the Museum from the Council offices

Reeves, Sidney b.c.1925, *Old Bourne Church*, gift from the artist, c.1974

Reeves, Sidney b.c.1925, *Landscape with Oasthouses*, gift from the artist, 1960s or 1970s

Russell, H. M. active mid-20th C, *The Old Book Shop*, gift from Mrs H. M. Russell, 1961

Seaby, Allan William 1867–1953, *The Wakes from the Park*, gift

Turk, W. *Farnham Castle*, gift from Mrs B. Willis, 1996

Turk, W. *Farnham Park Castle Approach*, gift from Mrs B. Willis, 1996

unknown artist *View over Bridgewater Bay*, gift from Mrs R. G. Mills, 1965

unknown artist *Panorama of Farnham*, gift from A. H. Stevens, 1965

unknown artist 18th C, *Mr Cranston*

unknown artist 18th C, *Portrait of a Lady*, gift

unknown artist *View of Farnham*, purchased from Caelt Gallery, London, 1991

unknown artist early 19th C, *Portrait of a Member of the Duncan Family*, gift from Potter, Kempson & White, solicitors

unknown artist early 19th C, *Sir David Ochterlony (1758–1825)*, gift from Potter, Kempson & White, solicitors

unknown artist 19th C, *Blacksmith Pulling Teeth*, purchased from Jordans, 1968

unknown artist 19th C, *Landscape at Night*, gift

unknown artist 19th C, *Poet Reading to a Seated Muse*, bequeathed by Wilson

unknown artist 19th C, *Riverscape with Windmill and Fishermen*, gift from Mrs C. B. Murray

unknown artist 19th C, *Seascape with Castle and Fisherman*, gift from Mrs C. B. Murray

unknown artist 19th C, *William Cobbett (1763–1835)*, on loan from Lady Lathbury

unknown artist 19th C, *Mrs William Cobbett (1774–1848)*, on loan from Lady Lathbury

unknown artist late 19th C, *Angel*, bequeathed by Wilson

unknown artist *The Maltings*, gift from Vicky King, 1994

unknown artist *Abstract*

unknown artist early 20th C, *Tilford Green and Cobbett's Oak*, gift

unknown artist early 20th C, *Weydon Mill*, gift from Mrs V. A. Dedman

unknown artist 20th C, *Shore Scene with Lighthouse*

unknown artist *Still Life with Bread and Meat*, gift

Verney, John 1913–1993, *The Three Graces*, gift from Peter Lloyd, 1999, © the artist's estate

Wonnacott, Thomas 1835–1918, *Black Lake, Waverley*, bequeathed by Miss F. M. Tomsett, 1987

Wonnacott, Thomas 1835–1918, *Weydon Mill*, gift from Mr S. F. Mundy, 1981

Wooderson, J. *Evening at Weydon Mill*, gift

University College for the Creative Arts at the Farnham Campus

Ball, Robin 1910–1979, *The Lovers*, purchased from the Institute Fine Art Degree Show, 2001

Butler, Paul b.1947, *Bus Stop*, purchased for the University College Collection, 1997

Butler, Paul b.1947, *City Night II*

Clamp, Laura b.1980, *Lips and Blue Straw*, purchased from the Institute Fine Art Degree Show, 2002, © the artist

Edmonds, Frances b.1953, *Blue Room*, © the artist

Hockey, James 1904–1990, *A Cyclamen*, purchased from Stephen Daffen, 2001

Hossain, Zahura Sultana *Where Am I?*, purchased for the University College Collection, 2001

Muszynski, Leszek b.1923, *James Hockey, RBA (1904–1990)*, probably donated, before 1990, © the artist

Northwood, Sally b.1935, *Two Figures*, Graduate Fine Art, 1994, © the artist

unknown artist late 20th C, *Untitled*, purchased from a student

Whamond, Andrew b.1947, *Leaning Figure*, donated by Christine Kapteijn, 2005, © the artist

Godalming Library

Wondrausch, Mary b.1923, *Dead Magpie*, gift, 1963–1965, © presented by Mary Wondrausch

Godalming Museum

Collier, John 1850–1934, *Thomas Henry Huxley (1825–1895)*

Duff, Pamela b.1920, *Miss Jekyll's Boots (after William Nicholson)*, gift, 1991

Duff, Pamela b.1920, *Gertrude Jekyll (after William Nicholson)*, gift, 1999

Harwood Eve *Great Pond, Frensham*

Jekyll, Gertrude 1843–1932, *Thomas in the Character of Puss in Boots*, purchased, 1999

Jekyll, Gertrude 1843–1932, *The Sun of Venice Going to Sea (after Joseph Mallord William Turner)*, gift, 1989

Lewis, J. active early 20th C, *Godalming: A Bit of the Old Town*, purchased

Martin, Ellis 1881–1977, *Jack Phillips (1887–1912)*, donated, 2004

O'Brian, Henry active 1950s, *Low Tide at Maldon, Essex*

O'Brian, Henry active 1950s, *Berkshire Downs*

O'Brian, Henry active 1950s, *Brixham Harbour*

O'Brian, Henry active 1950s, *Country Scene*

O'Brian, Henry active 1950s, *Glengarriff, Kerry*

O'Brian, Henry active 1950s, *Hastings Beach*

O'Brian, Henry active 1950s, *Killarney from Muckross House Terrace, Co. Kerry*

O'Brian, Henry active 1950s, *Lake Geneva, Montreux*

O'Brian, Henry active 1950s, *Lakeside*

O'Brian, Henry active 1950s, *Nocturne*

O'Brian, Henry active 1950s, *River Glaslyn, Wales*

O'Brian, Henry active 1950s, *Rolling Breakers at Evening*

O'Brian, Henry active 1950s, *Sea View with a Boat*

O'Brian, Henry active 1950s, *Self Portrait*

O'Brian, Henry active 1950s, *Studland Bay, Dorset*

O'Brian, Henry active 1950s, *Sussex Harvest*

O'Brian, Henry active 1950s, *The Church on the Hill*

O'Brian, Henry active 1950s, *Welsh Coast*

Peel, James 1811–1906, *Roke Farm, Witley, Surrey*, gift, 1984

Smallman-Tew, F. active 20th C, *Church Street, Godalming*, gift

Smallman-Tew, F. active 20th C, *Church Street, Godalming*

Smallman-Tew, F. active 20th C, *Old Godalming by Moonlight*

Smallman-Tew, F. active 20th C, *The Millstream at Godalming*

Smart, W. H. active mid-20th C, *Godalming Church*, gift, 2000

unknown artist *Dr Owen Manning*, purchased, 1985

unknown artist 19th C, *Ironstone Bridge, Tilthams Green*

unknown artist 20th C, *Old Borden Bridge*, donated by Miss Mountney, 1984

Godalming Town Council

British (English) School mid-19th C, *Sir Richard Balchin, Surgeon, Mayor of Godalming*

Donne, Walter J. 1867–1930, *Alderman Thomas Rea*

Kneller, Godfrey (style of) 1646–1723, *Vice Admiral Sir John Balchin*

Schumacher, Vera active 1911–1913, *Joseph E. Sparkes, Mayor of Godalming (1890–1892)*

unknown artist 19th C, *Henry Marshall, First Mayor of Godalming, 1836*

Watson, D. *John Simmonds, Mayor (1871 & 1875)*

Waverley Borough Council

Hollams, F. Mabel 1877–1963, *Horses Ploughing a Field*

Langley, Walter 1852–1922, *Cornish Village Scene*

unknown artist *Farnham Church from the Meadows*, on loan from the Museum of Farnham

The White Hart Barn, Godstone Village Hall

Burford, Eva active 1970–1985, *Godstone Pond*, presented in memory of Miss 'Vi' Amos, 1985

Butcher, Fred *Godstone High Street with the Clayton Arms*, presented by the widow of Arthur Dumville, apprentice to the artist, 2002

Hayner, D. (attributed to) *The Bay Pond, Godstone*, presented by Ted Simpson

unknown artist *Ivy Mill Pond, Godstone*, presented by Miss A. Goad

Guildford House Gallery

Allison, Jane b.1959, *Rose Cottage, Pockford Road, Chiddingfold*, purchased from the artist, 2005, © the artist

Allison, Jane b.1959, *View from the Chantries with Hawthorn Tree*, donated by the artist, 2005, © the artist

Boughton, Thomas 1812–1893, *Guildford High Street*, purchased, 1990

Caffyn, Walter Wallor 1845–1898, *The Weald of Surrey*, purchased with the assistance of the Friends of Guildford House Gallery and the Victoria & Albert Museum Purchase Grant Fund, 1989

Carter, William 1863–1939, *Mayor Ferdinand Smallpeice*, acquired, 1955

Charlton, Mervyn b.1945, *Moon Glow*, purchased from the artist, 1983, © the artist

Cheesman, Harold 1915–1983, *Landscape*, purchased at auction, 1991, © the artist's estate

Collins, Helen 1921–1990, *North Street, Guildford*, donated, 1996, © the artist's estate

Collins, Helen 1921–1990, *George Edward Collins*, donated, 1996, © the artist's estate

Cracknell, Jennifer active 1960s–1970s, *Rockfall*, purchased with the assistance of the Friends of Guildford House Gallery, 1973

Cripps, Clara *Narrow Lane, Guildford*

Dunn, John Selwyn 1895–1978, *St Martha's*, donated by the artist's daughter, 1998

Fedden, Mary b.1915, *The Lamp*, purchased from the Royal West of England Academy, Bristol, 1988, © the artist

Harris Hughes, Susanna b.1947, *St Catherine's, February*, purchased from the artist, 1997, © the artist

Harrison, Christopher b.1935, *Below Coldharbour*, purchased, 1971, © the artist

Harwood Eve *Old Guildford House*, acquired, 1962

Herringham, Christiana Jane 1852–1929, *Madonna and Child (after Sandro Botticelli)*, bequeathed by Alderman Laurence Powell

Hoyt Desmond, Charlotte d.1971, *Pot of Marigolds*, purchased with the assistance of the Victoria & Albert Museum Purchase Grant Fund, 1980

Huston active mid-20th C, *View of Guildford Castle*, donated by a benefactor, 2001

Hyde, William 1859–1925, *Landscape towards Peaslake*, donated by the artist's daughter, 1980

Laurence, Samuel 1812–1884, *The Fletcher Children*, transferred from Guildford Museum Collection, 1985

Le Mare, Frederick b.1846, *Landscape Millmead*, donated by a benefactor to Guildford Museum, 1959. Transferred to Guildford House Gallery, 1985

Lee, Ada *Cows and Boy in Landscape*, acquired, 1985

Marsham, Cara *Millmead Lock*, purchased, 1953

May, F. T. active c.1957–1968, *River Wey in Winter*, transferred from Guildford Museum, 1985

McCannell, Ursula Vivian b.1923, *Birches and Hollies*, purchased from New Ashgate Gallery, 1988, © the artist

Morris, Mali b.1945, *In Apple Blossom Time*, presented by the Contemporary Art Society, 1986, © the artist

Morshead, Arminell 1889–1966, *Guildford Cattle Market*, donated by the artist to Guildford Museum, 1966. Transferred to Guildford House Gallery, 1985

Narraway, William Edward 1915–1979, *Alderman Lawrence Powell*, purchased from the artist's widow, 1984

Parfitt, Ida 1910–1977, *Guildford Old and New*, purchased from the Guildford Art Society Exhibition, 1962

Passey, Charles Henry active 1870–c.1894, *A Lane at Albury, Surrey*, purchased, 1990

Penycate, Dorothy 1910–1969, *Roses*, donated, 1996

Perraudin, Wilfrid b.1912, *Black Forest Landscape and Farm Buildings*, donated by the artist, 1989

Pether, Henry active 1828–1865, *Old Guildford*, purchased with the assistance of the Victoria & Albert Museum Purchase Grant Fund, 1982

Pether, Henry (circle of) active 1828–1865, *St Mary's, Guildford*, purchased with the assistance of the Victoria & Albert Museum Purchase Grant Fund, 1995

Randoll, F. *The Eccentric Billy Hicks, Shere*, donated to Guildford Museum, 1962. Transferred to Guildford House, 1985

Ranken, Marguerite 1897–1973, *The Estuary*, purchased, 1979

Russell, John 1745–1806, *Micoc and Tootac*, purchased with the assistance of the Friends of Guildford House Gallery and the Victoria & Albert Museum Purchase Grant Fund, 1997

Russell, John 1745–1806, *Portrait of a Lady with Her Child*, purchased with the assistance of the Victoria & Albert Museum Purchase Grant Fund and the Museum and Galleries Commission, 1990

Russell, William 1780–1870, *Samuel Russell, Mayor of Guildford*, acquired, 1988

Schofield, Winifred d.2000, *The Oil Mills, Thames Lock*, donated by the artist to Guildford Museum and transferred to Guildford House Gallery, 1985

Schofield, Winifred d.2000, *The Oil Mills, Weybridge, Surrey*, transferred from Guildford Museum, 1985

Schofield, Winifred d.2000, *The Lone Manor House*, donated by the artist to Guildford Museum, 1979. Transferred to Guildford House Gallery, 1985

Scholfield, Margaret active 1922–1932, *Impression: Wey Navigation Canal*, transferred from Guildford Museum, 1984

Smoothey, Ronald 1913–1996, *Winter Landscape*, purchased with the assistance of the National Art Collections Fund, 1988

Smoothey, Ronald 1913–1996, *Headlamps*, purchased, 1990

Smoothey, Ronald 1913–1996, *Mutation*, donated by the artist's widow, 2005

Smoothey, Ronald 1913–1996, *Stress Forms*, purchased, 1970

Smoothey, Ronald 1913–1996, *Volcanic Creation*, acquired, 1988

Smoothey, Ronald 1913–1996, *Shadows of a Sculpture*, purchased, 1997

Smoothey, Ronald 1913–1996, *The Hawthorn Tree*, purchased with the assistance of the National Art Collections Fund, 1988

Smoothey, Ronald 1913–1996, *Space Horizons*, purchased, 1997

Smoothey, Ronald 1913–1996, *Howard Humphreys and Partners*, purchased, 1997

Smoothey, Ronald 1913–1996, *Howard Humphreys and Partners*, purchased, 1997

Smoothey, Ronald 1913–1996, *Skyscrapers 2*, purchased, 1997

Spurrier, Lanta c.1910–c.1980, *Floods*, purchased, 1982

Stedman, Roy b.1933, *Frosty Morning, Albury Park*, purchased from the artist, 1996, © the artist

Stoneham, Olive d.1966, *Great Quarry, Warwick's Bench*, donated to Guildford Museum and transferred to Guildford House Gallery, 1985

Stuart, Margaret active 1924–1988, *The Pest House, Pilgrim's Way, Shalford*, donated by the artist, 1988

Ta'Bois, Zweena *Through the Fields to Farnham*, purchased, 1980

Tenison, W. R. C. active 1926–1929, *Domenico*, donated, 1998

Tenison, W. R. C. active 1926–1929, *Souvenir de l'orient*, donated, 1998

unknown artist *Portrait of an Unknown Mayor (1810–1820)*, transferred from Guildford Museum, 1985

unknown artist *Abbot's Hospital, High Street*, transferred from Guildford Museum, 1985

unknown artist *Guildford Castle from the River Wey*, donated, 2005

unknown artist *The Mill, Guildford*, donated, 2005

unknown artist late 19th C, *Mayor Henry Neville*, transferred from Guildford Museum, 1985

unknown artist early 20th C, *Richard Heath*, transferred from Guildford Museum, 1985

Unwin, Ida M. 1869–1953, *Charles Baker*, donated by Mr Granger to Guildford Museum, 1960. Transferred to Guildford House Gallery, 1985

Waite, Edward Wilkins 1854–1924, *The Time of Wild Roses*, purchased with the assistance of the Victoria & Albert Museum Purchase Grant Fund and the Museum, 1984

Museum and Galleries Commission, 1987

Wesson, Edward 1910–1983, *River Meadow Landscape*, purchased, 1998, © the artist's estate

Widdes, C. A. *Richard Sparkes*, transferred from Guildford Museum, 1985

Wilkie, Mary b.1915, *Farley Heath Wood*, purchased, 1970, © the artist

Guildford Museum

Carter, William 1863–1939, *Mayor Ferdinand Smallpeice*, donated by Royal Surrey County Hospital, 2004

Eddis, Eden Upton 1812–1901, *Henry Sharp Taylor*, donated by Royal Surrey County Hospital, 2004

Eddis, Eden Upton 1812–1901, *R. J. Shepherd*, donated by Royal Surrey County Hospital, 2004

Eddis, Eden Upton 1812–1901, *Lieutenant Colonel Hankin*, donated by Royal Surrey County Hospital, 2004

Eddis, Eden Upton 1812–1901, *George Chilton*, donated by Royal Surrey County Hospital, 2004

Eddis, Eden Upton 1812–1901, *Reverend Robson*, donated by Royal Surrey County Hospital, 2004

Lintott, (Miss) *View of Park Street*, donated by Miss L. Boswell, St Catherine's, 1986

May, F. T. *View of South Hill*, donated by the artist, Hindhead, 1968

May, F. T. *View of Park Street*, donated by the artist, Hindhead, 1968

May, F. T. *View of 'The Old White Lion'*, donated by the artist, Hindhead, 1968

unknown artist *View of Guildford Town Bridge*, purchased from R. S. Hunt, Godalming, 1956

Van Jones active 1917–1941, *Artwork for Friary Ales Poster*, purchased from Nicholas Bagshawe, Nursling, 2001

Queen's Royal Surrey Regimental Museum

Bennett, John active 20th C, *Salerno 43*, gift from the artist

Daniell, William 1769–1837, *Burning of 'The Kent', 1st March 1825*, gift from the Sergeants' Mess

Davidson, Thomas *The Queen's (Second) Royal Regiment of Foot, c.1830*, gift

Deayton-Groom, (Major) active 20th C, *The East Surrey Regiment Passing through Cassino, 18th May 1944*, gift from the artist

Grant, Henry active 1950–1980, *Sergeant Major Lynch (d.1917)*, gift from the artist, 1952

Rocke, R. Hill (Major) *The Queen's (Second) Royal Regiment of Foot in South Africa*, gift

241

Surrey Archaeological Society

Christie, Ernest C. 1863–1937, *Interior View of Unidentified Cottage in East Surrey*, gift from the Christie family, 1974–1978
Christie, Ernest C. 1863–1937, *Interior of Room in a Cottage at Chaldon, with Fireplace*, gift from the Christie family, 1974–1978
Christie, Ernest C. 1863–1937, *Wall with Arched Gateway Opening on to a Field with Trees, Identified as the Entrance to Oxted Church*, gift from the Christie family, 1974–1978
Christie, Ernest C. 1863–1937, *Staircase in Cottage at Limpsfield*, gift from the Christie family, 1974–1978
Christie, Ernest C. 1863–1937, *Barn at Godstone*, gift from the Christie family, 1974–1978
Christie, Ernest C. 1863–1937, *Exterior of Cottage near Oxted*, gift from the Christie family, 1974–1978
Christie, Ernest C. 1863–1937, *Doorway between Two Rooms in Cottage at Godstone*, gift from the Christie family, 1974–1978
Christie, Ernest C. 1863–1937, *Interior View of a Cart Shed in East Surrey*, gift from the Christie family, 1974–1978
Christie, Ernest C. 1863–1937, *Room in Cottage at Godstone*, gift from the Christie family, 1974–1978
Christie, Ernest C. 1863–1937, *High Street, Bletchingley*, gift from the Christie family, 1974–1978
Christie, Ernest C. 1863–1937, *Kitchen Range at the Hare and Hounds, Godstone*, gift from the Christie family, 1974–1978
Christie, Ernest C. 1863–1937, *Staircase in Cottage at Godstone*, gift from the Christie family, 1974–1978
Christie, Ernest C. 1863–1937, *Exterior View of Unidentified Barn at Bletchingley or Godstone*, gift from the Christie family, 1974–1978
Christie, Ernest C. 1863–1937, *1 and 2 Needles Bank, Godstone*, gift from the Christie family, 1974–1978
Christie, Ernest C. 1863–1937, *Exterior View of Unidentified Cottage in East Surrey*, gift from the Christie family, 1974–1978
Christie, Ernest C. 1863–1937, *Exterior View of Unidentified Cottage near Bletchingley*, gift from the Christie family, 1974–1978
Christie, Ernest C. 1863–1937, *Fireplace and Post in Centre of Room in Cottage at Godstone*, gift from the Christie family, 1974–1978
Christie, Ernest C. 1863–1937, *Rear of Cottage at Godstone (probably Forge Cottage)*, gift from the Christie family, 1974–1978
Christie, Ernest C. 1863–1937, *Staircase in Cottage at Godstone*,

gift from the Christie family, 1974–1978
Christie, Ernest C. 1863–1937, *Streeters, Terrace and Huddle Cottages, High Street, Oxted*, gift from the Christie family, 1974–1978
Christie, Ernest C. 1863–1937, *Bonet's Farm, Capel*, gift from the Christie family, 1974–1978
Christie, Ernest C. 1863–1937, *Exterior View of Cottage at Oakwood*, gift from the Christie family, 1974–1978
Christie, Ernest C. 1863–1937, *Exterior View of Cottage at Ockley*, gift from the Christie family, 1974–1978
Christie, Ernest C. 1863–1937, *Exterior View of Cottage at Outwood*, gift from the Christie family, 1974–1978
Christie, Ernest C. 1863–1937, *Exterior View of Cottage at Outwood*, gift from the Christie family, 1974–1978
Christie, Ernest C. 1863–1937, *Exterior View of Cottages at Ockley*, gift from the Christie family, 1974–1978
Christie, Ernest C. 1863–1937, *Exterior View of Unidentified Cottage in East Surrey, with Prominent Chimney and Porch*, gift from the Christie family, 1974–1978
Christie, Ernest C. 1863–1937, *Exterior View of Unidentified House in East Surrey*, gift from the Christie family, 1974–1978
Christie, Ernest C. 1863–1937, *Exterior View of West End of Unidentified Church in East Surrey*, gift from the Christie family, 1974–1978
Christie, Ernest C. 1863–1937, *Part of 'The Barracks', Oakwood Hill, Ockley, near Dorking*, gift from the Christie family, 1974–1978
Christie, Ernest C. 1863–1937, *Shiremark Windmill, Capel*, gift from the Christie family, 1974–1978
Christie, Ernest C. 1863–1937, *Shiremark Windmill, with Mill Cottage on Bonet's Farm, Capel*, gift from the Christie family, 1974–1978
Christie, Ernest C. 1863–1937, *Brewer Street Farm, Bletchingley*, gift from the Christie family, 1974–1978
Christie, Ernest C. 1863–1937, *Ockley Windmill*, gift from the Christie family, 1974–1978
Christie, Ernest C. 1863–1937, *Pollingfold, Abinger (front view)*, gift from the Christie family, 1974–1978
Christie, Ernest C. 1863–1937, *View of North Downs in East Surrey*, gift from the Christie family, 1974–1978
Christie, Ernest C. 1863–1937, *Walton Heath Windmill*, gift from the Christie family, 1974–1978
Christie, Ernest C. 1863–1937, *Ockley Windmill*, gift from the

Christie family, 1974–1978
Christie, Ernest C. 1863–1937, *School House, Ockley*, gift from the Christie family, 1974–1978
Christie, Ernest C. 1863–1937, *Interior of Cottage, Ockley*, gift from the Christie family, 1974–1978
Christie, Ernest C. 1863–1937, *St John the Baptist Church, Okewood, near Ockley*, gift from the Christie family, 1974–1978
Christie, Ernest C. 1863–1937, *Exterior of Cottage at Forest Green*, gift from the Christie family, 1974–1978
Christie, Ernest C. 1863–1937, *Exterior of House at Dorking*, gift from the Christie family, 1974–1978
Christie, Ernest C. 1863–1937, *Pinkhurst, Oakwood Hill*, gift from the Christie family, 1974–1978
Christie, Ernest C. 1863–1937, *Distant View of Leith Hill, with Tower*, gift from the Christie family, 1974–1978
Christie, Ernest C. 1863–1937, *Farm Buildings at Dorking*, gift from the Christie family, 1974–1978
Christie, Ernest C. 1863–1937, *Gosterwood Manor, Forest Green*, gift from the Christie family, 1974–1978
Christie, Ernest C. 1863–1937, *Pollingfold, Abinger (rear view)*, gift from the Christie family, 1974–1978
Christie, Ernest C. 1863–1937, *Tudor Barn at Standen Farm, Ockley*, gift from the Christie family, 1974–1978
Christie, Ernest C. 1863–1937, *Gosterwood Manor Farm, Forest Green*, gift from the Christie family, 1974–1978
Christie, Ernest C. 1863–1937, *Pollingfold, Abinger (view towards a landing)*, gift from the Christie family, 1974–1978
Christie, Ernest C. 1863–1937, *Volvens Farm, Forest Green*, gift from the Christie family, 1974–1978
Christie, Ernest C. 1863–1937, *Pollingfold, Abinger (view of a landing)*, gift from the Christie family, 1974–1978
Christie, Ernest C. 1863–1937, *Exterior Chimney of Cottage at Mayes Green*, gift from the Christie family, 1974–1978
Christie, Ernest C. 1863–1937, *Exterior Chimney of Cottage at Mayes Green*, gift from the Christie family, 1974–1978
Christie, Ernest C. 1863–1937, *Exterior Chimney of Cottage at Mayes Green*, gift from the Christie family, 1974–1978
Christie, Ernest C. 1863–1937, *Fireplace in Cottage at Mayes Green*, gift from the Christie family, 1974–1978
Christie, Ernest C. 1863–1937, *Interior of Olde Bell Inn, Oxted*, gift from the Christie family,

1974–1978
Christie, Ernest C. 1863–1937, *Exterior View of Cottage at Mayes Green*, gift from the Christie family, 1974–1978
Kneller, Godfrey (after) 1646–1723, *John Evelyn, 1687*, presented to the Surrey Archaeological Society by Mr C. J. A. Evelyn, a Vice President of the Society, 1948
unknown artist *Study of a Castle on a Hill*, gift from Ann Christie, 1974–1978

The Guildford Institute of the University of Surrey

Harris, W. J. *George William Downes (1831–1915)*, presented by the artist, 1916
Russian School *Three-Quarter Length Portrait of a Female Saint*, possibly presented by a soldier of the 2nd Royal Surrey Regiment of Militia stationed in the Crimea, 1854–1856
unknown artist *James Macnab by the River Wey, with a View of Guildford Castle*, presented by Mrs Hill, 1866
Willis-Pryce, George 1866–1949, *High Street, Guildford, Looking West, with a View of Holy Trinity Church*

The Guildhall

Halliday, Edward Irvine 1902–1984, *Elizabeth II (b.1926)*, © the artist's estate
Highmore, Joseph (circle of) 1692–1780, *Portrait of a Gentleman, Wearing a Brown Coat, White Glove and an Academic Gown, Holding a Letter*
Lely, Peter (circle of) 1618–1680, *Charles II (1630–1685)*
Lely, Peter (circle of) 1618–1680, *James II (1633–1701)*
Lewis *Queen's Regiment Parade before the Mayor of Guildford*
Richardson, Jonathan the elder (circle of) 1665–1745, *The Right Honourable Arthur Onslow (1691–1768)*
Riley, John (studio of) 1646–1691, *Mary II (1662–1694)*
Riley, John (studio of) 1646–1691, *William III (1650–1702)*
Russell, John 1745–1806, *Sir Richard Onslow, Bt (1741–1817)*
Somer, Paulus van I (circle of) 1576–1621, *James I (1566–1625)*

University of Surrey

Allen, Michael b.1976, *Barriers*, winner of the Vice-Chancellor's Prize for Student Art at Wimbledon School of Art, 1999, © the artist
Allison, Jane b.1959, *Lord Nugent*, commissioned by Bill Simpson, former University of Surrey Librarian, to record the former

High Officers of the University, 1989, © the artist
Allison, Jane b.1959, *Lord Robens of Woldingham*, commissioned by Bill Simpson, former University of Surrey Librarian, to record the former High Officers of the University, 1989, © the artist
Allison, Jane b.1959, *Sir George Edwards*, commissioned by Bill Simpson, former University of Surrey Librarian, to record the former High Officers of the University, 1989, © the artist
Allison, Jane b.1959, *Sir William Mullens*, commissioned by Bill Simpson, former University of Surrey Librarian, to record the former High Officers of the University, 1989, © the artist
Allison, Jane b.1959, *Daphne Jackson (1936–1991)*, commissioned by the University, 2001, © the artist
Anderson, Freda b.1942, *Emma Jerman*, donated by Emma Jerman's family with funding for a suite of laboratories named after their daughter, who died, 2005, © the artist
Bachba, Emma & Powell, Alex *The Storm, October 1987*, commissioned from students at Roehampton Institute Art Department (now Roehampton University) for vegetarian restaurant by Allan Collinson, Head of Catering, after storm of 1987
Bachba, Emma & Powell, Alex *The Storm, October 1987*, commissioned from students at Roehampton Institute Art Department (now Roehampton University) for vegetarian restaurant by Allan Collinson, Head of Catering, after storm of 1987
Bachba, Emma & Powell, Alex *The Storm, October 1987*, commissioned from students at Roehampton Institute Art Department (now Roehampton University) for vegetarian restaurant by Allan Collinson, Head of Catering, after storm of 1987
Bachba, Emma & Powell, Alex *The Storm, October 1987*, commissioned from students at Roehampton Institute Art Department (now Roehampton University) for vegetarian restaurant by Allan Collinson, Head of Catering, after storm of 1987
Bachba, Emma & Powell, Alex *The Storm, October 1987*, commissioned from students at Roehampton Institute Art Department (now Roehampton University) for vegetarian restaurant by Allan Collinson, Head of Catering, after storm of 1987
Bachba, Emma & Powell, Alex *The Storm, October 1987*, commissioned from students

at Roehampton Institute Art Department (now Roehampton University) for vegetarian restaurant by Allan Collinson, Head of Catering, after storm of 1987

Bachba, Emma & Powell, Alex *The Storm, October 1987*, commissioned from students at Roehampton Institute Art Department (now Roehampton University) for vegetarian restaurant by Allan Collinson, Head of Catering, after storm of 1987

Bachba, Emma & Powell, Alex *The Storm, October 1987*, commissioned from students at Roehampton Institute Art Department (now Roehampton University) for vegetarian restaurant by Allan Collinson, Head of Catering, after storm of 1987

Bachba, Emma & Powell, Alex *The Storm, October 1987*, commissioned from students at Roehampton Institute Art Department (now Roehampton University) for vegetarian restaurant by Allan Collinson, Head of Catering, after storm of 1987

Bachba, Emma & Powell, Alex *The Storm, October 1987*, commissioned from students at Roehampton Institute Art Department (now Roehampton University) for vegetarian restaurant by Allan Collinson, Head of Catering, after storm of 1987

Bachba, Emma & Powell, Alex *The Storm, October 1987*, commissioned from students at Roehampton Institute Art Department (now Roehampton University) for vegetarian restaurant by Allan Collinson, Head of Catering, after storm of 1987

Bachba, Emma & Powell, Alex *The Storm, October 1987*, commissioned from students at Roehampton Institute Art Department (now Roehampton University) for vegetarian restaurant by Allan Collinson, Head of Catering, after storm of 1987

Bachba, Emma & Powell, Alex *The Storm, October 1987*, commissioned from students at Roehampton Institute Art Department (now Roehampton University) for vegetarian restaurant by Allan Collinson, Head of Catering, after storm of 1987

Bachba, Emma & Powell, Alex *The Storm, October 1987*, commissioned from students at Roehampton Institute Art Department (now Roehampton University) for vegetarian restaurant by Allan Collinson, Head of Catering, after storm of 1987

Barratt, Krome 1924–1990, *Cadmium and Compliments*, acquired, before 1983

Barter, Paul b.1945, *130204*, purchased from the artist after an exhibition, 2005, © the artist

Cuthbert, Alan 1931–1995, *Abstract: Yellow Series 3/13*, presented to the University by Mr & Mrs Peter Carreras, 1986

Daghani, Arnold 1909–1985, *Abstract: Portrait*, donated by Professor Carola Grindea, the artist's sister-in-law, 1989, © Arnold Daghani Trust

Daghani, Arnold 1909–1985, *Abstract*, donated by Professor Carola Grindea, the artist's sister-in-law, 1989, © Arnold Daghani Trust

Daghani, Arnold 1909–1985, *Portrait in Profile*, donated by Professor Carola Grindea, the artist's sister-in-law, 1989, © Arnold Daghani Trust

Daghani, Arnold 1909–1985, *Musical Abstract No.2*, donated by Professor Carola Grindea, the artist's sister-in-law, 1989, © Arnold Daghani Trust

Daghani, Arnold 1909–1985, *Décaméron: Studies of a Female in Metamorphosis*, donated by Professor Carola Grindea, the artist's sister-in-law, 1989, © Arnold Daghani Trust

Daghani, Arnold 1909–1985, *Abstract: House*, donated by Professor Carola Grindea, the artist's sister-in-law, 1989, © Arnold Daghani Trust

Daghani, Arnold 1909–1985, *Abstract*, presented to the University by Mr & Mrs Peter Carreras, 1986, © Arnold Daghani Trust

Dellar, Roger b.1949, *One Piano, Four Hands (Guildford International Music Festival)*, purchased at Guildford Arts annual exhibition, 2005, © the artist

Devitt, Margaret b.1944, *Mirabib, Namibia*, purchased from the artist, 2005

Devitt, Margaret b.1944, *Red Desert*, purchased from the artist, 2005

Di Duca, Adrian b.1966, *Big Red*, winner of the Vice-Chancellor's Prize for Student Art at Wimbledon School of Art, 1997, acquired 1999, © the artist

Edwards, George 1908–2003, *Boy Fishing*, purchased by the University from the artist's exhibition, 2004, © the artist's estate

Edwards, George 1908–2003, *Balloons over Longdown*, purchased by the University Library from the artist's exhibition, 2004, © the artist's estate

Edwards, George 1908–2003, *Newlands Corner*, purchased by the University from the artist's exhibition, 2004, © the artist's estate

Edwards, George 1908–2003, *St Martha's Hill*, purchased by the University Library from the artist's exhibition, 2004, © the artist's estate

Edwards, George 1908–2003, *Tyting Farm*, purchased by the University Library from the artist's exhibition, 2004, © the artist's estate

Enright, Madeleine *Mont Pilat*, donated by the artist after an exhibition, 1993

Farthing, Stephen b.1950, *The Eye of Information*, commissioned by the University, 2000, © the artist

Fitzgerald, Paul b.1922, *HRH the Duke of Kent*, commissioned by the University, 1999, © the artist

Fitzgerald, Paul b.1922, *HRH the Duke of Kent*, commissioned by the University, 1999, © the artist

Ganley, Brogan b.1971, *Cuenca Recollection*, purchased from the Guildford Arts Exhibition when the artist was a student at Wimbledon School of Art

Gildea, Paul b.1956, *White Cups and Shell*, purchased from the artist after an exhibition, 1995, © the artist

Gotlib, Henryk 1890–1966, *Sketch for 'Knossos'*, purchased for the University, 1980s, © the artist's estate

Grant, Keith b.1930, *Launch of the Ariane Rocket Carrying UOSAT*, donated to the University by the artist after an exhibition in the Library Gallery, 1984, © the artist

Grant, Keith b.1930, *Design for a Mural on the Leggett Building of UOSAT in the Night Sky*, donated by the artist, 1985, © the artist

Grant, Keith b.1930, *Design for a Mural on the Leggett Building of UOSAT in the Night Sky*, donated by the artist, 1985, © the artist

Grant, Keith b.1930, *Design for a Mural on the Leggett Building of UOSAT in the Night Sky*, donated by the artist, 1985, © the artist

Hardy, Anne *Blue Abstract*, purchased from an exhibition at the Lewis Elton Gallery, 2003, © the artist

Hepple, Norman 1908–1994, *Dr Peter Leggett*, commissioned by the University, 1974, © the artist's estate/ www.bridgeman.co.uk

Hornsby-Smith, Stephen b.1969, *Man outside a Nightclub in San Francisco*, acquired by the Sociology Department after an exhibition, 2000

Hornsby-Smith, Stephen b.1969, *Seascape II*, acquired by the Sociology Department after an exhibition, 2000

Jackowski, Andrzej b.1947, *The Way (Falmouth): Lovers II*, acquired when the artist was in residence at the university, 1976, © the artist

Jackowski, Andrzej b.1947, *Dinner Party for Four*, acquired when the artist was in residence at the University, 1976, © the artist

Jackowski, Andrzej b.1947, *Room at Midday*, acquired when the artist was in residence at the University, 1976, © the artist

Jackowski, Andrzej b.1947, *Room with Blinds*, acquired when the artist was in residence at the University, 1976, © the artist

Jackowski, Andrzej b.1947, *Room with Surprised Guest*, acquired when the artist was in residence at the University, 1976, © the artist

Jackowski, Andrzej b.1947, *Reclining Nude*, acquired when the artist was in residence at the University, 1976, © the artist

Jackowski, Andrzej b.1947, *Room with a View of the Road*, acquired when the artist was in residence at the University, 1976, © the artist

Jackowski, Andrzej b.1947, *The Room (A Lady Seated at a Table)*, acquired when the artist was in residence at the University, 1976, © the artist

Jordan, Valerie *I Wish Bonnard Could Come to Tea*, purchased from an exhibition at the Lewis Elton Gallery, 2002, © the artist

Jordan, Valerie *Kurdistan Garden*, purchased from the Vice-Chancellor's Discretionary Fund and Arts Budget, 2002, © the artist

Kannreuther, Caroline b.1964, *Movement in Four Colours: Large Pink (panel 1 of 4)*, winner of the Vice-Chancellor's Prize for Student Art at Wimbledon School of Art, 2005

Kannreuther, Caroline b.1964, *Movement in Four Colours: Red (panel 2 of 4)*, winner of the Vice-Chancellor's Prize for Student Art at Wimbledon School of Art, 2005

Kannreuther, Caroline b.1964, *Movement in Four Colours: Green (panel 3 of 4)*, winner of the Vice-Chancellor's Prize for Student Art at Wimbledon School of Art, 2005

Kannreuther, Caroline b.1964, *Movement in Four Colours: Yellow (panel 4 of 4)*, winner of the Vice-Chancellor's Prize for Student Art at Wimbledon School of Art, 2005

Kilpatrick, Alan b.1963, *Beijing Opera*, purchased from an exhibition in the Library Gallery, 1992

Lang, Kathryn b.1979, *Motion Pictures (panel 1 of 3)*, winner of the Vice-Chancellor's Prize for Student Art at Wimbledon School of Art, 2001

Lang, Kathryn b.1979, *Motion Pictures (panel 2 of 3)*, winner of the Vice-Chancellor's Prize for Student Art at Wimbledon School of Art, 2001

Lang, Kathryn b.1979, *Motion Pictures (panel 3 of 3)*, winner of the Vice-Chancellor's Prize for Student Art at Wimbledon School of Art, 2001

Lawrence, William b.1957, *The Painting Studio*, donated by the artist, 2006, © the artist

McClure, David 1926–1998, *Between Two Easels*, acquired, before 1983

McLynn, Rebecca b.1966, *Perspectives on the Wey (triptych)*, commissioned as part of a joint University and Guildford Borough Council millennium project of photos, paintings and poems in an exhibition, 2001

Mendoza, June active 1960–2006, *Professor Anthony Kelly*, commissioned by the University, 1994, © the artist

Mendoza, June active 1960–2006, *Professor Patrick Dowling*, commissioned by the University, 2005, © the artist

Mohanty, Michael *Abstract*, acquired through Wimbledon School of Art, 2000

Mohanty, Michael *Abstract*, acquired through Wimbledon School of Art, 2000

Muszynski, Leszek b.1923, *Sunrise (triptych)*, purchased by the University, 1996, © the artist

Muszynski, Leszek b.1923, *Heat of the Day (triptych)*, purchased by the University, 1996, © the artist

Muszynski, Leszek b.1923, *Twilight (triptych)*, purchased by the University, 1996, © the artist

Muszynski, Leszek b.1923, *Lemons*, purchased by the University, 2002, © the artist

Newbolt, Thomas b.1951, *Battersea Power Station*, acquired from the artist, 1984, © the artist

Oki, Yuji b.1949, *Dancing Tree*, donated by the artist after an exhibition at the Lewis Elton Gallery, 1998, © the artist/ www.bridgeman.co.uk

Paxson, Pat b.1938, *The Broken Dream (triptych)*, purchased from the artist, 2000, © the artist

Paxson, Pat b.1938, *The Broken Dream (triptych)*, purchased from the artist, 2000, © the artist

Paxson, Pat b.1938, *The Broken Dream (triptych)*, purchased from the artist, 2000, © the artist

Penn, William Charles 1877–1968, *Major F. H. Johnson, VC*, duplicate of a painting presented to the sitter by Battersea Polytechnic, in recognition of Major Johnson's outstanding contribution to the Polytechnic during his studies, 1916

Penn, William Charles 1877–1968,

243

Sidney G. Rawson, DC, Principal of Battersea Polytechnic (1907–1915), acquired from Battersea College of Technology

Prokofiev, Oleg 1928–1998, *Belle-Ile*, donated by the artist when he was the artist in residence at the University, 1970s

Prokofiev, Oleg 1928–1998, *Bodies*, donated by the artist when he was the artist in residence at the University, 1970s

Prokofiev, Oleg 1928–1998, *The Tree of Life*, donated by the artist when he was the artist in residence at the University, 1970s

Prokofiev, Oleg 1928–1998, *Allegory of Calumny*, donated by the artist when he was the artist in residence at the University, 1970s

Ramos, Theodore b.1928, *Lord Robens*, purchased from the artist, © the artist

Reason, Cyril b.1931, *Salome*, acquired, before 1983

Sajó, Gyula 1918–1979, *Yellow Flowers*, donated to the University, © the artist's daughter

Satchel, Hannah b.1980, *South Africa (pair)*, purchased from the artist when she was a student at Wimbledon School of Art, 2003

Satchel, Hannah b.1980, *South Africa III (pair)*, purchased from the artist when she was a student at Wimbledon School of Art, 2003

Spooner, Wendy *A New Moon and a Vortex (The Wave)*, donated by the artist before moving abroad, 1980s

Spooner, Wendy *Abstract Design: The Blue Tree*, donated by the artist before moving abroad, 1980s

Spooner, Wendy *Abstract: Street Light*, donated by the artist before moving abroad, 1980s

Spooner, Wendy *Christ in Gethsemane*, donated by the artist before moving abroad, 1980s

Spooner, Wendy *Flower Rocks*, donated by the artist before moving abroad, 1980s

Spooner, Wendy *Summer Wind*, donated by the artist before moving abroad, 1980s

Spooner, Wendy *The Annunciation*, donated by the artist before moving abroad, 1980s

Spooner, Wendy *The Garden*, donated by the artist before moving abroad, 1980s

Spooner, Wendy *The Hand*, donated by the artist before moving abroad, 1980s

Spooner, Wendy *Winter Wind*, donated by the artist before moving abroad, 1980s

Spooner, Wendy *Wooden Collage*, donated by the artist before moving abroad, 1980s

Stockbridge, Gill b.1938, *Populoso*, purchased by the University from Guildford Arts Exhibition when the artist was a student at Wimbledon School of Art, 2004, © the artist

Stokoe, Jack b.1980, *Two Figures*, winner of the Vice-Chancellor's

Prize for Student Art at Wimbledon School of Art, 2003

Swann, Marilyn b.1932, *Galloping Horse*, acquired, before 1983

Swift, Richard b.1918, *Manor House Hall of Residence*, acquired, before 1983

Taylor, Frank b.1946, *Methoni, Greece*, purchased from the artist, 2000, © the artist

Taylor, Frank b.1946, *Punch*, purchased from the artist, 2000, © the artist

Tipton, Heather b.1941, *Colin Tipton*, purchased by the Sociology Department when the artist's husband Colin worked there

Tipton, Heather b.1941, *Still Life: Plant*, purchased by the Sociology Department when the artist's husband Colin worked there

unknown artist late 20th C, *View of a Bridge in Richmond*, acquired, before 1983

unknown artist late 20th C, *View of a Bridge in Richmond*, acquired, before 1983

unknown artist *Jardinière of Flowers*, purchased for the University, 1994

Verrall, Nicholas b.1945, *Cerisiers dans le jardin*, acquired from an exhibition, 2006, © the artist

Wei, Feng *The Transfiguration of Landscape*, donated by the artist after his exhibition, 1989

Whishaw, Anthony b.1930, *Green Landscape*, on long-term loan from the estate of Henry Roland, © the artist

Windsor, Alan b.1931, *Stars, Fields and Trees*, purchased from an exhibition at the Lewis Elton Gallery, 2004

Windsor, Alan b.1931, *Gem II*, purchased from an exhibition at the Lewis Elton Gallery, 2004

Wolf, Tim *Abstract*, donated, 2006

Wright, Peter *East Coast*, acquired, before 1983

Wright, Steve b.1975, *Bonsai 1 (panel 1 of 2)*, acquired, 1998, © the artist

Wright, Steve b.1975, *Bonsai 2 (panel 2 of 2)*, acquired, 1998, © the artist

Watts Gallery

Alston, Rowland Wright 1895–1958, *Lough Conn, Ireland*

Alston, Rowland Wright 1895–1958, *Dead Bird (Sheldrake)*, acquired from the Rowland Alston Estate, 1958

Bauerle, Karl Wilhelm Friedrich 1831–1912, *Graham Robertson as a Boy*, bequeathed by the Graham Robertson Estate, 1951

Blunt, Wilfrid 1901–1987, *Michael Severne*, acquired from the estate of Wilfrid Blunt

Burne-Jones, Edward 1833–1898, *Laus Veneris*, bequeathed by Cecil French, 1954

Couzens, Charles active 1838–1875, *G. F. Watts*, gift from

Mrs Michael Chapman (née Lilian Macintosh), 1946

Graves, Henry Richard (attributed to) 1818–1882, *Mrs Graham Robertson, in Her Youth*, bequeathed by the Graham Robertson Estate, 1951

Hughes, Arthur 1832–1915, *Memories*

Leighton, Frederic, 1st Baron Leighton of Stretton 1830–1896, *Female Head*, bequeathed by Cecil French, 1954

Melville, Arthur 1855–1904, *Mrs Graham Robertson*, bequeathed by the Graham Robertson Estate, 1951

Prinsep, Valentine Cameron 1838–1904, *Nancy Hitchens*, acquired from the Hitchens Estate

Robertson, Walford Graham 1866–1948, *Binkie*, purchased by the Watts Gallery Trustees from Messrs Agnews, 1951

Robertson, Walford Graham 1866–1948, *Olga Brandon*, purchased by the Watts Gallery Trustees from Messrs Agnews, 1951

Robertson, Walford Graham 1866–1948, *The Amber Necklace*

Sargent, John Singer 1856–1925, *Mrs Graham Robertson*, purchased by the Watts Gallery Trustees from Messrs Agnews, 1951

Shannon, Charles Haslewood 1863–1937, *The Garland*, bequeathed by Cecil French, 1954

Shannon, Charles Haslewood 1863–1937, *The Bathers*, bequeathed by Cecil French, 1954

Shannon, Charles Haslewood 1863–1937, *The Toilet*, bequeathed by Cecil French, 1954

Shannon, Charles Haslewood 1863–1937, *An Idyll*, bequeathed by Cecil French, 1954

Shannon, Charles Haslewood 1863–1937, *The Pursuit*, bequeathed by Cecil French, 1954

Stott, William 1857–1900, *Washing Day*, bequeathed by Cecil French, 1954

unknown artist *Group Portrait*

Watts, George Frederick 1817–1904, *Early Copy from an Unidentified Baroque Portrait*, gift from Mrs Michael Chapman (née Lilian Macintosh), 1946

Watts, George Frederick 1817–1904, *Self Portrait, Aged 17*, gift from Mrs Michael Chapman (née Lilian Macintosh), 1946

Watts, George Frederick 1817–1904, *The Artist's Father*, purchased from Mrs Michael Chapman (née Lilian Macintosh), 1958

Watts, George Frederick 1817–1904, *The Artist's Father, Half-Length*, gift from Mrs Michael Chapman (née Lilian Macintosh), 1946

Watts, George Frederick 1817–1904, *The Falconer*, gift from Mrs Michael Chapman (née Lilian Macintosh), 1946

Watts, George Frederick 1817–1904, *Undine*, gift from Mary Seton Watts, 1913

Watts, George Frederick 1817–1904, *A Kneeling Figure (A Man of Sorrows)*

Watts, George Frederick 1817–1904, *Little Miss Hopkins*

Watts, George Frederick 1817–1904, *Portrait of a Boy's Head (Cornellius)*, possibly part of the original G. F. Watts Memorial Collection. Bequeathed, 1905

Watts, George Frederick 1817–1904, *The Wounded Heron*, part of the original G. F. Watts Memorial Collection. Bequeathed, 1905

Watts, George Frederick 1817–1904, *Reverend A. Wellsted*, purchased, 1961

Watts, George Frederick 1817–1904, *Gerald Hamilton as an Infant*, possibly part of the original G. F. Watts Memorial Collection. Bequeathed, 1905

Watts, George Frederick 1817–1904, *Blondel*

Watts, George Frederick 1817–1904, *Alexander Constantine Ionides and His Wife Euterpe, with Their Children Constantine, Alexander, Aglaia and Alecco*, purchased from Sotheby's with the assistance of the Heritage Lottery Fund and the National Art Collections Fund, 2005

Watts, George Frederick 1817–1904, *Lady Holland on Daybed*, purchased, 1942

Watts, George Frederick 1817–1904, *Lady Augusta Holland*, gift from Lord Ilchester, 1940

Watts, George Frederick 1817–1904, *Drowning of the Doctor*, gift from Mrs Michael Chapman (née Lilian Macintosh), 1946

Watts, George Frederick 1817–1904, *Fiesole, Tuscany*, gift from Mrs Michael Chapman (née Lilian Macintosh), 1946

Watts, George Frederick 1817–1904, *Villa Petraia*, purchased from Sotheby's with the assistance of the National Art Collections Fund, 2004

Watts, George Frederick 1817–1904, *Echo*, on long-term loan from Tate, London

Watts, George Frederick 1817–1904, *Miss Marietta Lockhart*

Watts, George Frederick 1817–1904, *Orderic and the Witch*, gift from Mrs Michael Chapman (née Lilian Macintosh), 1946

Watts, George Frederick 1817–1904, *Orderic and the Witch (large version in colour)*, part of the original G. F. Watts Memorial Collection. Bequeathed, 1905

Watts, George Frederick 1817–1904, *Diana's Nymphs*, part of the original G. F. Watts Memorial Collection. Bequeathed, 1905

Watts, George Frederick 1817–1904, *Guelphs and Ghibellines*, gift from Mrs Michael Chapman (née Lilian Macintosh), 1946

Watts, George Frederick 1817–1904, *Satan*, part of the original G. F. Watts Memorial Collection. Bequeathed, 1905

Watts, George Frederick 1817–1904, *Found Drowned*, part of the original G. F. Watts Memorial Collection. Bequeathed, 1905

Watts, George Frederick 1817–1904, *Aristides and the Shepherd*, part of the original G. F. Watts Memorial Collection. Bequeathed, 1905

Watts, George Frederick 1817–1904, *The Titans*, gift from Mary Seton Watts, 1931

Watts, George Frederick 1817–1904, *Olympus*, purchased from Mrs Michael Chapman (née Lilian Macintosh), 1958

Watts, George Frederick 1817–1904, *Under the Dry Arch*, part of the original G. F. Watts Memorial Collection. Bequeathed, 1905

Watts, George Frederick 1817–1904, *The Good Samaritan*, part of the original G. F. Watts Memorial Collection. Bequeathed, 1905

Watts, George Frederick 1817–1904, *Irish Famine*, part of the original G. F. Watts Memorial Collection. Bequeathed, 1905

Watts, George Frederick 1817–1904, *Song of the Shirt*, part of the original G. F. Watts Memorial Collection. Bequeathed, 1905

Watts, George Frederick 1817–1904, *Mrs Morris*, acquired via the Morris Bequest, 1943

Watts, George Frederick 1817–1904, *Lady Dalrymple*, bequeathed by Sir Weldon Dalrymple-Champneys, 1981

Watts, George Frederick 1817–1904, *St George*, gift from Mrs Michael Chapman (née Lilian Macintosh), 1946

Watts, George Frederick 1817–1904, *Study for Carlton House Terrace Frescoes*

Watts, George Frederick 1817–1904, *James Barr Mitchell*, bequeathed by Miss Marjory Isobel Mitchell Usher, 1997

Watts, George Frederick 1817–1904, *Miss Mildmay*, part of the original G. F. Watts Memorial Collection. Bequeathed, 1905

Watts, George Frederick 1817–1904, *Admiral Lord Lyons*, gift from Mrs Michael Chapman (née Lilian Macintosh), 1946

Watts, George Frederick 1817–1904, *The Sisters*, gift from Mrs Michael Chapman (née Lilian Macintosh), 1946 (originally part of the Memorial Collection)

Watts, George Frederick 1817–1904, *Georgina Treherne*, purchased from Sotheby's with the assistance of the National Art Collections Fund, 2004

Watts, George Frederick 1817–1904, *Bodrum, Asia Minor*, gift from Mrs Michael Chapman (née Lilian Macintosh), 1946

Watts, George Frederick 1817–1904, *In Asia Minor*, gift from Mrs Michael Chapman (née Lilian Macintosh), 1946

Watts, George Frederick 1817–1904, *Dr Zambaco*

Watts, George Frederick 1817–1904, *Study for Fresco of Corialanus for Bowood House*

Watts, George Frederick 1817–1904, *Study for Fresco of Corialanus for Bowood House*

Watts, George Frederick 1817–1904, *Study for Fresco of Corialanus for Bowood House*

Watts, George Frederick 1817–1904, *Study for Fresco of Corialanus for Bowood House*

Watts, George Frederick 1817–1904, *Achilles and Briseis*, presented by Lord Lansdowne, 1956

Watts, George Frederick 1817–1904, *Aileen Spring-Rice*, gift from Mrs Michael Chapman (née Lilian Macintosh), 1946

Watts, George Frederick 1817–1904, *Lady Lilford*, part of the original G. F. Watts Memorial Collection. Bequeathed, 1905

Watts, George Frederick 1817–1904, *Lady Somers*, given by Mary Seton Watts in exchange for another picture from the original core collection of 109 works, 1908

Watts, George Frederick 1817–1904, *Lord Campbell*, part of the original G. F. Watts Memorial Collection. Bequeathed, 1905

Watts, George Frederick 1817–1904, *Esau*, part of the original G. F. Watts Memorial Collection. Bequeathed, 1905

Watts, George Frederick 1817–1904, *'Long Mary'*, gift from Mrs Michael Chapman (née Lilian Macintosh), 1946

Watts, George Frederick 1817–1904, *Eve Repentant*, gift from Mrs Michael Chapman (née Lilian Macintosh), 1946

Watts, George Frederick 1817–1904, *Lady Archibald Campbell*

Watts, George Frederick 1817–1904, *Europa*, gift from Mrs Michael Chapman (née Lilian Macintosh), 1946

Watts, George Frederick 1817–1904, *Earl of Shrewsbury*, gift from Mrs Michael Chapman (née Lilian Macintosh), 1946

Watts, George Frederick 1817–1904, *Lord Lyndhurst*, gift from Mrs Michael Chapman (née Lilian Macintosh), 1946

Watts, George Frederick 1817–1904, *Head of an Ass*, part of the original G. F. Watts Memorial Collection. Bequeathed, 1905

Watts, George Frederick 1817–1904, *The Building of the Ark*, part of the original G. F. Watts Memorial Collection. Bequeathed, 1905

Watts, George Frederick 1817–1904, *The Midday Rest (Dray Horses)*, part of the original G. F. Watts Memorial Collection. Bequeathed, 1905

Watts, George Frederick 1817–1904, *Preaching of Jonah (or Noah)*

Watts, George Frederick 1817–1904, *Ganymede (Son of Dr Zambaco and Miss Mary Cassavetti)*, part of the original G. F. Watts Memorial Collection. Bequeathed, 1905

Watts, George Frederick 1817–1904, *Giuseppe Garibaldi (1807–1882)*, part of the original G. F. Watts Memorial Collection. Bequeathed, 1905

Watts, George Frederick 1817–1904, *Britomart*, part of the original G. F. Watts Memorial Collection. Bequeathed, 1905

Watts, George Frederick 1817–1904, *Dr J. Joachim*, part of the original G. F. Watts Memorial Collection. Bequeathed, 1905

Watts, George Frederick 1817–1904, *Sir Henry Taylor (unfinished)*, gift from Mrs Michael Chapman (née Lilian Macintosh), 1946

Watts, George Frederick 1817–1904, *The Standard-Bearer*, part of the original G. F. Watts Memorial Collection. Bequeathed, 1905

Watts, George Frederick 1817–1904, *Miss May Prinsep*, gift from Mrs A. K. Hitchens, 1907

Watts, George Frederick 1817–1904, *Thetis*, gift from Lord Iveagh, 1951

Watts, George Frederick 1817–1904, *Thetis*, bequeathed by Cecil French, 1955

Watts, George Frederick 1817–1904, *Mrs Percy Wyndham*, gift from Mrs Michael Chapman (née Lilian Macintosh), 1946

Watts, George Frederick 1817–1904, *Eve Tempted*, gift from Mrs Michael Chapman (née Lilian Macintosh), 1946 (originally part of the Memorial Collection)

Watts, George Frederick 1817–1904, *Florence Nightingale (1820–1910)*, gift from Mrs Michael Chapman (née Lilian Macintosh), 1945

Watts, George Frederick 1817–1904, *Rhodopis*, probably bequeathed by Cecil French, 1955

Watts, George Frederick 1817–1904, *Cedar Tree*, acquired via the Hitchens Gift

Watts, George Frederick 1817–1904, *A Fair Saxon*, part of the original G. F. Watts Memorial Collection. Bequeathed, 1905

Watts, George Frederick 1817–1904, *Orpheus and Euridice (small version)*, bequeathed by Cecil French, 1955

Watts, George Frederick 1817–1904, *Eve Repentant*, part of the original G. F. Watts Memorial Collection. Bequeathed, 1905

Watts, George Frederick 1817–1904, *Clytie*, bequeathed by Cecil French, 1955

Watts, George Frederick 1817–1904, *Donders Frans*

Watts, George Frederick 1817–1904, *George Peabody*, gift from Mrs Michael Chapman (née Lilian Macintosh), 1946

Watts, George Frederick 1817–1904, *Thomas Hughes*, gift from Mrs Michael Chapman (née Lilian Macintosh), 1946

Watts, George Frederick 1817–1904, *H. Toby Prinsep*, gift from Mrs A. K. Hitchens, 1908

Watts, George Frederick 1817–1904, *P. H. Calderon*

Watts, George Frederick 1817–1904, *Samson*, bequeathed by Cecil French, 1955

Watts, George Frederick 1817–1904, *The Denunciation of Cain*, part of the original G. F. Watts Memorial Collection. Bequeathed, 1905

Watts, George Frederick 1817–1904, *The Court of Death*, part of the original G. F. Watts Memorial Collection. Bequeathed, 1905

Watts, George Frederick 1817–1904, *Miss Virginia Julian Dalrymple (Mrs Francis Champneys)*, bequeathed by Sir Weldon Dalrymple-Champneys, 1981. Received by the gallery on Lady Dalrymple-Champneys' death, 1998

Watts, George Frederick 1817–1904, *Rith H. Wallis-Dunlop*, on loan from a private collection

Watts, George Frederick 1817–1904, *The Prodigal Son*, part of the original G. F. Watts Memorial Collection. Bequeathed, 1905

Watts, George Frederick 1817–1904, *The Prodigal Son (bust-length figure)*, part of the original G. F. Watts Memorial Collection. Bequeathed, 1905

Watts, George Frederick 1817–1904, *Paolo and Francesca*, part of the original G. F. Watts Memorial Collection. Bequeathed, 1905

Watts, George Frederick 1817–1904, *The Spirit of Christianity*, part of the original G. F. Watts Memorial Collection. Bequeathed, 1905

Watts, George Frederick 1817–1904, *John Stuart Mill (1806–1873)*, gift from Mrs Michael Chapman (née Lilian Macintosh), 1946

Watts, George Frederick 1817–1904, *The Denunciation of Adam and Eve*, gift from Mrs Michael Chapman (née Lilian Macintosh), 1946

Watts, George Frederick 1817–1904, *The Denunciation of Adam and Eve*, part of the original G. F. Watts Memorial Collection. Bequeathed, 1905

Watts, George Frederick 1817–1904, *Chaos*, part of the original G. F. Watts Memorial Collection. Bequeathed, 1905

Watts, George Frederick 1817–1904, *King Edward VII (1841–1910)*, possibly part of the original G. F. Watts Memorial Collection. Bequeathed, 1905

Watts, George Frederick 1817–1904, *Lady Garvagh*, part of the original G. F. Watts Memorial Collection. Bequeathed, 1905

Watts, George Frederick 1817–1904, *Study of Nude (Standing Figure)*, part of the original G. F. Watts Memorial Collection. Bequeathed, 1905

Watts, George Frederick 1817–1904, *Freshwater, near Farringford*, part of the original G. F. Watts Memorial Collection. Bequeathed, 1905

Watts, George Frederick 1817–1904, *Freshwater Farm Buildings*, part of the original G. F. Watts Memorial Collection. Bequeathed, 1905

Watts, George Frederick 1817–1904, *Ophelia*, part of the original G. F. Watts Memorial Collection. Bequeathed, 1905

Watts, George Frederick 1817–1904, *Genius of Greek Poetry*, part of the original G. F. Watts Memorial Collection. Bequeathed, 1905

Watts, George Frederick 1817–1904, *Jacob and Esau*, part of the original G. F. Watts Memorial Collection. Bequeathed, 1905

Watts, George Frederick 1817–1904, *King Edward VII (1841–1910)*

Watts, George Frederick 1817–1904, *Arcadia*, part of the original G. F. Watts Memorial Collection. Bequeathed, 1905

Watts, George Frederick 1817–1904, *Self Portrait*, gift from Mary Seton Watts, 1913

Watts, George Frederick 1817–1904, *Violet Lindsay*, part of the original G. F. Watts Memorial Collection. Bequeathed, 1905

Watts, George Frederick 1817–1904, *Sir Richard Burton*, part of the original G. F. Watts Memorial Collection. Bequeathed, 1905

Watts, George Frederick 1817–1904, *Lucy Bond*

Watts, George Frederick 1817–1904, *Mrs Lillie Langtry*, part of the original G. F. Watts Memorial Collection. Bequeathed, 1905

Watts, George Frederick 1817–1904, *Sketch of Lord Dufferin*

Watts, George Frederick 1817–1904, *Lady Godiva*, part of the original G. F. Watts Memorial Collection. Bequeathed, 1905

Watts, George Frederick 1817–1904, *Daphne's Bath*, bequeathed by Cecil French, 1955

Watts, George Frederick 1817–1904, *Laura Gurney (later Lady Troubridge)*

Watts, George Frederick 1817–1904, *Love and Life*, part of the original G. F. Watts Memorial Collection. Bequeathed, 1905

Watts, George Frederick 1817–1904, *Miss Blanche Maynard*, part of the original G. F. Watts Memorial Collection. Bequeathed, 1905

Watts, George Frederick 1817–1904, *The Creation of Eve*, part of the original G. F. Watts Memorial Collection. Bequeathed, 1905

Watts, George Frederick 1817–1904, *The Creation of Eve (unfinished)*, gift from Mrs Michael Chapman (née Lilian Macintosh), 1946

Watts, George Frederick 1817–1904, *G. F. Watts*, on loan from Compton Village Hall

Watts, George Frederick 1817–1904, *Tasting the First Oyster*, part of the original G. F. Watts Memorial Collection. Bequeathed, 1905

Watts, George Frederick 1817–1904, *The Condottiere*, part of the original G. F. Watts Memorial Collection. Bequeathed, 1905

Watts, George Frederick 1817–1904, *Time, Death and Judgement*, on long-term loan from St Paul's Cathedral

Watts, George Frederick 1817–1904, *Uldra*, purchased with the assistance of the National Art Collections Fund, 1995

Watts, George Frederick 1817–1904, *The Messenger*, part of the original G. F. Watts Memorial Collection. Bequeathed, 1905

Watts, George Frederick 1817–1904, *Idle Child of Fancy*, part of the original G. F. Watts Memorial Collection. Bequeathed, 1905

Watts, George Frederick 1817–1904, *Mammon*, purchased from Mr Arthur Spencer, 1948

Watts, George Frederick 1817–1904, *Near Brighton*, part of the original G. F. Watts Memorial Collection. Bequeathed, 1905

Watts, George Frederick 1817–1904, *Olympus on Ida*, gift from Mrs Michael Chapman (née Lilian Macintosh), 1946

Watts, George Frederick 1817–1904, *Rachel Gurney*, gift from Mrs Michael Chapman (née Lilian Macintosh), 1946

Watts, George Frederick 1817–1904, *After the Deluge*, part of the original G. F. Watts Memorial Collection. Bequeathed, 1905

Watts, George Frederick 1817–1904, *Study for 'Achilles and Briseis'*

Watts, George Frederick 1817–1904, *Study for 'Corialanus'*

Watts, George Frederick 1817–1904, *The Death of Cain*, part of the original G. F. Watts Memorial Collection. Bequeathed, 1905

Watts, George Frederick 1817–1904, *A Sea Ghost*, part of the original G. F. Watts Memorial Collection. Bequeathed, 1905

Watts, George Frederick 1817–1904, *Egyptian Landscape*, gift from Mrs Michael Chapman (née Lilian Macintosh), 1946

Watts, George Frederick 1817–1904, *Mrs G. F. Watts*, bequeathed by Mrs Edward Liddel, 1931

Watts, George Frederick 1817–1904, *Mrs G. F. Watts*, gift from Mrs Michael Chapman (née Lilian Macintosh), 1946

Watts, George Frederick 1817–1904, *Mrs G. F. Watts in a Straw Hat*, purchased from Sotheby's with the assistance of the National Art Collections Fund, 2004

Watts, George Frederick 1817–1904, *Peace and Goodwill*, part of the original G. F. Watts Memorial

Collection. Bequeathed, 1905

Watts, George Frederick 1817–1904, *Self Portrait, Aged 24*, gift from Mrs Michael Chapman (née Lilian Macintosh), 1946

Watts, George Frederick 1817–1904, *Sunset on the Nile*, purchased from the Maas Gallery

Watts, George Frederick 1817–1904, *The All-Pervading*

Watts, George Frederick 1817–1904, *The Sphinx*, part of the original G. F. Watts Memorial Collection. Bequeathed, 1905

Watts, George Frederick 1817–1904, *Recording Angel*, gift from Mrs Michael Chapman (née Lilian Macintosh), 1946

Watts, George Frederick 1817–1904, *Sunset on the Alps*, part of the original G. F. Watts Memorial Collection. Bequeathed, 1905

Watts, George Frederick 1817–1904, *The Alps near Monnetier*, part of the original G. F. Watts Memorial Collection. Bequeathed, 1905

Watts, George Frederick 1817–1904, *Progress*, part of the original G. F. Watts Memorial Collection. Bequeathed, 1905

Watts, George Frederick 1817–1904, *Naples*, gift from Mrs Michael Chapman (née Lilian Macintosh), 1946 (originally part of the Memorial Collection)

Watts, George Frederick 1817–1904, *The Bay of Naples*, part of the original G. F. Watts Memorial Collection. Bequeathed, 1905

Watts, George Frederick 1817–1904, *Lila Prinsep*, on long-term loan

Watts, George Frederick 1817–1904, *Patient Life of Unrequited Toil*, part of the original G. F. Watts Memorial Collection. Bequeathed, 1905

Watts, George Frederick 1817–1904, *Evening Landscape*, bequeathed by Cecil French, 1955

Watts, George Frederick 1817–1904, *Sympathy*, part of the original G. F. Watts Memorial Collection. Bequeathed, 1905

Watts, George Frederick 1817–1904, *Love Triumphant*, part of the original G. F. Watts Memorial Collection. Bequeathed, 1905

Watts, George Frederick 1817–1904, *'For he had great possessions'*

Watts, George Frederick 1817–1904, *In the Land of Weissnichtwo*, part of the original G. F. Watts Memorial Collection. Bequeathed, 1905

Watts, George Frederick 1817–1904, *Earth*, part of the original G. F. Watts Memorial Collection. Bequeathed, 1905

Watts, George Frederick 1817–1904, *Outcast Goodwill*, part of the original G. F. Watts Memorial Collection. Bequeathed, 1905

Watts, George Frederick 1817–1904, *John Burns*

Watts, George Frederick 1817–1904, *Can These Bones Live?*,

part of the original G. F. Watts Memorial Collection. Bequeathed, 1905

Watts, George Frederick 1817–1904, *George Andrews*, part of the original G. F. Watts Memorial Collection. Bequeathed, 1905

Watts, George Frederick 1817–1904, *A Dedication*, part of the original G. F. Watts Memorial Collection. Bequeathed, 1905

Watts, George Frederick 1817–1904, *Evolution*, part of the original G. F. Watts Memorial Collection. Bequeathed, 1905

Watts, George Frederick 1817–1904, *Invernesshire Landscape (Loch Ruthven)*, purchased from Mrs Michael Chapman (née Lilian Macintosh), 1958

Watts, George Frederick 1817–1904, *Seen from the Train*, part of the original G. F. Watts Memorial Collection. Bequeathed, 1905

Watts, George Frederick 1817–1904, *Study of Moorland, Invernesshire*, probably gift from Mrs Michael Chapman (née Lilian Macintosh), 1946

Watts, George Frederick 1817–1904, *The Right Honourable Gerald Balfour*

Watts, George Frederick 1817–1904, *Love Steering the Boat of Humanity*, gift from Mrs Michael Chapman (née Lilian Macintosh), 1946 (originally part of the Memorial Collection)

Watts, George Frederick 1817–1904, *Sun, Earth and Their Daughter Moon*, part of the original G. F. Watts Memorial Collection. Bequeathed, 1905

Watts, George Frederick 1817–1904, *Industry and Greed*, part of the original G. F. Watts Memorial Collection. Bequeathed, 1905

Watts, George Frederick 1817–1904, *Orpheus and Euridice*, part of the original G. F. Watts Memorial Collection. Bequeathed, 1905

Watts, George Frederick 1817–1904, *Fugue*, given by Mary Seton Watts in exchange for another picture from the original core collection of 109 works, 1908

Watts, George Frederick 1817–1904, *The Slumber of the Ages*, part of the original G. F. Watts Memorial Collection. Bequeathed, 1905

Watts, George Frederick 1817–1904, *Autumn*, gift from Mrs Michael Chapman (née Lilian Macintosh), 1946

Watts, George Frederick 1817–1904, *Sower of the Systems*, part of the original G. F. Watts Memorial Collection. Bequeathed, 1905

Watts, George Frederick 1817–1904, *End of the Day (Surrey Woodland)*, gift from Mrs Michael Chapman (née Lilian Macintosh), 1946

Watts, George Frederick 1817–1904, *Surrey Woodland*, gift from Mrs Michael Chapman (née Lilian Macintosh), 1946

Watts, George Frederick 1817–1904, *A Parasite*, part of the original G. F. Watts Memorial Collection. Bequeathed, 1905

Watts, George Frederick 1817–1904, *C. J. G. Montefiore*

Watts, George Frederick 1817–1904, *Endymion*, given by Mary Seton Watts in exchange for another picture from the original core collection of 109 works, 1908

Watts, George Frederick 1817–1904, *Green Summer*, given by Mary Seton Watts in exchange for another picture from the original core collection of 109 works, 1908

Watts, George Frederick 1817–1904, *Mother and Child*, part of the original G. F. Watts Memorial Collection. Bequeathed, 1905

Watts, George Frederick 1817–1904, *Self Portrait in Old Age*, gift from Mrs Michael Chapman (née Lilian Macintosh), 1946

Watts, George Frederick 1817–1904, *Destiny*, part of the original G. F. Watts Memorial Collection. Bequeathed, 1905

Watts, George Frederick 1817–1904, *Iris*, gift from Mrs Michael Chapman (née Lilian Macintosh), 1946

Watts, George Frederick 1817–1904, *Lilian*, given by Mary Seton Watts in exchange for another picture from the original core collection of 109 works, 1908

Watts, George Frederick 1817–1904, *Prometheus*, part of the original G. F. Watts Memorial Collection. Bequeathed, 1905

Watts, George Frederick 1817–1904, *A Fragment*

Watts, George Frederick 1817–1904, *Death with Two Angels*, gift from Mrs Michael Chapman (née Lilian Macintosh), 1946

Watts, George Frederick 1817–1904, *Lady Halle*

Watts, George Frederick 1817–1904, *Magdalen*, purchased, 1961

Watts, George Frederick 1817–1904, *Malta*

Watts, George Frederick 1817–1904, *Monochrome Study*

Watts, George Frederick 1817–1904, *Nude Standing (The Pool)*

Watts, George Frederick 1817–1904, *Portrait of a Small Girl with Fair Hair and Full Face*

Watts, George Frederick 1817–1904, *Portrait of an Unknown Lady (possibly Lilian Macintosh)*

Watts, George Frederick 1817–1904, *Prince de Joinville (1818–1900)*, gift from Mrs Michael Chapman (née Lilian Macintosh), 1946 (originally part of the Memorial Collection)

Watts, George Frederick 1817–1904, *Psyche*

Watts, George Frederick 1817–1904, *St George*, bequeathed by Sir Weldon Dalrymple-Champneys, 1981

Watts, George Frederick 1817–1904, *Study for 'Lady Godiva'*

Watts, George Frederick 1817–

1904, *Study for 'The Messenger'*

Watts, George Frederick 1817–1904, *Study of Armour*, part of the original G. F. Watts Memorial Collection. Bequeathed, 1905

Watts, George Frederick 1817–1904, *Study of Armour*, part of the original G. F. Watts Memorial Collection. Bequeathed, 1905

Watts, George Frederick 1817–1904, *The Countess of Kenmare (My Lady Peacock)*, gift from Mrs Michael Chapman (née Lilian Macintosh), 1946

Watts, George Frederick 1817–1904, *The Wine-Bearer*, gift from Mrs Michael Chapman (née Lilian Macintosh), 1946

Watts, George Frederick 1817–1904, *Unknown Landscape*

Watts, George Frederick 1817–1904, *Unknown Landscape, possibly Ireland*

Watts, George Frederick 1817–1904, *Unknown Portrait (possibly Lady Somers or Lady Lothian)*

Watts, George Frederick 1817–1904, *View from Monkshatch, Compton*

Watts Mortuary Chapel

Watts, George Frederick 1817–1904, *The All-Pervading*, possibly a gift to the parish when the chapel was complete, 1904

Yvonne Arnaud Theatre

Charters, Cecil *Yvonne Arnaud (1890–1958)*, presented by Mrs M. Dutton

Haslemere Educational Museum

Aborn, John d.1915, *Country Scene with Caravans and Peasants*, gift from Mrs H. Montaner, 1991

Ainsworth *Fungi*

S. E. B. *The Fish Shop, Haslemere*, gift from A. Williamson, 1964

Chandler, Allen 1887–1969, *Ann*

Chandler, Allen 1887–1969, *Opposite Shottermill*

Chandler, Allen 1887–1969, *A Woodland Industry (Glass Production)*

Chandler, Allen 1887–1969, *Early Old Stone Age*

Chandler, Allen 1887–1969, *Later Old Stone Age*

Chandler, Allen 1887–1969, *New Stone Age*

Cooper, Byron 1850–1933, *Blackdown from Hascombe*, gift from Mr G. G. Cooper, 1961

Cooper, Byron 1850–1933, *Aldworth*, gift from Mr G. G. Cooper, 1961

Cooper, Byron 1850–1933, *Freshwater Bay, Summer Moonlight*, gift from Mr G. G. Cooper, 1961

Cooper, Byron 1850–1933, *Freshwater Church*, gift from Mr G.

Cooper, 1961

Cooper, Byron 1850–1933, *Moonrise from the Downs*, gift from Mr G. G. Cooper, 1961

Cooper, Byron 1850–1933, *Stream through Countryside*, gift from Mr G. G. Cooper, 1961

Cooper, Byron 1850–1933, *Tennyson's Private Road from the Downs*, gift from Mr G. G. Cooper, 1961

Cooper, Byron 1850–1933, *The Brook*, gift from Mr G. G. Cooper, 1961

Cooper, Byron 1850–1933, *Moonrise on the Old Canal, Bude*, gift from Mr G. G. Cooper, 1961

Cooper, Byron 1850–1933, *Brook, May Morning*, gift from Mr G. G. Cooper, 1961

Cooper, Byron 1850–1933, *A Quiet Pool, near Haslemere*, gift from Mr G. G. Cooper, 1961

Cooper, Byron 1850–1933, *Sussex Weald*, gift from Mr G. G. Cooper, 1961

Cooper, Byron 1850–1933, *Barley Field*, gift from Mr G. G. Cooper, 1961

Cooper, Byron 1850–1933, *Gull Rock, Tintagel*, gift from Mr G. G. Cooper, 1961

Cooper, Byron 1850–1933, *In the Woods*, gift from Mr G. G. Cooper, 1961

Cooper, Byron 1850–1933, *Maple Tree*, gift from Mr G. G. Cooper, 1961

Cooper, Byron 1850–1933, *Moonlit Atlantic from Tintagel*, gift from Mr G. G. Cooper, 1961

Cooper, Byron 1850–1933, *Near Haslemere, Sunset*, gift from Mr G. G. Cooper, 1961

Cooper, Byron 1850–1933, *On the Cliffs, Tintagel*, gift from Mr G. G. Cooper, 1961

Cooper, Byron 1850–1933, *Solent from Farringford*, gift from Mr G. G. Cooper, 1961

Cooper, Byron 1850–1933, *Summer Moonlight*, gift from Mr G. G. Cooper, 1961

Cooper, Byron 1850–1933, *The Birches*, gift from Mr G. G. Cooper, 1961

Cooper, Byron 1850–1933, *The Poppy Field*, gift from Mr G. G. Cooper, 1961

Cooper, Byron 1850–1933, *Tintagel Coast*, gift from Mr G. G. Cooper, 1961

Cooper, Byron 1850–1933, *View from Farringford*, gift from Mr G. G. Cooper, 1961

Cooper, Byron 1850–1933, *View of a Sunset over Water by a Tree*, gift from Mr G. G. Cooper, 1961

Cooper, Byron 1850–1933, *View of Countryside Hills*, gift from Mr G. G. Cooper, 1961

Cooper, Byron 1850–1933, *View over a Pool*, gift from Mr G. G. Cooper, 1961

Cummings, Vera 1891–1949, *Portrait of a Maori Woman*, gift from Mr T. Harper

Dicksee, Frank 1853–1928, *Miss*

Edith Fitton, bequeathed by Mrs Lillian Fitton, 1951
Dobie, Joan *Waggoners Wells*, gift from Ted Orchard, 2005
Ewbank, S. *Pass of Elsinore*
Gridnev, Valery b.1956, *Fisherman*, gift from Ted Orchard, 2005
Hill, J. R. *View of Cottage Surrounded by Woodland*
Leizle, Eric *The Devil's Punchbowl*, gift from Mrs Barbara Dell, 1998
Nilsson, Johannes 1757–1827, *The Three Kings and the Wise and Foolish Virgins*, gift from Haslemere Peasant Handicraft Museum, 1926
Potter, Violet *Potter (after George Romney)*, gift from Mrs J. Dodge, 1998
Prossen, Henry *Killinghurst, Haslemere*, gift from Elkins
Storr, Milton active 1888–1891, *Cottage with a Man, Woman and a Dog*, bequeathed by C. G. Stephens, 1971
Swedish School *The Three Kings and the Wise and Foolish Virgins*, gift from Haslemere Peasant Handicraft Museum, 1926
Swedish School *The Three Kings and the Wise and Foolish Virgins*, gift from Haslemere Peasant Handicraft Museum, 1926
Swedish School *The Three Kings and the Wise and Foolish Virgins*, gift from Haslemere Peasant Handicraft Museum, 1926
Swedish School *The Three Kings and the Wise and Foolish Virgins*, gift from Haslemere Peasant Handicraft Museum, 1926
Tomes, Marjorie *On the Beach*, purchased, 2001
Tomes, Marjorie *The Anniversary*, purchased, 2001
Tomes, Marjorie *Two Men and Two Women Sitting in Deckchairs*, purchased, 2001
unknown artist *The London to Chichester Coach on Shepherd's Hill, Haslemere*, gift from Dr Rolston, 1948
unknown artist *New Mill*
unknown artist late 19th C, *Beach Scene*
unknown artist late 19th C, *Woodland Scene by a Lake*
unknown artist *Hammer Valley*
unknown artist *Haslemere Society of Artists Exhibition: Landscape*
unknown artist *Landscape of Iceland*
unknown artist *Landscape of Iceland*
unknown artist *Portrait of a Man*
unknown artist *Study of Dead Game Bird*
unknown artist *The Pigsties, Inval*
unknown artist *Winter Landscape with Reindeer and Sledges*
Whymper, Emily 1833–1886, *Still Life*, gift from Miss E. Morrish, 1970
Williams, Juliet Nora d.1937, *Winter Morning*, gift from Miss J. Williams, 1955
Wolski, Stanislaw Polian 1859–1894, *Winter Landscape with Horse Drawn Carriage*

Surrey County Council

Birch, David 1895–1968, *Morning in June, the Vale of Dedham*
Bloemen, Jan Frans van 1662–1749, *View of Rome from the Baberini Palace*, presented to Surrey County Council by H. M. Chester of Poyle Park, Tongham, Surrey, 1902
Bone, Charles b.1926, *Oxenford Grange, Peper Harow*, © courtesy of the artist/www.bridgeman.co.uk
Briggs, Henry Perronet (circle of) 1791/1793–1844, *John Leech*
Brooks, Henry Jamyn 1865–1925, *Sir William Vincent, Bt*
Carter, William 1863–1939, *Henry Yool Esq.*
Carter, William 1863–1939, *Edward Joseph Halsey*
Carter, William 1863–1939, *The Right Honourable St John Broderick, 9th Viscount Midleton*
Carter, William 1863–1939, *Thomas Weeding Weeding (1847–1929)*
Chamberlin, Mason the elder (circle of) 1727–1787, *Richard, 3rd Earl of Onslow*
Clay, Arthur 1842–1928, *Sir William Hardman, QC*
Daniels, Alfred b.1924, *Boats Moored on the River Thames*
Fildes, Luke (after) 1844–1927, *King Edward VII (1841–1910)*
Gunn, Herbert James 1893–1964, *Sir Lawrence Edward Halsey, KBE, JP*, © the artist's estate
Herkomer, Herman 1863–1935, *Edward Hugh Leycester Penrhyn, First Chairman of Surrey County Council (1889–1893)*
Jervas, Charles (style of) c.1675–1739, *Thomas Onslow, 2nd Lord Onslow (1680–1740)*
Kneller, Godfrey (style of) 1646–1723, *Sir Richard Onslow, 1st Lord Onslow (1654–1717)*
Llewellyn, William Samuel Henry 1854–1941, *The Right Honourable Lord Ashcombe, CB, TD*
Noakes, Michael b.1933, *The Right Honourable James Chuter Ede, CH, JP, DL*, © the artist
Phillips, Thomas 1770–1845, *Florance Young Esq.*
Ramsay, Allan (studio of) 1713–1784, *King George III (1738–1820)*, gift from Sir Joseph Lawrence, 1913
Ramsay, Allan (studio of) 1713–1784, *Queen Charlotte (1744–1818)*, gift from Sir Joseph Lawrence, 1913
Stewardson, Thomas 1781–1859, *The Right Honourable George, 4th Baron and 1st Earl of Onslow*
Symonds, William Robert 1851–1934, *The Right Honourable George Viscount Cave, CC, MC*

Leatherhead and District Local History Society

unknown artist *Mickleham Church*, gift from Mr Dowland, 1985
unknown artist *Mr S. Maw*

The Guest House, Lingfield Library

Akehurst, R. D. *Lingfield Coronation Decorations*

Oxted Library

Christie, Ernest C. (attributed to) 1863–1937, *Kentish Farm, E. Christie War Coppice*, on long-term loan from the Bourne Society
Christie, Ernest C. (attributed to) 1863–1937, *Prucks Works at Links Corner, Limpsfield (now demolished)*, on long-term loan from the Bourne Society
Christie, Ernest C. (attributed to) 1863–1937, *View of Pond Gate and Farm*, on long-term loan from the Bourne Society

Tandridge District Council

Collier, John 1850–1934, *Colonel Arthur Stuart Daniel, Chairman of Godstone Rural District Council (1900–1935)*
Grace, Harriet Edith active 1877–1909, *William Garland Soper, First Chairman of Caterham & Warlingham Urban District Council (1899–1908)*
Curzon-Price, Paddy *Councillor Mrs M. D. Wilks, First Lady Chair of Tandridge District Council (1977–1978)*
unknown artist *Marjory Pease, JP (1911–1947)*
unknown artist *Old Oxted*

East Surrey Hospital

Dorman, Ernest A. b.1928, *Darkness on Face of the Deep*, gift from the artist, 1999, © the artist
Dorman, Ernest A. b.1928, *Earth without Form and Void*, gift from the artist, 1999, © the artist
Dorman, Ernest A. b.1928, *Gathering of the Waters unto One Place and Dry Land Appearing*, gift from the artist, 1999, © the artist
Dorman, Ernest A. b.1928, *God Created Lights to Rule the Day and Night*, gift from the artist, 1999, © the artist
Dorman, Ernest A. b.1928, *Let There Be Light*, gift from the artist, 1999, © the artist
Dorman, Ernest A. b.1928, *Produce of the Earth by Nature and Creation of Every Living Creature*, gift from the artist, 1999, © the artist
Dorman, Ernest A. b.1928, *The Four Seasons, Winter*, gift from the artist, 1999, © the artist
Dorman, Ernest A. b.1928, *The Four Seasons, Spring*, gift from the artist, 1999, © the artist
Dorman, Ernest A. b.1928, *The Four Seasons, Summer*, gift from the artist, 1999, © the artist
Dorman, Ernest A. b.1928, *The Four Seasons, Autumn*, gift from the artist, 1999, © the artist

Dorman, Ernest A. b.1928, *Winter Tree*, gift from the artist, 1999, © the artist
Moosajee, Mariya *A Not So Funny Bone*, commissioned by East Surrey Hospital Arts Project, 2004
Moosajee, Mariya *High Heels and Fashion Fractures*, commissioned by East Surrey Hospital Arts Project, 2004
Moosajee, Mariya *Rugby Kicks and Patella Nicks*, commissioned by East Surrey Hospital Arts Project, 2004
Shepherd, Frank *Pastoral Scene via Open Window*, commissioned and purchased by East Surrey Hospital Arts Project, 2003
Stevens active mid-20th C, *Seascape*, donated by an ex-patient

Holmsdale Natural History Club

unknown artist early 19th C, *Portrait of a Man (possibly Baron von Humbolt)*, gift from Mrs Prentice (believed to be Baron von Humboldt), 1862
unknown artist 19th C, *Portrait of an Unknown Victorian Lady*

Reigate & Banstead Borough Council

Gogin, Alma 1854–1948, *Regrets*, presented by Mr Charles Gogin
Hooper, George 1910–1994, *The Garden at Loxwood, Redhill*
Little, George Leon 1862–1941, *Cows in a Landscape*
Little, George Leon 1862–1941, *Evening Lake Scene*
Little, George Leon 1862–1941, *Sheep in a Landscape*
Wells, Henry Tanworth 1828–1903, *Loading at the Quarry, Holmbury Hill*, presented by Mrs J. M. Hadley

Reigate Priory Museum

British (English) School *John Lymden (elected 1530, surrendered 1536), the Last Prior of Reigate*, purchased for a token sum from the Honourable Sir George Bellows, KCB, KCVO, 1974
Noakes, Michael b.1933, *F. E. Claytor, Headmaster (1948–1957), possibly presented to the school*, © the artist

Send and Ripley Museum

Baigent, R. active c.1920–c.1940, *Newark Mill, Ripley, Surrey*, gift from Roland Mells, 1985
Brown, Frank active 1950s–1970s, *Ripley Village*, gift from Mrs Hilary Street, 1995

Spelthorne Borough Council

Marion *At Sea 1*, acquired, 1974
Marion *At Sea 2*, acquired, 1974

Spelthorne Museum

unknown artist *Cottages in Thames Street*, donated
Vasey, M. *A Mother's Rosary*, donated
Winfield, G. E. *A Cottage on the Corner of Manygate Lane and Rope Walk, Shepperton*, donated
Winfield, G. E. *A Cottage on the Corner of Manygate Lane and Rope Walk, Shepperton*, donated

Sunbury Library

The Sunbury Art Group *The Thames at Sunbury*, presented to the library by the Sunbury Art Group, 1968

Dittons Library

Freeman, William c.1838–1918, *Thames Villa*
Freeman, William c.1838–1918, *'The Swan' at Claygate*
Freeman, William c.1838–1918, *'The White Lion', Esher*
Freeman, William c.1838–1918, *High Street, Thames Ditton?*
P. W. J. active mid-20th C, *'Ye Olde Swan', Thames Ditton?*, donated by P. J. Whitehorn
Stevens, Thomas active 1889–1893, *Cottage at Weston Green*
Stevens, Thomas active 1889–1893, *Weston Green Pond*

Warlingham Library, Lockton Collection

Lockton, Charles Langton 1856–1932, *All Saints' Church, North-West, before Enlargement*, bequeathed to the parish of Warlingham
Lockton, Charles Langton 1856–1932, *All Saints' Church, South Side, before Enlargement*, bequeathed to the parish of Warlingham
Lockton, Charles Langton 1856–1932, *Cottage on the Corner of Westhall Road and Ridley Road (demolished in 1898), Site of 'Teeton', the Artist's Home*, bequeathed to the parish of Warlingham
Lockton, Charles Langton 1856–1932, *Westhall Road, Corner of Workhouse Lane (now Hillbury Road)*, bequeathed to the parish of Warlingham
Lockton, Charles Langton 1856–1932, *Cottage between 'The Leather Bottle' and Mill House*, bequeathed to the parish of Warlingham
Lockton, Charles Langton 1856–1932, *'The Leather Bottle', with Butcher's Shop on the Left as it*

was in the 1880s, bequeathed to the parish of Warlingham

Lockton, Charles Langton 1856–1932, *All Saints' Church*, bequeathed to the parish of Warlingham, 1970

Lockton, Charles Langton 1856–1932, *All Saints' Church, Footpath from Village*, bequeathed to the parish of Warlingham

Lockton, Charles Langton 1856–1932, *All Saints' Church, Footpath from Village*, bequeathed to the parish of Warlingham

Lockton, Charles Langton 1856–1932, *Hamsey Green Pond*, bequeathed to the parish of Warlingham

Lockton, Charles Langton 1856–1932, *'The White Lion' as it was in the 1880s*, bequeathed to the parish of Warlingham

Lockton, Charles Langton 1856–1932, *Village Green, South-East Corner*, bequeathed to the parish of Warlingham

Lockton, Charles Langton 1856–1932, *Westhall Road, Warlingham (near Searchwood Road)*, bequeathed to the parish of Warlingham

Lockton, Charles Langton 1856–1932, *Tydcombe Farm*, bequeathed to the parish of Warlingham

Lockton, Charles Langton 1856–1932, *Blanchman's Farm from the South-East*, bequeathed to the parish of Warlingham

Lockton, Charles Langton 1856–1932, *Shops on the Village Green*, bequeathed to the parish of Warlingham

Lockton, Charles Langton 1856–1932, *Warlingham Vicarage*, donated, 1981

Lockton, Charles Langton 1856–1932, *All Saints' Church*, bequeathed to the parish of Warlingham

Lockton, Charles Langton 1856–1932, *All Saints' Church, before Enlargement*, bequeathed to the parish of Warlingham

Lockton, Charles Langton 1856–1932, *Alms Houses, Leas Road*, bequeathed to the parish of Warlingham

Lockton, Charles Langton 1856–1932, *Baker's Wheelwrights Shop on Farleigh Road*, bequeathed to the parish of Warlingham

Lockton, Charles Langton 1856–1932, *Barn and Post Office Cottage by 'The White Lion'*, bequeathed to the parish of Warlingham

Lockton, Charles Langton 1856–1932, *Barn between Glebe Road and 'The White Lion' (long since demolished)*, bequeathed to the parish of Warlingham

Lockton, Charles Langton 1856–1932, *Blanchard's Smithy, Farleigh Road*, bequeathed to the parish of Warlingham

Lockton, Charles Langton 1856–1932, *Bug Hill Road (Now Leas Road)*, bequeathed to the parish of Warlingham

Lockton, Charles Langton 1856–1932, *Bug Hill Road from the Village (Leas Road)*, bequeathed to the parish of Warlingham

Lockton, Charles Langton 1856–1932, *Cottage, Westhall Road, Demolished 1898 (The site of the artist's house 'Teeton')*, bequeathed to the parish of Warlingham

Lockton, Charles Langton 1856–1932, *Cottages and Baker's Wheelwrights, Farleigh Road*, bequeathed to the parish of Warlingham

Lockton, Charles Langton 1856–1932, *Cottages and Baker's Wheelwrights, Farleigh Road*, bequeathed to the parish of Warlingham

Lockton, Charles Langton 1856–1932, *Cottages between 'The Leather Bottle' and Mill House*, bequeathed to the parish of Warlingham

Lockton, Charles Langton 1856–1932, *Court Cottage, North Side (front view), Hamsey Green*, bequeathed to the parish of Warlingham

Lockton, Charles Langton 1856–1932, *Court Cottage, South Side (rear view), Hamsey Green*, bequeathed to the parish of Warlingham

Lockton, Charles Langton 1856–1932, *Crewes Cottages, opposite 'The Leather Bottle'*, bequeathed to the parish of Warlingham

Lockton, Charles Langton 1856–1932, *Horseshoe Cottages, Side/Rear View from Mint Walk, Farleigh Road*, bequeathed to the parish of Warlingham

Lockton, Charles Langton 1856–1932, *Post Office on North-East Side of the Green next to 'The White Lion' Cottage*, bequeathed to the parish of Warlingham

Lockton, Charles Langton 1856–1932, *Side/Rear view of Horseshoe Cottages from Mint Walk*, bequeathed to the parish of Warlingham

Lockton, Charles Langton 1856–1932, *The Font, All Saints' Church*, bequeathed to the parish of Warlingham, 1970

Lockton, Charles Langton 1856–1932, *The Forge, Farleigh Road*, bequeathed to the parish of Warlingham

Lockton, Charles Langton 1856–1932, *'The Leather Bottle' as it was in the 1880s*, bequeathed to the parish of Warlingham

Lockton, Charles Langton 1856–1932, *'The White Lion' as it was in the 1880s*, bequeathed to the parish of Warlingham

Lockton, Charles Langton 1856–1932, *Tydcombe Farm*, bequeathed to the parish of Warlingham

Lockton, Charles Langton 1856–1932, *Tydcombe Farm*, bequeathed to the parish of Warlingham

Lockton, Charles Langton 1856–1932, *Tydcombe Farm from the North-West*, bequeathed to the parish of Warlingham

Lockton, Charles Langton 1856–1932, *Unidentified Farm Buildings (possibly Crewes Farm)*, bequeathed to the parish of Warlingham

Lockton, Charles Langton 1856–1932, *Village Green, South-East Corner*, bequeathed to the parish of Warlingham

Lockton, Charles Langton 1856–1932, *Webbs Cottage, Farleigh Road*, bequeathed to the parish of Warlingham

Lockton, Charles Langton 1856–1932, *Westhall Cottage*, bequeathed to the parish of Warlingham

Lockton, Charles Langton 1856–1932, *Westhall Road (Narrow Lane to Right)*, bequeathed to the parish of Warlingham

Lockton, Charles Langton 1856–1932, *Woodland Scene*, bequeathed to the parish of Warlingham

Lockton, Charles Langton 1856–1932, *Woodland Scene*, bequeathed to the parish of Warlingham

Molesey Library

Helcke, Arnold active 1880–1911, *The Bridge over the Mole*, donated by Veronica Tudor-Williams

Brooklands Museum

Allison, Jane b.1959, *Sir George Edwards (1909–2003)*, donated, © the artist

Alton, Martin b.1957, *Vertical Reality*, donated, © the artist

Aveline, Josephine b.1914, *Hugh Locke King (1856–1926)*, on loan from the Brooklands Society

Boorer, Norman 1916–2004, *Prototype Wellington*, donated

Bromley, Mark *Avro Lancaster*, donated

Broomfield, Keith *Aircraft Designs from Weybridge and Kingston British Aerospace Projects Office since the 1940s*, donated

Broomfield, Keith *Some Aircraft in which Weybridge Design Office Has Been Involved since 1948*, donated

Burnside, Dudley 1912–2005, *Wellingtons in Hangar*, purchased, © the artist's estate

Carless active 20th C, *Hunters Attacking Tanks*, donated

Gaunt, David *Grindlay Peerless on Track*, on loan fom the artist

Hitchman, Fred (attributed to) d.1975, *SE5a in First World War Dogfight*, donated

Linnell, John 1792–1882, *Lady King*, on loan from the Harvey family

Lovesey, Roderick b.1944, *Incident in the Battle*, donated

Miller, Edmund b.1929, *Wellington on Airfield*, donated, © the artist

Nockolds, Roy Anthony 1911–1979, *Breaking the Brooklands Track Record, Kaye Don in Sunbeam*, donated

Nockolds, Roy Anthony 1911–1979, *Bentley on Banking*, on loan from the Brooklands Society

Nockolds, Roy Anthony 1911–1979, *Napier-Railton and Duesenberg on Banking*, on loan from the Brooklands Society

Preston, L. A. *Flight of Wellington Bombers over Airfield at Dusk*, donated

Reid Taylor, Alistair d.c.1993, *Green Racing Car No.6 (possibly a Lotus)*

Reid Taylor, Alistair d.c.1993, *Blue and White Racing Car No.4*

Reid Taylor, Alistair d.c.1993, *Blue Veteran Car*, donated

Reid Taylor, Alistair d.c.1993, *ERA No.6*, donated

Reid Taylor, Alistair d.c.1993, *Three Cars Racing on Brooklands Banking (seen from behind)*, donated

Reid Taylor, Alistair d.c.1993, *Yellow Racing Car No.3*

Reid Taylor, Alistair d.c.1993, *Ronnie Peterson Driving Orange Formula 1 Racing Car*

Reid Taylor, Alistair d.c.1993, *Three Formula 1 Racing Cars (seen from behind)*

Robertson, Duncan *Wellington 'R' for 'Robert' on Daytime Raid*, donated

Smith, David T. *Wellington Maintenance Scene*, purchased

Steel, Roger b.1928, *Jeffrey Quill, OBE, AFC*, donated

Steel, Roger b.1928, *First Flight of the Spitfire*, donated

Sturgess, Arthur c.1930–c.1995, *'Defender of this Sceptred Isle', Spitfire over the Needles*, donated

Sturgess, Arthur c.1930–c.1995, *'R' for 'Robert'*, donated

Surman, David *Wellington 'R' for 'Robert' Ditching in Loch Ness*, donated

Tootall, Ray *Sir Thomas Sopwith*, purchased

Turner, Graham b.1964, *A. V. Roe's First Flight*, on loan from the Verdon-Roe family

unknown artist *Sir Thomas Gore-Brown*, on loan from the Harvey family

unknown artist *Sir Percival Perry, Founder, Ford of Britain*, on loan from the Ford Motor Co.

unknown artist *Storm over Benevenagh*, donated

unknown artist *Wellington 'R' for 'Robert' Ditched in Loch Ness*, donated

unknown artist 20th C, *Hawker Horsley Biplanes in Flight*, donated

unknown artist *Tail Fin Section on Tow*, donated

Waller, Claude b.c.1920, *Vickers Valiant Night Scene*, donated

Waller, Claude b.c.1920, *Tiger Moth over Brooklands*, donated

Weekley, Barry active 1993–2006, *Wellington 'R' for 'Robert' in Flight*

Wells, Henry Tanworth 1828–1903, *Peter Locke King*, on loan from Elmbridge Borough Council

Wilson, Colin b.1949, *Hurricane Landing*, donated

Wootton, Frank 1914–1998, *BOAC Shorts S45A Solent Seaplane, 'Salisbury'*, donated, © the artist's estate

Elmbridge Museum

Bradley *Robert Gill, Railway Pioneer (1796–1871)*, gift from the estate of Mrs Madeline Allen, née Gill, 1986

Brewer, Derek *Cedar House, Cobham*, purchased as part of the Millennium Art Project 'Painting for Posterity' scheme funded by the R. C. Sherriff Rosebriars Trust, 2000

Butler, Villers *Amy Gentry, OBE*, on loan from Weybridge Ladies Rowing Club

Cobb, Charles David b.1921, *HM Torpedo Boat 2015*, donated to the Museum by the Mayor's Secretary, 1985

Dalby, John 1810–1865, *A White Horse with Dappled Legs Standing in a Stable*, gift, 1986

Dawson, M. *Cobham Mill with Houses on Right Bank of a River in the Distance*, purchased after being exhibited at the Thames Valley Art Society's annual exhibition at Kingston Library and Museum, 1974

Edwards (attributed to) *Going to the Post, Goodwood*, on loan

Ewan, Eileen *Swans on the River Wey*, purchased by Avril Lansdell (former Curator of Museum) from Weybridge Arts Society, c.1983

Godfrey, J. *A View of St George's Hill, with Dead Man's Pool in the Foreground*, on permanent loan from Mr Herringshaw

Gray, M. *Esher Road, Showing a Rustic Bridge (now demolished)*, donated anonymously to the Museum via Weybridge Library, 1982

Grosvenor, Jennifer b.1931, *Oxshott Station*, purchased as part of the Millennium Art Project 'Painting for Posterity' scheme funded by the R. C. Sherriff Rosebriars Trust, 2000, © the artist

Hobbes, Ian b.1969, *Cardinal Godfrey School, Sunbury*

Houssard, Charles 1884–1958, *Weybridge Park College*, possibly a gift from Peter Curchod, 1996

Lefevre, M. *The Lock-Keeper's Cottage by the Oil Mills on the River Wey*, gift, 1969

Lock, Edwin active 1929–1961, *The Duchess of York's Monument at Monument Green, Weybridge*, on long-term loan from Miss Lock

Lock, Edwin active 1929–1961, *An Old Chestnut Tree, Which Stood near the 'Ship Inn', High Street, Weybridge*, on long term loan from Miss Lock

Lock, Edwin active 1929–1961, *Shops in the High Street: 'Sough & Son'*, on long-term loan from Miss Lock

Lock, Edwin active 1929–1961, *The Entrance to Springfield Lane,*

Weybridge, on long-term loan from Miss Lock

Outram, Lance *Robert John Brook Gill, Aged Two*, donated as part of the Gill family collection of objects and artefacts, 1985, on loan to Elmbridge Borough Council, Esher

Saunders, Jutta *The Wey Bridge*, purchased, 1970

Scott, Peter Markham 1909–1989, *Flying Geese*, purchased, 1909–1989, on loan from the Rosebriars Trust, © C. Philippa Scott

unknown artist *Lady Louisa Egerton, Wife of Admiral Francis Egerton*, gift, 1973

unknown artist *Beach and Seascape*

unknown artist *Hamm Court Farm, Weybridge*, on long-term loan from Miss Millson

unknown artist *John Phillip Fletcher, Son of Sir Henry Fletcher, of Ashley House, Walton*, gift from Walter Sarel, 1936, on loan to Elmbridge Borough Council, Esher

unknown artist *Maypole on Monument Green, with Figures in 18th Century Costume*, possibly a gift from Mrs Charles Routh, 1914

unknown artist *Portion of Fresco from East Wall of Old St James' Church*, gift, 1910

unknown artist *Prince Charles (b.1948)*, donated by the Borough Surveyor, 1980

unknown artist *Second Walton Bridge*, on loan from Walton Library

unknown artist *'The Newcastle Arms'*, donated to the Council by G. Jarvis & Co. Ltd, 1938

unknown artist *Walton Bridge, with a Cottage on the Left, (possibly 'The Angler's Rest') and a Boat Drawn Up on a Bank of Pebbles*, purchased from Mr G. H. Clark, Sutton, Surrey, 1967

Wallis, Nancy *Baker Street, Weybridge in 1880s (taken from a postcard)*, possibly a gift from Mrs K. Charge, 1972

Wilcox, Doreen *The Ruined Temple*, unclaimed after School Art Exhibition, c.1985

Williams, F. S. *The Weir*, presented by Mrs Lilian Roome, 1955

Surrey History Centre

Lowther, Micheal Angelo *Dog*, on long-term loan from the Dodgson Family Trustees

unknown artist *Dorking Church and Churchyard*, on long-term loan from the Rector and the Parochial Church Council

unknown artist *An Alpine Village*, gift

Sidney H. Sime Memorial Gallery

Sime, Sidney Herbert 1867–1941, *A River in Scotland*, bequeathed by the artist's wife as a memorial to

her husband, © the trustees of the Sidney Sime Memorial Gallery

Sime, Sidney Herbert 1867–1941, *Archway*, bequeathed by the artist's wife as a memorial to her husband, © the trustees of the Sidney Sime Memorial Gallery

Sime, Sidney Herbert 1867–1941, *Autumn Landscape with Pond*, bequeathed by the artist's wife as a memorial to her husband, © the trustees of the Sidney Sime Memorial Gallery

Sime, Sidney Herbert 1867–1941, *Autumn Trees*, bequeathed by the artist's wife as a memorial to her husband, © the trustees of the Sidney Sime Memorial Gallery

Sime, Sidney Herbert 1867–1941, *Autumn Trees*, bequeathed by the artist's wife as a memorial to her husband, © the trustees of the Sidney Sime Memorial Gallery

Sime, Sidney Herbert 1867–1941, *Bare Tree*, bequeathed by the artist's wife as a memorial to her husband, © the trustees of the Sidney Sime Memorial Gallery

Sime, Sidney Herbert 1867–1941, *Cloud over Hill*, bequeathed by the artist's wife as a memorial to her husband, © the trustees of the Sidney Sime Memorial Gallery

Sime, Sidney Herbert 1867–1941, *Clouds*, bequeathed by the artist's wife as a memorial to her husband, © the trustees of the Sidney Sime Memorial Gallery

Sime, Sidney Herbert 1867–1941, *Dark Lakeside*, bequeathed by the artist's wife as a memorial to her husband, © the trustees of the Sidney Sime Memorial Gallery

Sime, Sidney Herbert 1867–1941, *Dark Landscape*, bequeathed by the artist's wife as a memorial to her husband, © the trustees of the Sidney Sime Memorial Gallery

Sime, Sidney Herbert 1867–1941, *Dark Landscape*, bequeathed by the artist's wife as a memorial to her husband, © the trustees of the Sidney Sime Memorial Gallery

Sime, Sidney Herbert 1867–1941, *Dark Landscape*, bequeathed by the artist's wife as a memorial to her husband, © the trustees of the Sidney Sime Memorial Gallery

Sime, Sidney Herbert 1867–1941, *Dark Landscape*, bequeathed by the artist's wife as a memorial to her husband, © the trustees of the Sidney Sime Memorial Gallery

Sime, Sidney Herbert 1867–1941, *Dark Mountains and Boat*, bequeathed by the artist's wife as a memorial to her husband, © the trustees of the Sidney Sime Memorial Gallery

Sime, Sidney Herbert 1867–1941, *Dark Mountains and Water*, bequeathed by the artist's wife as a memorial to her husband, © the trustees of the Sidney Sime Memorial Gallery

Sime, Sidney Herbert 1867–1941, *Dark Pine Trees*, bequeathed by the artist's wife as a memorial to

her husband, © the trustees of the Sidney Sime Memorial Gallery

Sime, Sidney Herbert 1867–1941, *Dark Sky*, bequeathed by the artist's wife as a memorial to her husband, © the trustees of the Sidney Sime Memorial Gallery

Sime, Sidney Herbert 1867–1941, *Dark Sky Tinged White*, bequeathed by the artist's wife as a memorial to her husband, © the trustees of the Sidney Sime Memorial Gallery

Sime, Sidney Herbert 1867–1941, *Dark Sky with White Clouds*, bequeathed by the artist's wife as a memorial to her husband, © the trustees of the Sidney Sime Memorial Gallery

Sime, Sidney Herbert 1867–1941, *Dark Trees*, bequeathed by the artist's wife as a memorial to her husband, © the trustees of the Sidney Sime Memorial Gallery

Sime, Sidney Herbert 1867–1941, *Dark Trees*, bequeathed by the artist's wife as a memorial to her husband, © the trustees of the Sidney Sime Memorial Gallery

Sime, Sidney Herbert 1867–1941, *Dark Trees*, bequeathed by the artist's wife as a memorial to her husband, © the trustees of the Sidney Sime Memorial Gallery

Sime, Sidney Herbert 1867–1941, *Dark Trees and Blue Sky*, bequeathed by the artist's wife as a memorial to her husband, © the trustees of the Sidney Sime Memorial Gallery

Sime, Sidney Herbert 1867–1941, *Dark Trees and Floral Urn*, bequeathed by the artist's wife as a memorial to her husband, © the trustees of the Sidney Sime Memorial Gallery

Sime, Sidney Herbert 1867–1941, *Dark Trees and Light Sky*, bequeathed by the artist's wife as a memorial to her husband, © the trustees of the Sidney Sime Memorial Gallery

Sime, Sidney Herbert 1867–1941, *Dark Trees and Mist*, bequeathed by the artist's wife as a memorial to her husband, © the trustees of the Sidney Sime Memorial Gallery

Sime, Sidney Herbert 1867–1941, *Dark Trees and Sky*, bequeathed by the artist's wife as a memorial to her husband, © the trustees of the Sidney Sime Memorial Gallery

Sime, Sidney Herbert 1867–1941, *Dark Trees and Sky*, bequeathed by the artist's wife as a memorial to her husband, © the trustees of the Sidney Sime Memorial Gallery

Sime, Sidney Herbert 1867–1941, *Dark Trees and White Houses*, bequeathed by the artist's wife as a memorial to her husband, © the trustees of the Sidney Sime Memorial Gallery

Sime, Sidney Herbert 1867–1941, *Dark Trees and White-Tip Clouds*, bequeathed by the artist's wife as a memorial to her husband, © the trustees of the Sidney Sime Memorial Gallery

Sime, Sidney Herbert 1867–1941, *Figure of a Man with Book*, bequeathed by the artist's wife as a memorial to her husband, © the trustees of the Sidney Sime Memorial Gallery

Sime, Sidney Herbert 1867–1941, *Figure of a Woman*, bequeathed by the artist's wife as a memorial to her husband, © the trustees of the Sidney Sime Memorial Gallery

Sime, Sidney Herbert 1867–1941, *Figure of Lady in Grey*, bequeathed by the artist's wife as a memorial to her husband, © the trustees of the Sidney Sime Memorial Gallery

Sime, Sidney Herbert 1867–1941, *Figure of Lady in White*, bequeathed by the artist's wife as a memorial to her husband, © the trustees of the Sidney Sime Memorial Gallery

Sime, Sidney Herbert 1867–1941, *Fir Trees*, bequeathed by the artist's wife as a memorial to her husband, © the trustees of the Sidney Sime Memorial Gallery

Sime, Sidney Herbert 1867–1941, *Flower Painting*, bequeathed by the artist's wife as a memorial to her husband, © the trustees of the Sidney Sime Memorial Gallery

Sime, Sidney Herbert 1867–1941, *Flying Creatures*, bequeathed by the artist's wife as a memorial to her husband, © the trustees of the Sidney Sime Memorial Gallery

Sime, Sidney Herbert 1867–1941, *Forest and Lake*, bequeathed by the artist's wife as a memorial to her husband, © the trustees of the Sidney Sime Memorial Gallery

Sime, Sidney Herbert 1867–1941, *Hills*, bequeathed by the artist's wife as a memorial to her husband, © the trustees of the Sidney Sime Memorial Gallery

Sime, Sidney Herbert 1867–1941, *House by a Lake*, bequeathed by the artist's wife as a memorial to her husband, © the trustees of the Sidney Sime Memorial Gallery

Sime, Sidney Herbert 1867–1941, *Illustrative*, bequeathed by the artist's wife as a memorial to her husband, © the trustees of the Sidney Sime Memorial Gallery

Sime, Sidney Herbert 1867–1941, *Illustrative*, bequeathed by the artist's wife as a memorial to her husband, © the trustees of the Sidney Sime Memorial Gallery

Sime, Sidney Herbert 1867–1941, *Illustrative Design of Fountain and Figures*, bequeathed by the artist's wife as a memorial to her husband, © the trustees of the Sidney Sime Memorial Gallery

Sime, Sidney Herbert 1867–1941, *Imaginary*, bequeathed by the artist's wife as a memorial to her husband, © the trustees of the Sidney Sime Memorial Gallery

Sime, Sidney Herbert 1867–1941, *Lady*, bequeathed by the artist's wife as a memorial to her husband, © the trustees of the Sidney Sime Memorial Gallery

Sime, Sidney Herbert 1867–1941, *Lake, House and Trees*, bequeathed by the artist's wife as a memorial to her husband, © the trustees of the Sidney Sime Memorial Gallery

Sime, Sidney Herbert 1867–1941, *Landscape*, bequeathed by the artist's wife as a memorial to her husband, © the trustees of the Sidney Sime Memorial Gallery

Sime, Sidney Herbert 1867–1941, *Landscape and Dark Sky*, bequeathed by the artist's wife as a memorial to her husband, © the trustees of the Sidney Sime Memorial Gallery

Sime, Sidney Herbert 1867–1941, *Landscape and Patterned Sky*, bequeathed by the artist's wife as a memorial to her husband, © the trustees of the Sidney Sime Memorial Gallery

Sime, Sidney Herbert 1867–1941, *Landscape and Red Sky*, bequeathed by the artist's wife as a memorial to her husband, © the trustees of the Sidney Sime Memorial Gallery

Sime, Sidney Herbert 1867–1941, *Landscape and Sky*, bequeathed by the artist's wife as a memorial to her husband, © the trustees of the Sidney Sime Memorial Gallery

Sime, Sidney Herbert 1867–1941, *Landscape and Sky*, bequeathed by the artist's wife as a memorial to her husband, © the trustees of the Sidney Sime Memorial Gallery

Sime, Sidney Herbert 1867–1941, *Landscape and Sky*, bequeathed by the artist's wife as a memorial to her husband, © the trustees of the Sidney Sime Memorial Gallery

Sime, Sidney Herbert 1867–1941, *Landscape and Sunset*, bequeathed by the artist's wife as a memorial to her husband, © the trustees of the Sidney Sime Memorial Gallery

Sime, Sidney Herbert 1867–1941, *Landscape Decoration*, bequeathed by the artist's wife as a memorial to her husband, © the trustees of the Sidney Sime Memorial Gallery

Sime, Sidney Herbert 1867–1941, *Landscape Decoration*, bequeathed by the artist's wife as a memorial to her husband, © the trustees of the Sidney Sime Memorial Gallery

Sime, Sidney Herbert 1867–1941, *Landscape, Mountain and Lake*, bequeathed by the artist's wife as a memorial to her husband, © the trustees of the Sidney Sime Memorial Gallery

Sime, Sidney Herbert 1867–1941, *Landscape, Mountains*, bequeathed by the artist's wife as a memorial to her husband, © the trustees of the Sidney Sime Memorial Gallery

Sime, Sidney Herbert 1867–1941, *Landscape of Fields and Bay of Water*, bequeathed by the artist's wife as a memorial to her husband, © the trustees of the Sidney Sime Memorial Gallery

Sime, Sidney Herbert 1867–1941, *Landscape, Scottish Mountains*, bequeathed by the artist's wife as a memorial to her husband, ©

the trustees of the Sidney Sime Memorial Gallery

Sime, Sidney Herbert 1867–1941, *Landscape, Scottish Mountains*, bequeathed by the artist's wife as a memorial to her husband, © the trustees of the Sidney Sime Memorial Gallery

Sime, Sidney Herbert 1867–1941, *Landscape, Trees and Green Field*, bequeathed by the artist's wife as a memorial to her husband, © the trustees of the Sidney Sime Memorial Gallery

Sime, Sidney Herbert 1867–1941, *Landscape with Ship*, bequeathed by the artist's wife as a memorial to her husband, © the trustees of the Sidney Sime Memorial Gallery

Sime, Sidney Herbert 1867–1941, *Landscape with Trees*, bequeathed by the artist's wife as a memorial to her husband, © the trustees of the Sidney Sime Memorial Gallery

Sime, Sidney Herbert 1867–1941, *Large Trees*, bequeathed by the artist's wife as a memorial to her husband, © the trustees of the Sidney Sime Memorial Gallery

Sime, Sidney Herbert 1867–1941, *Light Sky and Trees*, bequeathed by the artist's wife as a memorial to her husband, © the trustees of the Sidney Sime Memorial Gallery

Sime, Sidney Herbert 1867–1941, *Lowering Sky on Landscape*, bequeathed by the artist's wife as a memorial to her husband, © the trustees of the Sidney Sime Memorial Gallery

Sime, Sidney Herbert 1867–1941, *Moonscape*, bequeathed by the artist's wife as a memorial to her husband, © the trustees of the Sidney Sime Memorial Gallery

Sime, Sidney Herbert 1867–1941, *Mountain and Water*, bequeathed by the artist's wife as a memorial to her husband, © the trustees of the Sidney Sime Memorial Gallery

Sime, Sidney Herbert 1867–1941, *Mountains*, bequeathed by the artist's wife as a memorial to her husband, © the trustees of the Sidney Sime Memorial Gallery

Sime, Sidney Herbert 1867–1941, *Mountains*, bequeathed by the artist's wife as a memorial to her husband, © the trustees of the Sidney Sime Memorial Gallery

Sime, Sidney Herbert 1867–1941, *Mountains in Scotland*, bequeathed by the artist's wife as a memorial to her husband, © the trustees of the Sidney Sime Memorial Gallery

Sime, Sidney Herbert 1867–1941, *Mountains in Scotland*, bequeathed by the artist's wife as a memorial to her husband, © the trustees of the Sidney Sime Memorial Gallery

Sime, Sidney Herbert 1867–1941, *Mrs Mary Sime*, bequeathed by the artist's wife as a memorial to her husband, © the trustees of the Sidney Sime Memorial Gallery

Sime, Sidney Herbert 1867–1941, *Multi-Coloured Sky*, bequeathed by the artist's wife as a memorial to

her husband, © the trustees of the Sidney Sime Memorial Gallery

Sime, Sidney Herbert 1867–1941, *Mystery by Pool*, bequeathed by the artist's wife as a memorial to her husband, © the trustees of the Sidney Sime Memorial Gallery

Sime, Sidney Herbert 1867–1941, *Painting of Waves*, bequeathed by the artist's wife as a memorial to her husband, © the trustees of the Sidney Sime Memorial Gallery

Sime, Sidney Herbert 1867–1941, *Path through Trees*, bequeathed by the artist's wife as a memorial to her husband, © the trustees of the Sidney Sime Memorial Gallery

Sime, Sidney Herbert 1867–1941, *Patterned Clouds and Sky*, bequeathed by the artist's wife as a memorial to her husband, © the trustees of the Sidney Sime Memorial Gallery

Sime, Sidney Herbert 1867–1941, *Patterned Dark Trees*, bequeathed by the artist's wife as a memorial to her husband, © the trustees of the Sidney Sime Memorial Gallery

Sime, Sidney Herbert 1867–1941, *Patterned Hills*, bequeathed by the artist's wife as a memorial to her husband, © the trustees of the Sidney Sime Memorial Gallery

Sime, Sidney Herbert 1867–1941, *Patterned Hills*, bequeathed by the artist's wife as a memorial to her husband, © the trustees of the Sidney Sime Memorial Gallery

Sime, Sidney Herbert 1867–1941, *Patterned Hills*, bequeathed by the artist's wife as a memorial to her husband, © the trustees of the Sidney Sime Memorial Gallery

Sime, Sidney Herbert 1867–1941, *Patterned House and Trees*, bequeathed by the artist's wife as a memorial to her husband, © the trustees of the Sidney Sime Memorial Gallery

Sime, Sidney Herbert 1867–1941, *Patterned Lake, Sky and Trees*, bequeathed by the artist's wife as a memorial to her husband, © the trustees of the Sidney Sime Memorial Gallery

Sime, Sidney Herbert 1867–1941, *Patterned Landscape*, bequeathed by the artist's wife as a memorial to her husband, © the trustees of the Sidney Sime Memorial Gallery

Sime, Sidney Herbert 1867–1941, *Patterned Landscape*, bequeathed by the artist's wife as a memorial to her husband, © the trustees of the Sidney Sime Memorial Gallery

Sime, Sidney Herbert 1867–1941, *Patterned Landscape*, bequeathed by the artist's wife as a memorial to her husband, © the trustees of the Sidney Sime Memorial Gallery

Sime, Sidney Herbert 1867–1941, *Patterned Landscape*, bequeathed by the artist's wife as a memorial to

her husband, © the trustees of the Sidney Sime Memorial Gallery

Sime, Sidney Herbert 1867–1941, *Patterned Landscape*, bequeathed by the artist's wife as a memorial to her husband, © the trustees of the Sidney Sime Memorial Gallery

Sime, Sidney Herbert 1867–1941, *Patterned Landscape*, bequeathed by the artist's wife as a memorial to her husband, © the trustees of the Sidney Sime Memorial Gallery

Sime, Sidney Herbert 1867–1941, *Patterned Landscape and Trees*, bequeathed by the artist's wife as a memorial to her husband, © the trustees of the Sidney Sime Memorial Gallery

Sime, Sidney Herbert 1867–1941, *Patterned Landscape with Figure of Woman*, bequeathed by the artist's wife as a memorial to her husband, © the trustees of the Sidney Sime Memorial Gallery

Sime, Sidney Herbert 1867–1941, *Patterned Pool*, bequeathed by the artist's wife as a memorial to her husband, © the trustees of the Sidney Sime Memorial Gallery

Sime, Sidney Herbert 1867–1941, *Patterned Sky*, bequeathed by the artist's wife as a memorial to her husband, © the trustees of the Sidney Sime Memorial Gallery

Sime, Sidney Herbert 1867–1941, *Patterned Sky and Trees*, bequeathed by the artist's wife as a memorial to her husband, © the trustees of the Sidney Sime Memorial Gallery

Sime, Sidney Herbert 1867–1941, *Patterned Sky and Trees*, bequeathed by the artist's wife as a memorial to her husband, © the trustees of the Sidney Sime Memorial Gallery

Sime, Sidney Herbert 1867–1941, *Patterned Sky, Lake and Figures*, bequeathed by the artist's wife as a memorial to her husband, © the trustees of the Sidney Sime Memorial Gallery

Sime, Sidney Herbert 1867–1941, *Patterned Skyscape*, bequeathed by the artist's wife as a memorial to her husband, © the trustees of the Sidney Sime Memorial Gallery

Sime, Sidney Herbert 1867–1941, *Patterned Stream*, bequeathed by the artist's wife as a memorial to her husband, © the trustees of the Sidney Sime Memorial Gallery

Sime, Sidney Herbert 1867–1941, *Patterned Tree*, bequeathed by the artist's wife as a memorial to her husband, © the trustees of the Sidney Sime Memorial Gallery

Sime, Sidney Herbert 1867–1941, *Patterned Trees*, bequeathed by the artist's wife as a memorial to her husband, © the trustees of the Sidney Sime Memorial Gallery

Sime, Sidney Herbert 1867–1941, *Patterned Trees*, bequeathed by the artist's wife as a memorial to her husband, © the trustees of the Sidney Sime Memorial Gallery

Sime, Sidney Herbert 1867–

1941, *Patterned Trees and Sky*, bequeathed by the artist's wife as a memorial to her husband, © the trustees of the Sidney Sime Memorial Gallery

Sime, Sidney Herbert 1867–1941, *Patterned Trees and Sky*, bequeathed by the artist's wife as a memorial to her husband, © the trustees of the Sidney Sime Memorial Gallery

Sime, Sidney Herbert 1867–1941, *Patterned Waves*, bequeathed by the artist's wife as a memorial to her husband, © the trustees of the Sidney Sime Memorial Gallery

Sime, Sidney Herbert 1867–1941, *Patterned Winter Tree*, bequeathed by the artist's wife as a memorial to her husband, © the trustees of the Sidney Sime Memorial Gallery

Sime, Sidney Herbert 1867–1941, *Purple Iris and White Pansies*, gift from Mrs Francis Halsey, 1958, © the trustees of the Sidney Sime Memorial Gallery

Sime, Sidney Herbert 1867–1941, *Reclining Female*, bequeathed by the artist's wife as a memorial to her husband, © the trustees of the Sidney Sime Memorial Gallery

Sime, Sidney Herbert 1867–1941, *Red Sky*, bequeathed by the artist's wife as a memorial to her husband, © the trustees of the Sidney Sime Memorial Gallery

Sime, Sidney Herbert 1867–1941, *Red Sky*, bequeathed by the artist's wife as a memorial to her husband, © the trustees of the Sidney Sime Memorial Gallery

Sime, Sidney Herbert 1867–1941, *Scottish Landscape, Mountains with Moon*, bequeathed by the artist's wife as a memorial to her husband, © the trustees of the Sidney Sime Memorial Gallery

Sime, Sidney Herbert 1867–1941, *Scottish River and Trees*, bequeathed by the artist's wife as a memorial to her husband, © the trustees of the Sidney Sime Memorial Gallery

Sime, Sidney Herbert 1867–1941, *Sea and Rocks*, bequeathed by the artist's wife as a memorial to her husband, © the trustees of the Sidney Sime Memorial Gallery

Sime, Sidney Herbert 1867–1941, *Self Portrait*, bequeathed by the artist's wife as a memorial to her husband, © the trustees of the Sidney Sime Memorial Gallery

Sime, Sidney Herbert 1867–1941, *Sky and Bushes*, bequeathed by the artist's wife as a memorial to her husband, © the trustees of the Sidney Sime Memorial Gallery

Sime, Sidney Herbert 1867–1941, *Skyscape*, bequeathed by the artist's wife as a memorial to her husband, © the trustees of the Sidney Sime Memorial Gallery

Sime, Sidney Herbert 1867–1941, *Skyscape*, bequeathed by the artist's wife as a memorial to her husband, © the trustees of the Sidney Sime Memorial Gallery

Sime, Sidney Herbert 1867–

Sime, Sidney Herbert 1867–1941, *Skyscape*, bequeathed by the artist's wife as a memorial to her husband, © the trustees of the Sidney Sime Memorial Gallery

Sime, Sidney Herbert 1867–1941, *Skyscape*, bequeathed by the artist's wife as a memorial to her husband, © the trustees of the Sidney Sime Memorial Gallery

Sime, Sidney Herbert 1867–1941, *Snow-Capped Mountain*, bequeathed by the artist's wife as a memorial to her husband, © the trustees of the Sidney Sime Memorial Gallery

Sime, Sidney Herbert 1867–1941, *Storm*, bequeathed by the artist's wife as a memorial to her husband, © the trustees of the Sidney Sime Memorial Gallery

Sime, Sidney Herbert 1867–1941, *Storm*, bequeathed by the artist's wife as a memorial to her husband, © the trustees of the Sidney Sime Memorial Gallery

Sime, Sidney Herbert 1867–1941, *Storm Clouds and Water*, bequeathed by the artist's wife as a memorial to her husband, © the trustees of the Sidney Sime Memorial Gallery

Sime, Sidney Herbert 1867–1941, *Storm Scene*, bequeathed by the artist's wife as a memorial to her husband, © the trustees of the Sidney Sime Memorial Gallery

Sime, Sidney Herbert 1867–1941, *Stormy Sky*, bequeathed by the artist's wife as a memorial to her husband, © the trustees of the Sidney Sime Memorial Gallery

Sime, Sidney Herbert 1867–1941, *Sun through Clouds*, bequeathed by the artist's wife as a memorial to her husband, © the trustees of the Sidney Sime Memorial Gallery

Sime, Sidney Herbert 1867–1941, *Sunflower (recto)*, bequeathed by the artist's wife as a memorial to her husband, © the trustees of the Sidney Sime Memorial Gallery

Sime, Sidney Herbert 1867–1941, *Across the Field (verso)*, bequeathed by the artist's wife as a memorial to her husband, © the trustees of the Sidney Sime Memorial Gallery

Sime, Sidney Herbert 1867–1941, *Sunset Landscape*, bequeathed by the artist's wife as a memorial to her husband, © the trustees of the Sidney Sime Memorial Gallery

Sime, Sidney Herbert 1867–1941, *Sunset Sketch*, bequeathed by the artist's wife as a memorial to her husband, © the trustees of the Sidney Sime Memorial Gallery

Sime, Sidney Herbert 1867–1941, *Swirling Sky*, bequeathed by the artist's wife as a memorial to her husband, © the trustees of the Sidney Sime Memorial Gallery

Sime, Sidney Herbert 1867–1941, *Swirling Sky*, bequeathed by the artist's wife as a memorial to her husband, © the trustees of the Sidney Sime Memorial Gallery

Sime, Sidney Herbert 1867–1941,

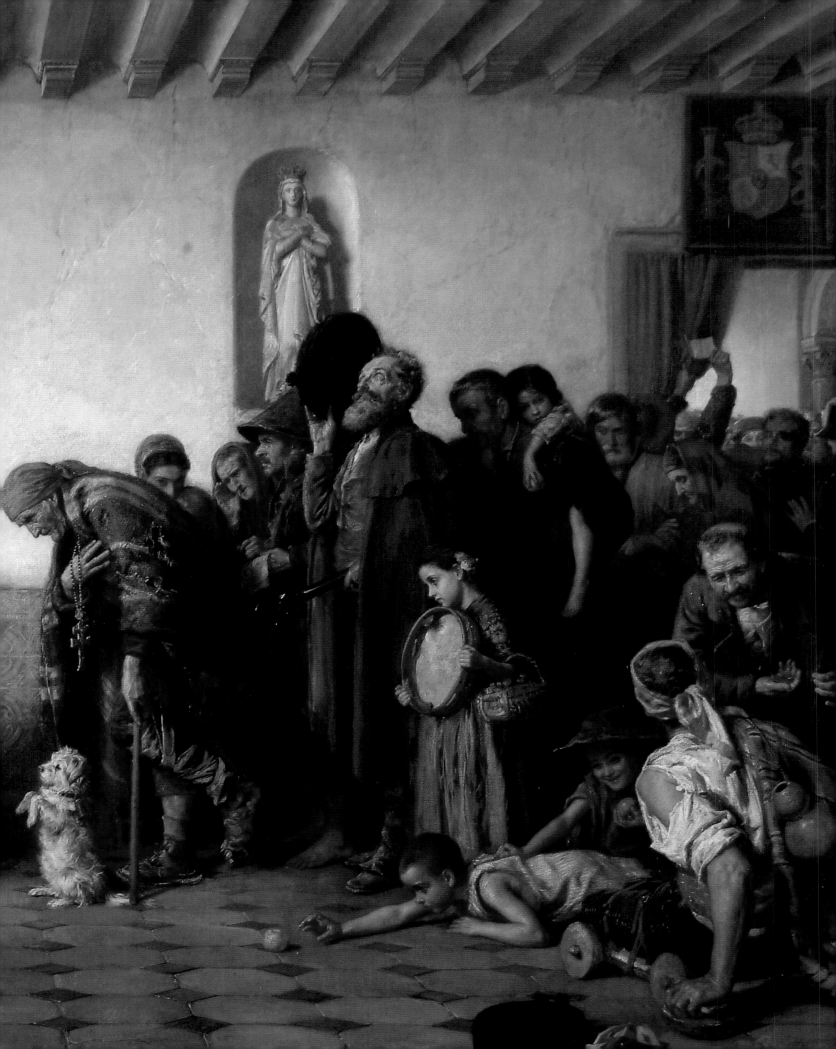

Collection Addresses

Ash

Ash Museum
Cemetery Chapel, Ash Church Road GU12 6LX
Telephone 01252 542341

Ash Vale

The Army Medical Services Museum
Keogh Barracks, Ash Vale GU12 5RQ
Telephone 01252 868612

Byfleet

Byfleet Heritage Society
Byfleet Library, High Road, Byfleet KT14 7QN
Telephone 01932 351559

Byfleet Village Hall
54 High Road, Byfleet KT14 7QL
Telephone 01932 336236

Camberley

Surrey Heath Borough Council
Surrey Heath House, Knoll Road, Camberley GU15 3HD
Telephone 01276 707100

Surrey Heath Museum
Surrey Heath House, Knoll Road, Camberley GU15 3HD
Telephone 01276 707284

The Royal Logistic Corps Museum
Princess Royal Barracks, Deepcut, Camberley GU16 6RW
Telephone 01252 833371

Caterham

Caterham Valley Library
Stafford Road, Caterham CR3 6JG
Telephone 01883 343580

East Surrey Museum
1 Stafford Road, Caterham CR3 6JG
Telephone 01883 340275

Chertsey

Chertsey Museum
The Cedars, 33 Windsor Street, Chertsey KT16 8AT
Telephone 01932 565764

Dorking

Dorking and District Museum
The Old Foundry, 62 West Street, Dorking RH4 1BS
Telephone 01306 876591

Mole Valley District Council
Pippbrook, Dorking RH4 1SL
Telephone 01306 882948

Egham

Egham Museum
Literary Institute, High Street, Egham GU25 4AN
Telephone 01784 434483

Royal Holloway, University of London
Egham Hill, Egham TW20 0EX
Telephone 01784 443664

Epsom

Epsom & Ewell Borough Council
The Town Hall, The Parade, Surrey KT18 5BY
Telephone 01372 732100

Esher

Esher Library
Old Church Path, Esher KT10 9NS
Telephone 01372 465036

Ewell

Bourne Hall Museum
Spring Street, Ewell KT17 1UF
Telephone 0208 394 1734

Ewell Court Library
Ewell Court House, Lakehurst Road, Ewell KT19 0EB
Telephone 0208 393 1069

Farnham

Crafts Study Centre, University College
for the Creative Arts
Falkner Road, Farnham GU9 7DS
Telephone 01252 891450

Farnham Maltings Association Limited
Bridge Square, Farnham GU9 7QR
Telephone 01252 718001

Museum of Farnham
Willmer House, 38 West Street, Farnham GU9 7DX
Telephone 01252 715094

University College for the Creative Arts
at the Farnham Campus
Falkner Road, Farnham GU9 7DS
Telephone 01252 892668

Godalming

Godalming Library
Bridge Street, Godalming GU7 1HT
Telephone 01483 422743

Godalming Museum
109a High Street, Godalming GU7 1AQ
Telephone 01483 426510

Godalming Town Council
Municipal Buildings, Bridge Street, Godalming GU7 1HR
Telephone 01483 523074

Waverley Borough Council
The Berrys, Council Offices, Godalming GU7 1HR
Telephone 01483 523000

Godstone

The White Hart Barn, Godstone Village Hall
High Street, Godstone RH9 8DT
Telephone 01883 742224

Guildford

Guildford House Gallery
155 High Street, Guildford GU1 3AJ
Telephone 01483 444741

Guildford Museum
Castle Arch, Quarry Street, Guildford GU1 3SX
Telephone 01483 444865

Queen's Royal Surrey Regimental Museum
Clandon Park, West Clandon, Guildford GU4 7RQ
Telephone 01483 223419

Surrey Archaeological Society
Castle Arch, Quarry Street, Guildford GU1 3SX
Telephone 01483 532454

The Guildford Institute of the University of Surrey
Ward Street, Guildford GU1 4LH
Telephone 01483 562142

The Guildhall
High Street, Guildford GU1 3AA
Telephone 01483 444035

University of Surrey
Guildford GU2 7XH
Telephone 01483 689167

Watts Gallery
Down Lane, Compton, Near Guildford GU3 1DQ
Telephone 01483 810235

Watts Mortuary Chapel
Down Lane, Compton, Near Guildford GU3 1DN
Telephone 01483 810684

Yvonne Arnaud Theatre
Millbrook, Guildford GU1 3UX
Telephone 01483 440077

Haslemere

Haslemere Educational Museum
78 High Street, Haslemere GU27 2LA
Telephone 01428 642112

Kingston-Upon-Thames

Surrey County Council
County Hall, Penrhyn Road, Kingston-Upon-Thames
KT1 2DW
Telephone 0208 541 9098

Leatherhead

Leatherhead and District Local History Society
Hampton Cottage, 64 Church Street,
Leatherhead KT22 8DP
Telephone 01372 386348

Lingfield

The Guest House, Lingfield Library
Vicarage Road, Lingfield RH7 6HA
Telephone 01342 832058

Oxted

Oxted Library
12 Gresham Road, Oxted RH8 0BQ
Telephone 01883 714225

Tandridge District Council
Station Road East, Oxted RH8 0BT
Telephone 01883 732973

Redhill

East Surrey Hospital
Canada Avenue, Redhill RH1 5RH
Telephone 01737 231719

Reigate

Holmsdale Natural History Club
14 Croydon Road, Reigate RH2 0PG
Telephone 01737 767411

Reigate & Banstead Borough Council
Town Hall, Castlefield Road, Reigate RH2 0SH
Telephone 01737 276000

Reigate Priory Museum
Reigate Priory, Bell Street, Reigate RH2 7RL
Telephone 01737 222550

Ripley

Send and Ripley Museum
Village Hall Car Park, Portsmouth Road GU23 6AF
Telephone 01483 725517

Staines

Spelthorne Borough Council
Council Offices, Knowle Green, Staines TW18 1XB
Telephone 01784 446433

Spelthorne Museum
1 Elmsleigh Road, Staines TW18 4PN
Telephone 01784 457970

Sunbury-on-Thames

Sunbury Library
The Parade, Staines Road West,
Sunbury-on-Thames TW16 7AB
Telephone 01932 783131

Thames Ditton

Dittons Library
Mercer Close, Thames Ditton KT7 0BS
Telephone 0208 398 2521

Warlingham

Warlingham Library, Lockton Collection
Shelton Avenue, Warlingham CR6 9NF
Telephone 01883 622479

West Molesey

Molesey Library
The Forum, Walton Road, West Molesey KT8 2HZ
Telephone 0208 979 6348

Weybridge

Brooklands Museum
Brooklands Road, Weybridge KT13 0QN
Telephone 01932 857381

Elmbridge Museum
Public Library, Church Street, Weybridge KT13 8HJ
Telephone 01932 843573

Woking

Surrey History Centre
130 Goldsworth Road, Woking GU21 6ND
Telephone 01483 518760

Worplesdon

Sidney H. Sime Memorial Gallery
Worplesdon Memorial Hall, Perry Hill,
Worplesdon GU3 3RF
Telephone 01483 232117

Index of Artists

In this catalogue, artists' names and the spelling of their names follow the preferred presentation of the name in the Getty Union List of Artist Names (ULAN) as of February 2004, if the artist is listed in ULAN.

The page numbers next to each artist's name below direct readers to paintings that are by the artist; are attributed to the artist; or, in a few cases, are more loosely related to the artist being, for example, 'after', 'the circle of' or copies of a painting by the artist. The precise relationship between the artist and the painting is listed in the catalogue.

Aborn, John (d.1915) 165
Adams, D. 16
Ainsworth 165
Akehurst, R. D. 178
Allam (active 1878–1880) 17, 18
Allen, Michael (b.1976) 113
Allen, William Herbert (1863–1943) 65
Allison, Jane (b.1959) 86, 113, 196
Alston, Rowland Wright (1895–1958) 133, 235
Alton, Martin (b.1957) 196
Anderson, Freda (b.1942) 113
Anderson, Will 62
Annear, Jeremy (b.1949) 38
Ansdell, Richard (1815–1885) 38
Archdale, W. M. 14
Arnold, Harriet Gouldsmith (c.1787–1863) 33
Assadourigil, H. 24
Atherton, Linda (b.1952) 38
Atroshenko, Viacheslav (1935–1994) 38
Aveline, Josephine (b.1914) 196
S. E. B. 165
Bachba, Emma 113–115
Backer 38
Baigent, R. (active c.1920–c.1940) 184
Ball, Robin (1910–1979) 74
Barratt, Krome (1924–1990) 115
Barter, Paul (b.1945) 115
Bauerle, Karl Wilhelm Friedrich (1831–1912) 133
Beckett, John (1799–1864) 24–26
Bennett, John (active 20th C) 97
Bentos, Achille (b.1882) 3
Bernhardt, Sarah (1844–1923) 38
Biggs, R. Henry (active c.1960–1970) 8
Bigland, Percy (1858–1926) 38
Billington, Neville (active 1990s) 8
Birch, David (1895–1968) 175
Birch, William Henry David (1895–1968) 58
Bloemen, Jan Frans van (1662–1749) 90, 175
Blunt, Wilfrid (1901–1987) 133
Body, A. M. (active 1975–1982) 33
Bone, Charles (b.1926) 175
Boorer, Norman (1916–2004) 196
Booth, Ashton (b.c.1925) 65

Bosher, M. A. 18
Botticelli, Sandro (1444/1445–1510) 48, 88
Boughton, Thomas (1812–1893) 86
Box, Helena (d.1914) 26
Boxall, William (1862–1937) 26
Bradley 204
Brason, Paul (b.1952) 38
Bratby, John Randall (1928–1992) 39
Breanski, Alfred de (1852–1928) 18
Brett, John (1830–1902) 39
Brettingham, L. 18
Brewer, Derek 204
Bridgman, Marjorie 4
Briggs, Henry Perronet (1791/1793–1844) 175
British (English) School 82, 184
British School 39, 40
Brockman, Dale 65
Bromley, Mark 196
Brooks, Henry Jamyn (1865–1925) 175
Broomfield, Keith 196, 197
Brown, Frank (active 1950s–1970s) 184
Brown, Mather (1761–1831) 3
Bruce, H. A. 40
Bryson, Frank 62
Burford, Eva (active 1970–1985) 84
Burgess, John Bagnold (1830–1897) 40
Burne-Jones, Edward (1833–1898) 133
Burnside, Dudley (1912–2005) 197
Butcher, Fred 84
Butler, H. C. 40
Butler, Paul (b.1947) 74
Butler, Villers 204
Caffyn, Walter Wallor (1845–1898) 32, 87
Carey, Charles William (1862–1943) 18, 33, 42
Carless (active 20th C) 197
Carter, William (1863–1939) 87, 96, 175, 235
Chamberlain, Brenda (1912–1971) 42
Chamberlin, Mason the elder (1727–1787) 176
Chandler, Allen (1887–1969) 165
Charlton, Mervyn (b.1945) 87
Charters, Cecil 163
Cheesman, Harold (1915–1983) 87
Christie, Ernest C. (1863–1937) 15, 100, 102–107, 178

Clamp, Laura (b.1980) 74
Clay, Arthur (1842–1928) 176
Cleaver, James (1911–2003) 33
Cobb, Charles David (b.1921) 204
Collier, John (1850–1934) 77, 179
Collins, Charles II (1851–1921) 26, 27
Collins, Helen (1921–1990) 27, 87
Collins, Samuel William (1849–1892) 27
Collins, William (1788–1847) 42
Conti, Tito (1842–1924) 42
Cooke, Edward William (1811–1880) 43
Cooper, A. L. 8
Cooper, Byron (1850–1933) 166–169
Cooper, Thomas Sidney (1803–1902) 43
Courtnell, Louise (b.1963) 43
Couzens, Charles (active 1838–1875) 133
Covey, Molly Sale (1880–1917) 43
Cowdrey 33
Cracknell, Jennifer (active 1960s–1970s) 87
Creswick, Thomas (1811–1869) 43
Cripps, Clara 87
Crome, John (1768–1821) 43
Cullerne, Rennie 59
Cummings, Vera (1891–1949) 169
Curzon-Price, Paddy 16, 179
Cuthbert, Alan (1931–1995) 115
Daele, Charles van den (d.1873) 44
Daghani, Arnold (1909–1985) 115, 116
Dalby, John (1810–1865) 204
Danckerts, Hendrick (1625–1680) 58
Daniell, William (1769–1837) 18, 97
Daniels, Alfred (b.1924) 176
Davidson, Thomas 98
Dawe, George (1781–1829) 59
Daws, Philip (b.1845) 27
Dawson, Henry (1811–1878) 44
Dawson, Henry Thomas (1841/1842–after 1896) 44
Dawson, M. 204
Deayton-Groom, (Major) (active 20th C) 98
Dellar, Roger (b.1949) 116
Desanges, Louis William (1822–c.1887) 3
Devitt, Margaret (b.1944) 116
Di Duca, Adrian (b.1966) 117
Dicksee, Frank (1853–1928) 169
Dillon, Frank (1823–1909) 44
Dixon, G. 44
Dobie, Joan 169
Dodd, Francis (1874–1949) 44
Donne, Walter J. (1867–1930) 82
Dorman, Ernest A. (b.1928) 179, 180
Drane, Herbert Cecil (1860–1932) 27
Duff, Pamela (b.1920) 77
Dunn, John Selwyn (1895–1978) 87
Earl, William Robert (1806–1880) 18
Eddis, Eden Upton (1812–1901) 96
Edmonds, Frances (b.1953) 74
Edwards 204
Edwards, George (1908–2003) 117
Ellis, Cuthbert Hamilton (1909–1987) 14

Ellis, Edwin (1841–1895) 44
Elmer, Stephen (c.1714–1796) 66, 67
Elmore, Alfred (1815–1881) 44
Enright, Madeleine 117
Ewan, Eileen 204
Ewbank, S. 169
Faed, Thomas (1826–1900) 44
Farthing, Stephen (b.1950) 117
Fedden, Mary (b.1915) 88
Fielding, Anthony V. C. (1787–1855) 45
Fildes, Luke (1844–1927) 45, 176
Fisher, Percy Harland (1867–1944) 8, 9, 11, 223
Fitzgerald, Paul (b.1922) 117, 118
Frankewitz, Bruno (1897–1982) 3
Freeman, William (c.1838–1918) 186
Frith, William Powell (1819–1909) 45, 170
Frowd, Thomas T. J. (active 1847–1864) 19
Fuller, Eugene (1889–1968) 19
C. F. G. 27
Gainsborough, Thomas (1727–1788) 11
Gallon, Robert (1845–1925) 19
Ganley, Brogan (b.1971) 118
Gaunt, David 197
Gere, Margaret (1878–1965) 45
Gherardo di Giovanni del Forla (1445–1497) 47
Gibbs, Charles (1834–1910) 27
Gildea, Paul (b.1956) 118
Gilson, J. 14
Girardot, Ernest Gustave (1840–1904) 45
Glindoni, Henry Gillard (1852–1913) 45
Godfrey, J. 204
Gogin, Alma (1854–1948) 183
Gotlib, Henryk (1890–1966) 118
Gowing, Lawrence (1918–1991) 45
Grace, Harriet Edith (active 1877–1909) 179
Grace, James Edward (1851–1908) 67
Graham, Jane 235
Graham, Nora (active 1990s) 12
Graham, Peter (1836–1921) 46
Grant, Henry (active 1950–1980) 98
Grant, Keith (b.1930) 118
Graves, Henry Richard (1818–1882) 133
Gray, M. 205
Green, Phillip (active 1980s–1990s) 12
Greenham, Peter (1909–1992) 46
Gridnev, Valery (b.1956) 169
Groom, Jon (b.1953) 46
Grosvenor, Jennifer (b.1931) 205
Gunn, Herbert James (1893–1964) 46, 176
Hadlow, Pauline 12
Halliday, Edward Irvine (1902–1984) 108
Hamme, Alexis van (1818–1875) 46
Hardy, Anne 118
Hardy, Frederick Daniel (1826–1911) 46
Hardy, James II (1832–1889) 46
Harris, Alfred John (1835–1916) 19, 20, 27, 28, 33
Harris, W. J. 108
Harris, William E. (1860–1930) 20, 67
Harris Hughes, Susanna (b.1947) 88

Harrison, Christopher (b.1935) 88
Harrison, Terry (b.1947) 12
Harvey, Michael Anthony (1921–2000) 28
Harwood Eve 78, 88
Haughton, Desmond (b.1968) 46
Hayner, D. 84
Hayward, J. F. 34
Hazelwood, David B. (1932–1994) 47
Helcke, Arnold (active 1880–1911) 194
Henderson, H. B. 4
Hepple, Norman (1908–1994) 47, 119
Herkomer, Herman (1863–1935) 176
Herkomer, Hubert von (1849–1914) 47
Herringham, Christiana Jane (1852–1929) 47, 48, 88
Heydorn, S. 48
Highmore, Joseph (1692–1780) 108
Hill, J. R. 169
Hill, O. F. 12
Hitchman, Fred (d.1975) 197
Hobbes, Ian (b.1969) 205
Hockey, James (1904–1990) 74
Hodgson, John Evan (1831–1895) 48
Holl, Frank (1845–1888) 48
Hollams, F. Mabel (1877–1963) 83
Holland, Doreen 34
Holland, James (1800–1870) 48, 141
Holmes, Betty 12
Hook, James Clarke (1819–1907) 49
Hooper, George (1910–1994) 183
Hornsby-Smith, Stephen (b.1969) 119
Horsley, John Callcott (1817–1903) 49
Hossain, Zahura Sultana 74
Houssard, Charles (1884–1958) 205
Howard, E. 20
Hoyt Desmond, Charlotte (d.1971) 88
Hubbard, Steven (b.1954) 49
Hughes, Arthur (1832–1915) 133
Hulk, Abraham (1813–1897) 32
Hunter, Thomas Jr (b.1821) 67
Hunter, Thomas Sr (b.1771) 67
Huston (active mid-20th C) 88
Hutton, John Campbell (1906–1978) 67, 68
Hyde, William (1859–1925) 88
P. W. J. 186
Jackowski, Andrzej (b.1947) 119, 120
Jagger, David (1891–1958) 49
Jekyll, Gertrude (1843–1932) 78, 234
Jervas, Charles (c.1675–1739) 176
Jordan, Denham (1836–1920) 28
Jordan, Valerie 120
Jory, Miriam (b.1933) 12
Jutsum, Henry (1816–1869) 20
Kannreuther, Caroline (b.1964) 120
Kerr-Lawson, James (1865–1939) 49
Kilpatrick, Alan (b.1963) 120
King, N. H. 34
Kiste, Hans 29
Kneller, Godfrey (1646–1723) 83, 107, 176
Knight, A. Roland (active 1810–1840) 20

Koike, Masahiro 49
Krish, Raymond 63
Landseer, Edwin Henry (1802–1873) 49
Lang, Kathryn (b.1979) 122
Langdon, Dorothy (b.1886) 29
Langer, D. 62
Langley, Walter (1852–1922) 83
Larcher, Dorothy (1884–1952) 62
László, Philip Alexius de (1869–1937) 49, 51
Laurence, Samuel (1812–1884) 88
Lawrence, William (b.1957) 122
Le Mare, Frederick (b.1846) 89
Leader, Benjamin Williams (1831–1923) 51
Lee, Ada 89
Lefevre, M. 205
Leighton, Edmund Blair (1853–1922) 51
Leighton, Frederic, 1st Baron Leighton of Stretton (1830–1896) 133
Leizle, Eric 169
Lejeune, Henry (1820–1904) 51
Lely, Peter (1618–1680) 109
Leslie, Charles (1835–1890) 51
Lewis 109
Lewis, J. (active early 20th C) 78
Linnell, John (1792–1882) 51, 197
Lintott, (Miss) 96
Little, George Leon (1862–1941) 183
Llewellyn, William Samuel Henry (1854–1941) 176
Lock, Edwin (active 1929–1961) 205
Lockhart, William Ewart (1846–1900) 5
Lockton, Charles Langton (1856–1932) 188, 189, 191–194
Lomas, Rod (active 1970s–1980s) 12
Long, Edwin (1829–1891) 51, 52
Loutherbourg, Philip James de (1740–1812) 68
Lovesey, Roderick (b.1944) 197
Lowther, Micheal Angelo 208
Lyndon, Herbert (active 1860–1922) 20
MacLeod, Fay 16
Maclise, Daniel (1806–1870) 52, 190
MacWhirter, John (1839–1911) 52
Mann, Joshua Hargrave Sams (active 1849–1884) 52
Marion 184
Marsham, Cara 89
Martin, Ellis (1881–1977) 78
May, F. T. (active c.1957–1968) 89, 96, 97
May, Robert W. 14
McCannell, Ursula Vivian (b.1923) 68, 89
McCannell, William Otway (1883–1969) 68
McClure, David (1926–1998) 122
McLynn, Rebecca (b.1966) 122
Melville, Arthur (1855–1904) 20, 134
Mendoza, June (active 1960–2006) 122
Miles, John James (active c.1906–c.1920) 3
Millais, John Everett (1829–1896) 52, 121
Miller, Edmund (b.1929) 197
Mohanty, Michael 122, 123
Moosajee, Mariya 182
Morland, George (1763–1804) 52, 53
Morley, Robert (1857–1941) 68
Morpurgo, Simonetta 53

Morris, Mali (b.1945) 89
Morshead, Arminell (1889–1966) 89
Müller, William James (1812–1845) 53
Munthe, Ludwig (1841–1896) 53
Murphy, Clara Joan (1900–1986) 68
Murray, David (1849–1933) 53
Muszynski, Leszek (b.1923) 50, 74, 123
Narraway, William Edward (1915–1979) 89
Nash, John Northcote (1893–1977) 53
Nasmyth, Patrick (1787–1831) 34, 53
Neale, Christine (active 1989–1992) 29
Newbolt, Thomas (b.1951) 123, 150
Newman, Beryl (1906–1991) 3
Newyin, R. Graham 69
Nicholson, William (1872–1949) 77
Nicol, Erskine (1825–1904) 54
Nicoll, John 14
Niemann, Edward H. (active 1863–1887) 20
Nilsson, Johannes (1757–1827) 169
Noakes, Michael (b.1933) 177, 184
Nockolds, Roy Anthony (1911–1979) 197, 198
Noël, Jules Achille (1815–1881) 54
Northwood, Sally (b.1935) 75
Oades, Emily W. (1836–1897) 20
O'Brian, Henry (active 1950s) 78–80
Oki, Yuji (b.1949) 123
Olivier, Herbert Arnold (1861–1952) 54
Orpen, William (1878–1931) 54
Outram, Lance 206
Painter, R. S. 15
Parfitt, Ida (1910–1977) 89
Passey, Charles Henry (active 1870–c.1894) 91
Paxson, Pat (b.1939) 123, 124
Peacock, Ralph (1868–1946) 69
Peel, James (1811–1906) 80
Penn, William Charles (1877–1968) 124
Penycate, Dorothy (1910–1969) 91
Perraudin, Wilfrid (b.1912) 91
Perry, Roy (1935–1993) 12, 13
Pether, Henry (active 1828–1865) 91
Pettie, John (1839–1893) 54
Pettit, D. 59
Pettitt, Charles (1831–1885) 22
Phillips, Patrick Edward (1907–1976) 54
Phillips, Thomas (1770–1845) 177
Pollock, Fred (b.1937) 54
Poole, Paul Falconer (1807–1879) 54, 55
Poole, R. F. 55
Popesco, George (b.1962) 22
Potter, Frank Huddlestone (1845–1887) 22
Potter, Violet 171
Powell, Alex 113–115
Preston, L. A. 198
Prinsep, Valentine Cameron (1838–1904) 134
Prokofiev, Oleg (1928–1998) 124
Prossen, Henry 171
Pyne, James Baker (1800–1870) 55
Ramos, Theodore (b.1928) 124
Ramsay, Allan (1713–1784) 177

Randoll, F. 91
Ranken, Marguerite (1897–1973) 91
Ransom, George (1843–1935) 69
Reason, Cyril (b.1931) 124
Redgrove 15
Reeves, Sidney (b.c.1925) 69
Reid Taylor, Alistair (d.c.1993) 198, 199
Reynolds, Joshua (1723–1792) 15
Rice, B. A. 13
Richardson, Jonathan the elder (1665–1745) 109
Riley, John (1646–1691) 109
Riley-Smith, Louise (b.1946) 55
Riviere, Briton (1840–1920) 55
Riviere, Hugh Goldwin (1869–1956) 55
Roberts, David (1796–1864) 55
Robertson, Duncan 199
Robertson, Walford Graham (1866–1948) 134
Robinson (active 20th C) 4
Robinson, Margaret J. 22
Rocke, R. Hill (Major) 98
Rose, Walter John (1857–1954) 29
Ruff, Agnes (active 1958–2001) 29
Russell, H. M. (active mid-20th C) 69
Russell, John (1745–1806) 91, 101, 109, 212
Russell, William (1780–1870) 92
Russian School 108
L. E. S. 59
Sajó, Gyula (1918–1979) 125
Sams, Ian (b.1945) 13
Sargent, John Singer (1856–1925) 134, 181
Satchel, Hannah (b.1980) 125
Saunders, Jutta 206
Scandrett, Graham (active 1960s–2006) 13
Schofield, Winifred (d.2000) 92
Scholfield, Margaret (active 1922–1932) 92
Schumacher, Vera (active 1911–1913) 83
Scott, Peter Markham (1909–1989) 206
Scott, William Wallace (1795–1883) 56
Scott-Moore, Elizabeth (1904–1993) 56
Seaby, Allan William (1867–1953) 69
Shannon, Charles Haslewood (1863–1937) 134, 135
Shannon, James Jebusa (1862–1923) 56
Shephard, Rupert (1909–1992) 56
Shepherd, Frank 182
Shotter, R. 15
Sime, Sidney Herbert (1867–1941) 61, 161, 210, 211, 213–222, 224–233
Smallman-Tew, F. (active 20th C) 80, 82
Smart, W. H. (active mid-20th C) 82
Smith, David T. 199
Smoothey, Ronald (1913–1996) 92, 93
Solomon, Abraham (1824–1862) 56
Somer, Paulus van I (1576–1621) 109
Spoade, John 22
Spooner, Wendy 125, 126
Spurrier, Lanta (c.1910–c.1980) 93
Stanfield, Clarkson (1793–1867) 56
Stedman, Roy (b.1933) 93
Steel, Roger (b.1928) 199
Stevens (active mid-20th C) 182

Stevens, Thomas (active 1889–1893) 186
Stewardson, Thomas (1781–1859) 177
Stockbridge, Gill (b.1938) 126
Stokoe, Elizabeth Calvert (active 1933–1937) 29
Stokoe, Jack (b.1980) 126
Stone, Helen C. (1884–1947) 60
Stoneham, Olive (d.1966) 94
Storr, Milton (active 1888–1891) 171
Stott, William (1857–1900) 135
Stuart, Margaret (active 1924–1988) 94
Sturgess, Arthur (c.1930–c.1995) 199
Summerville, D. 15
'Sunny', Batchelor 31
Surman, David 199
Swann, Marilyn (b.1932) 126
Swedish School 41, 171
Swift, Richard (b.1918) 126
Swinstead, George Hillyard (1860–1926) 4
Swynnerton, Annie Louisa (1844–1933) 57
Syer, John (1815–1885) 57
Symonds, William Robert (1851–1934) 177
Ta'Bois, Zweena 94
Taylor, Frank (b.1946) 127
Tenison, W. R. C. (active 1926–1929) 94
The Sunbury Art Group 185
Tipton, Heather (b.1941) 127
Todd, Daphne (b.1947) 57
Todman 31
Tolansky, Ottilie (1912–1977) 57
Tolles, W. 22
Tomes, Marjorie 171, 172
Tootall, Ray 200
Troyon, Constant (1810–1865) 57
Tura, Cosmè (c.1430–1495) 47
Turk, W. 69, 71
Turner, Graham (b.1964) 200
Turner, Joseph Mallord William (1775–1851) 78
Unwin, Ida M. (1869–1953) 95
Van Jones 97
Vasey, M. 185
Verney, John (1913–1993) 63, 73
Verrall, Nicholas (b.1945) 127
Vingoe, Francis (b.1880) 23
H. W. 59
J. C. W. 23
Waite, Edward Wilkins (1854–1924) 32, 95
Waller, Claude (b.c.1920) 200, 202
Wallis, Nancy 207
Wanklyn, Joan (active 1956–1994) 15
Warrenne, Joan 32
Watson, D. 83
Watson, Stella (d.1980s) 32
Watts, George Frederick (1817–1904) 10, 30, 70, 81, 110, 132, 135–140, 142–149, 151–160, 162, 201, 235
Webb, James (c.1825–1895) 57
Weber, Theodor Alexander (1838–1907) 58
Weekley, Barry (active 1993–2006) 202
Wei, Feng 127
Wells, Henry Tanworth (1828–1903) 58, 183, 202

Wesson, Edward (1910–1983) 95
Whamond, Andrew (b.1947) 75
Whishaw, Anthony (b.1930) 128
Whymper, Emily (1833–1886) 173
Widdes, C. A. 95
Wilcox, Doreen 207
Wilkie, Mary (b.1915) 95
Wilkins, Clive 58
Williams, F. S. 207
Williams, Juliet Nora (d.1937) 173
Willis-Pryce, George (1866–1949) 108
Wilson, Colin (b.1949) 202
Windsor, Alan (b.1931) 128
Winfield, G. E. 185
Wolf, Tim 128
Wolski, Stanislaw Polian (1859–1894) 173
Wondrausch, Mary (b.1923) 75
Wonnacott, Thomas (1835–1918) 73
Wooderson, J. 73
Wootton, Frank (1914–1998) 202
Wragg, Gary (b.1946) 58
Wright, Dorothy (1910–1996) 14
Wright, Joseph (1756–1793) 32
Wright, Peter (active 20th C) 128
Wright, Steve (b.1975) 128

Supporters of the Public Catalogue Foundation

Master Patrons

The Public Catalogue Foundation is greatly indebted to the following Master Patrons who have helped it in the past or are currently working with it to raise funds for the publication of their county catalogues. All of them have given freely of their time and have made an enormous contribution to the work of the Foundation.

Peter Andreae, High Sheriff for Hampshire *(Hampshire)*

Sir Nicholas Bacon, DL, High Sheriff for Norfolk *(Norfolk)*

Peter Bretherton *(West Yorkshire: Leeds)*

Richard Compton *(North Yorkshire)*

George Courtauld, Vice Lord Lieutenant for Essex *(Essex)*

The Marquess of Downshire *(North Yorkshire)*

Patricia Grayburn, MBE DL *(Surrey)*

Tommy Jowitt *(West Yorkshire)*

Sir Michael Lickiss *(Cornwall)*

Lord Marlesford, DL *(Suffolk)*

Phyllida Stewart-Roberts, OBE, Lord Lieutenant for East Sussex *(East Sussex)*

Leslie Weller, DL *(West Sussex)*

Financial Support

The Public Catalogue Foundation is particularly grateful to the following organisations and individuals who have given it generous financial support since the project started in 2003.

National Sponsor

Christie's

Benefactors (£10,000–£50,000)

Bradford City Council
The Bulldog Trust
A. & S. Burton 1960 Charitable Trust
The John S. Cohen Foundation
Christie's
Deborah Loeb Brice Foundation
The Foyle Foundation
Hampshire County Council
Peter Harrison Foundation
Hiscox plc
ICAP plc
Kent County Council
The Linbury Trust

The Manifold Trust
Robert Warren Miller
The Monument Trust
Miles Morland
Stavros S. Niarchos Foundation
Norfolk County Council
Provident Financial
RAB Capital
Renaissance West Midlands
Saga Group Ltd
University College, London
University of Leeds
Garfield Weston Foundation

Series Patrons (Minimum donation of £2,500)

Harry Bott
Janey Buchan
Dr Peter Cannon-Brookes
Paul & Kathrine Haworth
Neil Honebon
The Keatley Trust

David & Amanda Leathers
Miles Morland
Stuart M. Southall
University of Surrey
Peter Wolton Charitable Trust

Catalogue Patrons
(£1,000–£10,000)

ACE Study Tours
Adams and Remers
Marcus & Kate Agius
The AIM Foundation
Amberley Castle
Archant Ltd
Mr Ian Askew
Baisingstoke and Deane Borough
 Council
Barlow Robbins LLP
Mr James & Lady Emma Barnard
Sir Christopher Bland
The Charlotte Bonham-Carter
 Charitable Trust
H. R. Pratt Boorman Family
 Foundation
The Bowerman Charitable Trust
Bramdean Asset Management LLP
Peter Bretherton
Mrs T. Brotherton-Ratcliffe
Mr & Mrs Patrick Burgess
Mr & Mrs Mark Burrell
Arnold J. Burton Charitable Trust
C. J. R. & Mrs C. L. Calderwood
Chichester District Council
The Timothy Colman Charitable
 Trust
Cornwall County Council
Mr S. J. D. Corsan
Graeme Cottam & Gloriana Marks
 de Chabris
Elaine Craven, Earl Street
 Employment Consultants Ltd
Harriet Cullen
Deborah Gage (Works of Art) Ltd
The Duke of Devonshire's Charitable
 Trust
Sir Harry Djanogly, CBE
Professor Patrick & Dr Grace Dowling
Lord Douro
East Sussex County Council
Eastbourne Borough Council
EEMLAC through the Association
 for Suffolk Museums
Lord & Lady Egremont
Sir John & Lady Elliott
Andrew & Lucy Ellis
Essex County Council
Mrs M. A. G. Fenston
Elizabeth & Val Fleming
The Friends of the Royal Pavilion,
 Art Gallery & Museums, Brighton
The Friends of York Art Gallery
Christopher & Catherine Foyle
Lewis & Jacqueline Golden
Gorringes

Mrs Patricia Grayburn, MBE DL
Charles Gregson
The Gulland Family
David Gurney
Philip Gwyn
G. Laurence Harbottle
The Hartnett Charitable Trust
Hazlitt, Gooden & Fox Ltd
Heartwood Wealth Management Ltd
David & Prue Hopkinson
The J. and S. B. Charitable Trust
The Keatley Trust
Kent Messenger Group
Garrett Kirk, Jr
The Leche Trust
Leeds Art Collections Fund
Leeds City Council
Leeds Philosophical and Literary
 Society
Mark & Sophie Lewisohn
Maidstone Borough Council
The Marlay Group
The Mercers' Company
Rupert Nabarro
Newcastle City Council
Oakmoor Trust
Sir Idris Pearce
Portsmouth City Council
John Rank
The Hans and Märit Rausing
 Charitable Trust
Roger & Jane Reed
Michael Renshall, CBE MA FCA
Sir Miles & Lady Rivett-Carnac
Rothschild Foundation
Royal Cornwall Museum
Russell New
Scarfe Charitable Trust
Caroline M. Southall
Stuart M. Southall
Southampton City Council
Mrs Andrew Stewart-Roberts, OBE
Mr Peter Stormonth Darling
Strutt and Parker
Suffolk County Council, through the
 Association for Suffolk Museums
The Bernard Sunley Charitable
 Foundation
The John Swire 1989 Charitable Trust
The Tanner Trust
Chloe Teacher
The Thistle Trust
The Walland Trust Fund
Leslie Weller, DL
West Sussex County Council

PRACTICING RESEARCH IN WRITING STUDIES

Reflexive and Ethically Responsible Research

Research and Teaching in Rhetoric and Composition
Michael M. Williamson, series editor

Market Matters: Applied Rhetoric Studies and Free Market Competition
Locke Carter (ed.)

Composition(s) in the New Liberal Arts
Joanna Castner Post & James A. Inman (eds.)

Writing Assessment in the 21st Century: Essays in Honor of Edward M. White
Norbert Elliot & Les Perelman (eds.)

Collaborating(,) Literature(,) and Composition: Essays for Teachers and Writers of English
Frank Gaughan & Peter H. Khost

Professing Literacy in Composition Studies
Peter N. Goggin

Rhetoric in(to) Science Inquiry: Style as Invention in the Pursuit of Knowledge
Heather Graves

Judaic Perspectives in Rhetoric and Composition Studies
Andrea Greenbaum & Deborah H. Holdstein (eds.)

Basic Writing in America: The History of Nine College Programs
Nicole Pepinster Greene & Patricia J. McAlexander (eds.)

Before and After the Tutorial: Writing Centers and Institutional Relationships
Nicholas Mauriello, William J. Macauley, Jr., & Robert T. Koch, Jr. (eds.)

Writing in the Research University: A Darwinian Study of WID with Cases from Civil Engineering
Martha Davis Patton

Practicing Research in Writing Studies: Reflexive and Ethically Responsible Research
Katrina M. Powell & Pamela Takayoshi (eds.)

Composing Other Spaces
Douglas Reichert Powell & John Paul Tassoni (eds.)

Including Students in Academic Conversations: Principles and Strategies for Teaching Theme-Based Writing Courses across the Disciplines
Deborah F. Rossen-Knill & Tatyana Bakhmetyeva

Directed Self-Placement: Principles and Practices
Dan Royer & Roger Gilles (eds.)

Dead Letters: Error in Composition, 1873-2004
Tracy Santa

Who Can Afford Critical Consciousness?: Practicing a Pedagogy of Humility
David Seitz

Composing Feminism(s): How Feminists Have Shaped Composition Theories and Practices
Kay Siebler

The Elephant in the Classroom: Race and Writing
Jane Bowman Smith

Principles and Practices: Discourses for the Vertical Curriculum
Margaret M. Strain (ed.)

PRACTICING RESEARCH IN WRITING STUDIES

Reflexive and Ethically Responsible Research

edited by

Katrina M. Powell
Virginia Tech

and

Pamela Takayoshi
Kent State University

HAMPTON PRESS, INC.
NEW YORK, NEW YORK

Printed in the United States of America

Library of Congress Cataloging-in-Publication Data

Practicing research in writing studies : reflexive and ethically responsible research / edited by Katrina M. Powell and Pamela Takayoshi.
 p. cm. -- (Research and teaching in rhetoric and composition)
 Includes bibliographical references and index.
 ISBN 978-1-61289-088-3 -- ISBN 978-1-61289-089-0 (pbk.)
 1. English language--Rhetoric--Study and teaching. 2. Report writing--Study and teaching. 3. Composition (Language arts)--Research. 4. Written communication--Research. 5. Report writing--Research. 6. Rhetoric--Research.
I. Powell, Katrina M., 1976- II. Takayoshi, Pamela.
 PE1404.P635 2012
 808'.042071--dc23

 2012009492

Hampton Press, Inc.
307 Seventh Avenue
New York, NY 10001

CONTENTS

Foreword, *Ruth E. Ray* vii

1 Introduction: Revealing Methodology 1
 Katrina M. Powell and Pamela Takayoshi

PART I: THEORIES OF RESEARCH

2 A Modest Proposal for Common Ground and Language for 31
 Research in Writing
 Michael M. Williamson and Brian Huot

3 Ethics from Praxis 59
 Ellen Barton and Richard Marback

4 A Grounded Theory Approach for Studying Writing 81
 and Literacy
 Kerrie R. H. Farkas and Christina Haas

5 The Construction of Research Problems and Methods 97
 Pamela Takayoshi, Elizabeth Tomlinson, and Jennifer Castillo

6 Materializing the Material as a Progressive Method and 123
 Methodology
 Eileen E. Schell

PART II: RESEARCH AND INSTITUTIONAL PRACTICES

7 Practicing Socially Progressive Research: Implications for 143
 Research and Practice
 Sharon James McGee

8 Disability Studies Methodology: Explaining Ourselves to 159
 Ourselves
 Margaret Price

9 Critical Validity Inquiry 187
 Jeffrey W. Perry

10 Critical Pedagogy as Inquiry: Challenging Programmatic 213
 and Institutional Traditions
 Kelly Belanger and April Heaney

11 Archive This! Queering the Archive 237
 K. J. Rawson

12 Identifying Choices: Rhetorical Tactics in a Prison Art Program 251
 Wendy Wolters Hinshaw

 PART III: REFLEXIVE/DIFFRACTIVE RESEARCH PRACTICES

13 Composing Activist Research 275
 Stuart Blythe

14 Discourses of Preservation: The Gullah Community and 293
 Rhetorical Construction
 Annette Harris Powell

15 Considering Confidentiality in Research Design: Developing 307
 Heuristics to Chart the Un-chartable
 Christa B. Teston

16 Troubling Research: A Field Journey through 331
 Methodological Decision Making
 Gloria E. Jacobs

17 An Experiential Approach to Literacy Studies 349
 Gwen Gorzelsky

18 Narrative as Method and Methodology in Socially 373
 Progressive Research
 Joanne Addison

19 Transnational Literate Lives: An Emerging Research 293
 Methodology for a Globalized World
 Cynthia L. Selfe and Gail E. Hawisher

Epilogue: The Challenges of Conducting Ethically Responsible 409
 Research, *Gesa E. Kirsch*

About the Editors and Contributors 415
Author Index 421
Subject Index 429

FOREWORD

What have composition scholars been doing over the past 25 years? That period of time about covers my professional life in the field, from the PhD program through tenure and promotion to full professor. It also covers the time from the publication of the first major book to describe the field methodologically to the publication of this volume. In 1987, Stephen North's *The Making of Knowledge in Composition: Portrait of an Emerging Field* described the forces that he saw shaping composition as an academic discipline—a discipline he defined as "the study of the doing, learning and teaching of writing." Whereas North looked back at the conceptual influences on our field, Powell and Takayoshi use this volume to look forward. They invite us to move beyond past practices to embrace change, broaden our concept of research, and imagine bigger roles for our work and ourselves, both inside and outside the university. Whereas North tried to establish meaning and stability in the field by describing core practices that would help us determine what counts as knowledge, Powell and Takayoshi work to destabilize these early meanings and practices by arguing the necessity, now, of challenging what we have come to know and how we have come to know it. They argue that the field must turn back on itself to question and critique its research practices (the "reflexive" part of this book) in order to become more responsive to emerging social and ethical issues and to extend our "use value" beyond academe. The editors have been inspired by the feminist dictum to eliminate hierarchies (e.g., between theory and practice, researcher and subjects, university and community) and to subject our process of researching and knowledge making to greater scrutiny.

The social and intellectual forces that motivate the contributors to this book are far more extensive than those that motivated North in the 1980s. Whereas he was concerned about the status and sustainability of composition as a discipline,

Powell and Takayoshi are concerned about the worldly role of composition—how our work can better reflect our times; how we can document and shape the literacy learning called for in a complex global community that is linked through technology; and how our scholarship might bring about more just social relations. This extended role is the result of many changes in the field over the past 25 years, including the turn away from texts, writers, and the writing process to the sociocultural environment in which literate practices develop; the move beyond the study of native English speakers in a single classroom to the study of diverse students who speak multiple languages and inhabit many geographic locations; and the explosion of what Selfe and Hawisher (this volume) call the "tools of globalization"—Internet, cell phone, instant messaging, Skype, and other forms of new media. Selfe and Hawisher remind us that the physical and virtual places and spaces people occupy affect their literacy learning and, necessarily, affect research practices. The transnational scope of literate practices also calls for different ways of representing and distributing our research beyond the academic article and book. To be effective scholars, we also must consider reporting our findings in the form of the community report, the public presentation, the Web site, and the blog. Selfe and Hawisher propose that it is time to replace North's early description of the field. Having moved beyond "the study of the doing, learning and teaching of writing," we are now engaged in "the cultural ecology of literacy," which includes "how literacy is related in complex ways to existing cultural milieu; educational practices and values; social formations like race, class and gender; political and economic trends and events; family practices and experiences; and material conditions—among many other factors." Indeed, if this book is any indication, composition scholars hold themselves to high standards in addressing this most difficult agenda.

All the contributors to this collection seem to recognize and embrace the complexity of our work in the 21st century. Each provides thought-provoking ideas, questions, and strategies for investigating the "ecology of literacy" and for continually scrutinizing the assumptions and values underlying our research. The book is therefore interesting and exciting to experienced researchers, as well as to scholars who are new to the field. Being a composition researcher is more challenging now than it was 25 years ago, and the stakes are higher. In the 1980s, we asked, "Is what we do *scholarly?*" and we looked to other disciplines for answers. In the 1990s, many of us began to ask, "What can we contribute to *other* fields?" and we collaborated with colleagues in the social sciences and medical fields to publish our work outside of composition. Now we ask, "How does what we do *matter* in the world?" All the contributors to this book answer that question in their own way, and their challenging inquiries make me, a long-time researcher who has tried to develop along with the field, want to keep studying and learning anew.

—Ruth E. Ray

1

REVEALING METHODOLOGY

Katrina M. Powell and Pamela Takayoshi

... feminist researchers seek to eliminate hierarchies of knowledge construction. We are sensitive to our place in such hierarchies, so we disclose the multiple, historically specific positions we hold in relation to both study questions and participants. That is, we attempt to "write ourselves into the analysis" (Gilgun and McLeod 1999, 185). ... I maintain that we have not written ourselves in nearly enough.
 —Lois Presser (2005, p. 2067)

The problem is not that we tailor but that so few researchers reveal how we do this work.
 —Michelle Fine (1996, p. 218)

The best feminist analysis ... insists that the inquirer her/himself be placed in the same critical plane as the overt subject matter, thereby recovering the entire research process for scrutiny in the results of research.
 —Sandra Harding (1987, p. 9)

Feminist attention to (and insistence on) the relationship between ideologies and methodologies has foregrounded important ethical, methodological, and ideological issues faced by researchers in many contexts, whether that researcher is engaged in work grounded in explicitly feminist goals and perspectives or not.[1] There are important lessons to be learned from feminist theorists writing about methodological matters. Sandra Harding (1987) carefully distinguishes between methods (techniques for collecting data; p. 2), methodology ("a theory and analysis of how research does or should proceed," p. 3), and epistemology ("a

theory of knowledge," p. 3). Methodologies—as theories of how research does or should proceed—are conceptually quite distinct from methods—techniques for practice. The careful distinction between *methods* and *methodologies* is suggestive of the value feminist methodological theories offer to any researcher committed to understanding how research practice works to create knowledge. Identifying specific goals for methodology, Fonow and Cook (2005) write, "feminist methodology involves the description, explanation, and justification of techniques used in feminist research and is an abstract classification that refers to a variety of methodological stances, conceptual approaches, and research strategies" (p. 2213). Likewise, Taylor and Rupp (2005) assert, "what is distinctive about feminist methodology is not the use of particular techniques but rather an epistemological understanding of how knowledge is generated, how it is reported, and how it is used. ... In particular, self-reflexivity about the impact of researchers' gender and—if only recently much attended to—sexual identity on the research process is crucial" (p. 2116). What Taylor and Rupp underscore is the significant value of feminist *methodologies* for any research practice; although not tied to any specific methods, feminist methodology examines how knowledge is made through empirical research. Although feminist *methods* may not be appropriate or fitting to any research project, then, feminist *methodologies* can meaningfully contribute to our understanding of research as a knowledge-making practice generally.

A central concern of feminist epistemology and methodology has been self-reflexivity. Ingraham (2006), for example, cites Judith Butler's exhortation to remain actively critical of our assumptions: "as Butler warns in *Precarious Life*, we must be ever alert to our complicity in presumptions that may unintentionally result in securing oppressive interests. The remedy, she argues, is to keep the debate open and continue to question our assumptions" (p. 310). The impulse to keep debate open and question assumptions takes specific shape in relationship to research practice, as feminist methodologists have called on researchers to explicitly reflect on their epistemological, ideological, and subjective commitments and about their own positionality (vis-à-vis the research site, participants, data collection, as well as in the representation). Fonow and Cook (2005) suggest that reflexivity is "the tendency of feminists to reflect on, examine critically, and explore analytically the nature of the research process" (p. 2218). They later note that, "reflexivity has also come to mean the way researchers consciously write themselves into the text, the audience's reactions to and reflections on the meaning of the research, the social location of the researcher, and the analysis of disciplines as sites of knowledge production" (p. 2219). Michelle Fine (1996) is especially interested in the ways researchers represent themselves and their participants in what she calls "a delicate tailoring of texts." Of this tailoring, she notes, "The problem is not that we tailor but that so few researchers reveal *how* we do this work" (p. 218). Lois Presser (2005) agrees that revealing how the work is done is not only necessary but that "we have not written ourselves in nearly enough" (p. 2067).

In this collection, we consciously use the term self-*reflexive* as opposed to self-*reflective*. Both reflective and reflexive come from the same Latin root, *reflectere* (to bend back, to turn around, to retrace one's step), but whereas *reflective* is associated with deep or careful thought generally, *reflexive* carries with it a more systematic and methodological significance: "of a method, theory, etc.: that takes account of itself or especially the effect of the personality or presence of the researcher on what is being investigated" (OED). The words are so closely related that such a distinction might seem to be merely an academic exercise, but the distinction is an important one related to the focus of this collection. We are concerned not with deep or careful thought generally but with a particular kind of method: the self-reflexive narratives of researchers working in systematic, methodological ways (what Rich Haswell [2005] has described as replicable, aggregable, data-based research). We are not speaking here about strict personal narrative or the kind of research that relies on the author's personal experiences as its only data source. Instead, we are interested in subjectivity as it intersects with systematic, methodologically explicit research. Although reflexivity is the term we choose, we are open to challenging this common metaphor as well. Feminist philosopher Karen Barad (2007) offers a challenge to the notions of reflective and reflexivity that we feel is worth noting here. In *Meeting the Universe Halfway*, Barad discusses quantum physics' contribution to understanding "scientific practice and its relationship to ethics" (p. 6) and argues for the notion of "agential realism" in understanding the discursive practices and relationships in methodology. In building her theory, she first distinguishes between reflection and diffraction, an important distinction scientifically as well as philosophically. For Barad, the terms reflection or reflexivity are not acceptable metaphors because of their association with mirrors, and consequently with their association with exact representation. She says, "Mirrors upon mirrors, reflexivity entails the same old geometrical optics of reflections" (p. 88). Her "aim is to disrupt the widespread reliance on an existing optical metaphor—namely, reflection—that is set up to look for homologies and analogies between separate entities. By contrast, diffraction, as I argue, does not concern homologies but attends to specific material entanglements" (p. 88). In particular, Barad suggests that scientific and social theories can work together rather than as foils for each other (as they often are used); the "diffractive methodology" she offers engages both scientific and social

> theories in dynamic relationality to the other, being attentive to the iterative production of boundaries, the material-discursive nature of boundary-drawing practices, the constitutive exclusions that are enacted, and the questions of accountability and responsibility for the reconfigurings of which we are a part. ... Like the diffraction patterns illuminating the indefinite nature of boundaries—displaying shadows in "light" regions and bright spots in "dark" regions—the relation of the social and the scientific is a relation of "exteriority within." (p. 93)

For Barad, reflection is inadequate to describe a researcher's "looking back"; diffraction is much more precise because of its insistence on the complicated relationships between the elements involved in any research site. Barad's sense of diffractive methodology highlights the complexities of research and helps to trouble our own use of the term in this chapter. While this theory of diffractive methodology shares much with feminist epistemologies of reflexive practice, the move from reflective to diffractive focuses precisely on this collection's desire to reveal "the specific material entanglements" of research and display "shadows in 'light' regions and bright spots in 'dark' regions" (p. 93). Just as Barton and Marback (this collection) trouble what can be meant by so-called socially progressive research. Barad helps us trouble the very notions of reflexivity—not only its terminology but its narrative form.

As editors imagining this collection, we shared with Fine, Presser, and Fonow and Cook a desire for more revealing scholarship that captured the dilemmas faced by researchers at various stages of their research process and articulated the lessons those dilemmas present for future researchers. The authors in this collection capture a range of dilemmas encountered in their conduct of research and interrogate what their experiential knowledge reveals about the potentials and limitations of empirically based work. Writing self-reflexively, the authors use their experiences as researchers to think about disciplinary, epistemological, and ethical issues involved in the work of research, in this way, answering Joanne Addison's (1997) call for research that provides "the opportunity to see how the research affected the researcher as well as how the researcher affected it" (p. 117). Understanding how the personal informs or interacts with the professional is an important step in developing methodologically rigorous practices—it is one way to account for the influence of the individual researcher on the replicability of research design. These chapters contribute to a public reflection on the part of some researchers in how they have been involved in the making of research-based knowledge. We are not suggesting that *all researchers* should reveal the personal subjectivity from which they write or use their research reflectively as these authors do; instead, we are interested in the creation of a critical space in which some attention is paid to the ways our research plays a role in the making of knowledge and the subsequent representation of it. This move to self-reflexivity is one contextualized within a rich body of feminist methodologies. In this introductory chapter, we first contextualize the collection within these existing feminist methodological theories and suggest the ways our research matters. We believe the authors in this collection contribute meaningfully to the feminist challenge to think explicitly about epistemologies and ethics of our research practices.

METHODOLOGICAL MATTERS: FEMINIST REFLEXIVITY AS A (PROBLEMATIZED) MODEL FOR LITERACY RESEARCH

In the insistence on researcher reflexivity, feminist methodologists call on researchers to provide transparency and accountability. Numerous feminist researchers have recognized, as Cressida Heyes (2003) does, that "my personal motivations are, as always, deeply intertwined with the structure of my arguments" (p. 1096). Such a recognition is not meant to limit what can be learned from systematic, data-based research but rather is meant to point to an area of methodology which needs to be accounted for, a critical research practice Addison (1997) describes as "laying open and studying our epistemological stances while collecting and analyzing data" (p. 114). In part motivated by social constructionist theories of language and reality, such a critical research practice recognizes that "absolute claims should not be made about the world and ... social categories like gender have no meaning until they are put in a human context and interpreted through human eyes" (McKenna & Kessler, 2006, p. 343). Deborah Cameron (1997) similarly argues that "analysis is never done without preconception, we can never be absolutely non-selective in our observations, and where the subject of observation and analysis has to do with gender it is extremely difficult to subdue certain expectations" (p. 48).

Written representations of research tend to de-emphasize the researcher's nonacademic frameworks and investments, as writers negotiate what Kirsch and Mortensen (1996) call "the thin line between self-centered display and revealing positionality that researchers must negotiate when they foreground themselves in their texts" (p. xxvii). This thin line between self-centered display and meaningful reflexivity is present any time a researcher writes herself into the research. It is, indeed, a fine line to negotiate, and it is one that provokes a range of audience response, as Richard Miller (Symposium Collective, 2001) rightly points out: "there are always going to be those who are suspicious of your motives for revealing seemingly personal information, and there are always going to be those who insist that you always, in every venue and in every moment, front what they consider to be vitally important personal information"(p. 60). Caught within "such fractured responses" (Miller, p. 60), researchers responding to feminist calls to write themselves into the research need guidance. The ways other researchers have negotiated—either more or less successfully—this thin line provides some models for practice.

In her case studies of one group of women's uses of literacy in their spiritual growth, for example, Beth Daniell (2003) provides a careful model for practice. The significant problem Daniell faced when writing about her research is one shared by all researchers working with large collections of data:

what I write must be somehow true to the empirically collected data, that is, to the tapes of the interviews and to the 161 transcript pages of the women's responses. What I write, I believe, must reflect what the Mountain City Al-Anon women said in answer to the questions I asked. The story I tell must be not just mine or the culture's but also my research participants'. ... I don't want this book to be about me, although I know that it is and can't help being. (pp. 175-176)

In her Appendix, "An Essay on Research and Telling the Truth," Daniell is explicitly self-reflexive, revealing the struggle in deciding how to write herself into the narrative and the decision making behind the amount she does end up revealing. She considers the potential effects her study (and most importantly, its conclusions) had on the women: "My view of them as a community created to a large degree through their literate practices has given them a new way to see themselves and their relationship to one another" (p. 25). She does not erase herself from the research site or the interactions she observed and participated in. But most significantly, she reveals her own "little narrative" when it corroborates or provides another window of understanding on the six women's "little narratives." Little narratives, as opposed to the Grand Narratives of history,

examine literacy in particular local settings, the best of them presenting the contradictions and complexities of specific literate practices. While such little narratives of literacy offer valuable insights into literate behaviors and while they may theorize on these social practices, they seldom make statements that claim to be valid for literate persons in general or literate cultures in general. These studies assume, rather, that literacy is multiple, contextual, and ideological. (p. 4)

In the end, Daniell negotiates the fine balance between personal revelation and scholarly knowledge, it seems to us, by sharing her own little narrative as a key part of the process of making knowledge in this site. By treating her research experience as a little narrative, recognizing it as local, contextual, and specific, Daniell provides a model for researchers negotiating the fine balance between self-centered display and self-reflexivity.

Writing ourselves into the narrative of our work is very complex work (indeed, Daniell notes, "the problem isn't, as research courses had led me to believe, doing research with human subjects but in writing it" [p. 173]). At the heart of this complexity is a tension between "reality" and "representation." Kathleen Canning (1994), interested in "the historical analysis of representation as opposed to the pursuit of a discernible, retrievable historical 'reality,'" writes that "rather than simply reflecting social reality or historical context, language is seen instead as constituting historical events and human consciousness" (pp. 370, 369). This distinction between reality as it exists out "there" somewhere and the linguistic *representation* of reality suggests the significance of language partic-

ularly in self-reflexive research methodology. Specifically, it is important to remember that research itself is a linguistic representation and self-reflexivity is a linguistic construction. Research is a way we work with others, often resulting in some kind of linguistic representation (presentations or written manuscripts). This collection is an exploration of the discourses of research. The authors in this collection are interested in how and why discourses of research emerge, in how and why we research, and in how and why who we are and what we value matters. Additionally, the reflections of researchers are themselves a linguistic construction. They are not the "true" story of what happened behind the scenes of the research nor are they any more valuable than a research narrative that does not involve explicit attention to the researcher herself.

An assumption informing our work as editors has been that "when we compose stories of our lives we are making choices as to how we will fashion and refashion those aspects of our experience and identities" and "those choices are shaped not only by our reading of a particular situation and ourselves, but also by narratives that dominate our minds and world at the time" (Herrington, in Symposium Collective, 2001, p. 48). In the same way that "objective" researchers make choices as to how to fashion their research narrative, self-reflexive researchers make choices as to how to fashion their reflexive research narrative. Self-reflexive methodologies, then, are themselves constructs that narrow one's experiences down to a particular invested representation. The partiality of such perspective does not negate its value; instead, we might take these partial, interested, and even contradictory perspectives as nudges to think more fully about our research practices as knowledge-making practices. Ellen Cushman and Terese Quinsatao Monberg (1998) distinguish between self-reflexivity and "a more socially responsible reflexive research" that "uses self-reflection and active nostalgia in order to establish, maintain, and develop relationships between participants and researchers" (cited by Cushman, in Symposium Collective, 2001, p. 45). These reflections are best understood, perhaps, as heuristic in their ability to contribute to some change in researchers' future practices. Specifically, we believe feminist foregrounding of the subjectivity of the researcher contributes to richer, more robust understandings of research practices for us all, no matter what we call that kind of "strategic contemplation" (Kirsch & Royster, 2010, p. 656).

In their essay, "Feminist Rhetorical Practices: In Search of Excellence," Gesa Kirsch and Jacqueline J. Royster (2010) define as one of the key tenets of feminist rhetorical practice, "strategic contemplation." Their definition of this concept allows for the "noticing [of] patterns unseen or perhaps seen in a different way— the traces of the stream—that may not be visible without standing back, reflecting, observing, and reconnecting. This sort of back-and-forth movement calls for work that is not merely analytical but also embodied, grounded in the communities from which it emanates" (p. 659). The metaphors Kirsch and Royster use throughout their piece include landscape, fluidity, web, matrix—each suggesting the profound complexities that occur within research sites and projects (as does Barad's notion of diffractive methodology). Kirsch and Royster argue that this

moment in the field, where we have moved forward from "historical rescue, recovery, and (re)inscription" (p. 648), reveals a "tectonic shift" in the landscape, where the "evolution in methodological patterns" have gained a "coherence and normalizing" (p. 642). Kirsch and Royster suggest that the complexity (and sometimes chaos) of research, rather than being a disadvantage, might be viewed as a positive symptom of the multidimensionality of one's project. Kirsch and Rohan's (2008) *Beyond the Archives*, and Schell and Rawson's (2010) *Rhetorica in Motion* capture this "tectonic shift" Kirsch and Royster identify. Indeed, these collections insist that researchers work consciously and rigorously in light of the varying perspectives we have: a light that is not reflective, perhaps, of the "real" of the situation, but rather diffractive, accounting for the multilayered complexities of language, definition, and reality.

In addition to reflexivity, collaboration is a central issue for feminist researchers. Foregrounding themselves as participants in the knowledge-making potential of research led Patti Lather and Chris Smithies (1997) to understand their relationship with their research participants differently: "this work has made a claim on us to not drown the poem of the other with the sound of our own voices, as the ones who know, the 'experts' about how people make sense of their lives and what searching for meaning means" (p. xvi). Indeed, feminist researchers are deeply concerned about the relationships enacted through research practice, about the roles of researchers and participants (a term preferred over "subjects"), and about honoring the voices of all participants—in not drowning out the voices of participants with "the sound of our own voices." One strategy that feminists suggest for complicating the centrality of the researcher as meaning maker is *working with* rather than merely observing or taking from research participants. For example, Kirsch (1997) suggests that potential problems involving representation require more involvement with and input from research participants:

> Feminist scholars urge us to collaborate with participants during all stages of research: to solicit their input in the design, interpretation, and reports of our studies. ... Whether we are quoting students, research participants, colleagues, or writing teachers, we need to consult with them about when and what to quote, in what contexts, and for what purpose. Only when we begin to collaborate with the writers we study and the students we teach can we hope to represent the voices and views of others without misrepresenting or distorting their realities. (p. 199)

In this way, collaboration with participants in our research allows us not only to build more equitable working relationships but collaboration also becomes a way to better represent the realities of participants. In other words, collaboration contributes to a richer, more accurate understanding of the data we collect and represent.

Although collaboration addresses several problems of research relationships and representation, Taylor and Rupp (2005) discovered through their ethnographic study of drag queens in Key West that "the issue of power dynamics in feminist research is a complicated one" (p. 2122). They recognize, for example, that "even as we work to collaborate with those we are researching, [researchers] hold power in formulating questions and analyzing results" (p. 2123). But as lesbians and as feminist researchers, they found that "the drag queens had other kinds of power, particularly gendered power as men. And they did not hesitate to use their power to remind us that education and economic security are not everything" (p. 2123). In a self-reflexive essay published separately from the research-based book they published, Taylor and Rupp explain how they negotiated sometimes complex power relationships in the field. For example, they promised half their book royalties to start a community fund for the drag queens, and when they refused one drag queen's demand for a separate cut, the participant refused permission for Taylor and Rupp to use her interview. As they note, "It was their world, and in that sense, we, as strangers in a strange land, had far less power than they. At the same time, as the ones who were telling their stories, we held a great deal of power both to reveal information they might have wished they had withheld and to interpret their realities" (p. 2124).[2]

Addison (1997), too, points to the complexities of being the interpretive lens through which research is analyzed, constructed, and narrated:

> I have found that despite my objectives, careful tracking of my category construction and data analysis procedures reveal that as a researcher I have maintained a majority of the control over the origination and nomination of categories and analysis. This suggests to me that my research has not been as collaborative and participatory as I believe it needs to be to move toward its empowering potential. (p. 111)

Narratives of research like those provided by Taylor and Rupp and Addison reveal the difficulties of enacting methodological claims for collaborative research and the centrality of the researcher as the analytic center of the research process: the one who knows the issues in the field well enough to recognize new or beneficial knowledge, the one trained in methodological matters, and the one who in the end is often alone in composing the final representation of the research. As Golombisky (2006) notes, "because researchers not only act in their own research but also direct and produce it, they ultimately are responsible for the final production" (p. 166).

One response by feminist methodologists and feminist researchers has been to write ourselves into research narratives by "using methodological devices that consciously enhance and emphasize textuality" (Fonow & Cook, 2005, p. 2221). The difficulties of negotiating the problem of voice—Who speaks? Whose voice should participate in the research narrative?—is one which other feminist

methodologists have pointed our attention to, concluding (as Ruth Ray, 2000, does) that there is an ethical need for at least some to write alternative research-based narratives:

> gerontologists, at least some of us, have an ethical responsibility to function as social-change agents, broadening and deepening public perceptions and providing alternative images and conceptions to aging and old age. I refer to this cause as "narrative for social change," and I have explained elsewhere that it involves telling countercultural stories about aging and old age, celebrating the unexpected and the inexplicable in these stories, engaging as researchers and writers in the critical self-reflection and self-reflexivity needed to work through our own age anxieties, and, in the process, changing not only how we and others *think* about aging but also how we *feel* about it. (p. xi)

As Ray points out, acting self-reflexively as researchers can be a productive response to the problem of speaking for (as well as speaking about and speaking with) participants; it is also a stance necessary for becoming social change agents.

HOW OUR RESEARCH MATTERS

Recognizing the proliferation of multivocal texts in a variety of scholarly venues, Kirsch (1997) has identified the need for "critical analysis of their potential effects on readers, writers, and public discourse" (p. 191). Kirsch understands that "Many scholars are excited about these new forms of discourse because they reflect the interactive, dialogic nature of writing and research processes, because they honor and preserve the voices of others, and because they allow authors to situate themselves in specific social and cultural contexts" (p. 193). But as she rightly points out, these new textual forms present a number of thorny problems ("in terms of readability, accessibility, and interpretation") that we need to carefully analyze and understand in order to resolve. Although such an analysis might lead writers of such texts to better consider their (various) audience's needs and to develop better strategies for making interpretive sense without asserting a dominant, singular voice of the expert, our attention to these new textual practices (and to the epistemological assumptions which encourage them) might also connect us with feminists and others calling for expanding our thinking about the ways our research matters. As Joanne Addison (1997) asks, "How can researchers in composition studies conduct data analysis and represent our participants in meaningful and rigorous ways that embody the goals of empowering research?" (p. 108). The use value of the research we conduct, in other words, does not only reside in a carefully constructed final narrative but sometimes

resides in and arises out of multidimensional research processes—the (final, written) product need not be the only way we measure the success of a research practice. The value (and the way we measure the value) of our practices is determined by and discovered over time in ongoing interactions among multiple networks of practice. The chapters collected here complicate the so-called research process. They highlight the ways that research is not linear: We conceive of our questions and design the research, and in the middle of the chaos of data collection, we return to those questions and design and revise based on what's emerging at the site. This recursive research process, messy and complex, is exactly why this kind of reporting and reflexivity collected here is necessary. It matters.

In his chapter in this collection, Stuart Blythe thinks more broadly about the potential use value of our research. Blythe describes the risks involved in conducting research that does not neatly wrap up in a scholarly publication used toward tenure and promotion, and he complicates the very goal of the neatly packaged research report by concluding that "Although an activist empirical researcher most likely will be unable to report on unequivocal results, traditionally conceived, within the typical timeframes demanded by the promotion and tenure guidelines at most campuses, ... researchers might be able to generate various essays on method, epistemology, theory, ethics" (this collection). Like feminist theorists who push on the bounds of generic conventions associated with the research report (Laurel Richardson, 1997, for example, weaves together her research practices and reflections on those practices in order to "construct an academic life"), Blythe encourages us to expand our vision of acceptable uses of research. Certainly, given the constraints of the tenure and promotion system under which most of us labor, as Blythe acknowledges, there are bounds outside of which we venture at our own risk. But imagining new use values for research can work within those existing systems. Jeffrey Grabill (2000), for example, suggests that the research we conduct can matter outside academic conventions when he writes, "My primary goal in this article has been to argue for one way that professional writing researchers can influence public policy. In this respect, the client involvement study is an example ... but not the focus of the piece (this is not intended as a write-up of research)" (p. 45). The research study Grabill conducted into client involvement was used as an example for a theoretical, conceptual argument about how writing researchers can contribute to change in public policy. The research matters—it is a key element in the rhetorical appeals Grabill makes—but the research matters in a way not limited to the constraints of the traditional research report. What if we envision alternative research practices that use our research in alternative ways? Grabill suggests one possibility when his research's end goal is a contribution to public policy, and Blythe suggests another when he encourages us to use our research experiences to reflect on epistemologies, methodologies, theory, and ethics.

Understanding how our research impacts those we research and the sites we research (through self-reflexive or diffractive methodological narratives, perhaps) suggests other ways our research matters. Lisa Diamond (2006) reflects on what

she calls "the reflexivity problem"—the extent to which participation in her lon-
gitudinal study of sexual identity development "fundamentally influenced, and
some might say created, the very identity development process I have sought to
model" (p. 475). In interviews, participants indicated that the interviews con-
tributed in part to their developing understanding of their identities. For exam-
ple, one participant is quoted as saying: "What I remember about first question-
ing my sexuality was that a lot of my friends were questioning—actually, I think
you interviewed some of them—and that really made me think about it, and then
I had that interview with you, and then I was reading more in my feminism class,
and I realized that I really related to a lot of it, it really opened my mind" (p. 479).
Another thinks about something that's happened to her in terms of her future
interview with Diamond: "I finally made out with a girl! I remember thinking
afterward, 'Hey! I can talk about this in my next interview!'" (p. 479). Diamond's
study reveals that the effects of research on participants' lives can take place long
after the research is over and the researcher is gone. Diamond concludes,

> the researcher–participant relationship (especially in the context of qualita-
> tive, longitudinal, autobiographical interviews) not only co-constructs the
> very self-story being told to the researcher but has lasting implications for
> the participant (and perhaps for the researcher as well) ... long after the
> interviews end, the co-constructed autobiographical narratives they elicited
> remain forces for continued identity development, further channeling and
> organizing self-views in the service of consistency and coherence. (p. 481)

Diamond suggests the ways our research can have long-term (and we would sug-
gest diffractive) effects for researcher and research participant, which we cannot
begin to plan for. Imagining different use values might help us envision new
basic practices for research. Williams summarizes succinctly the well-developed
feminist belief that when researchers and research participants "co-author the
research questions, co-collect, co-analyze, and co-interpret the data, and they co-
construct the final product [, then they] develop an interactive, dialogic, recipro-
cal relationship that mitigates the strictures of traditional, imperialist hegemony"
(cited in Graham & Whalen, 2008, p. 72). But it may very well be the case that
the almost fixed process of forming research questions, collecting, analyzing,
interpreting, and authoring is in itself hegemonic. At the least, researchers might
turn their critical eye to the dominant linear construction of "the" research
process (research question, study design, data collection, data analysis, represen-
tation in written form). What other possibilities might occur, for example, when
we envision alternatives to any of the steps or their order?

Truly collaborative research might not involve research questions, collection
of data, analysis, and interpretation but some other ways of behaving and work-
ing together. That is, rather than envisioning new ways of conducting our exist-
ing practices, we might envision new practices. J. Blake Scott (2003), in his study

of the cultural and discursive practices involved in HIV testing, adopted the role of organic, or local, intellectual: "a scholar-activist whose situated involvement in local struggles fuels her or his analysis and intervention" (p. 124). As an HIV testing counselor at the AIDS Project he also studied, he says: "I was neither 'the researcher' nor a typical participant-observer. ... Although this position was a complicating factor, it was also a strategic advantage, as it helped me be more sensitive to the unique features of the practices I was studying and to better intervene in some of their problematic functions" (p. 124). Indeed, in at least two instances where he acted as a "rhetorician-critic" and intervened successfully in the problematic written language of an important client questionnaire at the AIDS Project, Scott is able to "export [his] analysis to nonacademic sites in order to develop alternative prevention discourses" (p. 113). Scott suggests that our research contributes to our expertise as rhetoricians intervening in important cultural and textual practices. When we see research practice as a site of collaborative knowledge-making where rhetorician-critics or local intellectuals are learning but also teaching, we might naturally build more reciprocal and balanced relationships with participants, as we design work where authority and knowledge circulate more or less evenly throughout the research relationship. Such a reconceptualization would require vigilance in our accountability but would not necessarily be any less rigorous than supposedly objective practices that do not acknowledge the role researchers play in influencing and shaping the research setting at every turn. In doing this work, we would add, sometimes the end goals of our research practice might not be as tangible as the scholarly publication but might involve contributing to ongoing conversations outside academia. Indeed, as Kirsch also acknowledges, the National Council of Teachers of English (NCTE) has begun to recognize the importance of communicating with parents, politicians, and the public through the creation of the position of associate executive director for higher education, the orchestration of lobbying efforts by executive committee members, and the establishment of the NCTE press center and communications division. The research we do potentially matters in less tangible and traditional ways than we have begun to imagine, and at the least suggests the need for thinking about tenure and promotion practices in more expansive ways than the current "publish or perish" environment fosters.

Understanding how our research matters also involves acknowledging the other ways research can enrich us intellectually, as scholars, as teachers, as researchers involved in other studies, and as human beings. As we have argued elsewhere,

> At the heart of calls for reciprocity in research [and in this context, we would add, at the heart of feminist and activist methodologies] is a recognition/ assertion/insistence that research involves building relationships among humans. At a basic level, research is about understanding other people, their lives, and their experiences. As researchers, we asked for admittance to our participants' lives, thoughts, and experiences, and our participants opened

their lives to us in sometimes surprisingly intimate detail. (Powell & Takayoshi, 2003, p. 399)

These new understandings we arrive at through the conduct of our research practice are almost always life-enriching. Research we conduct can change who we are, what we think about literacy, and how we conduct our work. Sometimes what is gained in the process—our renewed or new relationships with others, our new understandings of literacy and literate practice, our experiential understanding of knowledge production and research as a practice, our more detailed and robust understandings of phenomenon and the people experiencing them— cannot be measured by our traditional, academic standards. Research practice, that is, is not always instrumental. Sometimes it is a more amorphous process whose end result might be a variety of uses circulating through different contexts. As Cindy Selfe (1999) has elsewhere written,

> So can composition teachers address the complex linkages among technology, literacy, poverty, and race? The primary factors determining any individual's involvement, of course, must necessarily start with the local and specific—with social agents' own deep and penetrating knowledge of the specific colleges and universities in which they work; the particular families, communities, cultures within which we live and form our own understanding of the world; the individual students, teachers, administrators, board members, politicians, and parents whose lives touch ours. (p. 429)

The local and specific locations of our involvement, which Selfe identifies, are really the places where our research might take on new life distinct from traditional research narratives. Although the academic article or book is certainly a tangible manifestation of our work as researchers, our academic work also affects the ways we think about things and that we in turn can use to affect the way others—in our classes, our programs, our communities—think about things.[3] The action our academic work takes is always contingent on our location—on who we know, who we speak with, where we go, what we are committed to. This is the legacy of feminist theories for research methodologies. Feminist and socially progressive researchers believe that the work we conduct as academic researchers can and does require "self-critical, conscious navigation" (Cushman, 1996, p. 16) of ethical, methodological, and epistemological terrains. Research is a story about the researcher as well as the research participants and site—the researchers are, after all, the consciousness through which the analysis and representations flow, the individual who created the problem and research design, the laborer who went into the world and collected data to answer the question. Donald Schon (1984) argues that problem setting is "a process in which, interactively, we *name* the things to which we will attend and *frame* the context in which we will attend to them" (p. 40). We are the authors, namers, and framers of our research narra-

tives—even when we carefully erase our presence from the scholarly narrative. To recognize this is not to be laissez-faire about methodological rigor but rather to be aware of ourselves as variables to be accounted for in our representations.

All research can benefit from an examination of the ethical, epistemological, and procedural issues the authors in this collection identify. Our desire in this book is to bring together a sustained, multilayered examination and reflection of research methods, and in doing so, to potentially serve as a resource for researchers from the beginning stages of their research design through their data collection in the field to the analysis and final representations of the conclusions. What these authors reveal is that research is complicated, thorny, and rife with unpredictable constraints, but also that research can be enriching beyond our expectations: It can enrich us as scholars and as a discipline but also as people living and being in the world. In the end, these reflections not only contribute to the ongoing process of becoming a critically reflective researcher, as a regular part of the research process, they can contribute to our understanding of the research we have conducted and the relationships in which we have participated. The challenges and contradictions faced by the researcher-theorists in this collection and the feminist theorists we have discussed in this chapter are not just problems to be overcome in their specific context; these challenges are productive for thinking about ethical, systematic, methodologically sound research practices generally.

ORGANIZING THIS COLLECTION

The ideas and genesis of this collection came at a particular moment. With support from the Virginia Tech's College of Liberal Arts and Human Sciences, Katrina Powell, Kelly Belanger, and Diana George invited 18 scholars interested in feminist and socially progressive work to a working symposium held in April 2007. Participants brought ideas, texts, projects, and themselves together to workshop in small groups and hold sustained discussions about the issues represented in this book (and many that are not represented). The purpose of the gathering was to have a conversation about our work in particular, and the future of feminist research methods in general.[4] The conversations resulted in many unanswered (and unanswerable) questions, and ultimately arrived at a notion of convergence, although this is not to suggest that there was or should be consensus. Indeed, like Trimbur's notion of dissensus, we came together in collaboration to question our definitions, assumptions, and practices to recognize the ways that our conflicts and disagreements can be productive as we engage in research in literacy and writing. As Cindy Selfe put it in one of our discussions, "If the only tool you have is a hammer, every problem looks like a nail." Having multiple (and at times contradictory) kinds of tools available in conducting research allows for the kinds of

various, complicated, unpredictable, messy, and invigorating endeavors of ethno-graphic, participatory, action, community-based, rhetorical research, and inquiry. As we continue to expand our research sites to include border crossings, transnational issues, and technological spaces, we see this collection as a part of the growing conversation about the ways that research in literacy and writing contributes to broader disciplinary conversations about method and methodology.

As we developed this collection with essays from some of the Virginia Tech participants[5] and additional scholars across the country interested in similar issues, we held a goal similar to Fonow and Cook's (2005) in their recent article on feminist methodologies: "Our original goal in compiling these articles was to capture the dilemmas feminists faced at each step of the research process, from the formulation of research questions to the dissemination and utilization of research results" (p. 2212). As such, the authors in this collection interrogate the potentials and limitations of empirically based work for socially progressive ends; that is, these researchers are interested in research "oriented toward social justice" (Price, this volume). This research largely attempts to accomplish "political and ethical action" (Sullivan & Porter, 1997, p. 101) in the service of "social progress" (Harding, 2007).[6] Borrowing from Harding, we considered the viability of the notion of "socially progressive research" for these various research practices in an attempt to foreground—while remaining aware of their differences—these various practices' shared commitment to social progress, to "studying up," and to the development and elaboration of postmodern methodological practices for knowledge building. In literacy studies, such socially progressive research has contributed to an increasingly sophisticated understanding of writing as a socially and culturally embedded practice. We believe that these epistemological perspectives—a commitment to data-based methodological practice, a drawing together of socially progressive theories and methodological issues, and an awareness of writing as a socially embedded practice—are even more pressing now, in an increasingly multilingual, multicultural, transnational, and digital world.[7]

This is a collection of researchers thinking through their research experiences, reflecting on what those experiences reveal about the values we place on research, on activist work, and on the epistemological limits of data-based inquiry. The essays in this collection attend to a range of subject matter—prison art, archives, student reflections, oral deliberations, digital stories, a Bible translation—and represent diverse theoretical perspectives—feminist materialism, queer theory, transnationalism, grounded theory. We intend for this collection to be an example of continuing the work of scholars like Kirsch and Royster, among the many others who have influenced us, looking toward research that recognizes the complexities of research. Attending to notions of social progress and ethically responsible research, the collection is therefore organized around three themes: Theories of Research; Research and Institutional Practices; and Reflexive/Diffractive Research Practices. An early essay in this collection is Barton and Marback's, which challenges the very premise of this collection; indeed, their

challenge of the notion of "socially progressive" research mirrors Barad's challenge of "reflective" practice. We see this challenge as extremely productive. Indeed, feminist and postmodern discussions often value the kinds of varying viewpoints that can emerge from such fruitful challenge. Like the particular research sites highlighted in this collection, discussions of method and methodology are messy and rarely lack what we might call consensus. We hope this collection values that messiness, and ultimately calls for further messy research processes to be written about and learned from.

Theories of Research

The chapters in this section explore the theoretical dimensions of research that inform our practices and contribute to our understanding of language and learning. In Chapter 2, "A Modest Proposal for Common Ground and Language for Research in Writing," Michael Williamson and Brian Huot begin the collection by examining the ideological nature of research and the ways that methods and methodologies reflect the ideological questions of the field. Williamson and Huot remind us that with any method we use, whether as teachers or researchers (or both at once), we are engaging in theoretical questions. Tracing the development of the terms *epistemology*, *methods*, and *representation*, Williamson and Huot provide valuable insight into the ways research is a rhetorical practice.

Ellen Barton and Richard Marback's chapter, "Ethics from Praxis" (Chapter 3), is an example of generating methodologies from different theoretical perspectives. Their chapter discusses ethics in interaction; that is, the mixed-method linguistic and rhetorical analysis of how ethical matters are raised, explored, negotiated, justified, and settled (or not), particularly in institutional contexts. More specifically, this chapter addresses end-of-life discussions, an ethically charged communicative event for both physicians and families. The analyses represent a nuanced exploration of how medical decision making with ethical dimensions is negotiated among all of the parties involved—physicians, patients, and families—all of whom index (linguistically speaking) their ethical roles and responsibilities in a complex communicative event. Barton and Marback's chapter provides detailed linguistic and rhetorical analyses, then theorizes those analyses to help us understand the ways that counter epistemologies can work together to be mutually informing, much the way that Karen Barad argues for the hard sciences and the social sciences to inform each other. In doing so, they also challenge the notion of socially progressive research by questioning whether linguistic research, by its very epistemological nature, can be anything but "ethically neutral." In our minds, it is their mixed methodological approach that suggests their research to be socially progressive. They would disagree, however. Barton and Marback contend that claiming research is socially progressive is in part unethical because it is unattainable. Their chapter takes up the notion of social progress from the beginning of this book, challenging what we think that is. They

argue that rather than working toward a determined social progress (which they see as impossible anyway), that researchers, through interaction, could "encourage [readers] to be more ethical (by leaving them to decide for themselves). In other words, to be an ethical researcher is not to attempt to engineer a presumed social good but to leave people to decide for themselves what the ethics of the situation are by working them out in truly rhetorical interaction" (p. 31).

As Barton and Marback suggest, leaving people to "decide for themselves" implies a located theory of research practice. Kerrie R.H. Farkas and Christina Haas continue this discussion of specificity in Chapter 4, "A Grounded Theory Approach to Studying Writing and Literacy," by theorizing research in "complex" cultural sites with the illustration of a particular site. Just as Barton and Marback use a detailed analysis of end-of-life discourse as the particular example of their theory, Farkas and Haas illustrate their "modified grounded theory approach" through the illustration of the organization, Women's Choice Services. Farkas and Haas argue for the aptness of grounded theory for literacy research and discuss the co-occurrence of collection, analysis, and writing.

Similarly, Pamela Takayoshi, Elizabeth Tomlinson, and Jennifer Castillo (Chapter 5) examine the theoretical discussions happening at the beginning of the research process. In "The Construction of Research Problems and Methods," these authors theorize what happens before research questions are articulated. They argue that the formation of research questions is crucial to the shape of the research design, data collection, and analysis, but that we have very simplified notions of what it means to articulate a research question. Feminist research methodologists offer ways to understand the research problem and research question stage of research practice as acts of subjective creation. The authors then measure their theoretical understandings against survey data collected from writing scholars who offer their reflections on research problem and question formation in their recently published writing.

Finally in this first section, Eileen Schell (Chapter 6) moves us from the specificity of localized contexts and embodied rhetorics and asks us to consider them in material ways. As she points us to the material implications of our research in "Materializing the Material as a Progressive Research Method and Methodology," Schell analyzes the trends and patterns of socially progressive material or materialist research methods and methodologies. She argues for the significance of material analysis as a progressive research methodology within rhetoric, composition, and literacy studies. She points out that although many of us are concerned with researching issues related to material life and culture, our conceptual and methodological notions of the material differ significantly depending on what theoretical and political traditions we draw upon. Her chapter therefore identifies the major trends, patterns, and debates surrounding material analysis in the field, especially with respect to feminist analysis. She also provides scholars with very specific strategies for assessing their own approaches to materiality, namely, the contradictions and challenges of examining notions of the material when we have no governing or overarching agreement about what con-

stitutes a method or methodology for material or materialist analysis in our field. These specific strategies, informed by materialist theoretical considerations, move this first section about theories of research into the following section about how institutions both provide for and limit our research practices.

Research and Institutional Practices

Whereas the previous section asks us to think about the overarching theoretical considerations of our research, this section, Research and Institutional Practices, moves us toward the institutional constraints in which we work. Sharon James McGee begins this section in Chapter 7 by examining one of the essential governing checks and balances of empirically based research: institutional review boards. In "Practicing Socially Progressive Research: Implications for Research and Practice," McGee provides a brief history of institutional review boards and how that history has influenced current practices in reviewing social science and ethnographic research.

Shifting from institutional review boards and the academy as a factor in conceiving of research, Margaret Price then moves us to (inter)disciplinary concerns. In Chapter 8, "Disability Studies Methodology: Explaining Ourselves to Ourselves," Price highlights the ways that a discipline can both shape and be shaped by institutional discourses. Disability studies (DS), she argues, is a discipline that incorporates approaches ranging from biology to philosophy to dance, yet lacks a unified methodology. This can be to its advantage as well as its disadvantage; however, she argues that in order to maximize the advantages of an interdisciplinary methodology, a theoretical frame consonant with the principles of DS is needed. Speaking to an audience of DS scholars as well as those new to DS, this chapter offers such a theoretical framework for DS methodology. Drawing on an extensive review of DS research as well her study of disabled and nondisabled students in a writing class, Price proposes four themes that characterize empirical research in DS: *access, activism, identification,* and *representation.* Like Schell's chapter which provides specific strategies for attending to materiality in our research, Price provides these themes as a unifying frame for DS methodology, while allowing for a variety of approaches and locations within the disability-studies community. At the same time, Price highlights the tensions and potential pitfalls of self-reflexive research and recognizes that researchers' "identifications change over time." She suggests that research methodology is improvisational and therefore difficult to define. Like Barton and Marback, Price similarly challenges the notion of "liberatory" or socially progressive research and asks us to consider the realities of the consequences of our research endeavors.

In Chapter 9, Jeffrey Perry pulls back from site-specific research to generally accepted theories about literacy that work to inhibit our work as assessors of writing and writing programs. In "Critical Validity Inquiry" he proposes a theory of assessment that seeks to "unmask epistemological stances of assessment" and

"develop a reflexive, validation methodology" that works against current exclusionary power structures. Perry's chapter is an example of creating a theory that works from localized contexts; that is, Perry argues for reflexive inquiry into assessment practices so that assessments can more adequately assess the complex human task of writing (and writing programs). Like Schell, Perry's attention to the material consequences of research (and assessment) practices challenges the ways those practices are enacted.

Similar to Perry's approach to critical validity inquiry, Kelly Belanger and April Heaney in Chapter 10, "Critical Pedagogy as Inquiry: Challenging Programmatic and Institutional Traditions," use critical pedagogy inquiry as a way to understand and consequently change institutional practices, particularly in terms of the ways students are assessed. They detail a research-based approach to developing a pedagogical vision for a writing-intensive course. Techniques of critical pedagogy were integral to this research and curricular project for conditionally admitted, or "at-risk," students. The course is the foundation of a learning community called the Synergy Program at the University of Wyoming, a first-year, cluster-model cohort that prioritized critical pedagogy even though institutional stakeholders initially favored a skills-based curriculum. As a way to resist institutional assumptions about student success and literacy, Belanger and Heaney designed their course in which students were co-designers of course policies and co-researchers as they conducted mini-ethnographies of local communities. Although not all students in the course embraced the freedoms this model afforded, student interviews and first-year academic success data suggest that the approach had many positive effects on participating students—and, equally important, on the university itself. Their data reveal a way to address the assessment inequities that Perry outlines in his chapter and break "the cycle of social reproduction" with which Perry is concerned. Their teacher research of critical pedagogy used "data-based arguments on which to base decisions about the curricula, pedagogy, and program design." Their research highlights the ways that institutions often place teachers in contradictory roles as they adhere to institutional mandates yet also expect them to use their expertise to design programs. In this "vortex of competing concerns," Belanger and Heaney illustrate an example of critical pedagogy and ethically responsible assessment practices.

Out of the classroom and into the archives, K.J. Rawson's chapter, "Archive This! Queering the Archive" (Chapter 11), challenges what it means to archive institutional and individual histories, particularly when some histories are purposefully erased. As Perry and Belanger and Heaney point out, institutions can privilege certain ways of thinking about and teaching students that serve to reify dominant social relationships. Similarly, Rawson argues that archival practices within institutions "privilege some while oppressing others." Through several examples, Rawson locates the queering of archives as a methodology that accounts for the ways that many histories are often silenced, either by oppression or through resistance to dominant discourse. Queer archives, according to Rawson, account "for the past that confronts historical erasure and omission,

incorporates affect and trauma, and undermines an unequivocal embrace of longevity." As her analysis shows, what gets told and historicized should constantly be in question, as well as the purposeful erasures used as resistance, a "queer temporality." Ultimately, Rawson argues for an ethically responsible approach to archival practices that questions how we archive and what gets privileged in our archiving practices, preservation, and research.

The final chapter in this section, Chapter 12, is Wendy Wolters Hinshaw's "Identifying Choices: Rhetorical Tactics in a Prison Art Program." Hinshaw constructs a method of rhetorical analysis that specifically addresses the institutional limitations of the kinds of discourses that can be produced by incarcerated juvenile and adult women in Ohio. Examining women's art produced in prison, Hinshaw combines rhetorical theory from Burke, de Certeau, and Butler to analyze the ways that women in their art used tactics to produce resistant identities thereby subverting institutional identities. In doing so, the women's art reinvented institutional discourses, presenting for us a microcosm of the ways that institutional discourses are produced, resisted, and reinvented in other circumstances. Hinshaw's chapter also includes powerful reflexive moments about the access she had to women's prison art and the potential "risks [of] voyeuristic looking at incarcerated subjects" that exist at research sites such as this. As such, her chapter provides a salient transition between the two sections, Research and Institutional Practices and Reflections on Research Practices.

Reflexive/Diffractive Research Practices

Each of the chapters in this section provides an explicit self-reflexivity that is valued in rigorous research methodology (see the essays in "Part II: Reflective Applications" in Schell & Rawson, 2010). Again, we recognize the contested nature of self-reflexivity and emphasize that in these chapters, whether before, during, or after the research is conducted, the scholars in this section carefully attend to the multiple dimensions or diffractions of research. The chapters in this section, whether directly or indirectly, attend to the rhetoric of reflexivity, an aspect of the field that has little been discussed until now.

In "Composing Activist Research," Stuart Blythe (Chapter 13) first provides a unique reflection on the research he conducted and published (Blythe, Grabill, & Riley, 2008) in the *Journal of Technical Communication*. This rare opportunity to see the work behind the published piece challenges researchers to recognize the difficulties in writing multiple kinds of documents (i.e., scholarly articles versus community-based publications) while also working against various parameters (i.e., tenure clocks, client expectation, sustained activist research). Blythe's commentary on the risks and messiness of research caution us to consider how we view our research and how participants might view it differently. Whether we call it activist, socially progressive, or community-based matters because of the associations with each of those terms. Yet Blythe's chapter and his published work

with Grabill and Riley highlight the ways that rigorous attention to methodology (no matter what we call it) can still result in risk and tension-filled interactions fraught with contradictions. He offers us hope, however, by saying, "such problems inevitably require effective forms of communication, which means that experts in rhetoric and professional and technical communication have much to contribute" to the conversation and it is "worthwhile to explore ways to publish while engaging in reciprocal and sustainable research relationships." Based on an analysis of several published works in the field that he says provide alternative ways of presenting activist research, Blythe offers strategies, a heuristic, for composing activist research. Like Teston's heuristic later in this section, this practical approach will assist researchers interested in pursuing this kind of writing, yet also highlights the necessity for scholars, teachers, and administrators to recognize the value of this kind of composing in understanding epistemological and methodological issues related to research.

In Chapter 14, "Discourses of Preservation: The Gullah Community and Rhetorical Construction," Annette Harris Powell reveals reflection before an ethnographic project is started. Revealing similar issues to Blythe through questions asked at the beginning stages of her project, Harris Powell states, "I would like to shift the focus, to suggest that how we understand preservation informs how we understand and do ethnography, how we contribute to the work of revealing what has been hidden." Harris Powell's development of an ethnographic project examining the so-called preservation of the Gullah language and culture through the translation of the Bible, met difficulties from the outset as she designed a project that attended to varied definitions, expectations, and epistemologies. When Harris Powell questions, "How do they write their history onto the landscape, especially when, often, *what* is being preserved is the very thing being contested? What does preservation do, what are the effects of what it does, and what are the material possibilities?," she asks similar questions to Takayoshi et al., about how to plan for research and the ways our questions are posed by and for participants. As Harris Powell so poignantly points out, since Gullah is not a written language, the act of "preserving" Gullah through a written translation of the Bible has far-reaching performative, identity, and memory implications. Harris Powell's questions are examples of the kinds of complex thinking that must go into planning an ethnographic project.

Christa B. Teston's "Considering Confidentiality in Research Design: Developing Heuristics to Chart the Un-chartable" (Chapter 15), like Blythe's chapter, provides a useful heuristic for beginning and experienced researchers alike. Again a unique look into a researcher's meticulous development of a method of analysis for difficult data (she was not allowed to audio record the meetings she observed, nor were there written documents), Teston shows us step-by-step how she came to the rigorous data collection and analysis method that best suited her research site. What is most impressive about this chapter is Teston's ability to narrate the messiness of her research, yet also document the systematic and painstaking development of a heuristic that led her to thorough

analysis. Like Farkas and Haas, Teston's theoretical approach is grounded theory, which she uses to help develop what she calls "observational heuristics," whereby a researcher can account for the complexity of oral discourse without the aids of recording devices or written documents.

In Chapter 16, "Troubling Research: A Field Journey through Methodological Decision Making," like Annette Harris Powell and Takayoshi, Tomlinson, and Castillo, Gloria Jacobs attends to the processes and theories of research design. She resists "presenting a smooth narrative of data collection techniques, and instead trouble[s her] research by highlighting decisions made before entering and when working in the field in respect to the relationship between theory, methodology, and data collection." Using recreated narrative from her researcher's journal, Jacobs writes about her field experience working with adolescents and their teacher and the complicated "relationship building" that occurred during that study. She found that her goals did not always coincide with the teacher's goals, especially in relation to advocating for adolescent literacy practices. Jacobs' narrative provides a poignant account of the difficult decisions researchers must make in the middle of the research site, and how a desire for reciprocity may not always mesh with participants' goals and desires. The form of Jacobs' narrative challenges our notion of how research should be written up, and is written to "capture how the academic voice is informed by the lived experience of research."

In "An Experiential Approach to Literacy Studies," Gwen Gorzelsky (Chapter 17) proposes a way to systematically account for the "spiritual, emotional, and identity investments" that influence how people are motivated to learn, how research is conducted, and how data is analyzed. Calling her proposal an "experiential approach," Gorzelsky argues that investigating learners' identity investments is crucial if scholars hope to better understand how they acquire new literate practices. Her approach involves two methods. The first entails systematically documenting the researcher's own experiences of learning new literate practices. The second entails integrating key concepts from the literate practices under study into the researcher's theoretical frame for coding and analyzing qualitative data. Like Blythe, Gorzelsky analyzes several recent studies to illustrate the ways that literacy scholars attend to spiritual, emotional, and identity issues in their research, making a case for a more systematic way of addressing these issues. Doing so, Gorzelsky argues, addresses the limits of reflexivity (i.e., gratuitous researcher self-disclosure). Gorzelsky further argues for a data-driven analysis of researcher experience that replaces researcher anecdotes, and provides a demonstration of such an analysis.

In Chapter 18, "Narrative as Method and Methodology," Joanne Addison uses narrative inquiry to investigate the intersections of her life as a foster parent and as a researcher. Arguing for the value of narrative inquiry as constructed by Labov and Waletsky, Clandenin and Rosiek (among others), the primary goal of her chapter is to illustrate the ways that theory informs research practice, and the ways that daily or personal life influences our methodological approaches. As she weaves autobiography together with narrative inquiry, she wonders whether the

interrogation of a life and "scholarly personal narrative writing" leads to socially progressive research. She argues, "pairing narrative inquiry and case study research design … fosters systematic and rigorous analysis that can lead to social change."

Emphasizing an "emerging" method of data collection and analysis, Cynthia Selfe and Gail Hawisher craft a research approach that attends to issues of technology, identity, and transnationalism in Chapter 19, "Transnational Literate Lives: An Emerging Research Methodology for a Globalized World," Selfe and Hawisher examine what they do in much of their work, the cultural ecology of literacy. In this case, they use their evolving methodological approach of examining transnational digital literacy narratives to understand the fundamental and specific ways that peoples' literate lives have changed. Selfe and Hawisher's work asks the field not only to challenge our notion of "socially progressive" practices through digital questions, they also challenge the very form our research takes. How we represent the participants in our studies (like in a traditional, edited collection for instance) matters when the very texts we study may have little to do with printed, academic discourse. Selfe and Hawisher also draw our attention to the ways that their research in digital literacies has directly affected their pedagogy.

ENDNOTES

1. Recognizing the value of feminist methodologies to any research, explicitly feminist or not, is a point we make carefully, aware of the possibility that we could be viewed as arguing for an apolitical or gender-free feminist practice. We do not believe it is possible to understand feminist theories of research practice divorced from gender, women's bodies, or gender oppression. We are instead making a different kind of intellectual move—one which attempts to honor the work of feminist researchers and begin from their understanding to build better research practices generally.
2. Taylor and Rupp further realize "how real our power is as the authors of the book" (p. 2125) when, after the book has been published, one participant's mother wants to meet with them "to tell us that we had shamed her family by exposing Sushi's history as a prostitute on the streets of Los Angeles" and when another participant's mother, who thought her son was a bartender, found the book when her other son brought it home and learned for the first time what her son did for a living. Of these experiences, they write: "These encounters brought home to us, if we had forgotten, how much power we held in relation not only to the drag queens but to their families and friends as well" (p. 2125).
3. See Steven Parks (2009), for instance.
4. The format of the symposium itself reflected ideas about sharing research experiences to create conversations about methods, methodologies, reflexivity, and collaboration, as a way to operate under similar ideals where in-depth conversations could occur around individual work and issues of common concern for researchers of data. The symposium therefore unfolded in three formats: workshops, roundtables, and large group discussions.

Symposium attendees were clustered into small groups with related interests and with several Virginia Tech faculty from across disciplines. Pre-circulated project abstracts and/or drafts allowed for the full workshop time to be devoted to the discussion of participants' work and methodologies (these workshop group themes included literacy, social justice, technology, historical research, pedagogy, collaboration/connection, and transnationalism). While this space allowed for every participant to receive feedback specific to their particular projects, these breakout groups also provided a forum forming a community of scholars interested in feminist methodologies. In speaking about the methodologies of a particular researcher, groups were often faced with questions about feminist research methodology more generally. The content of the workshops often informed larger group discussions.

Another way that symposium participants spent their time was in roundtable discussions, which were self-selected and thematically based. Six groups were formed: race and the public sphere; interdisciplinarity; activist research; training of graduate students; technology; and future directions. At the end of two breakout sessions, roundtables reported back to the larger group about their discussions. While the reports from each group were topic-specific, several themes continuously emerged.

Finally, symposium participants collaborated during several large group discussions where the majority of our time was spent freely discussing issues and covering a lot of ground. During our final few hours of the symposium we all briefly spoke in turn in response to the prompt: what are the questions/challenges/topics that you believe need to be a part of the present and future state of Feminist Rhetoric and Research? In addition to this edited collection, several collaborative projects emerged from the symposium including this edited collection. See Min Zhan Lu and Bruce Horner's *College English* essay, "Composing in a Global-Local Context: Careers, Mobility, Skills" (2009) and Gesa Kirsch and Jacqueline Jones Royster's *College Composition and Communication* essay (2010), and book, *Feminist Rhetorical Practices: New Horizons for Rhetoric, Composition, and Literacy Studies* (2012). Thanks to the Virginia Tech College of Liberal Arts and Human Sciences, the English Department's Center for the Study of Rhetoric in Society, the Women's and Gender Studies Program, and the Virginia Tech Humanities Symposium Award for funding to conduct the symposium.

5. The original participants at Virginia Tech's Feminist Research Symposium included Dale Bauer, Kelly Belanger, Patricia Bizzell, Marilyn Cooper, Ellen Cushman, Diana George, Gail Hawisher, Bruce Horner, Susan Jarratt, Gesa Kirsch, Min-Zhan Lu, Shirley Logan, Peter Mortensen, Beverly Moss, K. J. Rawson, Jacqueline Jones Royster, Eileen Schell, Cynthia Selfe, Diane Shoos, Pamela Takayoshi, and John Trimbur. Several Virginia Tech faculty from across disciplines also participated including Carol Brandt, Tom Ewing, Maria Elisa Christie, Bernice Hausman, Jessica Alison Hubbard, Margaret L. Keeling, Corey M. MacDonald, Marie Paretti, Adrienne Trier-Bieniek, and Laura Zanotti. The editors wish to express gratitude for the work of the symposium participants and the ideas generated during the Feminist Research Symposium which led to this volume.

6. Prepared for the UCLA Center for the Study of Women Faculty Seminar, April 18, 2007, and the Center for the Study of Rhetoric in Society Conference on "Feminist Theoretical Inquiry, Collaboration, and Activism" at Virginia Tech, April 26, 2007. Note: Professor Harding was unable to present her work at the Feminist Research Symposium due to cancelled airline flights.

7. Heidi McKee and Danielle DeVoss' *Digital Writing Research* (2007) is an example of a more recent publication that attends to the specific issues related to research methods and methodologies facing researchers of online and digital spaces.

REFERENCES

Addison, J. (1997). Data analysis and subject representation in empowering composition research. *Written Communication, 14*(1), 106-128.

Barad, K. (2007). *Meeting the university halfway. Quantum physics and the entanglement of matter and meaning.* Durham, NC: Duke University Press.

Blythe, S., Grabill, J., & Riley, K. (2008). Action research and wicked environmental problems. *Journal of Business and Technical Communication, 22*(3), 272-98.

Cameron, D. (1997). Performing gender identity: Young men's talk and the construction of heterosexual masculinity. In S. Johnson & U. Meinhoff (Eds.), *Language and masculinity* (pp. 86-107). Oxford: Blackwell.

Canning, K. (1994). Feminist history after the linguistic turn: Historicizing discourse and experience. *Signs, 19*(2), 368-404.

Cushman, E. (1996). The rhetorician as an agent of social change. *College Composition and Communication, 47,* 7-28.

Cushman, E., & Monberg, T.G. (1998). Re-centering authority: Social reflexivity and re-positioning in composition research. In C. Farris & C.M. Anson (Eds.), *Under construction: Working at the intersections of composition theory, research, and practice* (pp. 166-180). Logan: Utah State University Press.

Daniell, B. (2003). *A communion of friendship: Literacy, spiritual practice, and women in recovery.* Carbondale: Southern Illinois University Press.

Diamond, L. (2006). Careful what you ask for: Reconsidering feminist epistemology and autobiographical narrative in research on sexual identity development. *Signs: Journal of Women in Culture & Society, 31*(2), 471-491.

Fine, M. (1996). *Disruptive voices: The possibilities of feminist research.* Ann Arbor: University of Michigan Press.

Fonow, M.M., & Cook, J. (2005). Feminist methodology: New applications in the academy and public policy. *Signs: Journal of Women in Culture and Society, 30*(4), 2211-2236.

Golombisky, K. (2006). Gendering the interview: Feminist reflections on gender as performance in research. *Women's Studies in Communication, 29*(2), 165-192.

Grabill, J. (2000). Shaping local HIV/AIDS services: The problem of client involvement. *Technical Communication Quarterly, 9,* 29-50.

Graham, S.S., & Whalen, B. (2008). Mode, medium, and genre: A case study of decisions in new-media design. *Journal of Business and Technical Communication, 22*(1), 65-91.

Harding, S. (Ed.). (1987). *Feminism and methodology.* Bloomington: Indiana University Press.

Harding, S. (2007). *Haunted modernities: Gender and science issues.* Paper prepared for Virginia Tech Feminist Research Symposium.

Heyes, C. (2003). Feminist solidarity after queer theory: The case of transgender. *Signs: Journal of Women in Culture & Society, 28,* 1093-1120.

Haswell, R. (2005). NCTE/CCCC's recent war on scholarship. *Written Communication, 22*, 198-223.

Ingraham, C. (2006). Thinking straight, acting bent: Heteronormativity and homosexuality. In K. Davis, M. Evans, & J. Lorber (Eds.), *Handbook of gender and women's studies* (pp. 307-321). London: Sage.

Kirsch, G. (1997). Multi-vocal texts and interpretive responsibility. *College English, 59*(2), 191-202.

Kirsch, G., & Mortensen, P. (1996). *Ethics and representation in qualitative studies of literacy*. Urbana, IL: National Council of Teachers of English.

Kirsch, G.E., & Rohan, L. (2008). *Beyond the archives: Research as a lived process*. Carbondale: Southern Illinois University Press.

Kirsch, G.E., & Royster, J.J. (2010). Feminist rhetorical practices: In search of excellence. *College Composition and Communication, 61*(4), 640-672.

Kirsch, G.E., & Royster, J.J. (2012). *Feminist rhetorical practices: New horizons for rhetoric, composition, and literacy studies*. Carbondale: Southern Illinois University Press.

Lather, P., & Smithies, C. (1997). *Troubling the angels. Women living with HIV/AIDS*. Boulder, CO: Westview Press.

Lu, M., & Horner, B. (2009). Composing in a global-local context: Careers, mobility, skills. *College English, 72*(2), 113-133.

McKenna, W., & Kessler, S. (2006). Transgendering: Blurring the boundaries of gender. In K. Davis, M. Evans, & J. Lorber (Eds.), *Handbook of gender and women's studies* (pp. 342-354). London: Sage.

McKee, H.A., & DeVoss, D.N. (2007). *Digital writing research: Technologies, methodologies and ethical issues*. Cresskill, NJ: Hampton Press.

Parks, S. (2009). Texts of our institutional lives: The role of communities publishing in English studies. *College English, 71*(5), 506-527.

Powell, K., & Takayoshi, P. (2003). Accepting roles created for us: The ethics of reciprocity. *College Composition and Communication, 54*(3), 394-422.

Presser, L. (2005). Negotiating power and narrative in research: Implications for feminist methodology. *Signs: Journal of Women in Culture and Society, 30*(4), 2068-2090.

Ray, R. (2000). *Beyond nostalgia. Aging and life-story writing*. Charlottesville: University Press of Virginia.

Richardson, L. (1997). *Fields of play: Constructing an academic life*. New Brunswick, NJ: Rutgers University Press.

Schell, E., & Rawson, K.J. (2010). *Rhetorica in motion: Feminist rhetorical methods and methodologies*. Pittsburgh: University of Pittsburgh Press.

Schon, D. (1984). *The reflective practitioner: How professionals think in action*. Hampshire: Ashgate.

Scott, J.B. (2003). *Risky rhetoric: AIDS and the cultural practices of HIV testing*. Carbondale: Southern Illinois University Press.

Selfe, C. (1999). Technology and literacy: A story about the perils of not paying attention. *College Composition and Communication, 50*(3), 411-436.

Sullivan, P., & Porter, J. (1997). *Opening spaces: Writing technologies and critical research practices*. Greenwich, CT: Ablex.

Symposium Collective (D. Brandt, E. Cushman, A. Ruggles Gere, A. Herrington, R.E. Miller, V. Villaneuva, M-Z. Lu, & G. Kirsch). (2001). The politics or the personal: Storytelling our lives against the grain. *College English, 64*(1), 41-62.

Taylor, V., & Rupp, L. (2005). When the girls are men: Negotiating gender and sexual dynamics in a study of drag queens. *Signs: Journal of Women in Culture & Society,* *30*(4), 2115-2139.

PART I

THEORIES OF RESEARCH

2

A MODEST PROPOSAL FOR COMMON GROUND AND LANGUAGE FOR RESEARCH IN WRITING

Michael M. Williamson and Brian Huot

Research on writing mushroomed in the 20 years between Braddock, Lloyd-Jones, and Schor's *Research on Written Composition* (1963) and Hillocks' (1986) *Research on Written Composition: New Directions for Teaching* published 20 or so years after. During that time, researchers from education, psychology, linguistics, and literature conducted empirical research on the writing process and other ways of teaching writing. "By the beginning of the 1990s, PhD programs in composition and rhetoric had grown from eight in 1977 to thirty-eight in 1987 to seventy-two in 1993" (Connors, 1999, p. 17). The majority of these PhD Programs were and remain in English departments. This disciplinary repositioning of the field, coupled with the critique of the cognitive focus of the writing process movement, helped to create distrust and acrimony between those who favored a strong empirical agenda for the study of writing and those who feared and questioned what they saw as a narrow, "scientific," and numerical explanation for writing. George Hillocks (2005) characterizes the move from quantitative to qualitative methods for the study of writing in this way:

> Increasingly, researchers turned away from the quantitative to the qualitative arguing quantitative research made use of methods that decontextualized learning and practice, that they posited an independent reality that they could only pretend to know and that they presented constructions of reality as if they represented reality. The tradition was derogated as "positivist." By the mid 1980s the battle had become venomous. (pp. 33-34)

Our paragraph-long history of research on writing reminds us that empirical research, both quantitative and qualitative, has occupied a contested and evolving position for the study of writing, with recent laments over a flagging and lost research agenda (Haswell, 2005). We believe that the discourse and arguments about researching writing among scholars in rhetoric and composition, linguistics, education, and literacy studies have not been especially productive. Davida Charney's (1996) *College Composition and Communication* article summarizes the basic positions between camps in composition and technical communication and illustrates the distrust and lack of a common ground and language for talking about research across different methodological approaches. In response to concerns about the lack of empirical research on writing, the Conference on College Composition and Communication (CCCC) is currently in the seventh year of its "research initiative" program that has already awarded more than $100,000 for empirical research projects. Although we applaud the CCCC's interest and effort to resuscitate a healthy, empirical research agenda for college-level writing, to harness this kairotic, disciplinary moment it is important to move beyond simplistic, essentialized discourses about and interpretations of specific research. In this chapter, we provide some common ground and language for thinking and talking about research. This common ground is rooted in a conceptual framework and language aimed at a shared, basic understanding of why researchers ask the questions they do (epistemology); what they do to ask, answer, and propose new questions (professional practices or methods); and how they communicate their research (representation); in addition, researchers must be able to document their practices and ask and answer questions about the suitability and impact of their epistemologies, methods, and representation.[1] These four elements (epistemology, methods, representation, and documentation) can provide the basis for new, more productive conversations about research, and for the teaching of research in graduate programs focused on writing. In teaching a doctoral-level introductory course on research in writing, we often experience several moments in which language adopted from the pervasive discourses about research in writing expose unfounded and uncritical attitudes. Whether these discursive moments focus on easy binaries like quantitative versus qualitative methods, narrative versus statistical reports of data analysis, or quasi-experimental versus ethnographic research designs, structuring the course around epistemology, methods, representation, and documentation moves student thinking and classroom discourse beyond merit judgments about the general, assumed value for particular research approaches toward explorations of how well specific research projects are positioned, documented, and communicated. In addition to furnishing new and older generations of scholars with more productive ways to talk about empirical research, we also hope to gain new insights into the ways in which research is conducted and professional and disciplinary knowledge is made.

Our focus on changing conversations and perceptions about research on writing is influenced by the work of linguistic philosophers. Richard Rorty (1992) defines linguistic philosophy as "the view that philosophical problems are

problems which may be solved (dissolved) either by reforming language or by understanding more about the language we use" (p. 3). Although we are not claiming to solve any problems, we do think that structuring conversations around four elements basic to the activity of research could help generate more productive professional discourse of the kind we have witnessed in our classrooms and informal professional conversations. Rudolf Carnap (1936, 1956), a well-known member of the Vienna circle or Positivists as they are commonly known, provides an increased understanding of the term positivism and the way it is used in discourse about research in writing. Unlike Carnap and his positivist colleagues, we do not believe that there exists any neutral, presupposition language about research in writing or anything else.

RATIONALE FOR ELEMENTS AND APPROACH

Regardless of the subfield of writing studies we choose to work in, research involves searching for an answer to a relevant question or set of questions posed in response to a perceived need in the field or subfield. Whatever orientation toward knowledge a researcher tacitly or explicitly holds, research involves searching. Whether the researcher consults texts or looks into the world for answers to questions, research involves searching. Whether the researcher formulates new perspectives or documents current and prior understandings, research involves searching. Formal research of any kind is a literate practice that attempts to explain the substance and meaning of the world as it is constructed by humans and their cultures. Susan Peck McDonald (1998) situates research on writing in this way: "An academic field gains its identity by some sort of cumulative work on a knowledge problem in the field. There will be agreements and disagreements that have to be sorted out explicitly by writing about them" (p. 112). Ultimately, we see research as a set of situated, literate practices in particular fields of study that address problems relevant to those fields. These literate, situated practices that comprise a specific approach to research are part of an ongoing rhetorical and therefore ideological orientation (Berlin, 1988) that helps establish what is important enough to warrant inquiry and what that inquiry will look like. All fields engage in rhetorical practices that define those problem areas important enough to the field or individual to receive research attention. The problems and methods of research are dependent on the literate practices in a field of study. The knowledge base and literate practices that constitute any research depend on specific disciplinary cultures that also determine their use of language and its relationship among people in the field and the subjects of study.

As Takayoshi, Tomlinson, and Castillo (Chapter 5, this volume) demonstrate, the genesis for research questions can be complicated and involve various people and positions in the field, not to mention the implications specific ques-

tions can have for individuals and groups. In addition to their chapter on research questions, we think it important to recognize in a more general fashion the ways in which we understand problem solving and setting in writing studies and other fields that employ empirical research methods to contribute to the knowledge of a field. In separating problem solving from problem setting, we rely on the ideas of Donald Schön (1983), an urban planner and philosopher in his work on reflective practice:

> But with this emphasis on problem solving, we ignore problem setting, the process by which we define the decision to be made, the ends to be achieved, the means which may be chosen. In real-world practice [like writing studies] problems do not present themselves to the practitioner [researcher] as givens. (p. 40)

Every attempt to do any kind of research, to formulate any set of researchable questions is already embedded in particular ways of knowing that make specific, though inherent, value judgments about specific beliefs, disciplines, ideologies, allegiances, arguments, and discourses. Like James Berlin (1988) we believe rhetoric, and we would add, the literate[2] practices of research are always ideological undertakings. Although research is searching, it also is about making an argument based on that search.

Disputes about different approaches to research can grow out of the tendency to essentialize different kinds of research in stereotypical terms that do not acknowledge the literate, rhetorical, and ideological complexity of the underlying assumptions of various practitioners working within different sets of conventions, traditions, and genres. Any attempt to categorize research is necessarily essentializing because a researcher often uses it to valorize or demonize what counts as an appropriate or inappropriate approach. Opening a discussion about the theoretical grounding for both explanation and critique of all research methods can lead to a greater understanding of any particular research study, ultimately creating a more inclusive understanding of the variety of approaches to research that historically have been part of the study of writing and its teaching. Eschewing more traditional categories like quantitative and qualitative or quasi-experimental and experimental provides the possibility for a new conversation and discourse about research in writing. We begin our discussion of different approaches to research on writing by referring to more or less implicit concepts that are either taken for granted or left unsaid in most discussions of the use and value of various approaches. We begin our examination by making the obvious visible and central, by foregrounding what is normally not the focus of discussions about research in Writing Studies. Ultimately, research on writing revolves around four basic elements of any research activity: What researchers believe, what researchers do, how researchers tell others about their work, and how researchers make an argument for research activity and decision making.

In the following section, we define what we mean by each of these elements and how their examination provides a deeper overall understanding of research in writing studies.

EPISTEMOLOGY

Much has been written about epistemology in the last few decades. In fact a heightened understanding and awareness of epistemology is one of the lasting contributions of postmodern theory in writing studies during the last couple of decades (Berlin, 1996; Faigley, 1992). A number of researchers have explicitly used the term to discuss their beliefs as part of making their approaches to research explicit. While Cy Knobloch and Lil Brannon's *Rhetorical Traditions* is an early critique of the epistemologies of classical rhetoric, more recently Howard Tinberg and Jean-Paul Nedeau's (2010) book, *The Community College Writer: Exceeding Expectations,* begins with a chapter that makes explicit the researchers' backgrounds, worldviews, and their relationships with their home institution and the site of the study. Since the 1980s, feminist scholars such as Elizabeth Flynn (1995), Gesa Kirsch (1999), Mary Lay (1991), and Patricia Sullivan (1992) have been raising questions about the epistemologies of research methods that were dominating writing research, as well as research methodologies in education and the social sciences in general. Egon Guba (1990) used the category of epistemology in his germinal book chapter, "The Alternative Paradigm Dialog." Although Guba recognizes the importance of epistemology in research methods, his purpose is to argue for a constructivist approach to research. Consequently, his definitions of various epistemological approaches are intended to make his argument for the constructivist approach over all others: "*Subjectivist*—inquirer and inquired are fused into a single (monistic) entity" (p. 27). The epistemological debates about research methods in writing are part of a larger, historical conflict stretching back to the late 19th century between what John K. Smith (1983) calls realists and idealists. A focus on epistemology can help make visible researchers' and their audiences' beliefs about the origins of knowledge, including ontology (a separate category for Guba), which addresses the researcher's beliefs about existence. This intellectual history of epistemological issues foregrounds its universality in all research and arguments for the study of writing. Unlike Guba we can't argue for one epistemological orientation for research over another because our argument would have to be based on our own epistemologies. And in truth, any epistemological argument ends tautologically.

Historically, human knowledge of the world was based on a set of beliefs grounded in religious authority. Research as valued cultural practice assumes a movement from religion to science as an ontological authority. Simply, science replaces religion as the primary authority for understanding the world. This replacement did little to challenge the realism that was fundamental to Medieval

Scholasticism. It is worth pointing out that one strand of classical rhetoric beginning with Aristotle suggests that the human mind works through the constructive activity of perception (Mitchell, 2003). However, the end of religion, at least in the Western Hemisphere, is probably foreshadowed by the limits of Scholasticism. In his discussion of rhetoric, George Kennedy (1980) notes that the medieval period in classical rhetoric saw an emphasis on translation of Aristotle and other early Greek rhetoricians. Citing work by Baldwin (1928) and Murphy (1974), Kennedy suggests, "The form of rhetoric that came closest to developing new theory in the Middle Ages was preaching" (p. 190). In theology, there was an emphasis on received meanings of texts because dogma had to be based in the interpretive reading, authorized by the church, of classical texts, including the Bible. Much of the focus of the Inquisition involved debate about the legitimacy of many texts.

The Enlightenment substitutes dogma based on interpretations by religious authority for a view of reality based in the authority of the scientific method. Method, that is, research, supplants the authority of ancient texts. Newtonian Mechanics represents a form of explanation based in what Joel Mitchell (2003) labels naïve realism and Cleo Cherryholmes (1992) calls scientific realism. In this formulation, knowledge arises from understanding the world through the application of universal laws that determine the way matter behaves. The existence of matter lies outside of the individual and is subject only to the universal laws that are uncovered by the scientist. Ontologically, the world really exists and our perceptions of it either match or fail to match reality. In contrast, postmodernism and post-positivism view knowledge as originating in the constructions particular cultures use to explain the world as it is perceived by the culture. Individuals' views are determined by the signification practices of that culture, both constructed by and constitutive of the individual. In this contemporary view of epistemology, beliefs about the origins of knowledge and the nature of being are subject to critique by others who hold differing epistemologies. Thus, there can be no universal knowledge, nor any knowledge that is free from what Berlin (1988, 1996) calls the ideology of the knower.

With the advent of postmodernism, science loses its burnished armor as the discoverer of absolute truth and generates only incomplete pictures of the world it studies, its agenda unfinished and its contribution partial, unlike the view of Enlightenment scientists such as Newton. In Newton's view, we only need to know the few laws of physics and the disposition of all the matter in the universe to make predictions about phenomena. Obviously, this view depends on both realism and a wildly unrealistic view of the capabilities of human sensation and perception. Although early scientists looked for the day when all the laws of the universe would be known, mid- to late 20th-century physical and social scientists came to view their explanations as simplifications of what they see, created in the space between their activities and the activities of what they study. The purpose for their explanations became less the discovery of truth and instead the creation of a space to begin understanding the subject(s) of their interests.

In discussing the role of questioning in Dewey's philosophical work, Nick Turnbull (2008) notes that Dewey viewed questioning as a path to "dissolving the question" with an answer. Like early science, questions could be answered with certainty and would cause the problems they raised to cease to be problems. Schön (1983) calls this approach technical rationality in which "professional activity consists in instrumental problem solving made rigorous by the application of scientific theory and technique" (p. 21). Like the questions that brought us to this chapter on research in writing, questions themselves are both constitutive of the methods that are used to answer them and are the answers themselves. Thus, the framing of a question is a research activity in and of itself: "It is rather through the non-technical process of framing the problematic situation that we may organize and clarify both the ends to be achieved and the possible means of achieving them" (Schön, 1983, p. 41). Understanding the epistemological and constructive work of problem setting makes us realize that the end of questioning never leads to firm answers and usually only leads to more questions (as Morris Young points out; see Chapter 5, this volume). Research may begin with questions or problems in writing studies, but the results are never definite and lead only to ways to frame better questions.

METHODS

The second element, method, refers to the activities of the researcher, whether it is reading in a library or interacting with others to collect data. Empirical research involves considerable reading before any data can be collected, whether it involves a large number of people in a quantitative study or going into the field for a qualitative study. As we already observed, setting research questions involves making assumptions about the world and what counts as the important or significant aspects of the world or, in the case of writing studies, a specific discipline and the activities of people within that discipline. It is deceptively simple, not to mention appropriate, practice to assume that research methods really depend upon the kinds of questions being asked. We have both worked with graduate students who approach us with a dissertation project in which they foreground their study by wanting to do an ethnography or some other form of research without first thinking about what it is they want to know from their research. Although we have correctly, we believe, directed these students back to the research-question stage,[3] we also must warn against any idea of a naïve pluralism in which research methods are simply the cart to the horse of the research questions. As we attempted to illustrate in the preceding section on epistemology, decisions about research questions and methods are also always decisions about value systems and importance. Setting a problem for research is ideological and rhetorical work.

It could be argued (with some difficulty, we believe) that our elements of method and epistemology could be simplified to a chart of various methods and their attendant epistemologies like the one John Cresswell (2009, p. 17) includes in the most recent edition of his popular textbook (see Fig. 2.1).

To Cresswell's credit he does preface the connections between philosophical assumptions, strategies for inquiry, employment of specific methods, and practices of the researcher with "Tend to or Typically" (p. 17). To his further credit he connects the beliefs and assumptions of researchers to their methods and research activities. Unfortunately, thinking of methods as connected to specific and particular world views perpetuates an unnecessary and unproductive divide (Hillocks, 2005).

On the other hand, conceiving of methods and epistemology as related, interactive, and separate elements focuses attention away from traditional categories of researchers with distinct methods, philosophies, and language as well as providing a more precise way to look at research that does not fall neatly into epistemologically specific methods. For example, Robert Connors' (2000) often cited essay, "The Erasure of the Sentence," and Susan Peck McDonald's (2007) more recent essay refer to the literature on sentence combining (SC) from the 1980s that demonstrates the link between increased syntactic maturity and SC instruction. This literature consists primarily of studies conducted with a quasi-experimental design, using inferential statistics. According to Table 3.1, these methods are based on post-positivist knowledge claims that are "Determination; Reductionism; Empirical Observation and Measurement; Theory Verification" (p. 6). Whether Connors, McDonald, or others who consider the findings of the SC literature favorably would ascribe to that worldview is questionable.

William L. Smith and Warren Coombs' (1980) study of SC published in an issue of *Research into the Teaching of English* complicates such an assumption that research methods are always connected to particular epistemologies. Employing a quasi-experimental research design and inferential statistics, Smith and Coombs looked at a group of college students who were given a semester's worth of SC instruction and whose post-course essays were significantly more complex in syntax. Smith and Coombs also analyzed the post-course essays of students who received no SC instruction but were told that the people reading the essays really liked long sentences. They reported similar findings of significant gains in syntactic maturity for both groups of students. Their title—"The Effects of Overt and Covert Clues on Written Syntax"—reminds us that writing, its teaching, and its research, are complicated and can be understood in various ways. Smith and Coombs' research question presupposes a different understanding of the ways in which college students can display knowledge of written syntax. This understanding is in contrast to Creswell's post-positivist knowledge claims, and we would also argue the worldview of most research on syntax aimed at connecting SC instruction with increased syntactic maturity.

Our focus on epistemology, methods, representation, and documentation make possible a systematic, interpretive frame for empirical research based on

Fig. 2.1. Table 1.4: Qualitative, Quantitative and Mixed Methods Approaches

• Use these philosophical assumptions	• Constructivist/ advocacy/ participatory knowledge claims	• Post-positivist knowledge claims	• Pragmatic knowledge claims
• Employ these strategies of inquiry	• Phenomenology, grounded theory, ethnography, case study and narrative	• Surveys and experiments	• Sequential, concurrent and transformative
• Employ these methods	• Open-ended questions, emerging approaches, text or image data	• Closed-ended questions, predetermined approaches, numeric data	• Both open- and closed-ended questions, both emerging and predetermined approaches, and both quantitative and qualitative data and analysis
• Use these practices of research as the researcher	• Positions him- or herself • Collects participant meanings • Focuses on a single concept or phenomenon • Brings personal values into the study • Studies the context or setting of participants • Validates the accuracy of findings • Makes interpretations of the data • Creates an agenda for change or reform • Collaborates with the participants	• Tests or verifies theories or explanations • Identifies variables to study • Relates variables in questions or hypotheses • Uses standards of validity and reliability • Observes and measures information numerically • Uses unbiased approaches • Employs statistical procedures	• Collects both quantitative and qualitative data • Develops a rationale for mixing • Integrates the data at different stages of inquiry • Presents visual pictures of the procedures in the study • Employs the practices of both qualitative and quantitative research

From John W. Cresswell, *Research Design: Qualitative, Quantitative, and Mixed Methods Approaches, 3/e.* © 2009 Sage Publications. Reprinted with permission.

how well research positions itself, explains relevant choices about data collection and analysis, and justifies its chosen form of communication. Smith and Coombs are hardly the only study that contradicts common conceptions of quasi-experimental design and inferential statistics as occupying stable theoretical and epistemological positions. Debra Brandt's (1990) book-length study, *Literacy as Involvement: The Acts of Writers, Readers and Texts,* belies the villainous reputation protocol analysis enjoyed in the late 1980s and beyond (Bizzell, 1982; Dobrin, 1986; Faigley, 1986; Smagorinsky, 1989; and others) by developing a socially based notion of literate activity. Conversely, qualitative research does not always illustrate unproblematic or socially progressive pictures of individuals and or groups in literacy research.[4]

As with all arguments, research method selection involves a particular purpose and audience. In this way discussions and conflicts about research methods in writing studies can be seen in terms of the purpose of research activity for a specified audience. For example, when Richard Haswell (2005) argues in "NCTE/CCCC's Recent War on Scholarship" about the dearth of empirical research being published in journals of those professional organizations, it might be possible to view these organizations' lack of empirical work in writing studies not only as the avoidance of empirical research methods but also an indication that there is lack of audience for empirical scholarship in these organizations' journals.[5] As a literate practice, formal research cannot be fully understood without a consideration of audience. Formulating research questions and making decisions about methodology must always involve thinking about purpose and audience for our research. Although we are a sympathetic audience for Haswell's argument about the need for more replicable, aggregable, and data (RAD)-supported research in the journals published by the National Council of Teachers of English and CCCC, we believe an examination of the rhetorical dimensions of RAD research and the theoretical research those organizations are publishing can provide a better understanding of the problem he identifies and possible solutions for that problem. This resetting of the problem would allow us to address such questions as how do we create an audience for the kind of scholarship Haswell advocates and how do we formulate the purpose or purposes of these journals in ways that are more receptive to RAD research? Often, discussions about research methods like Haswell's are really discussions about *empirical* research methods. While we agree with the need for a focus on empirical research in writing studies, especially in rhetoric and composition, we are also concerned that scholarly research not employing empirical methods (like much of the theory about writing and its uses in and outside of the classroom) is not explicit about its methodology.

REPRESENTATION

Our third element refers to what a researcher does to communicate the results of research to a field or discipline. As is the case with any situated, literate practice in a culture, there are conventions that determine the rhetorical grounding for disciplinary discourse practices. These literate practices may involve a set of conventions that enable members of a field to evaluate research within a shared framework of recognizable categories, or they may not be formally acknowledged. This third element of research involves the construction of meaning through the research and is a rhetorical act (like all aspects of research methods) that creates a record of the research subject for discussion by the members of a field and other interested parties. Although all aspects of any research are rhetorical in any sense, representation is important for understanding the limits that may be placed on researchers in terms of the way they write or otherwise present their research to their fields.

We are reminded of an interaction with an engineering professor when one of us was doing writing across the curriculum (WAC) work. This professor wanted the WAC program to grade his students' writing. However, when one of the WAC staff suggested that "three milliliters of water was measured into a glass beaker" be revised to "I measured three milliliters of water," the professor took the lab report out of the staff member's hands (Huot, 2000, pp. 98-99). Passive voice is an accepted and expected convention for representation in some disciplines and professions. In fact, it could be argued that "three milliliters of water was measured into a glass beaker" also represents a certain professional practice using specific tools for measuring and perhaps even a specific kind of water. In other words, the sentence we cite is more than just passive voice, it is a recognizable and expected convention within a specific genre whose connections help to make knowledge and promote a certain way of knowing and working in the world. Certainly, scholars in the humanities can and have critiqued such conventions for representations in the same way scholars on the social science end of research on writing critique narrative and anecdotal research reports for being unrepresentative and nonreplicable. What seems germane to our discussion of the representation of research is an understanding that the use of passive voice, narrative, or even inferential statistics are representations sanctioned by certain groups of researchers, scholars, and thinkers for portraying their work. These representations are an integral part of one's academic and professional culture and identity as they help to enact the use of symbolic action based on a shared understanding between a group of scholars about the world and the work they do. Even as we understand the importance of representation to an array of academic and professional knowledge-making cultures, we also understand that all representations are partial, and share a single task of how to best constitute something meaningful out of our individual literate research practices.

What is also germane is that researchers use particular modes of representation for specific purposes. For example, it is common in theoretical and/or historical research on writing for authors to arrange and present their ideas and arguments in charts, figures, and tables that ultimately grant the author's argument an authority beyond what might be conveyed in text alone. For example, if Huot (2002) were to have written that "writing assessment should be site-based, locally controlled, context-sensitive, rhetorically based and accessible," we might accord these ideas some consideration, but when they appear as Figure 3 under the heading of "Principles for a New Theory and Practice of Writing Assessment" (p. 105), the same ideas acquire an increased presence and authority. Some data display conventions significantly shape the message; Gerald Bracey (2004) points out in *Reading Educational Research: How to Avoid Getting Statistically Snookered* that

Fig. 2.2. Figure 3
Principles for a New Theory
And Practice of Writing Assessment

Site-Based
An assessment for writing is developed in response to a specific need that occurs at a specific site. Procedures are based upon the resources and concerns of an institution, department, program or agency and its administrators, faculty, students or other constituents.

Locally-Controlled
The individual institution or agency is responsible for managing, revising, updating and validating the assessment procedures, which should in turn be carefully reviewed according to clearly outlined goals and guidelines on a regular basis to safeguard the concerns of all those affected by the assessment process.

Context-Sensitive
The procedures should honor the instructional goals and objectives as well as the cultural and social environment of the institution or agency and its students, teachers and other stakeholders. It is important to establish and maintain the contextual integrity necessary for the authentic reading and writing of textual communication.

Rhetorically-Based
All writing assignments, scoring criteria, writing environments and reading procedures should adhere to recognizable and supportable rhetorical principles integral to the thoughtful expression and reflective interpretation of texts.

Accessible
All procedures and rationales for the creation of writing assignments, scoring criteria and reading procedures, as well as samples of student work and rater judgment, should be available to those whose work is being evaluated.

From Brian Huot, *(Re)Articulating Writing Assessment for Teaching and Learning*, © 2002 Utah State University Press. Reprinted with permission.

data displayed in rankings can be misrepresentative. For example, if a country's test scores rank 20th, but the actual range of scores is slight or even within the margin for error of the measures used, it is inaccurate to assume any substantive differences in educational achievement among countries.

Any representation of research, theoretical or empirical, is a rhetorical act that is subject to the judgment of the disciplinary community under any circumstances. McDonald suggests that this form of representation of research fulfills the call in composition for both an examination of the subject position and multivocality in research reports that has been suggested in research in education, humanities, and the social sciences for some time. It is likely that writing studies will see a proliferation of representations in the near future. For example, recent software programs can create data clouds from interview or other qualitative data in which frequency counts determine the size and position of the term in a visual display.

Although acceptable forms of representation in theoretical and empirical research have grown over the past couple of decades, it is still true that some forms of representation can imply certain values and judgments. In a state-level meeting about writing assessment, we mentioned the expert reader system for writing assessment—a system in which teachers without a formal rubric make a placement decision about which students best fit into the class they most often teach. This system was compared with holistic scoring and shown to place students more accurately and with better agreement between readers (Smith, 1993). The response we received was that we were describing a "subjective" assessment rather than an objective assessment. When we asked whether writing down evaluative criteria and assigning numerical value to these criteria made an assessment objective, it became clear to those in the conversation that the use of a rubric did not make one form of assessment more objective than another. This experience illustrates Carnap's principle of linguistic tolerance in which one form of representation (a rubric) is not superior to another (criteria teachers have for their students and classes). Carnap's principle underscores his point that

> In logic, there are no morals. Everyone is at liberty to build up his own logic, i.e. his own form of language as he wishes. All that is required of him is that, if he wishes to discuss it, he must state his methods clearly, and give syntactical[6] rules instead of philosophical arguments. (p. 52)

More importantly for our purposes, Carnap contends that no form of representation is superior to another and that language, gestures, or methods like ethnography are not automatically superior to the social, literate practices in methods like quasi-experimental and inferential statistics. Carnap's views on language in research are especially germane to our project of creating new avenues for conversation about research in writing because his study of language focuses on the ways in which scientific research is reported and understood. For example,

Carnap (1956) exhorts researchers to adopt a precision and caution when refer-ring to specific terms in their research:

> It seems best to reconstruct the language of science in such a way that terms like "temperature" in physics or "anger" or "belief" in psychology are intro-duced as theoretical constructs rather than as intervening variables of the observation language. (p. 230)

Carnap's contention that there are no given or foundational forms of data is based on a positivist epistemology in which knowledge-making depends upon an unstable empirical research base.[7]

DOCUMENTATION

Like the other elements discussed here, documentation is important for both the researcher and his or her audience. Documentation interacts with epistemology, methods, and representation to constitute a transparent record of explanation and rationale for specific methodological choices and decisions. In other words, as Smagorinsky (2008) contends, the documentation element assumes that researchers and readers of research have a responsibility for providing and expecting a visible, recorded set of procedures and arguments for specific methodological choices. Smagorinsky's focus on the methods section of a research report illustrates the importance of documentation for understanding and making new knowledge for the study of writing. Within our framework for thinking and talking about research in writing, documentation emphasizes that researchers must be explicit about why a specific line of research is important and relevant enough to warrant professional attention (epistemology). We must also document not only how we choose to study a specific issue or problem (methods) and the ways in which we communicate our research findings (repre-sentation) but also how we make the kinds of choices we do. For example, it is quite common for theoretical research to include a close reading of a specific text from the literature or even from a listserv conversation. It also is very common for the theorist to provide no reason other than the implied one that this text fits his or her purposes for making a specific argument. It makes sense for a reader to want to know how representative this text is of the field or even the corpus (like a listserv post) from which the text comes. In other words, it is reasonable to expect some argument for why this text is important enough to receive such consideration for the field and why and how the field might use the generated knowledge in important ways.

Although the documentation element might initially be conceived primarily in terms of accounting for adherence to certain conventions or formulae associ-ated with a method or approach to research, it is also conceivable to understand

the documentation element as an opportunity for productive, dialogic tension between various positions for the study of writing. For example, when a theorist who reads specific texts in certain ways is asked to account for the selection and use of this text, the field starts a dialogue about the use of textual material and the need for documentation in new ways for theoretical research in writing. A theorist or other researcher who understands the need for documentation in research can use this understanding not only for documentation but for searching and using new information to make his or her research more valuable for his or her own purposes as a researcher and for the study of writing overall. Using the documentation element to initiate new practices for specific kinds of research and particular uses of epistemology, methods, and representation provides the field with an additional heuristic for the study of writing.

While documentation can initiate new discussions about and uses of research and research elements, documentation cannot claim special status for a specific epistemology, method, or representation nor discount research on these bases either. The goal of inclusion aside, we contend that it is illogical to assume a privileged or marginal status for specific forms of research or research elements. Discounting or privileging one type of method or approach assumes an a priori or presuppositional relationship between epistemology, methods, and representation in a methodological approach and a way of studying writing. In other words, as Carnap's insistence on linguistic tolerance for scientific inquiry makes it clear, there are no special or favored ways of understanding the world, only arguments based on logic and evidence. Apart from obvious epistemological issues, affirming any special relationship for one way of asking and answering questions about writing runs a strong risk of creating a protected practice[8] for some methodological approaches. Using the four elements about research on writing not only can promote a more productive discourse, but it also can provide ways of thinking that require all researchers and readers to expect specific, detailed, and evidence-based arguments for research decisions and choices.

Documentation helps to frame questions about how many participants one needs or how long one needs to study a specific site as questions about the best argument and documentation we can make about these decisions. Like the other elements, researchers can use documentation to generate research design and situate a specific inquiry within and perhaps even up against other conventions within a community of researchers and/or research readers. Our point about the generative, heuristic possibilities for documentation as a core element for conducting and understanding research bears repeating here. Because documentation allows for the ways in which epistemology, methods, and representation interact with each other for a specific research design, we can only understand the full potential for research about writing by looking at the ways in which our three elements work together. Ultimately, our vision for research on writing as a socially situated, cultured, literate practice for exploring and generating new questions and knowledge is only limited by the arguments (documentation) one can make in conducting and reading research.

CONCLUSION: DOCUMENTING OUR MODEST PROPOSAL

It only seems fitting and, we hope, instructive to conclude this chapter by documenting our own epistemology, methods, and representation. It should become apparent as we struggle to use even in an abbreviated format the four elements of epistemology, methods, representation, and documentation that the "modest" part of our proposal is in the contribution it might make in forwarding a more productive conversation about research on writing and not the effort involved in using the four elements. Looking at any research through these four elements is an ambitious, messy task that should illustrate just how porous the elements are. We spend more time here documenting the epistemological element of our research, since changing the ways in which researchers, research teachers, and readers of research on writing think and talk about research is the main purpose of this chapter. Epistemologically, our positions as researchers and scholars involve a range of ways of looking at literate activity. Both of us wrote empirical dissertations and have been involved in various kinds of empirical research both as researchers, dissertation directors, and dissertation committee members. Nonetheless, most of our research has been theoretical. The epistemology underlying this chapter holds that no specific world view can or should be privileged over another (Carnap, 1936, 1956). Any arguments for new knowledge must be tethered to evidence produced through a documented process. We also believe all research is ideological (Berlin, 1988) and that writing studies should advance a socially progressive research agenda. Carnap and Berlin, then, ground writing research as an ideological process in which no form or process is more "true" than any other, making possible a common ground and conversation for research in writing. In addition to the wide net Carnap and Berlin provide for writing research, positivist and social epistemic orientations to research provide a focus on language and supplement what we see as the ultimate failure of either approach by itself.

 In addition to helping us remember how easily important scholars and their ideas can be marginalized without a full consideration or realization of the implications of their work, Carnap also helps us focus, in the case of writing studies, needed attention on the importance of empirical inquiry. Carnap's insistence that knowledge-making is a fluid, unstable activity that must be tethered to empirical evidence seems to be a relevant, almost kairotic message given the position of empirical research on writing and the desire of the profession to reinvest its energy in data-based inquiry. Carnap's connection to linguistic philosophy, his attention to the language of research, and especially his concept of linguistic tolerance provide a field like writing studies with an applicable and significant set of ideas for considering new ways to understand and talk about disparate means for doing research and to integrate this apparent disparity into a coherent and cogent approach to and conversation about research.

Unlike Carnap, Berlin is a well-known figure in writing studies and was influential for a variety of reasons, including his earlier, historical work and his later contributions to establishing a poststructuralist theoretical base for both the study and teaching of writing. In writing about the teacher as researcher movement, Berlin (1990) urges that we not be distracted by disputes associated with different research traditions but rather that we harness the moment to fuse teaching with research and to increase the status of teachers and attention to pedagogy while providing the field with new and important insights. Berlin's final book (1996) emphasizes the importance of seeing research on writing as embedded in the literate practices of a field. While we contend throughout this chapter that all research is literate activity, linking specific literacies with individual disciplinary practices underscores the ambitious nature of trying to change the literate practices for the study of writing, because such change involves modifying the culture and identity of those from various traditions who research writing. Although we acknowledge both Carnap and Berlin as important influences in our epistemological orientation, we also note that we use each of them to break with the other to create our vision for research in writing. For example, we cannot accept Carnap's idea that there is the possibility of a neutral, meta-language for understanding and talking about research and inquiry because as Berlin notes all language and therefore all research is positioned, biased, and ideological. At the same time, we reject Berlin's contention of the supremacy of an epistemic rhetorical approach, relying on Carnap's contention that research must be based upon all relevant and possible contributions because a research approach cannot by itself assume a moral or philosophical superiority. Berlin informs Carnap's project by positioning research as a force for improving a field's mission and effectiveness in the same way that Carnap aids Berlin's social mission by furnishing an array of research possibilities aimed at progressive social action. Harnessing Berlin's social agenda to Carnap's linguistic tolerance provides the possibility for a robust socially progressive research agenda, providing writing study researchers with a new array of methodological resources. As the Smith and Coombs (1980) study illustrates, for example, quantitative research approaches can be used to promote an increased understanding of the social nature of literacy important to any socially progressive research agenda. Similarly, Arnetha Ball (1997) implements a quasi-experimental design and inferential statistics in her study of the social nature of literacy—specifically, to compare the ways in which Euro-American and African American teachers read Hispanic American, Euro-American, and African American student writing. Ball's research illustrates that commonly held notions of writing quality and achievement can be socially constructed along racial lines. In addition to the potential for producing socially progressive knowledge about writing, quantitative research with epistemologies more often associated with qualitative approaches gives writing studies research access to a privileged discourse persuasive to powerful audiences in and outside the academy. Although we see studies like Smith and Coombs and Ball as illustrating that certain methods are not always linked to a fixed epistemological view,

we are not suggesting that these links do not exist between many uses of certain methods and the epistemologies of those who use the method. Our choice of these studies is part of our argument that any given epistemology is not inextricably tied to a specific method.

Our primary method is consulting and summarizing the literature about research methods and the debates and conversations about research in writing. Although we have focused most of our energy here on empirical research, we include theoretical research as well because we believe all research and inquiry employ the same elements. In our goal to enable all those who do research in writing to engage with each other, it is impossible not to include theoretical inquiry. Our exploration of the three activities of how researchers come to ask the questions they do, answer such questions, and communicate what they find out can bridge conversations about methods from theoretical to empirical. We propose these three givens and their documentation for analyzing, talking about, reading, and conducting research in writing as way to begin a new, more inclusive and productive conversation.

In order to establish a basis for a common conversation, we look beyond just those who are conducting research and include in our discussion those who read, teach, and learn research methods for the study of writing. The practices for the study of writing exist within an interactive, ecological web, and these practices will only be modified and appreciated through the efforts of the community of people who are concerned and affected by the ways in which knowledge is made and understood within a entire scholarly community. Our discussion of research in writing is bounded on the one hand by an acknowledgment that all forms of research are partial and constructed within a specific set of cultured, literate practices, and on the other hand that no single set of approaches is any better per se than any other approach. In keeping with our inclusive purpose, our analysis also includes theoretical and empirical foundations from a variety of theorists and researchers in and outside the field of writing studies interested in research and disciplinary knowledge-making.

In keeping with our inclusive approach, we have been especially conscious in our representation to underscore the partial nature of our contribution in trying to provide a common ground and language for talking about research in writing in new ways. Our use of the term element is meant to portray the importance of these four foci and the activity they engender while at the same to avoid terms like category or type or kind, because although we believe all research and its interpretation include some "elements" of epistemology, methods, representation, and documentation, we do not want to convey a taxonomic notion of discrete entities or any notion of hierarchical arrangement of specific types or categories. The specific elements we employ also are not novel or even of our own invention because they can be found in many discussions about empirical research. We use these terms to represent the common ground of all research activity. In other words, conducting, reading, and teaching research means some consideration of these basic elements and the need for principled argument for

the ways in which these elements are constructed and interpreted. Our representation is not only partial but consciously incomplete because a consideration of the ways in which these elements interact to constitute a specific design is beyond our focus in this chapter.

In addition to limiting the ways in which we represent our main focus, we attempted to challenge the available range of representative gestures and forms for research because our goal is to be as inclusive as possible and because we believe all forms of representation are not only valuable in themselves but are potentially necessary to furnish insight into the often complex and charged activities surrounding writing research of various kinds. In addition to trying to appeal to a wide range of audiences and satisfy our conviction that multiple forms of representation are a necessary part of making substantive knowledge, our use of various forms of representation are necessary to our own experience and the ongoing conversation that generated this chapter. Our impetus to write this chapter comes from a sporadic but ongoing conversation we've been having with each other over two decades or so in which we have at times disagreed, changed our minds, struggled to understand each other, and consulted an ever-increasing set of outside sources, so we might eventually communicate our vision for a unified conversation about research in writing. Our struggle to represent our ideas about research in writing has intensified over the 18 months or so it took to actually get to the draft we now share. We have haggled over the way in which we would communicate many parts of this chapter, including at least six different terms for two of the elements. Our teaching, professional interactions, and continued reading and conversations with each other feeds our representation.

Our notion of the literate activity of research and the practices that surround, advance, or regulate this research requires a synthetic notion of what it means to do research on writing. Any research design that asks questions about writing must be able to synthesize a huge base of disciplinary knowledge that stretches from classical rhetoric to neurolinguistics. Reading and writing are some of the most complicated and socially charged behaviors human beings can engage in and even the most "so-called" simple study requires an understanding of literacy from more than one disciplinary source. Given the nature of the field of writing studies and the range of researchers and research on writing, any contribution this chapter makes about writing research is, as we have contended about all research in this chapter, incomplete. Our hope is that in searching for a common ground and language for all writing researchers we can look forward to more productive conversation and research.

APPENDIX A
Epistemology, Accountability, and Representation: Building a New Model and Conversation for Research on Writing

Although the gulf between qualitative and quantitative research methods has lessened as scholars and researchers like George Hillocks (2005) have reminded us "that all quantitative research must be based upon interpretations of phenomenon" and that "counts are implicit in most good qualitative research" (p. 44), most conversations and models about empirical research in writing still frame the models for and conversations about empirical research in terms of quantitative and qualitative. Like Hillocks, we are interested in shared qualities of all research. We contend that all empirical research activity has three things in common: *epistemology*, the beliefs and assumptions about the nature of research and the creation of knowledge; *accountability*, the explicit articulation of our theories and practices; and *representation*, the communication of research practices and their contribution to a field. In other words, what a researcher knows and believes, how and why a researcher does what he or she does, and how a researcher makes his or her research public comprise the core elements of empirical research. Our overall and admittedly ambitious goal for this panel of three 15-minute presentations with a full 30 minutes for response and discussion is to explore the possibility for a new model and conversation for research on writing.

Presenter 1: Designing and Mapping Research

In this presentation, I examine research design as a map of *epistemology*, arguing that a researcher's epistemological commitments (about the value of research, of literacy, of being in the world) are mapped into the designs we create. Beginning with the research problem provides one way of thinking about the subjective process through which all research is shaped. The importance of the research question to design is noted by Corbin and Strauss, who write: "The original research question and the manner in which it is phrased lead the researcher to examine data from a specific perspective and to utilize certain data collection techniques and modes of data analysis" (p. 41). The research problem and question of any kind of research project leads researchers to construct designs *from a specific perspective*. Surveys on research questions and design collected for this presentation from publishing scholars reveal that research design is a process highly informed by the researcher's multiple ideological positions, commitments, experiences, and desires. If we grant that research design is a conscious process of building an *accountable* process for knowledge-making, I argue, it is important to understand design as a map written by our epistemological commitments and to account for that map in representations of our research.

Presenter 2: "But How Can He Be a Positivist"?
Using Epistemology, Accountability, and Representation as Heuristic Elements in an Introductory-Level Graduate Course on Writing Research

My title and presentation begin with a student's reaction to a short passage from Rudolph Carnap, a well-known positivist philosopher. In the short excerpt, Carnap (1956) contends "that terms like 'temperature' in physics or 'anger' or 'belief' in psychology are [best] introduced as theoretical constructs rather than intervening variables . . ." and that terms of this kind cannot be assumed as physical facts "but at best [be] inferred with high probability" (p. 230). Throughout the semester, we experienced several similar moments in which language adopted from the pervasive discourses about research in writing exposed unfounded and uncritical attitudes. Whether these discursive moments focused on easy binaries like quantitative versus qualitative methods, narrative versus statistical reports of data analysis, or quasi-experimental versus ethnographic research designs, structuring the course around epistemology, accountability, and representation helped move student thinking and classroom discourse beyond value judgments about the general, assumed value for particular research approaches toward explorations of how specific research projects are positioned, documented, and communicated. Using a specific course design as an example, this presentation illustrates the ways in which the use of epistemology, accountability, and representation as heuristics can provide students with important ways to understand the empirical research literature and their own development as researchers.

Presenter 3: Creating an Interpretive Frame for Reading and Interpreting

Empirical research has occupied a contested and evolving position in rhetoric and composition with recent laments over a flagging and lost research agenda (Haswell, 2005). In response, CCCC is currently in the seventh year of its "research initiative" program that has already awarded more than $100,000 for empirical research projects.

To harness this kairotic, disciplinary moment it is important to move beyond simplistic, essentialized discourses about and interpretations of specific research. For example, many research studies on SC statistically compare two groups of students—one with SC instruction and one without—to argue for the importance of SC in the writing curriculum (Hudson, 2009). Using the same research design and analysis of data, Smith and Coombs (1980) found that students who received SC instruction exhibited comparable levels of syntactic maturity as students without SC instruction who were asked to complete a writing assignment using longer sentences. Common conceptions of quasi-experimental design and inferential statistics as occupying stable theoretical and epistemological positions cannot adequately appreciate and interpret the contribution studies like Smith and Coombs can make. Using examples from empirical research, this presentation explores the development of a systematic interpretive frame for empirical research based on

how well research positions itself, explains relevant choices about data collection and analysis, and justifies its chosen form of communication.

APPENDIX B
Epistemology, Representation, and Documentation: Building a New Model and Conversation for Research on Writing

Although the gulf between qualitative and quantitative research methods has lessened as scholars and researchers like George Hillocks have reminded us "that all quantitative research must be based upon interpretations of phenomenon" and that "counts are implicit in most good qualitative research" (p. 44), most conversations and models about empirical research in writing still frame the models for and conversations about empirical research in terms of quantitative and qualitative. Like Hillocks, we are interested in shared qualities of all research. We contend that all empirical research activity has three things in common: epistemology, the beliefs and assumptions about the nature of research and the creation of knowledge; representation, the communication of research practices and their contribution to a field; and documentation, the explicit articulation of our theories and practices (these terms are hardly novel and can be found in many research and methods textbooks for the social sciences). In other words, what a researcher knows and believes, how and why a researcher does what she does, and how a researcher makes her research public comprise the core elements of empirical research. Our overall and admittedly ambitious goal for this panel of three 15-minute presentations with a full 30 minutes for response and discussion is to explore the possibility for a new model and conversation for research on writing.

Presenter 1: Designing and Mapping Research

In this presentation, I examine research design as a map of epistemology, arguing that a researcher's epistemological commitments (about the value of research, of literacy, of being in the world) are mapped into the designs we create. Beginning with the research problem provides one way of thinking about the subjective process through which all research is shaped. The importance of the research question to design is noted by Corbin and Strauss, who write: "The original research question and the manner in which it is phrased lead the researcher to examine data from a specific perspective and to utilize certain data collection techniques and modes of data analysis" (p. 41). The research problem and question of any kind of research project leads researchers to construct designs from a specific perspective. Surveys on research questions and design collected for this presentation from publishing scholars reveal that research design is a process highly informed by the researcher's multiple ideological positions, commitments, experiences, and desires. If we grant that research design is a conscious process of build-

ing a documented process for knowledge making, I argue, it is important to understand design as a map written by our epistemological commitments and to account for that map in representations of our research.

Presenter 2: "But How Can He Be a Positivist"?
Using Epistemology, Accountability, and Representation as Heuristic Elements in an Introductory-Level Graduate Course on Writing Research

My title and presentation begin with a student's reaction to a short passage from Rudolph Carnap, a well-known positivist philosopher. In the short excerpt, Carnap contends, "that terms like 'temperature' in physics or 'anger' or 'belief' in psychology are [best] introduced as theoretical constructs rather than intervening variables …" and that terms of this kind cannot be assumed as physical facts "but at best [be] inferred with high probability" (p. 230). Throughout the semester, we experienced several similar moments in which language adopted from the pervasive discourses about research in writing exposed unfounded and uncritical attitudes. Whether these discursive moments focused on easy binaries like quantitative versus qualitative methods, narrative versus statistical reports of data analysis, or quasi-experimental versus ethnographic research designs, structuring the course around epistemology, representation, and documentation helped move student thinking and classroom discourse beyond value judgments about the general, assumed value for particular research approaches toward explorations of how specific research projects are positioned, documented and communicated. Using a specific course design as an example, this presentation illustrates the ways in which the use of epistemology, representation, and documentation as heuristics can provide students with important ways to understand the empirical research literature and their own development as researchers.

Presenter 3: Creating an Interpretive Frame for Reading and Interpreting

Empirical research has occupied a contested and evolving position in rhetoric and composition with recent laments over a flagging and lost research agenda (Haswell, 2005). In response, CCCC is currently in the seventh year of its "research initiative" program that has already awarded more than $100,000 for empirical research projects.

To harness this kairotic, disciplinary moment it is important to move beyond simplistic, essentialized discourses about and interpretations of specific research. For example, many research studies on sentence combining (SC) statistically compare two groups of students—one with SC instruction and one without—to argue for the importance of SC in the writing curriculum (Hudson, 2009). Using the same research design and analysis of data, Smith and Coombs found that students who received SC instruction exhibited comparable levels of syntactic maturity as students without SC instruction who were asked to complete a writing assignment using longer sentences. Common conceptions of quasi-experimental design and inferential statistics as occupying stable theoretical and epistemological positions

cannot adequately appreciate and interpret the contribution studies like Smith and Coombs can make. Using examples from empirical research, this presentation explores the development of a systematic interpretive frame for empirical research based on how well research positions itself, explains relevant choices about data collection and analysis, and justifies its chosen form of communication.

ENDNOTES

1. We make no claim of originality for the terms epistemology, methods, and representation. In fact, they are a common part of many research textbooks. What we aim to do in this chapter is to add the fourth element of documentation and use the terms to think and talk about research in writing.
2. Brian Street' s (1984) contention that literacy is best understood as ideological seems relevant here.
3. We often suggest that students keep a research question journal in which they can ask questions that might eventually be refined into a set of researchable inquiries for dissertation and other research projects.
4. We refrain from citing any studies here because our goal is not to critique specific researchers or studies.
5. We have been reminded of the crucial nature of audience when our proposal, based on our ideas in this chapter, was rejected 2 years in a row (see appendices A and B). The rejections for this proposal are in sharp contrast to our history of acceptances over the years. Our plan is to submit the proposal again next year, hoping that eventually our use of the word positivism and references to research methods like quasi-experimental design and inferential statistics will not be deemed inappropriate for an audience with current-traditional views on research in writing, views this chapter hopes to revise.
6. Carnap's use of syntax is not linguistic. Rather as a linguistic philosopher, he believes logic "can only be studied with any degree of accuracy when it is applied, not to judgments (thoughts or the content of thoughts) but rather to linguistic expressions of which sentences are the most important, because only for them is it possible to lay down sharply defined rules" (p. 1).
7. It seems relevant to point out that Carnap and his colleagues' positivist philosophy rejects the concept of a stable, a priori notion of truth in response to the mathematical and scientific revolution brought on by the acceptance of Einstein's theory of relativity.
8. We borrow this term from George Hillocks' (1995, p. 28) discussion in *Teaching Writing as Reflective Practice* of a class observation in which the teacher accounted for the dismal class session solely in terms of student behavior and disposition, prompting Hillocks to label such teaching practice teaching as a protected activity.

REFERENCES

Baldwin, C.S. (1928). *Medieval rhetoric and poetic (to 1400) interpreted from representative works*. New York: Macmilllan.

Ball, A. (1997). Expanding the dialogue on culture as a critical component when assessing writing. *Assessing Writing, 4*, 169-202.

Berlin, J.A. (1987). *Rhetoric and reality: Writing instruction in American colleges 1900-1985*. Carbondale: Southern Illinois University Press.

Berlin, J.A. (1988). Rhetoric and ideology in the writing class. *College English, 50*, 477-494.

Berlin, J.A. (1990). The teacher as researcher: Democracy, dialogue and power. In D.A. Daiker & M. Morenberg (Eds.), *The writing teacher as researcher: Essays in the theory and practice of class-based research* (pp. 3-14). Portsmouth, NH: Boynton/Cook.

Berlin, J.A. (1996). *Rhetorics, poetics, and cultures*. Urbana, IL: National Council of Teachers of English.

Bizzell, P. (1982). Cognition, convention and certainty: What we need to know about writing. *Pre/Text, 3*(3), 213-243.

Braddock, R., Lloyd-Jones, R., & Schoer, L. (1963). *Research in written composition*. Urbana, IL: National Council of Teachers of English.

Bracey, G.W. (2006). *Reading educational research: How to avoid getting statistically snookered*. Portsmouth, NH: Heinemann.

Brandt, D. (1990). *Literacy as involvement: The acts of writers, readers, and texts*. Carbondale: Southern Illinois University Press.

Carnap, R. (1936). *The logical syntax of language*. London: Routledge & Kegan Paul.

Carnap, R. (1956). *Meaning and necessity: A study in semantics and modal logic* (2nd ed.). Chicago: Chicago University of Press.

Charney, D. (1986). Empiricism is not a four-letter word. *College Composition and Communication, 48*(4), 567-593.

Cherryholmes, C.H. (1992, August-September). Notes on pragmatism and social realism. *Educational Researcher*, pp. 13-16.

Connors, R. (1999). Composition history and disciplinarity. In M. Rosner, B. Boehm, & D. Journet (Eds.), *History, reflection, and narrative: The professionalization of composition, 1963-1983* (pp. 3-22). Stamford, CT: Ablex.

Connors, R. (2000). The erasure of the sentence. *College Composition and Communication, 52*, 96-128.

Corbin, J., & Strauss, A. (2008). *Basics of qualitative research* (3rd ed.). Thousand Oaks, CA: Sage.

Cresswell, J.W. (2009). *Research design: Qualitative, quantitative, and mixed methods approaches* (3rd ed.). Los Angeles: Sage.

Dobrin, D. (1986). Protocols once more. *College English, 48*(7), 713-726.

Faigley, L. (1986). Competing theories of process: A critique and a proposal. *College English, 48*, 527-542.

Faigley, L. (1992). *Fragments of rationality*. Pittsburgh: University of Pittsburgh Press.

Flynn, E. (1995). Feminism and scientism. *College Composition and Communication, 46*, 353-369.

Guba, E. (1990). The alternative paradigm dialog. In E. Guba (Ed.), *The paradigm dialog* (pp. 17-27). Newbury, CA: Sage .

Haswell, R. (2005). NCTE/CCCC's recent war on scholarship. *Written Communication, 22,* 198-223.

Heath, S.B. (1983). *Ways with words.* New York: Cambridge University Press.

Hillocks, G. (1986). *Research on written composition: New directions for teaching.* Urbana, IL: ERIC Clearinghouse on Reading and Communication Skills.

Hillocks, G., Jr. (1995). *Teaching writing as reflective practice.* New York: Teachers College Press.

Hillocks, G., Jr. (2005). Qualitative versus quantitative research: A false dichotomy. In R. Beach, J. Green, M. Kamil., & T. Shanahan (Eds.), *Multidisciplinary perspectives on literacy research* (pp. 33-46). Cresskill, NJ: Hampton Press.

Hudson, R. (2009). Measuring maturity. In R. Beard, D. Myhill, J. Riley, & M. Nystrand (Eds.), *The Sage handbook of writing development* (pp. 349-362). Los Angeles: Sage.

Huot, B. (2000). 79. In R.H. Haswell & M-Z. Lu (Eds.), *Comp tales* (pp. 98-99). New York: Longman.

Huot, B. (2002). *(Re) Articulating writing assessment for teaching and learning.* Logan: Utah State University Press.

Kennedy, G.A. (1980). *Classical rhetoric and its Christian and secular tradition from ancient to modern times.* Chapel Hill: University of North Carolina Press.

Kirsch, G. (1999). *Ethical dilemmas in feminist research: The politics of location, interpretation, and publication.* Albany: State University of New York Press.

Lay, M. (1991). Feminist theory and the re-definition of technical communication. *Journal of Business and Technical Communication, 5,* 348-370.

McDonald, S.P. (1998). Voices of research: Methodological choices of a disciplinary community. In C. Anson & C. Farris (Eds.), *Under construction: Working at the intersection of composition theory, research and practice* (pp. 111-123). Logan: Utah State University Press.

McDonald, S.P. (2007). The erasure of language. *College Composition and Communication, 58,* 585-625.

Mitchell, J. (2003). The quantitative imperative: Positivism, naive realism, and the place of quantitative methods in psychology. *Theory and Psychology, 13*(1), 5-31.

Murphy, J.J. (1974). *Rhetoric in the middle ages: A history of rhetorical theory from Saint Augustine to the Renaissance.* Berkeley: University of California Press.

Rorty, R.M. (Ed.). (1992). *The linguistic turn: Essays in philosophical method with two retrospective essays.* Chicago: Chicago University Press.

Schön, D. (1983). *The reflective practitioner: How professionals think in action.* New York: Basic Books.

Smagorinsky, P. (1989). The reliability and validity of protocol analysis. *Written Communication, 6,* 463-479.

Smagorinsky, P. (2008). The method section as conceptual epicenter in constructing social science research reports. *Written Communication, 25,* 389-411.

Smith, J.K. (1983, March). Quantitative versus qualitative research: An attempt to clarify the issue. *Educational Researcher,* pp. 6-13.

Smith, W.L. (1993). Assessing the reliability and adequacy of using holistic scoring of essays as a college composition placement technique. In M.M. Williamson & B.A. Huot (Eds.), *Validating holistic scoring for writing assessment: Theoretical and empirical foundations* (pp. 142-205). Cresskill, NJ: Hampton Press.

Smith, W.L., & Coombs, W.E. (1980). The effects of overt and covert cues on written syntax. *Research in the Teaching of English, 14*, 19-38.

Street, B. (1984). *Literacy in theory and practice*. Cambridge: Cambridge University Press.

Sullivan, P. (1992). Feminism and methodology. In G. Kirsch & P. Sullivan (Eds.), *Methods and methodology in composition research* (pp. 37-61). Carbondale: Southern Illinois University Press.

Tinberg, H., & Nadeau, J-P. (2010). *The community college writer: Exceeding expectations*. Carbondale: Southern Illinois University Press.

Turnbull, N. (2008). Dewey's philosophy of questioning: Science, practical reason, and democracy. *History of the Human Sciences, 21*(1), 49-75.

3

ETHICS FROM PRAXIS

Ellen Barton and Richard Marback

We practice a methodological mix derived from linguistics and rhetoric, two fields with contrasting yet complementary approaches to making knowledge. From linguistics, Ellen brings a commitment to the descriptive analysis of naturally occurring language, looking to see how microanalyses of interaction inform and complicate theoretical macroanalyses. Ellen looks to rhetoric to provide such a rich theoretical context to complicate the ideas and discuss the implications of descriptive work. From rhetoric, Richard brings a tradition of discovering in any given situation the available means of persuasion. According to this understanding of it, rhetoric is not primarily descriptive—it is generative. The available means of persuasion in any given situation are not ready at hand waiting primarily to be described, they are developed and discerned through the very act of analyzing a situation. What rhetoric brings to the analysis of any given situation is necessarily heuristic in nature; the contours of the analysis are determined by the specifics of the situation as much as the salient features of the situation are determined by the priorities of the analysis. As a result of the epistemological divergences separating linguistics and rhetoric, we struggle to find productive methodological overlaps. The tensions between descriptive and heuristic work is the crux of the methodological dilemma we explore in this chapter.

In examining these dilemmas, most recently we have been exploring the idea of ethics from praxis in medicine, with two central questions:

- What can be learned about ethics by looking at ethics in the real-time interactions of practice, particularly in medical decision making?

- How can research on ethics in practice be applied in medical communication?

This project has an ethical purpose that is a twist on the central principle of traditional medical ethics (provide the best possible care for the patient), in a question formulated by the sociolinguist Heidi Hamilton (1993):

- How can I make sure that patients are getting the best care possible whenever language is concerned? (p. 93)

Although the classic ethical concepts and dilemmas in medicine—autonomy, beneficence, justice; paternalistic physician–patient relationships with asymmetrical medical decision making; professional protection and privilege; conflict of interest; confidentiality; and privacy—are discussed endlessly in the literature (Beauchamp & Childress, 2001; Jonson, Siegler, & Winslade, 2006; Schneider, 1998), they have rarely been investigated in terms of the actual language of practice (Barton, 2011).

In this chapter, we explore a methodological dilemma related to this ethical purpose:

- How can (or should) the application of descriptive research be constrained by its theoretical and methodological frameworks, especially if that constraint is developed in terms of some assumed social good?

This methodological dilemma is a language-related variation of the classic tension between *is* and *ought* in the literature on ethics and bioethics (Solomon, 2005):

- What *is* in the language and interaction of ethically charged communicative events in medicine and what perhaps *ought* to be in this kind of medical communication?

We argue here that it is hasty to assume that theoretical and methodological frameworks can be termed socially progressive without a full consideration of the tensions between *is* and *ought*; that is, between descriptive and heuristic. In particular, we suggest that in composition/rhetoric we sometimes make questionable assumptions about the socially progressive nature of our research and its methodologies, assumptions that do not always contribute to the productive overlap of empirical investigation and theoretical complication.

As a linguist, Ellen is committed to the *is* end of the continuum, with the ethical temptation to remain there. As a rhetorician, Richard is drawn to the *ought* end of the continuum. Rhetoric as a generative art—as an art of discovering available means of persuasion—necessarily involves action in the ethical realm. For

example, identifying the available means of persuasion in medical communications between patients and physicians necessarily involves recognizing that patients together with physicians come to conclusions about best possible care. They attempt to persuade each other. Identifying the available means of persuasion by which patients and physicians arrive at their conclusions about care therefore also involve consideration of how in arriving at that conclusion (and the myriad decisions that it entails) physicians—as well as patients—create and maintain a relationship that gives satisfactory meaning to the notion of "best possible care." The version of the *is/ought* methodological dilemma in rhetoric consists in the fact that discerning what are all available means of persuasion in any given situation does not provide guidance in deciding which of those persuasive means *ought* to be used in that situation. The question of which persuasive means ought to be used in any specific communication between physicians and patients is still a rhetorical question—it is still a question about generating meaning, but it is much more so an ethical question. It is a question physicians and patients must ask about what ought to be done and what influences they want to have over as well as accept from each other.

This is not to say the rhetorician cannot provide insight in the form of helping discover the full range of persuasive means in research on the *is* end of the continuum, nor is it to say that the linguist cannot provide insight as to the ethical conduct of a communicative event on the *ought* end of the continuum. In every situation in which a physician interacts with a patient, the available means of persuasion must be discerned anew even though many of those means become over time generic and predictable (Barton & Marback, 2008). They become commonplace. Descriptions of the commonplace or generic features of medical communication—such as those discerned through discourse analysis—do contribute to finding all available means of persuasion. Those descriptive analyses do not therefore either limit or predict what ought to be done in any given situation but they can and do contribute information and sometimes even insight to those practitioners who must decide in any given situation the ethical question of what ought be done in the persuasion of another.

We explore the methodological dilemma of the tensions between *is* and *ought* by working our way in from the ends of the continuum. First, Ellen presents some descriptive analysis of an ethically charged communicative event— end-of-life (EOL) discussions and decision making. She then discusses the methodological dilemma of descriptive work, its provision of information for both ethical and unethical application. Second, Richard complicates the methodological dilemma, theorizing from the possible about our responsibility to the ethical.

ETHICS FROM PRAXIS: LINGUISTIC DESCRIPTION

For a linguist, what *is* is essentially an empirical question, so my (Ellen's) disciplinary research program, which I call ethics-in-interaction, asks an empirical question that leads to theoretical and applied questions:

- What are the linguistic means by which ethical matters emerge for physicians and patients/families in medical encounters, particularly with respect to decision making?
- What can a perspective on ethics as interactional contribute to our understanding of ethics in theory and practice?
- How can research on ethics in practice be applied in medical communication?

In this program, I work on transcribed data from fieldwork in medical clinics, identifying what seem like ethically charged communicative events. I work from small corpora of these events and use discourse analysis as my method of data analysis (Barton, 2004; Connor & Upton, 2004; Johnstone, 2000; Roberts & Sarangi, 1999; Schiffrin, Tannen, & Hamilton, 2001).

Medicine is a particularly appropriate field for asking these research questions about ethics from praxis for several reasons. First, at a general level, ethics is most often thought of as an abstract system of principles underlying moral reasoning, and contemporary bioethics is similarly considered the set of ethical principles that should normatively underlie medical decision making (Beauchamp & Childress, 2001). Medical decision making with ethical dimensions, however, most often takes place in interaction among real people, in real time, in (semi-)ordinary language that is typically more indirect than direct, and in complex contexts that are often institutional and asymmetrical (Barton, 2011). Furthermore, for many physicians, ethics are constituted relatively unself-consciously in the action and interaction of everyday work, most often without on-the-spot conscious or reflective attention to the ethical dimensions that are nonetheless an important part of the interaction of decision making (McGrath, Henderson, & Holewa, 2006). Ethics, in other words, can be seen as a conventionalized habit of practice, and thus amenable to investigation of its generic interaction.

One of the ethically charged communicative events I have worked on within this research program is EOL discussions in a surgical intensive care unit (ICU) (Barton, 2005, 2007; Barton, Aldridge, Trimble, & Vidovic, 2005). EOL care may be the most publicly visible topic in medical ethics, with well-known comparisons of this century's good death—a death with dignity, defined as physically pain-free and emotionally meaningful for the patient and family, a death preferably at home—versus this century's bad death—a death without dignity,

defined as technologically excessive and emotionally unsatisfying, perhaps for the patient but certainly for the family, often a death in an impersonal institution (Cassell, 2005; Christakis, 1999; Kaufman, 2005; Last Acts Coalition, 2002). In the medical literature, the end of life is widely recognized as one of the most ethically complicated aspects of medical care, from the provision of palliative care to chronically ill patients to the decision to change the goals of treatment from aggressive therapeutic care to comfort care in hospital ICUs (Curtis & Patrick, 2001; Jonson et al., 2006; SUPPORT, 1995).

In an ICU, an EOL discussion is typically convened when the ICU clinical team has determined that further therapeutic treatment would be medically futile, which is in line with traditional medical ethics (American Medical Association [AMA], 1997). From a physician's perspective, the goal of an EOL discussion is to reach a shared consensus to change the goals of treatment from aggressive therapeutic care to palliative comfort care at the end of life (Anspach, 1993; Cassell, 2005; Christakis, 1999; Curtis & Patrick, 2001; Kaufman, 2005; Zussman, 1997). In a discourse analysis, Barton et al. (2005) found that the EOL discussion has a recognizable structure as follows:

- Phase 1: Opening, with greetings and introductions;
- Phase 2: Description of Current Status, where the terminal status of the patient and the medical futility of further treatment is established;
- Phase 3: Holistic Decision Making, where the frame of the patient's wishes is used for decision making in ordinary language; and
- Phase 4: Logistics of Dying, where the process of dying is described and discussed in medical and ethical terms that are satisfactory for both physicians and families.

The ethical dimensions of EOL decision making are distributed across all phases of the discussion, particularly Phases 2 and 4: Physicians index their ethical accountability to professional standards of EOL decision making in Phase 2, and families index their ethical accountability to lay standards of EOL decision making in Phase 4, interactionally co-constructing a hybrid ethical frame of the ethics of death within a consensus that the right decision has been made (Barton, 2007). Indexing is a key linguistic feature characterizing this interactional ethical work: Technically, indexing indicates accountability inferentially by pointing to relevant evidence (Peräkylä, 1998); with respect to ethics, indexing points to the ethical basis of decision making, both by physicians and by families (Barton, 2011).

A brief discourse analysis of a typical case illustrates the indexing of ethical dimensions of decision making in EOL discussions.[1] Phase 2 of the EOL discussion is organized as a list of the patient's medical problems as shown in (1), culminating in a summary statement that implies the terminal status of the patient,

that is, that the patient is dying, as shown in (2), which allows the discussion to move to decision making in Phase 3 as shown in (3), which, in turn, allows the discussion to turn to the logistics of dying as shown in (4):

(1) Phase 2 Description of Current Status—Medical Problems
(1.01) Ph: Through the operation and postoperatively she had the arrest where her breathing stopped and her heart stopped … but since then she hasn't woken up at all.
(2) Phase 2 Description of Current Status—Summary Statement
(2.01) Ph: And this has gone on for a few days now and she's shown no improvement at all, zero…
(2.02) Ph: [W]e can confidently say—we don't have a crystal ball, we can never say 100%, but we can very confidently say that we don't think she's ever going to get better.
(2.03) Ph: We can keep her body alive on the machine for a very long period of time, but==
(2.04) Fam: ==but she is going now.
(3) Phase 3 Holistic Decision Making
(3.01) Ph: And it sounds like that's not what she would want.
(3.02) Fam: No.
(3.03) Ph: Everybody is in agreement with that. …
(3.04) Ph: Based on what everybody said, her to her doctors and all of you to me, it sounds like it's not what she would want.
(3.05) Fam: No.
(4) Phase 4 Logistics of Dying
(4.01) Ph: So what we do in circumstances like this is we take away the machines and the artificial support that we're giving her and we let nature take its course.

In (1.01), the physician not only describes the patient's chief medical problem (*the arrest*), he also explicitly mentions its negative outcome (*she hasn't woken up at all*). In (2.01), the physician sums up the patient's lack of response to aggressive treatment (*no improvement*), and in (2.02) begins to present the medical consensus on the patient's status, using the professional pronoun *we* and framing the presentation of information with the adverb *confidently*, although he interrupts himself to mitigate this framing as *not 100%*, thereby acknowledging the necessary degree of medical uncertainty (interestingly, he actually strengthens the framing after its mitigation, characterizing the medical consensus *very confidently*). Within this framing, the physician goes on to sum up the patient's terminal status fairly directly in lay language (*we don't think she's ever going to get better*). In (2.03), the physician describes futile treatment (*we can keep her body alive on the machine*), indexing the professional standard of medical futility as the basis for an ethical EOL decision (AMA, 1996). He invites the family to enter the decision-making phase of the discussion by using the incomplete utterance *but*, a pivotal term that establishes implies a contrast between artificially prolonged life and natural death. In (2.04), the key family member repeats the pivotal term *but* and establishes a consensus on the terminal status of the patient with an ordinary lan-

guage cliché (*she is going now*). With this consensus that the patient is dying established, Phase 3 of the EOL discussion begins with the physician establishing the frame of the patient's wishes as the basis for decision making in 3.01 (*that's not what she would want*). This frame indexes one aspect of the professional standard of surrogate decision making as the basis for an ethical EOL decision (AMA, 2001). In (3.01), this candidate decision-making statement, with the pronoun *that* referring back to *keeping her body alive*, receives the family member's explicit agreement in (3.02), and the physician checks for consensus with the incomplete utterance in (3.03), receiving no uptake from any family members. This decision-making sequence is repeated in (3.04) and (3.05), indexing the importance of consensus in EOL decision making, consensus that crucially includes the patient (*her to her doctors*) as well as the family and the physician (*all of you to me*). If there is alignment between the physician and the family, as there is in this case,[2] the decision-making phase in EOL discussions is often brief and inferential, as in (3), standing in contrast to the phases where the real work, including the ethical work, of the discussion takes place—Phase 2 for physicians, with the indexing as described above, and Phase 4 for families, as is shown below.

As shown previously, while the physician could be seen to have discharged his ethical responsibilities by indexing medical futility, surrogate decision making, and consensus, what the family provides is simple agreement to the terminal status of the patient in Phase 2 and the EOL decision in Phase 3, agreement that establishes and continues a consensus that allows the discussion to go forward within a trajectory of alignment. Both in terms of medical and ethical decision making, the physician is clearly in the interactional lead here, as shown by his dominance in numbers and length of turns as well as his control of the opening and closing of the phases of the discussion, from Phase 2 to Phase 3 to Phase 4. In Elliot Mishler's (1984) terms, the voice of medicine is dominant in Phases 2 and 3 of the EOL discussion, which raises questions about the considerations and contributions of the family in EOL decision making. Rhetorician Judy Segal (2005), for example, argues that families are not truly the decision makers in EOL discussions. I would agree that families are not taking the interactional lead in medical decision making in many EOL discussions (Barton, 2005); however, I also would point to a considerable body of literature that suggests that many patients and families do not necessarily want to be in the lead in medical decision making (Schneider, 1998), a position that is cautiously endorsed in contemporary bioethics (Beauchamp & Childress, 2001). But I would argue that families do wish to engage fully in the ethics of EOL decision making by establishing their own understanding and articulation of the ethical basis for the medical decision, and, interestingly, they do so by reviewing the medical decision in Phase 4 of the EOL discussion (Barton, 2007). As shown in (4), Phase 4 of the EOL discussion typically begins with a description of the logistics of dying in the ICU, with an explanation of the withdrawal of life support under terminal sedation. But families actively review the EOL decision and the process of dying in terms of an ethics of death that does not derive from medicine but from what Mishler (1984) calls the voice of the lifeworld.

In Phase 4 of the EOL discussions, physicians emphasize that patients will be *kept comfortable* under terminal sedation during the withdrawal of life support, as shown in (5.01). In this discussion, the family goes beyond agreement that the patient should be kept comfortable to review the EOL decision as shown in (5.02):

(5) Phase 4 Logistics of Dying—Ethical Review 1
(5.01) Ph: [after a description of the withdrawal of life support] But I can tell you that we can do this keeping her comfortable.
(5.02) Fam: Yeah, yeah. We want her being comfortable. It doesn't make sense when we know she is not going to be here any more.

In describing the process of dying, the physician emphasizes the medical aspects of EOL care—keeping the patient comfortable until death. The family goes beyond its immediate agreement to review the EOL decision, putting *it* in terms of their loved one *not going to be here any more*. Here the family indexes the decision—*it doesn't make sense*—within an ethical frame of death as the irretrievable loss of personhood. The decision is therefore articulated as a responsible one, accountable to a lifeworld ethics of death. In Phase 4 of the EOL discussion, the EOL decision often is reviewed and situated in a lay ethics of death multiple times, as, for example, in the repetition here:

(6) Phase 4 Logistics of Dying—Ethical Review 2
(6.01) Fam: If she's not in any pain, if she's not struggling with—If I'm standing there I don't want to see her going through this because that would make me feel that I made the wrong choice if she's trying to catch on. You know what I'm saying?

Here the family member explicitly specifies what would be the *wrong choice*—a decision made to withdraw life support if the patient has any human consciousness (*trying to catch on*).

Considered all together, the interactions in (1) through (6) suggest that physicians index their ethical accountability and responsibility earlier in Phase 2 of the discussion when they indicate that medical futility is the basis for the decision to withdraw life support. Families, in turn, index their ethical accountability and responsibility later in Phase 4 when they indicate that the irretrievable loss of personhood and consciousness is the basis for their consensus on the decision as a shared one. The close of the discussion again indexes these converging areas of ethical EOL decision making, the family in terms of the person and the physician in terms of the patient:

(7) Closing
(7.01) Fam: If you had known her, you would know that we're doing the right thing.
(7.02) Ph: And that's important. And again, I want everybody to know that from the doctors' standpoint we're doing the right thing.

Here, both the family and the physician use *we* to express the shared physician–family consensus that the right decision has been made responsibly within converging ethical frames incorporating both medicine and the lifeworld, as shown in the Venn diagram of Fig. 3.1.

FIG. 3.1. *The ethics of end-of-life decision making.*

To return to the questions of this chapter and the socially progressive orientation of this volume, so far, so good. Looking at ethics-in-interaction within EOL discussions provides an innovative method of analysis to describe both physicians and families indexing the basis for their consensus on an EOL decision as an ethical one (*the right decision*, to use the terms of the discussion). In fact, it provides one of the first empirical descriptions of families as well as physicians acting as ethical agents in medical discourse, and it clearly identifies consensus as a shared ethical value. The analysis contrasts nicely with the assumptions of bioethics that principles of ethics are to be applied top–down in a decision-making situation, showing that the basis for the ethical dimensions of a decision are actually negotiated bottom–up in the interaction among interested parties. ICU physicians have a perspective on care that includes what they call "taking care of the family" (Truog et al., 2001), so this could be seen to be a part of providing families with what is called good psychosocial care, accomplished primarily through language (Kirchoff, Song, & Kehl, 2004). By describing family understandings of an ethical EOL decision, the work also has several straightforward applications for physicians conducting EOL discussions: Most specifically, it points to the importance of Phase 4 of the EOL discussion in providing families with a chance to review the ethical dimensions of the EOL decision. So research on ethics in praxis provides interesting answers to the descriptive and theoretical questions set out above. In terms of a socially progressive end, as it often is

defined in composition/rhetoric (Sullivan & Porter, 1997), the analysis foregrounds the family as an ethical agent acting within a well-developed framework, which complicates the stereotyped view of families as being always at the mercy of an asymmetrical institutional discourse (Cushman, 1998). It is surely a socially progressive achievement to draw attention to the importance of negotiation and consensus among parties involved in what is usually regarded as a hierarchical communicative event.

The application question set out earlier, however, makes matters a bit trickier than this affirmational view. At the same time that this research suggests discourse strategies to foreground and support families' ethical concerns in EOL decision making, it also suggests that the same discourse strategies could be used to manipulate the EOL discussion. For example, if physicians know that families generally want to review an EOL decision in terms of an ethical framework that defines death as the irretrievable loss of personhood and consciousness, they can add this feature to their conventionalized genre of the EOL discussions particularly in Phase 4. By proactively addressing this topic with the language described earlier, a physician could easily provide false reassurance to the family to ensure their satisfaction with an EOL decision that may or may not reside in the Venn diagram convergence of *the right decision*. In such a manipulated EOL discussion, families do not negotiate with agency toward consensus on the ethics of an EOL decision.

This dilemma can be seen in even more detail by considering a brief summary of another study of the EOL discussions that focused on Phase 2.[3] In a comparative discourse analysis of the 14 EOL discussions in the corpus that moved to a decision to change the goals of treatment to comfort care (DM, or decision-making discussions) to the 6 discussions that did not (non-DM), we found differences in three specific features of Phase 2:

- In DM discussions, problems in the Phase 2 problem list were mentioned in terms of negative outcomes most of the time.
- In non-DM discussions, treatment options for problems were mentioned more of the time.
- In DM discussions, summary statements were presented in non-mitigated terms more of the time.

Taken together, the analysis of the constellation of these features in an EOL discussion found that a DM EOL discussion presents a consistent accumulation of negative evidence, whereas a non-DM EOL discussion is inconsistent in this respect. The analysis also found that DM discussions were more consistent with respect to the ethics of the end-of-life decision, both in terms of medical frames for physicians and lay frames for families.

First, in the 14 DM discussions in the corpus, 26 problems were mentioned in Phase 2 of the discussions. Twenty-four (92%) were described in terms of negative outcomes, with examples like the following:

(8) Ph: These were very serious strokes.
(9) Ph: [D]espite this, all her cultures of her blood are growing bacteria. The infection is doing more than we can to treat it.
(10) Ph: That means his brain is more swollen. From this he suffered severe irreversible brain damage.

In the six non-DM discussions, 14 problems were mentioned, but only 8 (57%) were described with negative outcomes. Six (43%) problems were mentioned in terms of positive outcomes like the following:

(11) Ph: He stayed on a smallish level of blood pressure medicine throughout the course of the night.
(12) Ph: [T]hey took out [his gall bladder] [...] and he wasn't getting much sicker, he was just kind of staying the course.
(13) Ph: I could not say that Mr. [...] could not come off of the breathing machine at some point.

Thus, non-DMD sometimes equivocated as to the negative outcomes of particular medical problems, allowing an inference to the possibility of improvement.

Second, in the non-DM discussions, problems also were mentioned in terms of possible treatment options more of the time than in DM discussions. In DM discussions, 5 of 26 problems (19%) were mentioned with possible treatment options. In non-DM discussions, 4 of 14 problems (29%) were mentioned with possible treatment options like the following:

(14) Ph: [I]f there is an infection [...] we can drain [the abdomen] by sticking a catheter in there.
(15) Ph: She'd be a candidate, assuming that she would recover from all this again, which I feel is unlikely, but assuming that she would recover from this, she would potentially be a candidate for radiation therapy or chemotherapy to try to prolong her life.

Most treatment options were presented in hypothetical or highly mitigated form, using *if* scenarios like (14) and adding mitigation features like *unlikely* and *potentially* in (15). Nevertheless, non-DMD discussions also equivocated as to the availability of treatment options, also allowing an inference to the possibility of improvement.

Third, DM and non-DM EOL discussions contrast in the summary statements physicians use to state or imply terminal status at the end of Phase 2. Summary statements varied in their directness, from the unmitigated and direct statement in (16) to the mitigated and indirect statements in (17) and (18):

(16) Ph: His chances of recovering from this are zero.
(17) Ph: He could get off of the breathing machine.
(18) Ph: We're still immediately life-threatened but slightly better than that.

Unmitigated summary statements like (16) do not mention survival; mitigated summary statements do mention the possibility of improvement or survival, as in (17) and (18). In the 13 DM discussions with a summary section, 11 (85%) were unmitigated. In contrast, in the 6 non-DM discussions, 5 (83%) were unmitigated. Non-DMD thus equivocated as to the end result of care, allowing an inference to the possibility of survival.

In summary, these findings suggest that presentation of the current status of the patient in Phase 2 of DM EOL discussions describe medical problems in terms of negative outcomes, do not offer treatment options, and culminate in a summary that implies terminal status without mitigation. Non-DM discussions contrast with DM discussions with respect to these features: Problems may be presented with positive outcomes, treatment options may be offered, and summary statements may be mitigated.

In answering the application question for physicians from this study, Aldridge and Barton (2007) suggested that if physicians enter an EOL discussion with the medical (and therefore ethical for them) opinion that the patient's status is terminal and the aim of the discussion is to change the goals of treatment to comfort care, an appropriate discourse strategy would be to describe the patient's status in Phase 2 with a consistent accumulation of negative evidence that would support the EOL decision in a medical frame. Based on the discourse analysis, however, Aldridge and Barton (2007) further advise physicians not to undermine themselves in the details of the interaction. Presenting a consistent accumulation of negative evidence with respect to the medical problems and terminal status of the patient articulates the medical basis for ethical EOL decision making. Being inconsistent or equivocal by describing problems in terms of positive outcomes, mentioning treatment options, and offering mitigated summary statements that imply the possibility of survival in Phase 2 can create uncertainty and doubt when there is none in medical assessment that can trouble families' participation in and satisfaction with an EOL decision. Put more specifically, in Phase 4 families cannot reason to accept as ethical an EOL decision when treatment options leading to improvement or survival seem to remain because there would still be the possibility of recovering human consciousness and personhood. In other words, if the medical conditions for an ethical EOL decision are in place, it is important for physicians not to let Phase 2 drift into a treatment discussion, either for the description of medical problems or for the summary of the patient's condition as a whole. This can be difficult to do, as physicians are professionally oriented toward treatment and talk more easily in this mode (Barton, 2004). It is also difficult to do, as physicians are philosophically oriented toward Osler's dictum to never let a patient lose hope (Nuland, 1995). Aldridge and Barton (2007) thus concluded that if the ethical basis for the medical decision is met, a discourse strategy of consistently presenting negative evidence in the EOL discussion is both appropriate and helpful for families.

But we come again to the ethical underside of the application question: both in terms of Phase 2 and Phase 4, the published recommendations for practice

assume that the ethics of the situation are oriented not only toward the best care possible for the patient but also toward the most ethical treatment of the family. To use Lisa Ede and Andrea Lunsford's (1984) terms, in these articles the reader that is invoked is a particular kind of ethical agent. If a reader wishes to set aside this ethical construction and escape from its constraints, however, the research provides specific suggestions for manipulating the EOL discussion in a way that would create an interactional trajectory toward the decision to withdraw life support, regardless of whether this decision is in the best interest of the patient and whether the discussion meaningfully incorporates the positions and perspectives of the family. It is for this reason that as a linguist, I would argue that investigating what is in medical communication does not necessarily lead to what *ought* to take place.

In fact, in terms of this volume, as a linguist I would argue that this work shows that descriptive research methodologies in and of themselves are not and cannot be socially progressive. Although this conclusion goes against a certain *zeitgeist* of the field (Barton, 2008), I would argue that the knowledge that results from the careful application of the methodology of discourse analysis is ethically neutral until it is applied in the discourse of a practitioner. When I write up the implications of my research, I make an assumption that the analysis will be used ethically; in fact, I construct the reader as an ethical agent, one who would use the discourse strategies described to good ends, even though, as I've said many times to colleagues in composition/rhetoric and medicine, I am aware that my research also shows reader-practitioners how to be both more efficient and less ethical, though I do not describe the specifics of how to do this in print. But I would be naïve to suppose that every reader feels constrained to be the particular ethical agent I invoke. The linguist thus has no way out of this theoretical, methodological, and ethical dilemma: findings that emerge from a methodological approach aimed at description simply cannot be constrained by the researcher's desire to be socially progressive when the readers can use the findings rhetorically for good or ill.

ETHICS FROM PRAXIS: RHETORICAL THEORIZING

As a rhetorician, I (Richard) cannot disagree with the claim that description of the *is* of medical communication does not lead medical practitioners to what *ought* to take place. In theory, what we ought to do in any given situation is not something we can decide through consideration of what is. In practice, especially in EOL discussions as described earlier, physician assessment of a patient's condition does at least inform decisions about what it is best to do. In practice then, deciding what ought to be done on the basis of a medical assessment of what is creates a very real opportunity for linguistically manipulating the nature of what is so that the expression privileges a determination regarding what *ought*

to be done. In the research of Aldridge and Barton (2007), the point is clear: Physician judgment of the patient's medical condition informs the presentation of treatment options to the patient's family. Of course it would be not only rhetorically wrongheaded but most certainly ethically and professionally irresponsible for the physician to not draw on assessment of a patient's medical condition, and to not present the consequences of that assessment as forcefully as appropriate, when deliberating with a family about what ought to be done. For researchers who observe and document the range of persuasive appeals made by physicians to their patients' medical conditions, then, evaluating those appeals necessarily involves more than simply describing what is said. It involves accounting for how and why those appeals function as they do.

As Ellen worries above, analysis of EOL discussions cannot help but provide information on suasive features that can be put to strategic use by someone—physician or patient—interested in forcing decisions that are not necessarily in the best interest of the patient. An example would be if the physician in (2.02) did not present as confidently the patient's terminal status, so as to arrive in (2.03) at something like, *We can keep her body alive on the machine for a very long time, and there is a chance.* In the same exchange, it also is possible for a family member, cognizant of the physician's persuasive attempt in (2.03), to respond to the pivotal *but* with *and maybe*, thereby prolonging the deliberation and even possibly forcing a revision of the decision. Recognizing the potential for manipulation I, as a rhetorician, cannot disagree with Ellen's conclusion that research methodologies cannot be straightforwardly socially progressive. It is after all the perennial criticism (and persistent appeal) of rhetoric that it can be used to make the weaker argument the stronger. At the same time I am not comfortable with the idea that research methodologies cannot somehow contribute to social progress. The question is still open as to just where and how such contributions could be made.

Like linguistic analysis, rhetorical analyses of the medical encounters described here do not and cannot determine what would be in all possible instances the ethically most appropriate means of persuasion. Observing what is persuasive in EOL discussions as a class is not the same as identifying what could be persuasive in a particular EOL discussion in the future, which is certainly not the same as determining what ought to be persuasive in any EOL discussion. This is a crucial distinction because it complicates the binary continuum of *is-ought*. It is through distinguishing *is* from *could* from *ought* that I think we better discern the potential ethical impact of at least a rhetorical methodology.

As I introduced rhetoric above, it is the art of finding the available means of persuasion, an activity both of describing what is and of discovering what could be used to persuade a person in a given situation. Describing and discovering the available means of persuasion is not an ethically neutral activity, even though I have at this point eased the ethical burden by removing (for the time being) consideration of the imperative *ought* in favor of pursuing the more pragmatic *could*. Identifying persuasive strategies that could be used in an EOL discussion, the rhetorician must discern between strategies that are more or less persuasive from

strategies that are more or less coercive. I can easily imagine the revision of (2) just suggested becoming coercive if, say, the physician is pressing for removing life support on the basis of the patient's medical condition with a family not yet interested in giving up hope. Analyzing this EOL discussion and turning from insights about how the physician could be more or less persuasive to recommendations about what the physician ought to say to in order to become more persuasive requires an additional theoretical step. Certainly, a consideration of all that is probable in any given attempt at persuasion requires some normative evaluations if such considerations are to inform judgments about what are imperatives. The implication is that discerning the differences among *is*, *could*, and *ought* requires the rhetorician to make multiple judgments about what is ethical in a given situation. Identifying what could be persuasive involves one kind of ethical evaluation of available means while identifying what ought to be persuasive involves another, in a way stronger, ethical prioritizing of available means of persuasion. Understood in this way, getting from an inescapable engagement with ethics to the making of explicit ethical decisions—what is described with reference to EOL discussions as *the right decision*—does, as Ellen suggests, take more than Sullivan and Porter (1997) imagine.

For their part, Sullivan and Porter do make a good faith effort to outline a methodology that leads researchers to acknowledge not only the situatedness of language practices but also and as a consequence the situatedness required of methods useful in the study of language practices. They develop their "postcritical research methodology" in part out of Donald Schön's (1983) conception of reflection in practice as problem setting, an alternative to technical rationality as a kind of problem solving which aims at reducing any and all phenomena to established theoretical categories. Schön makes use of suggestive ethical language in his description of reflection-in-practice, as when he writes of means and ends, but he pulls up short of making ethical claims about the consequences of this kind of research, as when he observes, "Implementation will be built into the process of reflective research, for practitioners will gain and use insights derived from it as they participate in it" (p. 324). For Schön then, reflective research articulates *is* and *could*, not *is* and *ought*.

The merging in Sullivan and Porter of theoretical reflection and empirical research does not prove itself socially progressive because it is less a derivation of *ought* from *is* and more a conflation of *ought* and *could*, "Methodology is not merely a means to something else, it is itself an intervening social action and a participation in human events. It is itself an act of rhetoric" (p. 13). As rhetorical intervention, empirical research can, as illustrated above through the example of a revised EOL discussion, discern what is and even what could be persuasive. Such insights do not, however, lead either directly or inevitably to conclusions about what patients or physicians ought to do to persuade each other. Implementation is, as Schön put it, built into the process of reflective research, but something more is needed to arrive at ethical evaluations of what *ought* to be from investigation of what *could* be.

The methodological consequences following from Sullivan and Porter's conflation of *could* with *ought* is given clearest expression in the conclusion of their book where they write that "empirical research can generate useful local knowledge as long as it exercises a kind of postmodern critical-reflective praxis" (p. 186). Putting aside the question of whether their proposed methodology is the means by which empirical research can generate useful knowledge, I focus instead on their notion of usefulness. They mean to argue for something beyond a more detailed description of an action useful for streamlining the performance of that action. By useful they seem not to mean Schön's implementation. Instead they seem to mean something like providing insight that can make action better in an ethical sense. The ambition motivating Sullivan and Porter is, as they put it, "to help empower and liberate" (p. 187). Empowerment and liberation are more than merely useful, they carry more than an expression of what *could* be, they are normative assertions of what *should* be. Empowerment and liberation as research ambitions presume an insight into what *ought* to be that is gained through investigation of what *is*. A research methodology that reliably enabled a researcher to generate persuasive characterizations of an empowering and liberating *ought* out of investigations of what *is* would be a methodology that manages consistently and coherently to direct attention to conditions that are not empowering and liberating, that are disempowering and constraining and in need of restructuring.

Whether or not such a methodology could be made consistently reliable, it is conceptually fraught. Again, as has been made clear from the examples of EOL discussions, descriptions of what a patient's medical condition is can and do contribute to decisions about what could be, and even what ought to be, done. Such contributions are less empirical and more rhetorical because they are, as descriptions, always evaluative. That they are evaluative in nature does not render those descriptions suspect. At the same time though, the evaluative nature of description does render all descriptions rhetorical. Sullivan and Porter acknowledge as much when they write that "methodologies are indeed rhetorical constructs, we think that all researchers and theorists work out a methodology ... and that their methodology constitutes their mode of rhetorical invention" (p. 10). I agree with the observation, but I disagree with the conclusions drawn from it. Yes, research in writing involves "relations with participants, and it is those relations, as developed (and perhaps changed) through the research process, that researchers have to interrogate and articulate," but this is far different from the claim, "the researcher is required to take ethical action to empower the researched—which is one reason that we so much stress contextualizing one's project, and which is one reason we view 'Liberate the oppressed' as such an important ethical/political stance for critical researchers" (p.140). Drawing from Ellen's discussion, research into EOL discussions could provide a cunning physician, one skilled in the art of rhetoric, the insight to more easily give a family false hope. Such research could also provide a determined patient the means of persuasion necessary to secure treatment not medically appropriate. This is not to say I abhor the

ambition to make research contribute to social progress, it is rather to say the confusion in Sullivan and Porter (1997) of *could* for *ought* in theoretical reflection fuels an unrealistic and so unrealizable ambition to manufacture a socially progressive research methodology. The confusion rests in large part on conflating problems of uncertainty with situations of ambiguity.

John Forester has drawn on the work of Schön and Jürgen Habermas to argue for clarifying the difference between uncertainty and ambiguity. As he puts it, "Faced with uncertainty we wonder if a particular strategy will work; faced with ambiguity we wonder what we should take as the standard of what works in the first place" (Forester, 1993, p. 89). On a continuum running from uncertainty to ambiguity, questions of empirical fit are questions of overcoming uncertainty, while questions of what Forester terms ethical illumination are questions of managing ambiguity by making judgments. To again quote Forester, "Questions of purpose and intent, of ethical and political choice, of obligation and responsibility, of the proper interpretation of meaning—these are issues of ambiguity; we look not for certainty but for justification" (p. 89). Between verification of empirical fit and justification of ethical illumination (between issues of *is* and *ought*) are pragmatic questions of appropriateness (questions of *could*). These are less questions of ethical illumination, less questions of what ought to be done; at the same time they are more than questions of empirical fit, questions of what is done. These are the questions I think Sullivan and Porter's (1997) postcritical research methodology can aim at answering, questions that arise in the realm between empirical uncertainty and ethical ambiguity, discovering what could be, articulating what are in the situations studied the available means of persuasion.

All this is not to say that a research methodology cannot contribute to social progress. It is to say that the ambition for a particular research methodology to be ethical and in its ethics to contribute directly to social progress is unrealistic and so misleading. Misleading appeal to a research methodology as socially progressive—as empowering and liberating—is undesirable because it becomes itself ultimately unethical. What makes appeal to a research methodology as socially progressive particularly unethical is that it is an ambition far enough out of reach to be an unrealistic goal. Attempts to do the ethically impossible run a greater risk of accomplishing the ethically undesirable because they encourage us to act with certainty in situations defined by ambiguity. At the same time we should not be dissuaded from avoiding any and all ethical concerns because our research methodologies do not realistically lead us directly from the *is* of research insights to the *ought* of socially progressive conclusions.

Rhetoric understood as the discovery of the available means of persuasion can travel the middle ground between the overambition of certainty and an aversion to ambiguity by encouraging us to rest content with *could*. Identifying all the available means of persuasion for an EOL discussion could not but give pause to both patient and physician to consider what they decided and how they decided it. They may choose not to accept any one means of persuasion as more or less

ethical, or as contributing more or less to the making at that moment of the *right decision*, or even as contributing more or less to social progress. Discerning the available means of persuasion, research can provide patient and physician with information and insight they can draw from as they anticipate the consequences of their persuasive actions in that situation. Whether any decision is right or ethical or socially progressive is theirs to decide. That is as it should be. Social progress is not something research methodologies ought to engineer. Unlike Ellen, I am hopeful that my research, because it can show readers how to be less efficient (by giving them more to consider) could encourage them to be more ethical (by leaving them to decide for themselves). In other words, to be an ethical researcher is not to attempt to engineer a presumed social good but to leave people to decide for themselves what the ethics of the situation are by working them out in truly rhetorical interaction.

CONCLUSION

So we end this chapter by proposing not a continuum, but the theoretical quadrilateral in Fig. 3.2, reminiscent of the rhetorical triangle: what *is* and what *ought* remain in the continuum of the base, but what *could* and what *should* form a plateaued apex, a mesa, actually, of rhetorical and ethical action in a given situation.

Within the entire range of the *could* exists the means patient and physician both decide they should use to persuade each other. What they decide they *should* do is not an expression of their obligation to what they *ought* to do. Instead what they decide they should do is identified as the best choice from among the available options for what they *could* do in that situation. Judging what should be done is an act of asserting and justifying what is perceived as the most ethical option from among all other options. Patient and physician could decide among options, but once they have decided on one, they commit themselves to the deci-

FIG. 3.2. The rhetorical quadrilateral.

sion as that which they should do. This quadrilateral, then, does not deny what *is*, nor does it prescribe what *ought*; rather, it opens up rhetorical and ethical possibilities through interaction. What *could* necessarily acknowledges the range of possibilities deriving from what is in interaction, and what *should* acknowledges the familiar ideas about what *ought* from ethical codes, but both together encompass the possibilities of meaningful rhetorical interaction in medical decision making with ethical dimensions that takes place among real people, in real time, in (semi-)ordinary language, and in a context thereby made less asymmetrical.

Taking this approach does not solve the dilemma of producing descriptive work that can be applied in ethical or less ethical ways, nor does it make a naïve claim that a combination of linguistics and rhetoric produces a socially progressive research methodology. Instead, it reframes and complicates the *is–ought* continuum by identifying the possibilities of what *could* and *should* take place in medical communication, using the investigation of ethics in praxis to point to the productive overlap of truly rhetorical interaction in description and in action.

ENDNOTES

1. See Aldridge and Barton (2007) and Barton (2005, 2007) for the full analysis of the corpus of EOL discussions. See Cassell (2005) for an ethnography of the surgical ICU where these EOL discussions took place. The analysis presented here makes claims about family satisfaction. Per Institutional Review Board approval, all data for this project was collected without identifiers and without follow-up with families. Barton (2007) discusses the methodological issues in using data-based definitions of presumed family satisfaction.
2. See Barton (2006) for a discourse analysis of EOL discussions where alignment and consensus are not established without considerably more negotiation or not established at all.
3. For the full analysis and discussion see Barton and Aldridge (2007).

REFERENCES

Aldridge, M., & Barton, E. (2007). Establishing terminal status in end-of-life discussions. *Qualitative Health Research, 17*, 908-918.

American Medical Association (AMA). (1996). Withholding or withdrawing life-sustaining medical treatment. Retrieved from http://www.ama-assn.org/.

American Medical Association (AMA). (1997). Opinion 2.037—Medical futility in end-of-life care. Retrieved from http://www.ama-assn.org/.

American Medical Association (AMA). (2001). Opinion 8.081—Surrogate decision-making. Retrieved from http://www.ama-assn.org/.

Anspach R. (1997). *Deciding who lives: Fateful choices in the intensive care nursery*. Berkeley: University of California Press.

Barton, E. (2004). Discourse methods and critical practice in professional communication: The front-stage and back-stage discourse of prognosis in medicine. *Journal of Business and Technical Communication, 18*, 67-111.

Barton, E. (2005). Institutional policies, professional practices, and the discourse of end-of-life discussions in American medicine. *Journal of Applied Linguistics, 2*, 249-267.

Barton, E. (2006). Trajectories of alignment and the situated ethics of end-of-life discussions in American medicine. In F. Salager-Meyer & M. Gotti (Eds.), *Advances in medical discourse analysis: Oral and written contexts* (pp. 23-42). New York: Peter Lang.

Barton, E. (2007). Situating end-of-life decision making in a hybrid ethical frame. *Communication & Medicine, 4*, 131-140.

Barton, E. (2008). Further contributions from the ethical turn in composition/rhetoric: Analyzing ethics in interaction. *College Composition and Communication 59*, 596-632.

Barton, E. (2011). Speaking for another: Ethics-in-interaction in medical encounters. In S. Sarangi & C. Candlin (Eds.), *Handbook of communication in organizations and professions* (pp. 215-234). Berlin, Germany: de Gruyter Mouton.

Barton, E., Aldridge, M., Trimble, T., & Vidovic, J. (2005). Structure and variation in end-of-life discussions in the surgical intensive care unit. *Communication & Medicine, 2*, 3-20.

Barton, E., & Marback, R. (2008). The rhetoric of hope in the genre of prognosis. In B. Heifferon & S. Brown (Eds.), *The rhetoric of healthcare: Essays toward a new disciplinary inquiry* (pp. 15-31). Cresskill, NJ: Hampton Press.

Beauchamp, T., & Childress, J. (2001). *Principles of biomedical ethics* (5th ed.). New York: Oxford University Press.

Cassell, J. (2005). *Life and death in intensive care*. Philadelphia: Temple University Press.

Christakis, N. (1999). *Death foretold: Prophecy and prognosis in medical care*. Chicago, IL: University of Chicago Press.

Connor, U., & Upton, T. (Eds.). (2004). *Discourse in the professions: Perspectives from corpus linguistics*. Philadelphia, PA: John Benjamins.

Curtis, J. R., & Patrick, D. (2001). How to discuss death and dying in the ICU. In J. R. Curtis & G. Rubenfeld (Eds.), *Managing death in the ICU* (pp. 85-102). New York: Oxford University Press.

Cushman, E. (1998). *The struggle and the tools: Oral and literate strategies in the inner city*. Albany: State University of New York Press.

Ede, L., & Lunsford, A. (1984). Audience addressed/audience invoked. *College Composition and Communication, 35*, 155-171.

Forester, J. (1993). *Critical theory, public policy, and planning practice: Toward a critical pragmatism*. Albany: State University of New York Press.

Hamilton, H. (1993). Ethical issues for applying linguistics to clinical contexts. *Issues in Applied Linguistics, 4*, 207-224.

Johnstone, B. (2000). *Qualitative methods in sociolinguistics*. New York: Oxford University Press.

Jonson, A., Siegler, M., & Winslade, W. (2006). *Clinical ethics: A practical approach to ethical decisions in clinical care* (6th ed.). New York: McGraw-Hill Medical.

Kaufman, S. (2005). *And a time to die: How American hospitals shape the end of life*. New York: Scribner.

Kirchoff, K., Song, M., & Kehl, K. (2004). Caring for the family of the critically ill patient. *Critical Care Clinics, 20,* 453-466.

Last Acts Coalition. (2002). Means to a better end: A report on dying in America today. Retrieved from http://www.rwjf.org/pr/product.jsp?id=15788.

McGrath, P., Henderson, D., & Holewa, H. (2006, June). *Ethics and communication in the real world of acute medicine: Australian findings.* Lecture presented at the COMET '06 Conference [Communication, Medicine, and Ethics], Cardiff University, Cardiff, Wales.

Mishler, E. (1984). *The discourse of medicine.* Norwood, NJ: Ablex.

Nuland, S. (1995). *How we die: Reflections on life's final chapter.* New York, NY: Vintage Books.

Peräkylä, A. (1998). Authority and accountability: The delivery of diagnosis in primary health care. *Social Psychology Quarterly, 61,* 301-320.

Roberts, C., & Sarangi, S. (1999). Theme-oriented discourse analysis of medical encounters. *Medical Education, 39,* 632-640.

Schiffrin, D., Tannen, D., & Hamilton, H. (Eds.). (2001). *The handbook of discourse analysis.* Malden, MA: Blackwell, 2001.

Schneider, C. (1998). *The practice of autonomy: Patients, doctors, and medical decisions.* New York: Oxford University Press.

Schön, D. (1983). *The reflective practitioner: How professionals think in action.* Surrey, England: Ashgate Publishing.

Segal, J. (2005). *Health and the rhetoric of medicine.* Carbondale: Southern Illinois University Press.

Solomon, M. (2005). Realizing bioethics' goals in practice: Ten ways "is" can help "ought." *Hastings Center Report, 35,* 40-47.

Sullivan, P., & Porter, J. (1997). *Opening spaces: Writing technologies and critical research practices.* Greenwich, CT: Ablex.

SUPPORT Principal Investigators. (1995). A controlled trial to improve care for seriously ill hospitalized patients: The study to understand prognoses and preferences for outcomes and risks of treatments (SUPPORT). *Journal of the American Medical Association, 274,* 1591-1598.

Truog, R., Cist, A., Brackett, S., Burns, J., Curley, M., Danis, M. et al. (2001). Recommendations for end-of-life care in the intensive care unit: The Ethics Committee of the Society of Critical Care Medicine. *Critical Care Medicine, 29,* 2332-2348.

Zussman, R. (1997). Sociological perspectives on medical ethics and decision-making. *Annual Review of Sociology, 23,* 171-189.

4

A GROUNDED THEORY APPROACH FOR STUDYING WRITING AND LITERACY

Kerrie R.H. Farkas and Christina Haas

> The only way to ... a larger vision is to be somewhere particular.
> —Haraway (1988)

We begin this chapter with the quote from Donna Haraway because it captures an essential tension in the conduct of qualitative research (and indeed inquiry generally): the tension between a situated "particular" and a "larger vision." For Haraway, a larger vision—what is referred to more technically as theory—must of necessity arise from the situated particular: localized and specific detail, or data.

Although Haraway probably would not call herself a grounded theorist, the same tension animates the name, and indeed the practice, of grounded theory. The goal of the grounded theory approach is a theory ("a vision") that is grounded to that "somewhere particular": data from a specific area of human practice. For Glaser and Strauss (1967), whose original rendering of grounded theory that we most clearly follow in this chapter, a grounded theory is a *substantive theory*, a small-t theory concerned with a substantive area, or an area of complex human practice. For us as writing researchers, this substantive area is literacy as it is practiced in complex cultural sites. Here we discuss in detail a grounded theory approach to one such complex cultural site: an urban abortion clinic, Women's Choice Services (WCS), serving middle- and low-income women, primarily women of color.

In this chapter, we argue for the aptness of a grounded theory approach for literacy research. After some background on the origins, assumptions, and gen-

eral procedures of grounded theory, we describe what we see as three dilemmas that arise from the tension between vision and particulars: the data dilemma, the theory dilemma, and the viewpoint dilemma. We then present our specific approach of grounded theory, a somewhat streamlined version, but one based closely on seminal works by Glaser, Strauss, and their colleagues; our version consists of two complementary movements, four phases, and three ongoing activities. We then use the case of WCS to illustrate our version of grounded theory, and in so doing, we hope to show how the strategies of grounded theory manage the data–theory tension and its attendant dilemmas.

The chapter, then, has three goals: to argue that a grounded theory approach can be useful in confronting these three dilemmas; to present a modified model that makes the underlying productive tensions between data and theory explicit; and to illustrate, in a fine-grained way, how grounded theory was used in a study of literacy practices in an urban abortion clinic (results of which have been previously published in Haas, 1999a, 1999b).

A BASIC DESCRIPTION OF GROUNDED THEORY

Before moving into our main argument, we briefly describe grounded theory, drawing on five major texts: Glaser and Strauss' (1967) *The Discovery of Grounded Theory*; Glaser's (1978) *Theoretical Sensitivity*; Strauss' (1987) *Qualitative Analysis for Social Scientists*; Strauss and Corbin's (1990) *Basics of Qualitative Research*; and Strauss and Corbin's (1994) "Grounded Theory Methodology: An Overview."

First, grounded theory is not a theory; it is an approach to data analysis, one that can result in *a* grounded theory, that is, a small-t *theory* clearly and explicitly *grounded* in data. Strauss and Corbin (1994) call grounded theory "a general methodology, a *way of thinking about and conceptualizing data*" (p. 275). Grounded theory might best be understood as a set of explicit, iterative strategies primarily based on the act of comparison; in fact, grounded theory often is called "the constant comparison method."

As a methodology, grounded theory is based in a set of assumptions about what is knowable and how it is to be known, including the core assumption that there is an external social reality that is, in some limited way, knowable. Grounded theory has its roots in both symbolic interactionism and American pragmatism (Tashakkori & Teddlie, 2008); truth is not found or made, but enacted (Strauss & Corbin, 1994). Grounded theory is unabashedly an interpretive approach in which the role of the researchers and their joint work is paramount. Although grounded theorists often refer to theory as "emerging," emergence really is a metaphor for the interpretive and constructive work of theory building, work that Strauss argues is best carried out by teams of researchers. Because grounded theory is a constructivist methodology, Strauss and Corbin

(1994) insist that "interpretations *must* include the perspectives and voices of the people" studied (p. 274). Indeed, whenever possible, names of categories and codes are drawn from the local terminology of site participants (*in vivo* codes).

Although Strauss and Corbin refer to grounded theory as a comprehensive methodology, the approach provides little guidance in data collection—beyond the admonition that data collection and analysis proceed simultaneously or in tandem. In its original formulations, it almost exclusively employed interview data or verbatim verbal accounts of interactions collected through fieldnotes. A grounded theory is iteratively built with painstaking attention to specific data, which are studied in context, compared, and assigned codes. Resultant categories are then compared, dimensionalized, combined, and distinguished to construct more abstract (but still data-based) categories and, eventually, core categories (of which the resultant substantive theory consists.) Through an iterative process of "constant comparison" (Glaser & Strauss, 1967), data are compared with data in an attempt to build more inclusive categories. However, because of the direct links between data, codes, and categories (and because the codings are always documented in memos), the theory that is eventually built can be traced to very specific data points. Although not replicable in the strict sense, other researchers ideally should be able to see how codes, categories, and core categories are tied to specific data points. For example, in a long-term study of instant messaging (Takayoshi & Haas, 2011), undergraduate researchers who joined the research team well into the project's life were able to rather quickly "learn" the categories because of explicit links—in written and graphic form—to the original data.

In summary, grounded theory provides a powerful way to approach the analysis of data and the building of theory. Its power lies in the explicit and overt ways that it tackles the primary conundrum of all research, the relationship between knower and known, or—more specifically—the relationship between data and theory.

Grounded Theory as a Response to Three Research Dilemmas

As preface to our description of the three dilemmas facing qualitative researchers, we explain three terms—data, analysis, and theory—which are understood in a particular way in grounded theory. Data, from the Latin meaning that which is "given," refers to something in the world, something that exists separate from the researcher's subjective viewpoint or rendering. This "something in the world" can take many forms, including complex sites like classrooms and workplaces, where literacy lives in context; events, like teacher–student interactions, instructional sequences, or collaborations between writers; artifacts, like student texts, conversation transcripts, or curricular materials; and temporal processes, like joint decision making or developing media-rich documents. Analysis is the heart of grounded theory, where data are not rendered or presented, they are analyzed (also from the Latin meaning "to undo" or "unloose"). At the heart of this analy-

sis is an initial disruption, a taking apart, a "fracturing" (Glaser & Strauss, 1967). Coding, which has a specific meaning as well in grounded (as we explain later), is the primary means by which data are fractured and the primary way they are reconstructed. In grounded theory, analysis is primarily inductive, iterative, and systematic—such analysis results in a "grounded theory," grounded in that it is clearly tied to data. The counter move to analysis is theory building, and theory provides the counterpart for analysis, both for data and for theory. The goal of grounded theory is not a solution to a problem or the answer to a question, although grounded theory, like all research, is inherently about problems and questions. Rather, the goal of grounded theory is a set of working relations—a theory—a fluid structure built through systematic analysis and writing.

> *That which is given is undone and then put together in new ways—what is "given" remains, but it is transformed into an explanatory substantive theory that allows it to be understood in new ways—both by researchers and by practitioners.*

The first dilemma, one that any qualitative researcher can understand, is *the data dilemma*. In qualitative projects generally, there is a tendency go deep and wide in the collection of data. In their enthusiasm, students and even seasoned researchers endeavor to gather as much of, and as many kinds of, data as they can. The dilemma, of course, is that one is then faced with the daunting tasks of rendering "all this data" into verbal and graphic form. There are two reasons why this dilemma is less problematic with grounded theory: first, the researchers are analyzing in preliminary ways from the very beginning—even as data collection proceeds. Indeed, in the later phases of grounded theory, analysis guides data collection. The second reason that this dilemma is minimized is that collection, analysis, and writing co-occur, through memoing, or the writing of theoretical memos (Glaser & Strauss, 1967).

The second dilemma, *the theory dilemma*, is similarly diffused in the grounded theory approach. By theory dilemma, we mean the potential mismatch between what a given theory would expect a researcher to find and what her data in fact reveal. We have heard this dilemma described bluntly by graduate students and novice researchers as "What do I do if my data don't match my theory?" Of course, more experienced researchers understand that theories are meant to be modified—although depending on how big the "T" of any given theory, this can be problematic. One conventional response to the theory dilemma is to label certain data as "outliers" and omit them from the analysis. With grounded theory, the approach is rather different: Because the theory is built from the data—and (ideally) each theoretical tenet or category is traceable to particular data points—data do not have to be cut to fit theory. In fact, an "outlier" in a grounded theory analysis might very well be an important lynchpin in the final theory rather than as something to be eliminated (as in our example of the Permanent

Injunction). In grounded theory, theory itself is a process (Glaser & Strauss, 1967), and the response to the theory dilemma is not "forced fit" or "selective observation" (Glaser, 1978) but rather an ongoing juxtaposition of datum-to-datum and datum-to-theory.

Closely related to both the theory dilemma and the data dilemma, *the viewpoint dilemma* concerns whose perspective—researcher or participant—should be foregrounded. In qualitative research generally, findings often are rendered as a narrative, but one constructed from the viewpoint of the researcher, sometimes with input from participants. Grounded theory is one way to confront, even upset, the theory–practice binary (Neff, 1998). In grounded theory, the goal is not to fuse the views or voices of participants into a more-or-less authentic narrative. In fact, constructing a narrative to explain the data is used infrequently in grounded theory. This is not to say that participants' experiences are not important; in fact, they are at the center of what is being theorized. However, with grounded theory, experience (both participant experience and researcher experience) is understood in new ways—data are fractured or "made strange" (Murray, personal communication, April 19, 2008), as it were, and then reconstructed in new ways. Neither the viewpoint of the researcher nor the viewpoint of the participants can remain intact.

Our Model of Grounded Theory and an Example of Its Application

The model of grounded theory that we present and illustrate in this section is simplified, truncated, and, by necessity, incomplete. There are important aspects and activities vital to the grounded theory method that we do not treat: axial coding, theoretical saturation, and so on. It is not our goal to provide this simplified version as a shortcut method for writing research, nor would we expect (or want) researchers to use this chapter as a hands-on guide to using grounded theory. Rather, our purpose is to argue for the value of a grounded theory approach for writing researchers through a particular illustration of its use in a specific study of workplace literacy. Because of the complexity and sometimes apparent unwieldiness of grounded theory (particularly as articulated by Glaser and Strauss, 1967 and Strauss, 1987), we have simplified and streamlined the presentation of the approach. What we present here is a general description of what we identify as the two basic movements of grounded theory, with their attendant phases and activities (presented by Farkas, 2008). The activities in each case are generally associated with the two movements, but in practice, activities will extend across movements and phases.

Ultimately, this presentation of our approach to grounded theory is an attempt to make explicit the relationship of data to theory and to show in a fine-grained way how a substantive grounded theory in the realm of writing research can be built from qualitative data. If we are at all successful in meeting our goals, researchers will want to use grounded theory in their studies of writing and lit-

eracy, and they will feel compelled to learn the approach through immersion in the key texts (Glaser, 1978; Glaser & Strauss, 1967; Strauss, 1987; Strauss & Corbin, 1990, 1994) and sustained practice. In the discussion here, we indicate parenthetically the main source from which we have primarily drawn our understanding of key concepts and activities in grounded theory.

Our modified grounded theory approach (shown in Table 4.1) consists of two interrelated movements, four iterative phases, and three recurrent activities. The two analytic movements are pushing data apart, undoing or disrupting accepted relationships, and "fracturing" (Glaser & Strauss, 1967) the everyday objects and activities of the phenomenon under study. The two phases of Movement 1 are open coding and dimensionalizing (each explained in some detail in Strauss, 1987). Recurrent through the two phases of Movement 1 are the activities of constant comparison and memo writing (Glaser & Strauss, 1967).

The counter to this pushing out or undoing is the synthetic work accomplished in Movement 2, where categories and concepts are pulled back together, but in new ways via selective coding (Strauss, 1987) and inductive or theoretically sensitive integration. In Movement 2 one sees the culmination of the grounded theory approach in the core activity of "generating" (Strauss & Corbin, 1990) or "building" theory (Strauss & Corbin, 1994). Key recurrent activities in Movement 2 are mapping (not discussed as such in the sources texts) and memo writing (Strauss, 1987; Strauss & Corbin, 1990), which occur in concert during the two phases of selective coding and integration. Of course, these two major movements—pushing out or undoing, on the one hand, and pulling together or redoing in new ways—are not unique to grounded theory, but are the two basic conceptual moves in any analysis. We are making them explicit in our approach to grounded theory, however, and we are associating each with specific phases and activities.

Table 4.1. Movements, Phases, and Activities in Grounded Theory Approach

Movement 1: Pushing out/undoing/fracturing
 Phase 1: open coding
 Phase 2: dimensionalizing
Recurrent activities: constant comparison, memo writing

Movement 2: Pulling in/redoing/building theory
 Phase 3: selective coding
 Phase 4: integration (via induction or theoretical sensitivity)
Recurrent activities: mapping, memo writing

Movement 1: Pushing Out/Undoing/Fracturing

The basic analytic step in Movement 1 is to pull apart, as data are described both within and outside their contexts; actions and texts are cataloged variously—by type, by temporal sequence, by participant. By examining data in these various configurations, they are pulled out of sequence or location, setting the stage for new insights and configurations to emerge later, in Movement 2. In such a way, *theory is discovered in data* (Glaser & Strauss, 1987). The "discovery" of theory is not to be confused with the notion that external reality is "out there," ready to be "discovered." Indeed, the grounded theory tradition, based in American pragmatism (Dewey, 1935), explicitly rejects the notion of a preexisting, external reality.

In the project at WCS, an initial step was collecting (where possible), cataloging, and describing the features of all texts in "everyday use" at the clinic. It was not possible to collect actual copies of all texts in use at the clinic; some were confidential (patient charts, copies of drivers' licenses), whereas others, such as charts displaying CPR procedures, were unwieldy and did not lend themselves to reproduction. At the same time, detailed descriptions of the form and content of each document were recorded in fieldnotes and later written about in memos. Additionally, information about use of the various texts was gathered through interviews or observation.

This simple description of initial procedures illustrates an important principle in the grounded theory approach: The distinction between data collection and data coding is only possible in the abstract. As soon as the researcher begins to "describe," however objectively, the act of interpretation, or coding, has begun.

Open Coding. As the label suggests, the goal of open coding is to "open up the inquiry," and during this phase, all interpretations are provisional (Strauss, 1987). An open coding of documents in regular use at WCS resulted in a list of more than 50 documents; Table 4.2 presents examples of the kinds of documents collected and described.

Note how this seemingly random list of documents has already been interpreted, or "coded," by the researcher. Items are grouped together by location (in

TABLE 4.2. Open Coding of Examples of Documents in Regular Use at WCS

Posted directions / magazines / directional signs / clock / painted door sign
Christmas cards / CPR chart / doctors' diplomas / do not enter sign
Emergency exit sign / patients' bill of rights / large calendar / phone list
Planned Parenthood brochures / printed directions (stacked) / info brochures
Emergency contact form / copies of drivers' license / legal ruling / sign on TV
Cat calendar / Cover sheet / pregnancy test form / insurance card / phone notes
Counseling form / appointment cards / parental permission forms

waiting room, in files, on the counter) and by type of display—for instance, the first 13 items are hanging or posted on the walls, and the next three are stacked in front of the check-in window. Chapter 4 of Strauss' (1987) *Qualitative Analysis for Social Scientists* presents a detailed example of open coding.

Dimensionalizing. Next, properties for each datum—in this case, texts—are identified, and texts are dimensionalized according to these properties. Some of the properties for the first items in Table 4.2—printed directions and magazines—are presented in Table 4.3.

Once properties for various data are determined, the data can be dimensionalized in any number of ways. In the clinic study, some of the important dimensions turned out to be *formal features* (brochures, signs, charts, forms); *form of display* (posted, stacked, filed); *number of copies* (unique, few copies, several copies, multiple copies); *frequency of use* (numerous times daily, daily, regularly, weekly, once, virtually never); *source* (patient, staff, American Medical Association, county court); *accessibility* (available to everyone, available to staff and patients, available to staff only); *actions taken on it* (read, signed, and filed; signed but not read; written, read, and filed; written but not read; distributed and discarded); *signed* (yes/no); and *location* (filed in nurses' area, stacked in waiting room, posted in patient care room, etc.). Note that some of the dimensions are just yes–no dyads, whereas others are scales, frequency of use, and number of copies. (Farkas, 2003, provides another example of dimensionalizing.)

Dimensionalizing, and comparing across dimensions, allowed us to note both general trends and outliers. For instance, the dimensions *number of copies*

Table 4.3. *Properties of Two Texts*

Printed Directions	Magazines
• Includes directions to WCS from three major thoroughfares	• Located in waiting room, on tables or in rack
• Posted near phone in nurse's area	• Includes ads, stories, photos, articles
• Stationary (i.e., isn't "moved about")	• Moved about frequently
• One version	• Multiple versions at any given time
• Produced "in house"	• Regularly replaced
• Seldom revised	• Produced commercially and brought to WCS
• One page	• Multiple pages
• Used by staff to give patients directions over the phone	• Nonspecific use; "for patients to look at"
• Used multiple times daily	• Identified by staff as peripheral to work of clinic
• Identified by staff as key to work of the clinic	

and *frequency of use* were related, as might be expected, with multiple copies of frequently used documents available. Similarly, generally accessible documents tended to be posted documents. Particularly interesting are the outliers that emerged through dimensionalizing. In the clinic study, such outliers included the Permanent Injunction, limiting some forms of public protest, posted on the door of the clinic, which was unlike most other signed documents in that it was available to all and posted rather than only available to a few and filed. It was also one of the only "unique" documents at this site in that the copy posted on the door was apparently the only copy in the clinic (at least according to the clinic manager, an LPN, who acknowledged that one of the doctors may have retained a copy either at the clinic or at his home, which was also protected by the Permanent Injunction).

Another outlier was a fetal development pamphlet that the state required be distributed to every patient. There were multiple, even myriad, copies of this document in the clinic, and it was distributed not just to every woman who underwent an abortion procedure but also to patients and even family members making inquiries. However, unlike other widely available documents, only seldom was any action taken on the pamphlet. Generally, the pamphlet was returned, unread, to the nurse, or it was discarded. (A more thorough treatment of these documents is provided in Haas, 1999a, 1999b.) The role of the patterns and outliers that emerge during dimensionalizing are examined further later.

Movement 2: Pulling In/Redoing/Building Theory

Movement 2—pulling in or redoing—is the counterpart to Movement 1. After the phenomena under study are "fractured" in Movement 1, the researchers begin to integrate the data in new ways and to build new understandings of the phenomena. The two movements are, of course, temporally related in that Movement 2 must, of necessity, follow Movement 1. Whereas Movement 1 might be characterized as an expansive move, Movement 2 can be understood as a contracting move. Additionally, although a wide-angle lens is appropriate for Movement 1, the two phases of Movement 2, selective coding and integration, require a more fine-grained look.

Selective Coding. During selective coding, aspects of the data set that emerged as salient through dimensionalizing are pursued in more detail. The goal of selective coding is to identify and to provisionally confirm a core category by systematically relating the core category to data and to other categories. The researchers often go back into the data to "sample," and indeed, selective coding is closely related to theoretical sampling (Strauss & Corbin, 1990) in that there is an attempt to bring seemingly disparate phenomena into a kind of dialogue with one another.

In the clinic study, the Permanent Injunction provided the impetus for selective coding. Because this document was a rare *posted, unique,* and *signed* document and because the Permanent Injunction came up (without prompting) in several open-ended interviews with staff, we decided to selectively code for *signatures* (which we believed was a potential core category) across other documents and locations. We found one other instance of a signed and posted document (the copies of the doctors' medical diplomas), but the diplomas were not placed in a prominent position (as the injunction was), they were not mentioned in participant interviews, and they were not unique, in that other copies were posted in patient care rooms. Other signed (or initialed) documents—parental permission forms, surgical release forms, patient counseling checklists—were filed in patient charts. (For another example of selective coding, see Farkas, 2003.)

Integration. In this phase, core categories and their attendant data are integrated into a tentative, substantive theory. A "substantive theory" pertains to a "substantive" area (Strauss, 1987), that is, one that arises from and pertains to "one particular situational context" (Strauss & Corbin, 1990, p. 174).

In the clinic study, categories were integrated in two ways: through general induction and via theoretical sensitivity. In the clinic study, one example of inductive integration is provided by "the front" (an *in vivo* category, or a category labeled with a term generated by participants, Strauss, 1987). The front turned out to be a central location for literacy activity in the clinic. It was a term used by clinic personnel to refer to the place where a great deal of clinic activity was centered and where a large number of key documents "lived." It included the tables with the two phones, the large vertical files where charts were housed, the counter that served as a "nurses' station," and so forth. Although it initially seemed that "the front" was defined by its physical parameters (roughly the doorways on the right to doctor offices and to patient care rooms and from the window to the waiting room to the wall behind the vertical files), the kinds of activities also helped determine how the front was understood by clinic personnel and patients. For instance, certain activities that were centered on the counter with a sliding glass window where patients and staff initially interacted was included as part of staff's understanding of the front (when patients were signing documents or receiving written instructions), but the brochures and pamphlets stacked there were not part of the activities of the front.

According to Glaser (1978), integration also can occur via researchers' theoretical sensitivity, which often is a "delayed action phenomenon" (p. 18). Theoretical sensitivity is explained by Glaser and Strauss (1967) as the ability to "conceptualize and formulate a theory" (p. 46). It is built over time and is potentially increased by being "steeped in the literature" of a given phenomenon or activity. As writing researchers, we came to the study with a background in literacy theory and history. Additionally, concurrent with the analysis, we were studying the scholarly literature on emerging concepts and categories (e.g., the-

ory and research on the signature as part of our interest in the signed documents). Our background and our reading during the project made us "sensitive" to concepts that might have explanatory power. Theoretical sensitivity is similar to the common experience of being introduced to an idea or object and then encountering it "everywhere": "Once I learned to identify a buckeye tree, I started noticing just how many there are in my hometown."

Specifically, in the case of the clinic study, we were "sensitized" through our reading of Derrida's (1981), Harris' (1995), and Olson's (1994) work on writing and the signature. Olson's (1994) *The World on Paper*, which deals with the way texts shape and delineate cultural work, was especially influential. At the same time, reading about the history of abortion and then the discourses of abortion (Bracher, 1993) led us to feminist texts, like Fraser (1990) and Benhabib (1993), who provide feminist interpretations of the delineation of public and private. This, in turn, led us to Habermas' (1989) *The Structural Transformation of the Public Sphere* and Arendt's (1959) *The Human Condition*, which helped us articulate the major theoretical claim to emerge from our study: *the distinction of public and private, fraught in this context of cultural ambiguity, is partially managed through a delineation of spatial relations.* (See Haas, 1999a, for further discussion of this theoretical claim.)

Recurring Activities: Constant Comparison, Mapping, Memo Writing

The three recurrent activities that we identify in our version of grounded theory are not singled out as such in the original formulation of the theory (Glaser & Strauss, 1967). However, in our experiences of using grounded theory for five distinct research projects over 11 years, we have found that these activities are key in using a grounded theory approach to examining literacy and writing.

In our description of the study of WCS presented here, the role of *constant comparison* should be obvious: Properties of data are contrasted (as in the case of x and y) and preliminary categories are compared; furthermore, dimensionalizing is essentially comparative: less to more, seldom to frequent, small to large, prevalent to unique, and so on. Glaser and Strauss (1967) note that the constant comparison method is designed to "allow, with discipline, some of the vagueness and flexibility that aid the creative generation of theory" (p. 103).

Possibly less obvious is the role of *mapping*. Strauss (1987) presents one kind of essential map—the concept indicator map—a nice summation of both constant comparison and mapping, as features of various "indicators" (i.e., data) are compared and combined, creating "concepts," and then compared again at a higher level of abstraction. Additionally, we found the mapping of physical space to be quite generative, as well as the mapping of what might be termed *literacy hot spots* (Platz, personal communication, March 1997) like the front at WCS. Also useful is a conceptual map in which relationships between codes, categories,

and concepts are represented in graphic form. One form of mapping is the logical diagram, a graphic representation of the relationship between categories (Strauss & Corbin, 1990). In the case of the clinic study, creating a graphic representation of public and private material spaces was key in theorizing the spatialization of these conceptual categories (Haas, 1999b).

Finally, the recurrent activity of *memoing* proved to be essential in our use of grounded theory at WCS. As described by Strauss (1987), theoretical memos have an "indispensible function in discovering, developing, and formulating a grounded theory" (p. 109). Furthermore, memos "represent the written forms of our abstract thinking about data" (Strauss & Corbin, 1987, p. 198). It is vital that the writing of theoretical memos occur with every data-gathering episode. In practice, many novice researchers say, "But there's nothing to write about yet." On the contrary, cataloging, listing impressions, and writing down verbatim quotes, can all be done from the very beginning. (Fig. 4.1 illustrates an early memo from the clinic study.) The point is not that early memos necessarily lead to great insights, but that the *practice* of memoing is built into the research project from the start. In this way, *writing* becomes a central strategy in the grounded theory approach. As writing researchers, this makes sense to us: Writing theorists have long understood the generative, epideictic function of writing (Elbow, 1973; Murray, 1982).

Theoretical Memo

September 27, 9:45 a.m. to 11:05 a.m.
Goal: catalog docs in waiting room and their use

Location: sat in two places in the waiting room: second chair in front of window and middle chair on south wall.

Procedure: noted every sign and text in waiting room and tallied their use by visitors.
7 magazines on tables and in vertical magazine file: women's mags, travel mag, health mags. Parts of today's paper. 6 signs. 1 poster. 2 typed forms. 3 stacks of documents on counter (planned parenthood, directions, abortion information), about 40 copies of each.

One person looked at poster—9.52; magazines picked up 11 times, for 30 sec to 4 min. 30 seconds; no brochures picked up; almost everyone looked at clock.

Questions—is the clock a document? Is looking at something the same as reading it? Why so many copies of brochures on counter?

FIG. 4.2. *Excerpt from early memo, based on written fieldnotes.*

CONCLUDING THOUGHTS:
ON AUDACITY AND HUMILITY

In the introduction to *Steps to an Ecology of Mind*, Gregory Bateson (1972) argues that research has two beginnings, each of which has a certain authority: "the observations cannot be denied, and the fundamentals must be fitted. You must achieve a sort of pincers maneuver" (p. xxii). Bateson goes on to describe how, in surveying land or mapping stars, one works with two bodies of critical knowledge:

> There are your own empirical measurements on the one hand and there is Euclidean geometry on the other. If these two cannot be made to fit together, then either the data are wrong or you have argued wrongly from them or you have made a major discovery leading to a revision of the whole of geometry. (p. xxii)

Here, Bateson has, as usual, captured a profound truth with a couple of simple metaphors. Using "pincers," the researcher must remain true to both observations and fundamentals—the someplace particular and the larger vision of Haraway. The countermovements of the pincer—open, close—resemble the pushing out (opening) and the pulling in (closing) of inquiry.

And, as usual in reading Bateson, we come away humbled. There is great audacity in upending Euclidean geometry, on the one hand, and there is, on the other, the more pedestrian and the much more likely possibility that one is simply wrong.

It is the "pincers maneuver" between observations and fundamentals where, we believe, grounded theory lives. Even to begin to engage this maneuver takes audacity: to imagine that one might turn geometry on its head is audacious. Equally audacious is the idea that one might, in some imperfect way, begin to capture the world through observation. At the same time, however, it is infinitely humbling to encounter both the unending particulars of the world and the complex beauty of explanatory theory. Grounded theory, then, is a way to pick up our pincers and, in the moment between audacity and humility, continue the work.

ACKNOWLEDGMENTS

Formative conversations with the late Steve Witte are acknowledged. In addition, the authors thank Bob Bracewell, Chad Wickman, the members of Haas' Research Design Seminar in spring 2008, and the students and faculty of the doctoral program in rhetoric at Texas Christian University—all of whom provided valuable feedback.

REFERENCES

Arendt, H. (1959). *The human condition.* Chicago: University of Chicago Press.

Bateson, G. (1972). *Steps to an ecology of mind: Collected essays in anthropology, psychiatry, evolution, and epistemology.* Northvale, NJ: Jason Aronson.

Benhabib, S. (1993). Models of public space: Hannah Arendt, the liberal tradition, and Jurgen Habermas. In C. Calhoun (Ed.), *Habermas and the public sphere* (pp. 73-98). Cambridge: MIT Press.

Bracher, M. (1993). *Anti-abortionist discourse. Lacan, discourse, and social change: A psychoanalytic cultural criticism* (pp. 103-118). Ithaca, NY: Cornell University Press.

Derrida, J. (1981). *Dissemination* (B. Johnson, Trans.). Chicago: University of Chicago Press.

Dewey, J. (1934). *Art as experience.* New York: Perigee Books.

Dewey, J. (1935). *Liberalism and social action.* New York: Putnam.

Elbow, P. (1973). *Writing without teachers.* New York: Oxford University Press.

Farkas, K.R.H. (2003). *Public discourse in the civic arena: Taxonomies of oral and written discourse in a local city government's council meetings.* Ann Arbor: Proquest UMI Dissertation Publishing.

Farkas, K.R.H. (2008, April). *Using grounded theory in composition studies.* Workshop conducted at the Conference on College Composition and Communication, New Orleans, LA.

Fraser, N. (1990). Rethinking the public sphere: A contribution to the critique of actually existing democracy. *Social Text, 25/26,* 56-80.

Glaser, B. (1978). *Theoretical sensitivity.* Mill Valley, CA: Sociology Press.

Glaser, B., & Strauss, A. (1967). *The discovery of grounded theory: Strategies for qualitative research.* Chicago: Aldine.

Haas, C. (1999a). On the relationship of old and new technologies. *Computers and Composition, 16,* 209-228.

Haas, C. (1999b). Materializing public and private: The spatialization of conceptual categories in discourses of abortion. In J. Selzer & S. Crowley (Eds.), *Rhetorical bodies* (pp. 218-238). Madison: University of Wisconsin Press.

Habermas, J. (1989). *The structural transformation of the public sphere: An inquiry into a category of bourgeois society* (T. Burger, Trans.). Cambridge: MIT Press.

Haraway, D. (1988). Situated knowledges: The science question in feminism and the privilege of partial perspective. *Feminist Studies, 14*(3), 575-599.

Harris, R. (1995). *Signs of writing.* London: Routledge.

Murray, D. (1982). Teaching the other self: The writer's first reader. *College Composition and Communication, 33*(2), 140-147.

Neff, J.M. (1998). Grounded theory: A critical research methodology. In C. Farris & C.M. Anson (Eds.), *Under construction: Working at the intersections of composition theory, research, and practice* (pp. 124-135). Logan: Utah State University Press.

Olson, D. (1994). *The world on paper: The conceptual and cognitive implications of writing and reading.* New York: Cambridge University Press.

Strauss, A. (1987). *Qualitative analysis for social scientists.* New York: Cambridge University Press.

Strauss, A., & Corbin, J. (1990). *Basics of qualitative research: Grounded theory procedures and techniques*. Newbury Park, CA: Sage.

Strauss, A., & Corbin, J. (1994). Grounded theory methodology: An overview. In N. Denzin & Y. Lincoln (Eds.), *Handbook of qualitative research* (pp. 273-285). Thousand Oaks, CA: Sage.

Tashakkori, A., & Teddlie, C. (2008). Quality of inferences in mixed methods research. In M. Bergman (Ed.) *Advances in mixed methods research: Theories and applications* (pp. 101-119). London, UK: Sage.

5

THE CONSTRUCTION OF RESEARCH PROBLEMS AND METHODS

Pamela Takayoshi, Elizabeth Tomlinson, and Jennifer Castillo

> People study what is accessible to study, what is available to them techno-
> logically. But why haven't researchers and scholars said so, and more impor-
> tant, why have they not raised questions about what was not studied?
> —Sullivan and Porter (1997, p. 9)

> We do not find problems, we create them.
> —Young (1981, p. 60)

It has been generally recognized that research questions are crucial to the shape research takes as a whole. Blakeslee and Fleischer (2007) acknowledge this when they write, "Although it sounds like a simple thing to do, articulating a good research question can be a challenge. Some scholars contend that research stud-ies are only as good as the research questions behind them, which can put a great deal of pressure on you as a new researcher" (p. 13). As a field, writing studies has recognized that forming good research questions is a crucial part of the research process. Beyond that acknowledgment, however, there is little under-standing of how researchers move from research problems to research questions, leaving the relationship between epistemology and research question largely invisible. Nancy Naples (2003) suggests that leaving the relationship between epistemological positions, experience, and research invisible leads inevitably to the reinscription of unexamined biases: "If researchers fail to explore how their personal, professional, and structural positions frame social scientific investiga-tions, researchers inevitably reproduce dominant gender, race, and class biases" (p. 3). These unexamined biases include not only the dominant gender, race, and class biases but a host of others related to social position (sexual orientation, edu-

97

cational attainment, able-bodiness, religious belief, etc.), as well as assumptions about the scholarly field to which our research contributes (what counts as knowledge, what counts as research, what is accessible to study, what is not, what methods are expected). These epistemological assumptions "also influence how we define our roles as researchers, what we consider ethical research practices, and how we interpret and implement informed consent or ensure the confidentiality of our research subjects" (Naples, 2003, p. 3). If researchers are to be in control of their research practice, it is crucial to explore (and understand) the roles our epistemological, political, and ideological assumptions and commitments, as well as our experiences and knowledge, play in the shaping of our problems and questions. Our epistemological positions influence what we even perceive to be a researchable problem, and further influence how we move from researchable problem to research question. It is important in this context to be precise about the distinction between "problem" and "question": We argue in this chapter that researchers "create" problems, and then develop research questions based on those perceived, rather than preexisting, problems.

Krista Ratcliffe (2005) argues that there is a formative connection between a researcher's assumptions about the objects of study, his or her expectations for research, and his or her understanding of her data:

> assumptions about identification ... inform researchers' assumptions about the identities of people, histories, cultures, or artifacts being studied. Indeed our (un)conscious assumptions about identification inform not just who we are but what we expect from ourselves, from others, and from language. And all of these assumptions affect the data and conclusions of a scholarly study. (p. 51)

Ratcliffe suggests that epistemological assumptions permeate the work we do as researchers, oftentimes unconsciously. If Ratcliffe is correct in the way epistemological assumptions permeate research work, then it is crucial to understand just exactly what role such assumptions play in our decision making as researchers. Patricia Sullivan and James Porter (1997) point out, "People study what is accessible to study, what is available to them technologically," and they call for more explicit reflection: "But why haven't researchers and scholars said so, and more important, why have they not raised questions about what was not studied?" (p. 9). Sullivan and Porter call on us as researchers to be explicit (in both our research practice and in the written texts that result from them) about the kinds of questions we feel are appropriate to ask, and (as importantly) what we don't ask. Richard Young (1981) says "We do not find problems, we create them" (p. 60). Problems, as well as questions, are not floating around the world somewhere waiting to be discovered; the very questions we ask are constructions by researchers. People study what is accessible to study; they also study what they have constructed as a problem worthy of attention.

In this chapter, we explore how researchers and scholars come to see problems as worthy of attention and how some writing studies scholars formulate research questions from these research problems. We take a cue from Hull, Rose, Fraser, and Catellano (1991) who point out that "knowing our intentions, we can forget to examine our assumptions" (p. 300). An (ongoing, continual) examination of our assumptions as researchers, as scholars, and as people enacting relationships through our research practices is important for understanding the potentials and limits of our research. Little attention has been paid to the epistemological and ideological processes that give shape to the research question, processes that give shape to the research project as a whole. In order to think about these processes, we begin with a theoretical discussion of felt difficulty and reflective practice and then turn to survey responses of recently published writing scholars who describe the formation of their research inquiry. We conclude with some guidelines and a heuristic for maintaining a reflective position toward the crucial formative stage in any research project.

THE FORMATION OF RESEARCH QUESTIONS

Research methodology texts tend to construct the research process as a consistently recognizable process: articulating a research question, planning research methods, collecting data, analyzing data, and writing up findings. Although the implicit linearity of the movement from stage to stage is perhaps an unintended consequence of analysis, research theorists do tend to begin the process with research question formation. Ann Blakeslee and Cathy Fleischer (2007), for example, structure *Becoming a Writing Researcher* (one of a small handful of methodology guide books authored specifically by and for writing and literacy researchers) around this stage model of research. Their text summarizes the generally consistent "tools for discovering, articulating, and narrowing questions" appearing in methodological texts, including taking personal and professional inventories, reading, observing, talking with others, writing, and gathering preliminary data. Frequently, researchers suggest that research questions begin with a "gap" in existing knowledge; of this gap, Blakeslee and Fleischer write,

> Sometimes … you sense a gap in what you are reading, something that is not addressed that you think should be. It may be a gap in the author's argument, or it may be a contradiction between what the author has claimed and what you have observed or experienced personally. Some scholars refer to this perception of a gap in the literature as a *felt difficulty*. You sense that something isn't quite right. … The gap, or felt difficulty, you perceive in your reading may well become the seed for the research question you formulate. (p. 19)[1]

Implicit in this gap (but crucial to any recognition of missing perspectives) is one's personal history of experiences, knowledge, and commitments, as Blakeslee and Fleischer suggest when they write, "In many cases, the topics you end up researching professionally will hold special meaning for you personally as well— they may be tied to your background or personal experience" (p. 15) and "the areas you research and the questions you pose for research are often connected to your personal and professional interests and experiences. They have a history" (p. 16).[2] When one's personal beliefs, epistemologies, experiences, and knowledge (all of which are grounded in gender, race, sexual orientation, age, class, religious affiliation, political commitment, and other subject positions) come in contact with existing scholarship, moments of dissonance might productively arise and begin to suggest potential research questions.

This lens of cognitive dissonance, in fact, has been one of the dominant ways research theorists have viewed research inquiry. MacNealy (1999), for example, identifies four categories of cognitive dissonance as the source of research problems—"a clash between beliefs, an expectation violated, a gap in knowledge, or a previously unnoticed connection between two phenomena" (p. 12)—and MacClean and Mohr (1999) similarly point to instances of cognitive dissonance as a source of research problems. Hayes et al. (1992) posit that the research problem "begins where all inquiry begins ... in a moment of puzzlement, or curiosity, or need to know; more generally it begins, not in some impulse peculiar to the scientist, but, as Aristotle observed when discussing the philosophic impulse, in wonder" (p. 9). In an earlier piece, Young (1981) suggests that research begins with "a felt difficulty" by which he means to capture "the wrinkled brow and uneasy feeling characteristic of the earliest stage of inquiry" that arises from inconsistencies among elements of one's cognitive system.[3] He explains more fully that:

> Problems do not exist independent of men. There are no problems floating around in the world out there waiting to be discovered; there are only problems for someone. For problems arise from inconsistencies among elements of the individual's cognitive system. We do not find problems, we create them. One's cognitive system, his Image of the world (Boulding, 1956), is composed of values, beliefs, opinions, organized and unorganized information, all of which combine to form an exceedingly complex, more or less coherent system. A problem begins to take shape when one element of the Image is perceived to be inconsistent with another. (pp. 60-61)

The concept of *felt difficulty* offers a more complex alternative to the recognition or discovery models of research questions, and perhaps more significantly, the concept of felt difficulty places the focus not on existing bodies of scholarship but on the researcher—and his or her intellectual, emotional, and subjective perspective. Rather than seeing research questions "floating around in the world" or

existing in a "gap" in the literature, we see the researcher as the interpretive point through which the research question is constructed as the researcher confronts inconsistencies in his or her "values, beliefs, opinions, organized and unorganized information." When we think of research questions as existing out there waiting to be identified, we separate the researcher from the research problem (the researcher's role being merely to identify research questions that exist "out there") and we downplay or ignore the role the researcher's subjectivity (his or her experiences, knowledge, epistemological beliefs; political and ideological commitments; and subject positions) plays in the construction of research questions. But like Young, we believe that problems do not exist independently of human beings—he asserts, "We do not find problems, we create them."

It is important to understand how these easily invisible processes of knowledge-making and knowledge-shaping can influence our research practice, and thus the types of conclusions we reach, in our research. Reflecting explicitly and articulating the choices we make as researchers is one way of being more in control of those influences:

> When we set the problem, we select what we will treat as the "things" of the situation, we set the boundaries of our attention to it, and we impose upon it a coherence which allows us to say what is wrong and in what directions the situation needs to be changed. Problem setting is a process in which, interactively, we name the things to which we will attend and frame the context in which we will attend to them. (Schön, 1982, p. 40)

Explicit reflection on our process of selecting the "things" of the situation, setting boundaries of our attention, and imposing coherence introduces a measure of accountability into the nascent beginning of our research process. As we set the terms of the research, the boundaries of our work, and the coherence of a research question that will guide the entire process, explicitly acknowledging how we arrive at the point of researching is crucial because when we do not interrogate these practices of what Schön calls problem setting and what Young would refer to as problem creation, we run the risk of implicitly reinscribing our own unexamined biases into the research design. Gesa Kirsch (1999) cautions that "We cannot help but be influenced by our own experiences, training, and ideological allegiances" (p. 18). Yes, research questions arise from and are grounded in a researcher's commitments; what is important is that we develop a richer understanding of how this is so and a more consistent recognition of the ways these too often invisible commitments have shaped the very study, in order to develop rigorous practices of accountability.[4]

In some ways, our research tells a story about us (the researchers) as much as it tells a story about the participants or site we studied. Mortensen and Kirsch (1996) point out that "Many scholars now assume that interpretation is central to all research, that researchers' values permeate and shape research questions,

observations, and conclusions" (p. xxi), and Laurel Richardson (1997) reflects, "What I choose to write about, how I choose to write it, and for whom I write it say more about me than sociodemographics, personality inventories, or horoscopes" (p. 19). In our case, this chapter began in a graduate seminar in which Pam was the instructor and Beth was a student. When discussion turned to an upcoming professional conference, Beth described the work she was presenting there—results from a study she and Jen had collected on how publishing scholars described their research question formation. In that study, they were seeking insight into how to frame researchable questions, how to determine appropriate methods, and how to articulate the relationship between the question and the methodological choices. Their interest began then with a felt difficulty: a desire to better understand how their own research processes might be modeled on the processes of successful scholars. This edited collection was in its initial stages, and Pam was planning a chapter about the need to understand research questions as a subjective process of creating problems rather than finding them. Pam had been interested in the complexity of research question creation and problem setting as a result of years of working with undergraduate and graduate students as they undertook research projects—from class projects to dissertations. Her interest in this issue began then with a different felt difficulty—a growing awareness that students needed more guidance in the problem and question stages of their research projects. All three of us worked in the same rhetoric and composition PhD program, yet only through impromptu conversation did we realize that we were independently working on virtually the same research question. The culture in which we worked—the program focus, the faculty and students in the program, the scholarly texts circulating through the program in official and extracurricular ways—all played an important role in positioning us to see the research project inherent in how researchers and scholars come to see problems as worthy of attention and how some writing studies scholars formulate research questions from these research problems.[5] In the following section, we turn to reflections we collected from recently published scholars about their research processes, particularly the formation of those processes, in order to examine how research problems, questions, and methods are constructed in actual practice. Meta-cognitive reflections such as these are rarely included in the final representations of research, although these reflections provide valuable insight into how some researchers and scholars work (and think about their work), which we believe is important not only in the way it provides models for other practicing researchers but also for the lessons we might learn about how knowledge is made in writing studies.

RESEARCH QUESTION FORMATION-IN-ACTION

Invention heuristics (Young, Becker, & Pike, 1970) and means of assessing argumentation's initiation (Perelman & Olbrechts-Tyteca, 1958; Toulmin, 2003) easily can be adapted to beginning research inquiries, and as we suggested earlier in this chapter, some writing studies theorists offer specific guidance in research practice. Yet few works examine what scholars actually do when they begin their research processes. What is involved in the creation of research questions? How do researchers make choices about methods? With these questions in mind, via email, we contacted 32 scholars who had published articles[6] in the previous two issues of *College Composition and Communication, College English, Written Communication*,[7] *Rhetoric Society Quarterly*, and *Research in the Teaching of English*. We narrowed our field of participants to those who had recently published in one of the major journals in composition studies in order to capture a "state-of-the-field" type of snapshot as well as to attempt to lessen the time lapse between the researchers' question formation and their reflections on that process.[8] Eleven scholars agreed to participate in an open-ended email survey (see Appendix B for interview questions). They generously permitted us to use their names, allowing those familiar with their work to recognize the cross-section of the discipline represented here (see Appendix A for participants). Although participants are diverse in terms of institutional location and professional rank, our participants are not necessarily representative of the diversity of scholars working in our profession. Further investigations might focus on how nondominant subject positions (vis-à-vis gender, race, class, sexual orientation, disability, among others) influence the kinds of problems researchers set or create.

The scholarship these participants discuss vary in their methods from empirical to theoretical to reflective narrative. Our participants engaged in empirical investigations (and thus followed a similar process to the one we described in the preceding section) but also were engaged in theoretical work that did not include data-based research. Across these varying types of scholarship, the survey responses suggest the range of ways research questions (of any kind) are grounded in our personal assumptions, belief systems, and ways of being in the world. If the personal, professional, and structural position us as researchers in the creation of research problems, then it is crucial to understand how we are positioned not only as a matter of research practice but also as a matter of knowledge construction. The processes of constructing research problems, research questions, and methodological approaches are central to the ways knowledge is constructed in our discipline. These issues are ones of how knowledge is made in our field and how subjectivity buoys and constrains what researchers see as worth knowing or studying. One research participant, Jeff Rice,[9] wondered in his response, "Why ... do we need to know about the early stages of research work? And where would such a project differ from the observations of Janet Emig [or]

the complexity of Bruno Latour?" We believe the answer to that question is that understanding the early stages of research work tells a great deal about the values of our discipline—what counts as knowledge and what is seen as researchable. Interestingly, Latour (1998) himself pointed to a parallel concern when he wrote, "There is a philosophy of science, but unfortunately there is no philosophy of research. There are many representations and clichés for grasping science and its myths; yet very little has been done to illuminate research" (p. 208). In effect, Latour calls for a greater understanding of the processes of knowledge-making involved in research as opposed to only paying attention to the form of research's final products. Although many in writing studies (Bazerman, 2008; Emig, 1997; MacNealy, 1999; Young et al., 1970) and in feminist research (Fine, 1996; Fonow, & Cook, 2005; Kirsch, 1999; Lather, 1991; Reinharz Davidman, 1992; Richardson, 1997) have theorized research practice while writing reflectively about their own research practices, this body of work has not been so comprehensive as to eliminate all need for further research into how knowledge is made in writing research. In the next section, we focus on our research participants' reflections on how they created research questions and the role their experiences (both professional and personal) played both explicitly and implicitly in the formation of those research problems and questions.

RESEARCHERS' REFLECTIONS ON PROBLEM SETTING AND THE CREATION OF RESEARCH QUESTIONS

When asked to reflect explicitly on the origins of their research questions, participants most prominently emphasized aspects of cognitive dissonance as the impetus for research problem formation: Eight participants (73%) described gaps in knowledge in the field; eight others referred to curiosity or personal desire to figure out how or why something occurs; seven participants (64%) discussed uneasy feelings, arising from a violation of expectation or a clash between beliefs; and creating or recognizing a new connection was cited by six respondents (55%). Although these responses all begin with some type of cognitive dissonance, they really begin with the researcher herself—what she sees as a gap in the field, the kinds of personal curiosity she connects to her professional life, the experiences she has had that left unresolved feelings, and the scholarly areas she believes might be productively (and uniquely) brought into conversation with one another.

In practice, these varying reasons for research come together in a nexus of forces, as Anne Haas Dyson describes:

> First, I start with the curiosities I have, which typically build on the last project I did. ... Second, those curiosities meet the particular site I choose; even

if I start focused on one issue, places have their own story to tell, so original intentions change. Third, all of this happens within the context of what is happening politically in terms of educational policy and ideologically in the field.

In this nexus of factors influencing the research questions she might ask, Dyson describes the relationship of the individual researcher (the curiosities she has) to larger contexts of meaning-making (the research site he or she selects and the field in which he or she works and to whom he or she speaks), emphasizing that research questions are a convergence of multiple forces.

But importantly, Dyson suggests, the process begins with the individual, the curiosities he or she has, and his or her larger research history. She elaborates in particular on beginning her article:

> Prior to this project, I had spent years studying the resources of children for entering into school writing, including their relationships with each other, their appropriation of material from human and technological sources of all kinds, including popular media, the diversity of social goals and textual practices they developed in the interplay of official and unofficial child worlds, and, ultimately, the diverse pathways children may negotiate into written language use. The challenges posed by moving among media, the way participation with peers fueled and shaped child writing—these were of great interest to me. But now, the space for children was becoming very tightly structured and there was intense interest in "the basics," particularly in Reading First schools in my new part of the country. I wondered what the consequences were of these structured contexts for how children participated in school writing. Little children, in general, try to be "good," as it were. So what did they assume they were supposed to do? How do they try to stay "within the curricular lines"? What are the consequences of their efforts to do the right thing for how they compose and what their teacher might learn about them as language users? And hence this project.

The years Dyson spent prior to this project poised her to see contemporary literacy challenges faced by children as "of great interest" and led her to "wonder" about a series of big questions. In her response, Dyson has provided us with a rich description of the process leading to research questions. Her professional history, as well as her ideological, epistemological, and scholarly commitments, combined with cultural forces she recognized as gaining momentum. These multiple forces all contributed to her interest and wonder—in both the sense of wonder as a verb (to be curious to know something) but also in the sense of wonder as a noun (a feeling of surprise caused by something beautiful, unfamiliar, inexplicable).[10] Another participant, Lynn Bloom, also notes a sense of wondering that led to her research: "I have been reading food autobiographies and cookbooks and food mags for a long time with great pleasure and wanted to figure

out why this reading is so much fun." Similarly, Richard Raymond begins with his experience as grounds for writing what he describes as an "academic memoir" about "teaching of American literature and Research Strategies at the University of Shkoder in Albania. ... This project led to a book, an academic memoir [which] details not only me teaching but also my work with the faculty—exchanging pedagogy and scholarship, collaboratively shaping a writing-centered curriculum in English studies, developing democratic departmental governance." And Barry Kroll describes his nonacademic interests and experiences as influencing the theoretical framework he develops: "I had studied tai chi for a while and was struck by its implications for arguing differently. When I read about aikido I knew I'd found something of great potential. So while the article had several roots and sources, the most important one was aikido."

Peter Smagorinsky recognizes that research ideas are more often grounded in longitudinal research agendas and experiential knowledge rather than existing out there somewhere waiting to be discovered: "The idea didn't quite so much come from somewhere, but rather was part of a long-time interest in what people now call multimodal composing. I published things on incorporating the arts into English instruction as early as 1991, and began publishing empirical studies of artistic composing in 1994." Smagorinsky goes on to explain that "This particular study was not a result of a design, but something that occurred in the classroom of third author Cindy O'Donnell-Allen ... I'd gotten a grant from the NCTE [National Council of Teachers of English] Research Foundation and observed her class (often with a research assistant) to study whatever went on, with a special interest in artistic interpretations of literature. The mask-making project was part of Cindy's curriculum, so I recorded kids as they did their masks." The resulting article focused on mask-making as a representational process. As Smagorinsky suggests, research questions don't come from "somewhere"—they arise from a nexus of the researcher's previous experiences, interests, and commitments, and as this example suggests, from the lifeworlds of the people involved—both the research participants and the researchers.

As these researchers explicitly acknowledge, research problems are situated within rich contexts developed over time—sometimes over the career of a researcher. Indeed, eight participants (73%) located their research problems within their own continuing lines of inquiry. Sometimes these continuing lines of inquiry began at the dissertation stage, as Nicole Amare acknowledges: "It came from a graduate student paper I wrote almost 12 years ago about linguistic sexism in print textbooks. I always liked that paper ... I decided to modernize the topic and instead look at gender fair language in an online medium." Likewise, Stephen Schneider describes how a chapter from his dissertation became "a response to Susan Kates' article on citizenship schooling and a more general response to the 'civic' claims common in rhetorical education." Sometimes, however, the research question arises from and is grounded in a longer career interest, as Barry Kroll explains: "The germ of the entire sequence was a growing dissatisfaction with classic pro/con argument, as I was teaching it in the late 1980s

early 1990s." In Kroll's recognition of "growing dissatisfaction," we see the manifestation of uneasy feelings arising from a particular social context in which Kroll finds himself uncomfortably positioned. Kroll related an anecdote from observing a teaching assistant:

> She was starting a unit on arguing about gun control. As the students came into the room, she asked each to state their position on gun control, and depending on their answer she had them sit on one side of the room or the other. Neutrality wasn't permitted: each student had to commit and then sit with like-minded peers, across the room from those with the opposing viewpoint. The task was to work to develop arguments that would convince those on the other side—literally. Though this was an extreme situation, it captured concretely many of the things that had been bothering me in my own teaching and in the field of rhetoric generally. With the best of intentions, I'd been promoting polarization and a fundamentally adversarial approach to argument.

Experiencing a violation of expectation through the extremity of the observed situation, Kroll comes to a new recognition of a problem that has been troubling him for some time—a growing dissatisfaction with his own teaching and the field's treatment of teaching argument. From this moment of recognition, Kroll goes on to develop ways of making new connections, through experimenting with his teaching and finally, beginning his article on aikido as a means of arguing differently. Other participants similarly describe their recent publications as situated within larger, longer research projects: Jeff Rice describes his article as part of a larger, book-length project, Barbara Waxman describes her article as arising from her multiple experiences teaching a course on the culinary memoir, and Tiane Donahue responds that her idea "came partly from the call for papers—it was about methodology, and I have been working on clarifying my methodology for other scholars. ... I've been trying to bring together linguistics and composition theory for a long time, and this seemed like the right opportunity to clarify this for myself and for others."

Even when researchers enter research sites open to what might develop there, they are the interpretive lens through which those observations filter. Past experiences, background knowledge, and research commitments contribute to our seeing. Good research always begins from a position of possibility with researchers entering research practice open to possibilities that might arise. In recognizing the individual as the interpretive lens through which data is filtered, we suggest the importance of articulating the role our subject positions have on what we notice, what we understand, and what we find interesting in our research practices. Perhaps this is what participants mean to suggest when they identify different forms of cognitive dissonance as their initial beginning—the dissonance between our individual subject positions and the field's understand-

ing—because in these participants contributions, research questions do not begin from simply "noticing a gap" in existing scholarship. It is a complex process of bringing the individual (and all his or her intellectual, epistemological, ideological, political, and nonacademic commitments and experiences) into conversation with the existing body of scholarship.

RESEARCHERS' REFLECTIONS ON PROBLEM FORMATION AND METHODOLOGICAL CHOICE

When queried about their methodological designs and decision making, 82% of participants identified experiential knowledge as the source of their methodological choices. In the same way that these research participants reveal research problems to be situated within rich contexts developed over time, the methods chosen are situated within rich contexts developed over time. For instance, five participants (45%) had used their chosen method before the current study, and six (55%) explained they used a method employed by other scholars (either research collaborators or others used by published scholars). Thirty-six percent of participants also noted that the methods they chose often were methods they had a good deal of experience using in their continuing line of inquiry. For example, Tiane Donahue has a history with her chosen methods: "This project is a part of my larger research path: looking cross-culturally at student writing, using methods and frames from literary criticism, linguistics, and composition. So, in the publication I was distilling a more broadly-developed methodology. That methodology developed from all of my career." Smagorinsky provides a nice summary of the multiple reasons researchers select methods: "I guess you'd say I selected protocol analysis because it was appropriate for the study and because I was experienced in the method and felt a high comfort level with doing it." To recognize that experienced researchers often employ the same methods repeatedly throughout their careers is not to suggest that the methods are blindly adopted; instead, as these researchers indicate, methodological practices are themselves worked out over time, and repeated use is an important element in a research agenda. We would note that once again the role of subject position and subjectivity significantly shape research in ways which as a field we have barely begun to recognize let alone understand. How does comfort level factor into decision making about research methods, and how does that factor shape the kinds of knowledge that are made and discovered? Lynn Bloom acknowledges that she draws from multiple research methods in her work: "As a rule, there is not one single research method in the work I do; I use combinations of methods in order to get good reliable trustworthy results." But the question remains—how do researchers draw on combinations of methods? How does that process of selection occur, what role does the subjective play in seeing some methods as good or

reliable and others as not? Our research participants are experienced, successful-
ly publishing scholars and researchers—much of their decision making is likely
tacit. We believe that it is crucial to understand how those decisions are made and
how successful researchers bring subjective experience to bear on the construc-
tion of research questions and the construction of research methods as appropri-
ate to those questions. Such an understanding can contribute to nothing less than
a more robust understanding of how knowledge is made in our profession.

The steps involved in the messy and subjective parts of knowledge construc-
tion remain largely untold in our professional conversations. Written representa-
tions of research tend to de-emphasize the researcher's nonacademic frameworks
and investments, as writers negotiate what Mortensen and Kirsch (1996) call "the
thin line between self-centered display and revealing positionality that
researchers must negotiate when they foreground themselves in their texts" (p.
xxvii). Barry Kroll's (2008) *CCC* article on aikido, for example, gives no indica-
tion of the visceral connection between research question and one's intellectual
life which he described to us:

> I keep coming back to the importance of practical significance and a level of
> interest and engagement that's deeper than intellectual. For example, while
> my initial interest in aikido was intellectual, it was also visceral—a connec-
> tion that deepened when I started practicing the art. And that experience
> (I've been doing it for nearly 4 years now) has led to many discoveries and
> insights. I'm now especially interested in mind-body learning, for example,
> as well as Asian contemplative practices and their significance for writing. In
> other words, I've found a trail of projects by following interest and instinct,
> rather than worrying too much about what's hot in the current discourse in
> the discipline.

Even further, Richard Raymond, author of the academic memoir we referred
to in the preceding section, suggests that a visceral and subjective commitment
is crucial to his research process generally: "As corny as it may sound, my deci-
sions about problems and methodology rest on my reflective answers to one
question: Why do I care?" Other participants concur that a personal investment
in the research question and methodology is crucial:

- "A key factor … is to be 'blown away' by a particular text and to
 try to figure out why it has such a powerful effect. …. Personal
 engagement with the topic of the research is critical." (Barbara
 Waxman)
- "I research what I'm interested in." (Jeff Rice)
- "Well, I suggest knowing what one is passionately interested in,
 and not just in the abstract. What are the situations, the popula-
 tions, that grip one's attention. Read the literature as somebody

> who is not just going to summarize it for a qualifying exam but as
> somebody who wants to figure out what engages one's passions
> and interests so that you want to join in." (Anne Haas Dyson)

Nine respondents (82%) suggested the importance of originality and creativity in formation of the research problem and/or in the writing of the results, and several framed research as a rhetorical problem. In his response, Smagorinsky noted, "being an insightful reader of results and then taking your writing seriously [is] a rhetorical problem ... as well as an intellectual one." Additionally, four responses (36%) mentioned the importance of following one's instincts and noticing felt connections.

Sometimes the construction of one's methods (as well as the research questions) are encouraged as well as constrained by the contexts in which one works. Nicole Amare, for example, is waiting until after the tenure decision to work on an idea she's had for some time "because the piece will take so much time and I have no guarantee that the idea will be publishable," and two participants, Tiane Donahue and Peter Smagorinsky, each point to the shaping effect grant opportunities can have on project formation. In his experience, Smagorinsky has found that being involved in collaborative projects creates a network of influence on his research:

> Actually there have been serendipitous events that have directed my deci-
> sion-making. I did a study (published in 1995) on what's taught in second-
> ary English teaching methods classes, based on an analysis of syllabi from
> around the country—I did that study because I wondered what people in my
> field were reading and assigning to their students, and ended up with a
> book-length study. Based on that publication, I was asked to be part of the
> proposal being written for the Center on English Learning and Achievement,
> doing the strand on teacher education, something I hadn't ever done. I
> agreed because it ... put me within a network of people I respected (not
> something I could say of the university in which I taught at the time, where
> I was intellectually very lonely). It ended up being a pretty productive line
> of inquiry for me, resulting in a dozen or so publications thus far and a cou-
> ple of national research awards. ... Similarly, a colleague here at UGA has
> recently asked me to be part of a grant doing the protocol analysis segment
> of a study of how students with learning disabilities use computers in writ-
> ing. Again, money dropped in my lap to work, and in service of someone
> else's research question, but it sounds interesting and the other serendipitous
> grant work turned out well, so why not? Plus it gives me the opportunity to
> work with an esteemed colleague.

In this description of a period in his larger research life, Smagorinsky identifies a number of influences on decision making: serendipitous events and contacts with colleagues, outside invitations to continue lines of inquiry already completed or underway, and entering into a network of colleagues. Indeed, in both the

situations Smagorinsky describes, one of the significant benefits was connecting with esteemed and intellectually stimulating colleagues. We'd argue that most successful researchers work within similar networks of influence—whether those networks are as present as the ones Smagorinsky describes, or whether they are more evanescent, as Huiling Ding suggests in his comment that "Discussion with other people, especially those outside my discipline, helps me to identity the research problem. For methodology, I talked a lot with people in the field."

Either way, methods like research questions are not discovered floating out there somewhere. They are constructed. Whereas researchers are often advised to select methods based on their fit with the research question, such advice (perhaps inadvertently) suggests that there is a one-to-one correspondence between research methods and research questions. But very few studies can actually only be accomplished using one method. There are many ways of knowing and many types of data we can collect to create narratives of understanding. It is more accurate to acknowledge that different methods are grounded in different epistemologies, ideologies, and political commitments and are sometimes determined as much by our research contexts and collaborative relationships as they are by fit with the research question. What researchers do when they make methodological choices is not chose the method which fits the research question; rather, researchers *construct* their methods as appropriate to the research question. We suggest there is a need for a more clear and well-researched understanding of how method is interwoven with invention and how our personal and public positioning influences our methods. Smagorinsky (2008), in a recent article arguing for situating the methods section as the heart of the article, comments on this need as well:

> I'd like to argue for greater attention to accounts of research method, both for the reader's sake and the writer's. As a reader, I simply need to know how data become results in order to trust the author's claims. But for me as a writer, the Method section plays a pivotal role in the production of a research article. It serves as the core from which radiate the content and organization of each of the other sections of an APA-style research report. (p. 394)

We agree with Smagorinsky's call for more attention to accounts of research method, particularly the relationship between the research question and methodological choice. It is in the research methods section, we would add, that we find traces of the knowledge-making process. By understanding "how data becomes results" we understand how the researcher constructed her research question, constructed her method as appropriate to that research question, and constructed a narrative from the raw materials of data she collected. In our participants' explicit reflections on their research processes (reflections of the type which do not for the most part make it into published scholarship) we see the impact of personal background on methodological choice.

SOME TENTATIVE CONCLUSIONS AND
AN OPENING MOVE

As Brewer and Hunter (2005) suggested, researchers will attend to questions that are "compatible with their own particular theoretical orientations and with the methods linked to those orientations, and will ignore problems that are either theoretically or methodologically incompatible" (p. 54). Acknowledging that we need richer understandings of how subjectivity flows through research processes, we believe this chapter is a beginning contribution to unpacking a complex methodological concern. The participants in our survey suggest some of the ways researchers are the interpretive lens through which research is conducted and data is filtered—but their reflections are a beginning move that need to be elaborated. What these scholars reveal about actual research practices provide a needed model for researchers. We believe that reflections of this type on actual experiences forming research problems, constructing research questions, and fitting research methods to the problem and question are important for methodological understanding. Being explicit about the decisions we make as researchers which lead to the final research problem and question (including decisions about our personal commitments to the research problem, questions, and methods) might be understood as a way of adding a layer of accountability and replicability to our research. Such accountability and replication are crucial to the development of knowledge in the field, as Richard Haswell (2005) notes: "RAD [replicable, aggregable, and data-supported] scholarship is a best effort inquiry into the actualities of a situation, inquiry that is explicitly enough systematicized in sampling, execution, and analysis to be replicated; exactly enough circumscribed to be extended; and factually enough supported to be verified" (p. 201). He asserts, "the value of RAD scholarship is its capacity for growth—its comparability, replicability, and accruability" (p. 202). Being explicit about the decisions we make as researchers contributes to this capacity for growth as comparability, replicability, and accruability can be accounted for in our final representations. Ignoring how subjectivity shapes our research keeps us from being able to account for it as an influence.

The scholars and colleagues whose reflections we shared in this chapter help demystify the research process and contribute to understanding research as a process of human knowledge making. They provide an important model for practices which researchers need to engage as part of the knowledge-making process even when those reflections do not become a part of the final representation of research. At the least, our research participants suggest that these processes of research practice are much more complex than our existing understandings of the beginning stages of research and particularly the advice we give beginning researchers. At its core, research is really a way of satisfying a curious mind. Yet, part of the social discourse of research has been to erase the individual—to strive

for an objective stance in which the researcher's subjectivity does not play a role in the final representation. Counter to this striving for objectivity is a feminist research practice and methodology that insists on the recognition of the researcher as a participant in the construction of what questions get asked (and which do not), in the collection of data and work in the research sites, in the relationships enacted with participants. What we are calling for is what feminist researchers have prepared us to see and want—a more explicit understanding and acknowledgment of how subjectivity, subject position, and sociocultural position shape our research processes and the knowledge that results from those practices.[11] Kirsch (1999) writes of these researchers that they "urge researchers to take responsibility for … recognizing that … data are always shaped, to a large extent, by researchers' values, theoretical perspectives, and personal histories" (p. 195). As so many feminist theorists point out, decisions about the conduct of research should be deliberate and thoughtful. Without such deliberation and examination, these very powerful forces can invisibly shape our knowledge production.

Writing can play a significant role in these deliberations. Recognizing that "The original research question and the manner in which it is phrased lead the researcher to examine data from a specific perspective and to utilize certain data collection techniques and modes of data analysis," (p. 41), Corbin and Strauss (2007) suggest the importance of writing in unpacking the researcher's perspectives, thinking, and developing analysis: "What our researcher requires are recording tactics that will provide him with an ongoing, developmental dialogue between his roles as discoverer and as social analyst" (p. 118). Significantly for Corbin and Strauss, reflective writing is more than a written record or representation of thought. Instead, they describe memos as "working and living documents. … Even when a researcher is working alone on a project, he or she is engaged in continued internal dialogue—for that is, after all, what thinking is" (p. 118). The ongoing, developmental dialogue Corbin and Strauss describe can and should begin even prior to the creation of the research problem and the formation of the research question. Especially in the beginning of a research project, using writing as a means of engaging in an internal dialogue with ourselves can help us identify and work through our motivations and purposes for researching and the ways our previous experiences, epistemological, ideological, and cultural assumptions influence what we see as researchable problems and appropriate methods. We agree with Young (1981) that "Control over a felt difficulty begins with its analysis and articulation (which seem to be mutually dependent processes)" (p. 62). Too often, we feel, the analysis of a felt difficulty remains almost tacit—not articulated explicitly, not revealed to audiences—but like Young, we believe that being aware of the complexities involved in the identification of one's research interests and ideological commitments is crucial to creating successful research questions. Grounded in this theoretical understanding as well as in our research participants' reflections, we offer a heuristic (see Table 5.1) for what researchers might do to acknowledge and complicate the invisibility of their own subjectivity.

This heuristic provides researchers with prompts for thinking about their construction of research problems, research questions, and methods. Being explicit and detailed about their decision making and the intersection of their personal as well as professional commitments can make researchers consciously aware of important shaping influences on the research they conduct. Researchers might use the heuristic in several ways:

- Write in response to these questions at the beginning of researching to articulate the (often implicit) influences that they can then account for in their design and analysis.
- Return to the initial heuristic writing as a record of their initial thinking about the problem, question, and methods.
- Write again in-process, after the research problem, questions, and methods have been determined, as a way of prompting their thinking about the intersection of their personal and professional commitments to the ongoing research and analysis.

This heuristic is not meant to be exhaustive of the preparatory thinking researchers need to do prior to forming their research question, nor do we suggest that every question is equally important for every researcher to answer. The questions are meant to suggest types of issues researchers might explicitly recognize. The heuristic is meant to be a prompt for thinking at any stage in the research process. Researchers should write as much as they can in response to each question, write with more concern for content than form, and let their ideas trigger one another in a kind of free-association fashion.

1. **What are your motivations or purposes for researching? What is it you want to know?** Sometimes research begins with a felt difficulty—with inconsistencies in a researcher's values, beliefs, opinions, knowledge, and reading of existing scholarship. Sometimes something in one's nonprofessional life throws new light on professional concerns. Sometimes research begins with a call within a community (a call for papers, a conference announcement, a research article that ends with ideas for future study). Sometimes research begins in a collaborative relationship—a conversation with a colleague, an invitation to participate in an already formed research project, or work that evolves into scholarship.

2. **What do you already believe about the research problem?** Once you've identified the exigency of your research project, being explicit about your relationship to that exigency and identifying your related experiences and knowledge about the research area can help you elaborate your research question and gain conscious control over the ways the particular subject positions you occupy might shape the research question and study method.

3. **What epistemological and cultural beliefs do you have related to the research problem?** How, in other words, is your research going to be influenced or shaped by your beliefs and assumptions about race/gender/class/sexual orientation/age, knowledge (who can make it, how it is made), and ways of being?

4. **What is your ideological commitment to the subject?** Are you interested in overturning existing understandings? In paying attention to people or practices that have been ignored or overlooked by existing researchers? Ideological commitments can be overtly articulated or not, but research (as any human practice) is always ideological in the sense that it involves the study of ideas.

5. **What professional or intellectual need does this research fill?** Often researchers are encouraged to think about research problems in terms of what hasn't been done in the field (i.e., filling a gap in the existing research). In addition to asking what work hasn't been done, however, is an even more important question, which is, "Does this work need to be done?"

6. **What assumptions about academic scholarship shape your work?** What purposes does your academic research serve? What purposes do you want it to serve? Whose voices and perspectives are important to include in the professional conversation? What kinds of evidence are expected or acceptable?

Even a cursory scan of the six questions in the heuristic presented in Table 5.1 suggests that thinking through the formation of research problems and questions can be a lengthy process. But it should be. As argued here, numerous methodological theorists have asserted that the creation of a good research question can shape the entire project. Time spent up front working out assumptions, beliefs, and commitments to the research question are an investment in successful research. The heuristic presented in Table 5.1 aims at assisting researchers in this initial investment of thinking and planning. As with any heuristic, the goal is not a *product* (some polished, formal piece of prose) but a *process* (of using writing to think through and identify the influences shaping your understanding of your research question as a question, as a researchable problem, and as worthy of your time and attention). These questions prompt researchers to think at the beginning of their planning stages about the relationships between their personal commitments and their professional interests: what they already know before they begin research, what they want to know, why they want to know it, and how their various subject positions intersect with the profession. The goal of the heuristic is to think through the problem, but also to begin an ongoing written dialogue with one's self that can be returned to throughout the research

process and that can develop in complexity and clarity throughout the research process. Corbin and Strauss (2007) argue that reflective writing is as important to the research process as any other part of the process: "One of the complaints we often hear from students is that writing memos ... is just too time consuming. ... We puzzle over those remarks. Writing memos is part of the analysis, part of doing qualitative work. They move the analysis forward and as such are just as important to the research process as data gathering itself" (p. 118). Likewise, we have found that writing at the initial research stage about what is involved in the shaping of our research questions is an important stage in understanding and planning our research processes (in ways that account for, control, or balance our initial subjective perspectives). Understanding the assumptions informing our research questions can help us be vigilant about how our subject positions shape what we see as researchable questions, appropriate methods, and significant data. In the final writing of our results, articulating these assumptions gives readers a fuller, more complex context for understanding our analysis.

These are questions for beginning researchers or researchers at the beginning of a thorny research problem—but they are also at the same time questions about which we need more explicit understanding. How have experienced scholars embedded these kinds of concerns into successful research practices? How does a researcher negotiate the tension between a personally meaningful research question and one that will be accepted by the field in which the researcher studies? How are research questions (and as a consequence, knowledge in the field) constrained or buoyed by currently dominant cultural forces? What kinds of questions do we not ask? Why do we not ask them (i.e., what forces keep us from recognizing them as relevant or interesting? What forces keep us from seeing them as questions at all?)? What happens when research questions sustain a lengthy part of a researcher's scholarly life (how do those questions evolve, get recharged)? As these questions suggest, a more robust understanding of research questions can help us better understand an important aspect of a disciplinary, knowledge-making process. We are calling for more meta reflection by researchers in their own work as well as for research that helps us understand what actually happens when researchers set problems for themselves and create research questions. Voicing some of the messiness, complexities, and humanness of the questions we ask can help us better understand research as a human endeavor.

APPENDIX A: RESEARCH PARTICIPANTS

Nicole Amare. "Where Is She? Gender Occurrences in Online Grammar Guides." *Research in the Teaching of English* 42.2 (Nov. 2007): 163-187.

Lynn Z. Bloom. "Consuming Prose: The Delectable Rhetoric of Food Writing." *College English* 70.4 (March 2008): 346-362.

Huiling Ding. "The Use of Cognitive and Social Apprenticeship to Teach a Disciplinary Genre: Initiation of Graduate Students into NIH Grant Writing." *Written Communication* (Jan. 2008): 3-52.

Tiane Donahue. "Cross Cultural Analysis of Student Writing: Beyond Discourses of Difference." *Written Communication* (July 2008): 319-352.

Anne Haas Dyson. "Staying in the Curricular Lines: Practice Constraints and Possibilities in Childhood Writing." *Written Communication* 25.1 (2008): 119-159.

Barry Kroll. "Arguing with Adversaries: Aikido, Rhetoric, and the Art of Peace." *College Composition and Communication* 59.3 (2008): 451-472.

Richard Raymond. "When Writing Professors Teach Literature: Shaping Questions, Finding Answers, Effecting Change." *College Composition and Communication* 59.3 (Feb. 2008): 473-502.

Jeff Rice. "Urban Mappings. A Rhetoric of the Network." *Rhetoric Society Quarterly* 38.2 (2008): 198-218.

Stephen Schneider. "Good, Clean, Fair: The Rhetoric of the Slow Food Movement." *College English* 70.4 (March 2008): 384-401.

Peter Smagorinsky. "The Method Section as Conceptual Epicenter in Construction of Social Science Research Reports." *Written Communication* 25 (July 2008): 389-411.[12]

Barbara Frey Waxman. "Food Memoirs, What Are They, and Why They Belong in the Literature Classroom." *College English* 70.4 (March 2008): 363-382.

APPENDIX B: INTERVIEW QUESTIONS

1. Tell us about the project you published recently—where did this particular idea come from?
2. How did you determine your methodology for this particular project?
3. Generally, how do you go about locating or identifying research problems?
4. What qualities should a research problem possess?
5. How does the current dialogue in the field influence your formation of research problems?
6. What factors influence the decisions you make about the research problem and your choice of methodology?
7. What advice do you have for students entering the field as to how to discover and then pursue a research problem?

ENDNOTES

1. As readers will see in the following section, this literature gap is a regularly cited rationale given by the scholars we interviewed and is more prevalent than thinking about what Blakeslee and Fleischer (2007) describe as "personal and professional inventories."

2. Blakeslee and Fleischer are unique in the attention they pay to epistemological processes that must take place prior to the articulation of the research question. Arguing that one's disposition toward research plays a crucial role in the research process, they begin by recognizing that just *seeing* oneself as a researcher is the first step in *being* a researcher. They refer to graduate students they have worked with who were actively involved in the conduct of research but did not identify themselves as researchers. Of these students, Blakeslee and Fleischer ask, "What did they do to be able to integrate research so seamlessly into their professional lives?" and they offer three factors that contributed to the students' success:
 - the recognition of the important role that research plays in both our personal and professional lives
 - the realization that research is something we all actually know a good deal about already
 - an interest in learning what is involved in doing research and how research is done (pp. 6-7).

3. Interestingly, this chapter, published in 1981, describes a moment in composition history when "Traditional approaches have been criticized for arbitrarily segmenting what is a continuous process at a fairly late stage, usually at the rough draft, and for saying little or nothing about the activities which precede this stage" (Young 1981, p. 59). This critique resonates when we think about discussion of research question formation in theoretical descriptions of the research process. Descriptions of the process can oftentimes implicitly suggest that there is a staged, linear process to *"the* research process" (invention of the research question, methodological consideration, data collection, analysis, and writing up results)—although all researchers know how the research process is a recursive one, as research questions are articulated, complicated through data collection, sometimes thrown aside or revised completely anew, sometimes strengthened through the data. It is interesting to think about the theoretical implications of the implicit linearity and segmenting of research processes.

4. Similarly, epistemological commitments, as well as political and ideological positioning, should lead us to ask why we choose the methods we choose and what is implied in that choice: "The argument put forth in most methods books is that the method one chooses should be the most appropriate for specific research questions you wish to answer. While I agree with this sentiment, I also caution that the methods we choose are not free from epistemological assumptions and taken-for-granted understandings of what counts as data, how the researcher should relate to the subjects of the research, and what are the most appropriate products of a research study" (Naples, 2003, p. 5). Methods are not free from epistemological assumptions; neither are they neutral.

5. All three of us are indebted to Christina Haas for her influence on our thinking about these issues. Beth and Jen had recently read the work of MacNealy and Young,

Becker, and Pike for Chris' class, and Pam was reminded of Richard Young's chapter on problem solving in a conversation with Chris about teaching the research design seminar that Beth and Jen were both taking. Additionally, Chris and Pam have worked together for several years studying the language of instant messaging (IM). In the course of those 3 years, their research team (at various times including a number of undergraduate and graduate students) has worked as collaborative researchers and has had substantial reflective discussions about not only the IM language but also about the conduct of the research. Research team members have included Diana Awad, Brandon Carr, Emily Dillon, Elizabeth Feltner, Jessica Heffner, Kimberley Hudson, and Ross Pollock. Pam is indebted to the research team members and thankful for the enormous amount she learned in working with them all. Their conversations have certainly contributed to the thinking in this chapter.

6. Editorial letters, interchanges, and book reviews were excluded. Additionally, only scholars of single-authored articles were invited in order to limit the variables that might factor into the formation of research questions in collaboratively authored research.

7. Due to an initial lack of response from authors in this journal, we solicited interview participants from a third issue.

8. We collated interview responses into one document, organized by question. We read the interview responses repeatedly, until we had a sense of what was there. We then worked inductively to identify salient analytic categories. Although we began by coding the questions separately, in a subsequent meeting and in phone and email discussions, we continued revising the categories and coded again collaboratively. We coded only one response per category for each respondent, attributing multiple references within a category to rhetorical emphasis. When creating our coding scheme, we noted anomalies, but focused primarily on themes represented across respondents and questions.

 As we have argued above regarding the generation of research questions, we also note here that the categories we generated in response to the data are influenced by our subject position. For Beth and Jen, our position as graduate students certainly impacted the categories we observed. For example, we composed question 7— advice for future scholars, explicitly because of our position at the time as first-year doctoral students. Then, as we read responses to this question, we found ourselves often personalizing the material and thinking about our own experiences being mentored by senior faculty. The categories that emerged for us reflected our ideological commitments and our subject positions. We were also influenced by our reading materials. For instance, Smagorinsky's (2008) insightful explanation of collaborative coding (p. 401) led us to similarly work through our codes together as a process of "collaborative discussion" rather than in search of "independent corroboration" (p. 401).

9 Unless otherwise indicated, quotes from scholars in the following section were collected through our research.

10. The language researchers used to describe their projects' beginnings is suggestive of the personal commitment involved in research practice. Words and phrases such as *wondered, wanted to figure out, growing dissatisfaction, things that had been bothering me, clarifying, explore,* and *opportunity* are all suggestive of the individual subjectivity involved in the shaping of what becomes the research question, the research site, and research design.

11. This is important in order to understand just how our research is bounded by who we are as a field—if indeed our research problems, questions, and methods are in part grounded in who we are as people, here then is another way it is crucial to encourage and support diversity in our field.

12. Although Smagorinsky's interview was solicited based on his 2008 *Written Communication* article, he noted, "The project that prompted this invitation was not a piece of research, but rather an article about writing research reports in general. So I'll answer these questions in relation to another recently published composition study, Zoss, M., Smagorinsky, P., & O'Donnell-Allen, C. (2007). Mask-making as representational process: The situated composition of an identity project in a senior English class. *International Journal of Education & the Arts*, 8(10). Retrieved from http://www.ijea.org/v8n10/v8n10.pdf."

REFERENCES

Bazerman, C. (2008). Theories of the middle range. *Written Communication*, 25, 298-318.

Blakeslee, A., & Fleischer, C. (2007). *Becoming a writing researcher*. Mahwah, NJ: Erlbaum.

Brewer, J.D., & Hunter, A. (2005). *Foundations of multimethod research: Synthesizing styles*. Thousand Oaks, CA: Sage.

Corbin, J., & Strauss, A. (2007). *Basics of qualitative research: Techniques and procedures for developing grounded theory* (3rd ed.). Thousand Oaks, CA: Sage.

Emig, J. (1997). Writing as a mode of learning. In R. Young & Y. Liu (Eds.), *Landmark essays on rhetorical invention in writing* (pp. 91-98). Davis, CA: Hermagoras Press.

Fine, M. (1996). *Disruptive voices: The possibilities of feminist research*. Ann Arbor: University of Michigan Press.

Fonow, M., & Cook, J. (2005). Feminist methodology: New applications in the academy and public policy. *Signs: Journal of Women in Culture and Society, 30*, 2211-2236.

Haswell, R. (2005). NCTE/CCCC's recent war on scholarship. *Written Communication, 22*, 198-223.

Hayes, J.R., Young, R., Matchett, M.L., McCaffrey, M., Cochran, C., Hajduk, T., & McCabe, M. (Eds.). (1992). *Reading empirical research studies: The rhetoric of research*. Hillsdale, NJ: Erlbaum.

Hull, G., Rose, M., Fraser, K.L., & Castellano, M. (1991). Remediation as social construct: Perspectives from an analysis of classroom discourse. *College Composition and Communication, 42*, 299-329.

Kirsch, G. (1999). *Ethical dilemmas in feminist research. The politics of location, interpretation, and publication*. Albany: State University of New York Press.

Kroll, B. (2008). Arguing with adversaries: Aikido, rhetoric, and the art of peace. *College Composition and Communication, 59*, 451-472.

Lather, P. (1991). *Getting smart: Feminist research and pedagogy within/in the postmodern*. New York: Routledge.

Latour, B. (1998). Essays on science and society: From the world of science to the world of research? *Science, 280*(5361), 208-209.

MacClean, M., & Mohr, M. (1999). *Teacher-researchers at work*. Berkeley, CA: National Writing Project.

MacNealy, M.S. (1999). *Strategies for empirical research in writing.* Boston: Allyn & Bacon.

Mortensen, P., & Kirsch, G.E. (Eds.). (1996). *Ethics and representation in qualitative studies of literacy.* Urbana, IL: NCTE.

Naples, N. (2003). *Feminism and method: Ethnography, discourse analysis, and activist research.* New York: Routledge.

Perelman, C., & Olbrechts-Tyteca, L. (1958). *The new rhetoric: A treatise on argumentation* (J. Wilkinson & P. Weaver, Trans.). Notre Dame, IN: University of Notre Dame

Ratcliffe, K. (2005). *Rhetorical listening: Identification, gender, and whiteness.* Carbondale: Southern Illinois University Press.

Reinharz, S., & Davidman, L. (1992). *Feminist methods in social research.* Oxford: Oxford University Press.

Richardson, L. (1997). *Fields of play: Constructing an academic life.* New Brunswick, NJ: Rutgers University Press.

Schön, D.A. (1982). *The reflective practitioner: How professionals think in action.* New York: Basic Books.

Smagorinsky, P. (2008). The method section as conceptual epicenter in constructing social science research reports. *Written Communication, 25,* 389-411.

Sullivan, P., & Porter, J. (1997). *Opening spaces: Writing technologies and critical research practices.* Norwood, NJ: Ablex.

Toulmin, S. (2003). *The uses of argument.* New York: Cambridge University Press.

Young, R. (1981). Problems and the composing process. In C.H. Frederiksen & J.F. Dominic (Eds.), *Writing: The nature, development, and teaching of written composition* (pp. 59-66). Hillsdale, NJ: Erlbaum.

Young, R.E., Becker, A.L., & Pike, K. (1970). *Rhetoric: Discovery and change.* New York: Harcourt Brace Jovanovich.

6

MATERIALIZING THE MATERIAL AS A PROGRESSIVE METHOD AND METHODOLOGY

Eileen E. Schell

> We are material objects, these bodies of ours. We are a material base to our rhetorical superstructure.
> —Villanueva (2005, p. 61)

One of the most important aspects of research methods and methodologies in rhetoric, composition, and literacy scholarship has been the concerted effort to analyze and assess how writing, rhetoric, and literacy practices have been shaped by material constraints and realities. By analyses that take up the "material," I am referring to efforts to assess how literacy, rhetoric, and writing address the following:

- a variety of material social relations (work/labor, institutional life), which include and are influenced by gender, racial, class, disability, and sexual hierarchy;
- the materiality of the body and its sexual, reproductive, and other biological functions;
- the materiality of texts and their contexts; and
- the materiality of space, place, cultural contexts, cultural artifacts, and lived experiences.

In this chapter, I examine how scholars across rhetorical studies, literacy studies, and composition studies have drawn on material or materialist analysis directly or indirectly as a methodology and a method—whether it is to examine the working conditions or material conditions and labor of teaching writing; to examine and uncover the historical rhetorical practices of women and people of

color; or to examine how literacy itself is a gendered, raced, sexed, and classed enterprise with a politics and economics that we must account for and address.

This chapter analyzes the trends and patterns of socially progressive material or materialist research methods and methodologies; it argues for the significance of material analysis as a progressive research methodology within rhetoric, composition, and literacy studies. Definitions of the "material" have varied, depending on how they have been tied—or not—to historical materialism, to Marxist thought or to connected branches of feminist inquiry interlaced with Marxist inquiry. Also, although many of us in rhetoric, composition, and literacy studies are concerned with researching issues related to material life and culture, our conceptual and methodological notions of the material differ significantly depending on what theoretical and political traditions we draw on. Therefore, this chapter identifies the major trends, patterns, and debates surrounding material analysis in the field, especially with respect to feminist analysis; it also provides scholars with strategies for assessing their own approaches to materiality, namely, the contradictions and challenges of examining notions of the material when we have no governing or overarching agreement about what constitutes a method or methodology for material or materialist analysis in our field.

SITUATING MATERIAL ANALYSIS IN
RHETORIC, COMPOSITION, AND LITERACY STUDIES

A concern with the concept of the material and with materiality has been a strand of research that has enjoyed a great deal of visibility over the past 15 years or so in rhetoric, composition, and literacy studies. Indeed, it could be said that a concern with *material conditions*—conditions of pay, contracts, and professional status and respect—characterizes our field; indeed, in many ways, analyses of our field's material conditions have determined our discipline's historical and professional narratives (see Berlin, 1987; Connors, 1990; Crowley, 1998; Strickland, 2001, 2011). Although scholars writing institutional and disciplinary histories of rhetoric and composition have been preoccupied with the material conditions that produced the rise of written composition and writing programs, there are many branches of material or materialist analysis. In an insightful review of three books that engage the "material," Krista Ratcliffe (2002) notes that the "concept of material" is deployed in five different ways, as "bodies of knowledge, bodies of matter (people and things), bodies of evidence, embodied discourses, and a corpus of historically grounded cultural structures" (p. 614). Each area draws on a mix of methods and methodologies: qualitative research in the form of interviews and observations; textual and rhetorical research; theoretical influences drawn from Marxist theory, cultural studies, critical theory, history and historiography, and economic theory; or a mix of all of these areas. A large portion of this work

draws on feminist theory and theories of embodiment and corporeality (see Selzer, 1999), emphasizing the "body" as a site of material, lived practice. Of this work, it is perhaps most accurate to say that multimodal methods and varying commitments to specifically material or *materialist* thought encompass it.

A key question to ask as we come to terms with our traditions of material and materialist research in rhetoric, composition, and literacy studies, however, is this: Is it materialist in orientation, connected explicitly to Marx's notion of historical materialism or connected to a broadly conceived notion of material culture or material artifacts—what Ratcliffe refers to as "people and things"? To explain the varied political and methodological approaches undergirding work on the concept of the material, Ratcliffe draws the useful distinction between historical materialism and cultural materialism. Historical materialism, according to Marxist thought, acknowledges materialism as a process in which material life shapes consciousness, not consciousness shaping material life. In the preface to "A Contribution to the Critique of Political Economy, Marx (1972) explains it this way:

> In the social production of their life, men enter into definite relations that are indispensable and independent of their will, relations of production, which correspond to a definite stage of development of their material productive forces. The sum total of these relations of production constitutes the economic structure of society, the real foundation on which rises a legal and political superstructure, to which correspond definite forms of social consciousness. The mode of production of material life conditions the social, political, and intellectual life process in general. It is not the consciousness of men that determines their being, but, on the contrary, their social being that determines their consciousness. (p. 4)

Max Horkheimer and Theodor Adorno (1947/2002) offer an alternate take on the concept of the material, addressing instead the idea of cultural materialism. In the *Dialectic of the Enlightenment*, Horkheimer and Adorno argue that materiality is mediated by language, by culture, not by an objective reality as Marx implies.

Of course, the distinctions between historical and cultural materialisms have been hotly debated across the humanities and social sciences. Some theorists argue for a return to historical materialism as Marx conceived it (Ebert, 1996) while others argue that historical and cultural materialisms can work more in tandem (Hennessy, 1993). As Ratcliffe (2002) puts it, the distinction is largely over how language is used—"as a transparent tool that anyone may use, first, to demystify reality, and, second, to explain it clearly" or as "implicated in its historical grounding, not simply representing reality, but constructing (in varying degrees) our perceptions of reality" (p. 616). Still others, like Deborah Kelsh (1994), whose work I discuss later, would argue that the debate is not over lan-

guage and narratives per se, but over economics, exploitation, and oppression. How does offering a material or materialist analysis of any given phenomenon address questions of class relations, the circulation of power, and struggles over exploitation?

Many of us in rhetoric, composition, and literacy studies engage cultural materialism over historical materialism because of our field's privileging of the social turn and the social construction of reality—a clear invitation to place our field's focus on rhetoric and language as central to analyses of the material world. Yet our field's focus on cultural materialism over historical materialism has troubled a number of scholars in the field who directly draw on Marxism. In a 1992 special double issue of *Pre/Text* on Marxism and Rhetoric, John Trimbur and James Berlin lament that Marxist thought has "been largely ignored" in our field (p. 7). Likewise, Patricia Bizzell (1991), in an essay entitled "Marxist Ideas in Composition Studies," argues that we "denature the Marxism of theorists whose work we use frequently" such as Bakhtin, Freire, and Vygotsky, and that we "assimilate the Marxist thinker into a more apolitical discourse that covers the same ground" (p. 35). Continuing on, Trimbur and Berlin (1992) argue that "Marxist rhetoric, properly speaking, exists mainly at the level of imagination— as something intuited as a possibility but neither theorized with any degree of rigor nor enacted practically in any kind of systematic way" (p. 7). The culprit for this lack of engagement, they claim, is "both internal and external factors at play in the current study and teaching of writing" (p. 7). As modern composition studies started up as a discipline in the Cold War era—the era of the "red scare"—there was no overt Marxist tradition to draw on (p. 7). This lack of a tradition, Trimbur and Berlin claim, has led theorists in our field to leap "over Marxism altogether—to begin theorizing from a post-Marxist vantage point" (p. 7). As Jack Selzer (1999) argues in "Habeas Corpus," the rhetorical turn across the disciplines and a focus on the social construction of reality led many to turn "scholarly attention from material realities and toward the way those realities are represented in text" (p. 4).

Yet even as Trimbur and Berlin decry the field's lack of concern with Marxism, they both take up Marxist ideas directly and indirectly in their own work. Berlin is one of the best-known scholars to engage Marxist analysis in composition studies in very direct and specific ways, citing Marxist texts and ideas alongside contemporary work in poststructuralism, postmodernism, and cultural studies. Trimbur's (1994) work connects cultural studies and Marxism in crucial ways; as a scholar, he has consistently maintained an interest in Marxist thought, what he refers to as a "plea for a dose of vulgar Marxism" (p. 195), an expression Cornel West used ironically in one of his lectures. In his use of the ironic term "vulgar Marxism," Trimbur points to a need for an abiding attention to material conditions without subjecting everything to the postmodern and post-Marxist tendency to dismiss such analysis and focus only on textual practices. Trimbur is not alone in his interest in so-called "vulgar Marxism." Ira Shor's (1992) work on critical pedagogy draws on a long tradition of Marxist thought

and praxis connected to the liberatory pedagogy of Paolo Freire. In his book, *Terms of Work*, compositionist Bruce Horner (2000) draws on the work of Marxist literary critic Raymond Williams and on theories drawn from cultural studies and critical theory, offering a thoughtful exploration of the materiality of the field and its definitions of work. Horner defines his book as a "cultural materialist critique of how, in Composition, we talk about work" (p. xv) in scholarly writing and in our day-to-day lives. Drawing on Raymond Williams' notion of the materiality of culture, Horner (2000) constructs a notion of "materiality" that is directly drawn from Marxist thought—from notions of historical materialism (p. xvii), and with significant attention to how the "work of composition" functions as "material, social practice " (p. xvii). Horner's work, in many ways, is a combination of both historical and cultural materialisms yet with cultural materialism as the more dominant partner.

Even as Trimbur and Berlin pointed to a lack of focus on Marx and on historical materialism in the *Pre/Text* special issue on Marxism, the concept of the material was popping up all over the place in our scholarship in the field in the mid- to late-1990s, but that focus on the material was more overtly tied to cultural, not historical materialism. For instance, at the Penn State Rhetoric Conference, which took place in July 1997, the entire focus of the conference was on the connections between material culture and rhetoric. As Selzer writes in the preface to the proceedings, *Rhetorical Bodies*, the conference highlighted "how the material conditions of rhetoric, the material embodiments of rhetoric, and the material configuration of rhetoric's technologies and artifacts shape the ways rhetoric is being practiced and theorized at the end of the twentieth century" (Selzer & Crowley, 1999, p. vii). The articulation of the material here is premised on material culture and embodiment—"the role of rhetoric in the construction and configuration of material bodies, conditions, and artifacts" (p. vii). Essays in the volume discuss and work through multiple sites where such analyses might be carried out—through bodily processes such as pregnancy, medical practices, monuments and public memorials, and a host of other material sites and practices. Throughout the conference and the published proceedings, the concept of the body and embodiment become a significant site of rhetorical work—an indication of an interest in things material and corporeal in the world. As feminist cultural studies scholar Elizabeth Grosz (1994) writes in her much-cited book *Volatile Bodies: Toward a Corporeal Feminism*, the body is not just a material object

> entirely reducible to being merely a thing; nor does it ever quite manage to rise above the status of thing. Thus it is both a thing and a nonthing, an object, but an object which somehow contains or coexists with an interiority, an object able to take itself and others as subject, a unique kind of object not reducible to other objects. ... If bodies are objects or things, they are like no others, for they are centers of perspective, insight, reflection, desire, agency. (p. xi)

Thus, the body is a site of interactive and productive function. Bodies "act and react" and "generate what is new, surprising, unpredictable" (p. xi). The body, as Grosz indicates, is not an entity in and of itself, but "it is a field, a two-dimensional continuum in which race (and possibly even class, caste, or religion) form body specifications" (p. 19).

As Sharon Crowley (1999) argues in the afterword to *Rhetorical Bodies*, the influence of feminist theories of embodiment and corporeality and the work of thinkers like Grosz was clearly visible at the Penn State Conference. An interest in the material world, Crowley notes, was evident in the "focus on bodies and material practices" at the conference, a focus that "owes much to the second wave of American feminists who launched a thoroughgoing critique of received attitudes about sex, gender, and the body during the 1970s" (p. 358). Second-wave feminists found that bodies were "intricately enmeshed in what Susan Bordo calls the 'micropractices of everyday life'—eating, cooking, cleaning house, wearing clothes, going to the store, to the hospital, to church, or to school" (Crowley, 1999, p. 358). Such practices were and are "saturated with politics" (p. 358), with power relations. Thus, feminist scholars in rhetoric, composition, and literacy studies have been concerned with the material practices and conditions of women's lives for quite some time; however, what is meant by a feminist approach to materiality, to the body, and to embodiment? How have feminists in rhetoric and composition studies engaged material and materialist analyses?

MATERIALIZING FEMINIST HISTORIES OF RHETORIC AND COMPOSITION STUDIES

Increasingly in historical studies of feminist rhetoric we are seeing an interest in material or materialist analysis that does not explicitly identify itself with socialist feminist, materialist feminist, or Marxist feminist traditions, but with feminist notions of "embodiment," material culture, and material artifacts. As feminist rhetoric and composition studies are the areas of the field I have worked in as a scholar, I offer a brief assessment of the ways in which the idea of materiality has been taken up in some key feminist texts in rhetoric and composition studies. My analysis takes up two specific areas of consideration: analyses of material rhetoric (material culture and artifacts) from a feminist perspective and analyses of disciplinary history—the rise of writing instruction and its feminized status.

One of the key areas of material analysis is feminist rhetorical history where feminist scholars have recovered and uncovered rhetorical texts by women and regendered the rhetorical tradition (see Bizzell, 2000; Glenn, 1997). The concept of materiality is frequently raised by feminist scholars as we analyze how women's texts and perspectives were and are muted or controlled by specific material conditions—pregnancy, childrearing, domestic labor, and care of others—and by

strictures against women speaking, reading, writing, or taking part openly in public life. To describe some of these specific conditions, the concept of material rhetoric and material analysis has been offered as a method and methodology by a number of feminist scholars. I discuss this work to point to the helpful insights it has created, but also to address how this work has defined a material approach to rhetoric, composition, and literacy studies grounded in the concept of material culture and cultural materialisms, not historical materialisms.

A wonderful example of material rhetoric applied in an historical context can be found in the 1999 essay by Vicki Tolar Collins on the rhetoric of Hester Anne Rogers, a British Methodist who was an 18th-century spiritual leader and mystic. Collins' article sets forth a method and methodology for studying the work of Rogers that is grounded in material rhetoric, what Collins refers to as the "theoretical investigating of discourse by examining how the rhetorical aims and functions of the initial text are changed by the processes of material production and distribution" (p. 547). Drawing on Michel Foucault, Jerome McGann, feminist Christina Haas and more broadly on reception theory and the history of the book, Collins (1999) argues for material rhetoric as a rhetorical methodology that "is interested in the broad implications of materiality, such as cultural formations and the shaping of gender roles" (p. 547). Material rhetoric, according to Collins, examines "the rhetorical functions in relationships among authors, text(s), publishing authorities, discourse communities, and readers" (p. 547). A key focus of material rhetoric with respect to gender is the act of accretion, "the process of layering additional texts over and around the original text" (p. 547). Collins studies how rhetorical accretion enacted on women's texts helps feminist critics analyze "material practices as mechanisms for controlling women's discourse and shaping representations of gender" (p. 548). In other words, studying material practices is useful for feminist rhetoricians as it will allow us to examine how women's texts and voices have been "culturally silenced" or muted. Collins (1999) argues that material rhetoric, when joined with the work of feminist historiography and feminist ethnography, can help feminist rhetoricians compile "material evidence of social, institutional, and commercial structures that brought women's rhetoric texts to print" and assess the ways in which they were modified over time to fit particular rhetorical purposes (p. 550).

Through her analysis of the ways in which Rogers' text undergoes accretion through prefatory remarks by male authorities, Collins demonstrates how Rogers' spiritual life and relationship with John Wesley were strategically managed by patriarchal authorities, thus her cultural and political influence were lessened. Through her analysis of the material process of rhetorical accretion, Collins provides readers with an intimate look at the gendered, material dynamics of the publication and circulation of women's texts. Thus, Collins' work is a key example of how histories of rhetoric have increasingly embraced the "materiality" of texts and social practices while drawing on feminist theories of gender and culture.

It should be clear, however, that Collins' focus is not specifically on the material conditions of women's lives during Rogers' time, although she does address that theme to some extent. Her interest is primarily in the ways that Rogers' persona is constructed and managed rhetorically by patriarchal authorities through the various published editions of her spiritual journal. Therefore, the physical artifact of the text and its various editions takes precedence in Collins' analysis because it is a concrete, physical artifact to analyze, but also because the text allows her to demonstrate a site where power, authority, and control are materially enacted over the body, reputation, and legacy of a woman.

Likewise, also working in historical rhetoric, Roxanne Mountford (2003) and Carol Mattingly (2002) and a number of other feminist rhetoric scholars have focused on material spaces and material artifacts. Mountford analyzes women's rhetorical practices as preachers, analyzing how "space, the body, and delivery" operate (p. 3). In the introduction to *The Gendered Pulpit: Preaching in American Protestant Spaces*, Mountford acknowledges the rich textually focused work of feminist rhetorical historians, but she notes that few to none of these theorists have engaged ethnographic research. Through her own ethnographic study of three contemporary women preachers, Mountford (2003) acknowledges "the need to focus on the materiality of rhetorical performance" (p. 4). Her study contributes to not only focusing on a "neglected art in the history of rhetoric"—preaching—but on understanding the function of gendered "performance, space, and the body" through ethnographic study. Ethnography as a research method allows Mountford to capture the performative qualities of women's preaching and to examine actual bodies moving through space and time, living, breathing, and witnessing with and among a congregation. Additionally, Mountford is interested in actual physical spaces—"lecterns, auditoriums, platforms, confession booths," but specifically in the pulpit, "the embodiment of clerical authority, a gendered location" and, thus, " a rich site for exploring rhetorical space" (p. 17). Throughout the book, Mountford combines rhetorical analysis of the history of preaching and women preachers with close ethnographic observation of the material world, shuttling back and forth between analysis of historical texts and ethnographic analysis of the material world. In doing so, she analyzes how "the body is not only an instrument of expression, but it is also itself expressive of meaning" (p. 7). As Mountford puts it, "it is really not possible to think about rhetoric without drawing in considerations of the body" (p. 8). Thus, refiguring delivery as a canon of rhetoric "is critically important for feminist transformation of rhetorical theory" (p. 9).

Paralleling the work done by Mountford, other feminist scholars have considered how the body, delivery, rhetorical space, and rhetorical artifacts need to be considered. Nan Johnson (2002) examines gender and rhetorical space and women's parlor rhetorics in antebellum America. Carol Mattingly (2002) addresses the rhetorical uses and effects of dress and costume for women platform speakers' and writers, focusing specifically on the connection between dress, costume, and delivery. Lindal Buchanan (2005) analyzes the effects of the

gendered and pregnant body on delivery and public reception. Scholars such as Maureen Goggin (2002) and Liz Rohan (2004) examine women's material arti-facts—samplers and quilts—as forms of rhetoric. Clearly, we have arrived at a place in feminist rhetorical studies where the body, lived experience, and mate-rial artifacts set the terms for rhetorical discussion, and where feminist rhetorical methods and methodologies are moving beyond rhetorical analyses that consid-er only texts to rhetorical analyses that consider a wide variety of material prac-tices, bodies, and objects. Yet these important rhetorical works are not addressed within the context of historical materialism, but more in the vein of cultural materialism, leaving us to ask: What would a feminist rhetorical analysis steeped in historical materialism look like? Also, what would a feminist rhetoric recovery project on the rhetorics of socialist feminist and Marxist feminist thinkers and activists look like? Scholars in communication studies have given us rhetorical analyses of radical figures like Mother Jones, but we have yet to see that kind of work in our own field.

As feminist rhetoric scholars have continued the important work of regen-dering rhetorical study, scholars in composition studies have engaged in a some-what parallel trajectory as they strive to account for the feminization of writing instruction and the material conditions that accompany feminization. Scholars concerned with histories of rhetoric and writing instruction (Berlin, 1987; Connors, 1990; Crowley, 1998) have sought to come to terms with the material conditions and professional status of the teaching of writing and also have sought to describe the association of teaching writing with feminization (Holbrook, 1991; Miller, 1991; Schell, 2003). In this scholarship, materiality has been defined as material conditions or specific working conditions: pay, concrete phys-ical work space such as offices, access to resources and equipment, and profes-sional status and treatment. In an effort to document the history of writing instruction and to draw linkages between the past and present of the field, histo-rians of rhetoric and composition studies have engaged in several key questions: Why have the material conditions of writing instruction been so problematic and continue to be so? Why was literacy work considered, as Robert Connors (1990) put it, drudge work for drudges, and why does the labor of teaching writing con-tinue to be regarded as "lesser than" the teaching of literature, literary criticism, or theory? Why has the teaching of writing been coded as work for women, as feminized labor? As Connors demonstrated in his insightful history of the schol-arship on "overwork" and "underpay" in the labor and status of teaching writing, one way for us to understand the present material conditions of the field is to look to the past, to historical research to provide us with some answers about why we have a permanent "underclass" of composition teachers—often low paid part-time and non-tenure-track faculty, many of whom are women. The "underclass," as Connors indicates in his piece, was created because of a specific "shift from oral to written discourse within rhetorical training" (p. 108). This shift brought with it an increase in the labor of writing teachers without an increase in pay or pro-fessional conditions. According to Connors, the historical explanation for the cre-

ation of a composition underclass is the shift in labor from oral instruction to written instruction and the rise of "increasing bureaucratization of the universities, [which] allowed the formation of permanent low-status jobs in composition which were not filled by upwardly mobile scholars, who increasingly gravitated to literary work, which was easier, offered a lighter load and was given more respect" (p. 108). As an historical researcher, Connors looks for patterns and common claims about the "underclass" across a series of National Council of Teachers of English and Modern Language Association labor reports and journal articles from a century ago. Traditional historical research, then, is used as a lens through which to understand the formation of particular patterns of labor and material conditions in the present moment.

Sharon Crowley (1998) also has recounted, in her collection of essays *Composition in the University*, the problematic working conditions of composition faculty working off the tenure track and has argued for abolition of the required first-year writing course as one way to deal with the problematic status of first-year composition teaching. Connors' and Crowley's historically based research on the problematic material conditions of the field has only been the tip of the proverbial iceberg, though; there have been a steady stream of articles addressing the working conditions of part-time and non-tenure-track faculty: pay, contractual length, status, and reforms needed to address those problematic conditions from a variety of perspectives, both historical and contemporary, feminist and otherwise. Indeed, a concern with the material conditions of writing instruction and its feminized status has been a subtheme that runs through much of the early scholarship in rhetoric and composition studies (see Holbook, 1991; Horner, 2000; Miller, 1991; Schell 1998)—a concern that continues to this day in a variety of ways as we continue to document the history of the field and its current material conditions (see Bousquet, Scott, & Parascandola, 2003).

As scholars have studied the histories of our discipline's gendered material conditions, we must ask what actual "material" we turn to when we investigate historical claims about the material status of those who teach writing: How is the past used to explain present material conditions—where do the analogies break down, where do they hold? How do we account for different shifts in the economy of higher education over time? How does looking to mostly artifacts from the discipline—from professional reports and journals and to readings of specific programs such as Harvard—help explain the shifts that took place around labor and status for writing instruction? How does looking to these documents and programs and not to other sources or programs account—or not—for other developments in the larger workforce and culture and society at large—the rise of the corporate workplace, to principles of scientific management, and to the increasing split between mental and manual labor?

Donna Strickland (2001) has argued persuasively that the scholarship on material conditions and the feminization of composition teaching has not yet examined the role/influence of the changes to the corporate workplace through scientific management and to the distinction between mental and manual labor.

She notes that the "current configuration of writing programs are analogous to the configurations of the corporate workplace; that divisions of labor emerge, as they emerged in corporations, to make work more efficient; and that when one level of work came to be associated with routine and correctness then it came to be associated with white women" (p. 460).

Strickland goes on to show in her article how writing programs have functioned as "divisions of labor that resulted not from the marginalization of writing or teaching," as has often been assumed by scholars of composition history like Connors, "but from the essential function of writing in the university curriculum" (p. 461). She also examines how this division of labor "was formed along lines familiar in the capitalist workplace—the division between head and hands, intellectual work and mechanical work" and that this division was gendered and racialized (p. 460). The logic of scientific management present in the corporate workplace was also manifested in the division of labor in English departments, a fact that scholars of composition history have not yet accounted for in much detail. Strickland (2001) also explores how these divisions of labor were supported through cultural ideologies, a central one being the association of White women teachers with maintaining standards of "mechanical correctness" and "racial propriety" (p. 470). Strickland's work, thus, offers us a materialist examination of how women's material conditions as composition teachers are linked to larger economic structures—the division of labor in the corporate workplace, which also became the division of labor in the academic workplace, and cultural ideologies that associated White women with the "routine" work of teaching composition, assessing mechanical correctness with its implication in early 20th-century discourses of mental hygiene and racial propriety. Strickland's work directly engages the questions of labor, the rise of principles of scientific management, material conditions, and the connection to specific ideologies perpetuated to keep women in subordinate roles in the workplace. Although she is concerned with texts that demonstrate specific examples of ideologies, she also is interested in the larger structural forces that govern and constitute a particular time, space, and workplace.

Yet even as there is work like Strickland's that explicitly engages in materialist analysis of the gendered division of labor and the emergence of principles of scientific management, there continues to be skepticism about whether or not feminist scholars in rhetoric and composition along with others in the field are actually doing the right kind of work on materiality. As noted earlier, the attraction to cultural materialism and to analyzing language has led to an uneasiness and outright critique of the tendency to reduce materialism to material, to text, to language, and to artifacts of material culture. In her response to the opening segment of essays in the edited volume *Feminism and Composition Studies: In Other Words*, Deborah Kelsh (1994) argues for a return to historical materialism over cultural materialism, noting that the tendency in the segment of *Feminism and Composition Studies* she is responding to is to ignore class divisions and to see struggles over language as more central than struggles over class and oppressive

social conditions. Kelsh urges readers to return to a "red feminism," one inflect-
ed by "[c]lassical Marxism, reinvigorated through confrontation with postmod-
ern tenets" (p. 106). Kelsh offers an important critique of the way we have done
business with the idea of the material and with the labor structures in composi-
tion studies. Her claim is that although we are concerned with the material in the
field, our concern only goes so far, especially with respect to considering the gen-
dered division of labor in composition: "We need a feminism that can explain the
local transmutation of gender features that allow for the feminization of a specif-
ic field, including both women and men in it, as well, as in the ongoing exploita-
tion of women" across the globe (p. 107). Kelsh urges composition scholars to
pay attention to class divisions and exploitation instead of discussing difference
as an issue of language, not the exercise of power and class privilege.

 Kelsh is not the only one concerned that we spend too much time in our
field on language and too little on economics and class structures. In a piece
offered up originally in the collection *Radical Relevance* and reprinted in the jour-
nal *Meat*, Victor Villanueva (2005) asks us to consider the ways in which we have
failed to confront the question of political economy in the field. Villanueva argues
for reconnecting political economy and rhetoric in our field:

> The role of rhetoric, according to Burke, is the demystification of the ideo-
> logical. The role of political economy is the demystification of relations tied
> to the economic. If we're to understand where we are and what is happen-
> ing to us—and maybe even to affect it—we need the tools provided by both.
> But we think of "economics" as a numbers game. And we humanities types
> fear numbers. (p. 58)

Yet as Villanueva points out, economics is rhetorical, as Deidre McCloskey
reminds us. McCloskey, author of several books on rhetoric and economics,
highlights the link between political economy and rhetorical practice, but as
Villanueva (2005) reminds us, most scholars in our field are largely unaware of
that work. We do not read Adam Smith, John Stuart Mill or a host of others
focused on political economy [including Marx]. The reason he cites is our own
material and disciplinary history. Villanueva (2005) maintains that the rhetorical
theorists we read are those read by literary critics, and "[t]hat to the degree that
we study political economy at all, it's through those critical theorists who also
touch on the economic, critics like Raymond Williams, Terry Eagleton, Lukacs,
Benjamin, and others. And there is a political economy to pedagogical theorists
we turn to, like Freire or Giroux. But our discussions by and large avoid econo-
my, or at least tend not to confront it" (p. 59). Moreover, our discussions about
race in the field have not begun to come to terms with the connection between
rhetoric and political economy. Villanueva (2005) argues that "[w]e do not have
a discourse with which to address the ways in which political economics repre-
sent the peoples of the world, particularly those of what we call the Third World,

as people of color" (p. 63). Although the concept of the "material" is being deployed with greater frequency than ever before, there is a larger sense, as is evident here from Kelsh and Villaneuva's critiques, that we have failed to be *materialist* enough. In Kelsh's view, we have failed to address class exploitation in the context of gender and feminism because we have not sufficiently engaged classical Marxism and red feminism. From Villaneuva's perspective, we have not engaged political economy enough, and, thus, we have not engaged race and racism in ways that allow us to think through and address the exploitation of people of color across the globe.

Even as I have engaged quite directly in scholarship on material conditions in the field through my on work on gender and contingent labor, I, like Kelsh and Villaneuva, have also lamented the dearth of work in our field that directly addresses materialist thought. In "Materialist Feminism and Composition Studies," an essay I wrote for the volume *Fractured Feminisms*, I tried to come to terms with the relationship between materialist feminism and composition studies. In the chapter, I began to note the ways in which Marxist feminist, materialist, and socialist feminist discourses were largely absent from the published scholarship on feminist composition studies (Schell, 2003). In my essay, like this one, I strove to account for the reasons why materialist thought as opposed to material thought is not as prominent as other research methods and methodologies, finding answers that are similar to the ones proffered earlier by Berlin and Trimbur, Kelsh, and Villaneuva. As I note in that essay, a salient feature of our field is its class contradictory position. Although "many of us embrace emancipatory pedagogical discourses and acknowledge working-class origins, we work in departmental structures in which literacy work is considered non-intellectual 'remediation' and devalued socially, politically in higher education" (p. 38). At the same time, a number of us, in contrast to our discipline's problematic status, have achieved comfortable middle-class lifestyles at this juncture in our field's history as independent departments of writing have sprung up and as traditional English departments have begun to hire and tenure large numbers of writing faculty. Some of us not only serve as writing program administrators, part of the managerial class that Marc Bousquet, Tony Scott, and Leo Parascandola (2003) and Donna Strickland (2011) have examined so insightfully in their work; we may chair English departments or independent writing programs (as I currently do), or we may serve as associate deans, deans, and provosts. Clearly, many of us have arrived at the top layers of our institutional structures in increasingly corporatized universities and colleges, and many of us clearly benefit in all ways material from the academic hierarchy even as our field continues to be largely staffed by those working off the tenure-track. I do not bring up these class contradictions to indict those who have achieved some measure of professional success in our field, but to indicate that our discourses about the material, about materiality, and materialism need to be healthily seasoned with an acknowledgment of class relations, managerial relations, and their imbrication with race, gender, and sexuality, power, privilege, and a careful analysis of our professional

conditions with respect to our own privileges in the academy relative to the lack of privileges experienced by other workers across the globe. We do not want to get in situations where, as Villanueva reports, our lack of awareness of privilege exposes glaring omissions in our understanding of our class positions with respect to that of others. Villanueva tells the story of being at a Conference on College Composition and Communication session where a founding woman scholar in the field speaks of the conditions of women in composition studies. This founding woman scholar notes that she is "fortunate" because she can hire a "live-in caretaker for her children so she can pursue her work." Villanueva cites this as a moment in which the contradictory conditions of our work have not been sufficiently theorized with respect to political economy.

All of the theorists in rhetoric, composition, and literacy studies who critique our relationships with the concept of material and materialism (Berlin, 1987; Bousquet, Scott, & Parascandola, 2003; Kelsh, 1994; Strickland, 2001, 2011; Trimbur, 1994; Villaneuva, 2005) appear to be asking us to come to terms with the reasons that materiality matters—what is at stake when we deploy the material as a concept in our work and who and what is left out of those processes of working with the concept of the material. Also what and whose interests are served by scholarship on the material world and feminism? And what does it mean to be doing material or materialist analysis in an age of corporate globalization? Nancy Holmstrom (2003) eloquently argues for the importance of socialist feminist analysis in our current moment of corporate globalization:

> The brutal economic realities of globalization impact everyone across the globe—but women are affected disproportionately. Displaced by rapid economic changes, women bear a greater burden of labor throughout the world as social services have been cut, whether in response to structural adjustment plans in the third world or to so-called welfare reform in the United States. Women have been forced to migrate, are subject to trafficking, and are the proletarians of the newly industrializing countries. On top of all this they continue to be subject to sexual violence and in much of the world are not allowed to control their own processes of reproduction. How should we understand these phenomena and, more importantly, how do we go about changing them? Feminist theory that is lost in theoretical abstractions or that depreciates economic realities will be useless for this purpose. Feminism that speaks of women's oppression and its injustice but fails to address capitalism will be of little help in ending women's oppression. Marxism's analysis of history, of capitalism, and of social change is certainly relevant to understanding these economic changes, but if its categories of analysis are understood in a gender- or race-neutral way it will be unable to do justice to them.

To better materialize our notions of the material and materialism and to account for the methods and methodologies that accompany them in an age of corporate globalization and hyperexploitation of particular gendered and raced bodies, we

need to engage in a rigorous interrogation of what, exactly, we mean by material and materialist analysis in the field. Because there is no common agreement about what constitutes material or materialist analysis, it seems useful to create a series of inquiry questions that will allow scholars to more explicitly identify their conceptions of these terms.

MATERIALIZING THE MATERIAL: WHY IT MATTERS

The inquiry questions I offer here are meant to help scholars find ways to materialize the material more concretely in their work. I offer these up in the spirit of mutual exchange and inquiry, not as a template.

- How am I defining the concept of the material? Is my treatment of the material tied specifically to historical materialism as Marx would describe it? To cultural materialism as Adorno and Horkheimer would name it? Or more specifically to a notion of materialism connected to feminist conceptions of embodiment, to the body, and corporeality, and to lived experience? What are the discourses and theoretical frames that are fueling my analyses—what are their origins, histories, and how does my analysis account for those?
- Am I concerned mostly with artifacts and objects in material culture, choosing to focus more on the idea of the material as a concrete concept, as matter in the world? If so, is the notion of an artifact or object tied to particular power relations, class structures, and racialized and gendered hierarchies? Who has access to or circulates these artifacts and objects, who does not, and why?
- Why does an analysis of the material matter? Why is materialist analysis called for at this particular moment? Why does it matter? Whose interests does it serve? What "blind spots" do I have about examining the concept of the material and materiality?
- How can I interrogate my own position with respect to materiality? How is my own material position accounted for in the project? In what ways will my own self-reflexivity and ethical position be named or addressed—or not—as part of this project?
- What research methods would best serve a material analysis? If we are truly addressing the material, does that necessitate more qualitative approaches such as ethnographic studies and interviews? Our tendency as a field has been to gravitate toward the textual, the printed word or the transcribed speech or classroom practice or consideration of the texts of historical rhetorics. How does

material analysis enable us to look more specifically at specific cultural, institutional, and economic structures and artifacts in very concrete and specific ways? And how does material analysis allow us to engage digital processes, production, and circulation?

- Finally, how do I connect my conceptualization and theorization of the material with actual economic and material conditions, movements, groups, and organizations in the world who are struggling to change conditions of exploitation and oppression? How can I think beyond the scope of my discipline/field and particular rhetorical situation to think more broadly about interconnected economic, social, and political structures in national as well as transnational ways?[1]

With our desire to bring the material and materialism to rhetoric, composition, and literacy studies must come the responsibility of deploying materiality with an awareness of what it means to purport to do material analysis and to lay claim to what historical and theoretical traditions we are drawing upon. Certainly, the material matters in our field, but what is at the base of material and materialist research in our field and why it matters are questions worth interrogating.

ENDNOTE

1. For more on the connections between feminist rhetorics and transnationalism, see Hesford and Schell (2008).

REFERENCES

Berlin, J. (1987). *Rhetoric and reality: Writing instruction in American colleges, 1900-1985.* Carbondale: Southern Illinois University Press.

Bizzell, P. (1991). Marxist ideas in composition studies. In P. Harkin & J. Schilb (Eds.), *Contending with words: Composition and rhetoric in a postmodern age* (pp. 52-68). New York: Modern Language Association of America.

Bizzell, P. (2000). Feminist methods of research in the history of rhetoric: What difference do they make? *Rhetoric Society Quarterly, 30*(4), 5-18.

Bousquet, M., Scott, T., & Parascandola, L. (2003). *Tenured bosses and disposable workers: Writing instruction in the managed university.* Carbondale: Southern Illinois University Press.

Buchanan, L. (2005). *Regendering delivery: The fifth canon and antebellum women rhetors.* Carbondale: Southern Illinois University Press.

Collins, V. T. (1999, May). The speaker respoken: Material rhetoric as feminist methodology. *College English, 61*(5), 545-573.

Connors, R. J. (1990). Overwork/underpay: Labor and status of composition teachers since 1880. *Rhetoric Review, 9*(1), 108-126.

Crowley, S. (1998). *Composition in the university: Historical and polemical essays.* Pittsburgh: University of Pittsburgh Press.

Crowley, S. (1999). Afterword: The material of rhetoric. In J. Selzer & S. Crowley (Eds.), *Rhetorical bodies: Toward a material rhetoric* (pp. 357-366). Madison: University of Wisconsin Press.

Ebert, T. (1996). *Ludic feminisms and after: Postmodernism, desire, and labor in late capitalism.* Ann Arbor: University of Michigan Press.

Glenn, C. (1997). *Rhetoric retold: Regendering the rhetorical tradition from antiquity through the renaissance.* Carbondale: Southern Illinois University Press.

Goggin, M. D. (2002). An essamplaire essai on the rhetoricity of needlework samplermaking: A contribution to theorizing and historicizing rhetorical praxis. *Rhetoric Review, 21*(4), 309-338.

Grosz, E. (1994). *Volatile bodies: Toward a corporeal feminism.* Bloomington: Indiana University Press.

Hennessy, R. (1993). *Materialist feminism and the politics of discourse.* New York: Routledge.

Hesford, W., & Schell, E. E. (2008). Introduction: Configurations of transnationality: Locating feminist rhetorics. *College English, 70*(5), 461-470.

Holbrook, S. E. (1991) Women's work: The feminizing of composition. *Rhetoric Review, 9,* 201-229.

Holmstrom, N. (2003). The socialist feminist project. *Monthly Review, 54*(10). Retrieved July 20, 2008, from http://www.monthlyreview.org/0303holmstrom.htm.

Horkheimer, M., & Adorno, T. (2002). *Dialectic of enlightenment: Philosophical fragments* (G.S. Noerr, Ed. & E. Jephcott, Trans.). Palo Alto, CA: Stanford University Press. (Original work published 1947)

Horner, B. (2000). *Terms of work for composition: A materialist critique.* Albany: State University of New York Press.

Johnson, N. (2002). *Gender and rhetorical space in American life: 1866-1910.* Carbondale: Southern Illinois University Press.

Kelsh, D. (1994). Critiquing the "culture" of feminism and composition: Toward a red feminism. In S.C. Jarratt & L. Worsham (Eds.), *Feminism and composition studies: In other words* (pp. 100-107). New York: Modern Language Association of America.

Marx, K. (1972). Marx on the history of his opinions. In R. Tucker (Ed.), *The Marx-Engels reader.* New York: W.W. Norton.

Mattingly, C. (2002). *Appropriate[ing] dress: Women's rhetorical style in nineteenth-century America.* Carbondale: Southern Illinois University Press.

Miller, S. (1991). The feminization of composition. In R. Bullock & J. Trimbur (Eds.), *The politics of writing instruction: Postsecondary* (pp. 39-54). Portsmouth, NH: Boynton/Cook.

Mountford, R. (2003). *The gendered pulpit: Preaching in American protestant spaces.* Carbondale: Southern Illinois University Press.

Ratcliffe, K. (2002). Material matters: Bodies and rhetoric. *College English, 64*(5), 613-623.

Rohan, L. (2004). I remember Mamma: Material rhetoric, mnemonic activity and one woman's turn-of-the-twentieth century quilt. *Rhetoric Review, 23*(4), 368-387.

Schell, E. E. (1998). *Gypsy academics and mother-teachers: Gender, contingent labor, and writing instruction.* Portsmouth, NH: Boynton/Cook Heinemann.

Schell, E. E. (2003). Materialist feminism and composition studies: The practice of critique and activism in an age of globalization. In L. Gray-Rosendale & G. Harootunian (Eds.), *Fractured feminisms: Rhetoric, context, and contestation* (pp. 31-43). Albany: State University of New York Press.

Selzer, J. (1999). Habeas corpus. In J. Selzer & S. Crowley (Eds.), *Rhetorical bodies: Toward a material rhetoric* (pp. 3-15). Madison: University of Wisconsin Press.

Selzer, J., & Crowley, S. (Eds.). (1999). *Rhetorical bodies: Toward a material rhetoric.* Madison: University of Wisconsin Press.

Shor, I. (1992). *Empowering education: Critical teaching for social change.* Chicago: University of Chicago Press.

Strickland, D. (2001). Taking dictation: The emergence of writing programs and the cultural contradictions of composition teaching. *College English, 63*(4), 457-479.

Strickland, D. (2011). *The managerial unconscious in the history of composition studies.* Carbondale: Southern Illinois University Press.

Trimbur, J. (1994). Review: The politics of radical pedagogy: A plea for "a dose of vulgar Marxism." *College English, 56*(2), 194-206.

Trimbur, J., & Berlin, J. (1992). Introduction. *Pre/Text, 13*(1-2), 1-7.

Villanueva, V. (2005). Toward a political economy of rhetoric (or a rhetoric of political economy). In L. Gray-Rosendale & S. Rosendale (Eds.), *Radical relevance: Toward a scholarship of the whole left* (pp. 57-68). Albany: State University of New York Press.

PART II

RESEARCH AND INSTITUTIONAL PRACTICES

7

PRACTICING SOCIALLY PROGRESSIVE RESEARCH

Implications for Research and Practice

Sharon James McGee

Writing and literacy researchers who engage in socially progressive research do so because they want the fruits of their investigations to lead to changes that will benefit society. As Omar Swartz (1997) says "[S]cholars in our discipline have both the obligation and the ability to work toward the condition of a radical democracy in the United States" (p. 1). He goes on to argue, "Moreover, our training as rhetorical scholars places us in instrumental positions to illustrate how the symbolic constructions of our society are reified in ways interfering with the establishment of a socially pervasive democracy" (p. 2). To conduct socially progressive research is to put front and center the conditions and needs of the marginalized, disenfranchised, and underrepresented of our society in order to strive for social, political, and economic change. In this volume, researchers actively engaged in socially progressive research practices offer theoretical and methodological discussions of why and how to engage in these sorts of research practices. In this chapter, my goal is to examine the ways in which our research agendas are helped and hindered by the institutional review boards (IRBs) from which we seek approval and that, ironically perhaps, seek to keep the best welfare of our participants at the fore of their mission.

INSTITUTIONAL REVIEW BOARDS

Those of us who conduct or plan to conduct research with human participants (or "subjects" as institutions often prefer to call them) are aware of the need for

our studies to receive the approval of our local IRB. IRBs were created in response to several events that raised questions about the ethical conduct of researchers, the appropriateness of the methodology used to collect data, and the risks put to human participants. The first event to bring attention to research ethics was the Nuremburg Tribunal at which Nazi physicians were accused of using prisoners of war to conduct various medical experiments. Although the physicians argued that their research aided the greater good and that no ethical standards existed when the research was conducted, the tribunal judges deemed that the atrocities the physicians inflicted on the prisoners were inhumane. The judges' resulting report, which is now called the *Nuremburg Code*, listed 10 principles to guide the ethical conduct of researchers working with human participants. In general, these principles include the notion that participants give voluntary consent for research and that they are informed of risks and benefits associated with the research. Furthermore, researchers must be able to demonstrate that any potential human risk is outweighed by the benefits of knowledge gained from the research. These principles established the first international effort to protect human participants and guide research ethics (Anderson, 1998; Murphy, 2004).[1]

Although the Nuremburg Code (and subsequent commissions on ethics) guided research practice and was accepted internationally, the United States did not actively disseminate it into law and ethical standards immediately (Murphy, 2004). However, in the United States, two research endeavors, the Tuskegee Syphilis Study and the Willowbrook Hepatitis Study, brought research ethics to the fore. In the Tuskegee study, the U.S. Public Health Service studied the natural progression of syphilis and recruited more than 600 African American men, most of whom were poor, lived in the rural areas in and around Tuskegee, Alabama, and had little access to health care. Some of these men had syphilis at the study's start but were not informed of their health status, and others contracted syphilis during the course of the study. The aim of the research was to examine the ways in which the disease progressed in African Americans because it was hypothesized that syphilis affected Black people and White people differently. When the study began in 1932, treatments for syphilis did not exist, but by the mid-1940s, effective treatment regimens had been developed. However, the men in the study were not offered treatment in order for researchers to study the disease's progression. After several high-profile news stories invoked public outcry, the Tuskegee Experiment was discontinued in 1972 (Bruner, 2008; Murphy, 2004).

What is referred to as the Willowbrook Hepatitis Study occurred over a nearly 20-year period at the Willowbrook State School for the severely mentally disabled in New York. The students at the school were racially diverse and often poor. Because Willowbrook housed more than 5,000 students who lived in close confines, children often contracted hepatitis naturally. The staff physicians at Willowbrook developed a research protocol to test the affects of gamma globulin as a preventative measure against contracting hepatitis. Willowbrook's director of research, Dr. Saul Krugman, sent parents a letter informing them of research,

although arguably, the letter is unclear as to the treatment conditions and protocol being used. The children of parents who gave consent were given immediate access to the school despite a waiting list for admission. These children were used in the research and received doses of gamma globulin and were deliberately given hepatitis as part of the protocol (Murphy, 2004).

Without a doubt, studies such as those conducted at Nuremburg, Tuskegee, and Willowbrook (and all of which set out to address medical research questions) egregiously violated moral and ethical standards about the way in which people (and especially those who are poor, marginalized, or vulnerable) are treated—even for the sake of the greater good. These concerns also have caused mistrust among the public about the conduct of researchers. A quick Google search on the term "Tuskegee Experiment," for example, reveals sites with document headings such as "Human Beings [were being used] as Laboratory Animals" (Information Please, 2007). As a result of these (and other studies) it became clear that the United States needed ethical guidelines for researchers using human participants, and in 1974 the National Research Act created IRBs in their earliest manifestations (Murphy, 2004).

Charged with protecting human participants, IRBs play an important role in research in that they must approve all research conducted at a university that involves human beings. Thus, IRBs hold similar core beliefs as socially progressive research—to protect the welfare of the disenfranchised, marginalized, and underrepresented. Research studies with broad and varying foci conducted by university researchers on new medical procedures, on a chemical's safety for people, on grieving rituals in a remote village in Africa, on students' use of technology for writing all fall under the purview of the IRB. In each case, the IRB reviews the research protocol to determine how the research meets the three principles stated in the Belmont Report and by which researchers must abide: *respect for persons, beneficence,* and *justice*[2] and how the researchers will obtain voluntary, informed consent from the participants. Furthermore, the IRB determines whether or not the group participating would be considered a protected class or vulnerable population, people who would possibly need additional protection of their health and well-being or of their confidential information. All in all, the original intent of the IRB is one that many of us would agree is both essential and limited in scope.

INSTITUTIONAL REVIEW BOARDS' CHANGE OF SCOPE

But, as with Alice and the looking glass, all is not what it seems. IRBs have in fact become more invasive into research design over the past 20 years or so.[3] While attending a conference recently, I had a conversation with a former graduate school office mate. We were both coming out of a session in which IRBs and their

scope had been introduced (by me in the question-and-answer period) and she and I began discussing the changes we have seen during our time as researchers. My friend was noting that she was beginning a meta-analysis of some of her research studies over the years and has had some difficulty in using her old data, some going back to her dissertation, because the informed consent document she used then was much less detailed than one she has used in a more recent study. We both recalled that when we were working on research projects some 15 or more years ago, we had very minimal paperwork to present to an IRB, which approved the work easily. Our informed consent documents were only a few paragraphs as opposed to the two- to three-page single-spaced document we need today. We also received no formal training from our institutions in research ethics, other than the localized research methods classes we took in graduate school. (In fact, for my master's degree, I conducted research without having had a qualitative research methods class; I designed and carried out a study as best I could by reading many methodology books.) A current colleague recollected a similar experience when he collected his dissertation research (also at a top research institution). He suggested to me that he might not even be able to conduct the same kind of research today in which he worked with immigrant students and studied their—and their children's—literacy habits because of the restrictions and standards being used by today's IRBs.

On the surface, these problems might seem merely logistical, that is, more paperwork is needed today than in years past and researchers need more training now than in the past. That our institutions require formal training in research ethics and federal compliance is something that many researchers agree is important. Renewing our commitment to research ethics through formal training and periodic updating strengthens the work that we do. Our quibbles, which are minor, would likely be the time involved and the material covered. For example, many institutions have outsourced this training, once done in institutional person-to-person workshops, with online tutorials provided by one of several vendors, such as Collaborative Institutional Training Initiative. A few years ago, I gained my "certification" to conduct research by attending a workshop led by the dean of graduate studies at my institution, but recently, when the time to renew my certification came, my only option was an online tutorial. This tutorial took me nearly 8 hours to complete and although the modules I worked through were for "Social and Behavioral Scientists," a great deal of the information addressed issues related to FDA guidelines and other medical research. That the training is time-consuming and contains some unrelated material does not mean that it is not worthwhile.

However, the issues that my colleagues and I have noticed point to more than logistical problems with IRBs; in fact, these problems are epistemological. To begin this argument, I want to analyze two (intertwined) changes that have occurred over the past several years and have been noted not only by my colleagues and me but also by other scholars (cf. Dougherty & Kramer, 2005; McKee, 2003; White, 2007). The first change is increased scrutiny of projects

and the second is the extended scope of the IRB's mission on many campuses. That IRBs are scrutinizing research projects more closely is not news to most researchers who have been engaged in research for more than 10 years. For example, for a graduate project in my master's program, I interviewed students enrolled in first-year composition courses about the feedback they received on their writing, their perceived level of confidence about writing, and their improvement over the course of a semester. I wanted to examine the relationship between teacher comments and student confidence about writing. Although this project relied on human participants, because it was not invasive (i.e., it involved no medical procedures and no obvious harm) and because I stated that I would work to maintain the confidentiality of students, it was approved quickly (and in fact, may have even been exempted from review). Today, such a project would certainly not be exempted; it would need expedited review. Looking back at my study now, I am certain that this project would also have garnered feedback from the IRB that would require me discuss specifically perceived harms, risks, and benefits to students.

One could argue that, again, this problem is merely logistical: As a researcher I would have had to do more work to design my study. That the approval process would have been longer and more involved is not in and of itself a problem. In fact, receiving feedback about ways to improve a study's protocol and design often are welcomed by researchers. This increased level of scrutiny, however, is not always productive. In their 2007 special issue of *Journal of Applied Communication Research*, co-editors Doughtery and Kramer (2005) wanted to use narrative essays as vehicle for scholars to examine IRBs. They had both served on their institution's IRB and found that they "were dismayed and surprised by the IRB's tendency to deviate from this narrow mission of protecting human subjects with the result that it can become a significant barrier to conducting even low risk projects" (p. 183). They recount their experiences with the special edition because although Doughtery and Kramer felt that the project would not fall under IRB purview (because scholars would be writing narrative essays about their experiences, thoughts, and reflections of IRBs), their institution's IRB claimed that the project was within its purview. The IRB insisted on language in the call for proposals (CFPs) that indicated risks to the participants (i.e., theoretical retaliation against the writers from their own IRBs) and the like, which Doughtery and Kramer felt ultimately affected how the CFP was perceived by potential contributors, how the articles were written, and possibly how the issue was analyzed by its readers:

> The approval process we went through has already shaped this discussion in at least two ways. First, by mandating the consent section in the call for narratives, the IRB approval process made the call more negative and critical than intended. This [special] issue is not intended to bash IRBs. It is intended to create an open discussion about communication scholars' positive and negative experiences with IRBs. The IRB-mandated consent statement may

have obscured our focus. Second, this particular essay has obviously been
shaped by the review process for this special issue. When we envisioned
writing this article, it never occurred to us that the IRB approval process for
the issue would provide the focus for its content. The review process has
shaped how the narratives were written, and how we read them and wrote
our analysis. It may also shape readers' understanding of the special issue.
(p. 186)

They further argue that if an IRB wishes to extend its purview to what they call
"an innocuous project" such as theirs, that other scholars who work with at-risk
populations and whose IRB protocols are more complicated will surely face dif-
ficulty and that such influence can potentially shape the knowledge generated.

Gunsalus et al. (2007) make a similar argument in their "Illinois White
Paper." They suggest that, in fact, academic freedom is at risk when IRBs exert
their influence over projects. They posit "academic freedom is threatened
through a chilling effect in which some studies are not even proposed for fear
that they will be rejected, whereas others are reframed simply to obtain IRB
approval. The literature is replete with anecdotal examples of work scaled back
or never attempted because IRB reviews are too burdensome or unresponsive"
(pp. 634-635). The white paper examines the ways in which a biomedical model
of research approval does not fit well with humanities or social sciences research
and calls into question the complexity of harms and risks of consenting adults
recounting a story (oral history) or conferring with researchers (via interview or
ethnographic observation). Gunsalus et al. ultimately argue that "expansive
notions of university 'research' and institutional commitments to the IRB review-
ing 'all' human research are untenable. The scope and purpose of IRB review
must be clarified" (p. 645).

Other scholars also have noted the increase in oversight extended by IRBs
and two origins to this oversight emerge: The first is a hegemonic ideology about
research and suspicion of what may be considered "alternative" methods and
methodologies, such as those espoused by socially progressive researchers. The
second is what White (2007) calls "mission creep" in that IRBs are now part of
universities' risk management infrastructure.

Arguing that a hegemonic ideology is influencing IRBs, Lincoln and Tierney
(2002), both regarded researchers in education, suggest that increased pressure
"from the political right [that] has intensified to discredit the products of post-
modern theorizing, including constructivist theories of knowledge, postmodern
epistemologies, Foucauldian analyses, poststructural investigations, and other
kinds of research associated frequently or always with qualitative research" (p. 2).
They point out the increased scrutiny of three kinds of research in particular:
classroom-based projects, funded projects, and dissertation projects. They also
argue that because alternative research methodologies are becoming more often
rejected by local IRBs that important research is not being conducted and there-
fore not making its way to administrators and lawmakers. They also fear that new

researchers who have been trained in alterative methodologies will not be able to garner approval for their projects and, as a result, will not conduct them.

Thus, if IRBs are reifying existing hegemonic notions about research practices, this stance can lead to epistemological clashes between socially progressive researchers and IRBs. Because researchers must receive IRB approval in order to conduct their research, we often find that we either have to negotiate or comply with IRB suggestions in order to conduct our work. As IRBs are more closely reading and managing study protocols, we can see them inserting their ideologies into researchers' methods and methodologies. In other words, as IRBs review research protocols, they often are asking the researchers involved to change the way in which their research is being conducted or the data that they will be collecting. Sometimes the changes have little to no effect on the project, but frequently, the research project or questions must change as a result of negotiation that occurs between the IRB and the researcher, as Doughtery and Kramer's experience indicates. When we begin to think about the fact that we must have IRB approval and revise our protocols if needed, it becomes more apparent that IRBs do, in fact, have the potential to shape not only the work of individual researchers but they can potentially shape disciplinary formation.

For example, frequently, protocols are rejected or need modification because many IRBs work under more positivistic notions of research; that is, they view "objective," "value-free," "replicable," "generalizable," experiments or other quantitative data methods as being "rigorous." Thus, IRBs review protocols from a particular epistemological position. Swartz (1997) calls the reification of hegemonic practices within a discipline "epistemological totalitarianism," which he defines as

> the practice of professionalization in which intellectuals use assumptions of "power" and "knowledge" to centralize truth in a priori postulates and defend those postulates by marginalizing opposing or contrary ideas. For example, the belief that scholarship is only "valid" if it produces value-free statements describing a mind-independent empirical world involves an instance of epistemological totalitarianism. (p. 2)

It can be safely argued that many IRBs operate within an epistemologically totalitarian worldview of research practices; thus, alternative methodologies are suspect or at the very least, should employ some of the practices used in more "scientific" research to increase their validity, reliability, and rigor. This epistemological position can potentially affect the research questions asked as well as the methods employed (quantitative over qualitative, traditional over alternative) by all researchers, but certainly literacy researchers because we may be likely to use a qualitative approach and alternative methods and methodologies.

Ironically enough, little empirical research on IRBs exist, as noted by De Vries, De Bruin, and Goodgame (2004). However, a survey of IRBs conducted by

De Vries and Fosberg (2002, cited in De Vries et al., 2004) found that "14% of IRBS are dedicated to behavioral science research, whereas 58% review both social science and medical protocols" (p. 355). In discussing this finding, De Vries et al. argue that "a majority of social science research is reviewed by boards lacking specific expertise" in social research practices and methodologies (p. 355). They report on further empirical research, observations of an IRB working from June 2002 to August 2003 and reviewing both medical and social science research. Their observations revealed that when social, behavioral, or economic (SBES) research protocols were reviewed, those protocols "were given much *more* scrutiny than medical protocols" (p. 363)—even though, as they point out, medical protocols involve much more potential physical risk to participants. They suggest several reasons why SBES research may draw more scrutiny:

1. Because SBES research was somewhat atypical for the IRB observed, it might draw more curiosity from the board members.
2. Because SBES research is considered "soft," more board members felt it was within their parameter to comment on it—as opposed to more specialized medical research in which members deferred to given area specialists on the board.
3. Physical harms are easier to identify and understand than potential "psychological" harm that SBES research might inflict on participants (p. 363).

The work of De Vries et al. points to some of the potential problems with the workings of the IRB as an organization, problems that could lead to what White (2007), Gunsalus (2004), and others call mission creep.

Although Gunsalus has widely discussed mission creep and the problems associated with IRB's drift in mission for researchers and the boards themselves, White (2007) goes further, positing that IRB mission creep, "signifies a more deliberate, sneaky, and nefarious form of devolutionary change than the more unintentional, randomized 'drift' evident in other government organizations" (p. 548). One of the ways in which IRBs have extended their scope beyond that of protecting human participants is to protect the institution from liability. Risk management has become part of their purview, as Malone, Yerger, McGruder, and Froelicher (2006) argue. As the United States has moved to being a more litigious society generally, institutions have become more sensitive to any potential risks that might smack of a lawsuit. And after all, IRBs are designed to question research protocol's definition of risk and ensure the principles of the Belmont Report are met: that participants know the potential risks and that they voluntarily participate in the study and that risks are shared equally among groups. Protecting humans from risk is essential. However, White argues that often IRB members are not necessarily trained in "risk assessment," particularly regarding nonmedical research. In other words, determining the potential risks inherent within medical research often is easier than determining the kinds of risks inher-

ent in behavioral or social science research. For medical research, the risks usually are physical, whereas for social science research the risks could be "psychological, social, economic, legal, and dignitary" (Labott & Johnson, cited in White, 2007, p. 555). IRB members, then, must determine what the potential risks are to participants' dignity? To their economic status? To their psyche? These are questions often without easy answers. Although it is important to examine the possibility of risk, IRBs should balance perceived potential risk with likelihood of risk. In other words, because an interviewee *might* experience frustration during an interview at what point does that emotion become a risk factor for the participant?

Furthermore, Malone et al. argue that part of an institution's view of risk management may be tied to implicit and unspoken, perhaps even unrecognized, reactions to class, race, and gender issues. Malone et al. discuss the problems they encountered receiving IRB approval for a community-based participatory health research project designed to investigate cigarette sales in an inner-city neighborhood. Their study provided a tangle of ethical questions to be unknotted by the researchers and their local IRB. As the researchers analyzed the problems with their IRB in the article "It's Like Tuskegee in Reverse," they questioned whether the fact that research was to be conducted in a low-income minority neighborhood had bearing on the IRB's review process. The IRB argued that the community partners (with whom the researchers were working) could face safety issues, which would be a risk management matter for the university. Malone et al. ask "Would such a fear have been raised if the proposed study was to be conducted in a wealthy White community?" (p. 1918). They suggest the following:

> The actions and behaviors of individuals and groups are associated with sociohistorical structures and cultural factors that may simultaneously reinforce and obscure oppressive power relationships. Race/ethnicity, class, and gender are part of this configuration and how groups act (or do not act) to further their interests or to change oppressive structures is related to their power position. Most academics and legal analysts are socially positioned in advantageous ways that may blind them to the power dynamics embedded in their ethical decision making. (p. 1918)

They further speculate that the IRB's anxiety about the proposed study may have "reflected deeply embedded assumptions about race/ethnicity and class behaviors in addition to insurance or litigation risks associated with working in poor neighborhoods. Class and intellectual culture may influence moral analysis more than many academics assume or want to acknowledge" (p. 1918). Literacy research often involves issues of race/ethnicity, gender, and class, so it is conceivable that if in fact these inherent power relationships shape IRBs' analysis of research methods and protocols, researchers may face similar issues about risk management, oversight, and second guessing.

WORKING WITH THE SYSTEM TO MAKE THE SYSTEM WORK

Regardless of why and how the problems and issues with IRBs have occurred (and I tend to think that these problems are not as intentional and malicious as White suggests), they nonetheless exist. As stated previously, IRBs and socially progressive researchers share a common assumption: The mutual desire to put the interests of human participants at the center of research practices. Although IRBs and socially progressive researchers share this common ground, literacy researchers and IRBs often differ in how to put those interests first, and that is the rub. Literacy researchers desire to speak with their participants rather than about or for them; literacy researchers wish to break down the separation between researcher and participant; literacy researchers seek to complicate the notion of objectivity, striving for collaboration rather than authority. These very methodological principles to which we subscribe conflict with positivistic notions of research often held by IRBs in which objectivity and anonymity are defined statically and where researchers and participants/subjects occupy particular roles within the research. Even though we seek the same ends, we may have a basic epistemological conflict about how best to do so.

Thus, researchers who are conducting socially progressive research in particular may face problems with IRBs. For example, researchers might encounter IRB resistance/hesitation/concern about sites for research or about participants. Just as Malone et al. encountered IRB resistance to their research, which was to be located in an inner-city, socially progressive literacy researchers might use low-income, inner-city, and/or minority neighborhoods, community literacy centers, or schools as sites for their work—locations that for some people, including academics, might be considered "unsafe" and present IRBs with liability concerns.

Literacy researchers also may desire to conduct studies with gay or lesbian students or immigrants, which because they could be considered a protected class, could pose problems for anonymity and confidentiality, especially if the researcher wanted to, for example, write the research narrative collaboratively with the participants. At the very least, *any* type of authorial collaboration complicates the notion of confidentiality and anonymity required by IRBs. When the issue of a protected population is involved, then the matter becomes sticky. IRBs and researchers will have to consider the potential risks and benefits to the collaboration. As researchers, we see the value in offering our participants a space for their views and voice in the research narrative, and in fact, could argue that this is a benefit to the participants that outweighs risk—as long as the participants are fully informed and offer voluntary consent. An IRB, on the other hand, might argue that the risk for violated anonymity is greater than any benefit, and that the researcher, a person in a power position, would have no risk but the participant would bear all the risk in such an endeavor.

Literacy researchers also may wish to consider "renegotiating" the informed consent documents with participants during the course of a study. Kirsch (2005) suggests that such a move is important because often when participants sign the informed consent document, they are imagining what the research will be like in the abstract. During the course of multiple interviews and visits, however, the line between a researcher's friendliness toward the participants and friendship may blur for participants. That the informed document could be considered dynamic and negotiable could pose a problem for an IRB.

Gunsalus (2004) goes further than Kirsch, arguing that what she calls "two-people-talking" situations defined as "an informational interview in nonbiomedical and nonbehavioral research involving decisionally capable adults being interviewed or surveyed by individuals affiliated with universities" (pp. 371-372). Two-people-talking situations can involve, of course, more than two people talking and would include situations like interviews, oral histories, and focus groups. These situations, she argues, fall well within the federal guidelines of "minimal risk" and perhaps by IRBs demanding oversight of such situations may even violate the Belmont Report's original intention to provide participants with decision-making capacity in their consent. Gunsalus' argument points to the tricky area of "consent," "knowledge," and "power." Power, of course, is the sticky wicket: Who has it? Who doesn't? Gunsalus cites Shopes (2004), who suggests that although the interviewer may in fact have certain powers, the participant holds power, too: "there are often power differentials (income, class, education) between the interviewer and narrator, but that the narrator always retains enormous power: the power to refuse to be interviewed, the power of refusing to be identified, of refusing to answer questions, or not answering them fully" (cited in Gunsalus, 2004, pp. 375-376). This argument poses a new way of examining power and consent, one that as a field we may not have probed deeply enough to date.

WORKING TOWARD THE FUTURE

Because the data and results that come from the projects that socially progressive researchers conduct shine light on issues involving the marginalized and because those of us in universities, sites of power, have the platform on which to raise awareness of these issues, we must not be intimidated by IRBs nor should we try to circumvent them. As this volume goes to press, in fact, the U.S. Department of Health and Human Services (HHS), which oversees IRBs and their practices, is considering changes to The Common Rule, the law that governs human participant protection. Although no changes have been made to date, the HHS does recognize that the IRB process has created "unnecessary burdens" for researchers and IRBs and that the system's "efficiency and effectiveness" are in question. What remains to be seen, however, is if any changes will improve the regulatory

process for socially progressive researchers or if it will hinder our work. We must continue to "engage the system" so that the system can work for and with us.

Drawing on the principles of collaboration and reflection, I offer the following ideas in order to start a conversation between researchers and IRBs.

- As socially progressive researchers value collaboration as a research tool; likewise, they should work collaboratively with their local IRBs to raise concerns about qualitative research practices and especially alternative approaches to research when those approaches come into conflict with an IRB's understanding of research. A few years ago, qualitative researchers on my campus came together informally to discuss the various concerns we had about the way that qualitative and other alternative research practices were apparently being viewed by our IRB. One faculty member sent a query to our university listserv and those of us who were interested met and developed several key points that we wished to discuss with our IRB. Faculty from across disciplines—foreign languages, education, English, and anthropology to name a few—worked together on common points of concern. Although the outcome of our work was not fully recognized, the IRB was perhaps more willing to listen to a cohort of faculty with similar concerns as opposed to individual faculty, and the collective view was potentially more powerful than any one individual's view.
- Furthermore, researchers could benefit by viewing IRBs not as adversaries but as co-participants for change. Thus, rather than entering any such meeting defensively, it would likely better serve researchers to view such an opportunity as a meeting to share viewpoints. What are the IRB's concerns? In what ways can researchers address those concerns in their research protocol narratives? Researchers also should listen for broader statements about qualitative and alternative methodologies. What assumptions does the IRB have about such methods? How can researchers better inform those in power (IRBs) about the valid research being done that doesn't conform to positivistic notions of research? Likewise, the IRB should seek points on which it can reach agreement with researchers.
- Researchers should reflect closely on the assumptions that they make about their audience (the IRB) when preparing research protocols for approval. Are they making assumptions that the IRB will know about and/or value the methods that they are proposing to use? How can researchers use the narrative as a way to inform the IRB about the tradition of alternative methodologies and methods that they seek to employ in their studies? Are researchers harnessing evidence in their protocols that indicate

that the methods they propose have been tried before successful-
ly or are grounded in other research practices that might not be
known to the members of the IRB?

- Researchers should seek to collaborate with one another. For
many researchers, research projects have been and likely will con-
tinue to be collaborative endeavors with co-researchers and par-
ticipants. But they should do more as well. They need to work
with new researchers, graduate students, and junior faculty mem-
bers, not necessarily as co-investigators, but rather to help them
negotiate their way through the sometimes difficult terrain of IRB
approval. New researchers often have very important projects that
promote various social, economic, and political agendas; rather
than having those projects become sidelined either because the
researchers cannot receive IRB approval or because they are intim-
idated by the process serves no one well.

In addition to mentoring new researchers, forming networks
of like-minded researchers would benefit us all. Whether those
networks be formed locally at the institutional level (as with the
group that came together at my university) or more broadly across
literacy studies (via listserv or special interest groups that meet at
conferences), they have the potential to transform not only our
ability to work for change locally but across multiple sites.
Furthermore, such collaboration can only strengthen the work
that we do in general as we plan projects and receive feedback
from one another.

This list is not exhaustive; rather it is merely suggestive of a starting point
for all literacy researchers to think constructively about how they can work with
IRBs so that they can conduct the important research projects they have in mind.
Readers will, I am sure, be able to add their own ideas to this list.

It has not been my intention in this chapter to frighten new researchers away
from projects because of potential issues with IRBs. Nor have I intended to sug-
gest that all IRBs insert their views on all research projects. IRBs do play an
important role in helping researchers think about their projects, and having an
IRB that can guide researchers through the ethical dilemmas that our projects in
particular may pose benefits us as researchers, our institutions, and ultimately
our participants to whom we wish to inflict no harm. On the other hand, it was
not that long ago that I was a researcher who felt that the problems I might be
experiencing with an IRB were because of some flaw in my thinking or research
design rather than because of larger epistemological or institutional issues about
research design. To explore the options available to researchers is an important
first step in working to reach an equitable solution that benefits both our insti-
tutions and our research projects.

ENDNOTES

1. Providing a detailed history of the creation of IRBs is beyond the scope of this chapter. For two compact histories of the IRB entity, readers would find Anderson (1998) and White (2007) useful.
2. The principle of *respect for persons* posits that participants are to be recognized first and foremost as human beings who have the right to make their own decisions, to offer their voluntary consent, and to be informed fully about the risks and benefits of their participation in a study. Those who are unable to make their own decisions must be protected. The concept of *beneficence* means that risks to participants cannot outweigh benefits. The principle of *justice* requires researchers to distribute risk evenly across all groups (in other words not to make one group bear all the risk and another group bear little or no risk) and all groups also must have the same opportunity for benefits (Office of Human Subjects Research, 1979). These principles align with those of socially progressive research practices.
3. I realize that not all IRBs operate in the ways in which I am about to describe. In the following paragraphs, I paint with broad strokes as a way to highlight some of the issues that have been raised in the literature about IRBs and problems that researchers are experiencing with them. Furthermore, it should be noted that although IRBs at some institutions have made considerable strides in accommodating qualitative research over the past several years, too many examples of far-reaching IRB arms remain (cf. Doughtery & Kramer 2005; Malone et al., 2006; Nelson, 2003; Nelson & Watt, 2004; etc.), suggesting that problems still exist for many researchers.

REFERENCES

Anderson, P. (1998). Simple gifts: Ethical issues in the conduct of person-based composition research. *College Composition and Communication, 49*, 63-89.

Brunner, B. (2008). The Tuskegee Syphilis Experiment. Tuskegee University, Retrieved from http://www.freerepublic.com/focus/f-news/2010486/posts.

De Vries, R., De Bruin, D., & Goodgame, A. (2004). Ethics review of social, behavioral, and economic research: Where should we go from here? *Ethics & Behavior, 14*(4), 351-368.

Dougherty, D. S., & Kramer, M. W. (2005). A rationale for scholarly examination of institutional review boards: A case study. *Journal of Applied Communication Research, 33*(3), 183-188.

Gunsalus, C.K. (2004). The nanny state meets the inner lawyer: Overregulating while underprotecting human participants in research. *Ethics & Behavior, 14*(4), 369-382.

Gunsalus, C.K., Bruner, E.M., Burbules, L.D., Finkin, M., Goldberg, J.P., Greenough, W.T. et al. (2007). The Illinois white paper: Improving the system for protecting human subjects: Counteracting IRB "mission creep." *Qualitative Inquiry, 13*(5), 617-649.

Information Please. (2007). Tuskegee Syphilis Experiment. Retrieved from http://www. infoplease.com/ipa/A0762136.html.

Kirsch, G. E. (2005). Friendship, friendliness, and feminist work. *Signs: Journal of Women in Culture and Society, 30*(4), 2163-2172.

Lincoln, Y., & Tierney, W.J. (2002). *"What we have here is a failure to communicate....":* *Qualitative research and institutional review boards.* Paper presented at the annual meeting of the American Educational Research Association, New Orleans, LA.

Malone, R. E., Yerger, V.B., McGruder, C., & Froelicher, E. (2006). "It's like Tuskegee in reverse": A case study of ethical tensions in institutional review board review of community-based participatory research. *American Journal of Public Health, 96*(11), 1914-1919.

McKee, H.(2003). Changing the process of institutional review board compliance. *College Composition and Communication, 54*, 488-493.

Murphy, T. (2004). *Case studies in biomedical research ethics.* Cambridge, MA: MIT Press.

Nelson, C. (2003). Can E.T. phone home? The brave new world of university surveillance. *Academe, 89*(5), 30-35.

Nelson, C., & Watt, S. (2004). *Office hours: Activism and change in the academy.* New York: Routledge.

Office of Human Subjects Research. (1979). The Belmont Report: Ethical principles and guidelines for the protection of human subjects of research. *Regulations and Ethical Guidelines.* Retrieved from http://ohsr.od.nih.gov/guidelines/belmont.html.

Swartz, O. (1997). *Conducting socially responsible research.* Thousand Oaks, CA: Sage.

U.S. Department of Health and Human Services. (2011). *ANPRM Frequently Asked Questions (FAQ).* July 2011. Retrieved from http://www.hhs.gov/ohrp/humansubjects/anprmqanda.html

White, R. F. (2007). Institutional review board mission creep: The common rule, social science, and the nanny state. *The Independent Review, 11*(4), 547-564.

8

DISABILITY STUDIES METHODOLOGY

Explaining Ourselves to Ourselves

Margaret Price

Disability studies (DS) lacks a unified methodology. To some extent, this is to our advantage: Practitioners of DS come from a wide variety of disciplinary homes, ranging from biology to philosophy to dance, and many of our most respected theorists are independent scholars and/or activists. Our research represents a great range of methods and beliefs, and the DS community routinely reads evidence that may come in the form of movement *or* statistics, references to Aristotle *or* Lady Gaga. However, this great variety of disciplines and approaches also brings a disadvantage: It can be difficult to identify common definitions, questions, and practices. In this chapter, I offer a framework of themes that characterize most, if not all, DS research, in an effort to build a unifying theoretical frame. This frame is intended to highlight concerns and practices that characterize us while also accounting for important differences. My aim is to offer an introduction to DS methodology for the interested researcher new to DS, as well as a compendium of international and multidisciplinary perspectives on DS methodology.

The form my account takes is layered. It reviews DS research from approximately the past two decades, analyzing the questions this research tradition has raised, and noting its accomplishments as well as its shortcomings. Interspersed with this theoretical framing is a story—the account of a classroom-based study I conducted in 2002-2003, as well as the years of reflection, revision, and representation that have followed. Hence, this chapter follows the important DS tradition of reflecting on our theories and practices in order to explain ourselves to newcomers—those who may be puzzled by our intense focus on language, for instance, or who may wonder why a key DS slogan is "Piss on Pity"[1]—as well as to ourselves—conducting constant "member checks" of our assumptions, prac-

tices, and beliefs. DS is a messy, rather contentious discipline, due both to its hugely variant constituency and to the sometimes conflicting goals it sets forth. As a consequence, we spend a lot of time explaining ourselves to ourselves, and explaining ourselves to those who are new to the discipline, or even hostile to it. This chapter is inspired by reflection-on-practice works, such as "Parasites, Pawns and Partners: Disability Research and the Role of Non-Disabled Researchers" (Stone & Priestley, 1996), as well as reflection-on-theory works, such as "Feminist Disability Studies" (Garland-Thomson, 2005). My layered analysis proposes four areas of productive tension—contact zones (Pratt, 1991)—that both characterize and are given particular shape by DS methodology. These zones are *access*, *activism*, *identification*, and *representation*.

BACKGROUND ON STUDY

The study centered on a first-year writing class I taught during the fall 2002 semester at the University of Massachusetts-Amherst. Themed "Exploring Normalcy," the course asked students to analyze and reflect on the way *normal/ normalcy* is constructed through texts, and through readings of those texts. Course materials included Lennard Davis' (1995) chapter "Constructing Normalcy" from *Enforcing Normalcy*, Malcolm Gladwell's (1997) essay "The Sports Taboo: Why Blacks are Like Boys and Whites are Like Girls," and Eli Clare's (1999) essay "The Mountain," as well as the films *Vital Signs: Crip Culture Talks Back* (D. Mitchell & Snyder, 1995) and *Tough Guise: Violence, Media, and the Crisis in Masculinity* (1999).[2] I worked from the position of a teacher-researcher, that is, one conducting a "systematic, intentional inquiry" while also teaching in a classroom (Cochran-Smith & Lytle, 1993, p. 23).

I approached the study with four research questions that focused on both critical thinking and resistance. As the semester and the study went on, these questions were revised to two, with critical thinking emerging as the key issue and resistance moving to the background.[3] These were the research questions that directed the main portion of my data analysis:

1. How is "critical thinking" defined in this environment, by *both* teacher and students?
2. What strategies do students use when they engage in critical thinking, reading and writing about disability? Specifically, how do students bring new ideas and discourses about disability, such as disability studies, into their writing?

I wanted students to know from the semester's beginning that I was conducting a study of our class, so that when the end of the semester came, they would

not feel I had (in a sense) sneaked up on them. On the other hand, I did not want them to worry that things they said to me as a teacher would find their way into my study. And I particularly did not want them to worry that their grades might depend in any way on their participation, or nonparticipation, in the study. With this in mind, I designed a three-tiered system of informed consent. The three documents involved were an informative letter about the study, distributed on the first day of class; a document I called a "willing-to-participate" form, distributed at the end of the semester; and a more conventional informed-consent form, distributed after the semester ended to students who had indicated their willingness to participate.

Twenty-three students returned the "willing-to-participate" form, giving me permission to study their writing, with seven also volunteering to take part in post-class interviews. After an initial group interview, I selected three "focal students" for intensive case study. I selected only three because my time and resources were limited; the principle of selection was to achieve a range of approaches to self-positioning in relation to disability among the students. In other words, I wanted to select focal students who took varied stances in relation to disability. The three focal students were Tara, who identified as nondisabled and as having "never really thought about" disability; Joe, who did not identify explicitly except to say that he had a number of friends and relatives with disabilities; and Kathleen, who identified as having a learning disability. For the purposes of this chapter, I focus on the case study of Kathleen, drawing examples from her writing and interviews. (More in-depth analysis of Tara's and Joe's case studies can be found in Price, 2007, 2008.) Table 8.1 summarizes the data I collected.

Interviews were semistructured, and employed an adaptation of discourse-based interviewing (Odell, Goswami, & Herrington, 1983). This involved presenting the student with a piece of paper on which was written a sentence taken directly from one of his or her essays, as well as one or more variations on the sentence. For example, I presented Tara with the following two sentences to investigate her use of presuppositions (the first sentence is the one that appeared in her essay):

1. Lack of access deprives *the disabled* from being able to shop anywhere they want.
2. Lack of access deprives *disabled people* from being able to shop anywhere they want.

After displaying the sentences, and reading each aloud, I asked, "How does the meaning seem to change between each of these, if it changes at all?" Discourse-based interviewing is aimed at learning about the writer's "tacit knowledge" (p. 223). My purpose in including these sets of questions in the individual interviews was not to uncover the focal student's "intent" or what they "really meant"; rather, it was to learn more about their readings of particular linguistic choices.

Table 8.1. Data Collected

Period	Data
May–August 2002	Student papers on Eli Clare's "The Mountain" written prior to fall 2002 semester.
May 2002	Group interview with teachers of English 112, in digital environment (Web CT; real-time discussion).
September–December 2002	Teaching journal. Write immediately after class (twice per week), plus at least one additional time if possible (e.g., after conferences with students). When time permits or a quickwrite is going on, write during class.
September–December 2002	Quickwrites written by students, during class, at four points during the semester.
January 2003	First small-group interview with focal students. (Five students present; audiotaped.)
January–May 2003	Essays by focal students on Eli Clare's "The Mountain," collected in multiple drafts when possible. (Earlier drafts may be handwritten.)
April 2003	Individual interviews with focal students (audiotaped).
May 2003	Second small-group interview with focal students. (Three students present; audiotaped.)

162

Unless asked, I didn't say which sentence had appeared in their essay, nor did I offer my own interpretation of the sentences.

To analyze interview transcripts and students' writing, I used an adapted form of critical discourse analysis (CDA). I have argued elsewhere that CDA is a particularly useful methodology for DS research, for reasons including their shared investment in linguistic and discursive formations, as well as in activism (Price, 2009a). My study of the "Exploring Normalcy" class used an adaptation of CDA as explicated by Fairclough (1992, 2003), as well as Ellen Barton's (2002) theory of rich-feature analysis. Through a constant-comparative analysis of my data sources, including my teaching journal and students' essays, I identified two "rich features" for study: *pronouns* and *key terms*. My overall aim in using these methods was to observe the development of students' critical thinking as they interacted with various discourses, including DS discourse, in their writing and speech.

As I carried out the study, it seemed that I kept running into dilemmas—of access, of language, of representation. Why wouldn't Joe explicitly identify his nondisabled status, choosing instead to talk about his mother's sickle cell anemia? Why did Kathleen sometimes say she was "learning disabled," but at other times say she "had a learning disability when I was little"? Why had Kathleen remained silent about her identification throughout the semester of the class, but then suddenly reveal it in the first small-group interview? To an extent, such dilemmas are in the nature of qualitative research, and of a novice's research. But another contributing factor was that DS methodology was (and is) a conflict-laden endeavor. Now, from the perspective of several years later, I can see that what I initially thought were simply my own difficulties are in fact difficult areas for DS research in general.

By conducting this layered, retrospective analysis, I hope to accomplish two things: first, to offer an introduction to DS methodology and its connections to other intersectional methodologies; second, to point out some areas within DS methodology that need further attention. I begin with an overview of the history of DS methodology, then move to the four contact zones.

DS METHODOLOGY

This is a queer time to explicate DS, because at this moment DS scholarship, methodologies, and pedagogies are changing at a fast pace. Although disability is still omitted from too many academic conversations (Davis, 2006), the proliferation of DS books, journals, special issues of journals, and conferences in the past two decades has been tremendous. Simi Linton's (1998) *Claiming Disability* offers an introduction to DS as a discipline. "The name," Linton explains, "organizes and circumscribes a knowledge base that explains *the social and political nature of*

the ascribed category, disability" (p. 117, italics added). Treating disability as a social and political phenomenon flies in the face of its conventional meaning, in which disability is an isolated, tragic condition that inheres in individuals' bodies. Linton argues that turning our attention to the theoretical and practical implications that arise from understanding disability as a social phenomenon will bring about a new understanding of foundational ideas:

> A disability studies perspective adds a critical dimension to thinking about issues such as autonomy, competence, wholeness, independence/dependence, health, physical appearance, aesthetics, community, and notions of progress and perfection—issues that pervade every aspect of the civic and pedagogic culture. (p. 118)

Or, as Harlan Hahn cheerfully puts it in the documentary *Vital Signs*, "All we want to do is change the world."

Central to DS is the *social model* of disability. The social model, in brief, proposes that disability is constructed through social, political, historical, and other contexts. This stands in radical opposition to the mainstream discourse of disability, sometimes called "the medical model," which assumes that disability inheres in individual bodies. The medical model carries a host of assumptions, such as the belief that disability is tragic and that it can be "overcome" through individual effort. Correspondingly, the social model assumes that disability is not a tragedy, and may in fact be a source of pride; moreover, that contexts, not individual people, need remediation. As DS has continued to evolve, a number of critiques of the social model have appeared from within the discipline (Clare, 1999; Corker & Shakespeare, 2002; Davis, 2002; Siebers, 2006; Wendell, 2001; A. Wilson & Beresford, 2002). These are largely not rejections of the social model, but rather re-readings of it, and arguments that it should be refigured or expanded in various ways.

The social model of disability reverberates through DS methodologies. In a groundbreaking article, Michael Oliver (1992) argued that DS research must strive to change "the social relations of research production," which are built on "a firm distinction between the researcher and the researched; upon the belief that it is the researchers who have specialist knowledge and skills; and that it is they who should decide what topics should be researched and be in control of the whole process of research production" (p. 102). So, like DS scholarship more generally, DS methodology aims at a radical reshaping of relations of power. As is clear from Oliver's list, DS research has much in common with feminist, action, and other forms of research oriented toward social justice. Many DS researchers, including Asch and Fine (1988), Stuart (1992), Fine (1996), and Petersen (2006), directly address the intersection of DS research with other socially progressive methodologies. However, as Mollow (2006) notes, such intersections require much more study than they have received thus far.

Through reflection on my 2002-2003 study, I have identified four contact zones that both shape, and have been shaped by, DS methodologies:

- access
- activism
- identification
- representation

These are not principles of DS research, such as Stone and Priestley (1996) have offered, nor are they items for the DS researcher's "to do" list, although I do hope they will be used in a guiding capacity. Rather, they should be understood as spaces where beliefs, knowledge, and assumptions collide. Pratt (1991) explained that she developed the notion of the contact zone "in part to contrast with ideas of community that underlie much of the thinking about language, communication, and culture that gets done in the academy" (p. 37). Whereas communities often are seen as utopian spaces, Pratt's theory intentionally foregrounds conflict: Contact zones are "social spaces where cultures meet, clash, and grapple with each other, often in contexts of highly asymmetrical relations of power" (p. 34). This chapter is as much about alliance as about conflict, but our research must pay attention to both.[4] By "our" research, I mean not just that of DS researchers but also of qualitative researchers more generally. Topics such as access and representation have preoccupied researchers across disciplines and paradigms; I am arguing that DS methodology reaffirms the importance of these ongoing debates, and also opens new questions for consideration.

The rest of this chapter discusses the four contact zones with specific reference to DS methodology. Each section follows a similar structure: It begins with some background on the history of that particular zone within DS methodology, then turns to analysis of the way that issue impacted my own "Exploring Normalcy" study, drawing examples from the case study of Kathleen.

Access

Disability studies places great emphasis on the importance of access. Access in DS does not simply mean creating ramps alongside stairs, although that's part of it. It also means, as Jay Dolmage (2008) explains, working within and toward a mindset that continually explores, re-maps, and revises built contexts in ways that reflect the needs and values of the people who use them. "Built context" may refer to a physical space, such as a building, but it also can refer to more abstract or metaphorical spaces, such as attitudes, institutions, or social groups. Dolmage argues that this continually evolving approach is the key to universal design (UD):

UD, registered as action, is a way to move. In some ways, it is also a world-view. UD is not a tailoring of the environment to marginal groups; it is a form of hope, a manner of trying. ... UD is disability praxis. We are not set free into an undifferentiated universe, but we begin to look for the broadest spaces in which we all share experience. Making space for others does not deny their difference but affirms a shared connection based on this difference. (pp. 24-25)

Dolmage's main topic in that case is the classroom, but his argument about accessible design as praxis also applies to disability methodology. Qualitative researchers are accustomed to thinking of our participants as people whose knowledge may be tapped through speaking, listening, or writing (to take a few examples), but if we re-examine our methods through a DS lens, we may notice that they are inaccessible to many. What happens to the speak-aloud protocol on writing processes, for example, if carried out by a student with a learning disability? What about the individual interview conducted with a d/Deaf student, by a d/Deaf researcher?[5] What kinds of participants are we imagining as we design our studies, and how well do our methods reflect our participants' strengths and abilities?

Access in disability research may mean many different kinds of arrangements. A few examples: Lipson and Wixson (1986) argue for an "interactionist" approach to researching reading disabilities; Egan, Chenoweth, and McAuliffe (2006) demonstrate that email interviewing improves accessibility for brain-injury survivors; and Booth (1996) and Engel and Munger (2007) show in different ways that the use of narrative methods in qualitative research creates a less ableist research environment. Far from being "add and stir" recommendations, such changes will require deep changes to qualitative methods and assumptions. At times, as Walmsley (2001) demonstrates, the aims of accessible research may even seem to conflict with the aims of DS research. Although DS takes a firm stand against "speaking for" participants, some participants with learning disabilities "rely on a team approach [with nondisabled persons]," and if this "team approach" were abandoned, it's unlikely that some people with learning disabilities "would be in a position to research and publish" (p. 200). In those situations, "speaking for" takes on a meaning that confounds the well-intentioned goals of socially progressive research aims. (Facilitated communication, discussed in more detail later, applies a similar kind of pressure to the "speaking for" debate.)

I argue that, as we attempt simultaneously to follow and draw maps of accessible research methods, we should include as much detail as possible about how those methods were applied, and what the outcomes were. A good example is Brenda Jo Brueggemann's (1996) discussion in "Still-Life":

Because of [participants] Anna's and Charlie's use of American Sign Language (ASL), interpretation became a very real, literal concern as well. Anna, for example, wished to conduct the interviews without an interpreter (mostly

because she is extremely proud of her ability to lip read and voice). And so I honored her wish, and our conversations and interviews took place in something like Pidgin Signed English (PSE), a composite of ASL and spoken English. Yet upon completion of my fieldwork, as I transcribed the videotaped interviews two months later and seven hundred miles away, I often found it difficult to make sense of Anna's equally "ungrammatical" spoken English and sign language, occurring simultaneously in our interviews. (p. 27)

As Brueggemann's example shows, accessible research designs often must be implemented on the fly, and sometimes have disappointing results. It is tempting to try to settle all questions of methodology beforehand, but the DS researcher cannot approach a participant assuming that he or she learns, speaks, listens, or makes sense of his or her experience in a particular way; and we do not always know our participants ahead of time. Piling on still more complexity is the fact that DS researchers work within a great variety of "terministic screens" (Burke, 1966), ranging from our disciplinary orientations to the language(s) in which we communicate. What this all means is that designing and carrying out accessible research requires attention to *both* planning *and* improvisation. To return to Dolmage's (2008) point, accessible methods are not concrete tasks to be fulfilled; they are a "way to move" (p. 24).

While I was designing the "Exploring Normalcy" study, I didn't know whether there would be any disabled students in my class, nor, if there were, what kinds of disabilities they would have. (As it turned out, 2 of the 24 students identified to me as disabled; both volunteered to participate in the study, but one eventually withdrew due to time constraints.) Nor was I sure how to go about designing an accessible study. Relying largely on feminist researchers such as Patti Lather (1991), as well as DS researchers such as Booth (1996), I collected data that drew on a variety of modalities, including on-the-spot writing, writing in untimed environments, individual interviews, and small-group interviews. I conducted my first group interview (of composition teachers) in an online format; however, on the assumption that students would be less comfortable expressing their ideas and responding to each other in an online format, I conducted the students' interviews orally.[6]

I now realize that my quandary about what "accessible methods" might mean was a function not only of my inexperience, but of an issue within DS that needs more attention: how exactly *access* and *methodology* do come together, both in specific situations, and also in the larger paradigms that govern DS research more generally. Mercer (2002) argues that "there has been a particular silence within the disability research literature on methodological issues" (p. 245), and that DS will benefit from more systematic attention to methods of all kinds, including quantitative as well as qualitative.

Activism

Disability studies arose from activist movements including the League of the Physically Handicapped (1930s), the Independent Living Movement (1960s), and the Union of Physically Impaired People Against Segregation (1970s).[7] Activism often is regarded as a necessary component of a DS research agenda, and a theory of "emancipatory disability research" was formulated and debated soon after the development of DS as a discipline. However, the form this activism might take, and how successful a given project may be in achieving activist ends, are arguable (Barnes, 2003; Walmsley, 2001). Barnes, Oliver, and Barton (2002) write in depth about the uneasy relationship between DS as an academic discipline and the activist "lay" community from which it developed. They explain:

> One of our greatest difficulties concerns the growing dilemma emanating from the demands and tensions of writing for both an academic and a lay audience. It involves issues of accessibility, values and purpose of writing, and also the regulatory influence of the academic role. Our very positions, titles and the growing demands of satisfying peer reviewers, the results of which involve status and money at an individual, departmental and university level, means that we are legitimators of that which we seek to critique. (p. 258)

Unarguably, this dynamic is an uncomfortable one for DS researchers. However, precisely because the dynamic is uncomfortable, it tends to be addressed explicitly and often. As DS researchers, we are forced to clarify ourselves to many audiences, often simultaneously: for instance, academics who may be skeptical of the whole notion of "disability studies"; activist allies who may be wary of academic pursuits; and multidisciplinary colleagues in DS who do not share our scholarly backgrounds and assumptions. Thus, DS research tends to be unusually reflexive and transparent. We are perpetually explaining ourselves to ourselves, and this, I argue, has a positive impact on research that aims to be both intersectional and activist.

In addition to explaining ourselves to ourselves, DS researchers end up explaining themselves to *others* quite often—that is, those not familiar with the theories and methodologies associated with DS. For instance, although it is common for an article on DS methodology to cite the influence of feminist and/or poststructuralist thinkers, these references rarely go the other way. Despite its decades of methodological (and theoretical and pedagogical) work, DS is still too often considered a "special" field, one with curiosity value but little to add to other disciplines or theories. However, I argue, if other socially progressive methodologies took more notice of DS, they would find that DS researchers are making similar arguments, and grappling with similar questions, but from interesting and previously unnoticed standpoints. For instance, what exactly does

"emancipatory" mean, and how does its meaning intersect with interdependence? (Many disabled persons are assumed to be "dependent" on technologies, mobility aids, or personal assistants in order to live their lives on their own terms; yet DS theory refigures dependence and interdependence, of people as well as devices, in complex ways [see Siebers, 2008]). How shall "accountability" be achieved, and to whom? (Is our research accountable to the academic community? To the "lay" disability community? Both?) How shall individuals' stories be collected, selected, and represented? (What does "narrative" mean when it is collected from a person who does not vocalize? How about a person who does not use language at all?)

Because my study focused on a classroom, I was particularly interested in the question of activism as it related to pedagogy. DS methodology, like activist methodologies more generally, questions the possibility of praxis in educational environments. To what extent can thinking, speaking, and writing be considered "action"? Is the classroom merely a sort of practice field whose activities should not be considered as action taking place in the "real world"? Although I believe that classroom discourses differ from other kinds of public discourses (such as letters to editors, public speeches, or protests), we should value classroom discourse as one kind of public discourse, a discourse that involves an audience as well as the possibility of change. Amy Lee (2000) argues along similar lines, showing how Freire's concept of praxis and Foucault's of power–truth–discourse both support a notion of classroom discourse as action:

> [T]here must be action and recognition of the context in which the action has taken place, a sense of the aim toward which it is directed. … [I]f we believe the nexus of power-truth-discourse produces a discourse of truth that serves to enable speakers/writers to cover up or maintain blindness to the various contradictions that structure their identities and relationships, then we cannot have material change without discursive change—the two, rather, must go hand-in-hand. (p. 150)

Lee does caution that we should not conflate "action" and "reflection" entirely: There is value in understanding their differences. What I take from Lee's interpretation is that the classroom is a political and, to some degree, public space. Not public in the same sense as, say, the lobby of Grand Central Station or the quad in the middle of the UMass campus, but rather in the sense that the words and actions of its participants make stands, take risks, speak to audiences both concrete and invoked, and have real-life effects.

This belief was solidified by my own practice as a teacher-researcher, when I observed, both during the "Exploring Normalcy" class and in the small-group and individual interviews that followed, exchanges which unmistakably impacted students' positions in their everyday, "real-world" lives, as well as my own. One example is the moment when Kathleen identified her disabled status to her

fellow interviewees. Kathleen had made this identification to me, privately, while the class was going on, but did not mention it to her peers during the semester. In fact, according to my teaching journal, she was generally very quiet during class, and particularly so when we discussed Eli Clare's essay on disability. (Later, in an individual interview, Kathleen would tell me she was fully engaged during these discussions, and often quite critical, thinking, for example, "What an asshole" in response to a classmate's belittling remark about Clare; however, she chose not to speak out in class.) During the first small-group interview, after the semester ended, Kathleen sat through several minutes of debate about Clare's essay. The four other students expressed puzzlement that Clare's narrative is so filled with "negative" issues (such as discrimination and abuse) but explicitly rejects pity. Melissa said, "The way she's writing, it makes it look like she wants you to feel bad for her." Kathleen, who had not yet spoken during the discussion on Clare, then said this:

> I kind of think from my point of view it's different, because I've grown up with a disability. I had a learning disability when I was little. So when I look at it I do, like, I wouldn't, if you haven't had a disability you don't understand where you're coming from. Like, I kind of agree with her [Clare]. Like, you want people to feel bad for you, but you don't at the same time. Like, I always wanted to be the same as the rest of my friends. They all got A's, always, like, got on the honor roll when we were little, and I never was.

Kathleen spoke at length, continuing to discuss her reading of Clare, and while she spoke, the room became very quiet. Following her comment, three changes occurred in the interview: First, Kathleen began to speak more often. Second, the other students began to defer to her as an assumed authority on the issue of disability. And third, another student, Frank, aligned himself with her, arguing that although Clare's essay might seem confusing (having "too many issues," as one participant put it), he saw it as having a clear focus on the topic of disability.

Later, reflecting on that moment in an individual interview, Kathleen said that it provided her with further confirmation that her perspective, as a disabled person, was different from those of her nondisabled classmates. "Like, that whole roomful of people didn't know until I said that, when we were in the meeting that night, that I had a disability. And that's why I felt different [from them]. Like, I mean, I probably had a different opinion on probably everything that was said that night than anyone else." Although this sense of distance could indicate a feeling of isolation, even ostracization, in Kathleen's perspective it seems to reflect a greater sense of being known and respected:

> Like when I mentioned it in the group [interview], we were sitting there with [Jon], and [Jon's] one of my closest people that I'm with at school. Like, he lives on my floor, I hang around with him every day. And just kind of the

look he gave me when I said it, and I knew I would get a response from him, cause I hang around with him. Him not knowing, and my roommate didn't know, until I did this thing. I mean, he never said anything to anyone else. But I mean, just like, we would have a certain respect for it. Like, he had respect for me for it.

Lest I be misunderstood, I am not advocating a simplistic "coming-out" strategy as a means of empowerment for disabled students (or anyone else). Such moments are tremendously complex and charged with risk. Rather, I am arguing that in Kathleen's *particular* case, coming to be known as a disabled person among her classmates, dorm-mates, and co-participants in the study was accompanied by a more authoritative position in their discussions, and also by a sense of having gained respect. The larger point I take away is this: As teacher-researchers, we should remember that the classroom often is a significant part of our students' social and political worlds. If we deny that the classroom is an active, and sometimes activist, space, we deny the important and sometimes life-changing moves made there.

Identification

Discussions of DS methodology seem to return inevitably to the question of identification. In fact, the principles of DS research laid out by Stone and Priestley (1996) were developed precisely because those researchers were concerned about the accountability of nondisabled researchers to disabled people and disability-centered institutions. Despite this, explicit discussions of a researcher's own identification in relation to disability are relatively rare in DS research. I am not going to pick on specific works or researchers here, but I will say that when reading DS-oriented studies, I have been puzzled by the frequent failure on the part of researchers to discuss their own positions, identifications, or other alliances with respect to the topic they research. Perhaps this is in part the bias of my discipline: I am situated in rhetoric/composition, and we do quite a bit of self-examination, arguably to the point of navel-gazing. I am also aware that, in some disciplines, publication is contingent on certain customs, including the valorization of a "neutral," or at least unmarked, position on the researcher's part. However, I argue that DS research must make more space for explicit identification by researchers—not in a rote, "here's my diagnosis" way, but in ways that are characterized by creativity, contradiction, and revision over time.

Linton (1998) argues, "Stating that one identifies as disabled or nondisabled calls attention to the absent voice of disabled people in scholarship and illustrates that the reader may tend to make the assumption, although probably not consciously, that the writer is nondisabled" (p. 153). Thus, identifying oneself as a disabled researcher, or a nondisabled ally, can help unsettle the hegemonic "god-trick" of gazing from an unmarked position (Haraway, 1991, p. 189). Disabled

researchers may choose to identify themselves in a number of ways. To give a sense of the great variety of possible identifications, I offer this short list of examples: Susan Wendell (1989) identifies herself as someone who has "a disabling chronic disease" but also is "very privileged among the disabled" because of her whiteness, her job as a university professor, and her adequate insurance. Davis (1995) identifies himself as a child of Deaf adults whose first language is ASL. Garland-Thomson (1995) calls herself "a white woman with a quite visible physical disability" (p. 15). Terry Collins (Collins, Schneider, & Kroeger, 1995) says he is temporarily able-bodied. Conversely, W.J.T. Mitchell (2001) positions himself in "the luxurious condition of temporary disability" (p. 391) following knee surgery. Wendy Marie Thompson (2007) connects her "mental illness" to "experiences of trauma (cultural, racial, class, diasporic, environmental, social)" (p. 374). And Tobin Siebers (2004) draws on experiences with his own impairments to propose a theory of "disability as masquerade" (p. 1), taking us beyond closet metaphors to consider disability in the contexts of passing, pretending, and drag.

Positioning oneself in relation to disability is not a simple announcement; it is part of a complex web of discourses and politics in which, as Davis (1995) argues, the disabled body "produces the demand for a response" (p. xvi). In an effort to subvert this demand, in *Claiming Disability* Linton (1998) makes a point of *not* positioning herself explicitly. Although she "immediately" identifies herself as a disabled person in the first chapter, she then adds that the "particulars of my condition are not of concern" (p. 5). Explaining that she will discuss these "particulars" later on, in the context of the sociopolitical model of disability that she wishes to apply, she resists speaking more specifically at the outset because she wishes to challenge the reader's assumptions upon learning that she has a disability. "[Y]ou may find yourself conjuring up some of the readily available images of disabled women," she warns, such as "the doleful poster child" or "the defiant disability rights activist" (p. 5). Thus, Linton consciously positions herself in a half-identified space and challenges the reader to consider the images that arise for them when they attempt to fill the part of the space left open.

Gesa Kirsch (1999) argues that a rote recitation of one's identities and affiliations may not add much value to a study, and may in fact encourage essentialist interpretations of herself or her work. Instead, Kirsch suggests, we "need to get beyond making facile statements about our identity and begin the admittedly difficult but important analytical work of assessing precisely how these personal factors affect our work" (p. 80). And yet, the researcher who spends too much time on self-reflexive pondering may end up in what Brueggemann (1996) describes as "a solipsistic, rhetorical position in which the researcher (the self)— ah, once again—usurps the position of the subject (the other)" (p. 19).

As the foregoing examples show, individual DS researchers have found different ways to navigate this dilemma. What makes the dilemma particularly interesting in DS is that our own identifications may change over time—a quality that is, if not unique to disability, at least unusual. One might think of minoritized identities as ones that people are born with, or at least that endure; howev-

er, disability may affect anyone at any time, and disabling conditions often manifest and change unpredictably. One way of negotiating the dilemma of self-identification, then, is to explain the changes in one's own identifications over the course of a study and its write-up. Brueggemann's (1996) "Still-Life," a narrative analysis of the many challenges she encountered while conducting research at Gallaudet University, is a vivid example. As a person who functions in both Deaf and Hearing worlds, Brueggemann found herself "between the two cultural borders, caught in the crossfire, as I ran across the hyphen, waving a tattered representative flag on both sides" (p. 23). Ultimately, Brueggemann's argument about researcher identification, a conviction I share, is that the search for concrete answers must ultimately be unsuccessful, and that we are better served by "(yet even more) questions that might guide us," such as "Which of our representations give us voice, make us silent?" (p. 34).

Self-identification worried me a great deal while conducting the "Exploring Normalcy" study, in large part because I identified at that time as nondisabled. I wrote long memos about my position, read everything I could find on disability identification, examined my motivations, and endlessly revised the relevant passages of the dissertation. In the dissertation itself—the first formal write-up of the study—I wrote this:

> When people learn that I work in disability studies, their first question is often, "How did you get interested in that?" It's intended as a courteous question, posed in much the same spirit that someone might ask, "How did you get interested in stamp collecting?" or "How did you start rock climbing?" But another question, perhaps not entirely conscious, lurks beneath the first: Why are you connected to disability? What binds you to it, and it to you? Faced with my evidently abled body, the question arises almost inevitably: What are you doing in this strange land?
>
> I could answer the question in a number of ways. I could go the insider route, reveal my autoimmune disease, tell about the hospital visits, steroids, surgeries, crumbling bones and lost kidney function. But this doesn't feel honest, because, although I am disabled according to most definitions, my disease doesn't interfere with "daily activities like work or keeping a household" (Shapiro 6), nor does it cause me to be "separated or isolated ... from nondisabled society." (Brownworth xvi)

Two years later, when publishing part of the study in *College Composition and Communication* (*CCC*), my identification had shifted. Oddly enough, it was not my autoimmune disease that caused the shift: My form of that disease is progressive, but "indolent" (a medical term that causes me to picture a figure lounging, long-legged and sloppy, in a hammock). But while my immune system behaved itself, something else began to dance out of control: mental disability.[8] I did not suddenly become mentally disabled in 2005, but that was the year I was—finally—separated from the "normals": I could not function like them. I could not get

out of the house unless I had taken my medication; could not count on a day without a panic attack; could not ignore the odd echoing voices that spoke occasionally from over my shoulder. Doctors offered me various labels, mostly from DSM-IV, and these provided some sense of grounding (as well as financial access to therapy and medications). But for me the overriding questions were still the old ones from my dissertation study: Did my conditions interfere with daily activities? Was I isolated? My answers had changed, and with them, what I wrote. Part of the study appeared in 2007 in *CCC*, and I was forced to account both for the nondisabled researcher who had conducted the study, and the disabled researcher now (re-)writing it up:

> In addition to situating the class, I want to situate myself as a teacher and researcher, since my own position impacts not only the study's design but also the nature of conversations I held with students. I identified to the ["Exploring Normalcy"] class as nondisabled and as queer. Perhaps ironically, my queer identity felt relatively easy to negotiate; it was my nondisabled identity that gave me more trouble. One reason for this was that, while I taught that class, I was living in a liminal space (the hyphen, so to speak) between "dis" and "abled." ... Thus, with hesitation that probably stemmed more from personal discomfort than with teacherly concern, I chose to identify to my students as nondisabled. In fact, it would have been "more DS" of me to discuss my dis/abled state more fully with my class, as suggested by Mark Mossman; or, as Linton does in *Claiming Disability*, to allow it to be present but consciously unspecified (5). However—perhaps in part because that year was one of several transitional years during which I slid with more finality from "abled" to "disabled"—I was simply too overwhelmed at being in the midst of these rapid physical and psychological changes to incorporate them into my pedagogy. This choice was problematic, not least because it allowed me to access nondisabled privilege as a teacher and researcher. (pp. 58-59)

I should note that, in an earlier draft, this discussion of my changing position was much briefer, and was tucked into a footnote. The editors and reviewers of *CCC* encouraged me to bring it into the body of the article and to look more closely at its impact on the study. I did this reluctantly (although I am now glad I did), and with some embarrassment. The fact is, I saw my disabilities as less legitimate because of their mutable and progressive quality. "Real" disability, I secretly felt, was easily noticeable and remained fairly static throughout one's life. I knew intellectually that disability is a hide-and-seek identity, elusive and problematic, but it was the act of writing, revising, and publishing this passage that helped me regard my own position with more conviction (and compassion) than I had before.

While I conducted the study, I paid considerable attention to my own identification, but for me, the drama of disability identification lay mostly in the future. During the study I was more preoccupied with Kathleen, who conducted

an intricate negotiation with her disability identification throughout the year I worked with her.[9] She told me about her disability in October, after a class spent discussing Eli Clare's essay "The Mountain." Kathleen didn't mention her identification to our class, but did disclose it to the members of the focal group during our first interview in January. Later, during her individual interview, she explained to me that she is careful about when and how to discuss her disability:

> I don't think, like, when we were watching those videos [during class] and we had some discussions afterwards. Just sitting back and hearing what certain people said about disabled, disabilities, I was kind of offended with some things that came out of certain people in the class. I didn't say anything, just because I wasn't about to come out in front of a whole class full of people who didn't have any clue. Just cause I'm not comfortable with certain people, like, knowing. Cause I mean, people do look at you differently when you tell them that you have a disability.

Kathleen came into our class with firsthand experience in discourses of disability that equate disability with stupidity, as well as those that see pity as an appropriate reaction to disability. Perhaps in part because of this experience, she sometimes separated herself from her disability by saying that she "had a learning disability when I was little," or that she had "overcome" it.

Kathleen's choice to speak from a disabled perspective during the small-group interviews was part of a larger process of coming to identify as a disabled person. Through writing her essay and discussing her work with classmates and me during the study, Kathleen's stance toward her disability shifted. Instead of treating it as something that she had to compensate for, or place in the past tense, she began to draw on it as a source of knowledge. However, that change in approach was not clear or simple. (To reiterate, I am not an advocate of simplistic views of "transformation" in either DS pedagogy or methodology.) Despite Kathleen's newfound sense of "crip pride," she retained a strong positive emphasis on the notion of "overcoming" disability throughout the class and the study. This led to a struggle for me in terms of how to represent her, because Kathleen's and my readings of the "overcoming" narrative are very different.

Representation

DS researchers have examined representation from many angles, including life writing (Couser, 1997, 2004, 2009); ethnography (Brueggemann, 1996, 1999; Rogers, 2002); and medical case studies (Lewis, 2011; A. Wilson & Beresford, 2002). Fine, Weis, Weseen, and Wong (2000) argue that we must pay attention to the imagined hyphen between researcher and researched (or self-other), and that if participants' stories "are considered and sought after as if multiple, varied, conflicting, and contradictory," it will then be impossible to represent oneself as

researcher in any way other than similarly multiple and contradictory (p. 119). Here, again, we see the overlap between the concerns of DS methodology and the concerns of qualitative research more generally.

However, the history and concerns of DS shape the problem in particular ways. A good example is the current debate within DS on "facilitated communication," a method of linguistic support that fosters the communicative abilities of persons who do not use more conventional communication methods, such as oral speech, signed language, or writing. Often, these are persons with severe cognitive or psychiatric disabilities. Lewiecki-Wilson (2003) explains the process of facilitated communication as follows:

> Facilitated communication is a process whereby a trained and caring learn-
> ing partner, the facilitator, provides emotional and physical support for a
> person who does not speak. The facilitator helps the lingual person point to
> pictures, letters, words, or symbols, or type them. Help may come in the
> form of steadying an arm or hand, giving cues, or providing a light touch
> that conveys emotional support. Those who have developed language using
> facilitated communication liken the process to a flow that at first is halting
> but that through practice over time gains momentum (p. 160)

As Lewiecki-Wilson points out, facilitated communication puts particular pres-
sure on debates about "speaking for," "speaking with," and representation. She suggests that we take facilitated communication as an opportunity to rethink rhetoricity, particularly its valorization of the liberal, individual speaking subject, and to consider the possibilities of what she calls "collaborative rhetoric" (p. 160). From a methodological point of view, it's easy to see why facilitated communica-
tion might provoke so much concern: It strikes at the heart of the progressive researcher's fear of "speaking for" others, and possibly misrepresenting them.

As a researcher, I attempted to find ways to intervene in, although not resolve, these dilemmas around representation. Following Lee's example (2000), I asked each of the six focal students in my "Exploring Normalcy" study to write a self-introduction. Here is Kathleen's:

> I am a small town girl from Hull, Mass. I am a 19-year-old freshman at col-
> lege and I am now going to University of Massachusetts at Amherst. I really
> like the school a lot and I am trying to get into HRTA [Hotel, Restaurant and
> Travel Administration] for my major. I am trying all kinds of classes out here
> and I am not sure what I truly want to do with my life yet. But hopefully the
> HRTA will be my field. I enjoy being busy in life and working hard. I was
> very happy to have such a good English 112 class, I learned a lot and I am
> helping Ms. Price with this study because I thought I could be very helpful
> to her. Speaking from someone who has faced having a disability. I have a
> learning disability and have had for many years. It has changed over the
> years but it is still present to me.

As I shaped my representations of Kathleen, one of the earliest decisions I had to make was how to present her written work. One issue was surface errors, which occurred in all students' writing, but were especially frequent in Kathleen's. Here's an example of a passage from an early, handwritten draft of Kathleen's essay:

> Well in my life expecially. I watched and had people do that for me. When you are sitting in your kidgarden class at age 5 and everyone around you can sing and spell out the alphabet. And your the only one having a problem. You began to relieze that life going to be alot harder.

My study didn't focus on spelling or grammatical features of writing, except insofar as they offered information about students' critical processes (e.g., I noted that when Kathleen seemed to be approaching a critical turn in her writing, she tended to write very long, run-together sentences). And I didn't want audiences to focus on them either, because I knew that could lead to facile judgments about her fitness as a student or even as a person (Dolmage, 2008). Kathleen had written at some length about being labeled "stupid," and openly laughed at, based on the way she wrote, and I knew that allowing me to study and quote her early drafts was a gesture of great trust. Yet I also didn't want to "clean up" her prose in ways that would cave to the stereotype that intelligence is always represented in smooth, error-free writing.

Finally, I decided to correct all students' quotations for spelling but not for grammar or punctuation. Even so, as I began to present parts of the study in public forums, I was dismayed to find myself in repeated conversations about the grammar of Kathleen's written work. One audience member asked me bluntly, "What did you do about all the mistakes?" This added another layer of pressure to the dilemma: Still a graduate student, I realized that my failure to "solve" the many grammar and spelling errors in Kathleen's essays could be taken as a judgment on my work as a teacher. My responses attempted to contextualize such errors within composition studies (drawing on Dunn, 1995, and Shaughnessy, 1977), but I worried that I might be misrepresenting DS pedagogy as sloppy and unrigorous.

As I continued to delve into Kathleen's work, I realized that a deeper problem of representation faced me, namely, our different takes on the concept of "overcoming." This led to the central crisis of representation in the entire study: a quandary on my part about how to respect Kathleen's views while also acting effectively as her teacher—not to mention as the researcher who would represent her. It also, I believe, opens up an important question for DS pedagogy as well as methodology. What are, what should be, our roles, as teachers and researchers (and teacher-researchers) when we perceive participants' or students' views of disability to be regressive, even self-destructive? Do we have some sort of "liberatory" obligation—and if we can move beyond simplistic, conversion-oriented understandings of *liberatory*, what might that look like?

In order to clarify this struggle, I will back up and explain the significance of "overcoming" in DS, and in the essay that Kathleen was analyzing. Linton (1998) provides an excellent overview of this concept as it is understood within a DS framework:

> The ideas imbedded in the *overcoming* rhetoric are of personal triumph over a personal condition. The idea that someone can *overcome* a disability has not been generated within the community; it is a wish fulfillment generated from the outside. It is a demand that you be plucky and resolute, and not let the obstacles get in your way. ... The individual's responsibility for her or his own success is paramount. If we, as a society, place the onus on individuals with disabilities to work harder to "compensate" for their disabilities or to "overcome" their condition or the barriers in the environment, we have no need for civil rights legislation or affirmative action. (pp. 18-19)

"Overcome" is an old chestnut in DS discourse, an eye-roller on a level with "tragic" or "inspiring." Yet, like tragedy and inspiration, it is not a concept that can be dismissed out of hand. As Linton argues, overcoming barriers is not itself the problem; rather, the problem is the notion that having a disability places an imperative on the disabled individual (rather than one's sociopolitical context and community) to achieve "triumph" on a normative scale. Moreover, disabled persons may easily internalize the rhetoric of overcoming, because we, like everyone else, are steeped in mainstream discourses of disability.

Clare's (1999) "The Mountain," which was the focus of Kathleen's third essay, examines this problem in depth. "The dominant story about disability," Clare writes, "should be about ableism, not the inspirational supercrip crap, the believe-it-or-not disability story" (p. 2). "The Mountain" is both a persuasive and a narrative essay. It is framed around a hike taken by Clare and his friend Adrianne, up Mount Adams in New Hampshire. However, the trail is steep and slippery, and they decide to turn around without reaching the mountain's summit. Using the account of this expedition as a framework, Clare intersperses flashbacks to his life growing up in Oregon, when he ran track and was viewed as a "tragic brave girl" (p. 3).[10] He introduces the term *supercrip*, identifying "supercrip stories" as ones that "focus on disabled people 'overcoming' our disabilities" (p. 2). The essay then questions to what degree Clare himself might wish to be a supercrip, and whether his desire to summit Mount Adams was part of this dominant narrative, attempted "because I want to say, 'Yes, I have CP [cerebral palsy], but see. See, watch me. I can climb mountains too.' I wanted to prove myself. ... Overcoming has a powerful grip" (p. 9). Clare concludes the essay with a call to resist ableist attitudes and to reject the myths of supercrip and overcoming:

> Someday after the revolution, disabled people will live ordinary lives, neither heroic nor tragic. Crip, queer, freak, redneck will be mere words describing human difference. Supercrip will be dead; the nursing home, burned down; the metaphoric mountain, collapsed in volcanic splendor. (p. 12)

As a teacher, I hoped students would come to understand—and, I admit, share—Clare's criticism of "overcoming" through their analyses of "The Mountain." However, Kathleen's reading of Clare's essay, and of the concept of "overcoming" in general, confounded my expectations.

For Kathleen, overcoming is positively charged. The first day that she told me about her learning disability (in an individual conference after class), she said, "I've pretty much overcome it." She also identified overcoming as having a positive charge in "The Mountain." In the mid-process draft of her essay, she summarizes Clare's stance toward Mount Adams as follows: "The fact that she was disabled and tried to do things on her own and didn't want help from anyone. That she was going to try really hard to make it up that mountain. Even if it was the hardest mountain to climb." This reading continues throughout the essay. In its closing lines, Kathleen reasserts the importance of individual achievement for herself and Clare: "The point is that we [Clare and I] want it and we have taught ourself that we won't stop until we get it."

When I responded to this draft as a teacher, both in an individual conference and in written comments, I saw Kathleen's take on "overcoming" as a fairly straightforward misinterpretation of Clare's point. In the margin of her first draft, for example, I wrote, "But does this idea—of overcoming—make you and Clare 'supercrips'?" In part in response to my challenges (I assume), Kathleen focused more closely on the issues of *pity* and *supercrip* in her final draft. However, her analysis remains firmly pro-overcoming, and again argues that Clare shares this stance:

> One of the most crucial points that Clare exhibits while climbing the mountain, is how she strives to climb to the highest of her ability, persevering through all. She pursues the highest altitude that she can attain, in order to create a sense of accomplishment which will aid her in feeling as though she has defeated an aspect of her disability. When she decides she wants to climb the mountain she wants to do it on her own, without assistance from anyone. Although on her first attempt Clare could not reach the top, she realizes that one day she will return to the mountain because she desires more from it.

Note the way that Kathleen enlists Clare as an ally, arguing that Clare too strives to overcome, despite the dramatic contrast between Clare's stated desire to see the mountain "collapsed in volcanic splendor" (p. 12) and Kathleen's assertion that Clare will "return to the mountain because she desires more from it."

Although she qualified the term with "somewhat" in her final draft, probably in response to my repeated queries, Kathleen continued to adhere to a positive reading of overcoming, through the end of the semester and beyond. In our final individual interview, nearly 6 months later, she continued to assert that both she and Clare valued the power of overcoming.

At first, I was baffled by this (apparent) resistance on Kathleen's part. I couldn't understand why, in the face of what I viewed as clear contradictory evidence, she stuck to her interpretation. Yet I didn't want to represent her as simply *wrong*—not in her beliefs about disability, certainly, and not even in her reading of Clare. More, I felt, must be going on here. Through key term analysis (Fairclough 1992, 2003), I developed a theory that for Kathleen, the prospect of letting go of her narrative of individual achievement was simply too costly. It was a large part of what helped her confront (and yes, overcome) the barriers placed in her way by an ableist educational system. Therefore, abandoning it—even temporarily, in a moment of critical detachment—was not an acceptable option. So instead, Kathleen formed a strategy of representation that turned the tables on me: She insisted that her reading of Clare was as valid as mine, not by openly disagreeing with me, but by simply continuing to stick to her stance on "overcoming" despite my teacherly protests. I believe Kathleen understood something I did not fully appreciate at the time: that adherence to narratives of overcoming oppressive structures can be "a powerful antidote to despair" (Mollow, 2006, p. 68), and as such makes its own kind of critical claim.

CODA

When I first conducted the "Exploring Normalcy" study, my struggles within each of these four contact zones felt like evidence of my shortcomings as a researcher. But in the years since, I have come to see them as areas that were and are difficult, not only because of my inexperience (which was certainly a factor), but also because they are spaces in which beliefs and value systems collide. Some of the issues I have raised, like identification and representation, are well known to qualitative researchers. Some, like access, may be newer territory. I argue that DS has an important contribution to make in each of these contact zones—new dilemmas to expose, new questions to suggest.

As I began to write up this chapter, I tried to figure out how to contact Kathleen so that I could send it to her. (In 2004, I had also sent her a copy of the dissertation chapter that focused on her work.) Since she had transferred schools, finding her involved a search on the online "White Pages" and a referral via her parents' answering machine. Was I trying too hard? I wasn't sure; all I knew was that revisiting Kathleen's work felt in a way like revisiting her, and I did not want to treat her first-year college self like a fly in amber.

At any rate, Kathleen did call me back, and recalled our class and the study affably. She gave me her new email address, and I sent a draft of this article, signing it "Margaret ('Ms. Price')" and encouraging her to read parts or whole, and comment or not, as she preferred. Then I (metaphorically) held my breath for a few weeks. At last I heard back. Kathleen wrote that she thought it was "great" and "brought me to tears at some points." She also asked if she could share it with her mother, who has been Kathleen's staunch ally through all her years in school. My relief was tremendous. The more abstract exercises of reflecting on my position, considering power imbalances, speculating on the politics of representation—these did not compare to the visceral sense of placing my representation of Kathleen in her hands. My relief at Kathleen's response reminds me of the ongoing importance of these questions, raised by Fine et al. (2000): "Who am I afraid will see these analyses? Who is rendered vulnerable/responsible or exposed by these analyses? Am I willing to show him/her/them the text before publication? If not, why not?" (p. 127). For I did feel some fear as I sent the chapter off to Kathleen. This is a fear that should be noted and respected—even cherished. It is not a fear I would want to stop feeling as a researcher.

Whether you are new to the concept of DS research, or an experienced DS researcher, I hope that this story has been of some use. One of the uses I attempt to provide is a framework for what "disability studies methodology" might mean, even across the vast array of disciplines and nonacademic locations in which we work. Another use I attempt to offer is an introduction to DS methodology for the newcomer, for in the 21st century, with its passionate interest in topics such as bodies, trauma, human rights, and eugenics, virtually every sociopolitical concern can be tied in some way to DS. Finally, I am trying simply to tell a story: that of a student I taught in Amherst, Massachusetts, nearly 10 years ago now, and what she said, and what I learned. This, perhaps, is the most important lesson of DS methodology, closely tied to the concept of universal accessibility: It is, as Dolmage has said, not a fixed set of rules, but a "way to move" (p. 24). Methodology is not prescription, but movement, improvisation, revision. I am hoping that practitioners of DS and writing research—a capacious crowd, more capacious than most now realize—can begin to move together.

ENDNOTES

1. "Piss on Pity" is a popular DS slogan, commonly seen on T-shirts or buttons at demonstrations or conferences. It represents the resistance by DS activists and scholars to the common assumption that a person with a disability is in a tragic, pitiable position. Its trenchant wording is characteristic of DS activism.

2. Although the main focus of the study was disability—specifically, how students took up discourses around disability—the class itself was broader based. This is not because disability studies couldn't form the basis for an introductory college writing course; it has been used successfully as a theme in many such courses. Rather, it was

because I was working in a program that took a generalist approach to teaching college writing, and I was reluctant to design a course that differed radically from the curriculum being used by its other teachers.

3. Resistance did not turn out to be a major issue in the specific context of that classroom, but it remains a rich area of study in disability pedagogy; see, for example, Brueggemann (2001).

4. Pratt, acknowledging the need for "healing and mutual recognition," argues that alongside contact zones we also need "safe houses," spaces that offer "high degrees of trust, shared understandings, [and] temporary protection from legacies of oppression" where allies can meet (p. 40).

5. Important to recognize here is the distinction between d/Deafness and disability, as well as the distinction between *deaf* and *Deaf*. With a lowercase *d*, *deaf* denotes impairment. With an uppercase *D*, *Deaf* denotes cultural Deafness. To be culturally Deaf, one may or may not have any auditory impairment; a fluent user of American Sign Language (ASL) who has Deaf parents and no auditory impairment, for example, could be considered Deaf. Many, if not most, Deaf people consider themselves members of a particular linguistically driven culture, rather than disabled (Brueggemann, 1999; Corker, 2003; Davis, 1995; Padden, 2005; Wrigley, 1996). However, there is an active relationship between Deaf studies and disability studies. In relating Deafness and disability, I rely on the work of Deaf studies scholars who have demonstrated links between the two, but I also acknowledge that some would disagree with this choice.

6. This assumption now seems hilarious, 8 years later and in a Web 2.0 world.

7. Helpful resources on the history of the disability rights movement include Burch (2009), Charlton (1998), Longmore (2003), Shapiro (1994), and Shaw (1994).

8. I use *mental disability* as an imperfect umbrella term, analogous to the way I use *queer* to identify my gender/sexuality. My choice of this term is inspired by Cynthia Lewiecki-Wilson (2003) and Catherine Prendergast (2001), both of whom have written insightfully about the ways that disabilities of the mind are unified by a loss of *rhetoricity*. My views on labeling mental disability are further amplified in *Mad at School* (Price, 2011).

9. Numerous DS researchers have discussed the interplay of the "coming out" figure between queer and disabled experience (Brueggemann, 1999; McRuer, 2006; Price, 2009b; Samuels, 2003; Siebers, 2004).

10. At the time of the "Exploring Normalcy" class, Clare identified as genderqueer; hence, students' essays use gender-neutral pronouns such as "hir," or sometimes "she." My use of masculine pronouns reflects Clare's more recent gender identification.

REFERENCES

Asch, A., & Fine, M. (1988). Beyond pedestals: An introduction. In A. Asch & M. Fine (Eds.), *Women with disabilities: Essays in psychology, culture and politics*. Philadelphia: Temple University Press.

Barnes, C. (2003). What a difference a decade makes: Reflections on doing "emancipatory" disability research. *Disability & Society, 18*(1), 3-17.

Barnes, C., Oliver, M., & Barton, L. (2002). Disability, the academy and the inclusive society. In C. Barnes, M. Oliver & L. Barton (Eds.), *Disability studies today* (pp. 250-260). Cambridge: Polity.

Barton, E. (2002). Inductive discourse analysis: Discovering rich features. In E. Barton & G. Stygall (Eds.), *Discourse studies in composition* (pp. 19-42). Cresskill, NJ: Hampton Press.

Booth, T. (1996). Sounds of still voices: Issues in the use of narrative methods with people who have learning difficulties. In L. Barton (Ed.), *Disability and society: Emerging issues and insights* (pp. 237-255). London: Longman.

Brueggemann, B.J. (1996). Still-life: Representations and silences in the participant-observer role. In P. Mortensen & G. E. Kirsch (Eds.), *Ethics and representation in qualitative studies of literacy* (pp. 17-39). Urbana, IL: NCTE.

Brueggemann, B.J. (1999). *Lend me your ear: Rhetorical constructions of deafness.* Washington, DC: Gallaudet Press.

Brueggemann, B.J. (2001). An enabling pedagogy: Meditations on writing and disability. *JAC, 21*(4), 791-820.

Burch, S. (Ed.). (2009). *Encyclopedia of American disability history.* New York: Facts on File.

Burke, K. (1966). *Terministic screens. Language as symbolic action: Essays on life, literature and method* (pp. 44-62). Berkeley: University of California Press.

Charlton, J.I. (1998). *Nothing about us without us: Disability oppression and empowerment.* Berkeley: University of California Press.

Clare, E. (1999). *Exile and pride: Disability, queerness, and liberation.* Cambridge: South End.

Cochran-Smith, M., & Lytle, S.L. (1993). *Inside/outside: Teacher research and knowledge.* New York: Teachers College Press.

Collins, T., Schneider, M., & Kroeger, S. (1995). (Dis)Abling images. *Radical Teacher, 47*, 11-14.

Corker, M. (2003). Deafness/disability: Problematising notions of identity, culture and structure. In S. Riddell & N. Watson (Eds.), *Disability, culture & identity.* London: Pearson.

Corker, M., & Shakespeare, T. (2002). Mapping the terrain. In M. Corker & T. Shakespeare (Eds.), *Disability/postmodernity: Embodying disability theory* (pp. 1-17). London: Continuum.

Couser, G.T. (1997). *Recovering bodies: Illness, disability and life writing.* Madison: University of Wisconsin Press.

Couser, G.T. (2004). *Vulnerable subjects: Ethics and life writing.* Ithaca, NY: Cornell University Press.

Couser, G.T. (2009). *Signifying bodies: Disability in contemporary life writing.* Ann Arbor: University of Michigan Press.

Davis, L.J. (1995). *Enforcing normalcy: Disability, deafness, and the body.* London: Verso.

Davis, L.J. (2002). *Bending over backwards: Disability, dismodernism and other difficult positions.* New York: New York University Press.

Davis, L.J. (Ed.). (2006). *The disability studies reader* (2nd ed.). New York: Routledge.

Dolmage, J. (2008). Mapping composition: Inviting disability in the front door. In C. Lewiecki-Wilson & B.J. Brueggemann (Eds.), *Disability and the teaching of writing: A critical sourcebook* (pp. 14-27). Boston: Bedford/St. Martin's.

Dunn, P.A. (1995). *Learning re-abled: The learning disability controversy and composition studies.* Portsmouth, NH: Boynton/Cook.

Egan, J., Chenoweth, L., & McAuliffe, D. (2006). Email-facilitated qualitative interviews with traumatic brain injury survivors: A new and accessible method. *Brain Injury*, *20*(12), 1283-1294.

Engel, D.M., & Munger, F.W. (2007). Narrative, disability and identity. *Narrative*, *15*(1), 85-94.

Fairclough, N. (1992). *Discourse and social change*. Cambridge: Polity.

Fairclough, N. (2003). *Analysing discourse: Textual analysis for social research*. New York: Routledge.

Fine, M. (1994). Working the hyphens: Reinventing self and other in qualitative research. In N.K. Denzin & Y.S. Lincoln (Eds.), *Handbook of qualitative research* (pp. 70-82). Thousand Oaks, CA: Sage.

Fine, M. (1996). *The rejected body: Feminist philosophical reflections on disability*. New York: Routledge.

Fine, M., Weis, L., Weseen, S., & Wong, L. (2000). For whom?: Qualitative research, representations and social responsibilities. In N.K. Denzin & Y.S. Lincoln (Eds.), *Handbook of qualitative research* (2nd ed., pp. 107-131). Thousand Oaks, CA: Sage.

Garland-Thomson, R. (1995). Integrating disability studies into the existing curriculum: The example of "Women and Literature" at Howard University. *Radical Teacher*, *47*, 15-21.

Garland-Thomson, R. (2005). Feminist disability studies. *Signs*, *30*(2), 1557-1587.

Gladwell, M. (1997, May 19). The sports taboo: Why blacks are like boys and whites are like girls. *The New Yorker*, pp. 50-55.

Haraway, D. (1991). *Situated knowledges: The science question in feminism and the privilege of partial perspective. Simians, cyborgs, and women: The reinvention of nature* (pp. 183-201). New York: Routledge.

Kirsch, G.E. (1999). *Ethical dilemmas in feminist research: The politics of location, interpretation, and publication*. Albany: State University of New York Press.

Lather, P. (1991). *Getting smart: Feminist research and pedagogy within/in the postmodern*. New York: Routledge.

Lee, A. (2000). *Composing critical pedagogies: Teaching writing as revision*. Urbana, IL: NCTE.

Lewiecki-Wilson, C. (2003). Rethinking rhetoric through mental disabilities. *Rhetoric Review*, *22*(2), 156-167.

Lewis, B. E. (2011). Narrative medicine and healthcare reform. *Journal of Medical Humanities*, *32*(1), 9-20.

Linton, S. (1998). *Claiming disability: Knowledge and identity*. New York: New York University Press.

Lipson, M.Y., & Wixson, K.K. (1986). Reading disability research: An interactionist perspective. *Review of Educational Research*, *56*(1), 111-136.

Longmore, P.K. (2003). *Why I burned my book: And other essays on disability*. Philadelphia: Temple University Press.

McRuer, R. (2006). *Crip theory: Cultural signs of queerness and disability*. New York: New York University Press.

Mercer, G. (2002). Emancipatory disability research. In C. Barnes, M. Oliver, & L. Barton (Eds.), *Disability studies today* (pp. 228-249). Cambridge: Polity.

Mitchell, D.T., & Snyder, S.L. (Dir). (1997). *Vital signs: Crip culture talks back*. Brace Yourselves Productions.

Mitchell, W.J.T. (2001). Seeing disability. *Public Culture*, *13*(3), 391-397.

Mollow, A. (2006). "When black women start going on Prozac": Race, gender and mental illness in Meri Nana-Ama Danquah's Willow Weep for Me. *MELUS, 31*(3), 67-99.

Odell, L., Goswami, D., & Herrington, A. (1983). The discourse-based interview: A procedure for exploring the tacit knowledge of writers in nonacademic settings. In P. Mosenthal, L. Tamor, & S.A. Walmsley (Eds.), *Research on writing: Principles and methods* (pp. 221-236). New York: Longman.

Oliver, M. (1992). Changing the social relations of research production. *Disability, Handicap & Society, 7*(2), 101-114.

Padden, C.A. (2005). Talking culture: Deaf people and disability studies. *PMLA, 120*(2), 508-513.

Petersen, A. (2006). An African-American woman with disabilities: The intersection of gender, race and disability. *Disability & Society, 21*(7), 721-734.

Pratt, M.L. (1991). Arts of the contact zone. *Profession, 91*, 33-40.

Prendergast, C. (2001). On the rhetorics of mental disability. In J.C. Wilson & C. Lewiecki-Wilson (Eds.), *Embodied rhetorics: Disability in language and culture* (pp. 45-60). Carbondale: Southern Illinois University Press.

Price, M. (2007). Accessing disability: A nondisabled student works the hyphen. *College Composition and Communication, 59*(1), 53-76.

Price, M. (2008). Writing from normal: Critical thinking and disability in the composition classroom. In C. Lewiecki-Wilson & B.J. Brueggemann (Eds.), *Disability and the teaching of writing: A critical sourcebook* (pp. 56-73). Boston: Bedford/St. Martin's.

Price, M. (2009a). Access imagined: The construction of disability in policy documents. *Disability Studies Quarterly, 29*(1), 2009.

Price, M. (2009b). "Her pronouns wax and wane": Psychosocial disability, autobiography, and counter-diagnosis. *Journal of Literary and Cultural Disability Studies, 3*(1), 11-34.

Price, M. (2011). *Mad at school: Rhetorics of mental disability and academic life.* Ann Arbor: University of Michigan Press.

Rogers, R. (2002). Through the eyes of the institution: A critical discourse analysis of decision making in two special education meetings. *Anthropology & Education Quarterly, 33*(2), 213-237.

Samuels, E. (2003). My body, my closet: Invisible disability and the limits of coming-out discourse. *GLQ, 9*, 233-255.

Shapiro, J.P. (1994). *No pity: People with disabilities forging a new civil rights movement.* New York: Random House.

Shaughnessy, M. (1977). *Errors and expectations: A guide for the teacher of basic writing.* New York: Oxford University Press.

Shaw, B. (Ed.). (1994). *Ragged edge: The disability experience from the pages of the first fifteen years of The Disability Rag.* Louisville, KY: Avocado Press.

Siebers, T. (2004). Disability as masquerade. *Literature and Medicine, 23*(1), 1-22.

Siebers, T. (2006). Disability studies and the future of identity politics. In L.M. Alcoff, M. Hames-García, S.P. Mohanty, & P.M.L. Moya (Eds.), *Identity politics reconsidered* (pp. 10-30). New York: Palgrave.

Siebers, T. (2008). *Disability theory.* Ann Arbor: University of Michigan Press.

Stone, E., & Priestley, M. (1996). Parasites, pawns and partners: Disability research and the role of non-disabled researchers. *British Journal of Sociology, 47*(4), 699-716.

Stuart, O.W. (1992). Race and disability: Just a double oppression? *Disability, Handicap & Society, 7*(2), 177-188.

Thompson, W.M. (2007). Her reckoning: A young interdisciplinary academic dissects the exact nature of her disease. In K.R. Myers (Ed.), *Illness in the academy: A collection of pathographies by academics* (pp. 373-380). West Lafayette, IN: Purdue University Press.

Tough Guise: Violence, Media & the Crisis in Masculinity. (1999). Dir. Sut Jhally. Perf. Jackson Katz. Amherst, MA: Media Education Foundation.

Walmsley, J. (2001). Normalisation, emancipatory research and inclusive research in learning disability. *Disability & Society, 16*(2), 187-205.

Wendell, S. (1989). Toward a feminist theory of disability. *Hypatia, 4*(2), 104-124.

Wendell, S. (2001). Unhealthy disabled: Treating chronic illnesses as disabilities. *Hypatia, 16*(4), 17-33.

Wilson, A., & Beresford, P. (2002). Madness, distress and disability: Putting the record straight. In M. Corker & T. Shakespeare (Eds.), *Disability/postmodernity: Embodying disability theory* (pp. 143-158). London: Continuum.

Wrigley, O. (1996). *The politics of deafness*. Washington, DC: Gallaudet University Press.

9

CRITICAL VALIDITY INQUIRY

Jeffrey W. Perry

The necessity for the field of composition to confront the powerful technology of testing and the misuse of testing as a means of reinscribing socioeconomic relations is crucial to the success of the field in gaining control over the design and administration of its own assessment practices. To this end, scholar-activists seeking change in the institutional use of assessments through their research must design reflexive methodologies that continually challenge the researcher's methods of producing results. Within the field of rhetoric and composition we have two proven models for our future research agenda into institutional change: Porter and Sullivan's (1997) institutional critique and Phelps' (1989) practice-theory-practice (PTP) arc. We can look outside of our own discipline to the scholarship of Educational Measurement for yet another methodological model, validity inquiry.

Porter and Sullivan quote Bourdieu's notion of "epistemological vigilance" as a correlative concept to their own reflexive methodology. Praxis, for Porter and Sullivan, is

> the move to problematize method—part of which requires overthrowing the neat compartmentalization offered by traditional methods, part of which requires a self-reflectiveness about process that is incompatible with traditional attempts to understand, undisturbed by the researcher, the cultures/phenomena they study. (p. 54)

Validity inquiry, as practiced within a unified theory of validity, is another correlative to critical practice and epistemological vigilance. A unified concept of valid-

ity does not differentiate in terms of the traditional categories of validity: criterion, construct, concurrent, and content. Instead, as Messick (1989b) explains, "validity is a unitary concept. Validity always refers to the degree to which empirical evidence and theoretical rationale supports the adequacy and appropriateness of interpretations and actions based on test scores" (p. 13).[1] In the same manner in which Porter and Sullivan discuss traditional understandings of methodology being "portrayed as a set of immutable principles, rather than as heuristic guidelines, masks the impact of the situation—of the practice—on the study in ways that could unconsciously reinscribe theory's dominance over practice" (p. 613), so too has the cultural dominance of testing as a method for sorting, placing, and inscribing individuals as gifted or deficient masked the original purpose for the use of testing. The now (in)famous Alfred Binet[2] is illustrative of theory's dominance over practice. Binet provided a list of cardinal rules for the use of his test:

- The scores are a practical device; they do not buttress any theory of intellect.
- The scale is a rough, empirical guide for identifying mildly retarded and learning-disabled children who need special help. It is not a device for ranking children.
- Low scores shall not be used to mark children as innately incapable. (Gould, 1996)

These rules were promptly ignored by American test theorists as they modified the original Binet test in order to first test members of the U.S. Army during World War I and later to make college entrance decisions (Elliot, 2005; Gould, 1996; Lehmann, 1999).

The benefits and usefulness of a unified theory of validity are found in the fact that validity is a degree and validation a process. More simply put, the decisions made based on a test score can be valid to a degree, and through an ongoing process of inquiry into the consequences, both for the institution as well as for the individual, that degree of validity can be continually tracked and the instrument of assessment tuned to increase the degree of validity.

Validity inquiry, a process of validating the decisions and inferences that are being made based on test scores, is an example of Porter and Sullivan's notion of reflexivity and Bourdieu's notion of "epistemological vigilance" in action. That decisions will be made based off of an assessment is one thing; it is a much more challenging process to determine whether or not the decisions have a high degree of validity. This notion of reflexivity and reflection also is understood through Phelps' (1989) PTP arc and is presented by Phelps as a way of understanding research, theory, and practice as ongoing, mutually dependent processes of amending praxes (classroom practices, responding to student writing, placement procedures). Phelps describes the PTP arc:

in composition practice, problems have been defined and tackled in a characteristic way. First, a situation arises where teaching breaks down in ways that don't yield to trial-and-error solutions. In these circumstances, the educational system shares with its popular critics the tacit assumption that pedagogy is both responsible for the problem and capable of solving it unilaterally. So crisis generates methodology, or more accurately, a babble of competing methods, each defended by passionate adherents. (p. 37)

The list of educational crises in America is plentiful. As Phelps explains, a crisis arises and leads scholars to inquire into "the constituent processes and activities that underlie surface behavior or its products. The scholars construct theories and models of these processes, often by borrowing or adapting basic research from other fields" (p. 37). An obvious example of such a theoretical shift in the common practices of compositionists would be portfolio assessments replacing conventional single-draft essays. When sociocognitive models of language gained traction among scholars and teachers of writing in the 1980s, the traditional writing assessment practices broke down. Scholars, borrowing from the fine art's tradition of judging complex performances as process rather than product provided a new practice that was in league with a deeper, richer theory of language. Phelps writes:

ultimately theories are brought into more comprehensive networks of meaning and metacriticism develops to evaluate the methods, assumptions, conclusions, and roles of the researchers themselves. At this point it is likely that theoretical frameworks may effect radical, even paradigmatic, changes in practice. (p. 37)

The current crisis facing writing assessment scholars is in many ways a problem that has dogged rhetoric and composition's endeavors since the inception of the College Entrance Examination Board. More generally, the crisis can be understood as the failure of institutional assessment practices to agree with and represent contemporary theories of teaching and learning. In the face of widely accepted theoretical views on language acquisition and writing, influenced by cognitive science, that argues for the local, contextual, cognitive, and cultural nature of learning and language, we see a commiserate growth of standardized testing informed by traditional test theory. This crisis calls for new theoretical frameworks for writing and educational assessment practices, and, just as important, for new methods for critiquing the institutional use of testing to reinscribe socioeconomic relationships.

To achieve change on an institutional level, I present an expansion of Educational Measurement's notion of validity inquiry. Critical Validity Inquiry (CVI) is a process that seeks to understand the misuse of power through educational assessment in general, and writing assessment practices specifically. CVI

seeks to critically examine assessment practices, to unmask epistemological stances of assessment, and to develop a reflexive, validation methodology that borrows from a number of disciplines in order to cut through the institutional cunning that reinscribes power relations through the use of educational assessment practices. The importance of understanding the role of power, its use and misuse, in relation to the institutional use of writing assessment is crucial if we have any hope of breaking the cycle of social reproduction inherent in the current educational system. By merging rhetorical and critical theory within the argument one can make for the use of educational measurement, CVI can provide an important lens for looking at the ways in which educational evaluations like writing assessment can be used to distribute opportunities, withhold access or other use or abuse of the power inherent in educational decision making.

This chapter is therefore presented in two sections. The first section contextualizes validity theory and validity inquiry within a social history of writing and writing assessment's roots in traditional test theory. The second section provides an explanation of CVI and presents a brief case of CVI in action.

WRITING ASSESSMENT AND VALIDITY THEORY: A BRIEF SOCIAL HISTORY

The subfield of college writing assessment has traditionally had two major roles that present their own unique challenges. One of those roles resides in the need for colleges and universities to place large numbers of students in the proper writing class, while the second challenge resides in the institutional requirement that teachers evaluate individuals at the end of a particular course. Although these two challenges, one about placement, the other about grading, seem quite different, they both are linked by the universal demand that writing assessments achieve reliability while being cost efficient. The answer to the dilemma of reliability and efficiency has invariably rested in standardized forms of assessment.

The history of writing assessment is linked with the history of standardized testing (Camp, 1993; Elliot, 2005; Huot, 2002; Huot & Neal, 2006; White, 1993; Williamson, 1993; Yancey, 1999) and this connection has created a lasting tension. The tension is between those dedicated to achieving high levels of validity and those institutions committed to placing large numbers of students efficiently. Like standardized tests, large-scale writing assessments are institutional devices that perpetuate socioeconomic divisions of power. Standardized forms of assessment, I argue, are a form of technology employed by institutions to recreate a social order that is most congenial to that institution's survival. Taken as a whole, the United States uses standardized testing, and, more specifically, standard writing assessments to reproduce the means of production.[3]

When viewed as a technology (Huot & Neal, 2006; Madaus, 1993) the role of writing assessment in social reproduction becomes apparent. As Madaus explains:

> much of present technology is specialized arcane knowledge, hidden algorithms, and technical art; it is a complex standardized means of attaining a predetermined end in social, economic, administrative and educational institutions (Ellul, 1990; Lowrance, 1986). Testing, embedded in our system of education with its arcane psychometric underpinnings, clearly fits this definition of technology. Testing also fits some very simple definitions of technology—the simplest being something put together for a purpose to satisfy a pressing or immediate need, or to solve a problem. (pp. 12-13)

Approaching writing assessment as a technology begs the question, "What problem is the technology of assessment trying to solve?" Martin Nystrand (2006), in "The Social and Historical Context for Writing Research," reveals that "problem." Nystrand cites *Time's* "Bonehead English" article of 1974 that decried the "sharp increase in unprepared students," and *Newsweek's* 1975 cover story "Why Johnny Can't Write," which "blamed the public schools for neglecting 'the basics'" (p. 15), as examples of a series of successive crises that traces back to the 18th century. The real problem, I argue, is that the changing population of students who inhabit the schools of America has always created problems for those interested in maintaining their socioeconomic dominance, and the technology of writing assessment has been crafted to solve these problems.

The use of large-scale assessments (Elliot, 2005; Gould, 1996), in general, has been a successful technology for maintaining this dominance: literacy requirements for voting staved off the threat posed to White landowners by freed slaves; IQ tests bolstered Eurocentric claims of racial superiority and served to explain a social hierarchy as a natural state; ACT/SAT entrance examinations continually punish minorities and lower-class students; and, the NCAA's Proposition 16 targets and punishes African American male athletes at an alarmingly high rate.[4] A historical look at standardized testing reveals the insidious nature of an assessment practice that sacrifices a high level of validity for reliability and efficiency. By employing critical theories of reproduction to both standardized writing assessments and other placement methods that sacrifice high levels of validity for efficiency and reliability the consequences of such assessment practices can be better understood.

A common definition and standard for validity has been elusive for writing assessment theorists, but the Educational Measurement community and other associations have been in agreement for sometime. The 1999 *Standards for Educational and Psychological Testing* (AERA/APA/NCME, 1999) argues that

statements about validity should refer to particular interpretations and uses. It is incorrect to use the unqualified phrase "the validity of the test." No test is valid for all purposes or in all situations. Each recommended use or inter- pretation requires validation and should specify in clear language the popu- lation for which the test is intended, the construct it is intended to measure, and the manner and context in which test scores are to be employed. (p. 18)

Writing assessment scholars (Gallagher, 2007; Huot, 2002; Williamson, 1994) also have argued for a unified theory of validity to encourage assessment prac- tices that include the social and individual consequences of decisions based on test scores. These scholars often cite the work of the Samuel Messick (1989) of the Educational Testing Service who defines validity as "an integrative evaluative judgment as to the degree to which empirical evidence and theoretical rationales support the adequacy and appropriateness of inferences and actions based on test scores or other modes of assessment" (p. 13).The import of validity and writ- ing assessment becomes clear when we contextualize assessment within the his- torical use of literacy as a punitive measure.

Operating within the parameters of validity theory, it becomes clear that decisions based on standardized writing assessments have a very low degree of validity for a variety of reasons. Chief among these reasons is the fact that the social nature of writing is altogether ignored. As Roger Cherry and Stephen Witte (1998) note, "reflecting on the extent to which and the ways in which acts of writing are embedded in larger social practices ... problematizes some underly- ing assumptions that guide assessment practices" (p. 73). Cherry and Witte argue that the basic construct of writing assessment, "writing ability," is problematic because direct forms of writing assessment fail to provide an opportunity for writers to display their true writing ability. The fact that writers write for differ- ent reasons in different ways is neglected by standardized writing assessments. As Cherry and Witte argue, the idea that writing prompts, timed writings, and con- trolled writing environments adhere to contemporary theories of language and writing is clearly wrong because "the 'contexts" specified in writing assessment prompts are both ahistorical and acontextual. Rather than providing information that facilitates text production, 'contextual variables' named in writing assess- ment prompts actually deprive writers of the opportunity to shape contexts of production and use" (p. 76). Cherry and Witte discuss the impact that the meas- urement community has had on writing assessment, and the tension between the need for standardization for measurement purposes and the attempt to achieve validity in accord with theoretical views of writing scholars. This tension is clear- ly explained by Pamela Moss (1994b). She writes:

assessments need to be standardized to some degree. Standardization refers to the extent to which tasks, working conditions, and scoring criteria are similar for all students. Emerging views of literacy, however, suggest the need

> for less standardized forms of assessment to support and document purpose-
> ful, collaborative work by students and teachers. This result is the tension
> between competing validity criteria that simultaneously advocate standardi-
> zation and purposeful, collaborative activity. (p. 110)

Moss's article reveals a historical moment when educational testing and writing assessment scholars were working together. The wave of test-based educational reform typified by No Child Left Behind (NCLB), the ACT writing exam, and a vast array of other standardized assessments are harbingers of a deteriorating collaborative effort. The need, as Brian Huot (2002) explains in *(Re)Articulating Writing Assessment*, to "begin a reflective inquiry to examine the problem with the practices we now use in assessment and to suggest practices that are more consonant with our theories" (p. 63) is as relevant now as when he wrote those words, but the current trend in which external forms of assessment ignore teachers and writing scholars is evident. The real problem for scholars and teachers lies in the cultural dominance of testing and its ability as an external assessment to hold power over our educational practices via curricular control.

Historically, standardized tests have been used (Elliot, 2005; Gould, 1996; Hanson, 1993; Sacks, 1999; Shohamy, 2001) to marginalize, compartmentalize, and organize individuals. Allen Hanson (1993) writes, "regardless of people's feelings about them, qualifying tests are a key factor for living successfully in contemporary society" (p. 186). He notes that an individual might "turn off on tests," but he stresses that "but then the system turns off on them. They are excluded from educational opportunities and good jobs and they never are able to accomplish much" (p. 186). This exclusion reveals the power of testing as a force for social reproduction. Those who opt out of standardized testing, those who participate and succeed, and those who participate and fail are all tied to those scores in very important ways. Is it conspiratorial to believe that all of this money is spent on testing our students in public education only to recreate the social inequality that marks members of our society through difference rather than a shared humanity? Harold Berlak (1992) writes:

> Assessment procedures are inherently political, not only because whoever
> controls the assessment process shapes the curriculum pedagogy and ulti-
> mately the students' life chances, but also because particular forms of assess-
> ment promote particular forms of social control within the organization,
> while suppressing others. (p. 18)

The history of assessment is closely linked to social and intellectual movements, such as eugenics, that adhere to notions of racial superiority and innate intelligence that argued for their beliefs through a pseudo-science of measurement.[5]

This historical link to oppressive assessment also operates in contemporary educational settings through the institutional use of writing assessments.

Educational assessments in the form of standardized writing exams are well suit-
ed to meet the demands of socioeconomic reproduction through their ability to
define the individual, to rank and organize members of a society, and to overpriv-
ilege a particular group.

Writing assessment scholars are in a unique place to inquire into this means
of social reproduction because as the tireless work of writing scholars over the
past five decades has finally produced a sociocognitive model of literacy and writ-
ing pedagogy, scholars in testing and in writing assessment have also produced
methods of assessment that take the sociocognitive model into account.
Unfortunately, these methods of assessment (performance, portfolios, direct[6])
resist the traditional attempts of psychometricians to standardize writing as a sta-
ble, static, and testable construct. In the face of almost insurmountable evidence,
however, the nonexperts (i.e., the testing industry, institutional administrations,
and federal, state, and city policymakers) have still managed to design and admin-
ister writing assessments that have a very low degree of validity. One rationale for
developing and implementing CVI is to reveal the political, social, and economic
forces that buoy up the culture of testing, while simultaneously ignoring scholar-
ship and theoretical explanations that demand new modes of assessment be not
only created but administered to assess complex human performances.

As a technology, writing assessment plays an integral role in a person's edu-
cational and economic opportunities, and this powerful role makes writing
assessment a place of contention. This view of writing assessment as a technolo-
gy allows for a conversation about the role that writing assessment plays in repro-
ducing the means of production. Huot (2002) reminds us that, "for the most
part, writing assessment has been developed, constructed, and privatized by the
measurement community as a technological apparatus whose inner workings are
known only to those with specialized knowledge" (p. 81). This specialized
knowledge has had the effect of limiting the conversation concerning issues of
writing assessment by limiting the number of people who feel qualified to enter
into such a conversation, and because of this, as a point of contention, writing
programs and writing instructors have historically been underrepresented in the
battle over assessment practices.

One reason that issues of writing assessment are so important is located in
the role that reading and writing play in educational opportunities. Huot argues
that, "instead of envisioning assessment as a way to enforce certain culturally
positioned standards and refuse entrance to certain people and groups of people,
we need to use our assessments to aid the learning environment for both teach-
ers and students" (p. 8). However, writing assessment practices that occur out-
side of the classroom often take on a far more sinister role. For the purposes of
entrance, exit, placement, and writing assessment specifically, and educational
assessment more generally speaking, are more often than not employed as gate-
keepers. It is this use of assessment practices as a form of technology designed to
solve a problem that Madaus (1993) describes when he writes that "testing,
embedded in our system of education with its arcane psychometric underpin-

nings, clearly fits this definition of technology. Testing also fits some very simple definitions of technology—the simplest being something put together for a purpose to satisfy a pressing or immediate need, or to solve a problem" (pp. 12-13). If we posit the "problem" facing institutions as a need to reproduce the social conditions of reproduction necessary for a global economy, then the role of writing assessment in higher education becomes more clear, and the battle over writing assessment practices become all the more important.

Putting the Critical in Critical Validity Inquiry

As a way, then, to address the inequities inherent in current assessment practices and theories, I propose CVI to address the complex human tasks that we seek to assess. The expansion of a methodology into a critical methodology has several precedents, the most notable being Fairclough's (1992) Critical Discourse Analysis (CDA).[7] CDA has at its foundation eight core principles:

- Social problems are addressed.
- Power relations are discursive.
- Discourse constitutes society and culture.
- Discourse does ideological work.
- Discourse is historical.
- A sociocognitive approach is needed to understand how relations between texts and society are mediated
- Discourse analysis is interpretive and explanatory and uses a systematic methodology.
- CDA constitutes a socially committed scientific paradigm.

For the purposes of writing assessment, CVI is interdisciplinary in that it seeks to unite both the field of Educational Measurement's concern for validity (as defined by Messick, 1989a) with Rhetoric's interpretation and explanation of language in context, and with Composition's concern with a sociocognitive approach to literacy and pedagogy. Just as the unitary concept of validity argues for the importance of guarding against the misuse of tests and the unintended consequences of decisions made based on test scores, so too does the field of writing assessment understand the need to guard against the exploitation of literacy. The social responsibility of both fields can be met by a critical approach to inquiry:

> an agenda for assessment that recognizes it as an important element for social action allows us the ability to guard against over-privileging the values, gestures and customs of certain groups and provides assessment with the potential to become an agent for progressive social change that includes and highlights the improvement of educational environments and opportunities for all students. (Huot, 2002, p. 9)

The case of the ACT writing exam at the City University of New York (CUNY) at Kingsborough provides a worthy example for a discussion of the foundational tenets of CVI. The rhetoric presented by the mayor's task force's report can appear as merely addressing what are basically laudable concerns. It is hard to argue against the idea that students and teachers should set high standards or that individuals should be held accountable in their respective roles as teachers and students. The case at CUNY, however, also can be seen as part of a move to restructure the public nature of education in America. Michael Apple (1993) argues in *Official Knowledge* that a public relations campaign to cast public education as a failed enterprise has been underway for 30 years and finds at its roots the neoconservative movement. He argues the following:

> One of the major causes of educational failure is seen to be the supposedly nearly complete control over policy and practice by teachers and other "professional educators." Such autonomy "has left the educational system both unaccountable to consumers (parents and communities) and open to precisely the sort of curriculum initiatives associated with 'liberal ideas'." (p. 3)

Apple also discusses the fact that much of this political unrest has been built on the notion that teachers cannot be trusted for either their "quality" of teaching or "commitment to education." This language is the key. Who defines the quality of or commitment to teaching, and what are the parameters for this judgment? The reliance on nonreferential qualitative measures has been illustrated by Bill Readings' (1996) explanation of "excellence" in the contemporary university. Apple outlines the shifts in educational policy achieved by the neoconservative movement:

> 1) proposals for voucher and choice plans and tax credits to make schools more like the idealized free-market economy; 2) the movement in the legislatures and state departments of education to "raise standards" and mandate both teacher and student "competencies" and basic curricular goals and knowledge, thereby centralizing even more at a state level the control of teaching curricula; 3) the increasingly effective assaults on the school curriculum for its supposedly antifamily and anti-free enterprise bias, its "secular humanism," its lack of patriotism, and its neglect of the "Western tradition"; 4) the growing pressure to make the needs of business and industry into the primary goals of the educational system. (p. 20)

The neoconservative movements' perceived failure of the public schools has been presented to the general public in various ways. The most notable failures, as we have seen, have been presented as a series of literacy crises. These failures are invariably accompanied by calls for reform, and, as in the CUNY case, these reforms are usually test-based reforms. The mistrust of "teachers and other 'pro-

fessional educators'" that Apple describes is more often than not rectified by external forms of assessment.

CVI for the purpose of writing assessment merges the sociocognitive model of learning with Cronbach's (1989) notion of validity as a neverending process. Schools should be held accountable, but the methods of assessing this accountability need to be commensurate with contemporary theories of literacy and learning. The move toward testing "writing ability" through standardized, impromptu, timed-writing examinations is theoretically informed by a notion of literacy that is no longer accepted by the majority of literacy scholars. This outdated theory holds that writing is rule-based and that writers write well because they know the rules of grammar. Perhaps even more important is that, as the work of Shirley Bryce Heath (1983) shows and as the case of CUNY at Kingsborough will show, these standardized writing assessments tend to privilege a certain kind of literacy and a certain kind of community. Finally, it has been shown that external forms of assessment affect classroom curriculum and teacher pedagogy and result in a skills-based education that stresses drilling and rote learning. These nonrecursive strategies for teaching have proven to be unsuccessful when used to educate a diverse population.

The pedagogy of drilling and rote learning does not demand a teacher reflect on her pedagogical practices. However, a more nuanced understanding of teaching, one informed by a sociocognitive model of language and learning does. Critical Reflective Teaching (CRT), for instance, is another precedent for critical practice that informs CVI.[8] Based on theories in CDA and CRT, then, I developed CVI to attend to the critical issues typically ignored in assessment practice.

This approach of CVI is concerned with Messick's (1989a) notion of "individual and social consequences of decisions made based on test scores" (p. 13) and inquiries into the presence of power and the misuse of power.[9]

CVI for writing assessment adopts a sociocognitive model precisely because of writing assessment's history as a means to maintain dominance. As we have seen through the "literacy test" of the South prior to the Voting Rights Act of 1965 and in the case of CUNY in a contemporary setting, writing assessment is "power." George Hillocks (2002), writing in the *Testing Trap: How State Writing Assessments Control Learning*, addresses the manner in which standardized writing assessments interfere with the teaching and learning of writing because of the narrow view by which these assessments are informed. He writes:

> in the past 30 years, researchers and theorists have come to know that teaching writing entails teaching thinking. Further, they would argue that people learn through writing ... writing is more than a mnemonic device. Its presence makes it an aid in thinking though highly complex processes and problems. But if writing is an aid to thinking, it is also obvious that thinking is requisite for most writing. The serious teaching of writing and thinking must go hand in hand. (p. 6)

Hillocks' understanding of the relationship between writing and thinking underscores the negative effects that standardization in education represents. When we think about the rote learning and drilling that accompanies standardized tests, this relationship between thinking and writing illustrates the uneven playing field of educational opportunities. For Heath's (1983) Trackton children, the wave of test-based reform spells trouble, and, as Nichols and Berliner (2007) explain in *Collateral Damage: How High-Stakes Testing Corrupts America's Schools*:

> Tests were chosen as the mechanism to measure productivity. Like those in the business community, legislators believed that productivity could be increased without more money needing to be spent simply by holding schools and educators accountable through the practice of high-stakes testing. Lazy teachers and their students would be detected and made to work harder. (p. 19)

The power that this investigation into the reproduction of the means of production locates can be considered "corporate power," and Nichols' and Berliner's connection of high-stakes testing to the business community makes the corporatization of the university as described by Bill Readings (1996) a logical step forward in the test-based reform movement. This corporatization is evident in many contemporary institutions of higher education and the modeling of these institutions on a corporate model of efficiency and productivity creates new conditions that need to be reproduced.

To this end, CVI is concerned with the manner in which assessment practices, intentionally or not, "distort educational processes and interactions." To investigate the misuse of power through assessment, CVI is founded on tenets that blend institutional critique, validity theory, and critical theories of reproduction.

- Validity is a unified though faceted concept and that validation is scientific inquiry (Messick, 1989b, p. 14).
- Tests do not have reliabilities and validities, only test responses do. Test responses are a function not only of the items, tasks, or stimulus conditions but of the persons responding and the context of measurement (p. 15).
- We can trace the social consequences of interpreting the test scores in particular ways, scrutinizing not only the intended outcomes but also unintended side effects (p. 16).
- Determining what a test is measuring always requires recourse to other forms of evidence (p. 17).
- We will underscore the continuing need for validation practice to address the realities of testing consequences, including the often subtle and systemic effects of recurrent or regularized testing on institutional or societal functioning (p. 18).

- The advice is not merely to be on the lookout for cases your hypothesis does not fit. The advice is to find, either in the relevant community of concerned persons or in your own devilish imagination, an alternative explanation of the accumulated findings; then to devise a study where the alternatives lead to disparate predictions (Cronbach, 1988, p. 14).
- We aim to change the practices of institutional representatives and to improve the conditions of those affected by and served by institutions (Porter, Sullivan, Blythe, Grabill, & Miles, 2000, p. 611).
- Institutions are both material and rhetorical spaces, and our definition of them must encompass these elements (p. 625).
- The ideological apparatus which has been installed in the *dominant* position in mature capitalist social formations as a result of a violent political and ideological class struggle against the old dominant ideological State apparatus is the *educational ideological apparatus* (Althusser, 2001, p. 103).

The principles of CVI represent a view that educational institutions have a responsibility to protect society and its individual members from the misuse of this powerful technology of educational assessment. Within validity theory the role of validity inquiry "to address the realities of testing consequences, including the often subtle and systemic effects of recurrent or regularized testing on institutional or societal functioning" (p. 18) is expanded in its capabilities by CVI's focus on "power." By focusing on traditional sites of educational exploitation like race, class, and gender, CVI allows researchers and assessors the capability of recognizing abuses of power that might be missed in a more generally focused inquiry. This misuse of educational assessments that fail to represent an equitable process for all and, instead, serve the purpose of reproducing the social relations necessary for the perpetuation of a vast disparity in the distribution of wealth, health services, and educational opportunities will be challenged.

Critical Validity Inquiry and Writing Assessment

The low degree of validity that standardized writing assessments of both direct and indirect writing deliver have been repeatedly reported in the scholarship of writing assessment and educational measurement (Bracey, 2000, 2001; Haswell, 2001; Moss, 1992, 1994a, 1996, 1998). The most difficult aspect of measuring "writing ability" as a construct is identified in the work of many scholars but no where more acutely than in Cherry's and Witte's (1998) "direct assessment." As we have seen in the first section of this chapter, Cherry and Witte identify the "messy and complex" nature of writing and outline the pseudo-contextual nature of writing prompts while at the same time identifying the importance of real context, both personal and historical, that defines a writer's approach to writing. This

deeply embedded process of social communication cannot be replicated by a timed, single sample, impromptu writing examination.

More so than any other area of assessment, writing assessment, and composition as a field of study, has produced an abundance of scholarship that details the sociocognitive nature of writing and language (Applebee, 1986; Durst, 1987; Freedman & Pringle, 1981; Langer & Applebee, 1987; Odell, 1981; Penrose, 1989; Pringle & Freedman, 1985), and is, therefore, more prepared to provide evidence of standardization's inability to produce equitable decisions based on scores. As Hillocks (2002) notes, "if states are concerned about encouraging high-level thinking in schools, that interest is more likely to be reflected in writing assessments than in assessments for any other subject matter areas" (p. 17) because "the kinds of writing tested may influence the kinds of writing taught in schools" (p. 19). Hillocks argues, in the tradition of Street and Heath, that "we learn by assimilating new experiences into our already known world" (p. 21) rather than arguing for the traditional view of learning that believes "truth is objective and may be apprehended directly through observation of the world" (p. 21). Hillocks, Cherry and Witte, Huot, Williamson, Moss, and Camp are representatives of a view of writing assessment that demands the proper conditions for organic writing.

The use of large-scale writing assessments, because they seek to create the traditional test conditions that value reliability more than they do validity, more often than not are informed by an autonomous[10] model of literacy. These large-scale writing assessments operate with the underlying assumption that writing is merely a means of producing a product and are not complex social acts embedded in individual and social practices. In short, the demands of psychometrics directly contradict the sociocognitive model of literacy. As Roberta Camp (1993) points out:

> We attempt to minimize or compensate for those factors most likely to create variation in writing performance from one occasion to another. We try to present prompts that are immediately accessible to all test takers—whatever their individual interests, knowledge, or cultural experience—and that can be dealt with in the limited time available for writing. (p. 50)

The notion that writing prompts create a real context or produce a writing task that is similar for all groups and individuals who are presented with this prompt has been disputed (Cherry & Witte, 1998; Hillocks, 2002; Nichols & Berliner, 2007). Camp (1993) notes that the compromises made in the name of reliability and testing conditions are problematic for measuring writing ability:

> Ironically, many of the efforts we made to enhance the reliability of the writing sample—especially those aimed at streamlining and universalizing the writing experience—appear now to limit the value of the assessment.

Very likely we are also seeing the signs of growing incompatibility between our views of writing and the constraints necessary to satisfy the requirements of traditional psychometrics—in particular, of reliability and validity narrowly defined. (p. 52)

CVI, in response to this contradiction, approaches all forms of writing assessment by keying its inquiry on areas that have, in a sociohistorical sense, been sites where literacy has been exploited for the purposes of reproducing socioeconomic relationships. CVI also investigates the ability of the writing assessment in question to achieve a context in which writers can approach the "writing task" in an authentic way so that the "complex nature of writing" and a writer's ability can be represented with a higher degree of validity.

An outline for the process of CVI contains several overlapping points of interest that represent the assessment practice as a complex interaction between the writer, the assessment instrument, the testing conditions, and the use of test scores to draw inferences and to make decisions. These points of interest are then analyzed in terms of a sociocognitive model of literacy to understand whether the conditions of the assessment as well as the consequences of the decisions made based on the test scores of the assessment are fair and equitable.

FIG. 9.1. *Critical Validity Inquiry*

Figure 9.1 introduces the foci of CVI and, as we can see, looks at race, ethnicity, gender, class, administration of test, and test conditions to understand the impact of the assessment on the individuals and social groups being assessed. CVI seeks to understand how "power" is exerted by the test design, test conditions, and decisions made based on the test scores, and how this power affects

the particular groups and individuals assessed. CVI, therefore, locates power by identifying the forces behind the assessment (i.e., politicians and policymakers, writing programs, instructors and teachers, a combination of these parties) as well as the purpose for which the assessment is undertaken (admission, place-ment, entrance, exit). The case of the ACT writing exam at CUNY provides an opportunity to look at the relationship between power and writing assessment through the process of CVI.

Critical Validity Inquiry in Action

CVI applied to the case of CUNY at Kingsborough is less about the unintended outcomes of an assessment practice and more about assessment as a site of con-tention. The chairman of the task force was, at the time of the report, directly linked to a privatization of public education movement represented by the Edison Project. Rudolph Giuliani, then mayor of New York, was a conservative politician who had voiced his disapproval of both open admissions and remedi-ation at the city university system.

The ideological tenets of conservatism and traditional test theory mesh nice-ly with the conservative agenda for education. Like a business, a school should be run on principles of "productivity," "accountability," and "high standards" (i.e., quality control). The implementation of broad test-based reforms is the obvious response of an institution that values "efficiency" above all other concerns.

The student population at CUNY at Kingsborough is revealed through both institutional statistics (see Table 9.1) and the evidence presented by Bruce Chadwick (2008) in "Tilting at Windmills: The City of New York's ACT Writing Exam." Chadwick describes his ACT prep class:

Table 9.1. Percent Enrollment by Ethnicity

Fall	White	Black	Hispanic	Asian/PI	Am Ind	Total
1998	48.2	30.0	12.6	9.1	0.1	100.0
1999	47.6	30.0	13.2	9.1	0.1	100.0
2000	46.7	30.3	13.4	9.5	0.1	100.0
2001	44.8	31.7	13.2	10.2	0.1	100.0
2002	43.4	32.5	14.0	10.1	0.1	100.0
2003	41.3	33.0	14.4	11.2	0.1	100.0
2004	41.7	33.1	14.2	10.9	0.1	100.0
2005	41.0	32.6	14.4	11.8	0.1	100.0
2006	41.1	32.0	14.4	12.4	0.1	100.0
2007	40.6	32.3	14.6	12.5	0.1	100.0

> twenty five students registered for this course. Eighteen are students whose
> first language is not English; only seven students are first-language English
> speakers and writers ... the breakdown is as follows: seven are originally
> from China; one is from Israel; one from Bangladesh; one from Bosnia-
> Herzegovina; one from Albania; one from Russia; one from Puerto Rico; one
> from the Dominican Republic and one from Mexico. (p. 2)

The diverse nature of both Chadwick's course and the CUNY at Kingsborough student body reveals the pedagogical challenges confronting the teachers at CUNY as well as the educational challenges confronting the students.

To confront the pedagogical challenges of teaching writing to such a diverse group, the writing program developed a portfolio assessment practice that stressed process over product. This pedagogy embraces a sociocognitive model of literacy. It introduces and informs students about the complex and recursive nature of writing, while at the same time, providing students with the necessary means of revising (peer review, instructor feedback, and self-assessment). The stress this pedagogic model places on revision allows second-language learners to approach writing as something that happens over time, instead of within a limited period of time, and keeps the focus on writing as a process rather than writing as a product. As Chadwick (2008) informs his audience, the effect of the CUNY ACT writing exam on the portfolio system was devastating.

In comparison, the theory of literacy informing the ACT writing exam can be understood through the inquiry methods of CVI for writing assessment. First, a sociocognitive perspective of literacy would expect that a diverse student population, with its lack of "command of spoken and written English" (p. 2), to struggle with the time constraints. The autonomous model of literacy that informs the ACT writing exam, however, ignores these important factors (race, ethnicity, second-language learners) and aggravates the situation through test design and test administration. We have seen the problems with a single, impromptu timed writing in our discussion of Cherry and Witte (1998). Foremost, single impromptu timed writings fail to view writing as a complex social act embedded in individual contexts and experiences. Instead, the design of the ACT writing exam assumes an autonomous model of literacy that understands "writing ability" as a stable, measurable construct. The added stipulation that prohibits students from using a dictionary places second-language learners at a further disadvantage.

The external origins of the test, its use as an exit exam, and the high stakes attached to success and failure (a failure rate of 50% for second-language students) locate the power of the ACT writing exam in its ability to deny a large number of students access to degree-earning programs and credit-earning courses. The ability of the test to organize and rank students, to offer or deny opportunity, and to reinscribe social relations is directly tied to the external nature of the examination. This outside influence "distorts educational interactions" by influencing curriculum and undermining the writing faculty.

A rival hypothesis for the 50% failure rate that Chadwick records at CUNY at Kingsborough could be that the test conditions (time restriction, impromptu, no dictionaries, no real context) when applied to second-language learners fail to produce a genuine situation or conditions for authentic writing. The failure to produce authentic representations of student writing undermines the construct of "writing ability" and invalidates the writing assessment practice represented by the ACT writing exam.

Most importantly, the use of the ACT writing exam, the inferences it draws, and the consequences and the decisions made based on the test scores it produces have such a negative impact on such a large portion of the assessed that the continued use is unwarranted. Judging the ACT writing exam against the backdrop of Cronbach's demands on validity reveals the cost of these consequences to be too high in several regards. First, Cronbach (1988) argues that ""because psychological and educational tests influence who gets what in society, fresh challenges follow shifts in social power or social philosophy" (p. 4). The social shift toward a corporate model's demand for accountability and test-based reform explains the use of testing and is highlighted in the task force's report, but the fact that the ACT writing exam continues to be used at CUNY illustrates that validators have failed. According to Cronbach, "the bottom line is that validators have an obligation to review whether a practice has appropriate consequences for individuals and institutions, and especially to guard against adverse consequences" (p. 6). The consequences at CUNY are very real, as we have seen, and the continued use of the ACT writing exam ensures that more people will suffer the consequences that come with failing the ACT writing exam. Because neither students nor teachers ever get to see the exam again, even if they appeal their score, Cronbach's assertion that "the worth of an instructional test lies in its contribution to the learning of students working up to the test, or to next year's quality of instruction" (p. 5), goes ignored by CUNY's assessment policymakers.

CONCLUSION

The importance of this investigation into the test-based writing assessment reforms at the CUNY college system can be located in the ability of nonexperts (policymakers and politicians) to implement policies and programs that undercut and undermine the pedagogies and policies designed by experts (writing scholars, writing instructors, and writing program administrators). The ability, power, and proclivity of policymakers and politicians to produce environments such as those seen at Kingsborough Community College reveal the institutional demand inherent in corporate, for-profit structures to reproduce the means of production.

The portfolio system designed at CUNY at Kingsborough Community College had its foundation in the most widely accepted theoretical explanations for how people learn to write, how people can best teach writing, and how teachers, students, and writing programs can best assess writing. That the same unexamined and deeply flawed views of literate practices represented by the "autonomous" model of literacy, and the deeply flawed educational measurement techniques of standardized writing assessment practices can merge to undermine the efforts of teachers and writing program administrators in the name of efficiency, standards, and accountability are discouraging to say the least. The good news is that we can look back to history as a prologue for challenging the assessment industry.

The historical proximity between the open admissions of CUNY in 1970 and the passage of the Voting Rights Act of 1965 provides a vivid backdrop to the standardized writing examination introduced at CUNY colleges in "the middle of the Fall 1999 semester" (Chadwick, 2008, p. 4). The use of the "literacy test" prior to the passage of the Voting Rights Act was a means through which White oppressors were able to deny non-Whites the ability to participate in the democratic process. The eerie similarities between the use of the literacy test and the use of the ACT writing exam at CUNY at Kingsborough reveal not only what Chadwick refers to as the "pernicious effect on the students and faculty at Kingsborough" (p. 1), but also the insidious manner by which external forms of assessment are capable of controlling curriculum and pedagogic practice. The implementation of CVI as a research methodology in tandem with a social and legal coalition under the banner of civil rights can make a difference.

For instance, Fairtest, the National Center for Fair and Open Testing, is an example of a coalition of different organizations that have, through their unity, been able to make a difference. Fairtest's mission states that it "advances quality education and equal opportunity by promoting fair, open, valid and educationally beneficial evaluations of students, teachers and schools. FairTest also works to end the misuses and flaws of testing practices that impede those goals" (Fairtest.org). As of April 2008, the coalition beneath the banner of Fairtest in an attempt to overhaul NCLB included 144 associations and organizations from the American Association of School Administrators to the Young Men's Empowerment Movement. As part of Fairtest's "emphasis on eliminating the racial, class, gender, and cultural barriers to equal opportunity posed by standardized tests, and preventing their damage to the quality of education," this organization provides organizing tools to aid individuals and communities to take action in their local areas, research information, links to published data and scholarship on testing and the misuse of testing, and, most importantly, a unified voice for change.

Fairtest can serve as a model for writing programs nationwide. A coalition of the writing programs might make it possible that cases like CUNY at Kingsborough become stories of the past rather than examples of outdated models of literacy and writing being perpetuated at the end of the first decade of the

21st century. The subversion of the scholarship produced within composition studies over the past 50 years devalues both the field and its research, but, more importantly, leaves the students in our charge at the hands of corporate powers that view productivity, efficiency, and profit as the primary purpose of public education. This corporate ideology, when adopted for the purposes of running an educational institution, inevitably reproduces the means of production by ignoring students who need our attention most. We have seen this reproductive technology at work through the use of culturally biased writing assessment practices designed on the tenets of traditional test theory, and the hue and cry of test-based reforms can still be heard through the words "accountability, higher standards, and measurement."

For those scholar-activists who want to affect change, the answer is on the street, in the neighborhoods, and, ultimately, in the courts of law. The paradigmatic shift that Phelps discusses is perhaps a shift in where our scholarship is ultimately put to use. To simply publish and share our work at conferences among like-minded professors and researchers is futile. The real arena of change is the court of law. CVI focuses on historical sites of educational abuse: the biases of standardized testing on women and minorities; the historical abuses that connect literacy to voting and employment opportunities; and the far-reaching affects of poverty to hamper opportunities to learn.

Moss (1996) attempts to "enlarge the dialogue in educational measurement" (p. 20) and explore what she calls the "dialectic between naturalist and interpretive conceptions of social science" (p. 21) in an attempt to "support a wider range of sound assessment practices, including those less standardized forms of assessment that honor the purposes teachers and students bring to their work; to theorize more productively about the complex and subtle ways that assessments work within the local contexts in which they are developed and used" (p. 20). Like Huot (1996, 2002) and Camp (1993), Moss cites Messick (1989a) and Cronbach (1989) as individuals who have attempted to integrate other "voices from research traditions" outside the Educational Measurement community into their conversation about assessing complex human performances like writing, and provides hope that a united front against the reductive psychometric tradition might be formed. Any hopes of replacing the positivist tradition of psychometric, standardized assessment practices that reduce complex human performances to numeric representations rests on uniting the social, political, and professional authority of educational measurement with the sociocognitive approach to teaching and learning. Until this united front is established, the powerful industry in control of the technology of assessment will continue to reproduce socioeconomic relations through the educational apparatus. These forms of assessment will be designed using the basic tenets of traditional test theory, ensuring that the racial, ethnic, and gender biases from which this tradition originated will be perpetuated ad infinitum. On the contrary, CVI offers a theoretical and methodological approach to assessment that works toward avoiding such a perpetuation.

ENDNOTES

1. "The term test score is used generically here in its broadest sense to mean any observed consistency, not just on tests as ordinarily conceived but on any means of observing or documenting consistent behaviors or attributes" (Messick, 1989b, p. 13).
2. Alfred Binet (1857-1911) created and used testing to identify children in need of special attention in French schools. His test would later become what we now call IQ tests. Later in life he argued vehemently against the idea of intelligence as a scalable, unitary concept.
3. The reproduction of the means of production refers to Marx's statement that "no production is possible which does not allow for the reproduction of the material conditions of production: the reproduction of the means of production" (Althusser, 2001, p. 86). Louis Althusser, however, draws a distinction between "the productive forces" (materials) and "the existing relations of production" (socioeconomic or class relations). The socioeconomic relationships that make production possible (class relations) also must be reproduced.
4. TestFair.org, citing NCAA research, found that NCAA data on student athletes' academic performance prior to the 1986 implementation of Prop., 48 reveal the discriminatory impact of these rules. The data, reanalyzed by the McIntosh Commission on Fair Play in Student-Athlete Admissions, show that had Prop. 48 been in effect in 1984 and 1985, it would have denied full eligibility to 47% of the African American student athletes who went on to graduate, but just 8% of the White student athletes. More recent NCAA research shows that the test score requirements disqualify African American student athletes at a rate 9 to 10 times the rate for White students.
5. Gould's (1996) *The Mismeasure of Man* provides a clear illustration of this historical link.
6. *Performance assessment* can be understood easily if we think about how a professor is hired. Instead of a simple test or the use of a sole writing sample, the performance of a candidate is judged by a committee of his or her peers. The committee often will ask to see the candidate present his or her research, teach a class as a "performance." Other factors such as student evaluations, letters of recommendation, and interviews also are included to provide an array of data points by which a hiring decision can be made. *Portfolios* for the purpose of writing assessment allow the instructor to assess a corpus of student work rather than a single piece of writing. The portfolio also allows the instructor to view the "process" that each draft has undergone, and, when done properly, allows the instructor to see where and how the student writer has grown over a certain period of time. *Direct assessment* is the flipside to indirect assessment. In the past the construct of "writing ability" often was assessed through indirect means (vocabulary, grammar exercises, fill-in-the-blank, etc.). Direct forms of writing assessment simply mean that a piece of writing is actually being assessed rather than indirect forms.
7. Rebecca Rogers (2004) describes CDA as "both a theory and a method. Researchers who are interested in the relationship between language and society use CDA to help them describe, interpret, and explain such relationships" (p. 2). What sets CDA apart, what puts the critical in critical discourse analysis, is the fact that CDA

"includes not only a description and interpretation of discourse, but it also offers an explanation of why and how discourse works" (p. 2).

8. Brookfield (1995) premises his notion of CRT with the belief that "we teach to change the world" (p. 1), and that "an uncritical stance toward our practice sets us up for a lifetime of frustration" (p. 1). The idea of a reflective practice finds its roots, arguably perhaps, in Schon's (1983) *The Reflective Practitioner* but has been absorbed by many teachers and scholars interested in pedagogy. CRT is founded on the notion that we all make assumptions about the way the world works. As Brookfield (1995) says, "we are our assumptions" (p. 2). He categorizes three types of assumptions. The first is paradigmatic assumptions:

> they are the basic structuring axioms we use to order the world into fundamental concepts ... paradigmatic assumptions are examined critically only after a great deal of resistance to doing so, and it takes a considerable amount of contrary evidence and disconfirming experiences to change them. But when they are challenged and changed, the consequences for our lives are explosive. (p. 3)

The second, prescriptive assumptions "surface as we examine how we think teachers should behave, what good educational processes should look like, and what obligations students and teachers owe to each other" (p. 3). The third, causal assumptions "help us understand how different parts of the world work and the conditions under which processes can be changed" (p. 3). For Brookfield "reflection becomes critical when it has two distinctive purposes. The first is to understand how considerations of power undergird, frame, and distort educational processes and interactions, and the second is to question assumptions and practices that seem to make our teaching lives easier but actually work against our own best long-term interests" (p. 8). Again, the focus on power and the manner in which it can "distort educational processes and interactions" is apropos of the situation of test-based reform at CUNY.

9. Foucault's (1979) concept of power as explained in *Discipline and Punish* is helpful when focusing on the relationship between power and educational assessment. Foucault argues that "Discipline 'makes' individuals; it is the specific technique of a power that regards individuals both as objects and as instruments of its exercise" (p. 170). For Foucault, the examination is capable of both objectifying the individual, an idea that is echoed by Hanson (1993), as well as organizing individuals into a hierarchy of observation. The use of tests scores to rank students and to organize society in turn creates this Foucauldian "hierarchy of observation" that makes "an apparatus in which the techniques that make it possible to see, induce effects of power, and in which, conversely, the means of coercion make those on whom they are applied clearly visible" (pp. 170-171). Foucault's conception of power as a "network of gazes" (p. 171) aptly captures the power inherent in large-scale testing and typified by test-based reforms. When Foucault refers to the examination as "a surveillance that makes it possible to qualify, to classify and to punish" (p. 184), he reveals the true power of assessment. When he adds that "it establishes over individuals, a visibility through which one differentiates them and judges them" (p. 184), he cuts to the institutional use of assessment as a means of surveillance and dominance as opposed to a notion of assessment that seeks progressive social action.

10. Brian Street (1984) differentiates between the "ideological model" of literacy and the "autonomous model" of literacy. The ideological model, he argues, grows out of social activity, culture, and power relations. The autonomous model argues that literacy is a human capability that needs to be activated.

REFERENCES

AERA/APA/NCME. (1999). *The standards for educational and psychological testing*. Washington, DC: American Educational Research Association.

Althusser, L. (2001). *Lenin and philosophy and other essays*. New York: Monthly Review Press.

Apple, M. (1993). *Official knowledge*. London: Routledge.

Applebee, A.N. (1986). Problems in process approaches: Toward a reconceptualization of process instruction. In A. Petrosky & D. Bartholomae (Eds.), *The teaching of writing: 85th yearbook of the National Society for the Study of Education* (Part II, pp. 95-113). Chicago: University of Chicago Press.

Berlak, H. (1992).The need for a new science of assessment. In H. Berlak, F.M. Newmann, E. Adams, D.A. Archbald, T. Burgess, J. Raven, & T.A. Romberg (Eds.), *Toward a new science of educational testing and assessment* (pp. 1-21). Albany: SUNY Press.

Bracey, G. (2003). *On the death of childhood and the destruction of public schools*. Portsmouth: Heinemann.

Bracey, G. (2004). *Setting the record straight*. Portsmouth: Heinemann.

Brookfield, S. (1995). *Becoming a critically reflective teacher*. San Francisco: Jossey-Bass.

Camp, R. (1993). Changing the model for the direct assessment of writing. In M.M. Williamson & B. Huot (Eds.), *Validating holistic scoring for writing assessment: Theoretical and empirical foundations* (pp. 45-78). Cresskill, NJ: Hampton Press.

Chadwick, B. (2008). Tilting at windmills. *Journal of Writing Assessment, 3*(2), 99-120.

Cherry, R., & Witte, S. (1998). Direct assessments of writing: Substance and romance. *Assessing Writing, 5*(1), 71-87.

Cronbach, L.J. (1988). Five perspectives on validity argument. In H. Wainer (Ed.), *Test validity* (pp. 3-17). Hillsdale, NJ: Erlbaum.

Cronbach, L.J. (1989). Construct validation after thirty years. In R.L. Linn (Ed.), *Intelligence measurement, theory and public policy: Proceedings of a Symposium in Honor of L.G. Humphreys* (pp. 147-171). Urbana & Chicago: University of Illinois Press.

Durst, R.K. (1987). Cognitive and linguistic demands of analytic writing. *Research in the Teaching of English, 21*(4), 347-376.

Elliot, N. (2005). *On a scale: A social history of writing assessment in America*. New York: Peter Lang.

Fairclough, N. (1992). *Discourse and social change*. Cambridge: Polity Press.

Foucault, M. (1979). *Discipline and punish: The birth of the prison* (A. Sheridan, Trans.). New York: Random House.

Freedman, A., & Pringle, I. (1981). *Why students can't write arguments*. Ottawa, Canada: Carleton University, Linguistics Dept.

Gallagher, C. (2007). *Reclaiming assessment: A better alternative to the accountability agenda*. Portsmouth: Heinemann.

Gould, S. (1996). *The mismeasure of man.* New York: Norton.

Hanson, A.(1993). *Testing, testing.* Berkeley: University of California Press.

Haswell, R. (2001). *Beyond outcomes: Assessment and instruction within a university writing program.* Westport: Ablex.

Heath, S.B. (1983). *Ways with words: Language, life, and work in communities and classrooms.* New York: Cambridge University Press.

Hillocks, G. (2002). *The testing trap: How state writing assessments control learning.* New York: Teachers College Press.

Huot, B. (1990). The literature of direct writing assessment: Major concerns and prevailing trends. *Review of Educational Research, 60,* 237-263.

Huot, B. (1996). Toward a new theory of writing assessment. *College Composition and Communication, 47,* 549-566.

Huot, B. (2002). *(Re)Articulating writing assessment for teaching and learning.* Logan: Utah State University Press.

Huot, B., & Neal, M. (2006). Writing assessment: A techno history. In C.A. MacArthur (Ed.), *Handbook of writing research* (pp. 417-432). New York: Guilford.

Langer, J.A., & Applebee, A.N. (1987). *How writing shapes thinking: A study of teaching and learning.* Urbana, IL: NCTE.

Lehmann, N. (1999). *The big test: The secret history of the American meritocracy.* New York: Farrar, Straus & Giroux.

Madaus, G. (1993). A national testing system: Manna from above. *Educational Assessment, 1,* 9-26.

Madaus, G.F. (1994). A technical and historical consideration of equity issues associated with proposals to change the nation's testing policy. *Harvard Educational Review, 64*(1), 76-94.

Messick, S. (1989a). Meaning and values in test validation: The science and ethics of assessment. *Educational Researcher, 18*(2), 5-11.

Messick, S. (1989b). Validity. In R.L. Linn (Ed.), *Educational measurement* (pp. 13-103). New York: Macmillan.

Messick, S. (1995). The standards of validity and the validity of standards in performance assessment. *Educational Measurement: Issues and Practice, 14*(4), 5-8.

Moss, P. (1992). Shifting conceptions of validity in educational measurement: Implications for performance assessment. *Review of Educational Research, 62*(3), 229-258.

Moss, P. (1994a). Validity in high stakes writing assessment. *Assessing Writing, 1,* 109-128.

Moss, P. (1994b). Can there be validity without reliability? *Educational Researcher, 23*(4), 5-12.

Moss, P. (1995). Themes and variations in validity theory. *Educational Measurement: Issues and Practice, 14*(2), 5-13.

Moss, P. (1996). Enlarging the dialogue in educational measurement: Voices from interpretive research traditions. *Educational Researcher, 25*(1), 20-28.

Moss, P. (1998). Testing the test of a test: A response to the multiple inquiry in the validation of writing tests. *Assessing Writing, 5,* 111-122.

Nichols, S., & Berliner, D (2007). *Collateral damage: How high-stakes testing corrupts America's public schools.* Cambridge, MA: Harvard Education Press.

Nystrand, M. (2006). The social and historical context of writing research. In C.A. MacArthur (Ed.), *Handbook of writing research* (pp. 11-27). New York: Guilford.

Odell, L. (1981). Defining and assessing competency in writing. In C. Cooper (Ed.), *The nature and measurement of competency in English* (pp. 95-138). Urbana, IL: NCTE.

Penrose, A.M. (1989). *Strategic differences in composing: Consequences for learning through writing.* Berkeley: University of California Press.

Phelps, L.W. (1989). Images of student writing: The deep structure of teacher response. In C.M. Anson (Ed.), *Writing and response: Theory, practice and research.* Urbana, IL: NCTE.

Porter, J. Sullivan, P., Blythe, S., Grabill, J.T., & Miles, L. (2000). Institutional critique: a rhetorical methodology for change. *College Composition and Communication, 51*(4), 610-642.

Porter, J., & Sullivan, P. (1997). *Opening spaces.* Greenwich, CT: Ablex.

Pringle, I., & Freedman, A. (1985). *A comparative study of writing abilities in two modes at the grade 5, 8, 12 levels.* Toronto: Ontario Ministry of Education.

Readings, B. (1996). *The university in ruins.* Cambridge, MA: Harvard University Press.

Rogers, R. (2004). *An introduction to critical discourse analysis in education.* Mahwah, NJ: Erlbaum.

Sacks, P. (1999). *Standardized minds.* Cambridge: Perseus.

Schon, D. (1983). *The reflective practitioner.* New York: Basic Books.

Shohamy, E. (2001). *The power of tests: A critical perspective on the uses of language tests.* London: Pearson Educational.

Street, B. (1984). *Literacy in theory and practice.* Cambridge: Cambridge University Press.

White, E.M. (1993). Holistic scoring: Past triumphs and future challenges. In. M.M. Williamson & B. Huot (Eds.), *Validating holistic scoring for writing assessment: Theoretical and empirical foundations.* Cresskill, NJ: Hampton Press.

Williamson, M.M. (1993). An introduction to holistic scoring: The social, historical, and theoretical context for writing assessment. In. M.M. Williamson & B. Huot (Eds.), *Validating holistic scoring for writing assessment: Theoretical and empirical foundations* (pp. 1-43). Cresskill, NJ: Hampton Press.

Williamson, M.M. (1994). The worship of efficiency: Untangling theoretical and practical considerations in writing assessment. *Assessing Writing, 1,* 147-174.

Yancey, K.B. (1999). Looking back as we look forward: Historicizingx writing assessment. *College Composition and Communication, 50,* 483-503.

10

CRITICAL PEDAGOGY AS INQUIRY

Challenging Programmatic and Institutional Traditions

Kelly Belanger and April Heaney

Inspired by the Brazilian educator Paulo Freire, critical pedagogies are distinguished from related approaches informed by cultural studies by "an explicit commitment to education for citizenship that reinvents the roles of teachers and students and the kinds of classroom activities they engage in" according to Ann George (2001, p. 93) in "Critical Pedagogy: Dreaming of Democracy." Because of these commitments to democratic practices in society and the classroom, techniques of critical pedagogies in the tradition of Freire, Henry Giroux, Peter McLaren, and others have been held up as exemplars of socially progressive teaching. At the same time, published reports of these pedagogies have been critiqued for lacking a basis in sound research that can justify the claims made for their effectiveness. Although it is true that experiments with critical pedagogy could benefit from more careful study using standard techniques from both qualitative and quantitative research, there is still an extensive literature of theoretically informed and deeply reflective discussions of classroom practices inspired by critical pedagogies (e.g., *Freire for the Classroom* [Shor, 1987], *Critical Literacy in Action* [Shor & Pari, 1999], *When Students Have Power* [Shor, 1996]).

Critical pedagogies, in their various forms, call for continual reflection on the part of both students and faculty as they experience together a shift in traditional classroom roles in which authority and decision making are shared in unconventional ways. This shift in roles itself often becomes the subject of an ongoing classroom inquiry, one that parallels and complements inquiry into the subject matter of the course (and that, too, is often negotiated with students when the class begins). As a result, techniques of critical pedagogy in and of themselves have the potential to enact socially progressive inquiry.

In this chapter, we trace a research-based process of developing a pedagogical vision for a writing-intensive course in which techniques of critical pedagogy were integral to a research and curricular project with socially progressive aims. The course we highlight is the foundation of a learning community called the Synergy Program at the University of Wyoming (UW), a program for conditionally admitted students that includes three courses: College Composition and Rhetoric, Political Science, and a first-year seminar called Critical Reflection in Intellectual Communities. The Intellectual Community course, the cornerstone of the learning community, was founded on strategies of critical pedagogy that we prioritized in the face of institutional pressure to offer a skills-based curriculum that administrators assumed would be in students' best interests. We see our vision for the program as socially progressive: to make the university environment more welcoming and effective for students who are often left behind in academe. Each year, thousands of young adults apply to universities despite marginal high school grades, little engagement with school, or low standardized test scores. Although for many of these prospective students, school or academic work has not been a high priority, they (and often especially their parents) understand the cultural and economic capital available through attaining a higher education. To earn that capital, they seek admittance to a college or university, and, once they arrive on campus, begin negotiating their new identity as college students. If institutions admit students conditionally whom they know to be "at risk" to succeed academically, principles of social justice insist they should provide appropriate support to these individuals.

In Fall 2003, 35 students labeled "conditional" because of low high school GPAs (below 2.5) or ACT scores (below 20 points) joined the Synergy program voluntarily and enrolled in three linked courses including the Intellectual Community course devoted to critical thinking, reading, and multimedia writing as well as community building and connecting to other Synergy courses. Throughout the semester, we conducted ongoing teacher-research as we piloted our vision for a socially progressive and academically effective pedagogy. In the classrooms we studied for this project, we invited students to play two important, unfamiliar, and potentially transformative roles—co-designers of the course and qualitative researchers. While they conducted quasi-ethnographic studies on university subcultures of their choice as part of their coursework, they also were engaged in designing many features of the course itself as it developed. Meanwhile, through informal assignments, discussions with the program's peer mentors, interactions with a graduate student participant-observer, conferences in our offices, and interviews with students in their dormitories or off-campus apartments, we asked them to reflect on the collective choices we made along the way. These reflections became part of a teacher-research methodology aimed at a minimally hierarchical research process, in which a range of participant/researchers could both pose and respond to questions about the course, its goals, and the implementation of its visions.

As faculty and administrators of the Synergy program, it was our task to guide the process of recording, collecting, and (long after the semester ended and students had moved on) analyzing data. Some of our attempts to flatten some of the hierarchical elements of many teacher-research projects worked better than others. Purchasing tape recorders for the students to take outside of class and use to interview each other about the course as it progressed was not successful. In the end, few of the recorders were returned to us and the recordings, although humorous at times, were not particularly helpful as research data. Still, sending students out with the recorders may have communicated our real commitment to enlisting students as co-researchers—not just the "the researched"—as the program was developed and assessed. Perhaps the most successful experience students encountered as researchers in the class was designing and implementing a mini-ethnography of a local community of the students' choice, an assignment that essentially asked students to broaden their (and our) understanding of course issues through their study and invited them to employ our classroom research methods in an individualized assignment.

Along with inviting students into co-researcher roles, another significant element of the program is the course's focus on issues of identity and success, particularly exploring how these factors are influenced by social class, a feature of identity often less visible among college students than race or gender but a long-standing concern of progressive thinkers concerned with democratic processes and decision making. Our methodology involved delving into students' and our own social-class identities from several angles. After obtaining institutional review board approval and informed consent from students, we first compared data from university records that included information about financial aid status and family income with information students shared in a series of tape-recorded interviews conducted with their permission in the spaces where they lived, where signs of their lives outside the classroom were more evident. Second, we used standard quantitative measures to determine the extent to which the program was successfully improving retention and academic achievement of conditionally admitted students, supplementing this data with deeper insights available through the qualitative methods. Finally, we kept detailed journals and field-notes and met regularly to discuss students' progress and work and our own reactions to course pedagogy, reactions we tried to better articulate through explorations of our own social class and cultural backgrounds.

THE CULTURE FACTOR: THE UNIVERSITY OF WYOMING'S RELATIONSHIP WITH SOCIAL CLASS

Like many educational programs, the Synergy Learning Community was funded and developed in a milieu of ideologically charged, competing institutional dis-

courses. Our research was shaped by and embedded in what Rubin (2003) characterizes as "a larger social, political, and economic framework marked by race and class-linked inequalities" (p. 543). Initial program developers chose a learning community model featuring purposefully connected courses, a strong support system, extracurricular events, and small class sizes to allow instructors to know each student as well as possible. When English faculty first learned of the nascent program, we heard arguments for developing a skills-based curriculum to compensate for students' perceived social, motivational, or cognitive deficits (an approach that contradicted our social constructivist approaches to literacy and learning). This basic skills, deficit-oriented vision also conflicted with the philosophy of the first-year writing program, which emphasizes teaching academic discourse from a writing across the curriculum perspective within a process-based, rhetorical pedagogy. Several writing instructors initially became involved in the new program in part to maintain the integrity of the writing course against the threat of a "dumbed down" appropriation of the course as it became part of this writing-intensive learning community housed outside the English Department.

Along with assumptions about students' literacy and cognitive deficits, common although often unspoken perceptions of "at-risk" students are that they disproportionately come from low socioeconomic backgrounds and for a variety of reasons, some but not all associated with socioeconomic status (SES), they are simply not "college material." These hasty assessments of conditionally admitted students' lack of fitness for college work among faculty and administrators at UW stems not only from nationwide cultural anxieties about SES, but also from UW's particularly complex relationship with social class. After the murder of Matthew Shepard, a gay UW student, on October 12, 1998, Wyoming residents (and Laramie residents in particular) grew increasingly sensitive to portrayals of Wyoming culture as "backward," "uneducated," and "in need of reform."

Located in Albany County, the poorest county in the state with a 21% poverty rate, UW has good reason to try and buffer its students against harmful representations of the city and state, especially considering that in 2003, 87% of the on-site students came from Wyoming towns.[1] Additionally, Wyoming falls below the national average for attainment of an associate's degree or higher, and although 87.9% of Wyoming adolescents graduate from high school, only 21.9% earn college degrees (compared with a 24.4% national average). These facts help to explain the need for a program like Synergy at UW and reveal the challenges that poor and working-class Wyoming students share with nonelite students everywhere as they pursue the upward mobility the university represents while negotiating relationships with their home cultures (see Leonhardt, 2005; Lubrano, 2004; Rose, 1989).

While speaking with faculty and administration at UW, Synergy instructors have encountered a common Wyoming sentiment that disadvantaged individuals need to take incentive for success into their own hands—a "sink-or-swim" mentality. This belief hinges around a conception that programs for at-risk stu-

dents do nothing more than "coddle" individuals who steal resources from more serious, more deserving students, and end up dragging the whole ship down (so to speak). These deeply rooted cultural attitudes, along with many faculty and administrators' unease about devoting resources to students they perceive as a threat to the university's integrity, may explain in part why we found it so difficult to gain institutional support for Synergy in its first few years despite promising retention and GPA data. In 2004, a combination of factors, including the creation of an administrative retention committee charged with forming concrete policies for conditionally admitted students, and Synergy receiving a national award, led to the learning community's expansion. And, as we discuss later, because the program gained external and internal recognition, our socially progressive pedagogy began to have marked changes on the university's approach to underprepared and disadvantaged students by influencing conversations about admissions policies and leading to the creation of other learning communities founded on Synergy's pedagogical approach.

PROFILE OF SYNERGY STUDENTS

In 2003, Synergy students represented a range of social-class backgrounds ranging from poor to upper middle class. This mix offered a potentially rich range of perspectives from which to explore "success" and introduce the analytic lens of socioeconomic class. Aware that social class can be difficult to classify without resorting to somewhat arbitrary standards that neglect important cultural factors, we based our classifications primarily on the Gilbert–Kahl Model (Gilbert, 2003), which includes six classes (underclass, working poor, working class, middle class, upper middle class, and capitalist class). As the model suggests, we considered "the occupation of a household's principal earner" and, when possible, students' family income and financial aid for college. But when a student seemed to straddle two of the categories, we considered any relevant cultural information acquired through interviews and writing assignments (i.e., information about neighborhoods, family members who went to college, number of siblings, financial circumstances such as "family money" or bankruptcies).

Except for the capitalist class, each of the Gilbert–Kahl Model's categories is represented in the Fall 2003 Synergy class:

- Underclass or working poor (13.6%)
- Working class (27.2%)
- Lower middle class (13.6%)
- Middle class: (36.3%)
- Upper middle class (18.2%)

Students admitted with conditions in Fall 2003 showed on average higher financial need and $10,000 a year lower family incomes than the larger UW student population. Of those students who enrolled in Synergy, 40.9% came from poor or working-class families and were first-generation college students. This percentage is somewhat higher that the 37% in the overall UW student population who are first-generation college students. The Fall 2003 class included at least five students who received Federal Pell grants, many who received a variety of loans, and two athletes on full scholarships (one from a working-class background, the other from an upper middle-class background, both male and from out of state).

The Synergy program attracts a disproportionate number of males, minorities, and students whose ACT scores, particularly in math and science, are lower than those of the conditionally admitted students who do not participate in the program. In the Fall semester, for instance, 72.7% of the Synergy students were male and 31.8% were minorities, in a university where minorities comprise only 8% of the student population. According to university statistics, males and minority students—as well as students admitted with conditions and first-generation college students—are at a higher risk for dropping out or failing than the overall population of students. As a result, students in the Synergy program often are considered "academically at risk" for multiple reasons.

The disproportionate representation of males among students in the Synergy program is more difficult to explain, although males are considered at higher risk for dropping out of high school, a trend that began in the 1970s, according to research compiled by the Southwest Educational Development Laboratory (SEDL, 2010). Along with gender (citing boys as more at risk), the SEDL study lists minority group status among eight background indicators (although not causes) of at-risk students. In an interview, one Black student in the Synergy Program recounts:

> There were a lot of Caucasians in my high school ... [it] had about four to five Black people and contained most of my family. I think at times it had an effect on me. Most of my complications that I had in school had to do with that. Racial slurs. (November 2003)

Other background factors include single-parent head of household, low SES, limited English proficiency, low educational attainment of parents, family mobility, psychosocial factors, and gender.

Besides background factors, the SEDL study (SEDL, 2010) cites three other factors associated with students not completing their high school educations:

1. behaviors (ranging from absenteeism and short attention spans to substance abuse and work commitments),
2. school practices (including instructional methods), and
3. contextual variables (such as school size and community norms).

Based on extensive interviews with students in 2003, we estimate that each year at least 30% of Synergy students are steeped in family and academic experiences that hurt their chances of succeeding at the university. Many students had no classroom experience with self-reflection or evaluation and few opportunities for discussion or sustained analysis of texts or ideas. Other than "getting the piece of paper" as one student called a diploma, they experienced little pleasure or meaning in academic work, failing to see any intrinsic relevance to their lives.

CHALLENGING A BASIC SKILLS APPROACH

Proceeding with the assumption that an institutional environment and classroom practices play a necessary although not sufficient role in helping any students succeed, the Synergy faculty, particularly beginning with the second year of the program, aspired to mirror the honors' experience by challenging students academically while supporting them with small class sizes (16 students in the Composition and Intellectual Community courses vs. 23 in regular courses), committed instructors, a challenging curriculum emphasizing active learning and democratic decision making, and support for enriching community activities. We knew that no matter how theoretically persuasive we might find this approach (and no matter how determined we were not to offer the "hidden curriculum" often served up to nonelite students), for the program to continue beyond the pilot stage, it needed to "work." That is, students had to earn higher grades and persist at statistically significantly greater rates than they would without the learning community.

As faculty responsible for the Intellectual Community course, we challenged the rudimentary skills approach that many administrators advocated or assumed was the only option, eventually deciding to gamble the program's future on a evolving critical pedagogy—one that increasingly focuses on student responsibility for learning and critical thinking about identity and success. Because Synergy students themselves often feel marginalized for a variety of reasons—not the least of which is a lack of investment in academic work—a curriculum founded on exploring the formation of identity and the quest for success among various groups of people, but particularly disadvantaged groups, seemed promising for improving student engagement and habits of thought. However, even before committing ourselves to experiment with classroom practices advocated by teacher-scholars such as Freire, Ira Shor, and others, we initiated a teacher-research and assessment process to allow for continual feedback and curriculum revision. In light of the institutional pressure for basic skills pedagogy, we understood the rhetorical and educational value of data-based arguments on which to base decisions about the curricula, pedagogy, and program design.

In 2001, while experiencing a tug of war among instructors between con-structivist and basic skills-based approaches to the first-year seminar course, we hired a graduate student in counseling to observe class sessions and conduct focus group interviews (he also tutored students and conducted periodic whole-class feedback sessions on the program without the instructors present). Results from these interviews showed that "students talked about how the instructors integrated the aspect of caring and wanting their students to have a successful semester. They identified that this aspect [of caring] was integrated across all the Synergy courses" (Graves, 2002, p. 7). At the same time, numerous students complained that "some professors act like they have to spoon feed us everything" (p. 1). Although well meaning, instructors often overemphasized students' immediate needs as a way to encourage their success, such as checking up on their homework, offering them extra tutoring time, giving them cookies and donuts in class, and arranging extensions of assignments. Those strong interven-tions may have given students the idea they could not handle college work on their own, reducing their sense of self-efficacy.

At this stage, Synergy faculty's pedagogies resembled what we later recog-nized as an "ethic of care" approach first described and advocated for by Nel Noddings (1984). As Nodding's critics have pointed out, an ethic of care can be perceived as patronizing in situations of unequal power relationships such as the student–teacher relationship if there is not an element of reciprocity in caring. In our search for a balance between the ethic of care and a challenging, democratic curriculum, we turned in Fall 2003 to strategies of critical pedagogy that empha-size power sharing in the classroom. As we began making this philosophical turn, we continued assessing the Intellectual Community course in particular through a series of taped interviews with students and faculty; fieldnotes and journals on most class sessions; and analysis of quantitative data in consultation with campus committees on retention and student success, the Office of Institutional Analysis, and the director of Enrollment Management. Additionally, one key assessment of the Composition course involved comparing students' midterm and final writing portfolio grades with grades from non-Synergy com-position courses.

THROUGH THE LENS OF SOCIAL CLASS: ENGAGING STUDENTS IN CRITICAL READING AND WRITING

Out of what sometimes seemed like a vortex of competing concerns, we crafted a curriculum for the Intellectual Community course that explored a nominal theme of identity and success, naming the theme "Identity Dialogues: The Search for Success in America." This theme invites varied approaches to critical reflec-tion on issues of identity broadly and complexly defined, but in Fall 2003 the

Intellectual Community course focused most purposefully on social-class identity, a factor often invisible yet frequently identified as a major predictor of academic and economic success (Gilbert, 2003; Sawhill, 2000). We wanted to explore how social class played a role in our students' relationships with academic work and their attitudes toward a university education. We also chose to focus on social class identity for Fall 2003 classes because we were working closely with members of the College Composition and Communication's Working Class Studies Special Interest Group via listserv discussions as a group of us from institutions across the country supported each other's efforts to employ critical pedagogies.

The theme surrounding identity and success played the most prominent role in the Intellectual Community course, where students had opportunities to read, reflect on, and discuss issues raised in the course texts. Students began the I-course by reading two books: Mark Hertsgaard's (2002) *Eagle's Shadow: Why America Fascinates and Infuriates the World*, a book that raises questions about how American politics oppress people in other countries as well as disadvantaged groups in the United States, and *Major in Success* (Combs, 2003), a compilation of advice and reflections on university success. Then, in both the Intellectual Community and Composition courses, students read LeAlan Jones and Lloyd Newman's (1997) *Our America: Life and Death on the South Side of Chicago*, a book written by two 11-year-old boys describing their lives in the South Chicago housing projects, a community they repeatedly compare to a war zone.

At midsemester, students chose from among four books to read and analyze in groups: *Geeks: How Two Boys Rode the Internet Out of Idaho*, John Katz' (2000) description of his relationship with two young computer "geeks" who dream of finding success outside their impoverished lives in Caldwell, Idaho; *Random Family: Love, Drugs, Trouble, and Coming of Age in the Bronx* (LeBlanc, 2004), Adrian Nicole Brown's inside look at socially destructive patterns affecting the lives of young women growing up in the bronx; *Across the Wire: Life and Hard Times on the Mexican Border*, Luis Urrea's (1993) narration of his experiences as a missionary among the desperately poor in Tijuana; and *Losing Matt Shepard: Life and Politics in the Aftermath of Anti-Gay Murder*, Beth Loffreda's (2000) analysis of the Laramie community before and after Matt Shepard's murder.

Faculty chose all these books in large part because they represent individuals striving through ethnographic methods to understand a community in hopes of gaining insight that could lead to positive social change. Additionally, all of the texts tell stories of people who faced a variety of obstacles in achieving their vision of success—obstacles related to their individual and group identities as well as social-class backgrounds. The book that students chose for their group book project became the basis for a series of Critical Reflection Essays and note-taking assignments in the Intellectual Community course. In the last third of the semester, students conducted an ethnographic research project of their own. These "mini-ethnographies" were modeled after the books students read throughout the semester, but were designed to become meaningful research proj-

ects in which students could connect with a community they found significant to their lives. Finally, students represented themselves, their backgrounds, their plans for the future, and their written work for the class on a Website they designed and constructed during the last weeks of the semester. Their oral presentations of the Websites constitute their final exam and the culminating activity for the Synergy Program (several of these assignments are discussed in more detail later in this chapter).

DEMOCRATIC DECISION MAKING AND CRITICAL THINKING

Recognizing the importance of hooking students into our theme and the academic work associated with it, during a 2-day, presemester "Synergy Seminar" in Fall 2003, held the weekend before classes began, we laid the groundwork for a semester of serious inquiry and critical reflection. Through focusing initially on the theme of "critical thinking about success," we "backloaded" (Shor, 1992) discourse on social class and identity. Our goal was to allow these issues to arise through class readings, activities discussions, and students' reflection on their personal experiences. As the course progressed, we wanted to guide students through a process of complicating their and our thinking about success and socioeconomic class (interrelated issues of gender, race, ethnicity, and other kinds of differences also arose in the course readings).

The theme of success seemed an appropriate subject for a course focused on making the transition to college, but we found that until we increasingly focused our own and students' attention on issues of class—making visible what bell hooks calls the elephant in the room—students had difficulty moving beyond the most surface approximations of critical thought. Especially in a program serving students who are ambivalent, resistant, or apathetic about the intrinsic value of a college education, we argue that investigating how socioeconomic class interacts with a multitude of other factors when people define and strive for "success" can be an empowering—though often sobering—catalyst for critical thought.

The process began, along with most of the university's "I" courses, by introducing critical thinking as habits of mind valued in the liberal arts tradition, described in Peter A. Facione's (1992) "Critical Thinking: What It Is and Why It Counts." Most recently, we have used a chapter from Michael Shermer's (1997) *How People Think About Weird Things* to introduce a language for discussing "critical thinking." From the beginning of the new "I" course, we worked with students to establish expectations for participation and standards for intellectual work, in part by collaboratively designing rubrics by which students would evaluate their development in the course. We saw this experience with democratic decision making as crucial for academically disenfranchised students unused to taking responsibility for learning in an academic setting.

Taking a more democratic approach to evaluation in the "I" course felt a bit risky for many of the same reasons it was necessary and crucial to the learning process. We would be placing key class decisions in the hands of students who, in past years, had been relatively unmotivated in their academic work, ambivalent about the value of anything to be learned in college, and sometimes unruly and disrespectful in class. Would they, like Shor's (1996) students in *When Students Have Power*, decide attendance was not necessary and negotiate themselves out of the chance to learn anything at all in the class? In Synergy's first years, we saw some of our students all too clearly in Chapter 6 of Shor's (1992) *Empowering Education*: playing dumb (asking teachers to answer the same questions again and again) and getting by (missing as many classes and assignments as they estimated to be possible while still passing the course). What we saw less of, however, was the strategy of "mimic[ing] the teacher's words or values in discussion, on a paper" just to get a good grade (p. 138). Despite our frustrations with students' habits of resistance, we enjoyed their energy in class and their refreshingly frank, although sometimes unpolished, reactions to a text or idea. So we wondered how much of students' disengagement would persist under a different, more critical-democratic pedagogy.

To implement a more democratic process and encourage student responsibility, on the first day of the presemester seminar we introduced the idea of co-designing rubrics in two areas: process and participation and critical reflection. As a prompt for thinking about critical reflection, we gave students a list of statements about critical reflection, many of them borrowed from Facione, and asked students to mark each statement as true or false. We asked students to join us in a process similar in spirit to the Delphi Method used by a group of international experts charged with "form[ing] a consensus about the meaning of critical thinking" (Facione, 1992). In this process, a central investigator collects input from the participants anonymously, compiles their ideas, and redistributes them for further discussion, repeating the process until consensus is reached. In class, students discussed their true or false answers in small groups and spokespeople reported back to the class. Together with the 14 students who attended the seminar (a little more than half of the class), we developed the rubrics that we would ask students to use three times during the semester to evaluate the growth of their critical thinking. These rubrics would also guide instructors in evaluating students' progress.

Working out the mechanics of this process created an engaging but tension-filled class that one student compared to the suspense over the outcome of Florida's votes in the 2000 presidential election. After creating the rubrics, students voted on how they would be graded over the course of the semester. They created options including giving students total control over their grades, giving instructors traditional authority over grades, creating a rotating student grading panel, and adhering to a system by which contentious grades would be averaged between the student's and teacher's score as long as students met with the instructor to discuss the grade first—an addendum suggested by instructors. In the end,

students voted by a rather narrow margin in favor of the averaging policy (over student-controlled grading). While the process captured students' attention, it also led April, one of the I-course teachers, to express some concerns in a subsequent post to the working-class research listserv:

> We realized this week after we collected the first of their self-evaluations that we left it unclear whether the averaging policy should be applied to only the Process and Participation rubric, or to both Process and Participation and Critical Reflection. I have some nagging doubts about carrying the policy over into Critical Reflection. The Process score seems a prime area where students have a strong and legitimate case to make—this score is determined in large part by the quality of their participation (and active listening) in class: their engagement in the course issues and interactions. The Critical Reflection score is based on their writing and reading notes, or their ability to demonstrate understanding and application of the elements of Critical Reflection that make up the foundation of the class. After receiving some very cursory self-evaluations claiming "excellent" from students who clearly at this point do not fit this category, I worry that they aren't taking the process seriously, that perhaps we're contributing to their vision of this process as a game or a joke. (September 26, 2003)

As we later learned from interviews near the end of the semester, some students at the presemester seminar shared our anxieties. They feared that in opening up the class and grading to so much student input, we were giving the class "too much leeway" that would result in instructors being "walked all over by the class" (Leslie, October 2003). This concern that the teachers maintain some appropriate authority may account for the students' votes that allowed us to maintain some power to evaluate them. Eventually, Leslie came to see value in the self-evaluation, albeit as a somewhat manipulative process for teachers to manage what she saw as students' inevitable challenges to class policies:

> I liked it because ... [students] can bite their own ass. Students chose it and this is how [they] wanted it to be. ... I think that's what I didn't realize at first. I was like why are they giving us so much leeway? And now I know, because you guys know what we have to look forward to. You are like this is how you want it, you want it to be like this. That's fine and students can't get mad at us.

Several of the students who had missed the presemester seminar never understood the purpose or accepted the validity of self-evaluation (in fact, the issue of how to handle students' absence from the seminar prompted a lengthy negotiation at the seminar). At the end of the semester, when we asked Tomas, a young man from an Hispanic immigrant family who never turned in a self evaluation, how he felt about being asked to grade himself, he said flatly that "It's difficult to gather everything you did and give yourself a grade. It's the teacher's job

to do that" (November 2003). Perhaps students like Tomas did not accept the process because they missed the seminar and were not involved in creating the rules or hearing our rationales we gave for seeking students' input (i.e., that negotiating reasonably with authorities and engaging in self-reflection were valuable life and school skills, that they would feel more invested in rules they contributed to making, that they would be more aware of what the polices and standards are). Or perhaps, as Lareau (2003) argues, poor and working-class students are less familiar—and therefore less comfortable—interacting through reasoning and persuasion with their parents or with school authorities. Instead of taking the opportunity to practice these skills, Tomas and others opted out. Some of the middle-class students seemed all too familiar with how negotiations with authorities can work. Several of them described having manipulated teachers and reported feeling disappointed with themselves after getting their way. One described "begging and begging" a high school to let him retake final exams he had failed (November 2003). For a variety of reasons about which we can only speculate, and despite our fears that we were opening ourselves up to be trampled on, not one student ever attempted to negotiate grades with us.

To address these complex cultural and power issues inherent in the evaluation process, we needed to move beyond the more narrowly defined, liberal arts model of critical thinking with which we began the Intellectual Community course. At least in the context of self-evaluations, the habits of mind emphasized on the rubric seemed to hold little relevance for the immediate, pressing concerns of students' academic or social lives. Few applied the rubric's criteria rigorously in their self-evaluations; few applied them to their discussions of social class and individual conceptions of success. In discussions, we observed an almost unshakable desire to view class members as a similar group of people with negligible variances in background—students seemed to feel most comfortable assigning an increasingly narrow, popularly defined notion of success to the class as a whole. This type of thinking mirrored the kind of sweeping statements we encountered in their self-evaluations of their critical thinking—a reluctance or inability to reflect on the complexities that each brought to the assignments, readings, and discussions, and how their differing identity positions played a role in their ability (and desire) to meet the rubrics' criteria.

During the first weeks of class, the group's collective ideas about successful lives had become a predictable litany of generic, generalized values: to earn enough money to be comfortable, to support a family, to do whatever makes you happy. This half-hearted response to the liberal arts model of critical thinking revealed more than simple laziness on the part of the class. It reflected a tendency to gloss over differences rooted in gender, race, class, or other identities that might be uncomfortable or painful to confront, especially in a first-semester college course. Whereas the liberal arts model of critical thinking encourages understanding other points of view, it stops short of offering questions that would challenge the easy commonplaces available in our culture's popular discourses about equality of opportunity and success.

To complicate readily available definitions of success, we needed to introduce a less homogenous picture of identity, one that includes factors that are less visible, such as social class. We wanted students to try on the postmodern idea that we have multiple and shifting identities, and if we examine them closely, we might find they are influencing some yet unarticulated beliefs about success.

COMPLICATING IDENTITY AND DEFINITIONS OF SUCCESS

In confronting students' tendency to "lump" people's goals and abilities into generalities, the Intellectual Community course instructors set up an activity designed to highlight less-than-obvious identity positions and explore how they might influence definitions of success. Recognizing that the two I-course instructors were similar in appearance, dress, occupation, and even mannerisms, Kelly conceived of an activity which asked students to compare her and the other instructor, April. She began by writing the word "WE" in large letters on the chalkboard. Then, standing next to April before a half-circle of Synergy students, Kelly asked simply, "What do you notice about the two of us?"

After a round of uncomfortable giggles and questioning looks, students settled into making comparisons. "You're both tall." "You both have brown hair." "You both enjoy your jobs." The discussion grew only slightly more complex when they were asked about differences. Based on information they picked up from earlier conversations, they made observations like "April is calm and quiet," and "Kelly is more outspoken and East Coast." As they became drawn into the exercise, they began questioning us about our political views and families. At one point, to prompt further thinking about differences that might not be obvious on the surface, we asked whether all teachers' jobs and social classes were the same. Kelly pretended for a few moments that she was married to a millionaire, leading to a few dramatic moments in which students considered how wealth might play a role in a teacher's relationship with work and peers. This question led students to debate whether a teacher in an inner-city school had the same social status as a suburban high school teacher or a college professor.

The activity continued with the instructors revealing more details of their backgrounds and some anecdotes about their current lives. One had grown up the youngest child in a poor family who spent some time on welfare before beginning to gain some financial footing. One had been raised the oldest child in a lower middle-class, highly competitive atmosphere with several female siblings. One had been encouraged academically—pressured, even, into striving for the very best grades. The other had been encouraged not to become too much of a "nerd." The differences and nuances of the two women's lives and motivations piled up over the course of the discussion. Kelly ended the activity by asking stu-

dents to consider again the word WE on the chalkboard. She pointed out the human tendency to make generalizations, to find similarities with which to group people, reminding everyone that the students had begun by focusing almost entirely on similarities. The students spent some time interviewing each other to reveal their own subtle differences, and then wrote a response to the class session.

Not surprisingly, students' attention seemed to have been captivated by hearing their instructors reveal fairly private details of their social class backgrounds. One wrote, "We all learned more about the professor's lives before teaching. To me, this builds trust. When you know issues on someone else's life you begin to interact … friendships are made." Our goal in the activity was not simply to emphasize the cliche that all people are different, but to help students recognize a messier picture of identity, one that includes factors that are less visible, such as social class. In emphasizing our own social-class backgrounds in this exercise, we also hoped to illustrate how class can powerfully affect academic and social success. Becoming more conscious of social-class identity, we reasoned, might help students to take advantage of the strengths of their socioeconomic class backgrounds, whatever they may be, while being aware that the values or habits stemming from that background could create obstacles or limit their perspectives in certain situations. Practicing this kind of awareness and self-reflection in the first 2 months of the semester was an important step toward developing several of the habits of critical thought listed on the class-designed rubric.

PROVOKING DEEPER REFLECTION: ROLE PLAYING, THESIS-SUPPORT ESSAYS, AND DIALOGIC INTERVIEWS

At midsemester, in the Intellectual Community course, students were assigned a "thesis support" Critical Reflection Essay based on the same books they were analyzing rhetorically in the Composition course. This assignment involves giving students "a controversial thesis to defend or attack," which John Bean (1996) argues supports critical thought by suggesting "a view of knowledge as tentative and dialogic where divergent interpretations of reality compete for allegiance" and calling for reasons, evidence, and attention to opposing views (p. 124). This assignment also offered practice in one of the student-identified elements of critical reflection: standing by a position or opinion and making a case for it. In this second of three Critical Reflection Essays for the class, we invited students to reflect on their own social-class backgrounds and consider how they influence their responses to course texts. We expected this assignment would push further students' thoughts about success in our society (and in a university setting) by prompting them to consider which factors boost or inhibit potential in our country—what kinds of systems promote or deny justice for individuals of varying

backgrounds. Specifically, students were prompted to write an individual reflection of their group book through the lens of Hertsgaard's statement in *Eagle's Shadow* that "social class and environment largely determine a person's chances for success in America." Then, as a group, they prepared a presentation that offered a refutation or support (or both) for Hertsgaard's claim based on the events in their book.

In end-of-semester interviews with students, students identified these group-book projects as the most memorable class assignments, and evidence from the interviews suggest that for some students, they prompted critical reflection about the source and validity of their beliefs about success. For the most part, however, their essays reflected somewhat dichotomous, social class-based readings of the texts, with the higher SES students mostly supporting Hertsgaard's deterministic thesis, and students from less-privileged backgrounds rejecting it. Consider how one upper middle-class student supports Hertsgaard's thesis in his Critical Reflection paper about the book *Geeks*, but offers little analysis to explain his suggestion that the upward mobility achieved by the boys in book was "luck": "I agree with Hertsgaard even more after reading *Geeks*; it is clear that success depends on the communities in which you are raised, the environment you live in, and where you stand in the social class. I will stand with Hertsgaard on his statement that our potential for success is almost entirely determined by our environment and social class. ... I see this story as a rare lucky occurrence." Later, after planning a presentation with his group about the book and listening to his peer's reactions, the same student reflects on how his background influenced his initial reading of the book and how the book gave his access to different life experiences (that only served to affirm his initial belief in economic and social determinism):

> I was brought up in a rich community in a suburb of [a large Western city] ... just from living in that environment where success is the normal it ties in with Hertsgaard's claim. People in my life are all successful and have good schools, opportunities, and money to get where they want to go. Most parents from my town own their own businesses and their kids will take it over ... whereas a kid in the country would not have this. Coming from a promising community, reading *Geeks* makes me see the other side of things ... where people don't grow up on the high side of social class and aren't expected to be successful. ... As I read *Geeks*, I discovered two computer geeks in Idaho were destined to never reach their potential as they were subjected to an environment that didn't accept their kind and were troubled with financial problems. For most people this would severely limit their potential for success but this book provides an example of how a few may find success. (November 2003)

Other students—mostly those from working-class backgrounds, reacted to Hertsgaard's claim angrily and emphasized the importance of the same examples

the more privileged student represents as mere luck. One student writes, "I lived in Rawlins on the less fortunate part of town. Did that stop my mom and dad from being successful? No! Based on my own life experiences, success is somewhat drawn out from mentors, parents, role models, etc. ... I say bullshit to Hertsgaard because look at Jesse and Eric in the book *Geeks*. I think Jessie and Eric would have still made it out of Caldwell, even if they hadn't met John Katz. ... Success isn't green and it doesn't come from your social class."

These examples display the strong emotions evoked by the assignment as well as students' tendency to offer what appear to be knee-jerk reactions that also reflect what they may feel they need to believe in order to imagine someone from their own social class background achieving success. While the assignment encouraged dichotomous responses despite our attempt to soften the "either/or" wording of Bean's sample prompts, it did help students begin to reflect on the factors that influence their response to economic determinism, including family environment and culture. Disappointingly few students occupied a middle space or used the writing assignment to explore reasons for exceptions to their points of view (and, it is important to note, only two-thirds of the students completed this assignment). It was only during extended one-on-one, dialogic interviews conducted initially for research purposes, that several students left our offices feeling somewhat unsettled by the contradictions and complexities exposed by more extended reflection and conversation about how their parents responded to their achievements and struggles in school, their social-class backgrounds, and their thoughts about class assignments and discussions. These students, in most cases, had already begun to address complexities in their written essays.

The best example of a student who demonstrates her willingness to wrestle with a less dichotomous view of social mobility than most of her peers is Maria, a Hispanic student whose grandparents had only a third-grade education and whose mother worked her way from the beet fields of Nebraska to gaining an administrative position at a university. In response to her chosen book, *Across the Wire*, she writes, "I think [my mom] would say that you can do anything and pull yourself up to anything. My critical thinking in that book is that a lot of people can't and that's sad. We have always had drilled into our head that we can do anything and become anything, but sometimes it's just harder." When asked in an interview how the book affected her attitude as a student, Maria's response demonstrates that she understands the important personal implications of what she chooses to believe, and she recognizes that her belief is a choice, a way of viewing and thereby constructing the world:

> I don't know if it motivates me. There are just some people out there that just can't make it and I don't want to think negative like that. When you actually think about it—it's something that made me angry in class—somebody said these people can pull themselves up and become anything they want just like we can. I was like, no they can't. If they make it they end up getting beat down. A lot of us are not being beat down. I want to believe that

we can become anything and I am going to try to cling to that so that I can become something instead of all of a sudden be shut down. (November 2003)

As these examples show, a recursive, multigenre approach to critical writing and thinking—combining role playing, rhetorical analysis, thesis-support writing, and dialogic interviews—prompted some students to engage the elements of critical thinking the class identified at the beginning such as examining evidence and opposing points of view, whereas others steadfastly and heatedly defended positions their backgrounds had formed. For most, this approach opened students' eyes to the idea that such a controversy about the effects of social class exists. For a few, they began to see that their own and others' attitudes toward the factors that aid and inhibit success could be a determining factor in their own futures. In all cases in which students completed the assignments, they invested themselves in a position and attempted to support it through both personal experience and outside evidence, a crucial first step in developing the critical habits of mind essential for critical thinking and writing.

PUTTING IT ALL TOGETHER: COMMUNITY RESEARCH PROJECT

By the final weeks of the course, students had opportunities to examine issues of identity, class, and success through three different lenses: an individualistic, liberal model for critical thinking; a postmodern perspective; and a more radical perspective grounded in economic determinism (we didn't name these theoretical perspectives for students, but they informed class activities and assignments). The final project for the course invited class members to apply these critical tools to a mini-ethnography of a community. After reading from Spradley and McCurdy's (1988) *The Cultural Experience* and receiving advice on research methods by a panel of expert professors, students chose a community to study in-depth by conducting observations and interviews with both "insiders" and "outsiders" to the community and writing detailed notes on their reflections. Students were encouraged to reflect, in part, on community members' definitions of success and abilities to achieve that success. The final component to the ethnography involved representing their study and findings on a Website.

The ethnographic research methods contained in the project were fitting for our goal to help students learn to identify the "rules for success" implicit in various communities, including academia and unfamiliar class cultures, and decide whether they wanted to conform to or push against those rules. As Lubrano (2004) argues, "College life is lived in a middle class space with middle class rules. People from the working class must change themselves—or at least impor-

tant parts of themselves—to fit in" (p. 81). Additionally, students had an opportunity to mimic the ethnographic process described in all of the group books, a process in which a researcher poses significant questions about a community and then attempts to answer those questions through "thick description."

The prompt for the mini-ethnography gave students great flexibility in choosing a community, by asking them to select a community that they belong to, wish to join in the future, or wish to learn more about. Because students had such freedom of choice, the communities they selected may reflect a pattern of aligning themselves with a certain class identity or set of values that they admire or feel comfortable claiming. For example, among the Wyoming resident students (10 total), all chose a community that emulates the values of the students' predominantly lower middle- or middle-class families. We recognize, too, that these choices may also have been influenced by the subjects of the group books, all of which focus on economically disadvantaged communities—although many students from upper-class backgrounds did not follow this trend. For example, Maria, the Hispanic student whose family had worked in Nebraska beet fields, chose to study theater majors, arguing in the end that theater majors do not use their education as a means to gain wealth, but rather to communicate marginalized and unpopular political views to the public. She writes in her ethnography:

> This community was truly original because they are taught to question society, and to talk about what people usually do not want to discuss (ex. Sex, drugs, war). Drama students believe that the play writes the truth and shows many things that people need to see and learn about. I found this surprising of the theater community because in a way drama students are leaders, martyrs, and revolutionists in today's society. I am sure that many outsiders of this community would not be aware of the message that theater students are always trying to send into the world in the form of simple school plays.

Tomas, a Hispanic student whose working-class, poor immigrant parents had pressured him for years to become a doctor, expressed great relief at his classmates' overwhelming opinion that success is not correlated with status or wealth. He chose to study local musicians (although he never finished the project). Other communities chosen by Wyoming students included campus security, rock climbers, Navy sailors, elementary school teachers, fire fighters, and graphic design majors (chosen by a student who hoped a graphic design degree would allow him to improve his family's body shop without alienating him from his family's culture). We were intrigued by these particular projects and their interviews because they reflected a degree of acceptance or rejection of striving for "mainstream" upward mobility through the college experience versus hanging onto a sense of defiance of that path. Although we did not prompt students to think about these issues at the time, we recognize now how valuable it would have been to ask students to think about the factors that led them to choose a

particular community—reflection that may lead to a deepening understanding of the unconscious variables that play a role in our decisions to embrace, investigate, or even distance ourselves from a variety of communities.

CONCLUSION

Our risky endeavor to counter the deficit, basic skills model with a more critical pedagogy did "work," to some extent, in the eyes of the administration, although, admittedly, we cannot pinpoint exactly which factors contributed to this success. Eighty-seven percent of Synergy students were retained from Fall to Spring 2003. Only 27% of the 2003 Synergy students were on academic probation at the end of the spring semester versus 63% of the comparison group (provisionally admitted students who did not join Synergy), and Synergy students had an average GPA of 2.39 (vs. 1.77 for the comparison group). The comparison group of students who did not participate in Synergy took the same required, general education courses their first year at UW, although these courses were unconnected, larger, and lacking an Intellectual Community course founded on democratic and critical pedagogies. Because it would have been almost impossible for us to avoid a personal investment in our students' performance, broad academic success indicators helped to provide some benchmarks for assessing the learning community's approach.

During Synergy's first year, before the program initiated a critical pedagogy in the Composition and Critical Thinking courses, Synergy students' final grades in the Composition course, as determined by the grading jury, reflected poorly when compared to regular Composition courses. "Regular" Composition students earned A: 25%, B: 47%, C: 23%, D: 3%, and F: 2%, whereas Synergy students earned A: 0, B: 39%, C: 15%, D: 38%, and F: 8%. In 2003, after extensive course revisions, Synergy's final Composition grades showed significant improvement: A: 28%, B: 48%, C: 24%, D: 0, F: 0.

Results like these led the administration to institutionalize and expand the Synergy Learning Community in the following years, nearly quadrupling the number of students and faculty involved from various disciplines. One consequence of our socially progressive approach to pedagogy in the learning community is that it made inroads into redefining the university's approach to at-risk students who had long been considered a "problem." Our research, presented within and outside the learning community, led some administrators to propose that conditionally admitted students constitute an important part of campus diversity, as they bring distinct cultural and class-based attitudes and identities unrepresented by many mainstream students. Additionally, Synergy's success helped to inspire similar pedagogical approaches in other learning communities on campus, including those aimed at athletes and undeclared students. These

consequences proved as dramatic as the effects of our pedagogy on the students in the learning community.

In assessing for ourselves the program's degree of success, we recognize the limitations of what can be accomplished in a single course, a single semester. Perhaps most striking are the challenges involved in breaking the cycle of social reproduction (like Perry, this volume, we are concerned with this issue). We learned the importance of getting students' attention, understanding their backgrounds, and earning their trust and respect relatively early in the semester. We came to appreciate the changes in habits and the leaps of faith required for them to experience our class as something a little different from the schooling in their pasts, something more than another hoop required in a degree-conscious society. And we learned that we certainly cannot predict which of the students will draw on some well of strong desire and persist against all signs to the contrary. We set out to help students gain the ability to assess a community and think critically about the role they wish to play in the community—the ability, more particularly, to truly feel and imagine in a realistic way what it is like to be part of a university community, to envision themselves—with all of their traits and experiences—functioning in what first was a rather foreign environment.

If students new to the university lack this ability to imagine themselves as successful college students, more often than not, they will benefit from seeing their struggle through the lens of social class. Whatever our class backgrounds, we bring into new settings an often inchoate sense that we are missing some crucial knowledge, cultural information we should know to make our way. As Shor suggests in a posting to the working-class research listserv, the missing pieces may fall into place with access to the language required to explore our social class identities. He argues that "Because social class as a factor is strenuously denied and dismissed in U.S. public discourse, we come of age without the lenses to see it at work in our autobiographies and in our society; we lack discourses to speak confidently and concretely about what class means and how to work with it. A key framework has been denied to our imagination of who we are, how we have been made, and what influences our choices and outcomes."

In the Synergy Learning Community, introducing a class-based analytic frame for critical thinking to a group of conditionally admitted students from varying social-class backgrounds—most of whom felt marginalized by the larger society—inspired significant leaps in critical thinking for a few and moderate leaps for many, increased a sense of economic determinism for others, and, we hope, left budding impressions on most that will continue to develop down the road.

ENDNOTE

1. Abolishing stereotypes can be tricky in a state where nearly 30% of schoolchildren qualify for free or reduced-priced lunches, real wages rank among the four or five lowest in the nation, and workers earn 75 cents for every $1 earned by the average U.S. worker (Loffreda, 2000).

REFERENCES

Bean, J. (1996). *Engaging ideas: The professor's guide to integrating writing, critical thinking, and active learning in the classroom.* San Francisco, CA: Jossey-Bass.

Combs, P. (2003). *Major in success: Make college easier, fire up your dreams, and get a very cool job.* Berkeley, CA: Ten Speed.

Facione, P. A. (1992). Critical thinking: What it is and why it counts. Retrieved February 15, 2010, from Insight Assessment: Measuring Critical Thinking Worldwide Website: http://www.insightassessment.com/9articles%20WW.html

George, A. (2001). Critical pedagogy: Dreaming of democracy. In G. Tate, A. Rupiper, & K. Schick (Eds.), *A guide to composition pedagogies* (pp. 92-112). New York: Oxford University Press.

Gilbert, D. (2003). *The American class structure in an age of growing inequality* (6th ed.). Belmont, CA: Wadsworth.

Graves, W. (2002). *Synergy program assessment.* Unpublished report on the Synergy Program. Laramie: University of Wyoming.

Hertsgaard, M. (2002). *The eagle's shadow: Why America fascinates and infuriates the world.* New York: Picador.

Jones, L., & Newman, L. (with Issay, D). (1997). *Our America: Life and death on the south side of Chicago.* New York: Pocket.

Katz, J. (2000). *Geeks: How two lost boys rode the Internet out of Idaho.* New York: Villard.

Lareau, A. (2003). *Unequal childhoods: Class, race, and family life.* Berkeley: University of California Press.

LeBlanc, A. N. (2004). *Random family: Love, drugs, trouble, and coming of age in the Bronx.* New York: Scribner.

Leonhardt, D. (2005, May 24). Class matters: The college dropout boom. *New York Times.* Retrieved February 15, 2010, from http://www.nytimes.com/indexes/2005/05/24/national/class/.

Loffreda, B. (2000). *Losing Matt Shepherd: Life and politics in the aftermath of anti-gay murder.* New York: Columbia University Press.

Lubrano, A. (2004). *Limbo: Blue-collar roots, white collar dreams.* Hoboken, NJ: Wiley.

Noddings, N. (1984). *Caring, a feminine approach to ethics & moral education.* Berkeley: University of California Press.

Rose, M. (1989). *Lives on the boundary: A moving account of the struggles and achievements of America's educationally underprepared.* New York: Penguin.

Rubin, B. C. (2003). Unpacking detracking: When progressive pedagogy meets students' worlds. *American Educational Research Journal, 40*(2), 539-573.

Sawhill, I. (2000). *Updating America's social contract: Economic growth and opportunity in the new century*. New York : Norton.

Shermer, M. (1997). *How people think about weird things*. New York: Henry Holt.

Shor, I. (1987) *Freire for the classroom: A sourcebook for liberatory teaching*. Portsmouth, NH: Heinemann.

Shor, I. (1992). *Empowering education: Critical teaching for social change*. Chicago, IL: University of Chicago Press.

Shor, I. (1996). *When students have power: Negotiating authority in a critical pedagogy*. Chicago, IL: University of Chicago Press.

Shor, I., & Pari, C. (Eds.). (1999). *Critical literacy in action: Writing words, changing worlds / a tribute to the teachings of Paulo Freire*. Portsmouth, NH: Heinemann.

Southwest Educational Development Laboratory. (2010). *Rural students at risk: In Arkansas, New Mexico, Oklahoma, and Texas*. Retrieved February 15, 2010, from http://www.sedl.org/rural/atrisk/why.html.

Spradley, J. P., & McCurdy, D.W. (1988). *The cultural experience: Ethnography in complex society*. Long Grove, IL: Waveland Press.

Urrea, L. (1993). *Across the wire: Life and hard times on the Mexican border*. New York: Doubleday.

11

ARCHIVE THIS!

Queering the Archive

K. J. Rawson

Particularly within the last few years, our understanding of archives in Rhetoric and Composition has been expanding. Two edited collections—*Working in the Archives: Practical Research Methods for Rhetoric and Composition* (Ramsey, Sharer, L'Eplattenier, & Mastrangelo, 2009) and *Beyond the Archives: Research as a Lived Process* (Kirsch & Rohan, 2008)—showcase the benefits of deeply engaging with our archival methods and methodologies. These collections expand our definitions of what counts as an archive and what counts as archival material. Lynée Lewis Gaillet's (2010) contribution to *Working in the Archives* provides a representative example of how scholars are extending the definition of archival materials for our field:

> I interpret the term *archives* broadly to include a wide range of artifacts and documents, such as (unpublished and published) letters, diaries and journals, student notes, committee reports, documents and wills, newspaper articles, university calendars/handbooks/catalogs, various editions of manuscripts and print documents (books, pamphlets, essays, etc.), memos, course materials, online sources, audiotapes, videotapes, and even "archeological" fragments and finds. (p. 30)

By broadening what counts as archival materials, definitions such as Gaillet's point to historical genres that may be especially useful for scholars in Rhetoric and Composition. Furthermore, Gaillet defines archives based on what materials can be included within them, which collapses archives as institutions and the

archival materials collected there. This is quite common, as even the Society of American Archivist's definition of archive, "the non-current records of individuals, groups, institutions, and governments that contain information of enduring value" (Society of American Archivists, 2010), does not distinguish between archives and archival materials, the container and the contained.

In this chapter, I offer three snapshots of queer archival practices that challenge normative conceptions of archives as document repositories and that continue to broaden our field's understanding of archives. Given the impressive lineage of rhetorical history and historiography, our field is particularly well equipped to interrogate, as Achille Mbembe (2002) articulates, the ways that "the time woven together by the archive is the product of a composition" (p. 21). As compositions, Mbembe explains that archives are:

> primarily the product of judgment, the result of the exercise of a specific power and authority, which involves placing certain documents in an archive at the same time as others are discarded. The archive, therefore, is fundamentally a matter of discrimination and selection, which, in the end, results in the granting of a privileged status to certain written documents, and the refusal of that same status to others, thereby judged "unarchivable." The archive is, therefore, not a piece of data, but a status. (p. 20)

Treating archives as a status is particularly important for oppressed communities who have been intentionally excluded from history, or only included in ways that would further enable and justify oppression.

Lesbian, gay, bisexual, and transgendered (LGBT) communities in the United States began to establish grassroots archives in the 1940s to respond to the systematic erasure of LGBT historical materials. Since that time, many institutional archives (e.g., university and public library collections) have worked to intentionally collect historical materials that positively represent LGBT people. While it would be possible to mine both grassroots and institutional archives for the LGBT materials that can be found there, to do so without a broader critical context would imbue archives with unquestioned authority and absolute power over representing LGBT lives. Although I am personally enchanted with archives and committed to their importance, I have learned in my research on transgender archiving that it is important to approach archives as "a status," as institutions that privilege some while oppressing others, even within libratory frameworks of archiving presumably positive representations of LGBT materials.

In Linda Ferreira-Buckley's (1997) contribution to Octalog II, aptly titled "Serving Time in the Archives," she calls for historians of rhetoric to return to the archives: "We must make archives our starting point, for failing to do so weakens both our historical accounts and our theorizing. Ten years ago our histories were undertheorized; today I fear they are underresearched" (p. 28). Although she acknowledges that researchers may be forced to start with *"fragments of local*

histories," she still warns that "primary materials should ground our projects, however slow and painstaking the work, however incomplete the records" (p. 26). But what counts as "primary" materials? As Antoinette Burton (2005) argues, "all archival sources are at once primary and secondary sources: neither raw nor fully cooked ... but richly textured as both narrative and meta-narrative, as both archive and history-in-the-making" (p. 12). Burton's point is that archives are temporally complex sites that are at once past and future oriented and that as a consequence, our sharp divisions between primary and secondary sources are perhaps not as straightforward as we imagine. Furthermore, if we recall Mbembe's point that archives privilege *written* documents, we also can see how quickly "primary" becomes equated with textual archival documentation, which is certainly only one approach to historical memory and representation.

The question "What counts as 'primary' materials?" is particularly vital for LGBT historical materials because it has important consequences for contemporary and future representations of still-oppressed LGBT communities. If we draw firm lines of truth and narrowly define what counts as primary evidence, entire factions of LGBT communities would be systematically excluded. Perhaps a better question for challenging archives as a status, then, is: How are archives *queered* in order to evidence "unarchivable" LGBT people and experiences?[1] Also, when the "unarchivable" is archived, how does that fundamentally alter the power of archives and their position as arbiters of historical fact?

To begin answering these questions, I offer three snapshots of queer archival practices that are nontraditional, anti-institutional, and ephemeral. They challenge basic understandings of what counts as evidence and where and how LGBT experiences can be represented.[2] These snapshots confront even the basic validity of archiving itself. Some might argue that it is inaccurate to consider these practices archival at all. But the argument that I am forwarding here is that if scholars of Rhetoric and Composition turn to institutional archives to seek LGBT historical materials without a critical understanding of archives as a status, we will be complicit in the political underpinnings and power dynamics of those archives, which determine whose materials are collected and what factions of LGBT communities are representable. By queering the archive, we can re-imagine the parameters of our evidence and the sources of our histories, which is relevant not merely for our interests in and commitments to LGBT people and histories, but for our field's reliance on archives more broadly.

SNAPSHOT 1: EMBODIED ARCHIVING

I was glad I had not eaten lunch when I walked into the gallery at the American University Museum on February 11, 2006. As I walked through the gallery and absorbed Mary Coble's work, in particular her installation titled "Note to Self,"

the gravity of her art settled on me. In an endurance performance, Coble had more than 100 names of LGBT hate crime victims tattooed all over her body with an ink-less tattooing needle (Fig. 11.1). As each tattoo was completed, a small piece of paper was blotted against it, producing a name written in mirror-imaged blood that was then posted around the gallery (Fig. 11.2). The exhibit I witnessed recalled the performance through photographs and a tidy display of the papers with the names.

Fig. 11.2. Mary Coble, "Wall Documentation" (from Note to Self).

Fig. 11.1. Mary Coble, "Untitled 1" (from Note to Self).

Although folklore and concerned parents would have you believe that tattoos are forever, they are only as long as a human life time (if they are not surgically removed even sooner). In the particular case of inkless tattoos, Coble estimated that the scars would last for about 6 months. She chose inkless tattoos because, as she told an interviewer with *The Washington Post*, "This isn't a memorial" (Dawson, 2005). By dissociating herself from a memorial, Coble resists the possibility that her performance is meant to provide a static tribute to these victims. Instead, she explains, "I want people to see a compilation of names, not to individually mourn, but to understand the broader scope. That this is going on, and people are not keeping track and taking note of it" (O'Sullivan, 2005). Her performance gains meaning, then, when people see it as a testament to the broader scope of this issue.

In this performance, Coble uses her body as a queer archive, challenging the historical erasure of LGBT murder victims, the invisibility of LGBT hate crimes, and more typical means of archiving such information. Although a monument might last longer than fading tattoos, Coble's bodily archive performs a type of queer temporality that does not unquestioningly embrace longevity and readability, but rather uplifts the immediate and fleeting remembering of performance.

Coble's performance is a queer response to many traumas: the trauma of hate crimes against LGBT people and the reverberations of those crimes within LGBT communities, the trauma of historical erasure, and the trauma of not having functioning archival practices. In the introduction to *An Archive of Feelings: Trauma, Sexuality, and Lesbian Public Cultures*, Ann Cvetkovich (2003) discusses the ways that trauma necessitates new archival strategies:

> [T]rauma challenges common understandings of what constitutes an archive. Because trauma can be unspeakable and unrepresentable and because it is marked by forgetting and dissociation, it often seems to leave behind no records at all. Trauma puts pressure on conventional forms of documentation, representation, and commemoration, giving rise to new genres of expression, such as testimony, and new forms of monuments, rituals, and performances that can call into being collective witnesses and publics. It thus demands an unusual archive, whose materials, in pointing to trauma's ephemerality, are themselves frequently ephemeral. (p. 7)

Coble's tattoo performance commemorating victims of LGBT hate crimes would certainly qualify as an "unusual archive," an ephemeral memorial, and a queer response to trauma. As an antitraditional archival practice, Coble relies on the collective witnessing and publics that Cvetkovich discusses in order to enact a queer remembering. Hers is a queer response to trauma because Coble's practices respond to historical erasure by creating new genres of expression.

The 8-hour tattoo performance also was a queer response to trauma in that it staged a traumatic event. Coble chose to tattoo herself as a parallel to the frequency with which LGBT victims had words like "faggot" or "dyke" etched into their skin (Dawson, 2005). She reenacted this history to make a statement about the way violence and historical negligence work on and against LGBT people. Despite the few high-profile LGBT hate crimes, Coble in fact found that the most difficult part of this project was actually collecting victims' names (O'Sullivan, 2005). Through her performance, Coble's body became a type of raw and corporeal publication of her research findings. Because the performance was videotaped, photographed, and documented with the index cards, the seeming transience of the performance is slightly misleading—although the performance was only done once and the tattoos will fade from her body, the related materials could endure much longer. While they will never fully capture the magnitude of the performance, the evidences of Coble's performance can serve as a partial recollection, paralleling the ways that material remnants of LGBT murder victims only partially recollect their lives.

In her more recent work, Coble has shown a continued interest in using performance and the body as an archive. In a three-part series of performances, MARKER NEW YORK (2006), MARKER DC (2007), and MARKER MADRID (2008), "Mary Coble stood silently for three hours while viewers were invited to

write in marker on her body derogatory words that had been spoken against them, or slurs that they had used or had heard used against others" ("Blood Script," 2008). She collected these slurs and selected the 75 most popular ones. Again, she staged an endurance performance called "Blood Script" where these words were tattooed onto her skin with an inkless tattooing needle. This time, the words were etched in an ornate script.

As the overview of the performance explains, "Using decorative letters, Coble creates a dichotomy between the beautiful visual form of the words and the ugly meanings they convey semantically" ("Blood Script," 2008). The use of ornate script was an intentionally rhetorical presentation of the words that Coble embodied. Although these performances were not particularly focused on LGBT communities, Coble's work continues to use the body as a method for confronting trauma. Unlike "Note to Self," Coble's more recent "Blood Script" used the marker performances as an unconventional means of data collection. Given that she tattooed the slurs that were most frequently written on her body, it was as if the hands that wrote on her with a marker were eventually also the hands of the tattoo artist.

This embodied archiving is queer because it is a practice of accounting for the past that confronts historical erasure and omission, incorporates affect and trauma, and undermines an unequivocal embrace of longevity. Coble's body archive dramatically parallels the violence LGBT people regularly face and responds to historical erasure, not by simply filling it in with traditional written documentation, but by embracing a queerer temporality that uses the body as a site of transient memory. Her work queers the archive by confronting the archival displacement (or erasure) of LGBT bodies and by confronting the particular vulnerabilities of LGBT people in archival contexts. Names in a database just would not do.

SNAPSHOT 2: THE FICTIONAL ARCHIVE

As Coble's difficulty in finding names of victims of LGBT hate crimes evidences, even in the contemporary moment there are still circumstances in which LGBT lives and experiences are forgotten or erased. Such erasure too often happens along racial or class lines, or in the case of illegal or illicit behavior. Faced with this problem, other artists have created "fictional" remembrances of historical figures and events that are either entirely or partially fabricated. Such fictions are not merely in lieu of absent history, but in the face of it, to confront it and to create new histories that reflect queer desires. Two examples of this type of created archive are the Fae Richards Photo Archive and Glenn Ligon's art installation "Lest We Forget."

In the process of making the 1996 mockumentary film *The Watermelon Woman*, Cheryl Dunye (1996) compiled the "Fae Richards Photo Archive, 1993-1996," which "consists of seventy-eight black-and-white photographs, four color photographs, and a notebook of seven pages of typed text on typewriter paper" (Cvetkovich, 2003, p. 240). The film *The Watermelon Woman* follows "Cheryl" (played by Cheryl Dunye), an African American lesbian and aspiring filmmaker, as she attempts to piece together the biography of the (fictional) Black lesbian Hollywood actress from the 1930s, Fae Richards (a.k.a. "The Watermelon Woman"). The movie maintains the documentary feel so well throughout the film that many viewers are surprised by the spoiler near the end of the movie that reads, "Sometimes you have to create your own history. *The Watermelon Woman* is fiction."

But what is fiction? Although Dunye created the Black lesbian actress Fae Richards, could she reasonably assume that such a person did exist even if we do not have a record of her life? *The Watermelon Woman* is not merely an experimental film, but it also is a protestation against the historical erasure of Black lesbians and binaristic definitions of fact and fiction. If there are no materials to document a person's life, the film seems to be asking, does that mean that person never existed? If certain groups of people are systematically omitted from history, intentionally or otherwise, how can fact be solely determined by the existence of historical records?

Although Fae Richards never existed, we now have the Fae Richards Photo Archive, an archive that "documents" the life of a Black lesbian actress from the 1930s (Leonard & Dunye, 1996). The Fae Richards Photo Archive opens the possibilities of what can be counted as fact and proposes an archival practice that is both adaptive and creative. In the book, *In a Queer Time and Place*, Judith Halberstam (2005) similarly calls for archives to become more fluid, "to become a floating signifier for the kinds of lives implied by the paper remnants of shows, clubs, events, and meetings" (pp. 169-170). Understanding an archive as a floating signifier acknowledges that there is always some distance, some disparity, between the materials collected in an archive and the lives they recollect. When archives are floating signifiers they invite, and indeed require, interpretation and imagination. As such, materials in an archive are only implications of lives and events—they are never constitutive—and they require the participation and interpretations of others in order to make meaning from them.

We might understand the Fae Richards Photo Archive as the ultimate floating signifier given that it has no attachment to a historical figure or event (with the exception of being attached to the creation of the film). Consequently, it confronts those who see it with large-scale questions about historical erasure, traditional archiving, the value of preserving history, and the possibility of historical "truth." In encountering the materials in the Fae Richards Photo Archive, a person is not actually offered a historical account of a Black lesbian actress from the 1930s, but a fragment of a history of the creation of *The Watermelon Woman*, a film that critiques unquestioned embraces of archival materials as historical

authority. When particular histories do not exist, it is not always enough to just continue looking for them … sometimes they need to be created.

Another example of a created archive is Glenn Ligon's art installation titled "Lest We Forget," displayed in Artpace San Antonio in 1998. In his discussion of the installation in an interview with Rachel Middleman (2006) titled "History With a Small 'H:' A Conversation with Glenn Ligon," Ligon explains that his exhibit consisted of a series of "metal plaques inscribed with personal anecdotes about cruising and desire" that were illegally displayed around the city in public spaces (p. 465).[3] Closely resembling the historical markers common in a tourist area, Ligon's plaques were meant to fit in and stick out at the same time, although he couldn't be sure if they would be noticed at all (Fig. 11.3).

Fig. 11.3. Glenn Ligon: "A Guy in Uniform" (from Lest We Forget).

Fig. 11.4. Glenn Ligon: "A Guy in Uniform" detail (from Lest We Forget).

The purpose of Ligon's illegal, expensive, and nontraditional art? He explains:

> I wanted people to think about public spaces, particularly queer uses of public spaces, because there was some cruising going on in the downtown area. … I was thinking that rock plaques are about the official record and asking what it would mean to do things that were in the same language but were about the temporary, the transient, and the illicit. And even beyond that, about things that were so ephemeral maybe they didn't even really happen, things that don't really leave a trace. (cited in Middleman, 2006, pp. 466-467)

As this rich quotation demonstrates, Ligon's project challenged the official record by providing an alternative type of evidence and historical archiving that would account for passing queer uses of public space, the kind of use that does not "leave a trace." As we can see in the close up of "A Guy in Uniform" (Fig. 11.4), some of the plaques recall cruisings that did not materialize, or may have been imagined altogether. Unlike a traditional historical plaque, they are written in the first person, inviting readers to identify with the speaker. They suggest a queer use of space, a queer public (although sometimes an unfulfilled) *desire*.

As an underground activity, queer cruising is difficult to account for archivally—it leaves few traces of its happening because while cruising itself is not illegal, its frequent outcome—public sex—is illegal. Even if cruising could leave behind evidence (notes on a bathroom wall? used condoms?), how well could it capture the complexity of public cruising? To parallel this activity, the plaques "have to be about this 'notice me, don't notice me.' They have to remain a bit obscure. They have to mimic, to look like other things, like cruising in public space has to look like you're just going to the bathroom or like you're just reading your book on the bench" (p. 472). Ligon's plaques reimagine evidence, or imagine it altogether, which is precisely why this work is a queer archive and queers the archives. Unlike other archival projects, Ligon's art does not seek to represent history or historical truth. The installation is playful and mocking—it engages with "History" through mimicry, by showing how easily history can be constructed.

Like the fleeting history Ligon attempts to capture, his plaques are equally vulnerable to erasure. Ligon left his plaques "to be discovered, stolen, or removed by whoever encountered them subsequently" (p. 465), although he did photograph them when they were first placed. He acknowledges that "It's kind of ridiculous to put up a bronze plaque and let it be stolen. I kind of liked that, so much of the work was about the disappearance of that thing" (p. 471). Like Coble's fading tattoos, the disappearance is part of the production because it enacts a type of fleetingness, a queer temporality. The disappearance was so important to Ligon, in fact, that some of the plaques were only hung with double-sided tape, an obvious commitment to the short-term intention of his installation. Ligon argues that his project makes "room for history with a small 'h.' All the other bronze plaques are about the big 'H,' the official history" (p. 471), and I would add, the History that refuses the queer evidence represented by Ligon's removable plaques.

Like Dunye's Fae Richards Photo Archive, Ligon created a specific history from a more general knowledge that something like his version of history occurred. For communities whose history has been systematically erased, such a refiguring of evidence and archival possibility may be the only way to reconcile historical silence and shape queer futurity. As Ligon and Dunye's work demonstrates, queer archiving can challenge capital "H" history by refiguring evidence to account for historical silences, queer temporality, and queer uses of public space, all of which evade traditional history and historical evidence.

SNAPSHOT 3: BURN THE ARCHIVE

On May 2, 2008, I presented a paper about the importance and complexities of transgender archiving at the TransSomatechnics conference in Vancouver, British

Columbia, where I stressed the rhetorical considerations that needed to be accounted for when a researcher approaches transgender materials in an archive. Like other archive-loving researchers, I uplifted archives, in this case LGBT archives, as unquestionably beneficial, and the effort to collect as much history as possible as a universal goal. I had only resumed my seat for a few minutes before the foundational assumptions of my talk were upended.

The presenter who followed me discussed a historical figure, Alan Hart, who burned evidence of his life in what seems to be an attempt to control how he would be remembered. According to a Website hosted by the Oregon Cultural Heritage Commission, "Alan died of heart disease on July 1, 1962. In accordance with Alan's will, his body was cremated. ... The will also provided that no memorial be erected or created, and he instructed his attorney to destroy certain letters and photographs contained in a bank safety deposit box and in a locked box in his home" (Booth, 2008). As a published medical doctor, Hart was not destroying all traces of his life, but seemingly only ones that revealed that he was born female.

Why would Hart save materials until his death if he would then order them to be burned? Like his body, the materials evidenced his transsexual life only as long as he was alive.[4] Upon his death, both his body and his personal archives were burned in what might be read as a ritualistic cleansing. Perhaps Hart was aware that future generations might find his story fascinating, that some might relish in the shock of his transsexual experiences.

Less than two decades after his death, Jonathan Ned Katz (1976) "recovered" Hart and maintained that Hart was "clearly a Lesbian, a woman-loving woman" (p. 277). As was the case with Hart, gay (and sometimes lesbian) historians have resolutely argued that particular transgender historical figures may have been posing as men or women, but they were "actually" gay or lesbian. I imagine that this is precisely the type of rewriting of history that Hart was attempting to prevent by burning his materials in the first place. Contemporary LGBT historians and scholars continue to argue over the "true" identity of people like Hart, despite what seems to be his clear commitment to being male. Yet even in granting that Hart was a transsexual man, contemporary writers (myself included) are still violating the past that Hart tried to burn from the record. I, along with the handful of others who circulate the story of Alan Hart, am implicated in the continued outing of Hart as a female-to-male transsexual against his clear wishes.

The juxtaposition of the presentation on Alan Hart and my own presentation was a compelling example of the vastly different relationships that transgender people (and LGBT people more broadly) can have to preservation and archiving. (See Powell, Chapter 14, this volume, for discussion of similar issues.) Indeed, it is as important to carefully examine who is left out of archives, as it is to examine who is included. As Hart's story illustrates, archiving is not always a desirable venture because material traces can betray a person's carefully constructed identity. LGBT archiving should encourage us to pause to consider the violence we have the potential to inflict on historical figures in our archival practices and

research findings—we may label anachronistically, use history for our own agenda, distort the historical record, dig up materials that were never meant to resurface, and violate a person's right to self-identification. Archival research is saturated with ethical decisions, as LGBT archives remind us.

More specifically, Hart's story queers the archive by being opposed to the very idea of archiving, of preserving the material traces of lives. While Coble, Dunye, and Ligon all engage with history of some sort (be it with a lowercase or a capital "h"), historical engagement is not always the ultimate goal for all LGBT communities. Just as Katz appropriated Hart for his own argument, archiving exposes LGBT people to future interpretation and appropriation that is out of their control and may be in direct contrast to their desired memory. Are archives, as floating signifiers, always complicit in this representational vulnerability? Or are there queer archival strategies that might allow for researchers to engage with LGBT histories, and the histories of other oppressed groups, in less potentially harmful ways?

CONCLUSION

Sarah E. Chinn (2008) observes in an issue of *GLQ* that, "With a few (although notable) exceptions, academic rhetoricians have been slow to integrate queer theory into their work" (p. 445). Chinn's observation likely is not surprising to readers of this book; I do hope, however, that such critiques might encourage scholars in our field to undertake the difficult work of not only engaging with LGBT materials, but via queer theory, to engage with LGBT materials queerly. One way of beginning this project is by broadening our understanding of what counts as an archive so that, as a field, we can meet LGBT texts and knowledge productions on their own terms rather than just on ours.

These three snapshots of queer archiving call for a reevaluation of how we understand archives, how we approach them, and how they figure in our field. In providing these examples, I do not want to offer anything resembling a taxonomy of queer archiving. As with the debated definitions of queer, there is no singular queer archival practice and there is no definable methodology for approaching LGBT texts in traditional archives. Instead, the work of this chapter as a whole has been to begin queering the invisible workings of our historical structures, including archives, archival methodologies, definitions of evidence, and theorizations of truth. I have sought to continuously ask: in archival practices, who is made visible and who is erased? This is a critical question, not just for queer archival work, but for any socially progressive and ethically responsible research that begins in the archives.

ACKNOWLEDGMENTS

I thank Margaret Himley, Lois Agnew, Eileen Schell, and Stephanie Crist for feedback and advice about this chapter. Thank you also to Katrina Powell and Pamela Takayoshi for their editorial guidance and their perseverance throughout this process.

ENDNOTES

1. Throughout this chapter, I intentionally distinguish between "LGBT" and "queer." LGBT is meant to signify groups of people who are categorized based on shared identity categories. Although "queer" also can signify an identity, I am instead using it as an analytic critique of normativity, particularly heteronormativity. For a good introduction to the continuing relevance of "queer," see the *Social Text* special issue "What's Queer About Queer Studies Now?" (Fall-Winter 2005).
2. This might be usefully connected with the work of feminist rhetorical historiography, which has asked similar questions about what counts as evidence of feminist rhetoric(s). The debate between Xin Liu Gale, Cheryl Glenn, and Susan Jarratt in a 2000 issue of *College English* is a particularly good example of the ways that scholars in our field have confronted the challenges of accounting for and representing historically oppressed people.
3. *Cruising*, in gay culture, is the public solicitation of sex, often through an intricate and complexly coded sign system.
4. My labeling Hart *transsexual* is not an uncomplicated decision. My use of *transsexual* is meant to signify that Hart underwent sexual reassignment surgery, one of the earliest (if not *the* earliest) on record in the United States (Note: medical records, as Hart must have known well, can be stubbornly difficult to eradicate). As I use *transgender* in other parts of this chapter, I mean it to imply the broad spectrum of gender nonconforming people.

REFERENCES

"Blood Script Statement." (2008). *Mary Coble*. Retrieved March 13, 2010, from http://www.marycoble.com/pages.php?content=galleryBig.php&navGallID=90&navGallIDquer=90&imageID=17&view=big&activeType=.

Booth, B. (2008). Alberta Lucille Hart/Dr. Alan L. Hart: An Oregon "Pioneer". Oregon Cultural Heritage Commission Website. Retrieved May 23, 2008, from http://www.ochcom.org/hart/.

Burton, A. (2005). Introduction: Archive fever, archive stories. In A. Burton (Ed.), *Archive stories: Facts, fictions and the writing of history* (pp. 1-24). Durham, NC: Duke University Press.

Chinn, S.E. (2008). Keeping secrets. *GLQ, 14*, 2-3.

Cvetkovich, A. (2003). *An archive of feelings: Trauma, sexuality, and lesbian public cultures.* Durham, NC: Duke University Press.

Dawson, J. (2005, September 1). An artist pricks her skin and our conscience over hate crimes. *The Washington Post.* Retrieved June 21, 2010, from http://www.washington-post.com/wp-dyn/content/article/2005/08/31/AR2005083102684.html

Ferreira-Buckley, L. (1997). Serving time in the archives. "Octalog II: The (Continuing) Politics of Historiography." 1997 CCCC Panel. *Rhetoric Review, 16*(1), 22-44.

Gaillet, L.L. (2010). Archival survival: Navigating historical research. In A.E. Ramsey, W.B. Sharer, B. L'Eplattenier, & L.S. Mastrangelo (Eds.), *Working in the archives: Practical research methods for rhetoric and composition* (pp. 28-39). Carbondale: Southern Illinois University Press.

Gale, X.L. (2000). Historical studies and postmodernism: Rereading aspasia of miletus. *College English, 62*(3), 361-386.

Glenn, C. (2000). Comment: Truth, lies, and method: Revisiting feminist historiography. *College English, 62*(3), 387-389.

Halberstam, J. (2005). *In a queer time and place: Transgender bodies, subcultural lives.* New York & London: New York University Press.

Jarratt, S.C. (2000). Comment: Rhetoric and feminism: Together again. *College English, 62*(3), 390-393.

Katz, J. (1976). *Gay American history: Lesbians and gay men in the U.S.A.* New York: Thomas Y. Crowell.

Kirsch, G.E., & Rohan, L. (Eds.). (2008). *Beyond the archives: Research as a lived process.* Carbondale: Southern Illinois University Press.

Leonard, Z., & Dunye C. (1996). *The Fae Richards photo archive.* San Francisco: Artspace.

Mbembe, A. (2002). The power of the archive and its limits. In C. Hamilton et al. (Eds.), *Refiguring the archive* (pp. 18-26). Cape Town, South Africa: David Philip.

Middleman, R. (2006). History with a small "H": A conversation with Glenn Ligon. *GLQ, 12*(3), 465-474.

O'Sullivan, M. (2005, September 2). "Note to Self": Painful reminders of crimes. *The Washington Post,* p. WE47.

Ramsey, A.E., Sharer, W.B., L'Eplattenier, B., & Mastrangelo, L. (Eds.). (2009). *Working in the archives: Practical research methods for rhetoric and composition.* Carbondale: Southern Illinois University Press.

The Society of American Archivists. (2010). So you want to be an archivist: An overview of the archival profession. Retrieved February 1 2010, from http://www. archivists.org/profession/overview.asp.

The Watermelon Woman. (1996). DVD. Director Cheryl Dunye. Producers Barry Swimar and Alexandra Juhasz. FirstRunFeatures.

ILLUSTRATION CREDITS

Fig. 11.1: Coble, Mary. "Untitled 1." *Note to Self.* 2005. Courtesy of Connor Contemporary Art.

Fig. 11.2: Coble, Mary. "Wall Documentation." *Note to Self.* 2005. Courtesy of Connor Contemporary Art.

Fig. 11.3: Ligon, Glenn. "A Guy in Uniform." *Lest We Forget*. 1998. Originally commissioned by Artpace San Antonio. Photo credit: Seale Studios, Dennis Cowley.

Fig. 11.4: Ligon, Glenn. "A Guy in Uniform." Detail. *Lest We Forget*. 1998. Originally commissioned by Artpace San Antonio. Photo credit: Seale Studios, Dennis Cowley.

12

IDENTIFYING CHOICES

Rhetorical Tactics in a Prison Art Program

Wendy Wolters Hinshaw

> All women's prison texts are political, each speaking uniquely for
> silenced women behind bars and prison walls.
> —Judith A. Scheffler, Wall Tappings

In this chapter, I analyze how art and writing empower prisoners to counter reductive representations of criminality. Specifically, I analyze how juvenile and young adult participants in a prison art program in Ohio rhetorically identify with and/or refuse the labels of "criminal" and "victim" in their poetry and artwork. In order to research art and writing by juvenile offenders, I directly observed and participated in art classes at a juvenile corrections facility for girls in Ohio.[1] The classes, facilitated by a community arts organization, The Art for a Child's Safe America Foundation (ArtSafe), varied in length from 1 week to 6 months, and included participants who ranged in ages from 14 to 19 (the residents of the juvenile corrections facility can range in age from 12 to 20). In addition to my participant observation of art classes at the juvenile facility, I also studied ArtSafe's publication of artworks produced by young adult offenders (ages 14-21) held at an adult corrections facility, the Ohio Reformatory for Women.

The goal of my research was to learn how the participants in the art classes use their art and writing to respond to and reinvent the institutional, pedagogical, and public discourses that shape their environment. I wanted to learn firsthand how the participants in the class respond through their art and creative writing to the pedagogical goals brought in by the ArtSafe facilitators, as well as the other elements of the institutional environment that shape their lives. I also wanted to learn how people who are partnering with the justice system and try-

ing to enact change talk about issues of victimization, criminality, and justice. I chose to participate directly in art classes offered at a juvenile facility for girls because of the rise in rates of arrest and incarceration for female offenders, particularly female juvenile offenders, despite the steady decrease in overall crime rates in the last decade (OJJDP, 2006). The standards and practices for incarcerating youth in our country vary tremendously from state to state and many states, most famously the California Youth Authority system but also the Department of Youth Services in Ohio, are under pressure to reform sentence lengths, disciplinary practices, and rehabilitative efforts in the juvenile system (see Demartini, 2007a, 2007b, 2007c, 2007d; Ludlow, 2008). The problems and criticism concerning juvenile justice are representative of the broader problems and criticism of the adult prison system in the United States—adult prisons are growing faster than the population and faster than the crime rate[2]—and in many ways juvenile justice in America has come to symbolize a final threshold in arguments about whether prisons should rehabilitate or punish; in other words, if we cannot commit to rehabilitating kids then there is little hope for rehabilitation in the adult system; similarly, if we can make changes in the ways in which we criminalize children, we may be able to impact not only what adult corrections facilities look like but also who enters them.

My observation and analysis of these art classes and artworks allowed me to learn firsthand how these incarcerated youth respond through their art and creative writing to the pedagogical goals brought in by the organization—"outsiders" entering the institutions—and how the goals and processes in art-making are shaped by institutional environments. The goal of ArtSafe is violence prevention and nonviolence education through the arts. ArtSafe is concerned that youth at risk for violence, and particularly youth already incarcerated, do not have access to the arts or other avenues for expressing themselves, and they see art as an outlet for self-expression and a means for building self-esteem, as well as for transforming traditional punitive models of punishment. ArtSafe facilitators emphasize choices and individual empowerment in art; however, despite art's empowering potential, it is impossible for the participants in a prison art class to make choices outside the boundaries of the institution.

Although all acts of making art may invoke the potential for individual choices, analyzing the works produced in ArtSafe's various corrections-based art classes reveals the choices the participants perceived to be available to them in creating their artistic expressions, and enables us to better understand the relationship between rhetorical practices and identity formation within institutional contexts. The art and writing produced in the classes provides us with a glimpse at how identities are negotiated within processes of institutional enculturation, as well as larger systems of power. As participants integrate representations of their home and community lives with institutional rhetoric as well as the pedagogy of the art class, their art and writing reveals the adaptations, ruptures, and resistances that take place in "contact zones" where, as Mary Louise Pratt (1992) argues, "subordinate or marginal groups select and invent from materials trans-

mitted to them by a dominant ... culture" (p. 6). I combine rhetorical and discourse analysis to investigate the rhetorical tactics of resistance the participants use in their art and writing to counter the discursive and institutional subjectivities imposed on them. Rather than impose a top–down materialist analysis that privileges the power of national/cultural discourses in structuring the discourses of the institution and the works produced by the young women, I use a rhetorical theory of identification and resistance, informed by theories of institutional and discursive power, in order to account for the circumstances of production of the art and writing, and to account for the relationship between rhetoric and discourse more generally. A rhetorical methodology configured this way allows us to identify the artistic choices made within their discursive and institutional environment, while also acknowledging the limitations of a rhetorical interpretation of prison art: Even when accompanied by close observation of the production of the art and writing, and interviews with the prison artists themselves, a rhetorical analysis of prisoner's art enables us to read *expressions* of carceral experiences, not the experiences themselves. However, we can recognize the rhetorical identifications made by the artists as they created and described their art and writing, and in doing so consider the relationship between identifications in art and writing and processes of identity formation in specific institutional as well as broader discursive contexts.

Such a method of analysis extends the parameters of rhetorical studies to a largely unexplored site: Although scholarship in composition studies has begun to take some notice of writing practices and practices for teaching writing in prisons (see Hastings & Morrison; Kerr; Jacobi; Mastrangelo; Pompa; Rogers, all in a 2004 issue of *Reflections*), rhetorical studies has paid only marginal attention to rhetorics of incarceration. With the exception of Patricia O'Connor (2000) and Paula C. Johnson (2004), those rhetorical projects that have addressed carceral productions have done so from a distance and focused primarily on published works by political prisoners (see Doyle, 1994; Hames-Garcia, 2004; Rodriguez, 2006), largely neglecting women's representations of incarceration and overlooking the experiences of juvenile offenders entirely. In the context of the growing interest in social justice issues within rhetorical studies, such absences represent more than just a gap in scholarship; they are a silence. This limited study of the art and writing of women and girls in a prison arts program cannot, of course, answer this silence on its own, but it does provide a method of analysis that will hopefully enable other scholars to continue this important work.

IDENTIFYING (WITH)IN THE INSTITUTION

Prisons are an example of what Erving Goffman (1961) calls a "total institution": an institution where all parts of life of individuals under the institution are sub-

ordinated to and dependent on the authorities of the organization (p. xiii); they are literal, physical structures that separate groups of people from the rest of society and also symbolic structures that shape language practices and beliefs—how one thinks about who is a "criminal" and who is a "victim." Goffman's sociological study of individuals in mental asylums provides an important account of how total institutions produce identities, and is a useful counterpart to Michel Foucault's (1975) discursive analysis of prisons. In his famous work *Discipline and Punish*, Foucault investigates how power circulates discursively through institutions, tracing the historical and discursive formation of the identity of "criminal" through the development of the modern prison and the scientific revolution. Foucault argues that prisons function to identify and produce criminals and criminality, to construct the criminal as simultaneously "monstrous" and outside of society, while at the same time fundamentally "in the law, at the very heart of the law, or at least in the midst of those mechanisms that transfer the individual imperceptibly from discipline to the law, from deviation to offence" (p. 299). Similarly, Goffman argues that one of the key features of a "total institution" is its disruption of an individual's identification of himself as an autonomous individual, "a person with 'adult' self-determination, autonomy, and freedom of action" (p. 43). Goffman provides a close study of how institutions identify the individuals within them: "expected activity in the organization implies a conception of the actor and … an organization can therefore be viewed as a place for generating assumptions about identity" (p. 186). Individuals' cooperation with or resistance to an institution's expectations provides an opportunity for them to "withdraw from the official self and the world officially available to it" (p. 187).

In the context of a prison art class, participants negotiate the disciplinary procedures of the institution itself, as well as the discourses about and pedagogical approaches to criminality and punishment that structure the programs, such as ArtSafe, offered within the institution. The young women I worked with at the juvenile facility have firsthand knowledge of what it is like to live in a correctional institution, and so are at once experts in how to negotiate the institution's rules and expectations and at the same time they are already *institutionalized*—a term used by many of the young women, as well as the staff, to describe someone who has become used to or dependent on the institution. Although ArtSafe emphasizes individual choices and empowerment in their classes, the facilitators are not concerned with an individual's control over her environment, but rather how the individual *identifies* herself in relation to her surroundings. They distinguish themselves from art therapy programs, which typically use art to diagnose and treat participants, because ArtSafe's programs are designed to encourage participants to see the choices available to them in creating art and writing, and through this to develop their perceptions of choices available to them in their lives more generally. This relationship that ArtSafe helps establish between the participants, their artwork, and their institution provides an opportunity for a more nuanced understanding of the relationship between rhetorical theories of identification and discourse. Rhetorical theories of identification, such as Kenneth Burke's

(1969), are based on understanding an individual's efforts to "form himself in accordance with the communicative norms" of his or her environment (p. 39). I argue that the identifications and rhetorical practices in the art and writing of the ArtSafe participants reveal how the participants represent themselves and form identities in relation to their institutional and pedagogical environments, and thereby also help us more broadly theorize the relationship between rhetoric and discourse: how subjects use rhetorical practices in their attempts to recognize and align themselves with—as well as distinguish themselves from—the discourses around them.

A primary way in which incarcerated artists negotiate public and institutional discourses with their own self-identifications is by incorporating images of the institution and its mechanisms of control into their art and writing. In *Cellblock Visions*, Phyllis Kornfeld (1997) notes that "[a] sentiment often expressed by inmate artists is that they are sick of the ugliness around them and have no desire to reproduce it. But sooner or later, most make a picture of prison" (p. 12). As I discuss in more detail later, participants in the ArtSafe classes realize and appropriate primary apparatuses of institutional control by incorporating images of things like their cells or their uniforms into their art, thereby reifying their bond to the institution and also foregrounding their resistance to it. Michel de Certeau's (1984) examination of how people respond to dominant cultural discourses and practices helps us to further understand the relationship between these artistic practices and their institutional context: de Certeau uses the term *strategies* to describe how institutions and structures of power generate control, and the term *tactics* to describe how individuals create space for themselves in environments designed by strategies. The primary distinction for de Certeau between strategies and tactics is their relationship to place and space: Strategies are a function of a distinct place, in many ways akin to the disciplining procedures described by Foucault in that they create a controlled environment that "disciplines," or renders "docile," the bodies contained within the place. In contrast, tactics "are procedures that gain validity in relation to the pertinence they lend to time," and capitalize on carefully timed moments of opportunity to intervene in relations of power (p. 38). In the process of "striving to form [themselves] in accordance with the communicative norms" (Burke, 1969) of the institution, the participants of the ArtSafe classes are compelled to enter a "bond" (Goffman, 1961) of implicit agreement; however, de Certeau's theory helps reveal the extent to which the participants are able to identify with and also disavow the dominant discursive strategies of the institution.

In the following sections, I configure a method of rhetorical identification to argue that through their art and writing the participants identify themselves with times and spaces that extend beyond their convicted offense and current institutional location, and focus on experiences and relationships that help them create an alternative to the institutional identity formed within the corrections facility. The participants identify the language and behavior patterns, customs, expectations, and rules of their institutional environment, and appropriate them in ways

that disrupt their formations or intended contexts; constitute new audiences for their artwork that undermines or subverts the institutional audience; and construct narratives in their art and writing that subvert the temporal relationships prescribed by the institution.

IDENTIFYING AVAILABLE MEANS OF RESPONSE

Figure 12.1, created by Acacia Hendricks[3] during an ArtSafe class at the Ohio Reformatory for Women (ORW) and published in ArtSafe's (2003) collection, *A Caged Bird*, provides an example of the ways in which the art class participants recreate dominant images of the institution in their artwork: Hendricks provides a humorous depiction of "hot fashion straight from the pen" and points out important features of the institution's uniform, including the ID badge "to be worn on the left collar" that "completes the prison chic look," "baggy, saggy" khaki pants that "can be worn to achieve that thugged-out look so popular in prison," and green button-down shirts, of which she says "stained, ripped, neon button-downs are all the rage with the felon girls!" Hendricks also depicts a con-

Fig. 12.1. "Hot Fashion Straight From the Pen" by Acacia Hendricks. Published in A Caged Bird *by ArtSafe.*

traband hair clip (made from thread and bobby pins), earrings (made from staples; "guarantees cell isolation in prison"), and makeup (made from colored pencils). De Certeau suggests that practices of reading are also practices of invention: we "poach" texts, insinuating into them our own pleasures and memories, thereby making the texts we read "habitable" (p. xxi). Hendricks makes her institutional environment more "habitable" by depicting, reflecting back at it really, its strategies of control through her drawing.

De Certeau argues that all communication acts must be understood as both *uses of* and *performances on* dominant language systems because all individuals are constantly using and adapting imposed knowledge and symbols to their own needs. Such uses of a language system involve a "realization" of the existence of the language system itself, an "appropriation" of it by the speaker to fit his or her needs, the creation of a relational "contract" between the speaker and an imagined or real audience, and the establishment of a "present," or the temporal context of the speaker. In Hendricks' drawing, her comment that her staple earrings "guarantee [sic] cell isolation in prison" realizes the rules and constraints of the institution by pointing out the earrings' contraband status—when allowed at all, real hair accessories, make-up, and other cosmetic products are usually permitted on a restricted basis in adult and juvenile women's corrections facilities. Women are usually required to purchase the products through the institution's commissary system, and typically only inmates who have reached the top behavior status or "level" at the institution are allowed access to such "luxuries."[4] Hendricks' "homemade" hair clip, choker, earrings, and make-up bypass the commissary system as well as the institution's rules for accessing it. Her depictions of contraband in her drawing provide her with a way to demonstrate her knowledge of how to break the rules without, perhaps, actually having to break them; in other words, it is possible that Hendricks is depicting her own staple earrings and make-up in her drawing, but it is also possible that she is depicting an imagined self who is wearing this contraband without fear of punishment.

Although she titles her sketch "2002 'Lifer' Collection by O.R.W.," Hendricks is not actually serving a life sentence.[5] In her poem "Walls of Pink," Hendricks identifies her prison cell as "my home till 2004" (*A Caged Bird*, 2003, p. 20). Because she is not serving a life term, Hendricks' representation of "Lifer" fashion could be read, like the contraband, as another "imagined self"—a self who could be serving a much longer sentence—or it could also be read as a disidentification from the ORW inmates who are serving life sentences. The number of U.S. prisoners with life sentences has been rapidly increasing in the past two decades, doubling between 1984 and 1992, and rising 83% from 1992 to 2003 (Mauer, King, & Young, 2004). Currently, 1 of every 11 offenders in state and federal prisons are serving a life sentence; in Ohio, 10.5% of prisoners are serving life sentences (Nellis & King, 2009). Women have been particularly affected by increases in sentencing laws and the expansion of incarceration in the United States even though they commit a small minority of violent crimes: Since 1977, women's rates of incarceration have increased 757%, compared with 388% for

men (Institute on Women and Criminal Justice, 2006). There is no current research on the number of women serving life sentences nationwide; however, at the ORW, 11.6% of the population is currently serving a life sentence.

Hendricks' disidentification with prisoners serving life sentences actually reflects her "realization" of the sentencing climate that structures her institution. Similarly, in the art project pictured in Fig 12.2, Alicia,[6] an ArtSafe participant at the juvenile corrections facility, imagines herself as simultaneously a physical part of the institution and as leaving it. Her piece was part of a mask project, in which ArtSafe participants decorated preformed masks and mounted them on poster boards in order to represent themselves and also to think about how we use or hide behind masks in our interactions with each other, mask our emotions, and so on. Because all of the participants used the same cardboard masks for the basis of their projects (as opposed to papier-mâché replicas of their own faces), the emphasis for the project was on how the participants decorated the mask and background, and used the available materials (a variety of colored paints, beads, and gemstones) to represent themselves and the various "masks" they may wear in their everyday lives. In her project, Alicia represents herself as literally coming out of the prison wall, and explained to me that "this is my life: in and out of places like this." Brick walls are a dominant feature of the juvenile institution, and Alicia's depiction of it reflects her own feeling of containment as well as the increasing emphasis on control and punishment—as opposed to rehabilitation and release—in juvenile corrections facilities more generally. Her identification with a cycle of incarceration anticipates a future in an adult corrections facility, and also reflects the growing resemblance between juvenile and adult corrections

Fig. 12.2. Mask project created by "Alicia."

practices; according to Eric Fritsch and Tory Caeti (2004), the "adultification" of the juvenile justice system through increasing rates of arrest and applications of adult sentences reflects its greater emphasis on "punishment, justice, accountability, and public protection" as opposed to rehabilitation (p. 206). Alicia's identification with the brick wall also demonstrates her awareness that by depicting her relationship to the institution she also is depicting herself as "the kind of person" (Goffman, 1961) who is in a corrections institution, and so she specifically addresses this in her piece. The message written on her wall, "look past the mask," addresses audiences who she believes discount the art that she and the other participants make because the girls are young and incarcerated: She explained, "a lot of people have hidden messages in their art and they want someone to see it," like "what they're feeling inside or a hidden face."

An emphasis on rhetorical tactics of identification and resistance is designed to reveal these "hidden messages." Such investigations always run the risk of simply speaking *for* or *about* prison writers and artists, or making generalizations about their experiences; however, when contextualized within larger investigations of U.S. carceral practices, the specific practices of the institutions in which the art and writing were produced, and perspectives of the artists and writers themselves, an investigation of rhetorical tactics of identification and resistance may speak *with* the composers of the art and writing it investigates. The voices of the artists and writers cannot fully authorize a rhetorical interpretation of the art and writing; as Kenneth Burke (1969) reminds us, the range of rhetoric extends beyond the intentions of the rhetorician to include the identifications "which we impose upon ourselves, in varying degrees of deliberateness and unawareness" (p. 35). Furthermore, the institutional context in which the participants are interviewed has an immeasurable effect on what they say about their art and writing: Because of the severe penalties for gang membership and for sexual relationships between the residents at the juvenile corrections facility, I did not ask the young women about their potential representations of these things in their art. All I know about gangs comes from scholarship on them and from the signals and policies the institution uses to detect gang affiliations; all I know about relationships between the ArtSafe participants and other young women was either offered to me in interviews without my asking, or from the signals and policies the institution uses to detect forbidden relationships. Finally, as Foucault suggests, discourses shape us without our knowledge or consent; although for Foucault this made the responses of individuals to discourses irrelevant, rhetorical theory suggests that rhetorical productions in any discursive context are responses to that context. We can't measure how much the ArtSafe participants resisted or identified with the discursive forces of their surroundings—neither the art nor the artists can give us an exact measure—but a combined study of the rhetorical productions and the discursive context provides an understanding of the *available means* of response, and therefore an opportunity to investigate how the artists responded within their means.

Beyond their alignment with the dominant institutional symbols and features, the ArtSafe participants test the guidelines for permissible content in their artwork by attempting to include forbidden elements such as gang signs, colors, or other symbols that identify them with locations and systems outside the institution. Within the context of the ArtSafe class, the participants are "free," to some extent, to express forbidden content in their art and writing because their projects are not collected or inspected by the ArtSafe facilitators for rule violations; the participants know that the ArtSafe facilitators are not briefed on all of the institution's rules for its residents, and that the facilitators are not held responsible, overall, for the content of the participants' projects. Nonetheless, the participants are under the institution's surveillance: A corrections officer supervises all classes and intervenes when participants' behavior breaks institutional rules (such as disobedience, fighting, or inappropriate contact with each other); participants know that the sketch journals they keep in class may be collected periodically by the institution for inspection (this happened once during the course of a 6-month class), and they know that their final projects will be inspected closely by institutional program supervisors before they are allowed to be displayed to other residents of the institution or to the community. Aside from photographs of family and friends and coded references to prohibited relationships with other girls, the most common resistances to institutional rules that appeared in the juvenile participants' art and writing referenced their home in some way. Like Fig. 12.2, Fig. 12.3 was created as part of the mask project at the juvenile facility. In this figure, Kaylee identifies herself as "Miss ATL" because she was partly raised in Atlanta, but also identifies herself with Cleveland, the city where

Fig. 12.3. Mask project created by "Kaylee"

she most recently lived. She includes the area codes for both Cleveland (440) and Atlanta (770), although the institution forbids the use of area codes or any references to specific cities because they may be used to represent gang affiliations. Her piece also prominently features black and red, which is common in her work as well as the work of several other participants, and may also potentially reflect gang affiliations.

Although Alicia's mask and depiction of the brick wall also feature red and black prominently, Kaylee's emphases on Atlanta and Cleveland in her mask, combined with her color choices, signal more likely her identifications with a gang. Kaylee's identification of herself in her mask as "Beautiful" and as "Atlanta Most Wanted" challenges reductive assumptions about femininity and criminality that have historically existed in women's corrections facilities and that continue to affect popular and academic representations of women and crime. Meda Chesney-Lind and Randall Sheldon (1998) note that girls' involvement in delinquent gangs has been vastly understudied, and when they have been represented it often has been through "media stereotypes of bad, evil, or even overly masculine girls, ignoring the social context, especially for young minority women" (p. 64). However, Kaylee's presentation of herself as beautiful and criminally dangerous, as well as gang affiliated, complicates carceral techniques that use gender-normative performances as markers of criminal reform, and also media and scholarly representations of female gang members as either "maladjusted tomboys" or inconsequential "sexual chattel" for male gang members (Joe & Chesney-Lind, 1995).

Early theoretical approaches to women's crime emphasized a link between criminality and gender behaviors that deviated from women's presumed biological nature, particularly sexual behaviors: "although most theories about male crime gradually began to consider a variety of causal factors, theories about female crime continued for many years to focus almost exclusively on women's anatomy and, particularly, sexuality" (Chesney-Lind & Sheldon, 1998, p. 101). Female corrections institutions, then, were designed to "reform" women's gender and sexual identifications by emphasizing normative gender behaviors: domestic skills, child care, and so on. As depicted in Acacia's drawing, women and girls in contemporary corrections facilities, although relegated to "masculine" or "gender-neutral" clothing, are given some access to hair accessories and other products that may reinforce normative gender practices. At the juvenile facility, the young women are penalized if they do not keep their hair combed or braided, but are forbidden by "sexual misconduct" rules from braiding each other's hair. These rules against hand-holding, touching, and other kinds of contact between the young women reflect the institution's concerns about preventing (both consensual and nonconsensual) sexual relationships between the residents; sexual misconduct is one of the most serious offenses a resident can be charged with at the institution, and may add as much as 6 months to the young woman's sentence. The confluence of rules about appropriate feminine appearance and inappropriate sexual behavior reflect a tension in the continued concerns about

female sexuality and gender normative behaviors at the institution. The institution frequently rewards those who have attained a particular behavior level with "extreme make-overs"—including hairstyle, make-up, leg shaving, facial waxing, manicure, and pedicure. The make-overs, sponsored and conducted by a faith-based volunteer organization, are the culmination of a week-long Bible-study program, and further emphasize the institution's link between gender-normative appearance and spiritual and behavioral "reform."

Kaylee's mask project also contains "I love you" messages addressed to her "best friend"; as stated above, sexual contact between residents of the juvenile corrections facility is strictly forbidden, although various kinds of close relationships exist between the young women within the spectrum of alliances they form with each other. Relationships with "best friends"—sexual and nonsexual—provide security and protection in the institution, as well as companionship. Kaylee's note to her "best friend" does not necessarily signal a sexual relationship between the two young women; however, the absence of her friend's name or even initials reveals Kaylee's awareness of the strict institutional surveillance of female friendships. Like her inclusion of her hometown(s) in her artwork and her (potential) gang affiliation, Kaylee's recognition of her relationship with her best friend in her artwork helps her construct an identity beyond that projected onto her by the institution. Even as she claims the title of "Atlanta Most Wanted," its smaller print and dark purple letters are much less prominent and harder to read than "Beautiful" or "Ms. ATL." Kaylee's identification with this marker of dangerous criminality may boost her image among her peers at the institution and provide preemptive self-protection, but her piece as a whole seems to represent a *disidentification* from the "criminal" identity imposed by the institution; "Atlanta Most Wanted" recognizes the criminal identity that she (and the institution) have already made, but the other components of her piece identify her with her family and community beyond the institution, and even with potentially illicit relationships within the institution that challenge its policies and restrictions.

CHOOSING SILENCE, REIMAGINING TIME

As the ArtSafe participants negotiate their institutional identifications through their art and writing, one of the most noticeable silences in their work involves their convicted offenses; although some participants do identify their offenses, most choose instead to focus their projects on other things. Cheryl Glenn's (2004) argument that "silence is rhetorical" helps us explore the ways in which the participants' silence about their convicted offenses addresses the multiple discursive environments in which they make their art, and also "the politics of speaking, not speaking, and who can speak" (p. 12). For the ArtSafe participants, silence is a tactic available for addressing the loss of privacy that they experience

upon entering the corrections facility, as well as the discursive expectations the institution prescribes on them, and it ultimately imagines new audiences for their artwork that undermine or subvert the institutional audience.

Loss of privacy is a crucial part of understanding this artwork: Individuals in a corrections facility have little control over how information about them circulates. In general, the offense with which they are charged is a primary identifier for them both in the institution and in the legal system. Public representations of crime further reinforce our identification of an individual by her or his offense by virtually guaranteeing audiences of fictional and news representations of crimes access to knowing *who did it* and *what they did*, and frequently *what they did* is all we really find out about *who did it*. Within the institution, the ArtSafe class is one of the only contexts in which participants are not identified by their offense or asked to talk about it; the rhetorics of choice making and empowerment embraced by the ArtSafe facilitators create a discursive environment that is distinct from the other programs. Although no outside programs are directly informed of their participants' offenses, many of the other programs offered at the institution focus on rhetorics of confession and religious redemption that may result in revealing the participants' offenses. Institutionally sponsored programs, such as the Victim Awareness class, are facilitated by institutional program administrators and social workers, and participants are clearly identified with their offenses. Victim Awareness Programs, developed through the efforts of Victims' Rights movements, are required of the majority of residents of the facility, and involves not only an identification of the participants with their offenses but also the supervised completion of a letter of apology by each participant to her victim. Programs like Victim Awareness emphasize pedagogies of confession and apology by requiring participants to write letters to their victims and by teaching participants about the impacts of various crimes (not just their convicted offenses) on victims through the testimony of victim-impact speakers and panels. This is a direct contrast to ArtSafe's pedagogy, which is purposefully designed to focus its participants on positive feelings of empowerment rather than guilt or regret for their crimes.

Although they do not typically address the nature or details of their convicted offense in their projects, the ArtSafe participants do resist dominant institutional rhetorics of confession by reframing their relationship to their conviction through phrases such as "I caught a case" or "when I was picked up" that appear frequently in their speech and writing. O'Connor (2000) suggests that this language indicates the speaker's lack of agency, and is the product of "the prison's compartmentalizing of prisoners into normalizing categories of criminality" (p. 15), but I argue that these phrases also are performances on institutional discourse in their resistance of the institution's confessional expectations. Rhetorical identification highlights the performativity of prison art and writing by revealing its "reiteration" of the institutional and discursive "norms" in which it was created (Butler, 1993), as well as its tactical responses to institutional and discursive strategies of control.

The unique discursive environment provided by the ArtSafe class may par-tially explain, then, the silence the participants choose concerning their offenses. A rhetorical methodology helps us understand this silence as a choice made within the available means of a complex discursive environment, as opposed to simply one of many countless hypothetical possibilities. In the context of an institution in which residents are regularly identified with and expected to iden-tify themselves with their convicted offenses—where demonstrations of confes-sion and remorse are, in fact, a fundamental component of "institutionalizing" processes—the ArtSafe participants' silence about their offenses in their art and writing represents "an act of invention," in Glenn's terms, of alternative rhetori-cal possibilities within this environment (Glenn, 2004). As stated earlier, it is impossible for participants in a prison art class to make choices outside the boundaries of the institution; however, the fact that the ArtSafe participants do invent alternative rhetorical possibilities for themselves within the context of the class demonstrates their recognition of ArtSafe's pedagogical emphasis on empowerment and choice making. Nonetheless, we also might understand this as a recognition of the limits of their available choices; although the participants have a unique opportunity to use their art and writing to re-tell the circum-stances that led to their incarceration from *their* perspective, without the pressure to confess, apologize, or seek redemption, the majority of them do not. In doing so they recognize their right to withhold the information about them in one of the only contexts in which they can control its circulation, while at the same time, perhaps, also recognizing the institution's ultimate control over the terms of their offense and conviction.

Silence as rhetorical invention can be seen in more than just the participants' refusal to disclose or confess their convicted offenses; secrets, such as Kaylee's "best friend" discussed in Fig. 12.3, are a dominant theme in much of the art and writing produced in the ArtSafe classes. Figure 12.4 was created as part of an activity called "found poetry," in which participants in the juvenile class cut up poems written by women at the ORW to make new poems. For her project Lisa combined lines from two poems published in *A Caged Bird* to create a hanging art/poetry piece dedicated to her best friend and a secret they share: "I've never told a secret/ The day will come I will hold the key to her heart I'm a complex girl." She created her poem by adopting words and phrases from the poems "I Hold a Secret," written by Tauheedah Muhammad, and the title poem of the col-lection, "A Caged Bird," written by Juanita Kennedy. Muhammad's poem focuses on what it feels like to keep a secret about herself but does not reveal what the secret is:

> Strange of me,/ but I've been told that I'm a complex girl./ I hold a secret I've never told that burns in my heart and makes me cold./ I hold the key to doors unknown:/ what hides inside goes untold. (*A Caged Bird*, 2003, p. 32)

Fig. 12.3. Found poetry project by "Lisa."

Kennedy's poem focuses on feelings of confinement and also of being the object of surveillance: "They put her in a cage to keep her from flying. They bring people into stare or even just to glare. Even though it seems unfair, she knows these people really don't care" (*A Caged Bird*, 2003, p. 6). In each of the three poems the authors are silent about a secret: Although written within the context of an immediate (ever-present) institutional audience, the writers imagine a dialogue with family and friends outside the institution, and even critique the gaze of the institution itself.

The ArtSafe participants also use their art and writing to assert different temporal narratives than that prescribed by the institution: Their relationship to the institution is defined by their arrest and the end of their sentence; in other words, their identity is defined by their crime. In their artwork and writing the participants reference various other times and places outside of their "institutional time" in order to complicate this institutional narrative and to provide a broader picture of their lives. Pieces such as Kaylee's mask in Fig. 12.3 identify the artist with a place and community outside the institution; in Kaylee's case a home that preceded her stay in the institution (Atlanta) and a home she will return to upon leaving the institution (Cleveland). Other pieces created by ArtSafe participants emphasize time as a way of recontextualizing their relationship to the institution. For example, in her poem "Survival," Heather Young writes:

> In the beginning I was a rose/ with no thorns/ Left unprotected/ To nature's horns./ I tried to blossom/ Through it all/ Yet, danger came to call./ I lost my

pride/ And tried to hide/ From danger's preying eyes—/ It came with so
many lies./ To swoop and steal/ With so much zeal,/ My precious little flow-
ers,/ My tears fell in showers./ Gradually I began to evolve / Having my
dilemma solved./ Thorns I did form / So I could be newly born./ And with
confidence / I faced the world.

Young's narrative of transformation challenges dominant rehabilitation narratives
that more typically represent change in prison. These representations often depict
inmates who enter the institution angry and without regret for their crimes, and
then, often through contact with a ministry or other prison program, take respon-
sibility for the wrongs they have committed and demonstrate remorse. In some
representations, such as the film *Dead Man Walking* (1995), the prisoner's
redemption is concluded by receiving forgiveness before his execution; in others,
such as *The Autobiography of Malcolm X* (Malcolm X, 1965), the prisoner eventu-
ally leaves the facility rehabilitated (and in the case of Malcolm X politically
involved) and motivated to inspire others with the story of his transformation. In
both cases, the prison (via its programs or other people within the prison) is the
agent of transformation for the individual. In Young's poem, however, she is the
transformative agent, and her transformation takes place before her incarceration.
Whereas Victim Awareness classes require the offenders to confess their crimes
and focus on the experiences of their victims, Young and others redefine these
institutional categories of "victim" by making us aware of the victimization *they*
have experienced. In his introduction to *Couldn't Keep it to Ourselves*, a collection
of short stories written by women incarcerated at the York Correctional
Institution in Connecticut, Wally Lamb (2003) writes that "[t]o imprison a
woman is to remove her voice from the world, but many female inmates have
been silenced by life long before the transport van carries them from the court-
house to the correctional facility" (p. 9). Importantly, although Young's poem tells
a story of how her violent experiences helped her develop "thorns" to protect her-
self, at the beginning and end of her poem she is whole and unharmed: Although
traditional representations of prison transformation begin with a damaged indi-
vidual (just as the institution's relationship with the individual begins with her
conviction), Young tells us that in the beginning she was a rose. At the end of her
poem, although she has grown protective thorns after surviving violence, she has
been "newly born" and faces the world with confidence.

The optimism in Young's poem appears in other art and writing by ArtSafe par-
ticipants, and may reflect the emphasis on self-esteem and empowerment that the
ArtSafe facilitators bring to their classes as well as institutional discourses of reha-
bilitation and reform. However, many participants forego hopeful depictions of the
future and turn instead to darker and more critical representations of their pasts.
In her piece titled "Nothing in the World," Corrinne further complicates divisions
between "criminal" and "victim" through her depiction of childhood trauma:

> She was turning a corner she felt deep in a cloud of deep and dark cloudy days. She's eight years old she's in a foster home being molested by her foster dad. She's only eight years old. She feels real nasty and sad. She hurts inside. Cries all the time. Only time she don't get hurt is when her foster mom is around. What is this? Nothing but hurt. She thinks all day wishing she can run away. She feels like there's nothing in the world she don't understand what she got in the world though because she's still a young girl eight years old and all alone no one to run to not even at school. She's so scared but all the pain she don't realize there's other people out there that care.

Confessional narratives remain a dominant mode particularly in literary representations of incarceration. H. Bruce Franklin (1989) observes this as a consistent feature in the history of writing by prisoners: "The criminal narrator characteristically is confessing his or her crimes, and this confession, especially its moral lesson, is ostensibly the purpose of the whole narrative" (p. 126). However, Franklin notes that although the intention of the literature may be a moral lesson, the main interest for readers "lies in vicarious participation in their thrilling, sordid adventures" (p. 126). Corrinne's ominous piece refuses to identify who "she" is that is being molested, but still pointedly addresses the foster care system, the people at school, and the various other "people out there that care" about the girl and yet have been unable or unwilling to intervene in her abuse. She shares the tactics of many of the ArtSafe participants, who reject the confessional expectations of the institution, recontextualizing the story of their convictions to include the offenses that first happened to *them*.

In addition to shifting the focus from her present state of incarceration to a past event, Corrinne's narrative also connects the past and the present through an emphasis on acquired knowledge and experience. The 8-year-old subject of Corrinne's narrative does not yet possess the experience and perspective of the narrator: "she don't understand what she got in the world ... because she's still a young girl," and doesn't yet "realize there's other people out there that care." Similar in many ways to Young's development of "thorns" in her narrative of transformation, Corrinne's narrative constructs a distance from the abuse—even as it has also distanced her from her present incarceration—that predicts an end to the "dark cloudy days," and potentially an end to her incarceration as well.

CONCLUSION

In order to learn about how young girls represent their experiences of incarceration in their art there must, of course, be young girls who are incarcerated. I learned this lesson during a brief break that I took from my research to attend an international conference on arts in criminal justice—the first of its kind on record—in Philadelphia in October 2007. The conference brought together rep-

resentatives from prisons and prison arts programs (among them the director of ArtSafe and the deputy superintendent of the juvenile facility where I was conducting my research) from across the United States and Europe to share experiences and best practices, but a highlight of the conference was a day of sessions held at the State Correctional Institution at Graterford, Pennsylvania's largest maximum-security prison. The day at Graterford provided those who had not worked in prisons an opportunity to see a maximum-security men's prison from the inside, and it provided the conference with an opportunity to hear from representatives of the population their programs serve—an otherwise striking, if understandable, absence from conference events and discussions. Inmate participants of the Philadelphia Mural Arts Program were able to chat with fellow conference attendees and share their experiences as participants of a long-standing prison arts program. Not surprisingly perhaps, the prison artists described the positive impact art had had on their experiences in prison and in their lives as a whole.

The following morning, as I waited for a conference session to begin, I overheard a woman who had gone to Graterford the day before describe the experience to a woman who hadn't attended as "amazing." And she was right: All who attended had certainly been amazed—by the talent of the artists we met and the beauty of the murals we admired, as well as the stark reality of the institution that housed them. We were tourists at Graterford, and upon leaving it we were relieved to breathe free air, but could also feel good about the impact of the arts in even this oppressive environment. Later that evening another woman who had attended the sessions at Graterford spoke to the conference and identified herself as a former inmate of the York Correctional Institution in Connecticut; she commented on how difficult it had been for her to enter Graterford, remembering so clearly her own experience of incarceration, and how much harder still it had been to leave Graterford at the end of our afternoon there, knowing the experience of being left behind in such an environment. She told us that she had heard several conference participants describe their visit to Graterford the day before as "amazing," and instructed us: "it's not amazing, it's fucking prison." Despite the "amazing" impact our tour of Graterford had on us, the men we met the previous afternoon remained there the next day, and probably do still. Similarly, during my 3 years of volunteer involvement with the juvenile facility, which I continued following the conclusion of my research, I observed several of my research participants either remain at the facility or leave briefly and return. The program at Graterford amazed us. The creativity, wit, and talent I witnessed in my art classes amazed me. However, it is unlikely that my findings concerning the interactions between rhetorical practices and their discursive contexts will amaze, or even impact at all, the people in the institution where I conducted my research.

In order to understand both the potentials and limitations of empirically based research requires, among other things, identifying the multiple discursive environments that help to produce, and may also be affected by, our research. In her introduction to the collection of women's writing *Interrupted Life*, Ruby Tapia (Solinger et al., 2010) negotiates the need to represent the "obscene ... material-

ity" of incarcerated women's lived experiences with the "risk of creating unproductive, even violent, relations of representation and interpretation" (p. 2). In other words, although bringing incarcerated women's—or in my case juvenile girls'—writing and art into public view may bring attention to the problematics of their institutions, it also risks voyeuristic looking at incarcerated subjects, as well as simplistic and essentializing impulses to rely on a few isolated voices to speak for an entire population. It is easy for art and writing by prisoners to become romanticized when mobilized by outsiders into research or into larger arguments for prison reform because we look to prison writing specifically for examples of agency; this is our reason for looking, our scholarly and political imperative. Both research and activist projects are based on the assumption that prisoners have a unique and valuable story to tell (which of course they do), and also that perspectives of incarceration by the incarcerated are more authentic. I suggest that art and writing by prisoners is authentic, in the sense that it provides us with a real interpretation of the circumstances under which they created it. But to the extent that we underestimate the complexity of these circumstances, or fail to perceive the multiple discursive contexts that help to create them, we risk simplistic, romantic, and even patronizing readings of such work. We need to be more aware of what we overlook when we presume agency, or when we look on with "amazement" at art and writing by disempowered subjects: We need to negotiate our desire to find and celebrate examples of agency in the context of oppression with an understanding of the limits of material circumstances.

Although as researchers we must understand the potential impacts of our research, we must also understand its limitations for impacting our research participants and the populations that support our investigations. My project is solidly located within the field of rhetorical studies, and my colleagues in the field of rhetoric remain my primary audience. Neither ArtSafe nor its participants care much about the issues in rhetorical theory that I have taken up in this chapter. However, to engage in feminist and socially progressive research means to determine how one's research does impact its participants; to speak with, rather than simply for or about, the participants of my research means listening to and joining their conversations, not just pulling them into mine. For ArtSafe, this has meant helping to support and raise awareness about their programs and the positive outcomes they provide even as I dissect in my own work what "choice making" in prison really means. For my research site, the juvenile corrections facility, it has meant committing my time as a volunteer—tutoring in the school, leading a book group, and participating in other various capacities—and understanding that the institution and the girls I got to know would not benefit from my research nearly as much as they would from my time. It has meant maintaining a commitment to them even after my research was completed.

I knew going into my research that I could not analyze the art without the artists. I incorporated observation and interview into my research, rather than simply looking at the finished products, because I understood that an analysis of the interactions between rhetoric and discourses required me to speak *with*, not

just *about*, these young women. I knew that I could not possibly understand the discourses that shaped their rhetorical practices, the means available to them in their artistic choices, without observing and talking with them about the environment in which they made their art, and how they felt it impacted the art and writing they created. My research design required me to reflect from the beginning on the limits of understanding the rhetoric of texts outside of the context of their creation, and also on the limits of relying on the creators of texts to authorize our interpretation of them.

According to de Certeau, institutional structures are the basis for strategic control, and this is perhaps clearest in the example of a correctional institution, where identities, relationships, and behaviors are determined by an individual's location within the institution. Tactical resistances require tactical *displacements* of dominant discursive strategies through carefully timed appropriations and effacements that subvert institutional identities and assert new ones. These subversive transformations of the physical and discursive spaces that define incarceration in America are, perhaps, exactly the kinds of transformations intended in art making: Charles H. Lawson (2007), an inmate at Graterford, argues that through art "we can and will start to win back most of our distracted youth and give meaning to our displaced men and women," and encourages his audience to use art to "meet these ends and start transforming thinking, behavior and, subsequently, lives." In their art and writing, the students I observed find ways to create new subjectivities while still staying below the institutional radar, and in doing so encourage us to take a closer look at both the circulation of larger, public discourses about criminality and incarceration and the rhetorical tactics used by individuals in their responses to them.

ENDNOTES

1. Institutional review board approval 2007B0052.
2. According to the U.S. Department of Justice Bureau of Statistics the number of prisoners under federal and state correctional authority increased by 2.8% in 2006 to 1,570,861; the current rate of population growth, as reported by the U.S. Census Bureau, is 0.9%.
3. Hendricks' drawings were collected with other works produced in the ArtSafe class for use in the publication *A Caged Bird*. ArtSafe owns the publication rights to all of the pictures collected for potential use in, as well as those appearing in, *A Caged Bird*. All images shown here produced by inmates at the Ohio Reformatory for Women are used by permission of ArtSafe. Images produced by residents at the juvenile corrections facility were collected during my fieldwork and are used by permission of the artists and, when applicable, their parent or legal guardian.
4. For example, in the juvenile facility there are four behavior levels; each increased behavior level brings increased commissary privileges—a higher limit of money individuals are allowed to spend on commissary items such as food, and a wider range of

products they are permitted to purchase. Those at the first level are only permitted to purchase hygiene items; only those at the third and fourth levels are permitted to purchase and wear hair accessories. No make-up is allowed. At the Ohio Reformatory for Women any products purchased by inmates or sent to them by family members must be ordered through the company Access Securepak, which is contracted with the Ohio Department of Corrections as a whole. Similar contracts are used in many states to insure that all items coming into the prison have been securely inspected (and also provide big revenues without competition for the contracted companies).

5. According to public records Hendricks was released from prison in 2007.
6. Not her real name—the names of all ArtSafe participants from the juvenile corrections facility have been changed.

REFERENCES

Art for a Child's Safe America Foundation. (2003). *A caged bird*. Columbus, OH: Author.

Burke, K. (1969). *A rhetoric of motives*. Berkeley: University of California Press.

Butler, J. (1993). *Bodies that matter*. New York: Routledge.

Chesney-Lind, M., & Sheldon, R. (1998). *Girls, delinquency, and juvenile justice*. Belmont, CA: Thomson & Wadsworth.

Correctional Institution Inspection Committee. (2005). *Evaluation and Inspection Report on the Ohio Reformatory for Women*. Columbus: Ohio Department of Rehabilitation and Corrections.

Dead Man Walking. (1995). Dir. Tim Robbins. Gramercy Pictures.

De Certeau, M. (1984). *The practice of everyday life* (S. Rendall, Trans.). Berkeley: University of California Press.

Demartini, A. (2007a, September 9). Long terms in solitary can warp minds, critics say. *The Columbus Dispatch*.

Demartini, A. (2007b, September 9). Most inmates mentally ill, but treatment can be sparse. *The Columbus Dispatch*.

Demartini, A. (2007c, September 9). Troubled teen prisons: Seething threat. *The Columbus Dispatch*.

Demartini, A. (2007d, September 9). Troubled youth, troubled system. *The Columbus Dispatch*.

Doyle, R. (1994). *Voices from captivity: Interpreting the American POW narrative*. Lawrence: University Press of Kansas.

Federal Bureau of Investigation. (2007). *Crime in the United States—2006*. Washington DC: U.S. Department of Justice.

Foucault, M. (1975). *Discipline and punish: The birth of the prison* (A. Sheridan, Trans.). New York: Vintage Books.

Franklin, H.B. (1989). *Prison literature in America: The victim as criminal and artist* (expanded ed.). New York: Oxford University Press.

Fritsch, E., & Caeti, T. (2009). Youth behind bars: Doing justice or doing harm? In P. Benekos & A. Merlo (Eds.), *Controversies in juvenile justice and delinquency* (2nd ed., pp. 203-222). Newark, NJ: Matthew Bender .

Glenn, C. (2004). *Unspoken: A rhetoric of silence*. Carbondale: Southern Illinois University Press.

Goffman, E. (1961). *Asylums: Essays on the social situation of mental patients and other inmates*. Chicago: Aldine.

Hames-Garcia, M. (2004). *Fugitive thought: Prison movements, race, and the meaning of justice*. Minneapolis: University of Minnesota Press.

Hastings, P., & Morrison, J. (2004). Do you hear what I hear? *Reflections, 4*(1), 101-113.

Institute on Women and Criminal Justice. (2006). *Hard hit: The growth in the imprisonment of women, 1977-2004*. New York: Women's Prison Association.

Jacobi, T. (2004). Foreword: Situating writing and literacy education in prison. *Reflections, 4*(1), 1-11.

Joe, K., & Chesney-Lind, M. (1995). "Just every mother's angel": An analysis of gender and ethnic variations in youth gang membership. *Gender and Society, 9*(4), 408-431.

Johnson, P. (2004). *Inner lives: Voices of African American women in prison*. New York: New York University Press.

Kerr, T. (2004). Between ivy and razor wire: A case of correctional correspondence. *Reflections, 4*(1), 62-75.

Kornfeld, P. (1997). *Cellblock visions: Prison art in America*. Princeton, NJ: Princeton University Press.

Lamb, W. (Ed.). (2003). *Couldn't keep it to myself*. New York: ReganBooks/HarperCollins.

Lawson, C. (2007). Art and its transformative power. Community Arts Network. Retrieved from http://www.communityarts.net/readingroom/archivefiles/2007/12/art_and_its_tra.php.

Ludlow, R. (2008, March 9). Everyone agrees: Chaotic youth prison needs help. *The Columbus Dispatch*.

Mastrangelo, L. (2004). First year composition and women in prison: Writing and community action. *Reflections, 4*(1), 42-50.

Mauer, M., King, R., & Young, M. (2004). *The meaning of "life": Long prison sentences in context*. Washington DC: The Sentencing Project.

Nellis, A., & King, R. (2009). *No exit: The expanding use of life sentences in America*. Washington, DC: The Sentencing Project.

O'Connor, P. (2000). *Speaking of crime: Narratives of prisoners*. Lincoln: University of Nebraska Press.

Office of Juvenile Justice and Delinquency Prevention, U.S. Department of Justice. (2006). *Juvenile offenders and victims: 2006 National Report*. Pittsburgh, PA: National Center for Juvenile Justice.

Pompa, L. (2004). Disturbing where we are comfortable. *Reflections, 4*(1), 24-34.

Pratt, M. (1992). *Imperial eyes: Travel writing and transculturation*. London: Routledge.

Rodriguez, D. (2006). *Forced passages: Imprisoned radical intellectuals and the U.S. prison regime*. Minneapolis: University of Minnesota Press.

Rogers, L. (2004). Where lifelines converge: Voices from the Forest Creative Writing Group. *Reflections, 4*(1), 12-23.

Solinger, R., Johnson, P., Raimon, M., Reynolds, T., & Tapia, R. (Eds.). (2010). *Interrupted life: Experiences of incarcerated women in the United States*. Berkeley: University of California Press.

U.S. Census Bureau. Country Summary: United States. (2008). Retrieved February 14, 2008 from, http://www.census.gov/ipc/www/idb/country/usportal.html.

X, Malcolm. (1965). *The autobiography of Malcolm X* (with assistance of A. Haley). New York: Grove Press.

PART III

REFLEXIVE/DIFFRACTIVE RESEARCH PRACTICES

13

COMPOSING ACTIVIST RESEARCH

Stuart Blythe

> But here's the paradox—we need to make activism part of our research and teaching, so that we can make a living in the university. How else will we be able to give in equal amount to what we take?
> —Cushman (1996, p. 20)

Many activist researchers seek reciprocal, sustainable relationships between themselves and the participants with whom they work (e.g., Cushman, 1996; Fals Borda, 1991; Flower & Heath, 2000; Grabill, 2000; Powell & Takayoshi, 2003; Simmons, 2007; Sullivan & Porter, 1997). In a reciprocal relationship, researchers must attend to the needs and agendas of participants. Purposes, questions, methods, and results should be developed collaboratively, rather than set by the researcher alone. Grabill (2000) goes so far as to argue that researchers should be "*invited* to participate in local problem solving" (p. 34; italics added). That is, researchers should begin to *contribute their expertise* only after local citizens have invited it.[1] Such a situation is desirable because research that emerges from an already existing relationship between people is more likely to be sustainable—that is, to transcend the limits of the academic calendar. Research should be part of a longer-term relationship in which all parties benefit. To conduct empirical research for the sake of scholarly publication alone risks "instrumentalizing" participants, as Sullivan and Porter (1997) put it. Although publication is an ineluctable requirement for many academics, activist researchers attempt to meet other outcomes defined by participants—outcomes not necessarily recognized within the rewards system of higher education.

The idealist in me loves these characteristics of activist research. Relationships that are reciprocal and sustainable are likely to promote greater respect for different ways of knowing while leading to empowerment and change—perhaps not grand, sweeping changes, but progress nonetheless for researchers and participants. But the worrywart in me sees risks to researchers and participants alike. Although an honest exploration of potential risks to research participants is equally important (or even primarily so), I explore a specific type of risk to activist researchers—the risk of engaging in reciprocal and sustainable research relationships, especially in projects that may take years to complete, when the tenure and promotion clocks are ticking.[2] Although some scholars have succeeded brilliantly in balancing the needs of publication with sustainable and reciprocal research agendas, it is a tricky feat for reasons that I explain in this chapter. I explore this risk by drawing on my own experience with a 3-year activist research project and by analyzing ways that other activist researchers have managed to publish while engaging in sustained projects.

BACKGROUND: A WICKED PROBLEM IN HARBOR

Because my comments in this chapter are based in part on my own experience with an activist research project, a little background seems necessary. (For a more detailed description of this project, see Blythe, Grabill, & Riley, 2008.) Jeff Grabill and I worked from 2003 to 2006 on behalf of a group called Technical Outreach Services for Communities (TOSC), which was headquartered at Michigan State University. TOSC got involved through an EPA grant to review the plans for dredging a canal in a town we call Harbor and storing the sediment within city limits.[3] Because the canal is one of the most heavily polluted waterways in the country, because it contains developmental toxins, and because the sediments were to be stored approximately 800 yards from two schools, significant numbers of citizens questioned or opposed the project. They expressed worries about health effects (e.g., breathing contaminated airborne particles) and also about the economic impact of having what would essentially be a landfill located in their city. TOSC brought together third-party experts (professors with experience in dredging, measuring air quality, constructing landfills) who could review the Corps' plans and offer their expertise and judgment to the community.

TOSC had not included communication specialists in its projects before. That Jeff and I became involved shows how important it was for TOSC to earn trust and thereby be able to function effectively in a mistrustful environment. Trust was difficult to earn because many saw the city government as being corrupt, and that perception applied in many citizens' minds to other government agencies. One citizen argued, for example, that "outsider" organizations like the EPA "are not coming to talk to us as residents in a neighborhood. They are com-

ing with technobabble" designed to fill the available time in a meeting and to silence local residents.[4] Two others claimed that a government agency had tried to buy their silence with an offer of office space and equipment for their group. (I must emphasize that we did not confirm these stories, only that we heard them and that they indicated the mistrust and rancor in the city.) Given such widely shared stories and perceptions, many citizens in Harbor mistrusted any group that looked like it was affiliated with a government agency, which included TOSC initially. Kirk Riley, the project coordinator, required that TOSC pay extra attention to how citizens communicated with one another and with outsiders, which is why Jeff and I were brought in.

Jeff and I spent most of our first year meeting with local residents, journalists, government employees, and members of environmental groups. We conducted interviews in offices, libraries, and people's homes, and we attended several meetings per year of a local environmental group. As we developed a clearer picture of how citizens understood the problems in Harbor and communicated their understanding to one another, we reported to Riley, who used that information to shape the kinds of advice he gave the subject matter experts as they prepared their reports. We also used our evolving sense of the situation when we helped edit reports or organize meetings at which TOSC discussed its findings with the community.

What Jeff and I worked on was a wicked environmental problem—a term I borrow from Rittel and Webber (1973). Wicked problems defy easy definition or solution for many reasons, including the following:

- Such problems involve so many variables, and institutions, and individual stakeholders that it is hard to know where to begin seeking a solution.
- Comprehending such problems requires technical and scientific data that even supposed experts sometimes lack.
- An attempt to fix one part of a wicked problem usually raises a new one.

To understand the third point, consider the example of what has been called the "tortilla wars." In January 2007 about 75,000 people in Mexico City protested the price of corn in their country ("Tortilla Wars Erupt," 2007). Because of corn prices, the price of tortillas in Mexico City had doubled in less than a year. The protesters blamed this inflation on the diversion of corn from food markets to biofuel markets, but the Mexican government blamed farmers of hoarding their crops in the hope of selling their corn at a higher price. As with any wicked problem, an effort to address one exigency—in this case, to reduce reliance on fossil fuels through the creation of biofuels—simply created another. Actually, the problems with corn and tortillas are even more complicated than that because they also involve struggles between corporate farms that use hybrid seed stocks patented by multinational corporations and independent Mexican farmers who

use unpatented Indian "Pinto" corn stocks (Ross, 1999). And the problem gets even more complicated: Because corn growers in the United States use fertilizers that flow into nearby waterways and eventually down the Mississippi River, a dead zone roughly the size of New Jersey has developed in the Gulf of Mexico (Roach, 2005). Plant and animal life cannot exist in that zone because the fertilizers cause algae blooms that eventually die off. The bacteria that eat the dead algae consume the oxygen in the water, which means that all marine life must leave the area or die, which in turn creates the zone (Roach, 2005). Thus, the deeper we look at the problem, the more complicated, the more "wicked," it grows.

I introduce the concept of wicked problems because it reinforces the risk I identified for activist researchers who want to engage in reciprocal and sustainable research relationships when the tenure and promotion clocks are ticking. Because a wicked problem is so complex, it can take years if not decades to sort out. Given this dilemma, it might seem prudent for a graduate student or junior faculty member to avoid working on such problems. But such problems deserve our attention. They are, in many ways, the most worthy problems to address. Also, such problems inevitably require effective forms of communication, which means that experts in rhetoric and professional and technical communication have much to contribute. So it is worthwhile to explore ways to publish while engaging in reciprocal and sustainable research relationships.

FOUR DILEMMAS FOR ACTIVIST RESEARCHERS

When it comes to scholarly publication, activist research presents at least four practical dilemmas:

1. Such work often requires scholars to write in multiple registers and genres, many of which may be unfamiliar to them.
2. Such work often is seen by colleagues more as service than research.
3. The work can require methodologies that seem unconventional to reviewers.
4. The exigencies that researchers may explore with participants may not lend themselves to promotion or tenure deadlines, as can be the case with wicked problems.

That activist researchers must write in multiple registers and genres is inevitable considering the nature of sustainable and reciprocal research. Because scholarly publication rarely if ever benefits nonacademic audiences directly, a researcher engaged in a sustained, reciprocal research relationship most likely

will be asked to produce texts for nonacademic audiences. For example, Cushman (1996) worked on various projects with citizens in an inner-city neighborhood in upstate New York. She writes:

> Over the course of two and a half years of research, we've written resumes, job applications, college applications, and dialogic journals; when asked to do so, I've written recommendations to landlords, courts, potential employers, and DSS representatives. (p. 13)

The demands can extend to other types of literacy events. Jeff and I were asked, for example, to edit an expert's dredging report and to plan the agenda for a public meeting. The latter task required us to research the expectations of local citizens regarding such meetings and to read about the public meeting as a genre (see McComas, 2003). We also had to meet with other area representatives to argue for our approach to the meeting agenda. Flower (2003) and her colleagues faced similar tasks when organizing a presentation by teens in Pittsburgh to city and state officials regarding the effects of a recent curfew. In reciprocal relationships, we become learners as much as scholars as we attempt to meet the expectations of research participants. To meet those expectations can take extra time as we learn to meet new writing exigencies, and such writing is often seen as service work.

As Harrison and Zappen (2003) remark regarding their work developing a community-based Web system, that effort "has taken us considerably far afield of what we thought we would be doing as social researchers and produced a few raised eyebrows from colleagues who have chosen to describe our work as 'community service'." To help participants complete applications as Cushman (1996) has done, to attend planning meetings as Grabill (2000) has done, even to help plan meetings as Flower (2003) and Grabill and I have done all looks more like service than research. A reciprocal, sustainable project can require researchers to devote much of their time to work that colleagues may not count as research, which leads me to the third problem.

Such projects also may require methodologies that seem unconventional to colleagues. And, as Simmons (2007) writes, such research may require "research methodologies that can function in the spaces between the institution and the community and still yield positive and credible results" (p. 8). The kinds of methods that may yield valid, usable results in a community may not always be the kind that reviewers of journal submissions or promotion and tenure cases expect to see.

When it comes to timelines, what is true for service learning is true for activist research: town and gown timelines often clash. Many problems that a community faces are long-term exigencies that cannot be resolved in a 16-week semester. Some service-learning programs can be faulted for what Cushman (2002) calls a "'hit it and quit it'" approach offering "few guarantees that the researcher will be

around in the morning" (p. 40). I sense a similar potential problem with many activist research projects. A junior faculty member needs to publish an adequate body of work in time to get tenure, but a community-based research project may take years before it begins to yield what people would count as results.

To illustrate the time it might take, even for less daunting problems, I offer Grabill's (2006) list of practices that make up community-based research:

1. *Initiation*, or where do studies come from?
2. *Access*, or how do I get permission to do my work?
3. *Participation* (with sponsors, clients, all those impacted; in planning, design, method, analysis, and communication)
4. *Studying up* (or studying one's client or sponsor as well)
5. *Local politics* (mediation, advocacy, relationship building and maintenance, community and political mapping)
6. *Communication* (as day-to-day research practice itself as well as in myriad settings during the research process regarding "nonresearch issues"—all in addition to the communication of the research results themselves)
7. *Sustainability* (p. 161, italics added).

Consider the challenges of initiation and access alone. It can take significant amounts of time to build the trust necessary to get invited to participate. In fact, time may be the key factor during initiation and access. "It's the staying power that builds trust," write Flower and Heath (2000, p. 46). In the case of the Harbor project, Jeff and I devoted most of the first year of our work to gaining the trust of local citizens. One of the most effective things we did to gain trust, I think, was to show up repeatedly at various events and meetings held during the first year. As people began to see us at meetings, and even by happenstance in local restaurants, they began to know that we were serious. Even once trust and access are attained for any researcher, the pace of research is never entirely in the researcher's hand. Regarding his work with an HIV/AIDs task-force planning committee in Atlanta, Grabill (2000) says he "was never 'in charge' of this project. ... We didn't conduct ourselves as 'researchers' in ways I would have always chosen, and the pace of the project had all the fits and starts, dead times and manic phases of inquiry by committee" (p. 46). Jeff and I experienced the same in the Harbor project. We had to wait for technical experts to provide data, for local boards and citizen groups to call meetings, for powerful agencies to respond to the work that TOSC produced or to provide data that TOSC had requested. At some points during the project, we faced the same problem that technical writers face when waiting for the work of subject matter experts.

I return again to a central challenge for activist researchers: In a place such as Harbor, progress may be too slow, or the situation may be too complex, and much of the work may look too much like service for scholars to be able to report on common types of scholarly deliverables within the time frame required by

promotion and tenure cycles. As Herndl and Nahrwold (2000) claim, "Researchers want to get things done, whether that be improving a specific task of rhetorical production or effecting fundamental cultural change, through a meaningful and persuasive research practice that motivates action" (p. 260). But the nature of the wicked problem in Harbor has left Jeff and me unable to report yet on the efficacy of any rhetorical action we undertook. Although we began working in Harbor in 2003, the dredging and landfill project that we were supposed to help review has been postponed. (According to a government Web site, the U.S. Army Corps of Engineers released a bid for proposals for dredging the canal. As of the 2010 announcement, the Corps said the dredging would take place between 2011 and 2019. Another source says they expect to start dredging at the end of 2011.) And because all work is ongoing, Jeff and I have had little that we could report in terms of outcomes 8 years later.[5] This lack of tangible outcomes has made some forms of publication inaccessible for us at the moment. We cannot, for instance, offer a traditional report that shows how communication affected the outcome of a public project. This has caused us to find other ways to write about our work (as I do with this chapter).

How do activist researchers manage to write to other researchers about their work, especially when their research may not have yielded obvious results? I explore that question in the rest of this chapter by examining ways that scholars have managed to write about research projects that were ongoing or that did not produce the kinds of evidence that Herndl and Nahrwold (2000) say is expected by so many researchers.

EXPLORING ALTERNATIVES FOR PUBLISHING ACTIVIST RESEARCH

To explore the question of how activist researchers write about their work, I analyzed a set of articles produced by such researchers. I did this for the same reason I might assign students in a writing class to find examples of, say, introductory paragraphs. Rather than simply lecture students on the form of an ideal introduction, I prefer to have them compare and contrast the many forms that introductions can take (a strategy I learned from reading Lindemann, 1991). Likewise, I wanted to explore the ways that activist researchers wrote about their work, even when the research may still be underway, when "results" remain elusive. I wanted to see how researchers used scholarly genres even when their work may not have yielded the clear improvements or change that Herndl and Nahrwold (2000) say is so often expected. To do this, I took a convenience sample of articles authored by researchers engaged in empirical forms of activist research. Some of the articles I had read before, some I read after finding them listed in bibliographies, and some I read on the recommendation of colleagues. Although I know of several

books that rely on the results of activist research (e.g., Cushman, 1998; Faber, 2002; Grabill, 2007; Scott, 2003b; Simmons, 2007), I stuck with articles based on empirical research because I think for most researchers—at least those who do not work in Research 1 institutions—article publication is the primary form of evidence needed to establish a scholarly record. Also, I focused solely on empirical research, the kinds that might involve a researcher in long-term reciprocal and collaborative relationships. This meant that I had to forego some significant examples of socially progressive research that is not strictly empirical. Scott (2003a), for instance, offers a significant example of socially progressive research through his thick description of the development and implementation of an HIV/AIDs home-collection testing product. Scott develops his case by examining various texts, including those created by marketers, the Centers for Disease Control and Prevention, and the FDA. But he does not report working with research participants. I do not see evidence of such examples of empirical data gathering as interviews, on-site observations, and so on. Although Scott's work is a valuable example of socially progressive research, it did not have the empirical characteristics I sought, and so I excluded it from this study.

I chose eight examples that fit my criteria, each of which includes one or more authors using their experience with empirical research:

- Cushman (1996): "The Rhetorician as an Agent of Social Change"
- Cushman (2002): "Sustainable Service Learning Programs"
- Flower (2003): "Talking across Difference: Intercultural Rhetoric and the Search for Situated Knowledge"
- Flower and Heath (2000): "Drawing on the Local: Collaboration and Community Expertise"
- Grabill (2000): "Shaping Local HIV/AIDS Services Policy through Activist Research: The Problem of Client Involvement"
- Harrison and Zappen (2003): "Methodological and Theoretical Frameworks for the Design of Community Information Systems"
- Powell and Takayoshi (2003): "Accepting the Roles Created for Us: The Ethics of Reciprocity"
- Simmons and Grabill (2007): "Toward a Civic Rhetoric for Technologically and Scientifically Complex Places: Invention, Performance, and Participation"

Complete bibliographic information for each work appears in the reference section.

Although the purpose of the eight articles I reviewed differed significantly (as I explain), there were some common elements. All the authors did at least three things: (a) frame the debate they wanted to address, (b) describe a particular research site and their involvement in it, and (c) discuss implications of their work. In framing the debate, the authors define issues relating to a particular topic and show how their work can be used to comment on that discussion. Some authors begin by citing key sources who call for a particular course of

action. Cushman (1996) begins, for example, by reviewing several scholars' comments about what causes the divide between a campus and its surrounding communities and the effects of that divide. Some provide a more traditional literature review. Powell and Takayoshi (2003), for example, present current debates on the ethics of maintaining reciprocity with research subjects. Others offer less of a literature review and instead frame the problem by describing the dilemmas they face in their communities. Flower (2003), for instance, draws on relatively few sources as she describes the difficulty of communicating across significant cultural differences defined by factors such as income, race, education, and gender.

When authors describe a particular research site, they describe several factors, including the geopolitical community, people involved in that community, the issues those people face, the role of rhetoric in facing and perhaps resolving those issues, and the roles that the author-as-researcher faced when working with people in that community. Cushman (2002) describes the Richmond Community Literacy Project, U.C. Berkeley, the local YMCA, and people involved in those organizations. Flower (2003) describes the participants from "Pittsburgh's urban neighborhoods" who took part in an event sponsored by the Community Literacy Center (CLC) with which she worked. Simmons (Simmons & Grabill, 2007) describes how a citizens group works to educate itself on the ways that a mill in Planttown may be polluting the air and water. In all cases, the authors also describe their roles as participant-researchers. The authors take great care, as they should, to describe the contexts in which they are working and the contributions they are attempting to make..

All the authors also reflect on the contingency of their work. Because outcomes are most often murky in these ongoing, sustained projects, the authors reflect on the potential benefits and pitfalls of their work, or they speculate on what seems to be a clear outcome and what remains unclear. "I have been involved in a process of understanding the problem of client involvement for nearly a year and a half now," Grabill (2000) writes regarding his work with a local HIV/AIDs task force, "and honestly, I'm not sure I understand it yet" (p. 30). He also is willing to question whether his work has changed anything: "as the project now stands, the meaning of 'involvement' has not changed, and the meeting is still the dominant practice" (p. 45). Flower (2003) expresses similar concerns: "Though it would be nice to say that in the wake of this event the curfew policy was changed, the police reformed, and the teens became literate activists, social change doesn't seem to happen that way" (p. 62). In some cases, such as the article by Simmons and Grabill (2007), the authors do not talk about potential outcomes at all. What is more important is for the authors to use their research experience to inform other issues.

Although long-term empirical research on wicked problems may sometimes lead to "solutions," such work can be important for other reasons. Activist researchers publish article-length works not so much to report results of research—those improvements or changes that many readers may expect—but to comment on issues related to research and social problems:

- Cushman (1996) hoped "to reveal a tentative model of civic partic-ipation" for researchers who wish to help "empower people in our communities, establish networks of reciprocity with them, and cre-ate solidarity with them" (p. 7). That is, Cushman uses her commu-nity work as a way to build a model for other activist researchers.
- Cushman (2002) used her experience teaching a course called Social Issues in Literacy, the research she conducted with students on campus and on site, to argue for a new role for professors who offer service-learning courses: The new role being professors as fellow researchers.
- Flower (2003) used her experience with the CLC to help build "a preliminary theory, a hypothesis really, about what could happen were we to ground intercultural rhetoric in inquiry, including a deliberate search for situated knowledge" (p. 40). That is, her pur-pose wasn't to document the results of the CLC event but to use her experience with that group to help build theory about inter-cultural inquiry.
- Flower and Heath (2000) used their experiences to argue about the nature of knowledge and the importance of fostering recipro-cal, sustainable relationships. Regarding the nature of knowledge, they wrote, "We see these two cases as ways to challenge some tra-ditional assumptions about where expertise 'naturally' resides in a community/university relationship and how knowledge is con-structed (and by whom)" (p. 53). That is, Flower and Heath used their experiences to make an epistemological argument.
- Grabill (2000) used his experience with an HIV/AIDs planning committee to explore "what an explicitly activist research stance in technical communication might look like" (p. 32). Also, "My primary goal in this article has been to argue for one way that pro-fessional writing researchers can influence public policy" (p. 45). Grabill illustrates a form of activist research focused on the study of institutional policymaking and revision (see also Simmons, 2007). He also attempts to write about how activist research might be enacted in technical communication.
- Harrison and Zappen (2003) used their experience developing a community-based Web resource to argue for the value of partici-patory design for the development of community-based resources and for the suitability of researchers in writing and communica-tion for that work. "Although new technologies always take mate-rial forms and provide capabilities that did not previously exist," Harrison and Zappen argue, "what they do and how they do it are choices exercised, consciously or not, by their human creators." Researchers in writing and communication are ideally suited to "opening up the design process to human actors beyond those historically involved in building ICT artifacts."

- Powell and Takayoshi (2003) used their experiences as researchers in order to explore the ethical implications of establishing reciprocal relationships with research participants—the kinds of relationships advocated by Cushman (1996). Claiming that methodological issues had been addressed, Powell and Takayoshi focused on ethics. (See also Barton, 2008.)
- Simmons and Grabill (2007) used their experiences on two different projects to argue for a greater understanding of the ways citizens make sense of scientific and technical information and of the role that invention plays in that effort. They also argue for a greater understanding of the networked, collaborative nature of that effort. Like Flower (2003), Simmons and Grabill describe ways that people work together to make knowledge. They use their experiences to make an epistemological argument.

In summary, all the researchers used their experiences to reflect on such issues as methodology, ethics, epistemology, the role of activist researchers, and the role of communication technology in communities. These authors used their local experiences in order to speculate or make more general propositions regarding issues surrounding activist research.[6] A cynic might say that these scholars were merely seeking a way to publish, but I believe the articles are much more valuable than that. As Takayoshi pointed out to me recently, such articles contribute to our understanding of methodology, epistemology, and ethics. Such work presents "research that not only strives to improve the research participants' community but that also has its sights set on the researchers' community and work practices" (personal communication). Because such work based on ongoing projects is important, I want not only to describe it but also to consider how it may be produced.

STRATEGIES FOR COMPOSING ACTIVIST RESEARCH

... this is not intended as a write-up of research. (Grabill, 2000, p. 45)

When Herndl and Nahrwold (2000) claim that "Researchers want to get things done, whether that be improving a specific task of rhetorical production or effecting fundamental cultural change" (p. 260), they seem to refer to a linear conception of research and publication—one in which, as I try to illustrate in Fig. 13.1, we inch toward greater certainty through repeated processes of speculation, research, and knowledge creation. This linear conception assumes that questions are posed about one topic, that research yields insights into that topic, and the knowledge is shared through publication.

FIG. 13.1. A simple linear conception of research and publication.

Although this conception is not entirely inaccurate, it is obviously too simple. Consider instead, a more complex conception of research and publication (see Fig. 13.2). Instead of one line of questioning being pursued, the very act of research leads us into unexpected areas. For instance, the research method itself may raise unexpected questions: Why did a chosen method prove less effective than we expected? Would another method, or a modification to the original one, work more effectively in this situation? Sometimes projects yield entirely unexpected results: We were looking for X, but we were surprised to discover Y and Z instead. Sometimes researchers feel compelled to question the reliability or validity of their results, which can lead to new speculations and studies. Or sometimes we feel called to explore the ethics of what we are doing.

What I am describing here should not be new to anyone, but I believe the point is worth restating because it helps illustrate ways that activist researchers involved in sustained, reciprocal relationships also have been able to publish—and the value of that activity:

- Some make a methodological argument. They show how their research experience exposes the strengths or weaknesses of a particular method or set of methods.
- Some make a theoretical argument about communication, epistemology, ethics, and ontology. They show how their research complicates (or contradicts) accepted theory on some issue, such as communication across different communities.
- Some make an argument about praxis. For example, Cushman (2002) argues for a new role for professors. She says they should take more of a research role in service learning. Harrison and Zappen (2003) argue for the value of researchers engaging in the design of community-based communication resources.

FIG. 13.3. *A more complex (but still too simple) conception of research and publication*

Given these possibilities, a heuristic seems possible. Table 13.1 shows how activist researchers can explore ways to create publishable work that emerges from sustained, reciprocal relationships:

The first column of the heuristic comes from Grabill's (2006) list of practices that make up community-based research, and the top row presents the usual journalistic questions. Table 13.1 is designed to generate questions about com-

Table 13.1. *A Heuristic for Exploring Ways That Reciprocal, Sustained Research Relationships Might Lead to Publication*

	Who	What	When/Where	How	Why
Initiation					
Access					
Participation					
Studying up					
Politics					
Communication					
Sustainability					

munity-based research, some of which are likely to lead to publishable work. For example, a look at the second row in the second column (Access: What) could prompt questions like these: What is access? What does genuine access look like? Are there weaker and stronger forms of access? Has our field explored such differences? Does the project I am pursuing illustrate valued notions of access? In what ways could access be stronger for participants? A researcher could keep moving down the access row: When/where does access seem most appropriate or most likely? How have others described access? Do those descriptions conflict? If so, why? How is genuine access achieved? Why is it important anyway? Or consider the questions that might be generated by filling in the row on sustainability: Who argues for sustainability? What is sustainability? How have they described it? Do those descriptions sometimes conflict? In what ways is the project I am pursuing sustainable? In what ways is it not? And so on. Given such a crop of questions, a researcher is likely to find unresolved issues regarding ethics, the role of researchers, epistemology, methodology, communication—issues that do not necessary emerge directly from some initial hypothesis and research method but that emerge instead from the effort to build a sustainable, reciprocal relationship that benefits researcher and participants alike.

CONCLUSION

We all face numerous wicked problems in this world—global warming, increasing energy demands, overpopulation, pollution, intergroup tensions and violence, an evermore argumentative and polarized U.S. culture, inequitable distributions of wealth, and inadequate water and food supplies being just a few contemporary problems. Many of these will be with us for a long time, and many of the people who struggle with such problems could use the help of researchers trained in writing studies. Not only can we help in solving such problems, but we also must hope that others will get involved as well—our personal lives depend upon such solutions even if our research agendas do not always relate directly. Research on wicked problems is too important to leave to others. Although an activist empirical researcher most likely will be unable to report on unequivocal results, traditionally conceived, within the typical time frames demanded by the promotion and tenure guidelines at most campuses, I hope that I have illustrated ways that researchers might be able to generate various essays on method, epistemology, theory, and ethics.

ENDNOTES

1. When I use the phrase *contribute their expertise*, I refer to situations in which academics use their specialized knowledge of content or method to contribute to an exigency. Many academics may contribute to social exigencies in ways that do not require such expertise. A person who fields phone calls and files records for a nonprofit organization may perform significant community service without drawing significantly on her or his expertise.
2. As a tenured faculty member, one of my most pleasant assignments has been to mentor junior faculty. I have written this chapter in a similar frame of mind. I envision myself writing this as a mentor to graduate students and junior faculty, or as one tenured mentor speaking to other mentors about insights that they might want to share with their junior colleagues. As you read this chapter, I hope you might be able to invoke one of these roles for yourself.
3. Due to our institutional review board (IRB) agreement, all names of places and people in reference to the Harbor project are pseudonyms, except for public institutions.
4. Because of the politically charged nature of the situation in Harbor, Jeff's and my research ethics and related IRB procedures have been complex. For example, we requested and received permission to collect oral consent from study participants because we believed that individuals would not participate if they had to sign a document. According to our IRB contract, therefore, I am observing strict confidentiality, excluding from the references all citations that would identify the site.
5. Jeff and I have faced another dilemma that other activist researchers may face. As I wrote in the previous note, we had to preserve the anonymity of research participants to a significant degree. As a consequence, it is difficult for us to document sources. Much of our knowledge about the community came from newspaper reports and interviews, but we cannot document those sources because to do so would reveal the location of the project.
6. Even this chapter illustrates how one who has conducted activist, empirical research can find an occasion to publish. Although Jeff and I lack clear outcomes from our project because of delays instituted by others, we are finding other ways to write about our work. In addition to Blythe, Grabill, and Riley, see Grabill's "The Study of Writing in the Social Factory" (2006) and *Writing Community Change* (2007), and Grabill and Blythe (2010).

REFERENCES

Barton, E. (2008). Further contributions from the ethical turn in composition/rhetoric: Analyzing ethics in interaction. *College Composition and Communication, 59*(4), 596-632.

Blythe, S., Grabill, J. T., & Riley, K. (2008). Action research and wicked environmental problems: Exploring appropriate roles for researchers in professional communication. *Journal of Business and Technical Communication, 22*(3), 272-298.

Cushman, E. (1996). The rhetorician as an agent of social change. *College Composition and Communication, 47*(1), 7-28.

Cushman, E. (1998). *The struggle and the tools: Oral and literate strategies in an inner city community.* Albany: State University of New York Press.

Cushman, E. (2002). Sustainable service learning programs. *College Composition and Communication, 54*(1), 40-65.

Faber, B. (2002). *Community action and organizational change: Image, narrative, identity.* Carbondale: Southern Illinois University Press.

Fals Borda, O. (1991). Some basic ingredients. In O. Fals Borda (Ed.), *Action and knowledge: Breaking the monopoly with participatory action research* (pp. 3-12). New York: Apex.

Flower, L. (2003). Talking across difference: Intercultural rhetoric and the search for situated knowledge. *College Composition and Communication, 55*(1), 38-68.

Flower, L., & Heath, S. B. (2000). Drawing on the local: Collaboration and community expertise. *Language and Learning Across the Disciplines, 4*, 43-55.

Grabill, J. T. (2000). Shaping local HIV/AIDS services policy through activist research: The problem of client involvement. *Technical Communication Quarterly, 12*(3), 29-50.

Grabill, J. T. (2006). The study of writing in the social factory: Methodology and rhetorical agency. In J. B. Scott, B. Longo, & K. V. Wills (Eds.), *Critical power tools: Technical communication and cultural studies* (pp. 151-170). Albany: State University of New York Press.

Grabill, J. T. (2007). *Writing community change: Designing technologies for citizen action.* Cresskill, NJ: Hampton Press.

Grabill, J. T., & Blythe, S. (2010) Citizens doing science in public spaces: Rhetorical invention, semiotic remediation, and simple little texts. In P. A. Prior & J. A. Hengst (Eds.), *Exploring semiotic remediation as discourse practice* (pp. 184-205). London: Palgrave Macmillan.

Harrison, T. M., & Zappen, J. P. (2003). Methodological and theoretical frameworks for the design of community information systems. *Journal of Computer-Mediated Communication, 8*(3). Retrieved from http://jcmc.indiana.edu/vol8/issue3/harrison.html.

Herndl, C., & Nahrwold, C. (2000). Research as social practice: A case study of research on technical and professional communication. *Written Communication, 17*(2), 258-296.

Lindemann, E. (2001). *A rhetoric for writing teachers* (4th ed.). New York: Oxford University Press.

McComas, K. A. (2003). Citizen satisfaction with public meetings used for risk communication. *Journal of Applied Communication Research, 31*(2), 164-184.

Powell, K., & Takayoshi, P. (2003). Accepting the roles created for us: The ethics of reciprocity. *College Composition and Communication, 54*(3), 394-422.

Rittel, H., & Webber, M. M. (1973). Dilemmas in a general theory of planning. *Policy Sciences, 4*, 155-169.

Roach, J. (2005, May 25). Gulf of Mexico "dead zone" is size of New Jersey. *National Geographic News.* Retrieved from http://news.nationalgeographic.com/news/2005/05/0525_050525_deadzone.html.

Ross, J. (1999). Tortilla wars. *Progressive, 63*(6), 34-35.

Scott, J. B. (2003a). Extending rhetorical-cultural analysis: Transformations of home HIV testing. *College English, 65*(4), 349-367.

Scott, J. B. (2003b). *Risky rhetoric: AIDS and the cultural practices of HIV testing.* Carbondale: Southern Illinois University Press.

Simmons, W. M. (2007). *Participation and power: Civic discourse in environmental policy decisions.* Albany: State University of New York Press.

Simmons, W. M., & Grabill, J. T. (2007). Toward a civic rhetoric for technologically and scientifically complex places: Invention, performance, and participation. *College Composition and Communication, 58*(3), 419-448.

Sullivan, P., & Porter, J. (1997). *Opening spaces: Writing technologies and critical research practices.* Greenwich, CT: Ablex.

Tortilla wars erupt. (2007). *Ecologist, 37*(3), 11.

14

DISCOURSES OF PRESERVATION

The Gullah Community and Rhetorical Construction

Annette Harris Powell

To endure, a community must be able to bequeath its shared traditional expressive culture to the next generation. Without the living context in which that expressive culture arises, cultural endurance is by no means certain.
—Charles Joyner (1999, p. 281)

Julie Dash's 1991 film *Daughters of the Dust*, set in the turn of the century Sea Islands of South Carolina, opens with matriarch Nana Peazant's incantation: "I am the first and the last; I am the honored one and the scorned one. I am the wife and the virgin; I am the barren one, and many are my daughters. I am the silence that you cannot understand; I am the utterance of my name." Nana Peazant represents the complicated history of the Gullah people in the space of the Sea Islands; they are a community whose isolation from the mainland resulted in the creation and maintenance of a distinct, original African American culture from South Carolina to Georgia.[1] Peazant is the family's connection to slavery as the film charts the family's preparation to leave Ibo Landing on St. Helena Island to migrate north to the mainland. She is the voice of the past telling Ibo tales, yet she embodies the contradictions and paradoxes of history. Nana Peazant is both "honored" and "scorned." She is "barren" yet she has borne many. She is the "silence" and the "utterance." Peazant is disconnected from her own historical experience because someone else has had a hand in shaping it. The fruits of history have been removed from her story, leaving her barren, unable to (re)produce anything comprehensive for future generations. Peazant represents the tension between preserving and maintaining history and culture, as generations cross into the future. She represents the history that cannot speak for itself, and

she constitutes a living memory of the Gullah culture through the telling and re-telling of the Ibo tales. Dash's film is resonant both because of its pivotal terrain between Africa and Diasporic blackness as it enters into modernity, and because of its emphasis on the importance of transmitting heritage from one generation to the next. In this instance, the inherent paradoxes represented by Nana Peazant characterize the complexities of space, how collective memory and meaning are (re)produced and circulated within situated space, and how both are preserved in/through the landscape. These very complexities or tensions exist in the Gullah community.

The Gullah of the Sea Islands, a unique and relatively shrouded culture, represent the historical silence of a region that various constituencies are now working to make legible as well as to preserve. The process of preserving Sea Islands language, land, and heritage has been a decidedly slow and complex one, owing in part to the very nature of preservation and the variety of interest groups involved. Although discourses of preservation primarily are concerned with the transmission of cultural heritage, as well as the revision and possible contestation of it, the tendency is to talk about preservation as though one is in agreement about its meaning. In fact, we do not all mean the same thing when using the term, and we do not necessarily have the same intentions when engaging it. For example, the 2005 translation of *The New Testament* into Gullah suggests a pre-scriptive form of preservation that was grounded before local conservation efforts, and potentially colors the way preservation takes place. Given that Gullah is an oral language, the Gullah Bible translation into written form is important for many in this community because it represents a part of cultural memory and meaning that they believe to be a crucial link to African pasts. However, the translation project also illustrates the central tension between preservation and conservation; the former codifies and freezes culture as it works to transmit it, while the latter, conservation, maintains it in a usable state. This chapter explores competing tensions and current efforts to preserve the "life ways" and living culture of the Sea Islands.

MAPPING THE SEA ISLANDS' CULTURAL LANDSCAPE

Due to increasing seaside development, other commercial efforts, natural demographic shifts, and the influence of popular culture and television on the younger generation, many Gullah are leaving the Sea Islands to pursue economic and educational opportunities, threatening an already rapidly eroding culture. This has resulted in local efforts led by grass-roots coalitions of environmentalists, artists, preservationists, and entrepreneurs seeking to write this local culture into American history—to document, reclaim, and preserve the unique cultural landscape of the Sea Islands culture.[2] Recently, large-scale efforts to preserve the her-

itage of the Gullah-speaking Sea Islands community have resulted in the passage of the federally funded 2006 Geechee-Cultural Heritage Act. The bill established the Gullah-Geechee Cultural Heritage Corridor, the only one dedicated to the preservation and interpretation of African American culture and heritage. The Corridor, comprised of approximately 40 Heritage Areas along the Atlantic Coast from southeastern North Carolina through South Carolina and Georgia, to northern Florida, is dedicated to identifying and protecting historical sites, data, and artifacts.

Given the lack of documented historical narratives representing the Gullah, this preservation project faces some challenges. There are limited traditional forms of historical evidence and documentation of the language and culture, and the Gullah do not have significant control of the spaces that reflect their history. The Corridor commission is working to construct new narratives that contextualize Gullah experience. The new Sweet Grass Cultural Arts Pavillion in Mt. Pleasant, South Carolina, contributes to such narratives. It represents a tangible structure where visitors can see "one of the key vestiges of Gullah culture" in its usable state—in the form of exhibits and displays about sweet grass baskets and their importance to the culture and history of the region (Byrd, 2010).

Although still in its nascent stages, preservation efforts have increased the visibility of the Gullah considerably. Commercial development stimulates tourism, and increased tourism stimulates further development. Local preservation efforts, such as storytelling events and the translation of the New Testament into Gullah, as well as federal and local institutional efforts such as the recent reinstallation of The Old Slave Mart Museum in Charleston produce tensions that complicate preservation in this region.[3] Efforts to preserve Sea Island culture naturally call into question the effects of the double-edged sword of preservation—retaining culture and history and the simultaneous risk for freezing or deadening language and culture, as well as questions about how local and regional cultures are structured and represented. How can the Gullah, a distinct ethnic group within American culture, maintain its unique identity while continuing to be a part of mainstream culture?

The threatened erasure of the Gullah-speaking Sea Islands culture, and local and national efforts to preserve this culture are significant issues that ethnographic study might address. In addition to researching and understanding the competing tensions at work in ensuing preservation efforts, understanding the "cultural landscape" of the Sea Islands requires an appreciation of what it might mean to preserve such a distinct culture, and how the practices of preservation both reflect and shape the realities of the Gullah-Geechee. How do they write their history onto the landscape, especially when, often, *what* is being preserved is the very thing being contested? What does preservation do, what are the effects of what it does, and what are the material possibilities?

A useful way of thinking about the landscape onto which the Gullah are working to write themselves is through the term *cultural landscape*, coined by cultural geographer Carl Ortwin Sauer in the 1920s. Sauer (1963) described a *cul-

tural landscape as "an area made up of a distinct association of forms, both physical and cultural ... fashioned from a natural landscape by a culture group. Culture is the agent, the natural area is the medium, the cultural landscape the result" (pp. 321-343). In this instance, the landscape is a material thing acted on by those who inhabit it. In discussing how ethnic groups write their identity onto the landscape, Christopher Airress (2002) has described landscapes as "the *ordinary* or *commonplace* visual elements of a community that residents create to satisfy their needs, wants, and desires" (p. 228, italics added). As preservationists have suggested, landscapes are texts that "tell stories" and "concretize ideology" (Riesenweber, 2008, p. 31). Preservation is, itself, an act of memorialization, and memorials are inherently rhetorical.

Any ethnographic landscape can be seen as rhetorical—constantly being struggled for. In fact, the very act of preserving changes that which is being preserved. You might say that preservation is always about simulacra, never the original. But, if memory is rooted in specific communities, as Joseph Roach (1996) suggests, how do we preserve it? The act of preservation is protean, multiple, contentious, and often contradictory. By its very nature, then, preservation requires a redefinition of what it means to preserve. With increasing globalization comes an increased homogenization of culture. As we struggle to assert a cultural identity the local becomes more desirable. The resulting phenomenon has been an effort to reclaim and preserve unique local cultures.

A broader understanding of such distinct and unique cultures, in particular, suggests a need for research methods that recognize the significance of the local and its connection to the everyday. One way to understand what it means to preserve culture, in terms of memory, cultivation of space, and public history is through Wendy Hesford's (2006) concept of critical localism—"methods that recognize the ongoing cultural work of 'local' spaces" (p. 790). My intention here is to use the Gullah preservation efforts as an example to foreground those questions with which researchers should be concerned. For instance, who determines what is being preserved; how does what is being preserved reinforce, reflect, and shape Gullah identity; and how can we, as researchers, facilitate the work of the community without intervening? My experience has been that in most cases the community does not want or need intervention, but as a field, our assumption continues to be that they do. I see intervention as a particularly loaded term, primarily because it is always *us* intervening *there*, and secondarily, because it is impossible to intervene without being self-interested. But, as Blythe (Chapter 13) has suggested in this volume, we need to reconsider the uses of our research. What I have found, in the process of doing this research, is that although I can offer insight, I continue to return to the default position—gathering data, and interpreting rhetorical significance.

Although the overall challenge for the Gullah entails doing what Kathleen Stewart (1996) suggested, "[to] imagine [and conserve] this 'space on the side of the road' without freezing its moves in a grand totalizing scheme of 'objects' and 'gists'" (p. 4), a more specific challenge for researchers is to come to a better

understanding of preservation. Indeed, how we understand preservation informs how we understand and do research, and how we contribute to the work of revealing what is been hidden. Doing research around issues of preservation requires an examination of what is at play, what drives certain assumptions around, for example, economics, politics, and differential power that mediate what becomes a part of public, cultural memory and what we forget. However, because preservation is inherently conservative, and because ideology surrounding preservation is typically conventional, discussions fail to address concerns about which practices and memories are made visible and legible when local cultures work within national preservation legislation to construct "imagined communities" (Anderson, 1983). This is important because preservation is at once a recovery and a (re)interpretation of history; it flattens history through a rhetoric that embraces some elements and erases or trivializes others.

DEFINING PRESERVATION

Cultural and historical preservation efforts in urban terrains, small towns, and rural enclaves have been increasing across the country. Exhibitions, monuments, documentary, and translation are iterations of these efforts. Although all preservation projects are explicitly ideological, it is important that we understand the discourses and projects of preservation as inherently *rhetorical*. Preservation projects and discourses are inherently rhetorical not only because they identify, construct, and mediate which subjects are constructed by an interest group or community, but also because they mediate what a group or community chooses to preserve or reclaim, reconceive the community's artifacts, reconstruct the vehicles (memories) necessary to particular kinds of preservations, and determine how those memories function or are deployed to produce certain effects.

The Society of American Archivists (2005) defines preservation as the maintenance or restoration of documents, records, and artifacts through study, treatment, and prevention of decay, damage, and loss. The superficial nature of this definition is apparent with its emphasis on preserving objects and forms rather than valuing contextual social meaning that informs interpretation of the artifact or text, and creates material preservation of memory. My intention is to put pressure on disciplinary uses of the word preservation—to protect, to restore, to save objects and artifacts from damage or destruction, by thinking about preservation of a living culture as conservation, which is focused on restoring or maintaining natural resources, historical sites, and cultural artifacts for sustainable use. Conservation, rather than preservation, suggests maintaining or keeping alive— a memory, a name, a culture. Part of the rhetoric in using the word preservation is how we associate it, what we bring with the word. When we preserve something, do we keep it alive or do we put it on a shelf and "freeze" it temporally? If

we use the word conservation, we see this enterprise differently. It evokes association with the environment, with natural resources, with things living, breathing, and usable. This is an important intervention because in the act of preserving cultural heritage—practices, traditions, beliefs, expressive culture, and language—things that are near impossible to quantify, we do not want to displace or disconnect groups from their history and culture. I also want to emphasize what I see as a distinct conservative component to preservation that freezes culture in a static, fixed, and formulaic way as opposed to a continued sustainable use. The tension between conservation—the method of connecting the vital cultural aspects of history to the present, and preservation— which freezes history and decontextualizes the connection between past and present should be explored. This tension structures meaning, with conservation undermined by the overriding concern with preservation. The past is foregrounded so that the vitality of the present is ignored—preservation trumps conservation. The act of preservation is not just about the past, it is also about the future, about possibility; it is at least a double gesture toward what was and what can be. Indeed, the vitality of "what can be" is central to conservation—meaning is in the present.

Because socially progressive research, "political and ethical action" in the service of progress, like rhetoric in the world, is connected to a kind of real-world practicality, it advances a critical approach that rejects static aspects of historical rhetorical and embraces rhetoric as a real-world, practical component of a living history. Just as rhetoric is concerned with the function and effects of the everyday, a socially progressive research method understands itself to be rhetorical and concerned with the everyday. Both the everyday practices in which particular communities engage and the methods researchers use to investigate them are grounded in rhetoric; they consider words and language central to memory, to creating institutions, and to having an effect in the world. To contribute to social progress, research methods must examine the pasts that have been constructed— those narratives that make certain claims about pasts through verbal and visual tools, and ask, what is being reclaimed or preserved, and what are the effects of reclamation? Socially progressive methods should understand that any act of preservation is always a rhetorical act. Therefore, how a socially progressive researcher understands the *effects* of preservation is important. For example, although local and spatial, it is not only the land that counts. If you own land, you can interpret it however you would like to, but land does not signify on its own. The interpretive sites proposed as part of the conservation of Gullah heritage have a different effect. That is, there is a difference in what it means to be there, to have a physical presence. The interpretive sites make the material effects possible, establishing a place to work, exhibit, and tell stories there. Of course, they should always be struggling for both—the land and the opportunity to effect material change.

Preservation is already constructed around typography and geography—the built environment—however, it also goes beyond the concrete to include a variety of texts such as museums, memorials, practices, and memories. These texts are

centered on the ideological and political, which is typically what is obscured. Preservation of Gullah heritage is being promoted around a particular social policy that is going on right now, but policy is ideological and often shifts. This prompts us to consider how we might rethink cultural preservation in ways that allow for or consider the gaps we find in terms of politics, imagination, and ideology.

Preservation as rhetoric is concerned with which artifacts and practices are included, which are elided in public discourses and practices, and the role of memory, affect, and episteme in the erasure or reconception of history. Arjun Appadurai (1996) has forcefully suggested that as group pasts become increasingly parts of museums, exhibits, and collections ... culture becomes less what Pierre Bourdieu (1984) called habitus (a tacit realm of reproducible practices and dispositions) and more an arena for conscious choice, justification, and representation, the latter often to multiple and spatially dislocated audiences (Appadurai, 1996). As such, meaning is effectively frozen so that history is disconnected from the vitality of the present. Appadurai productively illuminated how the rhetorics and practices of preservation, then, are about selectively creating narratives that resemble a degree of present-day reality while capturing memories of the past. Still, preservation is as much about the future as it is about the past, as we construct the future based on what we choose to preserve. In the case of the Gullah-Geechee, decisions about what to preserve, and how to go about doing it have been given some consideration. The emphasis should not be on selective preservation, but on the conservation of the historical whole as it relates to the forward-looking practices of conservation.

The National Park Service's (NPS) 2005 Special Resource Study of the history, the practices, and the traditions of Low Country Gullah Culture, in consultation with the local community, recommended the establishment of a National Heritage Area (NHA), generally considered to be "the most effective and efficient," as it would be a place where the Gullah-Geechee can tell their story (NPS, p. 10). The latter was selected with a management commission of local people and the responsibility for interpretation shared with individual sites. The NHA allows for "complementary" and "conflicting points of view to find expression, as befits a living, changing culture" (NPS, pp. 141-146).

Although the enduring effects of preservation efforts in this coastal region are left to be seen, the primary objective is to support local and living representations of a culture and people historically regarded by tourists (and the government) as "relics of a bygone era." The national attention recent preservation efforts have garnered has worked to entice tourists to the region in search of its history, so that a culture previously hidden, and seemingly irrelevant, is now being revealed. But, the move to reveal, to memorialize, to interpret is often contested and produces real tensions about what is selected for preservation, how it will be interpreted, and who will do the interpreting. When revealing tacit or hidden aspects of this unique culture for which there is partial documentation, memory can be displaced and often contested. This increases the potential risk of misinterpreting or misrepresenting parts of the very culture being preserved. As I discuss, transla-

tion of the Gullah Bible is an example of a contested site, complicated by the tensions surrounding sponsorship as well as form and meaning.

TRANSLATION AS A FORM OF PRESERVATION

The 2005 publication of the translation of the King James version of the New Testament into Gullah, which coincided with the passage of the Gullah-Geechee Cultural Heritage Act, was the culmination of a 26-year project by the American Bible Society (ABS) with the support of several "sponsors." Prior to this, the Sea Island Translation team's initial efforts had resulted in the translation of the Gospels of Luke (1995) and John (2000). Criticism of these earlier publications by other translators, including linguist David Frank, suggested that they were too "anglicized" (Holmes, 2006). Active efforts were then made by the translation team to authenticate the language, to ensure that the verses reflected "deep" Gullah rather than the modernized, English-sounding slang to which it has evolved. Such a prescriptive approach to the translation indicates that there are different groups, with different investments involved in preservation efforts. Preserving the Gullah language is a difficult proposition given that it is not a written one. In foregrounding conservation, I am arguing for a living language, one that evolves naturally, as language does, and does not necessarily adhere to standards. According to the Sea Islands translation team, the method undertaken is a dynamic equivalent translation which is not a word-for-word translation, but rather, one that "follows the expressed preference of the Gullah community" (ABS, 2005a, p. vi). It also is annotated with English in the margins. Still, the translation preserves more than it conserves; therefore, it replicates the tension mentioned earlier.

The sponsors of this translation include the ABS, a nonprofit ministry with a mission "to make the Bible available to every person in a language and format each can understand and afford so that all people may experience its life-changing message"; SIL International (formerly known as the Summer Institute of Linguistics), a faith-based organization that studies, documents, and assists in developing the world's lesser-known or unwritten and endangered languages; the Wycliffe Bible Translators who work in more than 90 countries to make "God's word accessible to all people in the language of their heart, in their mother tongue"; and The Penn Center, the site of the first school for freed slaves and a regular meeting place for members of the Civil Rights Movement. The Penn Center sponsored occupational programs, and later evolved into a cultural center for St. Helena citizens. Presently, the center is focused on preserving the language, culture, and history of the Island's Gullah population. In her discussion of sponsorship, Deborah Brandt (1998) explains how sponsors "set the terms for access to literacy ..." (p. 19). The sponsors of this translation raise expected

questions about their economic, political, religious, and commercial goals in participating in this publication, as their motivations set up the "purpose" of the text and how it actually functions within the culture. And as Brandt (1998) suggests, this form of sponsorship dictates specific standards for Gullah language, standards that restrain and codify its natural evolution.

It is significant, although perhaps not surprising, that all of these sponsors have faith-based affiliations and foreground evangelical agendas. The Penn Center, however, despite its Quaker beginnings, foregrounds a mission that appears to be more intentionally focused on the economic uplift of the community, such as preserving Gullah farmland and securing adequate housing. The other sponsors' interests in the Gullah translation, and their vision for translating/publishing this version is evident in how they represent it: In a press release issued by the ABS (2005b), Dr. Robert Hodgson, dean of the Nida Institute for Biblical Scholarship at the ABS, noted that the institute's involvement in this project was not a commercial one—it provided accuracy checking for the translation, but rather, "the Bible Society's mission is to provide Scriptures for various language groups that desire to read God's Word in their heart language." Hodgson further stated, "The Gullah New Testament raises the Gullah language and culture to a new level by enshrining the Scriptures in a Creole language once denigrated as a second class version of English" and that "African American churches around the country will celebrate this new translation for its lively tone and musical rhythms, reminiscent of today's Hip-Hop vernacular, but also for its *recovery* of an almost forgotten chapter in the history of African Americans." The ABS has said its "hope is that this New Testament will help keep the Gullah language and culture living and active among future generations." At the time of publication, it was generally believed, by translators and linguists that churches would be the primary audience for this translation because preachers would now have a consistent reference, and would not have to make up translations into Gullah. The agenda of these institutions seems clear—to spread the Word—in whatever language, although some might not see the translation as much of a tool for evangelizing. In fact, the Penn Center and many members of the Gullah community who have associated themselves with the project assert a primary interest in the renaissance of Gullah language and heritage.

Historically, Bible translations have been done to enable more effective—easily understood—transmission of God's Word. This suggests access to be a key motivating factor. But, what does it mean to have access to the Word; should it be stripped down or sanitized so that it is accessible to all people in a neutral way; does it alter or create new meaning based upon the target audience; and who is the presumed audience for this text? While access might be significant for some—rendering the text so that it is contextually meaningful for speakers of Gullah, the modernization of Gullah complicates access so that the question of who the presumed audience for the text might be is not quite so straightforward. We have questions of access on the one hand, and preservation on the other—an attempt to historicize a language in its "original" form. If, according to Joseph

Roach (1996), memory is rooted in specific communities, how do we preserve it? Moreover, how do the Gullah want their culture preserved and represented? Linguists such as John Rickford (cited in Chepesiuk, 1988) have suggested that the forces of change facing the Sea Islands will be difficult to reverse and based on past attempts to preserve local languages, he cautions that although the translation will likely help in preserving Gullah heritage, the hands of time cannot be turned back. Still, if we think about this in terms of memory, the translation does a particular kind of work. It serves as a catalyst for resurrecting or making visible certain memories; the power of the Word, or the use of particular words or phrases are connected to these memories. I am particularly interested in which memories will be deployed and *how* they will be deployed. That is to say, the deployment of memory becomes problematic when it is done without social or political context. In this way, translation can become a kind of performance.

So, spreading the Gospel and preserving culture are seemingly competing principles complicated by the fact that the target audience for the translation is said to be "the church and the preacher." With the church as the primary audience for this translation, what are the possibilities for how this text will function in this community? What are the implications of using a text with strong colonial resonance to preserve language and culture, given the historical use of the Bible for conservative, hierarchical purposes, such as the enslavement and oppression of indigenous and diasporic people, and women?

Arguably, Christianity's connection to colonialism (and the teaching of English) bears its own complexity, yet many contend that because Christianity values vernacular languages, it assists native cultures in resisting the homogenizing effects of Western culture. Gambian historian Lamin Sanneh (1987) has documented similar occurrences of translation preserving local culture throughout Africa and has written that in Africa, "The vernacular Scriptures and the wider cultural and linguistic enterprise on which translation rests provided the means and occasion for arousing a sense of national pride," and Sanneh went on to say, this dynamic "undercuts the alleged connection often drawn between missions and colonialism" (p. 333). Given the responses of the Gullah members of the translation team, there has indeed been revival of a kind of "nativist" pride, as the Gullah language reveals the culture and is an important part of people's sense of identity." Community responses have been overwhelmingly positive. During a ceremony launching the 26-year translation, Gullah translation team member Ardell Greene (ABS, 2005b) described it as "a treasure," noting that it "will be read in churches and our youngsters will be encouraged by it to keep the Gullah tradition alive. The Word of God speaks to your heart and, as a Gullah speaker, God speaks to me in Gullah." Emory Campbell (ABS, 2005b), executive director emeritus of the Penn Center, and former member of the translation team noted, "This New Testament has created much excitement among Gullah speakers and it is a gift to all as we treasure our heritage and *work to preserve it*." Campbell added that "a Bible in [their] language is gold," and that the Gullah New Testament is "validation for a community that for many years was mostly illiter-

ate and much of their history lost" (Huntley, 2005, p. 1). Vernetta Canteen (ABS, 2005b), another member of the translation team, also expressed excitement saying "That's the first time I heard God talk the way I talk," suggesting the translation validates Gullah culture and heritage.

Because Gullah was not previously a written language—itself problematic, many in the Gullah community believe the recent translation of *De Nyew Testament* (ABS, 2005a) offers hope that the native tongue and culture will be preserved. Some speak of the translation as powerful because "faith is all the Gullah people had," proclaiming Gullah roots to be in Christianity. The power of the Word resonates with many in the community, at least according to translation team members. Is this enough? What material practices might be ignored by saying, "All we have is faith, the Word?"

Understandably, some members of the community see this project differently. Lula Mitchell, an 82-year-old school teacher says, "It's nothing but broken English," a sentiment initially shared by members of the translation team until they were later convinced otherwise (Simon, 2005). Translation team member Campbell acknowledged that he did not agree to help with the translation until a University of California professor validated Gullah as a language: "I thought then it was a legitimate project" (Associated Press, 2005). On the other hand, Arthur Chisholm, a deacon at Ebenezer Baptist Church, which has a sizable Gullah congregation, expresses skepticism about using the Gullah Bible for worship: "You want to learn the one that speaks God's word in the King's English. I'd stick to that" (Simon, 2005, p. 3). Chisholm's point of view complicates what has become a celebrated affair. His perspective belies a certain ideological understanding of what the King's English represents—that from an epistemic standpoint this text translates a particular kind of knowledge that you need to read, in the King's English, in order to "learn" it. The question becomes, what is it about the translation that compels a reading in Gullah in order to learn or understand? In other words, what does one get from the Gullah translation that one cannot get from the King's English version? If we understand literacy as "always embedded in socially constructed epistemological principles" (Street, 2001, p. 7), and if we understand the practices of reading and writing as "rooted in conceptions of knowledge, identity, and being," this question has larger implications for the kind of knowledge that conceives Gullah identity (Street, 2003, p. 78). Moreover, if you put into written form an otherwise oral language, one that is dynamic and continually changing, what are the effects of this stabilizing process—on the language as well as on community identity?

Suresh Canagarajah (1999) has argued against binary positions—for or against English; for or against the vernacular—noting that native speakers may in fact transcend the conflict by creatively using English in ways that serve local needs while resisting linguistic imperialism. Canagarajah promoted a *resistance perspective*, the view that

each language is sufficiently heterogeneous for marginalized groups to make it serve their own purposes. It provides for the possibility that, in everyday life, the powerless ... may find ways to negotiate, alter, and oppose political structures, and reconstruct their languages, cultures, and identities to their advantage. (p. 2)

Although Canagarajah (1999) has made useful points about the possibilities that exist, there is still room to question how the discourse surrounding this translation and other preservation efforts result in agency for the Gullah. The $10 million allocated for preservation efforts, for example, will come from the U.S. government, and because we do not yet know exactly who will be controlling it, it is left to be seen whether and how much discretionary power the Gullah community will have. So, although translation has agency, it also has limited possibilities. What I'm really stressing are the competing discourses that seem to exist around notions of access and preservation, including the ways that different groups want to insert Gullah into the culture—the reasons different sponsors have for participating—as well as the differing epistemologies that construct Gullah identity. I'm interested in finding out why people are buying the Gullah Bible—whether as a kind of "collectible" or frozen cultural artifact, or whether they are really engaging with it in a way they would not engage with the King James version of the Bible, or other Bibles.

According to Canteen (ABS, 2005b), the Gullah Bible translation is now in many, though not all of the churches. People are buying them by the dozen, and the youth of this community are "paying attention because it's their history." In fact, the Gullah Bible is now on its second printing, and preparations are being made to work with the Hosanna publishers who are interested in producing the New Testament on tape.

Certainly, one might argue, as a number of academic theorists do, that "the practice of heritage is false and misguided, and saturated in nostalgia" or that it is "political and can be exclusive" (Denkler, 2007, p. 59). The practice and preservation of heritage can be false and misguided *because* it is inherently political and complex, inherently rhetorical. Although the Gullah-Geechee preservation project is in its nascent stage, initial examination of this site suggests that the community has a significant stake in how its history will be memorialized and interpreted. Even as tourism burgeons in the Sea Islands, and, perhaps, transforms the culture, local expressions of heritage continue to be significant in conserving its usable state.

As top–down discourses of preservation potentially collide with local conceptions, what is the terrain upon which those local voices are heard? A primary consideration of socially progressive researchers (as Takayoshi, Tomlinson, & Castillo, Chapter 5, this volume, suggest) will be to understand the material effects of preservation and conservation so that as we do ethnography, we might question and reveal appropriately. As we build potential ethnographic projects such as this one, we must consider these initial textual and theoretical questions.

ENDNOTES

1. The Sea Islands, comprised of Gullah-Geechee–speaking communities previously enslaved Africans and their descendants, extends from the South Carolina coastal region to the edge of Florida. The Gullah language is an English-based Creole developed by the Sea Island slaves.
2. In May 2004, the National Trust for Historic Preservation (NTHP) named the Gullah-Geechee culture, coastline, and Sea Islands to its list of 11 Most Endangered Historic Sites. The NTHP described the area as under considerable threat due to new roads and bridges that "have opened the area to intensive development and tourism, and sprawling resorts, residential subdivisions and strip malls are sprouting everywhere. Family cemeteries, archaeological sites and fishing grounds are being paved over or put off limits by new owners, and familiar landmarks—stores, churches, schools, and houses—are being demolished or replaced with new structures" (see www.national-trust.org/11Most/2004/gullah-geechee.html).
3. The 2007 installation is an exhibition of historical documents, recorded accounts, and tools displayed to tell the story of Charleston's participation in the domestic interstate slave trade.

REFERENCES

Airress, C. A. (2002). Creating Vietnamese landscapes and place in New Orleans. In K. A. Berry & M. L. Henderson. (Eds.), *Geographical identities of ethnic America: Race, space, and place* (pp. 228-254). Las Vegas: University of Nevada Press.

American Bible Society. (2005a). *De Nyew Testament.* New York: Author.

American Bible Society. (2005b, November 16). *God speaks in Gullah: Gullah language translation of the American Bible Society celebrated as 26-year project is concluded* [Press release]. Retrieved from http://www.americanbible.org/absport/news/item.php?id=142.

Anderson, B. (1983). *Imagined communities: Reflections on the origins and spread of nationalism.* New York: Verso.

Appadurai, A. (1996). *Modernity at large: Cultural dimensions of globalization.* Minneapolis: University of Minnesota Press.

Associated Press. (2005, November 18). The Word of God is out-in Gullah. Associated Press. *St. Petersburg Times.* Retrieved from http://www.sptimes.com/2005/11/18/news_pf/Worldandnation/The_word_of_God_is_ou.s.

Bourdieu, P. (1984). *Distinction: A social critique of the Judgment of Taste* (R. Nice, Trans.). Cambridge, MA: Harvard University Press.

Brandt, D. (1998). Sponsors of literacy. *College Composition and Communication, 49*(2), 165-185.

Byrd, A. (2010, April 12). Gullah-Geechee corridor taking its place in history. Columbia, SC: South Carolina Radio Network. Retrieved from http://www.southcarolinaradionetwork.com/2010/04/12/gullah-geechee-corridor-taking-its-place-in-history-audio/.

Canagarajah, S. A. (1999). *Resisting linguistic imperialism in English teaching.* London: Oxford University Press.

Chepesiuk, R. (1988). The Gullah bible: A link between past and future? *American Visions, 3,* 32-36.

Dash, J. (Director). (1991). *Daughters of the dust* [motion picture]. United States: Kino International.

Denkler, A. E. (2007). *Sustaining identity, recapturing heritage: Exploring issues of public history, tourism, and race in a southern town.* Lanham, MD: Lexington Books.

Hesford, W. S. (2006). Global turns and cautions in rhetoric and composition studies. *PMLA, 121*(3), 787-801.

Holmes, K. E. (2006). Putting the word into Gullah language. *The Inquirer.* Retrieved from www.philly.com/mld/inquirer/news/editorial/13680268.htm?template=contentModul...

Huntley, D. (2005, October 25). Scripture translation brings old tongue alive. *Charlotte Observer.* Retrieved from http://www.charlotte.com/mld/charlotte/news/12989562.htm.

Joyner, C. (1999). *Shared traditions: Southern history and folk culture.* Champaign: University of Illinois Press.

National Park Service. (2005). *Low country Gullah culture special resource study and final environmental impact statement.* Atlanta: NPS Southeast Regional Office.

Riesenweber, J. (2008). Landscape preservation and cultural geography. In R. Longstreth (Ed.)., *Cultural landscapes: Balancing nature and heritage in preservation practice* (pp. 23-34). Minneapolis: University of Minnesota Press.

Roach, J. (1996). *The cities of the dead: Circum-atlantic performance.* New York: Columbia University Press.

Sanneh, L. (1987). Christian missions and the Western guilt complex. *The Christian Century,* 331-334.

Sauer, C. O. (1963). The morphology of landscape. In J. Leighley (Ed.), *Land and life: A selection from the writings of Carl Ortwin Sauer* (pp. 315-350). Berkeley: University of California Press.

Simon, S. (2005, December 29). Gospel according to gullah. *Los Angeles Times.* Retrieved from http://linguafranka.net/gullahbible/latimes.htm.

The Society of American Archivists. (2005). Retrieved from http://www2.archivists.org/glossary.

Street, B. V. (2001). Introduction. In B.V. Street, *Literacy and development: Ethnographic perspectives* (pp. 1-18). London: Routledge.

Street, B. V. (2003). What's "new" in new literacy studies? Critical approaches to literacy in theory and practice. *Current Issues in Comparative Education, 5*(2), 77-91.

Stewart, K. (1996). *A space on the side of the road: Cultural poetics in an other America.* Princeton, NJ: Princeton University Press.

15

CONSIDERING CONFIDENTIALITY IN RESEARCH DESIGN

Developing Heuristics to Chart the Un-chartable

Christa B. Teston

Collaborative decision making, or deciding about future courses of action in the workplace has been the subject of study for many in the field of rhetoric and writing studies (see, e.g., Barton, 2004; Bazerman, 1994; Bazerman & Prior 2004; Bracewell & Witte, 2003; Haas & Witte, 2001; Medway, 1996; Sauer, 1996). Much of this scholarship uses workplace documents, or their production, as evidence or data for better understanding how work gets done and decisions are made. Prior to, and even during the production of workplace documents, however, are hours' worth of oral deliberations and debates that invariably play a part in decision making. An investigation into the role of these knowledge-building and decision-making processes in workplace practices—processes that may or may not yield formal, textual documentation—has not yet been exhausted. The object of study described herein, therefore, is cancer care professionals' private, collaborative deliberations at a Midwestern hospital's weekly meeting.[1]

Researching medical workplace decision making in one of its rawest forms—oral deliberation—is a complicated undertaking, however. In this chapter, I detail the methodological approach necessary when shifting the investigative gaze away from textual products or production and onto undocumented, unsurfaced knowledge construction (for more detailed discussions of knowledge work, see Spinuzzi, 2006; Winsor, 2001). Specifically, I describe the methodological approaches developed at a site where an interdisciplinary group of medical professionals make difficult decisions about patient care primarily through oral exchanges, but these oral exchanges may *not* be collected because they are considered confidential and private.

The question motivating this chapter, therefore, is, how can researchers in Rhetoric and Writing Studies come to understand the role of rhetoric and writing in the construction of knowledge and everyday work at a site where, for various reasons, there is not, and cannot be a textual or oral trace? If researchers cannot use tape-recorders and video cameras to capture collaborative deliberations, does that mean these particular sites are unavailable for study? Or does it simply mean that the kinds of conclusions the researcher ultimately makes will be speculative at best? How can we, therefore, as researchers interested in the role of rhetoric and writing in the construction of knowledge gain access to, collect data from, and make defensible conclusions about workplace practices at sites that do not facilitate the collection of textual or oral data?

These are some of the methodological dilemmas I had to contend with while attempting to observe and document how a group of medical professionals deliberate about decisions pertaining to their patients' care during a private, weekly meeting called a Tumor Board Conference. In this chapter, I demonstrate how I managed the collection of data during Tumor Board deliberations while also remaining sensitive to the confidential nature of their content. What follows is not meant to be a how-to or a step-by-step protocol for the collection and analysis of data from particularly confidential workplace sites. Instead, I argue that collecting confidential data in private sites can be done rigorously and responsibly by creating and relying on inductively derived observational heuristics that, over time, act as an observational trace where there was or could not be one before. I hope by telling my own research design narrative, we as a field might continue to have our own deliberations about how to study writing and rhetoric not only as a tangible, final product, but also as a complex, dynamic, multidimensional process sometimes involving untraceable, undocumentable practices.

WHAT IS SO UNCHARTABLE ABOUT THE TUMOR BOARD?

This project is a long-range case study of a state-of-the-art, Midwestern cancer care facility's Tumor Board meeting. Tumor Board meetings provide a forum in which medical professionals from various specialties collaboratively deliberate about particularly difficult patient cases. Those in attendance may include primary care physicians, oncologists, surgeons, radiologists, pathologists, case managers, nurses, and even medical students. At this particular cancer care facility's Tumor Board meeting, two specific patients' cases are discussed during each weekly meeting. The health care professional responsible for bringing their patient's case to the attention of the board asks for interdisciplinary medical opinion regarding many care-related issues. Typically, the surgeon or oncologist involved with a patient faces a particularly difficult patient-care scenario and will make the move toward collaboration with colleagues from in and outside their

specialty during these Tumor Board meetings. Every participant at the Tumor Board recognizes that those in attendance have varying educational and experiential backgrounds. So, for example, the surgeon or oncologist presenting their patient's case wants to know what the more experienced surgeon trained at a different school or hospital might do. Or perhaps the surgical oncologist collaborates with the Tumor Board chairperson and his colleagues about recently published studies about the increase in life expectancy for patients who receive both chemotherapy for and surgical removal of their tumor. Typically, the Tumor Board chairperson contributes knowledge about what the particular "standard" or "protocol" is for managing patients' care (referred to as the "Standard of Care"). In cases like these, then, Tumor Board participants share with one another, and sometimes argue about, what the best course of action is before the presenting physician meets with the patient and their families to discuss options.

Treatment options, prognostic and staging estimations are what lie at the heart of Tumor Board deliberations in almost every meeting. So, for example, dilemmas that frequently initiate the move toward collaboration are moments of uncertainty spawned by questions like: "what is the best option for treatment for this patient in this particular situation?" or "if we embark on this particular treatment plan, what is this patient's prognosis?" or "now that we have performed surgery on the patient to remove their tumor, how might we approximate the stage their cancer is in at this time?" Because the patient is not present for these meetings, there is no final, official decree about what will be done. Rather, what ensues is 60 minutes' worth of debate about past action and deliberation about future action among medical professionals who bring with them varying levels of expertise, experience, and education.

The Tumor Board is a unique site for investigation in that although there are no formally written decisions made by the end of the meetings (at least at this particular Tumor Board location), these private conferences are one of the few slices in patient-care time when a group of experts sits down and candidly debates what should be done to and for their patients. As the doctors, nurses, and other medical professionals present for Tumor Board meetings are not actually involved in producing written text, the focus of this study is not the production of text but the ways in which medical professionals orally deliberate about the future in this particular workplace setting. To that end, the question motivating my research is: what are the kinds and forms of knowledge Tumor Board participants rely on and, more specifically, how are these kinds and forms of knowledge made material to others during Tumor Board deliberations?

Whereas other scholarship that explores the ways in which medical practice is rhetorical oftentimes relies on the textual production and/or analysis of workplace documents (see Atkinson, 1992; Dautermann, 1997; McCarthy, 1991; Segal, 2005), or a discourse analysis of patient–doctor and/or doctor–doctor communications (see Barton, 1999, 2000, 2004; Ellingson, 2003), this particular research site does not lend itself to either one of these methodological approaches. Not only are Tumor Board participants not engaged in the production of text during

Tumor Board meetings, *but their verbal exchanges may not be tape-recorded or video-taped due to the sensitive and confidential nature of their discussions.*

According to one of the oncologists at the Tumor Board, nothing discussed during Tumor Board deliberations can be used as discoverable evidence in a court of law should a lawsuit ensue. The private nature of these deliberations poses quite a methodological dilemma for a researcher interested in the ways in which language shapes meaning-making in the workplace. These very stipulations, however, are what facilitate an openness and collaborative candor these particular medical professionals have come to rely on in order to further knowledge in their field and engage in interdisciplinary decision making. The medical professionals involved in Tumor Board deliberations are making their way through a labyrinth of guidelines, expectations, and standards while at the same time having to consider the unique, personal lives of their patients as well as their own individual, professional experience. Documenting how Tumor Board participants negotiate all of these varying and often competing factors in patient care, however, has proven to be a difficult endeavor.

What follows, therefore, is my own research design narrative of Tumor Board conferences as it has unfolded over the past 3 years. In order to make some sense of the multiple directions this study has taken over time, this chapter is first structured around an initial set of research design questions I have had to attend to due to the many methodological constraints posed by the research site and its context. Later I provide more specific descriptions and models for how I negotiated the complexity of this particular research site while maintaining methodological rigor.

WHAT KINDS OF DATA ARE "COLLECTABLE" AT THIS SITE?

Given the kinds of research questions common to scholarship in Rhetoric and Writing Studies, an immediate impulse when visiting the Tumor Board for the first time is to gather as much data as possible about the kinds of documents and texts medical professionals used and produced during their meetings. Interestingly, upon entering the room where Tumor Board meetings were held, the very first thing participants are greeted with is a colorful stack of papers stapled together at each seat on top of the placemat and next to a silverware and napkin roll (see Fig. 15.1), or the "Tumor Board participant packet."

The contents of the Tumor Board participant packet include a cover sheet that lists the two patient cases to be presented that day, the physician associated with each case, the patients' diagnosis, and the "learning objective" for each case presentation.[2] Beneath the colored Tumor Board participant packet cover sheet is a blue "Category 1 Oncology Conference Evaluation Form" that medical professionals are asked to fill out and submit at the end of the conference so that they

FIG. 15.1. Placement of Tumor Board participant packets

can receive continuing medical education (CME) credit (see note 2). This form also allows the quality assurance manager to assess the efficacy of the conference as the participant is asked to rate the "quality of instruction," the "acquisition of new knowledge," and the "quality of audiovisuals" on a scale from 1 to 4 and also to circle "yes" or "no" in response to whether or not the conference was "free of commercial bias."[3] Beneath the CME form is a page dedicated to a brief description of the first patient case to be presented that day. In addition to the doctor's name are descriptions of the patient's "chief complaint," "medical history," "surgical findings," "family history," "social history" (e.g., tobacco and alcohol use), "lab findings," "x-ray findings," "surgery procedures," and "pathology." Beneath that descriptive page are photocopied pages of staging protocols from the American Joint Committee on Cancer (2002). Staging protocols allow oncologists and surgeons to describe how far a patient's cancer has spread anatomically. Depending on how far the patient's cancer has spread, the patient is put in a particular "staging" category that ultimately determines what kinds and forms of treatment will have the most impact. The "stage" of a particular patient's cancer effects what their prognosis is as well. There are staging protocols for every type of cancer, and included with these protocols are very graphic illustrations of specific bodily sites and possible areas for cancer. Finally, the Tumor Board participant packet may include a bibliography that cites current medical literature pertaining to the case at hand. This page allows participants to request a copy of the articles listed from the hospital's library. The same patient-case description page and staging sheets are included for the second case as well.

Much to my disappointment as a researcher in writing and rhetoric studies, however, the Tumor Board participant packet is rarely ever used in any kind of explicit way during the conferences. In my observations, Tumor Board participants enter the room, get their lunch, choose a seat, and glance at the cover sheet before the conference begins. Outside of this and filling out the CME credit form at the end of the conference, in my 45 hours of observations, I have neither observed nor heard any reference made to the contents of the Tumor Board participant packet. Not only is there no reference made to the few textual documents present during Tumor Board deliberations, but there also is very little actual writing going on during these meetings. In my observations, Tumor Board participants do not bring or use laptops or other tools for writing during these meetings. The only time during Tumor Board conferences that all medical professionals are asked to collectively or individually view and "read" something is when the radiologist or pathologist projects images from their patients' scans or tests. Outside of the projection of radiological or pathological findings, the exchange of information and ideas during Tumor Board conferences is strictly oral in nature.

Although the exploration of how the patient's chart or other medical workplace documents were referenced during Tumor Boards was not pursuable, the interdisciplinary and complex nature of medical professionals' decision-making processes was. Medical professionals were engaged in intense, real-time debates about what to do about their patients' treatment. Surgeons, oncologists, radiologists, pathologists, and retired physicians who still attend Tumor Board meetings for CME credit juggle the latest evidence and medical research, their own practical experiences, standards-of-care protocols, and issues of liability while deliberating. Indeed, although no formal documents were being constructed, knowledge about the patient, their cancer, and oncological practice itself was. What counts as "data," however, at a site where processes of knowledge construction are virtually untraceable?

Initially, I tried to document every word or article referenced, every gesture, and every image used during those 60 minutes (see Fig. 15.2). For the first few visits, then, I transcribed my handwritten notes on the computer, attempting to engage in what Geertz (1973) refers to as "thick description." Soon, however, I found myself filling in numerous gaps—gaps that are inevitable when trying to handwrite conversations as they unfold in real time. Filling in the gaps while transcribing my notes involved not only having to follow up with one of the Tumor Board participants about what one particular drug mentioned was and what it could do, but also the identities, professional expertise, and roles of each deliberator. Often while transcribing I found that I had more of an impression of what went on that day in the Tumor Board than I did actual, verbal, or textual evidence. In other words, because of the fast-paced nature of their discipline-specific exchanges, trying to recall the specifics of Tumor Board deliberations, even with handwritten notes, was akin to trying to recall the specifics of a phone conversation I had with a good friend earlier that day—although actual, verbal

FIG. 15.2. An early example of fieldnotes from Tumor Board research.

expressions were undocumentable, a kind of experiential impression of what went on in that hour was somewhat available. After several months of drowning in pages upon pages of inadequate fieldnotes and unreliable transcriptions, it was clear that this particular approach would prove problematic later on when it would come time to write up results and conclusions. There were very few textual or oral traces available as a "check" for the events and discussions transcribed and described in my observational notes.

Because of how challenging it was to document not only the fast-paced debates among medical professionals at the Tumor Board, but also their discipline-specific dialogue, I engaged one of the regular Tumor Board participants about the possibility of bringing in either a laptop to type my observational notes as they happened, or a tape recorder so that a later discourse analysis could be performed. The oncologist was opposed to the introduction of a tape recorder or computer at the meetings. She described that not only might the presence of documenting technologies challenge the confidential environment Tumor Board participants assume exists upon entering the boardroom, but she believed that formally documenting each and every expression might actually impede participants from genuine expression and honest deliberation typical of Tumor Board conferences. Not wanting to risk losing access to this unique site or alter its confidential environment in any way, it became clear that my methodological approach would need to accommodate the needs and expectations of Tumor Board participants.

At this point, I needed to reevaluate the kinds of research questions that were actually explorable in this particular site given what little material, tangible data I had access to. Toward that end, I took inventory of all the data points I did or did not have access to during weekly Tumor Board meetings. I could not access patient charts. I could not capture a copy of the slides and images projected onto the screen of patients' radiological and pathological findings. Trying to actually get into the examination room to observe the ways medical professionals spoke with their patients about their cancer after their case was discussed at the Tumor Board was a major legal challenge due to patient confidentiality issues. No text production took place during these meetings, and no workplace documents other than the Tumor Board participant packets were present.

To complicate matters, the research compliance administrator at my university with whom I was in correspondence about gaining IRB approval had just sent me an email asking: "Are you planning to use any of the medical information discussed during the Tumor Board meetings in your research? If so, please address how confidentiality of the information will be maintained." Implicit pressure from the medical professionals at the Tumor Board combined with explicit pressures from my own IRB to maintain confidentiality now seemed overwhelming. After taking an inventory of what kinds of data I could or could not collect based on several months of sketchy fieldnotes and "impressionistic" transcriptions, it became clear that what was collectable at the Tumor Board could be an accounting of the various deliberative moves or references made, the rank and title of those in attendance as well as those who spoke, the sequential and temporal flow of deliberations, and the various modalities employed during deliberations (i.e., gesture, screen, pointer, speech). Each of these elements were, according to research conducted thus far, integral components of the decision making that went on during Tumor Board deliberations. Taken together, they are the building blocks for constructing how deliberations unfolded in this particular workplace environment.

WHAT METHODOLOGY WILL FACILITATE THE COLLECTION OF CONFIDENTIAL DATA?

Given that the Tumor Board is a medical workplace site that, more than anything else, facilitates candid discussion and debate between medical professionals, and given that I was unable to record these deliberations in any other way than handwritten notes devoid of a co-investigator's review, it was clear that there was no methodological formula, prescription, or approach already in existence that would facilitate the systematic collection of data at this particular site. I could not, if I expected to be able to do anything more than tell a story about what goes on at the Tumor Board, impose one particular methodological approach or

another on the Tumor Board. Any methodological approach, therefore, needed to develop out of the site, itself.

The only investigative approach that speaks to this kind of inductively derived method for data collection and subsequent analysis is Glaser and Strauss' (1967) grounded theory approach. Glaser and Strauss argue that "grounded theory is derived from data and then illustrated by characteristic examples of data" (p. 5). In their preference for "grounded" over "grand" theory and the "generation" of theory over its "verification," Glaser and Strauss create a space for the rigorous and systematic collection of data for researchers in sites like mine where some kinds of data simply are not as collectable as others (see Farkas & Haas, Chapter 4, this volume, for a more detailed, expert discussion of grounded theory approaches for the studying of writing and literacy).

Embracing Glaser and Strauss' notion of how theory is built as a result of collecting a vast amount of data, coding it, constantly comparing it and categorizing it meant the relinquishment of trying to prove or disprove preexisting theories of knowledge construction, deliberation, or medical rhetoric in this particular setting. Any theories built are the result, therefore, of months' worth of data collection, coding, and comparisons and not a result of having cherry-picked specific data points in order to prove a hypothesis about x, y, or z.

Embracing a grounded theory approach at this particular site was not a feigned attempt at preventing researcher bias or obtaining objectivity. Rather, grounded theory approaches facilitate an explicit surfacing or tracing of the development (or, to use Glaser and Strauss' word, "emergence") of codes, categories, and subsequent theories. Indeed, Emerson, Fretz, and Shaw (1995) extend Steedman's (1991) assertion that "knowledge cannot be separated from knower" (p. 53) in their argument that "what is observed and ultimately treated as 'data' or 'findings' is inseparable from the observational process" (p. 11). The very methodological lens through which any researcher—not just a grounded theorist—looks during Tumor Board observations, therefore, both affords and constrains their ability to access and make substantive claims about Tumor Board happenings. A methodological lens devoid of the ability to collect data pertaining to the production or use of workplace texts certainly shapes the kinds of questions available for investigation.

After recognizing that there were certain questions that were simply not explorable because of the methodological constraints with which I had to negotiate, and after embracing that *what* I find out is invariably connected with *how* I find it, new possibilities for investigation at the Tumor Board began to open up. I felt somewhat emancipated by the constant, self-imposed pressure to *make* the data fit. In what follows, I describe how, after having been released from worries about how I would make the data I did have access to say something relevant and revealing, I revisited Tumor Board conferences with a new approach for systematically collecting confidential data.

WHAT DATA COLLECTION TECHNIQUES WILL ALLOW THE CHARTING OF THAT WHICH IS UNCHARTABLE?

Given that much of what goes on at the Tumor Board is essentially "unchartable," in the sense that there are no tangible traces for what goes on in the conference room, the inductive development of observational traces became necessary. Preexisting documents, texts, or artifacts simply were not available. The very tools used to research Tumor Board deliberations were developed in tandem with the research itself. Meaning was constructed at this particular site in ways that were *heuristic*.

Heuristics, or tools for understanding, facilitate the collection of certain kinds of data while limiting the collection of other kinds. Specifically, a series of observational tools, or heuristics, were designed, therefore, in order to gather "starting-point" data, or things that were more readily observable. Heuristics acted like a templated document that afforded me, by virtue of a preestablished set of readily observable phenomena, an opportunity for early, tentative constructions of reality at the Tumor Board.

Templated documents are a common phenomena in many situations where the knower seeks to better understand that which is unknown. Take, for instance, the new patient medical form that someone fills out upon entering the doctor's office. Although this form only affords access to particular kinds of information for the doctor, once cross-referenced with a face-to-face visit with the patient, and various other scans and tests, it acts as the starting point by which further investigations might ensue. Similarly, a series of observational heuristics were developed and deployed—heuristics that facilitated the systematic collection and analysis of data in a setting where, due to methodological constraints and discipline-specific dialogue, any data collection at all appeared impossible.

All of the observational heuristics designed to investigate the deliberative practices of medical professionals at the Tumor Board were developed from data collected from a complementary data-collection phase, however. Each time an observational heuristic was designed and deployed, I was relying on a large corpus of fieldnotes in which I "free-handed" observations. As a result of this kind of recursive research process (see Miles & Huberman, 1994)—free-handing observations, designing observational heuristics, free-handing, revising, and designing new heuristics, and so on—I was able to systematize my research and do justice to the complex, yet confidential nature of the Tumor Board conference. What follows are more details about how observational heuristics were designed and what is meant by observational "free-handing."

Observational Heuristics

The decision to use heuristics in this particular setting is motivated by the methodological challenges experienced when visiting Tumor Board conferences. In what follows, I describe how heuristics became a central component of this particular modified grounded theory approach.

The etymology for "heuristic" is from the Greek, meaning "to discover." In a research setting like the Tumor Board, heuristics have the potential power to invent or discover in a rhetorical sense. Observational heuristics can be, therefore, epistemic in nature in that they make possible the invention or construction of knowledge. Given that they are developed inductively, observational heuristics are particularly congruent with a grounded theory approach in that codes and categories are to be inductively derived, and not retroactively imposed.

Enos and Lauer (1992) explore classical uses and meanings for heuristic, and ask if heuristic processes "actually help invent discourse and generate probable knowledge" or do they only "'translate' meaning to others through forms compatible with rhetor and audience?" (p. 80). The center of any debate about the nature of rhetoric—whether the art of persuasion, or something more epistemic in an ontological sense (Scott, 1967)—has at its core certain assumptions about knowledge and reality—assumptions every researcher must grapple with (see also Barton & Marback's discussion, Chapter 2, this volume, of the *is/ought* methodological dilemma). That is, if rhetoric is only persuasive art, implicit in that assumption is the existence of an *a priori* truth that merely needs to be aptly, rhetorically, or persuasively communicated.

Rhetoric as epistemic, however, assumes no preexisting "T"ruth, but truths about which we collaboratively construct meaning (see Scott, 1967)—perhaps in ways that are heuristic. Enos and Lauer (1992) argue for the ways that rhetoric is epistemic in nature, and propose that heuristics are a way for the "rhetor and audience to share in the determination of meaning, to engage in creating meaning based on shared interpretive patterns" (p. 85). For Enos and Lauer, heuristics are epistemic in that they are more than "an instrument for inventing techniques to articulate to others" but also are a "*techne* enabling the rhetor and audience to cocreate meaning" (p. 80). The ways in which observational heuristics were deployed in this particular research setting, therefore, are congruous with the ways Enos and Lauer envision heuristics. That is, they are more than data-collection tools; they are the means by which meaning about Tumor Board deliberations can be made. Observational heuristics facilitate and afford the *analysis* of data.

Using heuristics for data collection and analysis also is inspired in part by Sauer's development of what she refers to not as a heuristic, but a rhetorical framework for understanding the varying ways in which risk is represented and rhetorically transformed for different audiences over time. Sauer (2003) designed her Cycle of Technical Documentation as a result of 5 years of observations of and interviews with miners, engineers, writers, and safety trainers from various mines in the United States, Great Britain, and South Africa, as well as an exami-

nation of various workplace documents (agency reports, training manuals, accident investigation reports, etc.). Sauer's Cycle of Technical Documentation was developed inductively out of her research and used as a tool to both describe and analyze the spatial and temporal dimensions associated with the "full range of rhetorical strategies that individuals employ when they observe, analyze, and assess risk" (p. 7). In the same sense that the Cycle acts as a kind of framework for understanding how workplace professionals in "large regulatory industries" (p. 72) reconstruct and re-represent information for different audiences, observational heuristics provide an inductively derived framework for understanding how medical professionals collaboratively deliberate about patient care. In fact, I would argue that a researcher could take Sauer's six "critical moments of transformation" (p. 75) identified in her Cycle of Technical Documentation and walk into other large regulatory industries and use them as categories for the collection and ultimate analysis of data. Sauer's Cycle, therefore, could be used in ways that are epistemic—as a tool for both inquiry *and* analysis.

Because I was not permitted to tape-record or videotape Tumor Board conferences, and could only document by hand and later transcribe fieldnotes, having some kind of categorized or systematic method for collecting data became essential. Inspired by Enos and Lauer's definition for heuristic and Sauer's six critical moments of transformation inductively derived from her data and the resulting Cycle of Technical Documentation, I revisited my own corpus of thick description fieldnotes collected and transcribed from the past 12 Tumor Board visits.[4] Several weeks were spent reading, re-reading, highlighting, and composing memos about some of the recurring events in each of my transcriptions. Over time, a pattern of recurring, standard features at the Tumor Board could be observed. I began, therefore, to map out the general flow of Tumor Board deliberations as they unfolded over each 60-minute meeting.

Because Tumor Board conferences are a relatively bounded-off workplace environment, in that they are never longer than 60 minutes, always have a Tumor Board chairperson present, always have two case presenters (although different in each Tumor Board), and are always initiated by some felt need to collaborate with other experts about treatment options, prognostic estimations and/or staging estimations, there is a kind of standard, reliable framework to Tumor Board deliberations from week to week. These standard features are very general in nature, however. Every week, for instance, the Tumor Board chairperson gives the standard opening introduction, the presenting physician details relevant patient and tumor information, pathology and/or radiology displays images from scans and biopsies, and discussion about what the "standard of care" is in this case ultimately ensues. A list of recurring deliberative moves made during Tumor Board conferences was constructed with one reliable and consistent data point to which I would always have access: the passage of time. Investigations proceeded, therefore, with a mapping of the temporal dimension of deliberations onto actual deliberative references made. What resulted was the first Tumor Board observational heuristic (see Fig. 15.3).

FIG. 15.3. The first Tumor Board observational heuristic.

The first observational heuristic was an attempt to map the temporal and sequential components of Tumor Board deliberations onto the various references made during the 60-minute meetings. Along the x-axis was documented the temporal passage of time, measured in 1-minute increments, while the y-axis listed the kinds and types of references made during Tumor Board deliberations. Different symbols were used to indicate the role or rank of each speaker. Observations up to this point indicated that there were three "types" of references during Tumor Board deliberations: oral, visual, and gestural. The bottom half of, or what lies below the x-axis along the y-axis in Fig. 15.3 was one of the first attempts at accounting for those kinds of deliberative modes.

It was not too long before I felt unable to adequately account for the gestural references made, however (i.e., a pathologist describing with his hands how one patient's tumor cells had lined up in a row in what is referred to as "Indian filing"). Because managing the documentation of the passage of time in minutes (while having to keep one eye on a stop watch) while also watching Tumor Board participants' gestures was increasingly impossible, a second heuristic (see Fig. 15.4) that sliced gestural references from its focus was designed. Additionally, the 10 references from the first heuristic were condensed to 5 references in the next heuristic. This iterative, painstaking process of constant comparison, dimensionalization, and recombination of codes and categories is described by Farkas and Haas (Chapter 4, this volume):

A grounded theory is iteratively built with painstaking attention to specific data, which are studied in context, compared, and assigned codes. Resultant categories are then compared, dimensionalized, combined, and distinguished to construct more abstract (but still data-based) categories and, eventually, core categories (of which the resultant substantive theory consists). (p. 83)

The observational heuristic in Fig. 15.4, therefore, afforded the capturing of the ways in which Tumor Board deliberations unfolded temporally and sequentially, while also allowing documentation of when and in what order references to the patient's chart, the tumor's specifications, outside literature, or the speaker's own "experiential" knowledge about the dilemma at hand took place during deliberations.

FIG. 15.4. *A more condensed, earlier observational heuristic used in a templated, checklist-like manner.*

The observational heuristic in Fig. 15.5 provides one example of how this data-collection tool was modified over time while also leaving enough "empty space" to record meaningful occurrences during observations—occurrences that current heuristics did not, at that point, account for. After several visits with the observational heuristic in Fig. 15.5, I started to recognize the importance of this empty space and began to make good use of it as an additional data-collection technique. This data-collection technique—what is referred to as observational "free-handing"—augmented observational heuristics in productive and meaningful ways. In what follows, I describe the importance of observational free-handing to this particular modified grounded theory approach.

FIG. 15.5. Earlier observational heuristic used in a templated, checklist-like manner with an option to free-hand some notes on the side.

Observational "Free-Handing"

The components within each of the above observational heuristics are informed by and grounded in a less formal, "thick description" phase of research. Although what I am calling observational free-handing is akin to what the field of Rhetoric and Writing Studies usually refers to as descriptive or ethnographic fieldnotes, I argue that when paired with the development and use of observational heuristics, the free-handing phase has the power to move the researcher beyond mere description.

Indeed, much of existing scholarship on composing fieldnotes treats the documentation of observations as descriptions that tell a story or narrate a series of events, complete with scenes, characters, events, and emotions. Clifford (1990) speaks to the difficulty inherent in this notion of "description" (Geertz's notion of thick description, in specific): "description inevitably suggests a specular, representational relation to culture. I have argued that such a relation is always rhetorically (also historically and politically) mediated" (p. 68). If what Clifford says is true—that the relationship between description and culture (or medical workplace deliberations, in this case) is rhetorically mediated—observational heuristics are one mediating tool within a larger research process that relies upon a more discursive, observational free-handing phase.

Specifically, observational free-handing is a result of returning from a Tumor Board conference and feeling as though a good deal of what was deliberated about that day was lost in some kind of experiential ether because the templated, checklist-like heuristics that were deployed no longer accounted for the kinds of deliberative events that took place during the meetings. I would later return to the Tumor Board *without* a heuristic, therefore—a pencil and some paper as my only accompaniments (see Fig. 15.6). Initially, I had hoped that by free-handing Tumor Board observations for a visit or two, a newer, more inclusive observational tool would be developed. Interestingly, however, and probably due to months and months of using various observational heuristics, even when free-handing observations, I found myself relying on some of the core categories or key concepts that had previously been identified when using prior observational heuristics (i.e., the letters A, B, C in Fig. 15.6 are remnants of codes used for speakers in previous heuristics). In other words, even in the free-handing phase of data collection, after a period of relying on heuristics, my ear and hand were prepared to, or biased toward hearing and documenting previously defined recurring references and connecting them with their relevant temporal and sequential dimensions. Perhaps it could be said that the heuristics trained me, the researcher, to be my own data-collection tool. Although, admittedly, there were moments during observational free-handing where it was tempting to document everything interesting within earshot, by focusing attention on the passage of time, the speaker, and what kinds of references were made over the course of the 60-minute meeting, I was able to discipline my observational gaze and come away with a better understanding of how deliberations unfolded in that particular setting. After only two or three observational free-handing phases, more inclusive, revised observational heuristics—ones that were more specific and conceptually dense—were developed.

Engaging in the simultaneous use of observational heuristics and observational free-handing added yet another level of complexity to my documentation habits. In a more recent Tumor Board visit, for instance, the observational heuristic in Fig. 15.7 was relied on as a guide for engaging in observational free-handing. I brought with me not just a stopwatch, observational heuristic, and pencil, but also a blank sketchpad in which I documented the passage of time and the deliberative moves made using referential codes outlined by the observational heuristic in Fig. 15.7.

In this particular instance, the observational heuristic could be imagined as a kind of background image with dark outlines on which more transparent, free-handed sketches could be laid and subsequently "traced." This kind of recursive use of the heuristic—as both a "templated" checklist and a "traceable" outline—facilitated a fuller, more complex rendering of Tumor Board deliberations as they unfolded in real time, and revealed where previous observational heuristics failed to account for particular references and would need to be revised for future use. Over time, observational free-handing practices began to meld with the revised observational heuristics (see Fig. 15.8). In the next section, I describe how this

FIG. 15.6. *More specific heuristic used as an outline for observational notes.*

FIG. 15.7. *Specific codes within a heuristic that can be used as either an outline or as a templated checklist.*

phenomenon—the melding of the free-handing and heuristic approach to data collection—acted as a cue that it was time to move out of data collection and into data analysis.

FIG. 15.8. *Composing observational notes using the observational heuristic in Fig. 15.7 as an outline.*

HOW MIGHT HEURISTICS FACILITATE MORE THAN DATA COLLECTION?

The cycle of creating, deploying, revising, and re-deploying, based on observational free-handing practices, heuristic after heuristic in order to better collect data could go on endlessly. So, what is next? In this section I argue that heuristics can be used for more than data collection in at least two ways.

First, the data documented on observational heuristics, by nature of their comparative design (with the *x* and *y* axes), reveal what kinds of deliberative moves or references act as background information or starting points for deeper debates at the Tumor Board. Upon review of each heuristic, I am able to generally quantify how many times certain kinds of references are made and in what

sequence certain deliberative moves are consistently made. In this sense, observational heuristics act as analytic tools in that the data documented therein are the dots the researcher can begin to connect in order to better understand how medical professionals collaboratively deliberate about patient care.

Second, by designing and using observational heuristics at the Tumor Board, a kind of observational trace for medical professionals' deliberation has been created—a trace that did not necessarily exist prior to the heuristic's design. Observational heuristics, therefore, lend this study a bit more rigor and systematic support than if I had continued to try and document by hand each and every word, reference, image, gesture, and speaker during every visit. Furthermore, by making a kind of meta-analytic move in reviewing how each heuristic evolved over time, the groundwork for reflective practice in Tumor Board research has been laid. Further details about each of these affordances are described in the next section.

Using Heuristics as Analytic Tools

Sauer's (2003) Cycle for Technical Documentation acts as a rhetorical framework for understanding how workers in large regulatory industries represent and communicate risk during various workplace interactions. Similarly, the heuristics used over time while researching the Tumor Board—the material tools, themselves, and the specific temporal, sequential, and referential data they encapsulate—afford subsequent analyses toward a better understanding of collaborative deliberations regarding patient care amid uncertainty.

The more conceptually rich observational heuristics became, the more I was able to dimensionalize and compare the various kinds and forms of data collected. As it stands now, Tumor Board deliberations can be coded as always involving and sometimes resting on some kind of discussion about the questions listed in Fig. 15.9.

1. Who is the patient, what are their demographics?
2. What are the patient's risk factors for disease?
3. Where and how big is their tumor?
4. What has already been done and why?
5. What stage is the patient's cancer currently in?
6. What is the standard of care for treating this cancer?
7. What do available studies, statistics, or trials recommend?
8. What have other hospitals or medical professionals done?
9. What have I done in the past?
10. If we do x, what will be the patient's quality of life?
11. If we do x, what is the patient's prognosis?

Fig. 15.9. Eleven data-generated questions that facilitate analysis.

Each of the 11 questions in Fig 15.9 has been inductively derived from the data. They also are now the framework for the most recent observational heuristic—one that has been in use for the past five Tumor Board visits—a phase known in grounded theory as "theoretical sampling." These questions are the framework whereby an understanding of Tumor Board deliberations' complexity might be captured. Moreover, connections between variables and relevant, pre-existing theories are data-based rather than retroactively imposed. For instance, only after comparing and dimensionalizing each of the 11 questions or categories in Fig 15.9 might it be concluded that these same, recurring 11 questions are one of four "first principles" in stasis theory—fact, definition, quality, and procedure/jurisdiction (further details about this particular theory is discussed in later reports of this research). It should be noted, however, that deploying a series of observational heuristics while recursively engaging in observational free-handing has facilitated what Glaser and Strauss (1967) refer to as "theoretical sensitivity," or the opportunity to better perceive variables and their relationships. Perceiving variables and their relations are the building blocks in the analysis of data.

Using Heuristics as Tools for Reflective Practice and Methodological Transparency

In order to build substantive and formal theories about the role of language in the construction of knowledge in the workplace, scholars in Rhetoric and Writing Studies must engage in empirical research of literate practices in places that may exist outside the walls of the composition classroom. Moreover, objects of study should be more than products, but should account for literate practices. Literate practices are complex activities, however, and generally do not lend themselves to simple study; they require long-term, *in situ* research. Longitudinal studies of literate practices may leave researchers at a loss for how to trace why and how they arrived at any kind of substantive or formal conclusions or theories. Certainly, no researcher's methodological design can be wholly shielded from critique. But after investing the time and energy it takes to conduct the kind of long-term study described herein, and having also to contend with the complex and confidential nature of sites like the Tumor Board conference, researchers in Rhetoric and Writing Studies might be inspired to employ methods for data collection and analysis that can be revealed to others and reflected on—approaches that are deemed methodologically transparent.

Maintaining methodological transparency would mean ensuring not necessarily that the details of these kinds of studies could be *replicated*, but that they could be *reviewed*. More specifically, engaging in a recursive act of developing and revising observational heuristics based on several observational free-handing phases yields a series of methodological artifacts, or observational traces, that can later be reflected on and reviewed either individually or in sequence. Alvesson

and Skoldberg (2000) quote Geertz (1973) when arguing that "reflection can, in the context of empirical research, be defined as *interpretation of interpretation*, and the launching of critical self-exploration of one's own interpretations of empirical material (including its construction)" (p. 6; italics in original). By keeping and maintaining a visual representation, or observational trace, of the very tool we use to collect and analyze data, we can engage in this kind of "interpretation of interpretation." As has been described herein, methodological transparency is possible—even in sites where confidentiality is an issue—as a result of the design and use of observational heuristics. The inductively designed tools used to collect and analyze data facilitated rigorous review of the ways in which the study evolved and theory was built; such a practice not only lends ethos to researchers' efforts, but lays the groundwork for a respectable research tradition in the field of Rhetoric and Writing Studies.

CONCLUSION: MOVING BEYOND DESCRIPTION AND INTO "CAPTURING COMPLEXITY"

In *Qualitative Analysis for Social Scientists*, Strauss (1987) makes the claim that "The basic question facing us is how to capture the complexity of reality (phenomena) we study, and how to make convincing sense of it" (p. 10). In this chapter I have demonstrated one approach for capturing the complexity of a research site that is rich with data about deliberative decision making, but poses many methodological dilemmas. I have proposed a modified grounded theory approach for studying a complex cultural site that does not and cannot facilitate the collection of textual or oral data. By drawing on Enos and Lauer's (1992) work on the epistemic nature of heuristics, I have argued that writing and rhetoric researchers, when studying sites where the collection and subsequent analysis of data is complicated by confidentiality issues, might maintain methodological rigor as well as respect for their participants' need for privacy by inductively developing observational heuristics and engaging in a recursive process of observational free-handing.

Research design in these particular situations may involve several cycles of each of the following phases: observational free-handing --> developing observational heuristics based on the data collected from the free-handing phase --> employing the heuristic --> revising the heuristic, and so on. Although the arrows may convey a sense of linearity to research design, it is important to emphasize that each phase is dependent on one another, but there may not be an end to how often Phase 1, the observational free-handing phase, is returned to or engaged in simultaneously with the other phases.

"Description," as Clifford (1990) suggests, is a complicated, if not impossible activity. But by being more aware of the ways in which our data-collection

tools make possible but also constrain certain types of descriptions, particularly at sites where privacy and confidentiality are at stake, researchers in Rhetoric and Writing Studies may work toward developing methodological tools and processes that aim to capture even just a fraction of the complexity in workplace settings. Observational heuristics that are inductively derived and recursively developed after a series of observational free-handing phases are one way to construct a material or observational trace where there was not or could not be one before—a trace that can be reflected on, revised, analyzed, and reviewed. Maintaining methodological transparency through the use of inductively developed, observational heuristics, therefore, moves researchers in Rhetoric and Writing Studies beyond "description" and into "capturing the complexity" inherent in confidential research sites.

ENDNOTES

1. In order to be in compliance with the institutional review board (IRB), the identities of all participants are kept confidential, as is the actual location for this study.
2. It should be noted that Tumor Board conferences at this particular hospital serve not only to "render multidisciplinary opinion and benefit our patients with cancer" (as noted on the Tumor Board participant packet cover sheet), but that by attending Tumor Board conferences, medical professionals can receive CME credit.
3. This question points to the fact that typically a representative from a pharmaceutical company provides lunch for Tumor Board participants and is permitted to set up an educational table about its latest drug products outside the room.
4. I chose the past 12 Tumor Board visits because that was the exact number of Tumor Boards I had attended in the previous 12 months. Any earlier additional visits I made to the Tumor Board took place prior to truly learning how to collect qualitative data or writing ethnographic fieldnotes.

REFERENCES

Alvesson, M., & Skoldberg, K. (2000). *Reflexive methodology: New vistas for qualitative research*. London: Sage.

Atkinson, P. (1992). The ethnography of a medical setting: Reading, writing, and rhetoric. *Qualitative Health Research, 2*, 451-474.

Barton, E. (1999). The social work of diagnosis: Evidence for judgments of competence and incompetence. In D. Kovarsky, J. Duchan, & M. Maxwell (Eds.), *Constructing (in)competence* (pp. 257-290). Hillsdale: Lawrence Erlbaum Associates.

Barton, E. (2000). The interactional practices of referrals and accounts in medical discourse: Expertise and compliance. *Discourse Studies, 2*, 259-281.

Barton, E. (2004). Discourse methods and critical practice in professional communication. *Journal of Business and Technical Communication, 18*, 67-111.

Bazerman, C. (1994). Systems of genres and the enactment of social intentions. In A. Freedman & P. Medway (Eds.), *Genre and the new rhetoric* (pp. 79-104). London: Taylor & Francis.

Bazerman, C., & Prior, P. (Eds.). (2004). *What writing does and how it does it.* London: Erlbaum.

Bracewell, R., & Witte, S. (2003). Tasks, ensembles, and activity. *Written Communication, 20*, 511-559.

Clifford, J. (1990). Notes on (Field)notes. In R. Sanjek (Ed.), *Fieldnotes* (pp. 47-70). Ithaca, NY: Cornell University Press..

Dautermann, J. (1997). *Writing at Good Hope: A study of negotiated composition in a community of nurses.* Greenwich, CT: Ablex.

Ellingson, L. (2003). Interdisciplinary health care teamwork in the clinic backstage. *Journal of Applied Communication Research, 31*, 93-118.

Emerson, R., Fretz, R., & Shaw, L. (1995). *Writing ethnographic fieldnotes.* Chicago: University of Chicago Press.

Enos, R., & Lauer, J. (1992). The meaning of heuristic in Aristotle's *Rhetoric* and its implications for contemporary rhetorical theory. In S. Witte, N. Nakadate, & R. Cherry (Eds.), *A rhetoric of doing* (pp. 79-87). Carbondale: Southern Illinois University Press.

Geertz, C. (1973). Thick description: Toward an interpretive theory of culture. In C. Geertz (Ed.), *The interpretation of cultures: Selected essays* (pp. 3-30). New York: Basic Books.

Glaser, B., & Strauss, A. (1967). *The discovery of grounded theory.* New York: Aldine de Gruyter.

Haas, C., & Witte, S.P. (2001). Writing as an embodied practice: The case of engineering standards. *Journal of Business and Technical Communication, 15*, 413-457.

McCarthy, L. (1991). A psychiatrist using DSM-III: The influence of a charter document in psychiatry. In C. Bazerman & J. Paradis (Eds.), *Textual dynamics of the professions: Historical and contemporary studies of writing in professional communities* (pp. 358-378). Madison: University of Wisconsin Press.

Medway, P. (1996). Virtual and material buildings. *Written Communication, 13*, 473-514.

Miles, M., & Huberman, A. M. (1994). *Qualitative data analysis.* Thousand Oaks, CA: Sage.

Sauer, B. (1996). Communicating risk in a cross-cultural context. *Journal of Business and Technical Communication, 10*(3), 306-329.

Sauer, B. (2003). *Rhetoric of risk.* London: Erlbaum.

Scott, R. (1967). On viewing rhetoric as epistemic. In J. Lucaites, C. Condit, & S. Caudill (Eds.), *Contemporary rhetorical theory* (pp. 131-139). New York: Guilford.

Segal, J. (2005). Interdisciplinarity and bibliography in rhetoric of health and medicine. *Technical Communication Quarterly, 14*, 311-318.

Spinuzzi, C. (2006). What do we need to teach about knowledge work? [White Paper]. Retrieved from http://www.drc.utexas.edu/research/what-do-we-need-teach-about-knowledge-work.

Steedman, P. (1991). On the relations between seeing, interpreting and knowing. In F. Steier (Ed.), *Research and reflexivity.* London: Sage.

Strauss, A. (1987). *Qualitative analysis for social scientists.* Cambridge: Cambridge University Press.

Winsor, D. (2001). Learning to do knowledge work in systems of distributed cognition. *Journal of Business and Technical Communication, 15*(5), 5-28.

16

TROUBLING RESEARCH

A Field Journey through Methodological Decision Making

Gloria E. Jacobs

"It's a good thing we've got this on video. I can show your parents how you act in school," Sophia said to her seventh-grade class as I cringed. A few students looked at me with hooded eyes and later Keysha approached me.

"You taping us?" she said.

I nodded and smiled.

"Why?" The tall slender seventh grader stood in front of me, feet planted firmly on the floor.

"For my research," I answered. "Remember, at the beginning of the year I said I was trying to learn how your teacher uses technology so I can help teachers become better teachers."

She stood silently in front of me, her face a blank mask.

"I'm the only one who looks at the video," I told her, sensing her unasked question.

She snorted then returned to her desk. At that moment I decided to stop videorecording and to strictly rely on fieldnotes to capture classroom interaction. Given that my research involves looking at the intersection of what people do in physical space with what they do when online (see Jacobs, 2004), I knew I would be losing valuable data, but I decided that no data was better than further damaging my relationship with the students.

Sophia had used the same threat a few times before, and perhaps I should have said something to her at that time, but as a guest in her room I was hesitant to do so. As a former teacher, I understood her frustration with restless seventh graders and her desire to use any tool at hand to get control of an unruly class,

but as a researcher who was trying to build trust with adolescents in order to better understand their out-of-school digital literacy practices, I was upset. My immediate reaction was that Sophia's words had ruined and possibly ended my research.

My more considered response to this event is that Sophia's action did not ruin my research so much as she brought into focus the role I had taken in the classroom and the relationships I had built with the study participants. It became my responsibility to understand the event and my reaction as part of the data and ultimately what the event means in relation to the theoretical framework I bring to my work, my position as a researcher, a college professor, and a former teacher as well as the questions that drive my research. An overarching concern in my work has been to identify how literacy and technology is used by youth inside and outside of school and to understand what the implications of those literacy practices are in relation to people's participation in an information-driven, fast capitalist society (Jacobs, 2006). In the research discussed in this chapter, I was working with a group of adolescents and their teacher in an effort to move my research beyond the single-participant case study I had conducted earlier. I quickly learned that the type of research I was attempting was difficult in that I was attempting to build alliances and trust with two groups that are historically at odds, and as the event that opens this chapter shows, I was not particularly successful.

As my experience demonstrates, data collection is more than just identifying study participants, asking questions, and observing phenomena. It also requires skill at relationship building and also of recognizing the limitations of our own positions, both how we see ourselves and how others see us. In my case, the reality was that as a White middle-class, middle-aged, highly educated woman I was immediately allied with Sophia and not with the African American and Latino adolescents with whom I wanted to build a relationship. In order to earn the trust of the students, I would have had to distance myself from their teacher, a position I was unprepared to take, and maybe even unable to take. Of course, this situation is not unusual, but other researchers appear to have been much more successful than I (e.g., Finders, 1997; Moje, 2000). Finders was able to earn the trust of a group of young women and thus gained access to a wide range of in and out of school literacies that she saw as gendered and classed. Likewise, Moje worked with a number of young people and gained extraordinary insights into their worlds and their thinking about literacy both inside and outside of school. Finders' and Moje's work provided a model for the type of work I wanted to accomplish, but whereas their work focused primarily on print-based texts, I hoped to build deeper understandings about the world of adolescent digital literacies.

As I found, however, conducting such research is difficult on many levels. In this chapter, I focus on the relationship between my theoretical framework and methodology to my research plan as well as to my actions in the field. For instance, the episode I describe in the opening of this chapter is one example of the decisions and actions taken in the moment-to-moment reality of research and

the implications of those decisions on research. I choose to focus on the relationship between theory, methodology, and data collection in the spirit of earlier work such as Fine (1994), who explored the idea of "working the hyphens" as a way to understand how our roles as researchers carried implications for the relationships we build with our study participants, and Peskin (1988), who articulated the various subject positions we take as we move through our research projects. I am also inspired by autoethnographers such as Reed-Danahay (1997) and Ellis (2004) and Ellis and Bochner (2006), who discuss the necessity of inserting the autobiographic self into the research in order to better understand the phenomenon being studied, and Anderson's (2006) articulation of the ways the complete member researcher can add layers of understanding to a study while maintaining analytic rigor.

My purpose in this chapter is to use a discussion of the decisions made during planning and the microdecisions made during planning and data collection to trouble what it means to be a researcher, how we go about our research, and most importantly to explore how theory informs our actions in the field. By discussing the methodological decision-making process of my research, I hope to provide novice researchers with insights into their own emerging research projects and to challenge established scholars to pull back the curtain on their work. My hope is that by opening up discussion of the ongoing decision-making process, we can continue discussions of how to move research methodologies forward in ways that honor those who open up their lives to our inquiry as well as to dig deeper into the questions that continue to trouble us and the world.

I have designed this chapter to include both traditional academic writing style and a more personal narrative or evocative style inspired by the autoethnographic work of Ellis (2004). The narrative sections are recreated from my fieldnotes and are written to capture the essence of the event rather than the exact words that were spoken, as I would do if I were conducting a discourse analysis of the interaction. These autoethnographic sections are set off from the academic sections through the use of italics. I use this style and create juxtaposition between the evocative and the academic and in order to capture how the academic voice is informed by the lived experience of research and how that lived experience does not exist outside of theory. I also provide excerpts from the original research proposal that was submitted to the Spencer Foundation and my institutional review board (IRB) as well as an excerpt from my fieldnotes. These excerpts are set off from my commentary through the use of boxes and Garamond font. The issues I discuss in and between the different sections include the design and negotiation of roles prior to and during data collection, the development and recognition of boundaries that arise in the field, and finally, the limitations of data collection based on the roles the researcher takes up when in the field. I work to embed all of these issues within the theoretical framework of my research.

CONNECTING THEORY AND DATA COLLECTION

Theory, or our understanding of how the world works, is lived every day and informs our actions. Likewise, theory informs how we approach our research, even the moment-by-moment actions that happen in the field. Harding (2004) calls methodology a "theory of method" (p. 1), and Bloome, Carter, Christian, Otto, and Shuart-Faris (2005) describe methodology more specifically as the integration of theoretical and methodological issues and warn against a focus on method without reflection and attention to theory. In that my research is informed by the New Literacy Studies (NLS) my methodology needs to reflect the underlying theories of knowledge, learning, truth claims, and power on which the NLS is built. Specifically, the NLS moves the definition of literacy from the psychological and cognitive act of reading and writing to a sociological and cultural practice (Gee, 2000). Text is defined as being part of a meaning-making system within localized sociocultural, historical, and political contexts (Hull & Schultz, 2002a, 2002b; Lankshear & Knobel, 2003; Street, 1995), and being literate includes being able to use multimodal semiotic systems such as the visual, the audio, and the gestural as well as spoken and written language systems in order to communicate within one's community (New London Group, 1996). Because the NLS sees literacy as a cultural practice, researchers and educators must look beyond the walls of the school or official learning spaces to understand how text is used in a variety of settings. This multifaceted definition of literacy therefore leads me to observe how people use texts, what texts they use, and to talk to them to find out what meanings they bring to and take from those texts. Whereas triangulation is usually seen as a way to ensure validity and veracity, within the NLS multiple data sources are paramount if an understanding of a literate practice is to be built.

The NLS researchers' task is also complicated by the understanding that literacy is tied to the ideologies of a culture (Street, 1995). What counts as literacy is intrinsically associated with the historical, cultural, social, and political values of a community and is contested in relations of power. The NLS asks "whose literacies are dominant and whose are marginalized or resistant" (Street, 2003, p. 77). Therefore, those skills typically associated with literacy are not neutral but are instead part of the local context and also act as indices of the power relations that inform both local and global context (Barton, Hamilton, & Ivanic, 2000; Hull & Schultz, 2001, 2002a; Lankshear & Knobel, 2003; Luke, 1994; New London Group, 1996; Street, 1995, 2003). As a result of this theoretical understanding of literacy, the researcher's gaze must continually shift from the local to the global. As such, data collection must focus on the local but do so with the knowledge that local data does not stand alone and needs to be contextualized. Figure 16.1 shows an excerpt of my research proposal wherein I attempt to set forth the types of data needed in order to achieve adequate contextualization.

The research in the classroom will be conducted using ethnographic methods including participant observation, fieldnotes, videotaping of classroom activities, audiorecording of interviews and focus group meetings, and collecting artifacts such as work done for the class as well as public Internet sites created and maintained by the students (such as myspace.com pages, blogs, wikis, and web pages).

FIG. 16.1. Research proposal (data collection) excerpt.

My decision to use ethnographic methods to collect data was driven by the theoretical framework of the NLS. Specifically, if literacy is a social practice, I needed to document what that social practice was, and observing people engaged in literate practices provides deeper insights especially when observations are followed up by interviews. Furthermore, participating in those practices provides even greater insights. Therefore, participant observation, documentation of participation and observation through fieldnotes, and interviews became a part of my methods and methodology. Furthermore, if texts are seen as being multimodal and include gesture and speech as well as typographic text, then videorecordings of classroom interactions are required as well as the collection of artifacts. Finally, because the NLS sees literacy as being a local practice embedded within global contexts, I needed to extend my data collection beyond the walls of the school or official learning spaces to understand how text is used in a variety of settings. Although I did carry out the letter of the proposal in terms of the types of data collected, as seen throughout this chapter, carrying out these ethnographic methods was not as straightforward as the plan made it appear. Compromises had to be made in order to stay true to the spirit of the proposal

TROUBLING THE PLAN: THE PROPOSAL MADE IT SEEM SO STRAIGHTFORWARD

I thought everything was falling into place. In the spring I met with the district superintendent and the supervisor of instruction of a suburban school district to casually talk about my research interests and the technology initiatives they were beginning in their school. They seemed enthusiastic about my work and my perspective on technology and literacy and said they were interested in working with me. Later I met the technology coordinator and other district-level administrators

who seemed a little more wary of what I had to say, but nonetheless, the adminis-
tration as a whole indicated support for having a researcher on site. They told me
they would identify a teacher with whom I could work, and would get back to me.
I sent them my research proposal (see Fig. 16.2), submitted it to my IRB and
received approval, and was even able to obtain the support of the Spencer
Foundation. It all seemed quite straightforward. All I needed was the actual name
of the teacher with whom I would be working.

> The teacher-participant will be identified by district administration as someone who is interested in developing classroom practice consistent with the goals of this research project and willing to work collaboratively with the researcher. Adolescent participants will be a convenience sample based on the classroom population of the participating teacher. All students in the participating teacher's class will be asked to complete the questionnaire. Those students selected for interviews and focus groups will be selected to include a diversity of gender, culture, race, and socioeconomic backgrounds as well as a variety of experiences with digital literacies.
>
> FIG. 16.2. Research proposal (participants) excerpt.

The excerpt presented in Fig. 16.2 was based on what I had worked out with the district superintendent and other administrators, but it also was predicated on my desire to move toward a participatory research practice as informed by feminist theory. Specifically, I view my work as fitting within the feminist goals of asserting the voices of those who have been marginalized, providing multiple perspectives on the same phenomenon, and the desire to understand and transform power relationships within society (Fine, 1994; Haraway, 2004; Harding, 2004). Kemmis and McTaggart (2000) describe participatory research as being rooted in the goal of social transformation and differing from conventional research in that there is shared ownership of the research projects, it is centered around a community-based analysis of social problems, and is oriented toward social action. As such, participatory research changes the roles of those involved in the research from subjects to participants and also changes the power relations. Specifically, hierarchy between the researcher and the researched is flattened.

I suggest that Kemmis and McTaggart's definition of participatory research complements the NLS theoretical framework and feminist standpoint theory in that power is a central concern of all three approaches to research. The NLS and feminist standpoint theory emerge from similar epistemological viewpoints that see knowledge as socially situated (Gee, 1996; Haraway, 2004; Street, 2003) and

never neutral (Harding, 2004; Street, 2003). Whereas the NLS focuses on the role of text in constructing power relationships at multiple contextual levels (Luke, 1996; Street, 2003), feminist research strives to understand a phenomenon from multiple perspectives and to recognize that the voices of those on the margins provide ways of seeing that are invisible to those in the center of power (Fine, 1994; Harding, 2004). If the researcher understands knowledge as being socially constructed and that all perspectives are partial (Haraway, 2003), then we seek multiple sources in order to construct a multifaceted understanding of a given phenomenon. That involves working with and listening to various people who are engaged in the same phenomenon, but experience it differently.

In my research, that means I needed to work with the students as well as the teacher. I included a focus on the teacher because I wanted to push my research beyond theoretical concerns and into the realm of application. One of the projects of the NLS is to connect what youth do outside of school with what they do inside of school (Hull & Schultz, 2001). Therefore, it was important that the research include an implementation component based on what I learned from the students, and in order to implement teaching innovation, it was imperative that I build a relationship with the teacher and understand the teacher's position and understanding of adolescent digital literacies. I also wanted to include the voices of the students, not only as subjects to be observed and interviewed but as community ethnographers as well. Although this was not written into the research proposal, I envisioned them collecting data from their communities and sharing it with me as co-participants in the research project. Furthermore, in order to move toward participatory research, the people engaged in the research had to be part of asking the questions, doing analysis, and using the understandings that emerged from the analysis to make changes in their world. In order to accomplish this, the teacher and I would have to construct a partnership in both the classroom and in the research. As the rest of my story shows, however, my ideals fell far short of the reality.

Late summer: I still hadn't heard from the school district I had planned on working with. I sent emails and called and left messages. Finally, as the beginning of the academic year neared, I heard. None of the teachers in the targeted district were interested in working with a researcher given the pressures of standards and accountability as well other district mandates. Rather than seeing me as the support I wanted to be, I was seen as an unwelcome imposition.

I asked various people I knew who were working in other districts, and my department chair knew of some teachers in the nearby urban district with whom she had been working on an NCLB [No Child Left Behind]-funded project. She mentioned my work to them and told me that Sophia was interested in what I was doing. I was thrilled because this new opportunity provided me with access to a population I was interested in working with and had not yet been able to build connections with. My original site was a wealthy suburban district with a predominantly White population and Sophia worked in a low-income urban district with

a mostly African American and Latino population. Furthermore, although Sophia taught in a large urban district, her school was small and followed a nontradition-al, community-based curriculum. I contacted Sophia via email and then by tele-phone. She was gracious and interested in my research, so we scheduled a meeting.

When I met with Sophia, I explained to her what it was I wanted to learn and accomplish. She told me that my plans fit well within the structure of the school and that the idea of asking the students to be researchers was consistent with the expeditionary learning program the school was beginning that year. Permission from the principal was easily obtained. As Sophia put it, "in this school, we assume the answer is yes for anything innovative we want to do." I told Sophia that I was able and willing to help co-teach lessons or to assist her in any way. I also had some monies available with which to buy technology and supplies for her class-room. In that Sophia had only been teaching a few years, and the school itself was only in its second year, providing classroom materials consistent with the research focus seemed a way to build the reciprocal relationship I desired and that was con-sistent with my theoretical stance. Sophia was excited about the prospects.

First interview with Sophia: As I set up the voice recorder and settled in, Sophia went somewhere and got me a parking pass. She made it so that it was good until June. That was wonderful. She's been so accom-modating of me. I really hope that I can be useful to her. She had a grad class tonight, so I promised her that I wouldn't take much of her time and that I would try not to be a burden to her and instead would try to help her in any way I could. She signed the consent form, and then I started the interview. She had seen the questions beforehand, so I suspect she had already thought about some of the answers. She was very fluid in her answers.

FIG. 16.3. *September 11, 2006 fieldnote excerpt.*

From a feminist perspective, I wanted to position myself not as an observer and Sophia and the students not as subjects, but rather as the three of us work-ing together toward a better understanding of the issue of teaching and adoles-cent use of digital technologies and literacy. Finally, I hoped that our relationship would be reciprocal; in that Sophia was helping me by opening up her classroom and the students were helping me by opening up their lives, I wanted to help them by providing support in any way I could. All of this, however, was easier to write than it was to enact. As Fine (1994) points out, the act of asking for con-

sent makes apparent the differences between the researcher and the study participant and affects the relationship between the two. Additionally, during the interview, we quickly fell into the question–answer pattern common to interviews rather than the interactive interview (Ellis, 2004) or conversational style of sharing information that I had hoped to foster. This may be in part because I had sent her the questions beforehand, a decision I had made to show respect for Sophia, but now see that doing so may have set up a more traditional relationship than I had wanted.

DEVELOPING ROLES

Despite my desire for participatory research and collaboration, my original design of the project clearly spelled out roles, and those roles followed traditional research lines.

> The researcher will play two related roles. In her role as a literacy educator and participant-observer, the researcher will work with the participating teacher to develop classroom practice based on extant and emerging research on adolescent use of digital literacies and best teaching practices. The researcher also will be responsible for collecting and analyzing all data related to the adolescents' use of digital literacies outside of school.
>
> *FIG. 16.4. Researcher's roles from research proposal.*

Although I wanted a reciprocal relationship guided by the principals of feminism and participatory research, I had constructed a research plan that clearly delineated who was the teacher and who was the researcher. I did, however, plan to collaborate with Sophia to plan classroom activities and hoped to include Sophia in data analysis at some level. Making this happen, however, was more difficult than I imagined.

October, Year 2: Sophia's student teacher took over the class and Sophia and I pulled chairs into the hallway to talk about introducing digital storytelling into her curriculum. I was excited. I had watched a number of digital stories online, created several digital stories as a way to learn about the process, attended conference sessions led by Glynda Hull, who is the founder of Digital Underground

Storytelling for Youth (DUSTY) in Oakland, and read a number of research and how-to articles about digital storytelling. I was eager to share what I learned with Sophia and help her create an exciting activity that hopefully would draw on the cut and paste literacy practices (Perkel, 2008) the students had told me about when I interviewed them.

This was also the first time Sophia and I were able to co-plan an activity, and it was one that fit within the NLS and with what I had learned about the students' out-of-school digital literacy practices. I fidgeted in my chair as I waited for Sophia to get settled. After more than a year of collecting data and doing preliminary analysis, we were finally working together to move into the second phase of the study—implementation.

Sophia sat next to me and opened the Macbook borrowed from the school's laptop cart. I smiled and typed in the URL of the DUSTY Website.

"I don't know much about digital storytelling," Sophia said, "but I've heard of it and I'm interested in doing it."

I nodded. "The kids do a lot of cutting and pasting from Websites for their myspace pages, so I think they'll like pulling images and music for their digital story. Here, let me show you a couple of examples."

I clicked on one called "Lyfe & Rhyme" and then "Capoeira: A History" (http://oaklanddusty.org/videos.php). I then switched to the Center for Digital Storytelling (http://www.storycenter.org/stories/) and we watched a few of the stories. The students had been reading the book Seedfolk by Paul Fleischman and writing memoirs, so it seemed to me that creating digital stories about their lives or interests would be a wonderful next step.

"I don't know what software they used to create some of these stories," I told Sophia as we watched. "But your Macs have iMovie and that's a popular one. I created mine just using PowerPoint and setting the timing to run automatically. It's not hard."

"That's great," Sophia answered. "They're done writing their memoirs and now we're moving on to Native American myths and then we'll be reading Walk Two Moons by Sharon Creech. I'm going to have them write their own myths before we start the book. I'll have them turn their myth into a digital story."

I bit my lower lip. The digital stories I'm familiar with are personal stories or social statements. What Sophia planned is exactly what Lankshear and Knobel warn against—the pedagogization of a literacy practice.

Sophia flipped through her planning calendar. "We'll be starting the stories the week of November 12."

"I'd love to co-teach it with you if you want," I told her.

"That'd be great if you and maybe some of your students could come the days we're in the computer lab to give tech assistance," she answered.

"I'll email you the links to the digital storytelling samples and materials, and give my students your email so they can work out times and days with you. Let me know the days you're in the computer lab, and I'll make sure I'm here."

I paused for a minute and looked at the computer screen. I wanted Sophia to see this project as more than just technologizing an existing assignment. I didn't want this assignment to be a case of what Lankshear, Snyder, and Green (2000) call "old wine in new bottles." Instead, I said, "You might want to show some of these clips to the students first to give them ideas of what they can do." I was hoping that by watching the digital stories, both Sophia and the students would discover the possibilities that tapping into digital literacy practices opens up. I was hoping she would move beyond doing school as usual.

There are several tensions that occurred within this exchange. These include the logistics of collaboration, the process of developing boundaries, and accepting limitations. I discuss each of these three tensions in the following sections and end by suggesting that despite all the difficulties, we can somehow make our research work if we are able to view the challenges as providing a new set of insights.

WORKING OUT THE LOGISTICS

The first is just the logistical reality of collaboration. Despite my intentions, the simple realities of Sophia and my schedules made it difficult for us to have the time to do the type of collaboration that would result in the type of innovative teaching I was envisioning. If we had had more conversations prior to this planning session, we might have been more likely to have a shared understanding of each of our intents. As it was, we were limited in the amount of time each of us had available for this project. Sophia was in the third year of her teaching career and had just started her graduate work. She was taking two classes a week and also was planning her wedding. My schedule was equally full. We had met several times for formal interviews, talked as we could when I was visiting the classroom, and exchanged occasional emails, but the planning session described here was, in fact, made possible only because Sophia had a student teacher in her room.

DEVELOPING BOUNDARIES

The second tension within the previously described event is based within teacher education and professional development as well as the theoretical concerns of qualitative research. Qualitative approaches push the researcher to consider her position in respect to the phenomenon and to the participants (Fine, 1994). However, if we view qualitative research on a continuum, on one end are methodologies that work to approach qualitative data through a lens of objectivity (Strauss & Corbin, 1990) and on the other end are critical approaches that

view the researcher as an activist or agent of change (Ladson-Billings, 2000). That is, part of the purpose of research is to bring about transformation in the social institution being studied. On both ends of this spectrum, however, the researcher is not a full member of the phenomenon being studied, and brings with her an etic or outsider's viewpoint. Forms of participatory research (Joyappa & Martin, 1996), participatory action research (Kemmis & McTaggart, 2000), and autoethnography (Ellis, 2004; Reed-Danahay, 1997) take the role of the researcher even farther and make the researcher part of the study either as a complete member researcher (Anderson, 2006) or through the insertion of the autobiographic self (Ellis, 2004; Ellis & Bochner, 2006). I had hoped to engage Sophia in participatory action research, but the realities of her schedule precluded this and ultimately I acted as the researcher and she and the students became the researched.

Despite the shift to more traditional research roles, I maintained my commitment to research as a form of social activism and wanted my work with Sophia to contain the seeds of pedagogical innovation, not only within her classroom but for other teachers as well. As such, I needed to ask how much can or should I interfere with what is going on in Sophia's classroom. If I remained quiet when I heard Sophia planning to use digital storytelling in a way that was contrary to what I envisioned, was I selling out or was I being respectful of her position as the teacher? Ultimately, I believed it was enough that I had presented her with the ideas, the tools, and the materials for creating an innovative and potentially transformative teaching and learning experience. My conclusion came from my knowledge of research into teacher education and professional development that indicates that teachers change practices following opportunities for reflection following learning experiences (Farmer, Gerretson, & Lassak, 2003). With that in mind, I determined that my role should be to support Sophia as she asked and to use follow-up interviews as a space for her to reflect on the experience. Although the first attempt may not have matched my original attempt, it held the potential for change.

ACCEPTING LIMITATIONS AND MAKING IT WORK

Although my belief in the power of feminist methodologies lead me to desire a project in which the participants were collaborators rather than the researched, in addition to the logistics of scheduling affecting how Sophia and I were able to collaborate, the social realities of being a highly educated, White, middle-class woman limited the roles I was able to take up with the students. The students were used to having White women coming into their class as teachers or paraprofessionals. I was just one more, and I easily slipped into that role. However, because I did not have the specter of accountability for student grades and test scores hanging over me, unlike teachers and paraprofessionals, I had the option

of retreating from teacher-like behavior when I felt it was appropriate. The following narrative demonstrates the two roles I played even when working with the same student.

The room was quiet as the students bent over their papers, pens moving and papers flipping as they began constructing drafts of their myths. A few students talked quietly with one another, and a handful of students left the room with the special education teacher. This was a small class to begin with, and now there were only around 10 students left in the room. Sophia moved around the room encouraging students to write.

As the students worked, I too moved around the room peering over their shoulders. Marina, a light-skinned girl with thick, curly, deep gold hair pulled into a ponytail called me over. "I don't get it," she said.

"What don't you get?" I asked.

"What we're supposed to be doing."

I squatted down next to her so that our heads would be at the same level and looked at her paper. She didn't have anything written.

"Sophia wants you to write a story about how something was created. Do you have your brainstorming list?"

"I wrote a story about a haunted house. Can I use that?" she asked.

"I don't think so." I said. I looked at the list of characteristics of a myth that the students had developed and asked her if her haunted house story matched the list. We brainstormed some ideas for myths, and I wandered off to see what other students were doing. When I returned to Marina, I overheard her friend Laura say that Marina's story was the same as the movie Twitch.

"If a myth is supposed to explain something," I said looking at the list of characteristics, "what does your story explain?"

Marina crinkled her forehead for a minute then said, "I get it." She began writing. The next time I worked with the students, they were in the computer lab digitizing their stories. Once again Marina called me over. She had abandoned the haunted house story, but I noticed that her new story still did not match Sophia's requirements. I assumed Sophia had already given Marina's story approval, so I did not comment on the content and simply helped her with her technical questions. She had already typed in her text and added her pictures. She was pleased to have gotten as far as she did on her story, and was now focused on adding sound. She asked me for help, and I walked her through the steps. I stepped back and watched as she added the sound of someone laughing.

"What does that have to do with your story?" I asked. I wanted her to think about her reasons for selecting different things for the story.

Marina shrugged and giggled. "I just think it's funny."

Marina continued adding sounds to her digital story, and stopped only to teach a classmate the steps she herself had just learned. I stepped back, checked that my video camera was still capturing Marina's activities, and jotted notes into my field journal.

As the preceding narrative shows, I moved between acting as a teacher and as a researcher during my interactions with Marina. Although these moves were not premeditated, they do reflect the tensions within the roles I took up and the decisions I made based on my research goals. My foremost concerns were with respecting the rights and needs of those I was working with. For instance, Marina treated me as a teacher by asking me for help, and I responded in kind by providing her with directions and guiding questions. I suggest that this was a normalized role for me given that teacher is the most common role the students see adults in at the school and given my background as a former English teacher. Furthermore, my willingness to support Sophia added to my identity as a teacher. However, when Marina no longer needed me, I was able to step back and take up the role of observer and researcher.

The ability to step back and observe became highly important as the project progressed and it became obvious that the students saw me as a teacher or authority figure. As I began analyzing the data from the first year of interviews and compared my fieldnotes and videotapes, also from the first year, I realized that the interview data was incomplete and at times deceptive. For example, during focus groups, students stopped themselves from sharing what they knew about circumventing the firewalls the schools had put into place. Students would also dissemble during the focus groups and overstate their use of or facility in using computer technologies. I realized this when their friends would either call them out, or when observation showed that some of them were unfamiliar with some of the most basic computer operations such as opening up applications. What I describe here demonstrates that triangulation and multiple data sources are not just theoretical or methodological issues to be addressed in research proposals, but rather have very real implications for data collection and finding at least some answers to the research question posed.

As I worked with the students, I shifted between the roles of researcher and teacher or teacher assistant according to the student needs rather than the needs of my research project. My doing so was based not only on the way the students saw me, my alliance with Sophia, or even my past experience as a teacher. My decision also comes from my belief that research and education should be grounded in an ethic of care (Noddings, 2003). Noddings defined caring as concrete and that it involves tending to and responding to the needs of others as well as building reciprocal relationships. Because I see research as part of the feminist project not only of understanding the world from situated, subjugated, and multiple perspectives (Haraway, 2004; Harding, 2004), but also as a way expressing care, I consciously and unconsciously made decisions that foregrounded the needs of the study participants while also honoring my own needs as a researcher and as an educator. Although this stance was not explicitly stated in my research protocol, it is one that underlies my interactions with my research participants. Because of this stance, I may have lost some data that more traditional researchers may have valued, but I argue that moving between the roles of researcher and teacher, I was able to gain a different set of insights than if I had remained solely in the role of researcher.

IMPLICATIONS AND CONCLUSIONS

I share my stories as a way to demonstrate how theory and what we do in the field are intricately connected. Theory underlies all of our actions, planned and unplanned, articulated and unarticulated. In the writing up of qualitative research, we strive to make clear the relationships between theory and methodology and to integrate the theories into our findings, but we tend to obfuscate the messiness of data collection and gloss over the connections between our theoretical underpinnings and our actual actions. In most cases, methodologies and methods are presented as a way to reassure the reviewers and readers of the veracity, validity, or reliability of the research rather than to provide insight into what it means to research and what the methodology reveals or fails to reveal about the phenomenon being studied.

I argue that all research is intrinsically flawed, but it is the responsibility of the researcher to acknowledge those flaws, not only in terms of limitations of the study, but in terms of how the researcher herself negotiates the process of research. This argument does not negate research, but instead calls for attention not only to researcher subjectivity but to a second layer of analysis; that of the research itself. I suggest that socially progressive research must, if it is to move forward, make transparent the decisions and tensions researchers negotiate as they are in the field as well as when they plan their research and analyze the data. Without such transparency, we are at risk for producing research that pays lip service to consistency between theory and methodology, but is lacking such consistency within the daily realities of research.

ACKNOWLEDGMENTS

The research described in this chapter was made possible by a grant from the Spencer Foundation. Special thanks to Kenneth Fasching-Varner, St. John Fisher College, for reviewing the initial draft of the manuscript and making sure I did not write anything too crazy and to Pam Takayoshi, Kent State University and editor of this book, for believing in me and pushing me to write this piece.

REFERENCES

Anderson, L. (2006). Analytic autoethnography. *Journal of Contemporary Ethnography, 35*, 373-395.

Barton, D., Hamilton, M., & Ivanic, R. (Eds.). (2000). *Situated literacies: Reading and writing in context.* London: Routledge.

Bloome, D., Carter, S. P., Christian, B. M., Otto, S., & Shuart-Faris, N. (2005). *Discourse analysis & the study of classroom language & literacy events: A microethnographic perspective*. Mahwah, NJ: Erlbaum.

Ellis, C. (2004). *The ethnographic I*. Oxford: Alta Mira Press.

Ellis, C., & Bochner, A. (2006). Analyzing analytic autoethnography: An autopsy. *Journal of Contemporary Ethnography, 35*, 429-449.

Farmer, J. D., Gerretson, H., & Lassak, M. (2003). What teachers take from professional development: Cases and implications. *Journal of Mathematics Teacher Education, 6*, 331-360.

Finders, M. (1997). *Just girls: Hidden literacies and life in junior high*. Urbana, IL: NCTE.

Fine, M. (1994). Working the hyphens: Reinventing self and other in qualitative research. In N. Denzin & Y. S. Lincoln (Eds.), *Handbook of qualitative research* (pp. 70–82). Thousand Oaks, CA: Sage.

Gee, J. P. (1996). *Social linguistics and literacies: Ideologies in discourses*. Philadelphia: Falmer.

Gee, J. P. (2000). The new literacy studies: From "socially situated" to the work of the social. In D. Barton, M. Hamilton, & R. Ivanic (Eds.), *Situated literacies: Reading and writing in context* (pp. 180-196). London: Routledge.

Haraway, D. (2004). Situated knowledges: The science question in feminism and the privilege of partial perspective. In S. Harding (Ed.), *The feminist standpoint theory reader: Intellectual & political controversies* (pp. 81-102). New York: Routledge.

Harding, S. (2004). Standpoint theory as a site of political, philosophic, and scientific debate. In S. Harding (Ed.), *The feminist standpoint theory reader: Intellectual and political controversies* (pp. 1-16). New York: Routledge.

Hull, G., & Schultz, K. (2001). Literacy and learning out of school: A review of theory and research. *Review of Educational Research, 71*(4), 575-612.

Hull, G., & Schultz, K. (2002a). Connecting schools with out-of-school worlds. In G. Hull & K. Schultz (Eds.), *School's out!: Bridging out-of-school literacies with classroom practice* (pp. 32-57). New York: Teachers College Press.

Hull, G., & Schultz, K. (2002b). Negotiating the boundaries between school and nonschool literacies. In G. Hull & K. Schultz (Eds.), *School's out!: Bridging out-of-school literacies with classroom practice* (pp. 1-57). New York: Teachers College Press.

Jacobs, G. (2004). Complicating contexts: Issues of methodology in researching the language and literacies of instant messaging. *Reading Research Quarterly, 39*(4), 394-406.

Jacobs, G. (2006). Fast times and digital literacy: Participation roles and portfolio construction within instant messaging. *Journal of Literacy Research, 38*(2), 171-196.

Joyappa, V., & Martin, D. J. (1996). Exploring alternative research epistemologies for adult education: Participatory research, feminist research, and feminist participatory research. *Adult Education Quarterly, 47*(1), 1-15.

Kemmis, S., & McTaggart, R. (2000). Participatory action research. In N. K. Denzin & Y. S. Lincoln (Eds.), *Handbook of qualitative research* (pp. 567-605). Thousand Oaks, CA: Sage.

Ladson-Billings, G. (2000). Racialized discourses and ethnic epistemologies. In N. K. Denzin & Y. S. Lincoln (Eds.), *Handbook of qualitative research* (2nd ed., pp. 257-278). Thousand Oaks, CA: Sage.

Lankshear, C., & Knobel, M. (2003). *New literacies: Changing knowledge and classroom learning*. Buckingham: Open University Press.

Lankshear, C., Snyder, I., & Green, B. (2000). *Teachers and techno-literacy: Managing literacy, technology and learning in schools*. St. Leonards NSW, Australia: Allen & Unwin.

Luke, A. (1994). *The social construction of literacy in the primary school*. Melbourne: Macmillan Education Australia.

Luke, A. (1996). Genres of power? Literacy education and the production of capital. In R. Hasan & G. Williams (Eds.), *Literacy in society* (pp. 308-338). London: Longman.

Moje, E. (2000). *All the stories that we have: Adolescents' insights about literacy and learning in secondary schools*. Newark, NJ: International Reading Association.

New London Group. (1996). A pedagogy of multiliteracies: Designing social futures. *Harvard Educational Review, 66*(1), 60-92.

Noddings, N. (2003). *Caring: A feminine approach to ethics and moral education* (2nd ed.). Berkeley: University of California Press.

Perkel, D. (2008). Copy and paste literacy? Literacy practices in the production of a MySpace profile. In K. Drotner, H. Siggard Jenson, & K. Schroeder (Eds.), *Informal learning and digital media: Constructions, contexts, consequences*. Newcastle, UK: Cambridge Scholars Press. 203-224.

Peskin, A. (1988). In search of subjectivity: One's own. *Educational Researcher, 17*(7), 17-21.

Reed-Danahay, D. E. (Ed.). (1997). *Auto/ethnography: Rewriting the self and the social*. Oxford: Berg.

Strauss, A., & Corbin, J. (1990). *Basics of qualitative research: Grounded theory procedures and techniques*. Newbury Park, CA: Sage.

Street, B. V. (1995). *Social literacies*. London & New York: Longman.

Street, B. V. (2003). What's "new" in New Literacy Studies? Critical approaches to literacy in theory and practice. *Current Issues in Comparative Education, 5*(2), 77-91.

17

AN EXPERIENTIAL APPROACH TO LITERACY STUDIES

Gwen Gorzelsky

For more than 20 years, the sociocultural approach to studying literacy, pioneered by researchers like Shirley Brice Heath (1983), Sylvia Scribner and Michael Cole (1981/2001), and Brian Street (1993/2001), has offered crucial insights into how local contexts shape the learning, uses, and effects of literacy. Following such scholars, many researchers study literate practices, defined broadly as all activities related to the reading, writing, production, and/or use of texts. In turn, as scholars like Deborah Brandt (2001) demonstrate, we examine the effects of literacy in terms of social, cultural, and economic implications—often with multiple and even conflicting directions—as well as cognitive implications.

Many sociocultural studies, from classic texts that have shaped the field of literacy studies, like Heath's (1983), to more recent works like those by Herrington and Curtis (2000) and Mahiri (1998), conclude that holistic engagement is required for people to successfully learn new literate practices. For example, in their case studies of four basic writing students' development as writers throughout their college careers, Herrington and Curtis (2000) correlate students' level of engagement in writing assignments with the extent to which they can use such assignments to pursue questions and issues in their personal development. Similarly, based on ethnographic data on K–12 students in afterschool programs, Jabari Mahiri (1998) shows that the opportunity to draw on knowledge and literacy practices that involve identity investments (like writing rap lyrics and using sports statistics) enables struggling students to achieve stronger academic performance.

More recent studies of both writing pedagogy and extracurricular literacies show that emotional, spiritual, and identity investments play a crucial role in pro-

moting the kind of holistic engagement that Mahiri and others argue is necessary to learning new literate practices. For example, Julie Lindquist's (2004) article on affect in college writing classrooms highlights the differences in perception and emotional habits between most working-class students and their middle-class instructors to argue that to succeed in college writing, these students need instructor support to use—rather than suppress—their existing emotional investments. Similarly, David Seitz's (2004) ethnographic study shows how working-class and immigrant students' identity investments—whether in a rebellious ethos or in enacting a home culture's beliefs about good manners—can often lead them to take stances teachers may interpret as resistant. Seitz (2004) argues that to help these students succeed in learning the literate practices of the academy, teachers must encourage them to draw on these identity investments rather than demanding students forego them. Trainor's (2002) examination of white students' resistance to, and engagement with, critical pedagogies likewise emphasizes that to successfully enlist such students' energies, teachers must open rhetorical spaces for articulating an identity that accords with their key investments.

Recent studies of extracurricular literate practices that have deeply engaged significant numbers of people also stress the central importance of spiritual, emotional, and identity investments in channeling learners' energies toward such literate practices. For example, Vicki Tolar Burton (2001) documents the wide range of literate practices required by Methodism's founder John Wesley of the many lay preachers he trained. While acknowledging the cultural and social benefits of lay preaching for Wesley's primarily working-class trainees, Burton (2001) emphasizes the spiritual commitment that motivated these learners. Beth Daniell (2003) examines the literate practices in a women's 12-step group designed to teach members strategies for coping with spouses' addictions and their own related dysfunctional behaviors. As Daniell (2003) illustrates, these strategies include prominently literate practices like journal and reflective writing; reading, analysis, and discussion of texts in relation to members' own lives and concerns; and writing to apply principles and key practices. Many of the group's participants did not consider themselves readers or writers but took an active role in its literate practices because of their commitment to its goals of personal and spiritual growth. Thus studies of both academic and extracurricular literacies demonstrate the significance of emotional, spiritual, and identity investments in motivating people to learn and use new literate practices.

Yet despite this significance, no studies of literacy or discussions of methodology have addressed the question of how to investigate the way such investments develop, or how they foster literacy learning and vice versa. I argue that investigating such investments is crucial if scholars hope to better understand how learners acquire new literate practices. Furthermore, I contend that researching such investments requires that we supplement the sociocultural approach to studying literacy with an experiential approach—one that specifically examines how spiritual, emotional, and identity investments foster literacy learning and how they develop through the process of acquiring new literate

practices. I hold that developing this approach involves two steps. First, we must devise more systematic, principled means of incorporating reflexive material into our studies, not just as material to help readers evaluate our analyses but as data. Second, we must develop principles for constructing studies that are dialogic not necessarily because research participants respond to our texts but because we take a dialogic approach to constructing the theoretical frameworks we use for data analysis. Through these steps, researchers can generate greater holistic understanding of how people experience the process of learning new literate practices. As I show here, such holistic understanding furthers key goals of socially progressive research, namely, more accurate representations of the people and phenomena we study and a type of reciprocity between researchers and research participants that prompts the researcher to internalize aspects of the participants' worldview. I argue that such changes provide an important foundation for more socially just relationships.

EMOTIONAL, SPIRITUAL, AND IDENTITY INVESTMENTS IN LITERACY LEARNING

In this section, I review Trainor's (2002) and Seitz's (2004) studies of writing pedagogy and Daniell's (2003) study of extracurricular literate practices to show why an understanding of learners' emotional, spiritual, and identity investments is crucial to explaining how these learners develop expertise in new literate practices. By considering each researcher's findings, I illustrate how such investments can either obstruct or foster engagement in learning these practices. Thus, I demonstrate the significance of investigating how these investments operate and of developing an effective methodology for studying them.

Like much recent scholarship on critical pedagogy, Trainor's (2002) article considers the tendency of this teaching approach to foster students' resistance to engaging with the very concerns and analytic practices central to its goals. Specifically, she examines how critical pedagogy constructs whiteness because, she explains, teachers using it must consider what identity options—in the form of rhetorical positions—we offer our students when we ask them to take up particular narratives and forms of critique. To illustrate, she offers the example of Paul, a white composition student who concludes that both assigned texts and some of his classmates "were literally blaming him, personally, for past injustices or current inequalities" (p. 643). Trainor (2002) shows how this belief led Paul to significantly misread several course texts. For example, he concludes that June Jordan's phrasing, "'standard English, the language of the killers'" means that "she's saying that all people who speak standard English are killers. All white people. Just because of slavery or something" (p. 644). When Trainor (2002), during an interview, presses him to consider the comparison statement, "Nike, the

tennis shoe of the Chicago Bulls," Paul immediately acknowledges that the statement does not indicate that everyone who wears Nike shoes plays for the Bulls. But in the next breath, he insists, "I still think she [Jordan]'s saying standard English speakers, white people, are killers" (p. 644). Trainor (2002) concludes that the problems in literacy learning that Paul demonstrates result from his emotional and identity investments:

> Paul's difficulty with formulating palatable subject positions in relation to the text seemed to contribute to misreadings or to simplified, resistant readings. For example, Paul's strong identification with the "bad guys" in each text made him a defensive and emotional reader, less inclined to suspend judgment or to hypothesize sympathetic intentions on the part of the writer. (p. 643)

I see Paul's response to the assigned texts, and Trainor's (2002) reading of it, as crucial for several reasons. First, her analysis usefully highlights the role of emotional investments in Paul's relationship to the literate practices his teacher—and later Trainor, as researcher—asks him to undertake. Because he is "defensive and emotional," Paul cannot accurately characterize Jordan's position. The ability to produce such accurate characterizations of others' positions is, of course, a central skill college-level writers are expected—in fact, in most cases required—to develop. Paul's ability to follow and respond to the analogy between Jordan's statement and Trainor's Nike/Chicago Bulls statement demonstrates that he has the cognitive capacity to explain the position implied in the particular phrasing in question, as well as to make the more complex move of understanding a comparison that highlights syntactic structures. These abilities with language foreground more strikingly the role Paul's emotional response plays in preventing him from accurately characterizing Jordan's position.

Furthermore, Trainor's (2002) analysis makes clear that Paul's identity investments prompt his strong emotional response. Specifically, she asserts that his "difficulty with formulating palatable subject positions in relation to the text" and his "strong identification with the 'bad guys' in each text" largely prompted Paul's misreadings or his "simplified, resistant readings" (p. 643). That is, as other comments from Paul's interview demonstrate, his investment in identifying with the White males depicted in course texts interferes with his ability to construct complex, engaged readings of the assigned texts.[1] Thus, identity investments fundamentally disrupt Paul's ability to develop a set of literate practices for which he clearly has the cognitive capacity and that play a central role in higher education, not only in writing courses but in the production of academic prose more generally.

Like Trainor's (2002) work, Seitz's (2004) ethnography considers students' responses to critical pedagogy approaches, as well as to a revised critical pedagogy. And like Trainor's work, Seitz's stresses the significance of students' emotional and identity investments in determining whether and how they will engage

with academic literate practices. His analysis shows these investments to be just as significant in promoting and shaping such engagement as they can be in discouraging it.

Seitz's ethnography shares Trainor's concern with investigating student behaviors and positions often seen as resistant by teachers using a critical pedagogy approach. He studies a research writing course that enrolled an ethnically and socioeconomically diverse urban student body in a writing class that focused on women in the third world to consider social systems and contradictions and students' relations to them. Through extensive interviews with a range of students, Seitz (2004) shows the varying responses to the course's assigned readings and papers by U.S.-born working-class Black and White students and first-generation immigrant students originally from Mexico, Puerto Rico, mainland China, Hong Kong, and India.[2] His nuanced readings of students' descriptions of how they understood the course and their relation to the work it solicited illuminate the range of motivations and perceptions behind student responses often depicted as resistant.

One such analysis illustrates particularly clearly how students' preexisting social, emotional, and spiritual investments can fundamentally shape their relationship with academic literacy and guide them in deciding which specific academic literate practices to use in a given situation, and to what ends. The relevance of these investments appears in Seitz's (2004) introduction of this student, Lilia, who "describes herself as a Latina who rejected the Catholic tradition, although not the Mexican culture, to become a disciple in the Chicago Church of Christ" (p. 154). Stressing that Lilia's fundamentalism is atypical in some respects, Seitz emphasizes that in repeated conversations with him, Lilia associated her religious beliefs with the ideals of the research writing course: "feminism, the political power of speaking out, social critique, and activism" (p. 154). Yet, he notes, these positions worked in tension with Lilia's valuing of unity, despite her willingness to engage substantively with the course's readings focused on difference.

This tension structured Lilia's engagement with the academic literate practices encouraged by the research writing course. As Seitz (2004) explains, "Unlike most of the students in [the] class, Lilia sought to incorporate into her writings some of the course's most explicitly theoretical positions on difference, race, class and women's struggles" (p. 154). Although more than half the students responded to a writing assignment requesting such work by spending no more than a paragraph discussing such texts, Lilia "used [one author's] theories of social geography to examine her own heritage as a Mexican Latina and the value of all women gaining ... 'a voice to fight against 'exploitative structures'" (p. 154). Despite her willingness to work substantively with critical texts on difference, Lilia nonetheless concludes in this paper that women who "find themselves in different locations do have a similar struggle that brings them together despite their differences. The struggle to describe themselves and express themselves freely in society" (pp. 154-155). In subsequent conversations with Seitz about

the paper, Lilia explicitly linked her focus on women's unity with her involvement in her church. She cited her renunciation of Catholicism to join a fundamentalist church as a challenge to her parents' expectations that she would play the role of "the submissive Mexican daughter," and she stressed her concern with women's political involvement and struggle against exploitation and suppression in workplace, religious, and cultural practices (Seitz, 2004, p. 155).

This set of concerns particularly shaped Lilia's work in her final research paper, not only in terms of its content but, just as importantly, I suggest, in terms of its use of specific types of literate practices. Not surprisingly, Lilia focuses in this paper on "the prospects for 'global feminism' despite the power relations structured in different women's situations of races and nations" (p. 155). After noting that most of the texts she had read for the course critique this notion of global sisterhood, Lilia nonetheless insists, "'Much 'difference' among one another when there are internalized and extroverted 'differences' crush the spirit of 'sisterhood' and cause discord among women" and that "'Recognizing the false assumptions and their development is just the beginning of effective research. Soon let's write about research expressing fine productive, edifying results and solutions to the crisis women in the third world countries face today'" (p. 156).

This position apparently informs Lilia's choices about where and how to engage with the literate practices encouraged by the course. Seitz notes that "unlike Lilia's previous papers, her final paper reads like a hybrid gene of sermon and editorial calling for unity within women's common struggles, rather than an argumentative researched inquiry into an issue" (p. 156). While acknowledging that the final paper was also more rushed than Lilia's earlier work for the course, he concludes that "her driving concern for speaking out—as she stressed in conversations with me, for directly addressing a positive message of unity tied to her religious beliefs—may have also worked to overpower the expected critically academic discourse" (p. 156). Through additional interview data, Seitz shows persuasively that Lilia's concern for unity emerged in significant part from adolescent experiences that, in her view, made finding unified communities a key survival strategy for teens living in the midst of urban neighborhoods and peer groups where "drugs, gangs, or crime or abuse" are prevalent (p. 156). Thus Lilia's deep investment in unity as a survival strategy, as well as her investment in spiritual beliefs and a religious community that promote unity, shaped not only her position on key issues in the course but—even more significantly—her choices about where, when, and how to take up academic literate practices like "argumentative researched inquiry" and where to turn instead to literate practices familiar from other venues, like sermons and editorials.

Beth Daniell's (2003) work with the development of literate practices in a nonacademic context highlights even more dramatically the role of spiritual investments in prompting people to learn new literate practices. In *A Communion of Friendship: Literacy, Spiritual Practice, and Women in Recovery*, she documents the literate practices of a group of female members of Al-Anon, a 12-step group adapted from Alcoholics Anonymous (AA) to help spouses of alcoholics "use AA

principles to repair the damage of living with an alcoholic" (Daniell, 2003, p. 9). Daniell explains that group members sought "serenity, release from their confused and distressed thinking" (p. 9). Interview data illustrating this focus builds throughout the study and unfolds participants' understanding of what "serenity" means in their lives. This illustration highlights both participants' motivations for developing particular literate practices and the specific goals and uses to which those practices contribute.

Explaining that the women in her study read and write daily "with the purpose of changing their minds—changing their hearts [they] would say. ... Their purpose is not to become experts on the texts of Al-Anon but rather to change their own perceptions, to shift their attention, to attain a spiritual awakening" (p. 134). Clearly, this purpose is holistic and cannot be reduced to primarily cognitive functions, although it just as clearly includes cognitive work and in fact attempts to fundamentally change participants' own thinking processes. Linking such personal changes to the potential for broader sociocultural change, Daniell (2003) cites Cornel West's argument for a politics based in spiritual changes that affirm one's own worth, and she concludes that, "the task of oppressed people, therefore, is to come together to provide places where this [process of change] might be nourished" (pp. 144-145). She shows how the Al-Anon group she studied pursues this goal through a set of literate practices fashioned by members, in dialogue with the larger Al-Anon organization, specifically for this kind of self-transformation, defined in explicitly spiritual terms.

Based on extensive interviews with her participants on their reading and uses of a wide range of texts, Daniell (2003) contends that the women she studied have taught themselves to consider how what they read might make a difference in their own lives. Jennie, for instance, "believes that it is through reading with an awareness of the possibility of a spiritual message that she finds [such a message]" (p. 101). In analyzing Jennie's position, Daniell (2003) suggests that "the point is that ... spirituality is made, created, brought into being by our interactions with the text. It is through the exercise of reading ... spirituality that we find it" (p. 102). Although reading and writing "do not automatically constitute us as subjects," Daniell argues, "[they] can if the context allows it" (p. 166). She concludes that the context of the Al-Anon women "teaches them that their reading and their writing can be self-constituting activities," and her study as a whole makes clear that the women consciously undertake the group's literate practices with the goal of precisely this self re-constitution.

One such literate practice is the fourth step (of the adapted AA 12 steps), which consists of a "'searching and fearless [self-]inventory'" (Daniell, 2003, p. 39). As Daniell explains, this step is "the most obvious writing assignment in the Al-Anon program and often the first thing that newcomers to Al-Anon write" (p. 39). Noting that many of her participants name this writing process as the first period during which they experienced healing, she points out that many interviewees associate it with "the beginning of the end of the personal confusion that brought them to Al-Anon in the first place" (p. 40). Jennie, for instance, describes

doing a fourth step "whenever I get stuck" because "when something permeates my life, I need to get it on paper so I can determine what the connection is, the similarity. The things that are happening, that I'm having problems with, are usually all the same" (Daniell, 2003, p. 41). Daniell describes Jennie's use of an AA format for drafting her fourth-step inventory, a format that involves making three columns that indicate what the writer resents, the cause of the resentment, and what in the writer's life is affected by the resentment. Although other study participants use different formats, some even substituting audiotaping for writing, Daniell (2003) documents participants' consistent accounts of experiencing peace and healing as a result of their completion of the fourth-step process.

She draws on these accounts to argue that participants seem to find "that self-analysis is easier if the statements we make about ourselves have some material existence outside ourselves. Words on a page or on a tape seem somehow more real and are more easily examined than the ephemeral chunks of language that float through our minds or memories" (p. 44). For instance, Jill, another research participant, explains using the fourth-step inventory to separate her reactions from what others did to her, citing the example of how her step-father kicked her, and she responded with hate. "When I can separate it on the page, I can separate it inside: Here's what he did, he kicked me, and here's what I did, I started to build a wall and decide that I was going to hate him. ... I wasn't responsible for the fact that he kicked me, but I was responsible for what I decided to do. This was a real spiritual awakening" (p. 45). Other research participants similarly emphasize the centrality of making events, feelings, and attitudes concrete by writing them or audiotaping them and then discussing them with another Al-Anon participant. As Daniell shows, this process typically provides her participants with new, and very different, perspectives on their experiences, relationships, and identities.

She concludes that the wide range of literate practices the women use work together toward such shifts in perspective and, in fact, in identity:

> These women devise various literate strategies for coming to terms with their experiences, dealing with their emotions, reassessing other people's rules and cultural expectations, and accepting the unchangeable conditions of their lives—in short, for letting go of their own private struggles. They use their writing to chart, record, analyze, accept, and change their emotions and their lives. Using various written forms—prose, Dear God letters, journals, God Can notes, and letters—these women are ... negotiating their own identities. (p. 63)

For Daniell's research participants, the motivation to learn and use these literate practices is explicitly spiritual, emotional, and oriented toward self-transformation. As she demonstrates, the use of these literate practices "provides a new version of reality" (p. 51). Specifically, they "mak[e] one aware of self in relation to

other selves" (p. 166). By cultivating this awareness, the Al-Anon literate practices offer participants new definitions of self that challenge those provided by spouses, supervisors, children, coworkers, churches, friends, and the like. Daniell shows that as Al-Anon members realign their own self-definitions in relation to these groups, their identities change in turn. Thus, in the case of Daniell's research participants, literate practices do revise users' basic sense of self, although as she is careful to note, "this sort of literacy doesn't just happen; it has to be nurtured" (p. 166).

Her point that literacy can—but does not necessarily—lead to such redefinition of one's identity is a central issue for literacy researchers. Perhaps even more strikingly than in the cases of Trainor's (2002) and Seitz's (2004) research participants, the account of Daniell's (2003) Al-Anon members highlights the role of emotional, spiritual, and identity investments in shaping people's choices about what kinds of literate practices they develop and use. Furthermore, Daniell's (2003) study underscores the energy and commitment required to learn and use literate practices that can produce such powerful results. Various literacy research suggests that these extracurricular literacies often are those people find most meaningful and use most extensively. Furthermore, as many researchers have shown, such extracurricular literacies fundamentally shape people's encounters with school-based literacies. Trainor's (2003) study illustrates that identity investments (e.g., in a particular version of the White male role) play a key part in structuring these encounters. Seitz's (2004) and Daniell's (2003) studies show how extracurricular literacies themselves—from sermons to fourth-step inventories—can carry with them deep emotional, spiritual, and identity investments that similarly shape people's interaction with school-based literacies.

Given the pivotal role of such holistic investments, I argue that literacy scholars should develop research methods and methodology suited to investigating them. Many studies have emphasized the significance of such investments, and many have called for pedagogies that promote them (e.g., Ball, 2006). But little or no literacy research has focused on how such investments develop, although some scholars have called for investigations of the affective dimensions of literacy learning (Hidi & Boscolo, 2006; Pajares & Valiante, 2006). To cultivate these investments in any context, and certainly to develop pedagogies that can succeed in fostering them in classrooms, literacy scholars must first understand how they take root and grow. To do so, we must of course design studies that focus on this topic. To make these studies effective, however, we also must adjust our research methods. Our current sociocultural approach to studying literate practices powerfully illuminates how social relations and cultural habits structure the acquisition, and the form, of particular literacies, and it often highlights the specific cognitive skills these literacies develop. I recommend that we extend the sociocultural approach by developing methods that highlight how people *experience* the acquisition of literate practices that play a significant role in their lives, as well as how they experience the development of related spiritual, emotional, and identity investments. Such methods must make visible not

only the initial investments that lead people to acquire new literate practices but also how those investments develop and change through the process of achieving proficiency in the new practices.

REFLEXIVE APPROACHES: SEEKING EQUITY AND VALIDITY

To develop these methods, the next section shows how an experiential approach to literacy studies builds on existing arguments for incorporating reflexive components into qualitative studies of literacy. This section lays the groundwork for that demonstration by explaining the concerns motivating reflexive arguments and describing two key strands. The first incorporates reflexive material on the researcher's position into published studies. The second emphasizes constructing reciprocal relationships with research participants. Both strands focus on equitable relations between research and research participants and on sound bases for constructing knowledge.

Ellen Cushman (1999) articulates these foci in "The Public Intellectual," where she argues that such intellectuals should reach beyond the walls of the university to "create knowledge with those whom the knowledge serves" (p. 330). Therefore, she holds, researchers must devise methods that rework the top–down relations of traditional ethnographic study. Instead, she advocates activist research that "combines postmodern ethnographic techniques with notions of reciprocity and dialogue to insure reciprocal and mutually beneficial relations among scholars and those with whom knowledge is made" (Cushman, 1999, p. 332). Cushman (1996) indicates one way that she undertakes such work in another essay, "The Rhetorician as an Agent of Social Change," in which she uses "a self-reflexive rhetoric" to describe her participant-observer role during a study in an urban African American neighborhood (p. 7).

Taking a reflexive approach allows the researcher to reveal important information about her relation to research participants, as Elizabeth Chiseri-Strater (1996) contends in "Turning In upon Ourselves: Positionality, Subjectivity, and Reflexivity in Case Study and Ethnographic Research." Without reflexive components, the study would omit such information and, in doing so, potentially obscure important perspectives that could impact research findings by reshaping the interpretation of key data. Contending that reflexive work pushes the researcher to examine how she is positioned, Chiseri-Strater holds that it prevents the researcher from removing herself from the research process, relationships with research participants, and from the process of turning data into ethnographic texts. She concludes that in undertaking such work, the researcher makes "herself as well as the other an object of study" (p. 119).

In "The Rhetorician as an Agent of Social Change," Cushman (1996) also calls for reciprocity between researchers and research participants. Warning

against the colonizing tendencies embedded in ethnographic methods, Cushman (1996) argues that "we should take social responsibility for the people from and with whom we come to understand a topic" (p. 11). This work requires forging closer connections with research participants and "a deeper consideration of the civic purpose of our *positions* in the academy, of what we do with our knowledge, for whom, and by what means" (Cushman, 1996, p. 12). It involves both giving to, and receiving from, the community members serving as research participants, offering them tangible benefits such as access to technology and other university resources, literacy tutoring, and the like, in exchange for the data they provide. Cushman (1996) defines the relationship as one of interdependence, rather than one of altruism, and she holds that it involves "accepting a civic duty to empower people with our positions" (p. 14).

Other scholars of qualitative methodology also raise concerns about the colonizing tendencies embedded in the evolution of qualitative research methods. In "Ethnography and the Problem of the 'Other,'" Patricia Sullivan (1996) suggests we consider ethnography not only in terms of methodology but in terms of social practice, that we see it as "an engagement with a culturally significant other who has a decided stake in the understanding our research is said to produce" (p. 98). Given that the author's perspective inevitably shapes all representations, Sullivan argues, qualitative studies must prioritize not only accurate depictions of their research participants but also accountability to those depicted. To pursue this goal, Sullivan advocates a form of reflexivity that explicitly produces a dialogue between researcher and participants, claiming that this approach creates a reciprocal relationship and texts that more accurately convey the perspective of research participants to readers.

Similarly, in "Constructing Voices in Writing Research: Developing Participatory Approaches to Situated Inquiry," Blakeslee, Cole, and Conefrey (1996) recommend incorporating participants' perspectives on the issues researchers address and participants' responses to researchers' interpretations. They advocate "negotiating with participants to find a common place where we can represent their voices fairly and critically while also allowing our participants to critique our own methodology and interpretations" (p. 134). Like Sullivan (1996), they raise concerns about researchers silencing participants' voices in published accounts and argue that "by allowing subjects to speak for themselves and to clarify or correct our interpretations of their ideas, we reduce the possibility of misnaming, misrepresenting, burying, or confusing our subjects' voices and perspectives," and they advocate "co-construction" of research reports with participants (Blakeslee et al., 1996, p. 147). And like Sullivan (1996), they recommend reflexivity about researchers' relationships with participants and the representation of these relationships in study reports.

I see both strands of arguments for reflexivity—incorporating reflexive material and establishing reciprocity with research participants—as important contributions to literacy studies' research methods. I concur with their goals and the approaches for pursuing those goals described by Cushman (1996, 1999),

Chiseri-Strater (1996), Sullivan (1996), and Blakeslee et al. (1996). Furthermore, I have used each of the approaches in prior research projects, and I provide brief examples in a later section. Yet I also see important limits to these approaches.

First, although incorporating reflexive material into qualitative studies of literacy does offer more accurate depictions of research participants and their concerns, this approach is designed to provide only such information about the researcher's position and experience as is useful for understanding research participants or study ethics and methods/methodology. As Chiseri-Strater (1996) suggests, limiting disclosures about the researcher to those that serve these ends provides a crucial way of responding to charges of self-indulgence. Other proponents of reflexivity in qualitative studies of literacy take similar positions on the goals, approaches, and complexities of doing such work (e.g., McCarthy & Fishman, 1996; Sunstein, 1996). Although these limits rightly discourage gratuitous researcher self-disclosure in texts focused on research participants' literate practices, they also risk foreclosing systematic investigation of the researcher's literacy learning.

Second, although Cushman's (1996, 1999) approach to reciprocal exchange with research participants is significant in establishing ethical relationships and rightly stresses the importance of providing tangible benefits to participants, it is not the only—and not always the most effective—approach to establishing reciprocity in the construction of knowledge. As I illustrate in the section on using the experiential approach, some research participants stand to gain little in the way of tangible benefits in their exchanges with me, as researcher. Similarly, although I believe in the value of inviting research participants to read and critique texts depicting them, that approach is not always the most effective means of producing dialogic knowledge. The section on using the experiential approach explains my use of this approach in previous studies and shows that some participants have little stake in academic texts' depictions. In the next section, I outline an approach to reciprocal knowledge construction that, instead of stressing the exchange of tangible benefits or the construction of explicitly dialogic texts, emphasizes creating the conditions for a shift in the researcher's perceptual structures. This approach seeks to prompt change in scholarly discourse as a result of such perceptual shifts. It extends earlier reflexive approaches by replacing anecdotal depictions of the researcher with data-driven analyses of her experiences of learning new literate practices.

BEYOND REFLEXIVITY:
SHIFTING THE GROUND OF PERCEPTION

In this section, I argue that the experiential approach offers two research methods that can help shift the researcher's perceptual structures. The first involves systematically documenting his or her experiences of learning new literate prac-

tices. The second entails integrating key concepts from the literate practices under study into the researcher's theoretical frame for coding and analyzing qualitative data. Together, these methods promote the goals of reflexive scholarship by providing sound bases for constructing knowledge and equitable relations between researcher and research participants. Because literacy learning involves people holistically and initiates fundamental shifts in identity investments, investigating it requires methods that illuminate learners' holistic experiences, as those change throughout the learning process. That is, to achieve validity, studies of literacy must devise methods that move beyond what can be learned from incorporating reflexive material to help readers evaluate the researcher's relation to research participants or from engaging research participants in dialogue about our depictions of them. Both of these approaches are important. Both offer crucial insights. But scholars also need new kinds of insight into the experience of literacy learning to fully understand how it taps—and revises—identity investments. Because such learning does reshape these investments, I contend that one important way for researchers to establish reciprocity with research participants it to undertake—and not merely depict—such significant personal risk and change. The experiential approach's methods promote this work by using key features of writing to construct genuinely dialogic knowledge.[3]

This potential also inheres in the two methods of the experiential approach. Like think-aloud protocols, these methods each use the designative and expressive functions of writing in complementary fashion. In fact, the complementary relationship between the two is embedded in the process of learning new literate practices. That is, as Gee (2008) shows, such learning entails both imitating the performance of proficient users and taking on the values, attitudes, and perspectives embedded in the new practices. Thus it requires both public speech and the (re)development of one's own thinking, processes that inform one another. The result is dialogic, in that the learner constructs new perspectives woven into the new literate practices and, inevitably, puts those perspectives in dialogue with older ones provided by previous experiences. Research methods designed to make visible this kind of dialogue can provide new insights into the changes that occur as people learn new literate practices. Because the experiential approach's methods promote a complementary relationship between the designative and expressive functions of writing, they enact the kind of dialogue required to learn new literate practices. Although they lack some aspects of the reciprocity Cushman (1996, 1999) and others advocate, they offer a new perspective grounded in the researcher's perceptual shifts, a perspective that can enrich the one provided by more traditional forms of reciprocity.

The first method fosters such perceptual shifts by combining the designative and expressive functions of writing. It entails writing fieldnotes on the researcher's experience of learning a new set of literate practices to produce valid empirical data as such experience unfolds, rather than after the fact. Because fieldnotes are drafted over the course of the learning process, they provide insight into the nature of a learner's identity investments and the changes in those invest-

ments as the learner internalizes values embedded in the new literate practices. Such work offers two crucial benefits to literacy researchers seeking to understand literacy from an experiential perspective.

First, it provides access to a level of subjective understanding and detail otherwise unavailable to any researcher, because it represents internal experience unmediated by another person's perspective. Naturally, the mediations of one's own subconscious and semiconscious remain an issue, but such mediations occur with any research participants, whose perspectives then also get filtered through the researcher's. Taking fieldnotes on one's own learning process uses the expressive function of writing because it requires the researcher to use writing to construct an understanding of the changes he or she is experiencing. That is, he or she produces this understanding precisely through the process of writing. But the writing process also uses the designative function because it demands that the researcher articulate this understanding in terms both of the new literate practices and of literacy scholarship. That is, while the researcher writes fieldnotes to construct her own understanding of events observed or experienced, she also always has in mind the goal of communicating this understanding to her eventual audience, readers in her scholarly field (Emerson, Fretz, & Shaw, 1995).

This combination of expressive and designative functions highlights the dialogic nature of writing fieldnotes on one's own process of learning new literate practices. Drafting the notes demands that the writer construct an understanding that integrates the perspectives embedded in the new set of literate practices with previously internalized perspectives from literacy scholarship. Thus it puts the two perspectives in dialogue with one another. Although to some extent, the writing of traditional fieldnotes can encourage such dialogue, it does not require the researcher to internalize new perspectives in the way that learning a new set of literate practices demands. Thus writing fieldnotes on this learning process furthers an existing internal dialogue experienced by anyone learning new literate practices. Additionally, it begins the process of communicating the experience to others. Therefore, it encourages the recursive relationship between expressive and designative functions that Smagorinsky (1997) documents. In doing so, it fosters a dialogue between worldviews that, while very different in form from the dialogic texts advocated by scholars like Blakeslee et al. (1996), nonetheless offers important—and complementary—insights.

The second benefit offered by this method is that it requires researchers to develop systematic means of collecting reflexive data on our own experiences of developing proficiency in new literate practices. These means provide scholarship on such experiences with a level of validity not possible for reflective memoirs or literacy narratives. Again, they do so by combining expressive and designative functions. As noted earlier, because they provide greater access to subjective experience than do fieldnotes on others' learning processes, they offer deeper insight into such experience, which is depicted through the expressive function. Because they make possible systematic coding and analysis of that experience using traditional qualitative methods, they enable a level of rigorous examination less possi-

ble for reflective memoirs or literacy narratives. To do so, they draw on the designative function. But again, the two functions support one another, given that while coding the fieldnotes, the researcher inevitably constructs a richer understanding of his or her experience precisely by developing an analysis designed to communicate it to others. Because that experience inherently involves a dialogue between worldviews, it promotes the goals of dialogic qualitative study, although in a textual form quite different from that typically advocated.

Because this acquisition process inherently produces internal dialogue, and because the two methods augment that dialogue, they promote an alternative form of reciprocity. In this form, dialogue occurs not between individuals, as in the form advocated by researchers like Blakeslee et al. (1996), but rather between the conceptual systems embedded in literate practices. Although this dialogue between conceptual systems is by no means a substitute for that between individuals, I see it as an important extension of the effort's two guiding goals. The first involves producing more epistemologically sound knowledge that foregrounds participants' perspectives rather than subsuming them in the researcher's. The second entails creating mutually beneficial, rather than exploitative, relationships between researchers and research participants. The method of putting conceptual frames in dialogue pursues these goals.

It does so by bringing participants' perspectives into research studies not only in presenting interpretations of study data but also in *producing* those interpretations. Thus, it structures participants' views into research reports at an earlier, more formative stage of development. It brings participants' voices more extensively into our texts, not only by offering them space to contest researchers' interpretations and/or by reporting researchers' relationships with them, but also by incorporating key concepts from their worldviews into data analysis, and thus into our conclusions. Given that an experiential approach seeks to foreground participants' holistic experiences of literate practices, incorporating their voices in this way provides crucial insights because it offers a richer, deeper understanding of how participants themselves view these experiences. It does so by using the concepts that shape participants' experiences to help produce researchers' interpretations of those experiences. Incorporating participants' conceptual frames into the researcher's fosters a shift in perceptual structures, a shift I argue is a key underlying goal of reciprocity between researchers and participants. Such shifts inevitably change the nature of both arguments made about participants and relations with participants. Although they don't offer the kind of tangible benefits Cushman (1996) usefully advocates, they provide another basis for an ethical relationship: holistic, rather than strictly cognitive, understanding grounded in a synthesis between the values of researcher and participants. I suggest that such a synthetic perspective is key to promoting ethical relationships.

Of course, the methods of the experiential approach are not appropriate for all studies of literate practices. Such perceptual shifts may be undesirable, even dangerous, in some circumstances. For instance, a researcher might seek to avoid internalizing the values embedded in the literate practices of a fascist group. Nor

is it always useful—or even possible—to take fieldnotes on the researcher's experience of learning new literate practices. For example, typically researchers have achieved proficiency in both functional and academic literacies in their native languages, so the possibilities for collecting empirical data on their experiences of such processes are highly constrained at best. On the other hand, a researcher could document his experience of developing proficiency in a set of spiritual literate practices like the set Daniell (2003) studies; in a form of digital literacy (e.g., in an environment like Second Life) in which he had little or no prior competence; or in the literate practices of a grassroots political movement (like MoveOn.org). In such cases, the researcher would act as his own research participant, and he would study his own developing competency in the literate practices he investigated. While those helping him learn the new literate practices might not directly participate in his study as participants, part of his goal in using the experiential approach would be to internalize—and then represent—their conceptual frames, as embedded in their literate practices.

I do not suggest that all studies of literacy should use the experiential approach. I do, however, suggest that literacy research as a whole needs such studies. Therefore, I believe that literacy scholars should use the methods proposed here, examine their effects from methodological and epistemological standpoints, and revise them. In the next section, I offer an example from one recent and one current research project to begin such efforts.

USING THE EXPERIENTIAL APPROACH

This section describes two research studies to offer short examples of how a researcher might use the methods. Both studies investigate literate practices used by two teachers who prompt students to expand their awareness of their relationships with themselves, others, and their communities, from families and classrooms to workplaces and wider social and political arenas. One, the Zen Buddhist teacher Thich Nhat Hanh, is a Vietnamese monk who has taught in the West for more than 40 years. I investigate the literate practices embedded in his work through three approaches:

1. historically situated textual analysis of his writings from the Vietnam War era,
2. textual analysis of more recent works published in the West, and
3. systematic qualitative documentation of the effects of these literate practices on me as I undertook them over several months.

In this section, I explain the data-collection procedures I am using to implement the third approach.

The second teacher, Justin Vidovic, is a highly successful university writing instructor who combines elements of critical and process pedagogies. I investigate the literate practices embedded in his teaching and his students' work, based on qualitative data collection over two semesters, during which I took extensive fieldnotes, audiotaped most class meetings, collected all instructor-generated and many student-generated texts, and interviewed students and instructor. Using this data, I document the literate practices Justin models and advocates, as well as when and how his students took up these practices in their writing and contributions to class discussion.[4] In collecting this data, my focus was on research participants' experiences, rather than on my own. But as I show in this section, in interpreting the data, I found it important to integrate concepts introduced by one key research participant—Justin—into the theoretical framework I had originally intended to use.

I begin by explaining the data-collection procedures I am using to investigate my efforts to learn Nhat Hanh's literate practices. In doing so, I show an example of how a researcher can use systematic methods to document her experience of acquiring a new form of literacy. I began working personally with Nhat Hanh's teachings a few years before starting this research project, so I cannot document my experiences from the earliest stages of my learning process. However, given the depth and breadth of Nhat Hanh's work, even after a few years of effort, it is clear that I have reached only the early stages of proficiency with the literate practices he teaches. Given how much more I have to learn and the fact that it has taken time for me to develop consistency in my efforts, this stage of literacy acquisition seems well worth investigating. Devising methods for systematically recording my experience of learning these practices and their effects on me has provided a kind of data unavailable through textual analysis or through qualitative data collection on others' experiences.

In developing these methods, I focused on seeking ways to record my initial responses to specific literate practices and these practices' effects on me, as well as changes in these responses and effects over time. My goal in doing so was to make visible shifts in perception, emotional responses, level and kinds of investments, and the like, and thus to make such shifts available for analysis. Examining these shifts seems crucial to me because it has the potential to illuminate phases of the learning process—and its attendant investments—that might otherwise disappear from memory once proficiency develops. Therefore, I decided to draft daily fieldnotes for 4 months on my efforts to pursue Nhat Hanh's teachings on mindfulness. These teachings emphasize the use of various kinds of exercises. Many are designed to integrate awareness of body and emotions with awareness of one's own thinking patterns. Like other Buddhist teachers, Nhat Hanh calls such awareness "mindfulness." All of his mindfulness exercises help the practitioner to develop a deeper understanding of Zen concepts and to apply those concepts in daily life.

I had not kept notes on my work with Nhat Hanh's practices, or even a journal, prior to the study. The fieldnotes on my mindfulness practice were intended

as data, with any personal insights a welcome by-product but not the primary goal. Nonetheless, to document the nature and role of my investments, the fieldnotes needed to be as honest as a personal journal, so I planned to code and analyze them in the way I would any ethnographic fieldnotes, using excerpts, summaries, and descriptions in study reports to document claims, without revealing potentially compromising details, such as the identities of people mentioned in the notes. Given that Nhat Hanh recommends attempting to practice mindfulness every moment of every day, it would have been impossible to produce fieldnotes that provided a comprehensive record of all my efforts to use his texts and exercises to promote mindfulness, much less the experience and results of these efforts. Therefore, I decided to spend 30 minutes per day drafting my fieldnotes.[5]

I also sought to maximize the chances for illuminating the nature and role of my spiritual, emotional, and identity investments in learning these practices, as well as changes in these investments. Thus, I decided to start the fieldnote record at my current point of work with Nhat Hanh's materials, rather than to adjust my learning process to meet particular requirements of the research study. Nhat Hanh has published nearly 100 books in English (as well as books in French and Vietnamese), so, of course, various principles of selection could be used to decide which texts to use as the focal point of a study on his work. But for the purposes of this component of my study, the most relevant selection criterion seemed to me the trajectory of my own practice. That trajectory had brought me to a point where my efforts were centered on using Nhat Hanh's exercises to practice mindfulness more consistently in my daily life and to deepen my understanding of Zen's central beliefs and concepts. The two Nhat Hanh books I happened to be reading when I began taking fieldnotes integrated explanations of beliefs and concepts with exercises and explanations of those exercises, so I decided to read (or reread) a small section of each book daily as one basis of both my mindfulness practice and my fieldnotes on it. Developing this systematic approach to collecting data on my experience of gaining proficiency in Nhat Hanh's literate practices has made it possible for me to document my learning process and the resulting perceptual shifts.

I suggest that these shifts can provide a significant form of reciprocity. If I were to undertake the type of reciprocity Cushman (1996, 1999) and other literacy scholars advocate, I would need to find a way to reciprocate Nhat Hanh's indirect participation in my study, given that he provided the literate practices I examine. But as a Buddhist teacher whose reputation in the West is second only to that of the Dalai Lama and who explicitly renounces concern with reputation and other material advantages, he stands little to gain in any exchange I might devise from Cushman's (1996) suggestions. The one thing he would be likely to seek in exchange, based on his texts, is my commitment to practicing the literate practices he teaches, with the long-term goal of enacting the values they embed in my day-to-day life. Thus, internalizing the perceptual shifts associated with those values offers a significant form of reciprocity in the framework of Nhat Hanh's thinking. This form of reciprocity prompts deep changes that lead a

researcher to new courses of action she would not have undertaken, had she not been fundamentally changed by deep engagement with the perspectives and values of her participants. Because I believe it can contribute to significant change in social relations, I argue that this form of reciprocity is well worth cultivating.

I experienced a similar perceptual shift during my study of Justin Vidovic's teaching, when I put some of the key concepts I held at its start in dialogue with some of Justin's. To illustrate, I explain how one of Justin's central beliefs challenged some of mine. Having read recent critiques of critical pedagogy (e.g., Durst, 1999; Smith, 1997; Trainor, 2002) at the time I began the study, I started my observations of Justin's class with concerns about this pedagogy but a deep commitment to its goals of working toward social justice and greater socioeconomic equity. I particularly believed in trying to find ways to promote such change through my professional life as a teacher and researcher. I chose to study Justin's classes because I knew of his commitment to progressive political change and of his reputation in our department as an outstanding teacher who engaged students, rather than prompting their resistance. I wanted to learn whether and how he pursued a progressive political agenda in classes that so clearly won students' participation.

Although my fieldnotes on both of the semesters I observed Justin's teaching show that he raised relevant sociopolitical issues for discussion, they also clearly show a teacher primarily committed to airing a range of positions on each issue under consideration and, most of all, to helping students develop and pursue the implications of their own ideas. In interviews and many informal conversations with Justin, I learned that he was in the process of dedicating himself to leading a creatively and artistically engaged life, and that for him this goal was subsuming and transforming his understanding of political change. He explained that his developing artistic life as an actor, playwright, director, and writer led him to believe that prioritizing efforts to promote social change over one's creative, personal, and spiritual goals could in fact promote dysfunctional interpersonal dynamics and relationships that, in turn, maintain systems of political and economic inequity. For years, I had believed in the immense potential of art to inspire personal and social change, but Justin's conception of how artistic engagement encourages such change challenged my earlier beliefs. I had presumed such art needed to embody progressive values. In contrast, Justin contended that art's potential to foster social change lay not in its progressive message but in its ability to engage people holistically in self-revision. In his view, even art conveying a socially problematic message, such as patriarchal or classist tenets, might still engage those involved in its creation and appreciation in progressive forms of change.

In coding my data on Justin's classes, I worked to negotiate my earlier beliefs with his evolving ideas about art and social change. On one hand, I continued to believe that, for me, integrating work toward social justice into my professional life, including my teaching, is an important part of my commitment to pursuing my fundamental values through my work. That belief certainly informed my

process of coding study data, and thus my analysis of the literate practices embedded in Justin's teaching. At the same time, while coding and while developing my analysis, I consciously considered the data through the lenses of Justin's belief that encouraging personal change through artistic and creative engagement is a crucial way of promoting social change. I examined fieldnotes, assignments, and student texts in light of Justin's belief that such engagement spurs transformations in one's relationships with oneself, others, and one's various communities in ways that promote progressive social values. Thus, I developed my interpretations of the study data from this negotiation between Justin's and my concepts, as those relate to the topics raised in the data. In the process, my understanding of how best to pursue social change through my own teaching and research also shifted to incorporate Justin's beliefs. Furthermore, I constructed an analysis of the literate practices embedded in his teaching in a more fundamentally dialogic way by using theoretical lenses that integrated his key concepts with my own. Thus, I undertook the type of reciprocity associated with the experiential approach's methods.

But I also sought to construct the type of reciprocity Cushman (1996, 1999) recommends in my relationship with Justin, as I have in earlier research studies. In working with Justin, I shared my fieldnotes and coding in hopes that those would be helpful as he drafted and coded his own fieldnotes in the process of writing a dissertation on the spiritual dimensions of his teaching. Although his study draws extensively on his independently drafted notes and coding, it taps mine at some points, as well. I have asked for Justin's feedback on drafts of all publications based on my study of his teaching and have revised depictions each time he has asked (or even suggested) that I do so.

In an earlier study of literate practices used in a project of Pittsburgh's Community Literacy Center (CLC), I worked with my research participants and colleagues there to develop and administer the project I studied. I sought to enact reciprocity in my commitment to the project. I also requested my participants'/ colleagues' feedback on drafts of dissertation chapters I wrote based on the study. Although they graciously read the work and met with me to respond to it, I had the sense during and after the meeting that their polite responses smoothed over the fact that, rather than offering them a voice in a depiction that was meaningful to them, I had asked for yet more of their time and energy for a project that was of concern primarily to me, rather than to them. They suggested no substantive changes. While in that study I followed the methodological recommendations for constructing a dialogic text, I do not believe those recommendations produced meaningful dialogue. Thus, although these recommendations are valuable and I believe do generate dialogic relationships in some cases, in other cases—for instance, my studies of Nhat Hanh's and the CLC's literate practices— alternative methods are needed.

I argue that the experiential approach's methods offer such alternatives, both of which promote the underlying goals of reciprocity. As I understand literacy scholars' arguments for reciprocity, as enacted both through dialogic and reflex-

ive methods, the goals of reciprocity involve epistemological validity and socially just relationships. Although I support traditional approaches to reciprocity and believe they are effective in many cases, I also believe that ultimately the most effective means to understanding the other and constructing more just relationships entails a perceptual shift. Accomplishing it requires the kind of holistic change undertaken in learning new literate practices, that is, the kind of change that revises one's attitudes, perceptions, and behaviors as one internalizes new values. Accepting the risk to one's sense of identity associated with such change reciprocates, in a deep way, the equivalent risk assumed by all learners who hail from marginalized groups and seek to learn dominant literate practices. The experiential approach's methods augment this change process. In it, the researcher internalizes key elements of the other's worldview, and in doing so he inevitably takes a path of revised actions more likely to promote that other's well-being. I believe this kind of change supports the deepest goals of reciprocity.

ENDNOTES

1. In addition to presenting Paul's interview responses to demonstrate this identification, Trainor (2002) also quotes from comments he made during four different class discussions of texts that depict the oppression of minorities.
2. Socioeconomic backgrounds of the immigrant students vary.
3. As Peter Smagorinsky (1997) shows, when research methods tap such features, they can offer particularly generative insights into literate practices. In his study of a high school senior's composing processes, Smagorinsky used think-aloud protocols in which Doug, the research participant, audiotaped reflections on his drafting process and its significance for him. Based on 68 pages of transcripts, Smagorinsky examines two important aspects of writing that sometimes appear to have conflicting goals, namely, its designative and expressive functions. The former focuses on finished public speech whose purpose is "to represent meaning in an artifactual form that allows for mediation by either the speaker or other people" (p. 68). In contrast, the latter focuses on the composing process, whose purpose is "to mediate the thinking of the speaker," serving as a "tool that enables one to experience changes in consciousness through the articulation of fluid, condensed thinking in the form of the linguistic signs it produces" (p. 68). Noting that these two functions are each tied to competing traditions of scholarship on composing, Smagorinsky argues that the two are actually complementary (p. 76).

 Furthermore, he shows that Doug used the think-aloud protocol both to develop his own perspective and to more effectively communicate his experience to others (p. 34). Thus the research method itself, as a means of data collection that enacts the literate practice of reflecting on one's writing, encouraged Doug to use both functions of writing in conjunction with one another. In doing so, it tapped the potential of literate practices to modify a learner's perspective through inherently dialogic means.

4. Justin and the students in the study agreed to participate in a research protocol approved by our university's Human Investigation Committee. Justin chose to use his real name in publications based on the study.

5. Although think-aloud protocols may offer more spontaneity in recording than do fieldnotes, I believe fieldnotes offer a more developed, structured form of data because they are written. Over 4 months of data collection, Doug, Smagorinsky's (1997) research subject, generated think-aloud protocols that produced 68 transcript pages. Over 4 months of data collection, I generated more than 260 typed, single-spaced pages of fieldnotes in the study of my efforts to learn Nhat Hanh's literate practices.

REFERENCES

Ball, A.F. (2006). Teaching writing in culturally diverse classrooms. In C.A. MacArthur, S. Graham, & J. Fitzgerald (Eds.), *Handbook of writing research* (pp. 293-310). New York: Guilford.

Blakeslee, A.M., Cole, C.M., & Conefrey, T. (1996). Constructing voices in writing research: Developing participatory approaches to situated inquiry. In P. Mortensen & G.E. Kirsch (Eds.), *Ethics and representation in qualitative studies of literacy* (pp. 134-153). Urbana, IL: NCTE.

Brandt, D. (2001). *Literacy in American lives.* Cambridge: Cambridge University Press.

Burton, V.T. (2001). John Wesley and the liberty to speak: The rhetorical and literacy practices of early Methodism. *College Composition and Communication, 53,* 65-91.

Chiseri-Strater, E. (1996). Turning in upon ourselves: Positionality, subjectivity, and reflexivity in case study and ethnographic research. In P. Mortensen & G.E. Kirsch (Eds.), *Ethics and representation in qualitative studies of literacy* (pp. 115-133). Urbana, IL: NCTE.

Cushman, E. (1996). The rhetorician as an agent of social change. *College Composition and Communication, 47,* 7-28.

Cushman, E. (1999). The public intellectual, service learning, and activist research. *College English, 61,* 328-336.

Daniell, B. (2003). *A communion of friendship: Literacy, spiritual practice, and women in recovery.* Carbondale: Southern Illinois University Press.

Durst, R.K. (1999). *Collision course: Conflict, negotiation, and learning in college composition.* Urbana, IL: NCTE.

Emerson, R.M., Fretz, R.I., & Shaw, L.L. (1995). *Writing ethnographic fieldnotes.* Chicago: University of Chicago Press.

Gee, J.P. (2008). *Social linguistics and literacies: Ideology in discourses* (3rd ed.). London: Routledge.

Heath, S.B. (1983). *Ways with words: Language, life, and work in communities and classrooms.* Cambridge: Cambridge University Press.

Herrington, A.J., & Curtis, M. (2000). *Persons in process: Four stories of writing and personal development in college.* Urbana, IL: NCTE.

Hidi, S., & Boscolo, P. (2006). Motivation and writing. In C.A. MacArthur, S. Graham, & J. Fitzgerald (Eds.), *Handbook of writing research* (pp. 144-157). New York: Guilford.

Lindquist, J. (2004). Class affects, classroom affectations: Working through the paradoxes of strategic empathy. *College English, 67*, 187-209.

Mahiri, J. (1998). *Shooting for excellence: African American and youth culture in new century schools.* Urbana, IL: NCTE.

McCarthy, L.P., & Fishman, S.M. (1996). A text for many voices: Representing diversity in reports of naturalistic research. In P. Mortensen & G.E. Kirsch (Eds.), *Ethics and representation in qualitative studies of literacy* (pp. 155-175). Urbana, IL: NCTE.

Pajares, F., & Valiante, G. (2006). Self-efficacy beliefs and motivation in writing development. In C.A. MacArthur, S. Graham, & J. Fitzgerald (Eds.), *Handbook of writing research* (pp. 158-170). New York: Guilford.

Scribner, S., & Cole, M. (2001). Unpackaging literacy. In E. Cushman, E.R. Kintgen, B.M. Kroll, & M. Rose (Eds.), *Literacy: A critical sourcebook* (pp. 123-137). Boston, MA: Bedford. (Original work published 1981)

Seitz, D. (2004). *Who can afford critical consciousness? Practicing a pedagogy of humility.* Cresskill, NJ: Hampton Press.

Smagorinsky, P. (1997). Personal growth in social context: A high school senior's search for meaning in and through writing. *Written Communication, 14*, 63-106.

Smith, J. (1997). Students' goals, gatekeeping, and some questions of ethics. *College English, 59*, 299-320.

Street, B. (2001). The new literacy studies. In E. Cushman, E.R. Kintgen, B.M. Kroll, & M. Rose (Eds.), *Literacy: A critical sourcebook* (pp. 430-442). Boston, MA: Bedford. (Original work published 1993)

Sullivan, P.A. (1996). Ethnography and the problem of the "Other." In P. Mortensen & G.E. Kirsch (Eds.), *Ethics and representation in qualitative studies of literacy* (pp. 97-114). Urbana, IL: NCTE.

Sunstein, B.S. (1996). Culture on the page: Experience, rhetoric and aesthetics in ethnographic writing. In P. Mortensen & G.E. Kirsch (Eds.), *Ethics and representation in qualitative studies of literacy* (pp. 177-201). Urbana, IL: NCTE.

Trainor, J.S. (2002). Critical pedagogy's "Other": Constructions of whiteness in education for social change. *College Composition and Communication, 53*, 631-650.

18

NARRATIVE AS METHOD AND METHODOLOGY IN SOCIALLY PROGRESSIVE RESEARCH

Joanne Addison

My partner and I have been foster parents for 4 years. Our role has always been described to us as one of keeping children safe and providing a stable, predictable, and loving environment while social services works with family members to determine if the child can return home. Children return home once a biological parent(s) has proven to be "minimally competent." Although it seems to us children who have been neglected and abused deserve more than minimal competence, a legal system that still treats children as property allows the standard of minimal competence to thrive. We are told by very smart and dedicated caseworkers that the respite provided in our home will make a difference for these children. It is a story they must tell and we must believe.

Actually, the injuries were more severe than reported in the local press but that is not my story to tell.

The story that I can tell is how I came to narrative inquiry as a socially progressive research method. My goal is not to present the results of an empirical study. Rather, following the lead of Sandra Harding (2006) and others, my goal is to show the ways in which starting research from the daily life of one of those "who have benefited least from the advance of modernity's so called social progress" alters this endeavor. (p. xx). Although certainly connected to my academic endeavors as a literacy researcher this story is rooted in my life as a foster parent. Because one day, as I sat with an 8-month-old in my lap, his therapist said to me: "You must help him create a new narrative for his life."

Longmont Times-Call
Publish Date: 12/14/2007

Baby's life likely saved by neighbors

— An alert housing manager might have saved an 8-month-old baby's life when he reported the infant's visible injuries to officials last month, according to Longmont Police Cmdr. Craig Earhart. ...

"If that didn't happen, we believe the child would have been killed eventually," Earhart said.

The baby is now in foster care.

... doctors found he had an untreated broken leg, three skull fractures, several broken ribs and multiple bruises ...

[the officer] also described six dime- to quarter-size bruises on his forehead and a circular bruise on his left cheek that extended around the corner of his lip and onto his chin. The baby's "upper lip was covered with bleeding sores," according to the warrant affidavit.

He had a cut on his left ear with "deep purple bruising on the top and inside the ear." His hands and wrists were bruised and he had marks on his back and side.

A bite mark was found on the baby's shoulder, the affidavit said ...

FIG. 18.1. *Longmont Times-Call 1*

WHAT IS NARRATIVE?

In its most basic form narrative is a sequenced telling of events. Aristotle's understanding of narrative as a dramatic art that forefronts plot followed by character and then thought and language has been a controlling definition for centuries. According to this definition, plot constitutes action, which springs from characters and thoughts. Language itself is not considered an action but rather more of a dressing. It is with the influence of linguistic analysis in the 1960s that narrative takes a turn toward the social sciences, opening the door to narrative inquiry as an empirical method.

Several histories of narrative inquiry as an interdisciplinary field begin with the definitions of narrative found in work of sociolinguists in the late 1960s and early 1970s. Of particular note is work by William Labov and Joshua Waletzky. In 1967, Labov and Waletzky wrote "Narrative Analysis: Oral Versions of Personal Experience." Here they argue that if our understanding of narrative and narrative analysis is to progress in systematic and substantive ways then we need to take at least a momentary turn away from "the products of expert storytellers," as in literary analysis, and toward the original narratives of personal experience. In considering the possibilities of narrative inquiry as a socially progressive

research method it is important to keep in mind that an explicit purpose of this early research was to counter the "deficit theory of educational psychologists who see the language of black children as inadequate for learning and logical thinking" (Labov & Waletzky, 1972, p. xvi). It might be argued that narrative inquiry as practiced in the social sciences arose from a need for the very types of socially progressive research methods that can provide systematic and rigorous challenges to destructive cultural assumptions.

For Labov and Waletzky, narrative is a specific way of reporting and understanding past events. In "Narrative Analysis: Oral Versions of Personal Experience," Labov and Waletzky use 14 illustrative examples from among the 600 interviews they gathered in relation to four distinct linguistic studies. Their analysis operates on both formal and functional levels. It suggests that all narratives have up to five basic structural components: orientation, complication, evaluation, resolution, and coda (see Table 18.1).

TABLE 18.1. Five Basic Structural Components of Narrative

Orientation	Contextualizing features that orient receiver in terms of time, place, participants, and/or behavioral situation
Complication	Event(s) constituting the main body of the narrative that are regularly terminated by a result
Evaluation	Significance accorded events as narrator reveals the relative importance of narrative units on various levels
Resolution	Often the end of the narrative, immediately following the evaluation
Coda	At times the narrator will bring the receiver back to the present moment

In more recent work, Labov (2006) expands on this definition claiming that "the very concept of narrative demands that we recognize as an essential first step the decision to report an event, and the entailment that it is judged to be reportable" (p. 2). It is the "entailment" that interests me the most from the perspective of socially progressive research. For example, it is a rather recent development that domestic violence constitutes a reportable event. And, what of those who are unable to report, due to a lack of access, disability, or, in my foster son's case, his status as a preverbal being? Here, the entailment requires some other to determine that an event is reportable.

Labov (2006) takes us even further, asking us to consider narrative preconstruction:

The concept of narrative pre-construction lays the foundation for further inquiry into how narrative events are stored in memory and accessed by the narrator, how the narrator makes selection from that storage, and how that selection is rearranged to transform the normative significance and evaluation of the events in the interests of the narrator. (p. 38)

Longmont Times-Call
Publish Date: 12/14/2007

Baby's life likely saved by neighbors

... [The stepfather] told police the baby, who was 8 months old when officials removed him from the home, was mobile and injuring himself on toys. However, [he] also told officers he fell down the stairs multiple times while holding the baby and had dropped the baby while giving him a bath. [He] told officers the child hit his head on the faucet in the fall, the affidavit said.

According to the warrant, neighbors knocked on the door on Nov. 20 when the baby's cries were particularly bad, but no one answered. The next day, the manager confronted [him] when he ran into the family outside and saw the baby's bruises.

According to the warrant, the baby began suffering injuries when his 14-year-old sister stopped watching him to concentrate more on school and [the stepfather] began watching the baby.

The infant's 33-year-old mother told police she does not believe [the stepfather] abused the baby.

FIG. 18.2. *Longmont Times-Call 2*

Labov provides his own example of narrative preconstruction via a 1997 scholarly personal narrative titled "How I Got into Linguistics, and What I Got Out of It," for a publication directed at undergraduates. Toward the end of this narrative Labov asserts: "I myself have always felt that theory can only be justified if it fits the facts, and that some facts—the ones that affect people's life chances—are more important than others" (p. 4). It is this evaluation, or determination of significance, of his own narrative of being a linguist that continues to draw so many practitioners of narrative inquiry to Labov's work.

Within Labov and Waletzky's framework we might locate a number of different types of narratives, perhaps most notably identity narratives. Certainly Labov's scholarly narrative would fall into this category. At the heart of identity narratives is not a process of description or even drama per se (a la Kenneth Burke). Rather, these narratives are rooted in a recursive process of becoming, where the orientation and complication may change while the evaluation increases in complexity and the resolution may, or may not, differ through time. It is here that I struggle as an academic and a foster parent—how do I help this child,

this baby, construct a new narrative? One that does not erase the orienting features but that interrupts the recursive process of becoming, the complication, in ways that lead to progressive evaluation and positive resolution? Furthermore, how does this work as a foster parent inform my academic work? In what ways, and at what moments, might it be important that I insert myself into this text in order to understand it, challenge it, and share it with others in ways that make my signifying practices and their effects apparent?

NARRATIVE INQUIRY, CASE STUDY RESEARCH, AND PERSONAL SCHOLARLY NARRATIVES

By now it is clear that I have framed this chapter within my own scholarly personal narrative, or perhaps within the intersection of a scholarly personal narrative and the narrative(s) being constructed for my foster son. How might a scholarly personal narrative differ from, say, an autobiography that, in and of itself, is not an example of narrative inquiry? Furthermore, why should those who engage in narrative inquiry also, at times, engage in scholarly personal narrative writing in pursuit of socially progressive research?

I distinguish narrative inquiry as an interdisciplinary field of study from narrative analysis as not all narrative analysis is necessarily narrative inquiry. Although narrative inquiry is a field diverse in method and methodology there are certainly defining features that provide field-specific coherence. From the perspective of empirical research I am not concerned with texts such as an individual autobiography as narrative inquiry into one's own life. Rather, I am concerned with systematic study, largely rooted in case-study methods including narrative as one type of data, that may start with an individual (single case) but must go beyond the individual for validity as it leads to broader categories of lived experience. In its most basic form, narrative inquiry refers to the empirical practice of narrative analysis within the human sciences, notably psychology, linguistics, anthropology, sociology, and related disciplines.

This definition of narrative inquiry is useful for literacy researchers if we follow the lead of Louise Weatherbee Phelps (1988) in *Composition as a Human Science*. Phelps positions literacy studies as a human science as a way for our field to develop as we more fully engage in interdisciplinary dialogue about language studies. Like Labov and Waletsky, Phelps approaches her field from a contextual account because such accounts:

> are powerful not only in themselves, as exciting and generative for teaching practice, but in their affinities and connections with the work of other fields. The effort to relate language, cognition, writing, and rhetoric in terms of a contextualist framework finds its echo in every human science, especially of

course those of language, literature, psychology, and social practices, but also in history, critical theory, philosophy, and many others. For the first time, and not altogether self-consciously at present, composition finds itself in the mainstream of intellectual thought, contributing its own perspective to theoretical and empirical inquires of far-reaching import. Not only is it exploiting ideas from these fields … but it is beginning to draw such figures into dialogue with rhetoric and composition. [This] link[s] composition to the more fundamental task being pursued across the disciplines, namely, to evaluate and balance interpretive (natural or contextualized) approaches with critical and objectivist understandings of human life and experience. (p. 115)

Narrative inquiry is an important contextual method insofar as it insists that the context in which any given phenomenon occurs is equal to the phenomenon itself at the point of evaluation. Perhaps one of the most useful frameworks for narrative inquiry in literacy research is case-study research. Case-study research is useful both because it is a method that has been developed specifically to understand complex social phenomenon such as literacy and it is a method already widely in use among literacy researchers.

In pairing narrative inquiry and case-study research design, I am arguing that in order for narrative inquiry to be useful we must be able to explain the ways in which it fosters systematic and rigorous analysis that can lead to social change. One way to do this is to insist on multiple data points. That is, although in narrative-based case-study research the narrative may be primary, it must be interpreted in light of at least two other data sources. Indeed, if the narrative of my foster son's parents was the only data relied on by the police to explain his bruises it is quite possible he would not be alive today. It is not narrative in and of itself that can lead to socially progressive research but rather narrative as its entailments are complicated and reoriented via other data that can lead to socially progressive research.

Robert Yin (1994) states that case study research relies on one or more of the six following types of data that are analyzed using qualitative and/or quantitative approaches:

- Documents
- Archival records
- Interviews
- Direct observation
- Participant-observation
- Physical artifacts

In considering narrative-based case-study research, the narrative forming the basis for inquiry could be an archival record, a recently published document, or, adding a seventh type of data, a newly constructed personal narrative in response to the social phenomenon under study.

At times, as researchers we may want to write ourselves into a research report. This is not simply a means of personalizing our writing but can also be a way to obtain the "strong objectivity" argued for by Harding and others. For example, in *Liberating Scholarly Writing: The Power of Personal Narrative*, Robert Nash (2004) lays out his arguments for why it is important for scholars to bring their critical habits of mind to personal narratives and why they should teach others to do the same. For Nash, "scholarly personal narrative writing is the unabased, up-front admission that your 'own life signifies,' in the words of [Vivian] Gornick" (pp. 23-24). His arguments are a good jumping off point for empirical researchers to consider as *one* way to address often raised issues of subjectivity, representation, and empirical/narrative gaze when discussing socially progressive research methods. Although it is beyond the scope of this chapter to address the multiple issues related to subjectivity, representation, and gaze I do want to suggest that, at times, empirical researchers must do more than reveal (often in the form of a disclaimer) the situated nature of their research and the ways in which they are socially positioned in relation to that research. Instead, we can reliably claim the signified and signifying nature of our lives as they bear on our research in ways that meet the call for "strong objectivity" set forth by Harding and others.

Harding and others call for objective accounts of the world that acknowledge conceptual biases and apply research methods that not only reveal the various standpoints we inhabit but that also show how these standpoints bear on our research as well as the research of others. This move is often referred to as "strong objectivity." "Strong objectivity asks us to take a critical look at the conceptual schemes, the frameworks, that comprise our social location" (Harding, cited in Hirsch & Olsen, 1995, p. 18).

As I have discussed elsewhere, questions of objectivity are primarily questions of method or the techniques we use to gather data. Dorothy Smith and Sandra Harding advocate a broadly conceived notion of method, one that might include the following considerations:

- Why are certain phenomenon selected for research and not others?
- What are the multiple locations from which the researcher(s) approaches the phenomenon?
- What are the multiple locations from which the "subject" experiences the phenomenon?
- What aspects of the phenomenon are made accessible via this method?
- What aspects of the phenomenon remain inaccessible via this method?
- What theoretical and practical norms govern the researcher's discipline and how might these constructs bias the research?

- How might the researcher's position of dominance bias the research at the same time that it calls her into a position of critical advocacy for others?
- How might this research be disseminated within the academic community and beyond?

From this position it is not enough to simply acknowledge one's position in relation to the research participants, leaving the audience the work of critical analysis. Instead it is the researcher's job to critically analyze his or her position in relation to the research participants in an effort to establish strong objectivity (Addison, 2010). This requires more than disclaimers about one's position in the world. Case-based narrative inquiry allows for the evaluation of one's position in relation to the study of a particular phenomenon through a critical interweaving of personal experience, perhaps even as a single case in a multiple case study.

In *Liberating Scholarly Writing* Nash (2004) suggests 10 tentative guidelines for writing scholarly personal narratives. Although Nash does not have in mind the empirical project with which this chapter is concerned, his guidelines are still useful to keep in mind at times when we do write ourselves into our research and can actually work as strategies for obtaining strong objectivity:

- Establish clear constructs, hooks, and questions.
- Move from the particular to the general and back again ... often.
- Try to draw larger implications from your personal stories.
- Draw from your vast store of formal background knowledge.
- Always try to tell a good story.
- Show some passion (or stand for something).
- Tell your story in an open-ended way.
- Remember that writing is both a craft and an art.
- Use citations whenever appropriate.
- Love and respect eloquent language.

Nash's guidelines seem particularly well suited to forwarding the efforts of socially progressive research because of the ways in which they can help identify the multiple locations from which the researcher(s) and subject(s) approach a phenomenon, explain researcher bias and critical advocacy, and result in wider distribution of results in the academic community and beyond. All three of these components are important aspects of socially progressive research.

Case-based narrative inquiry can lead to socially progressive research not only because it can lead us to newly reportable events but also because it can lead to different evaluations of existing complications within a narrative especially when prevailing evaluations are rooted in cultural norms and assumptions, not facts. Other recent examples also can be found in evolutionary biology. As explained by Judy Stamps (1998), a behavioral ecologist at University of California Davis, cultural norms often motivate the preconstruction of scientific narratives:

For instance, scientists have tended to study species that fit their perceptions of how things should work. Then, when they observe the animals, they often see what they expected to see. An example of this is primate research. The first species people studied were the ones in which males were fighting, females were scrapping with each other; it was sex and fighting all over the place. Most people didn't go out to look at the most boring primates they could find, the ones who sat around peaceable, with one occasionally looking askance at another, who in turn moved away, and that was it for two weeks in terms of aggressive interactions. So all the studies that came out for awhile stressed the importance of dominance. It's because we selected species that reflected what we thought was interesting.

Of course, these species were deemed interesting because they allow for an easy reconciliation of evaluations of narratives that reinscribe traditional lines of dominance in our culture.

NARRATIVE INQUIRY AND LITERACY STUDIES

Clandinin and Rosiek (2007) assert that "the most defining feature of narrative inquiry … is the study of experience as it has been lived" (p. 69). Relatively little research that might broadly be categorized as literacy research concerns literacy as it has been lived.

In *Literacy in American Lives*, Deborah Brandt (2001) states:

> Only recently have we begun to accumulate more systematic and direct accounts of contemporary literacy as it has been experienced. Nevertheless, many current debates about literacy education and policy continue to be based largely on indirect evidence, such as standardized tests scores or education levels or surveys of reading habits. (p. 11)

In this research, Brandt calls for direct accounts of literacy and explains that the purpose of her research is to describe literacy as it has been lived within certain cultural, historical, and socioeconomic moments in time. In obtaining direct accounts Brandt gathered the life histories of 80 participants to "understand the vicissitudes of individual literacy development in relationship to the large-scale economic forces that set the routes and determine the worldly worth of that literacy" (p. 18). Brandt's research is clearly phenomenological in nature and framed by a case study research design. The interviews are analyzed in relation to historical records concerning economic conditions that bear upon each participant.

If we take this a step further following Ricouer (1981), case-based narrative inquiry is an important way to study discourse from a situated perspective espe-

cially if we view narrative as a process of becoming shared by researcher and participant. As Ricouer argues:

> what we understand first in a discourse is not another person, but a project, that is, the outline of a new being-in-the-world. Only writing, in freeing itself, not only from its author, but from the narrowness of the dialogical situation, reveals this destination of discourse as projecting a world. (p. 202)

If we view discourse as projecting a world and writing as an artifact of discourse, then understanding literacy as it is variously situated in the world may require narrative inquiry. In the end, the goal of narrative inquiry is to create friction. Friction is little more than the movement of one body in relation to another. We are all always in a state of friction as the worlds we project slide, scrape and bump along each other. Perhaps what is socially progressive about narrative inquiry is not only that it results in friction but that it calls for us to stop and determine the degree and source of the friction. Importantly the goal is not to eliminate the friction, but rather to find ways to harness the strength of friction to move us all forward. As for my foster son, the narrative we create for him can never erase his preexisting narrative, but hopefully it can reach a point of friction that propels him forward.

REFERENCES

Addison, J. (2010). Understanding literacy as lived experience: Feminist standpoint theory, strong objectivity, and experience sampling methods. In E. Schell & K. Rawson (Eds.), *Rhetorica in motion* (pp. 136-151). Pittsburgh: University of Pittsburgh Press.

Brandt, D. (2001). *Literacy in American lives.* Cambridge: Cambridge University Press.

Clandinin, D.J., & Rosiek, J.(2007). Mapping a landscape of narrative inquiry: Borderland spaces and tensions. In D. Clandinin (Ed.), *Handbook of narrative inquiry* (pp. 35-76). Thousand Oaks, CA: Sage.

Harding, S. (2006). *Science and social inequality: Feminist and postcolonial issues.* Chicago: University of Illinois Press.

Hirsch, E., & Olson, G. (1995). Starting from marginalized lives: A conversation with Sandra Harding. *JAC: A Journal of Composition Theory, 15*(2), 193-225.

Labov, W. (1972). *Language in the inner city: Studies in the Black English vernacular.* Philadelphia: University of Pennsylvania Press.

Labov, W. (1997). How I got into linguistics, and what I got out of it. Retrieved from http://www.ling.upeen.edu/~wlabov/Howlgot.html.

Labov, W. (2006). Narrative pre-construction. *Narrative Inquiry, 16*(1), 37-45.

Labov, W., & Waletzky, J. (1972). Narrative analysis: Oral versions of personal experience. In J. Helm (Ed.), *Essays on verbal and visual arts: Proceedings of the 1966 annual spring meeting of the American Ethnological Society* (pp. 12-44). Seattle: University of Washington.

Nash, R. (2004). *Liberating scholarly writing: The power of personal narrative*. New York: Teachers College Press.

Phelps, L.W. (1988). *Composition as a human science*. New York: Oxford University Press.

Ricouer, P. (1981). *Hermeneutics and the human sciences: Essays on language, action and interpretation* (J.B. Thompson, Ed. & Trans.). Cambridge: Cambridge University Press.

Stamps, J. (1998). Feminism prompts new perspective in biology. *UC Davis Biological Sciences Newsletter.* Spring 1998. Retrieved from http://biosci.ucdavis.edu/alumni/newsletter/spring98/feminism.html.

Yin, R. (1994). *Case study research: Design and methods* (2nd ed.). Thousand Oaks, CA: Sage.

19

TRANSNATIONAL LITERATE LIVES

An Emerging Research Methodology for a Globalized World

Cynthia L. Selfe and Gail E. Hawisher

with Patrick W. Berry, Shafinaz Ahmed, Vanessa Rouillon, Gorjana Kisa, and Mirza Nurkic

> The global turn necessitates new collaborations and frameworks, broader notions of composing practices, critical literacies that are linked to global citizenship, a reexamination of existing protocols and divisions and the formation of new critical frameworks in the light of a changing world.
> —Hesford (2006, p. 796)

> Ethnographic practices ... need to consider how the classroom is a location that connects to other locations, locations that subjects constantly inhabit, dwell in, and move between.
> —Keller (2004, p. 210)

Learning to live gracefully in a globalized world and to understand its cultural, linguistic, and communicative complexities is not a task to be underestimated and not one for which those of us in the United States have historically been recognized. Nor, might we add, have those of us in the field of rhetoric and composition always been up to the task of carrying out research studies that, as Wendy Hesford (2006) points out, "[pay] particular attention to the methodological challenges we face as we turn toward the global" (p. 788) or taken into consideration how, as Hesford suggests in the epigraph, literacies connect up with responsibilities of a global citizenship. Yet as we interact daily with students and colleagues from around the world, many of us have come to realize, at some level, that our current lifeworlds and futures are intimately connected to the lifeworlds and futures of people in places as far flung as Australia, Norway, China, India, and parts of Africa, and on dimensions that extend far beyond the limits of the world market. It is for these reasons that we have begun to focus our

research on the life histories and digital literacies of transnational students, attempting to take into account the local perspectives of students themselves and the larger landscape of the complex processes of globalization.

With this term transnational,[1] we hope to signify a growing group of students who are at home in more than one culture and whose identities, as Wan Shun Eva Lam (2004) notes, are "spread over multiple geographic territories" (p. 79). These students typically speak multiple languages, often including variations of World Englishes; and maintain rich, active networks of friends, family members, and contacts around the globe. Often, transnational students, alone or with their families, "move physically, economically, and emotionally back and forth across borders and between cultures" (Martinez-Leon & Patrick, 2003, p. 138), frequently using their "multiple subject positions situated in various cultural and sociopolitical arenas to subvert the social categories imposed on them by any one system" (Lam, 2004, p. 81). Some—but not all—of these students are part of diasporic movements motivated by wars in their homelands; some migrate and travel along the economic vectors of globalization; and others move across conventional geopolitical borders because they seek educations abroad and, in the process, develop new literate practices marked by their latest cultural experiences. And, not surprisingly perhaps, all the transnational students with whom we have worked have been touched irrevocably by what Alex MacGillivray (2006) calls the "tools of globalization" (p. 14), that is, the Internet, mobile phones, email, instant messaging, Skype, and an array of digital media that populates their every day lives.

RESEARCH METHODOLOGIES IN AND OUT OF THE CLASSROOM

In this chapter, we demonstrate an emerging research approach that recognizes issues of globalization while, at the same time, makes use of digital tools to capture literate practices as represented to us by transnational students. In doing so, we sometimes employ digital media as research tools for collecting and exhibiting life-history interviews while, at other times, we ask students to represent their literate practices by videoing their writing processes themselves. In our earlier research, we had conducted life-history interviews either face-to-face with participants or had asked them to complete online an interview protocol to which they contributed written responses. Usually reports of the research took the form of first talking through the research with participants, writing it up, eliciting their responses, and then presenting in print an analysis and interpretation of the interviews, given the historical, cultural, economic, political, and ideological factors at the time. As Mary Queen (2008) suggests, we sought through our research "to make visible the ways in which all of our knowledge is mediated—techno-

logically, historically, geopolitically, culturally" but were perhaps less successful in demonstrating how such knowledge can be changed simultaneously "by our encounters with others, *down the block and across the globe*" (Queen, 2008, p. 486, italics added). In many ways, our current research is similar to the earlier research, but here we take into our field of vision those who have crossed national borders, with our focus turned toward local and global influences. We also depart from our customary research format in that this study is available through video clips of participant life-history interviews, as well as through video clips that the students themselves made to represent their writing processes.

In this endeavor, we have been helped by the advice we received in 2004 when we had an opportunity to present our initial life history and digital literacies research at the University of Oslo. After discussing our research, the audience offered comments that encouraged us to rethink the ways in which we worked with participants and that touched the very presentation of the research itself. Synne Skjulstad, then a graduate student and research fellow at the University of Oslo, asked us why we did not present our research on the Web itself? Why did we not make more use of images and especially moving images or video clips in doing and showing our research? Why did we not, in other words, step forward into the 21st century with our research? She was, of course, much too polite to make that last observation, but we understood her implication and began to think seriously about how digital research tools might serve a methodology that was also informed by a socially progressive feminist agenda.

In *Literate Lives* (Selfe & Hawisher, 2004), we attempted to put forward a feminist research agenda through a methodology that sought ways to demonstrate the active agency of the participants with whom we worked. We asked, for example, all of the participants to co-author their chapter with us. We were influenced in this decision by Caroline Brettell's (1993) collection *When They Read What We Write*, which presents a series of perspectives on studies like ours—anthropological projects, ethnographies, and life histories—and talks about the ways in which modernist approaches to such writing has often suffered from the limited perspectives of academics and professional scholars. As Alexandra Jaffe (1993) points out in the same collection, such an approach to research claims a "distance between observer and observed" that is, to a great extent, an "ethnographic fiction," one that scholars have employed to "maintain control over ... 'subjects'" (p. 51). As a corrective to this modernist approach, Brettell and others in her collection suggest the alternative method of having subjects "talk back" (p. 9), comment on, modify, change, correct scholars' interpretations of what they said. Talking back, as Jaffe goes on to say, helps to "undermine" professional ethnographers' "ability to construct an unproblematic other, and hence, an unproblematic self" (p. 52). In our experience, the reflexivity established by this dialogue is not only a positive and productive characteristic of postmodern anthropology, but, as Jaffe points out, a realistic and "essential condition of interaction with the people we study" (p. 51).

Throughout the research presented here, we have also attempted to heed Nedra Reynolds' (2004) contention that "places are hugely important to learning processes and to acts of writing because the kinds of spaces we occupy determine, to some extent, the kinds of work we can do or the types of artifacts we can create" (p. 157). We would add that they are equally important to the kinds of research in which we can participate. And we have attended as well to Christopher Keller's (2004) admonition, as expressed in the epigraph opening this chapter, on the importance of connecting classrooms to other crucial locations in research participants' lives. Thus, we have sought through a variety of what we consider socially responsible approaches to understand the digital literacy practices of transnational students in and out of school and in various spaces that mark their literate activity.

We note up front that the digital interviews with some of the students were collected on the grounds of the University of New South Wales in Sydney, Australia, in classroom spaces and with cameras that the students themselves provided for us. Although the interviewed Australian undergraduates were not our students—indeed, they were student organizers at a conference we were attending—the second group of students, those who videotaped the representations of their own writing processes, were actually graduate students in classes that one of us taught at the University of Illinois. As in our earlier digital literacy studies (e.g., Hawisher, Selfe, Coffield, & El-Wakil, 2007; Hawisher, Selfe, Guo, & Liu, 2006; Selfe & Hawisher, 2004; Selfe, Hawisher, Lashore, & Song, 2006), each of the individuals in our current study has participated as a co-author. In seeking to demonstrate the active agency of those with whom we work, we believe that co-authorship in this study also can enhance collaborative efforts to understand the world of literacy. Our overarching methodological goal, as Laurel Richardson (2000) says so well, is to develop ways of researching that "support our writing and develop a care for the self" (p. 153), while at the same time honoring "the ethical subject's relation to [our] research practices" (p.153). Through co-authorship and through attempts to put the tools of research in the hands of participants, we have tried to craft a research approach that will help us understand and do justice to the digital literacy practices of a generation of transnational students in the global and local contexts that they inhabit.

BACKGROUND OF THIS PROJECT

The individuals whose stories constitute our larger international project ranged in age from 19 to 62 years old at the time of their participation and were brought up or lived in multiple countries for extended periods of time, including Nigeria, China, Taiwan, Bosnia, Indonesia, Australia, Bangladesh, Korea, Montenegro, Egypt, the United Kingdom, Peru, Chile, and the United States. Most of the par-

ticipants, like other transnationals during the latter half of the 20th and first part of the 21st centuries, moved from one area to another because of difficult lives often exacerbated by wars, the flow of global capitalism, and their quest for an education that included opportunities to study English. Several of the participants grew up in relatively rural areas, several in good-sized towns, and others came of age and attended schools in large cities such as Sydney, Sarajevo, Santiago, Belgrade, London, and Beijing, among others. All had earned high school diplomas; several were university students or had completed their baccalaureates, and many were enrolled as master's and doctoral degree students or had already earned advanced degrees.

Here we focus on four of the research participants with an eye toward demonstrating our evolving methodological approach to the research at hand. We have chosen to feature these particular transnationals' stories for several reasons. First, we think they provide an interesting set of cultural tracings—albeit fragmentary and incomplete—of how transnational students learn, choose, and use digital technologies to extend their communicative reach, to maintain their social and cultural identities, and to construct their literate worlds. As Carmen Luke (2001) points out, our understanding of globalized culture is only intelligible from a local perspective: "Globalization is as much about difference and ambivalence as it is about the sameness and similarities at the level of *local uptakes*, appropriations, identities, and engagements with global processes, structures, and ideologies" (p. 95). We use the students' literacy narratives and video representations to get a sense of these local uptakes because they are so "deeply perspectival" and "inflected by the historical, linguistic, and political situatedness of different sorts of actors" (Appadurai, 1996, p. 33). Second, because the students grew up under markedly different local circumstances, we believe their cases will help readers further appreciate the importance of situating digital literacies in specific cultural, material, educational, and familial contexts. For transnational students attending institutions of higher education, information and communication technologies represent a fundamental feature of a globalized world undergoing a period of major social, educational, and technological change, one in which peoples' lives, and literacies—and language use—have been altered in fundamental and specific ways (Luke, 2006; Hawisher, Selfe, Guo & Lu, 2006).

In this sense, the case studies provide some clues about the constellation of factors that can affect and be affected by digital literacy practices. We call this interrelated set of factors the *cultural ecology* of literacy (Selfe & Hawisher, 2004). With this term, we hope to suggest how literacy is related in complex ways to existing cultural milieu; educational practices and values; social formations like race, class, and gender; political and economic trends and events; family practices and experiences; and material conditions—among many other factors. As the work of Paul Kei Matsuda (2006), John Duffy (2007), Carmen Luke and Allan Luke (2000), Suresh Canagarajah (2002, 2007), and Morris Young (2004) reminds us, we can understand transnational literacies, generally, and digital literacies, more specifically, as a set of practices and values only when we properly

situate our studies within the context of a particular historical period, a particular cultural milieu, and a specific cluster of material conditions. Finally, we feature these stories because they resonate with and against parts of our own stories: the ways in which these people's lives are situated historically and culturally; their economic backgrounds; the ways in which they have learned to use and cope with technologies; the schools they have attended; their experiences as students and instructors; their relationships with family and friends; and the literacies and languages they share and do not share with us. As White, middle-aged female academics, who have primarily lived and worked in the United States (although each us has resided in either Germany or Scotland before beginning graduate studies), our understanding of the world is necessarily limited. Through our research, travels, and everyday lives, however, we have come to realize how issues surrounding digital technology and literacy practices are intimately connected whether here or abroad. Hence, the literacy narratives and digital stories of the participants in this study speak to us and teach us, and we hope they will to readers as well.

LITERACY NARRATIVES, WRITING-PROCESS VIDEOS, AND DIGITAL STORIES

When we met the four transnational students and co-authors of this chapter—Gorjana Kisa, 24; Mirza Nurkic, 20; Shafinaz Ahmed, 25; and Vanessa Rouillon, 36—they were either undergraduates attending the University of New South Wales in Sydney, Australia (Gorjana and Mirza), or graduate students in a writing studies class at the University of Illinois, Urbana-Champaign in the United States (Shafinaz and Vanessa). Although each of these students occupies a transnational landscape, they also differ in marked ways in terms of their motivations, experiences, and positioning within the topographies fashioned by globalization. Both Gorjana and Mirza, for example, were born in Sarajevo, Bosnia, part of the former Yugoslavia. Gorjana, describes herself as a "Bosnian Serb" and an "Orthodox Christian," and Mirza notes that he is a "secular Muslim." In contrast, Shafinaz, a Muslim, was born in Dhaka, Bangladesh, grew up in the United Kingdom, and, at the time of crafting her writing-process video, had spent the last 13 years in the United States; Vanessa, on the other hand, was born in Lima, Peru, went to boarding school in Santiago, Chile, and was completing her second year of graduate school in the United States. For the purposes of this print chapter, we describe the digital interviews (in the case of Gorjana and Mirza) and writing-process videos (in the case of Shafinaz and Vanessa) with alphabetic text, but note that a major component of this transnational research has been to feature our co-authors online through video footage in order to represent more fully their oral narratives and interpretations of their literate lives.

GORJANA AND MIRZA

We begin with our conversations with Gorjana and Mirza, which were held in an empty classroom the students located at the University of New South Wales, where, as mentioned, we were attending an international conference. The students had heard about our digital literacies research and were eager to contribute their stories through life-history interviews, which we subsequently spent the larger part of two days videotaping.

Both students were from Sarajevo before their families migrated to Australia as a result of the Bosnian War; Mirza was born in 1987 and Gorjana 4 years earlier in 1983. Mirza's Muslim family migrated to Australia first. They left Sarajevo in 1988, anticipating a worsening of ethnic and political strife in Bosnia. Although Mirza, himself, identifies as only a *secular* Muslim, he further explains that he has a "Muslim cultural outlook." During the war in Bosnia, Mirza's family opened their home in Australia to a series of friends—primarily Muslim refugees—who needed a temporary place to stay before they found more permanent housing. Gorjana's family, which she identifies as Serbian Orthodox Christian, migrated to Australia in 2001 as refugees from the increasing violence of the Bosnian War, leaving behind their possessions and homes in Sarajevo and Belgrade, where they had moved to escape the rising prejudice against Bosnian Serbs. These experiences, she says, strengthened the family members' ties to one another and heightened their understanding that local material conditions can change rapidly in unstable times.

Despite their families' migration experiences, the literacy environments in which Gorjana and Mirza grew up were richly textured. Both students had parents who had pursued advanced education. Gorjana's father, for example, studied economics and her mother attended several years of law school; Mirza's mother was a mathematician and his father a computer scientist. Both parents had completed doctoral degrees and focused on jobs in the information technology (IT) sector of Australia's economy. This educational background contributed, in large part, to the high value the two families placed on literacy activities, particularly reading. Both Mirza and Gorjana remember enjoying the process of being read to by their parents and learning how to read by themselves at an early age. Writing, too, was a part of the early literacy experiences in the two families. Mirza, however, as a child of IT specialists, started writing in online environments at an earlier age than Gorjana, and thought, in retrospect, that his love of the television program *Sesame Street* led to his acquisition of keyboard literacy.

The multiple languages spoken and written within the two families also added to the literacy environment. Gorjana, her 19-year-old sister, and their parents speak, read, and write both Serbo-Croatian and English. Mirza, his younger sister, his mother, and father also speak Serbo-Croatian and English, although the children are increasingly apt to mix English words into their Serbo-Croatian con-

versations. But Mirza's parents, in particular, value the ability to speak to friends and relatives in the language of their heritage. Mirza also speaks German, having learned that language in school in Sydney.

Both families also were able to provide their children with access to digital communication environments at home. Gorjana's family, for example, bought their first computer in 1999 when she was in high school in Belgrade, Serbia, and, at the time, she was the only one who knew how to use it. But that situation changed rapidly as she taught her parents how to use the machine, and her sister taught herself how to do so. Gorjana was convinced—from these experiences and others—that most young people discover how to use computer applications by themselves, just as she did, and without a great deal of formal instruction. By the time that we talked to her in 2007, Gorjana noted that her parents were using the family computer along with their cell phones to stay in touch with friends and family in Bosnia and Serbia—choosing the specific mode of communication they used (email, phone calls, letters) to match that of the person they were contacting. During her high school years, Gorjana used the family computer primarily for writing assignments and for chatting online with friends. And although she clearly appreciated the value of computers and other information technologies for these pragmatic purposes, she was not supportive of some online activities—computer games and MySpace, for example—that distracted young people from interactions with family or friends: the "real things" in life.

It was not until her university studies began in Australia that Gorjana began to use computers regularly in her schoolwork. By that time, however, it was quite clear to both her and her family that—within the context of increasingly technological local and global cultures—computers had become a necessity rather than a luxury. In some respects, Mirza from the start was always more intimately involved with computers, in part perhaps, because he was younger and, in part, because of his parents' professions. For as long as he could remember, Mirza's family had personal computers in their home—sometimes more than one. Additionally, both he and his parents used a range of information technologies to stay in touch with relatives in Bosnia-Herzegovina and in other places around the world. Like Gorjana's family, Mirza and his parents matched the particular communication technology they used to that of their relatives, recognizing that not all of their family members had access to the same range of computer technology as they did in Sydney.

Although, at home, Mirza began writing and reading in digital environments at a relatively early age and continued to use a range of digital technologies throughout his adolescence, he, like Gorjana, encountered a relatively narrow and unremarkable range of computer applications in the Australian secondary schools he attended. He remembered his high school, for instance, as having a limited number of computer classrooms—especially in comparison with his university environment. Mirza also learned to read and play music as he grew up, a long-term interest that he pursued throughout his secondary and college years. When he reached Grade 10, he began downloading and sharing music files in

peer-to-peer digital environments, a practice that allowed him to expand both his encounters with music and his range of musical tastes. Like many of his peers, Mirza articulated what he considered to be an ethically informed stance on file sharing in such digital environments, albeit not one that adhered to the letter of the law as it might be interpreted by commercial music companies. He recognized that the very limited file-sharing practices in which he engaged during his high school years was a kind of free sampling—not strictly legal, but ethically acceptable on a limited basis for young people who, during their adolescent years, could not afford to pay for music. When he entered college and began to acquire jobs that paid a better wage, Mirza noted, he was happy to spend money on the technologies of CDs and pay-for-play music. At that point, he noted, he ended up spending his wages across the wider range of musical genres that he had come to appreciate, thus balancing out his sampling activities in previous years.

Both Gorjana and Mirza use digital technologies extensively as a means of social networking. Gorjana, for example, like her parents uses digital technologies—as well as paper technologies like letter writing—to stay in touch with friends and family members in Sarajevo. Along with her parents, Gorjana decides on the particular medium of communication based on an analysis of the person with whom she is communicating and the rhetorical conditions of their exchange. Factors in her nuanced consideration include convenience, the purpose of the conversation, her correspondents' access to technology, their material conditions, and propriety among other factors. Gorjana also uses a range of digital communication technologies—especially mobile phones and SMS, but also email—to maintain her network of local friends. Her explanation about how she chooses the specific medium of communication is characterized by an insightful understanding of its appropriateness or inappropriateness for particular rhetorical situations. Importantly, Gorjana makes a distinction between communication technologies that she feels served primarily to support exchanges between friends when it was not possible or convenient to meet with them in person, and those communication technologies that support cruising for acquaintances in relationships that were born and maintained only online. The latter, Gorjana noted, demands so much time at the keyboard that they actually diminish the time one can spend with existing family and friends, and are, thus, a bad investment of people's time.

Mirza, too, makes extensive use of digital communication technologies for sustaining his global social networks and noted that he had used MSN Messenger and Skype to correspond with his cousin attending college in Austria. Email, however, generally proved more reliable as a means of staying in touch with relatives abroad, he observed, because of the uneven nature of technological diffusion along the axis of class in Bosnia. As he noted, many of his relatives have computers that are older or that are connected to the Internet via dial-up lines, and many other Bosnians remain reliant primarily on Internet cafes. In contrast, his uncle, who was the mayor of Sarajevo during the war and who currently

holds a "high-ranking position" in Bosnia, has broadband access and talks to his college age daughter (Mirza's cousin in Austria) using Skype.

To maintain his social network of friends in Sydney, Mirza uses cell phones, MSN Messenger, Facebook, SMS, and email. He explained, however, that of these forms of communication, he prefers online exchanges and Facebook to cell phone exchanges, not only because there is no cost-per-call for social interaction, but also because online exchanges give him additional time and opportunity to reflect on his language use and the opportunity to decide if and when to reply without seeming "rude." Mirza's sense of politeness also informs his understanding of when particular technologies are appropriate and inappropriate for dating, breaking up, and casual conversations. Perhaps most interesting to members of the interviewers' media generation was Mirza's observation that writing a letter to a girl he was dating would be perceived as both "creepy" and "clingy" within his local youth culture.

SHAFINAZ AND VANESSA

Along with refining the tools of our research for collecting literacy narratives through the use of digital video cameras, we also have encouraged students in our classes to make use of video cameras in tracing their own writing processes and digital literacies. Shafinaz and Vanessa, who with Mirza and Gorjana are co-authors of this chapter, crafted videos of their writing processes in response to the following assignment:

> You should attempt to capture a representation of your writing processes on camera. You do not have to video yourself, but you do need to try to represent some of the thinking and processes you experience as you approach and carry out a writing task.

Inspired from observing Maria Lovett's "Writing with Video" course and her advocacy for video as a rhetorical narrative medium (Hawisher et al., 2009; Lovett & Squier, 2009), we have given this assignment since 2005, first with graduate students and, more recently, with participants at the University of Illinois Writing Project site. Before that, we had asked students in our classes to draw, by hand, images of their writing processes, drawings where writers feature texts, writing tools, clocks, food, people, pets, and various concrete scenes and activities. With the move to incorporating video cameras into our teaching and research, however, we find that the graduate students and teachers tend to feature some of the same sorts of "things" but also take up the video challenge with clips that are often more complex in portraying various cultural practices and a local sense of place as connected to their writing processes.

In the videos described here, Shafinaz Ahmed and Vanessa Rouillon demonstrate their ways of writing and being in the world as they compose. We first describe Shafinaz's video titled "Born-in-a-Dish" before moving on to Vanessa's. Each alphabetic description of the videos includes still images extracted from the videos themselves, which we have inserted in the text for readers. Although the stills miss much of what the videos convey—parts of the videos use voiceover narratives, music in the background, and sometimes animated on-screen texts— these glimpses of each woman's conception of her writing processes suggest the ways in which acts of writing are not restricted to inscription alone but touch multiple parts of their transnational lives. The videos themselves also take advantage of sound effects and particular pacing to convey affect, atmosphere, and modes of engagement that can be absent in alphabetic texts.

In Shafinaz's video, we see her eating, writing on her bed, books at feet, while she also reads in preparation for writing. We hear the Bangladesh music in the background and focus on Shafinaz, the writer, who now sits in front of a computer screen. Then, as the music stops, we shift to Shafinaz's brushing and braiding of her hair, as her grandmother once did. Shafinaz tells us that her grandmother would say: "a woman is like a braid, simple yet complicated, delicate but strong, plain but elegant." Her grandfather, on the other hand, would insist that "a woman's true beauty is not what lies on top of her head but what she possesses beneath it." We also see in her video a 1950s western representation of "Babe In Total Control of Herself," that is, a "BITCH," with all capitals, an image that is in direct contrast to the concept of woman with which she grew up. And throughout the narrative, we watch and listen as Shafinaz composes her poem, "Born in a Dish," a play on the way "Bangladesh" is sometimes taken up by those of us who are not Bangladeshi.

In writing about and reflecting on her video, Shafinaz talks about the "unique perspective" she has as one who claims "a multicultural background." She admits, however, that when she was growing up first in the United Kingdom until she was 12 and then in the United States, she "hated the fact that [her] culture wasn't the same as everyone else's." Unlike Mirza and Gorjana, Shafinaz did not always prize her ability to speak more than language and often resented the fact that her mother's English could not keep up with her own. As she puts it,

> I was incredibly impatient with my mom and would get mad at her very quickly when she didn't understand something. On many occasions I would speak to her in English and she just wouldn't understand me. This frustrated me and made me reluctant to talk to her. I remember thinking "my mom doesn't understand me, so why should I talk to her? Why should I even bother?"

Thus, Shafinaz expresses some of the difficulties those with transnational connections face as they try to cope with the competing demands of multiple

Shafinaz Ahmed and her literacy practices.

worlds and inevitably bump up against the language and customs of their family while trying to adapt to the new country in which they find themselves.

Shafinaz also admits to bringing to the classroom a perspective on literacy and learning that differs from many of the students in the United States and from many of their instructors in writing studies classes as well. When, for example, her class participated in an electronic discussion group with Moodle, an open-source class management program, Shafinaz explained:

> [It] took a long time to realize that with Moodle there are no "right" or "wrong" answers. … I've never been a big fan of using technology—it scares me because I have no idea how to use it. The thought of doing anything dealing with technology makes me cringe; it's foreign to me … and if I had my way, it'd stay like that. However, I know this cannot be.

Shafinaz's response to the new information technologies is complicated. It is not, of course, the software Moodle that dictates open discussion rather than correct answers, but an instructor's pedagogical use of the software. And, mechanically, despite her resistance, even fear, in working with new computer applications, she takes pride in what has been able to achieve. As she says:

> The process of doing the [writing video] itself was hard, but extremely rewarding. Deciding which images would best represent my writing process was time consuming. But I am happy with the end product. Once again, I proved to myself that I can work with technology!

The dual challenges that Shafinaz takes on—negotiating a school setting in which instructors sometimes expect students to take risks rather than finding only the right answers and, at the same time, make use of digital media in doing so—are differences with which Shafinaz contends in the university setting. She finally concludes that her mother's struggle and resistance to English is not unlike her own resistance to new technologies. She explains:

> I see many similarities between my mother's linguistic abilities, and my technological ones. My apprehension about technology is the same as my mother's about English. She doesn't like using it because it's foreign to her. But she does it. Everyday my mom interacts in a foreign language in situations that make her uncomfortable. She may not do it perfectly, but she does it with dignity.

If her mother is a "foreigner" because her English is not what her daughter at one time thought it should be, then Shafinaz herself claims outsider status through her resistance to taking on digital media. Over the years, however, she

has come to respect her mother's attempts to straddle two worlds and now sees the dignity inherent in her mother's efforts "to fit in." Shafinaz too is proud of her own efforts with digital media as she notes above.

As she has come to take pride in her mother and her family heritage, Shafinaz tells us that there are many images from Bangladesh that she tries to incorporate in her writing, especially when she's writing poetry outside of school:

> I visit Bangladesh once every 3 years, but I think about it every day. [My poetry] talks about the different images I associate with Bangladesh: exotic fruit, the sweet laughter of children, the dark-skinned women with their beautiful silky hair. The poetry also addresses the war Bangladesh fought with Pakistan. We fought for the right to be a free country, for the right to speak Bengali, and for the right to be called Bangladeshis.

When Shafinaz crafted her writing-process video, she began to bring together some of these disparate strands of her life. Because she was representing her writing process, she chose to represent her own poetry—her passion when it comes to writing. She also chose to touch on Bangladeshi life in her video through the poetry she had written. In a scene from the video, for example, as explained earlier, Shafinaz braids her hair, a custom intimately connected to her life in Bangladesh. Of a second poem, "Benni Advice" (see appendix), which she recites in part in the video, she tells us:

> Benni in Bengali means braid. I structured this poem to resemble a braid. It begins fat and then tapers towards the end. The lines in the middle create a twisting effect, similar to that of a braid. It is, or should I say was, very typical for Bengali girls to have long hair. When I was younger and living in England at the time, my family and I would visit Bangladesh every summer. And, each night my grandma would braid my hair. We would sit on the veranda overlooking the Mosque and my grandma would sing Bengali songs to me. I remember my grandma's soft hands, her slender fingers, the tips always dyed with henna. My grandma no longer braids my hair, but I do think of her as I brush and braid my own.

Her other poem "Born in a Dish"[2] (see appendix) deals more closely with the political realities that many students who live between countries experience. She describes her poem as being a play on words with the title really signifying "Bangladesh" and tells us that the poem "represents what [her] native homeland means to [her]." In the last stanzas of the poem, Shafinaz writes:

> I tell them of the red earth of sorrow
> through which the lotus blooms.
> Of sons who gave their lives,

daughters their blood and honor.
We waited through the long night
to rise again in the fresh air
to say we are free.
We are not India! We are not Pakistan!
Yet,
they still ask me if
Born in a dish is the capital of India.

Here she suggests the difficulties in trying to talk to speakers of English in her adopted home about a country that some do not even recognize as a nation-state. In doing so, Shafinaz's passion for her homeland comes through in this writing that began outside of school but made its way into the classroom and onto the Web through the use of digital media.

As we turn to Vanessa, who, as mentioned, was born in Lima, Peru, in 1969, we encounter a video that represents the author as totally immersed in academic writing but who also has a wry sense of humor that emerges in her depiction of her writing processes. Vanessa, who left her parents' house in her early 20s to study in Chile and then went on to work in Santiago for several years before coming to the United States, framed her video with the music of the Italian Vivaldi. Of her literacy practices, she states:

My literacy practices have to do with a narrow "culture," which would be that of my parents' and grandparents' environment, where reading was what adults did for leisure, and where I had access to literacy tools (due to my parents' efforts). That may not have been the case of average Peruvian households, since Peru is a poor country.

Vanessa's video begins with the words "writing an essay implies reading, eating, thinking, eating, revising, eating," and we watch as Vanessa walks back and forth between the computer screen and extracting Lean Cuisine or snack food from the refrigerator as her words "Denial: I'll be finished tonight" flash across the video. When we see her again, she is sitting in a La-Z-Boy chair, feet up, reading but really wondering what Simon, her husband now at another university, is doing. As we listen to Vivaldi's "Summer" in the background, Vanessa checks her cell phone and sees that Simon is indeed calling her. Much later, we were told, images of Vanessa's book, covered in post-its and propped against her computer screen, come into view, and she reads from her book "[imageword's] doubleness is complicit in the physiological creations of bodies, both as chemical matrix and as coding in the cellular process of embryogenesis."[3] She follows these words with a resounding "HUH?" spread across the width of her screen and then a "Let me go—this is boring!" The repetition or iterative processes in her writing life become evident as she again flashes, "Denial: I'll be finished tonight," and returns

Vanessa Rouillon and her literacy practices.

400

to her kitchen once again for coffee and sustenance. She moves to calm herself by watching ducks out her window but then tells us that her deadline is approaching "like the face of Kong."

Although Vanessa wraps herself in a traditional Peruvian blanket while reading, when she writes she inevitably turns to her favorite writing tool: post-its, a relatively recent development in the world of note-taking. In her video, she attaches post-its to the pages of her books as she reaches toward her computer and types out her thoughts and jottings while at the same time petting the cat who has settled in her lap. Instead of using Munch's *Scream*, as did a student from Korea, to express her angst about writing, Vanessa includes a film clip of *King Kong* and Fay Wray, with Wray's mouth poised in a scream. Vanessa's use of clips from *King Kong* reflects her view of writing in the academy as "excruciating," her interpretation of how Victor Villanueva would interpret his early writing life (Casanave, 2002). As she finishes her draft, she decides that she needs to print it out before submitting and vows to finish her writing assignments earlier the next time around. At one point following the *King Kong* clip, Vanessa says, "God works in mysterious ways, I work with Post-its."

In some sense, Bruno Latour's (2005) notion of "assemblies of things" and "attachment to things," applies here. As he notes, "when we are focused on things, we are actually focused on ourselves" (Prieto & Youn, 2004).[4] According to Latour, things—or more precisely the displaying of things—leads us to draw connections to other people, places, and attachments that may not automatically be evident in the things themselves but rather in the "different ways of gathering things together" (p. 3). Vanessa and Shafinaz, like other writers in the study, arrange their writing spaces with images, food, objects, and often local music that hail from their home countries—artifacts that may comfort them as they immerse themselves in writing. Mixed in with these artifacts, however, are also objects from the new places in which they dwell: a small American flag on Shafinaz's desk, a Lean Cuisine frozen dinner in Vanessa's refrigerator. Other students with transnational connections commonly surrounded themselves in their writing-process videos with music in Portuguese of the Brazilian "Girl from Ipanema"; or Chinese pillows from T.J. Maxx—all of which, we would argue, have become part of our larger, shared global landscape.

In the end, Vanessa tells us that the video experience was very satisfying for her. In her words: "now that I know what to do, how to handle the technology, and the time it takes to visually produce and represent your writing process ... I am more than eager to engage in a related project again." And she was quite serious with her intentions: Before the semester was over, she had videoed a series of mock interviews in which she asked friends to assume the roles of leading writers in the field and to engage in a videotaped dialogue that she subsequently folded into her digital portfolio. Always interested in how new technologies might contribute to her learning, Vanessa lost no time in adopting video production as integral to her scholarly repertoire.

SOME OBSERVATIONS

As we look back on the literacy narratives of Gorjana and Mirza, and the writing-process videos of Shafinaz and Vanessa, all born between 1969 and 1987, we note that for most of their lives they have never known a world devoid of communication networks—linked telephone and computer systems, fax and telex connections, cell phones and text messaging—and rapid technological change. Even for the older participants, the innovations of personal computers, large-scale computer networks, and cell phone technologies, along with the increasing levels of migration and international travel, have been with them since they were teenagers or younger. In the midst of a 50-year period of rapid worldwide diffusion that fueled the engine of multinational capitalism and globalization, they moved sometimes with parents across the globe because of war (Gorjana and Mirza), at other times because of a father's career path (Shafinaz), and at still others to improve their opportunities for education (Vanessa). Regardless of the reasons, however, each became part of a pattern of migration for transnational students that is more than merely "an awkward interval between fixed points of departure and arrival" but often, and for many other people in the world, a "mode of being" (Carter, 1992, p. 101). Moreover, their relocation and subsequent adaptation to new places worked to change not only their literacy practices but also the kinds of subject positions and identities available to them and often to their parents or other family members. Gorjana, and Shafinaz, especially, were aware of their mother's struggles with the dialects of English, and Mirza at one point in his interview says that his 14-year-old sister was native born to Australia, suggesting perhaps that as an Australian citizen she might somehow be exempt from the tumultuous times his parents experienced.

Each example demonstrates how family lives and cultural customs of the research participants we describe here are folded into everyday literacies and how their identities are no longer constituted solely by nationality or ethnicity although both play a role. The local-global hybrids we see emerging here—the blurred identities that are at once Australian but also Bosnian (Christian and Muslim); Bangladeshi but also British and American; and Peruvian but also Chilean and North American—are surely part of a larger global culture. All suggest the need to move toward the global networked society while, simultaneously, underscoring the need to stay rooted in particular cultural subjectivities. The global "things" that saturate our co-authors' local worlds include Vivaldi, an Italian composer but also central to a global repertoire every bit as much as Munch's *Scream*, Dali's painting of time pieces, *King Kong*, and the music Mirza downloads from across the globe. But the literacy narratives and videos also speak to current conflicts in how we constitute our own literate identities, conflicts that some of the students appear to resolve with some sense of ease but others, like Shafinaz, continue to negotiate. As Shafinaz and the other students con-

tinue to plan their futures, they will, undoubtedly, be influenced in their "daily life routines" by "electronic media [which continues to] provide resources for self-imagining as an everyday social project" (Appadurai, 1996, p. 3). The transnational students' literate experiences further illustrate—and we are convinced will continue to illustrate—that "the new power of the imagination in the fabrication of social lives is inescapably tied up with images, ideas, and opportunities that come from elsewhere often moved around by the vehicles of mass media" (Appadurai, 1996, p. 54). Indeed, some of the transnational students are, like Mirza, themselves distributing images, ideas, and often videos over the web every bit as much as they are consuming them.

The narratives these students relate about their literacy practices either through their life-history interviews or writing-process videos are both rich and informative, and, we believe, have benefited from a methodology that brings together several approaches. As in our earlier studies, we have set the literacy narratives in the frames of large-scale social, historical, and cultural trends that have exerted shaping influences on people's digital literacy practices. Recognizing too that social or cultural patterns within a cultural ecology are constituted by the actions—and the divergent experiences—of people living out their lives, we base this work on the research of Anthony Giddens (1979), Paul Kei Matsuda (2006), John Duffy (2008), Luke and Luke (2000), Canagarajah (2002, 2007), and Young (2004), who remind us that human agents both shape and are shaped by the cultural, educational, economic, and social contexts that they inhabit. And, as in our earlier studies, we have also invited the participants in this research to become co-authors with us so that they too can contribute their interpretations of globalization and transnationalism as they influence, and are influenced by, their own everyday literacy practices and the literate activity of those around them. With this study, however, we have also tried new approaches. Heeding, for example, Keller's (2004) contention that ethnographic practice needs to "trace paths of circulation and travel rather than assume the fixity and rootedness of its subjects" (p. 206), we have tried to explore issues of migration with the students, believing with Appadurai (1996) that media and migration have been powerful forces in shaping this phase of globalization. Convinced as well that the lifeworlds of transnational students are better understood when we, too, are willing to cross borders, we have tried through our work in Sydney to benefit from face-to-face encounters and conversations with individuals in the cultural and material settings they inhabit on a daily basis. At the same time, however, we have tried to honor the local by asking students themselves to videotape their writing processes as a class assignment in an effort to encourage students to connect the classroom to their own lived experiences outside of school. As Keller (2004) so aptly states, "rather than imagine the classroom as a mirror that reproduces on a smaller scale what stands in front of it, it is important that we not erase the power of classroom spaces to allow students to create their own positions to the larger society" (p. 210). We have tried to heed this admonition as well. These last two moves, along with our increasing use of dig-

ital tools to capture literate activity and to present it to readers and viewers, attempt to extend the reach or our study and, we hope, do justice to the representation of transnational students' literate lives.

Here we offer several tentative observations that grow out of our initial analysis of the research at hand. The transnational students presented here:

- share the trait of having a perceptive, and personal, sense of events in both localized contexts and a transnational world.
- possess a rich set of linguistic resources—including variations of English—that help define and situate their multiple identifications both locally and globally.
- do a great deal of their learning, reading, composing, and communicating in various print, digital, and online contexts, in part, creating their own transnational identities.
- have acquired a set of digital literacy practices that extend across national, cultural, and linguistic borders that help sustain and extend these multiple cultural and social identifications locally and globally.
- possess a personal sense of their responsibilities as citizens who dwell on the blurred borders of nation-states that helps inform their idea of being in the world.

In this emerging study, then, we have attempted to balance our understanding of global trends—the increasing reach and scope of expanded digital networks—with people's own local sense of place, identifying the specific historical, political, and social factors that influence the use and availability of digital technologies in various places and at various times. Through the rich narratives and self-authored videos of transnational students, we have also attempted to include personal understandings and appropriations of digital communication technologies as well as to suggest issues associated with gender, age, and class; cultural values; historical circumstances; pragmatic needs; and local living conditions that also play a role in literate lives. If we have succeeded at all in this effort, it has everything to do with the generous insights of the transnational students with whom we live and sometimes teach in this globalized world. As we constantly discover in our own research and literate lives, it is ultimately these students who teach us.

APPENDIX

Born in a Dish

From the bedroom window,
we look out
at the glistening night sky.
The grimace of the moon
glimmers in the frozen night,
a fusion of gossip, song, and laughter.

Each night my grandma braids my hair,
gliding the comb through the glossy black mass.
Her fingers slip through the thick silkiness,
weaving the strands into a single stream.

"A woman is like a braid,"
my grandma tells me.
"Simple, yet complicated,
delicate, but strong,
plain, but elegant.
Sometimes,
she is a bun,
hidden and constrained"

But,
my grandpa tells me,
"a woman's true beauty,
is Not
what lies on top of her head,
but what she possesses
beneath it."

ENDNOTES

1. We thank Eileen Schell, who, after reading a draft of our research at the Virginia Tech
 Feminist Research Symposium (2007), suggested we take a look at the scholarship
 currently being published in transnational studies. See also Hesford and Schell
 (2008).

2. Born-in-a-dish

Bubble gum pops,
doodles begin.
A head settles
on the desk...

I stand before them
and speak of a land,
far away,
where cinnamon women,
with sapphire eyes,
and coconut hair,
that flows,
like a river dancing in the moonlight,
gently lull their children to sleep.

Sing something in Abudda Budda!

I tell them of mangos, guavas, and jackfruit.
Pomegranates-
rubies laughing in your mouth.
Of children playing the juice game;
the sweet golden fruit,
a squeeze of its flesh,
the tickle of the tongue
chasing the juice as it slides down the arm.

They ask me if people drive elephants.

I tell them of the red earth of sorrow
through which the lotus blooms.
Of sons who gave their lives,
daughters their blood and honor.
We waited through the long night
to rise again in the fresh air
to say we are free.
We are not India! We are not Pakistan!

Yet,
they still ask me if
Born in a dish is the capital of India.

3. Fleckenstein, Kristie, p. 164.
4. We are grateful to Chip Bruce (2007) for drawing our attention to this article in his
 "Coffee Cups, Frogs, and Lived Experiences."

REFERENCES

Appadurai, A. (1996). *Modernity at large: Cultural dimensions of globalization.* Minneapolis: University of Minnesota Press.

Brettell, C.B. (Ed.). (1993). *When they read what we write: The politics of ethnography.* Westport, CT: Bergin & Garvey.

Bruce, B. C. (2008, June). Coffee cups, frogs, and lived experience. *International Journal of Progressive Education, 4*(2), 22–39.

Canagarajah, A.S. (2002). *The geopolitics of academic writing and knowledge production.* Pittsburgh: University of Pittsburgh Press.

Canagarajah, A.S. (2007). The ecology of global English. *International Multilingual Research Journal, 1*(2), 89-100.

Carter, P. (1992). *Living in a new country: History, travelling and language.* London: Faber & Faber.

Casanave, C.P. (2002). *Writing games: Multicultural case studies of academic literacy practices in higher education.* Mahwah, NJ: Erlbaum.

Duffy, J. (2007). *Writing from these roots: Literacy in a Hmong community.* Honolulu: University of Hawai'i Press.

Giddens, A. (1979). *Central problems in social theory: Action, structure and contradiction in social analysis.* Berkeley & Los Angeles: University of California Press.

Hawisher, G. E., Prior, P., Berry, P., Buck, A., Gump, S.E., Holding, L. H, Olson, C., & Solberg, J. (2009). Ubiquitous writing and learning: Digital media as tools for reflection and research on literate activity. In B. Cope & M. Kalantzis (Eds.), *Ubiquitous learning* (pp. 254-264). Urbana: University of Illinois Press.

Hawisher, G.E., & Selfe, C.L., with Coffield, K., & El-Wakil, S. (2007). Women and the global ecology of digital literacies. In B. Daniell & P. Mortensen (Eds.), *Women and literacy: Local and global inquiries for a new century* (pp. 207-228). Mahwah, NJ: Erlbaum

Hawisher, G.E., & Selfe, C.L. with Guo, Y-H., & Liu, L. (2006). Globalization and agency: Designing and redesigning the literacies of cyberspace. *College English, 68,* 619-636.

Hesford, W.S. (2006). Global turns and cautions in rhetoric and composition studies. *PMLA, 121*(3), 787-801.

Hesford, W.S., & Schell, E.E. (2008). Configurations of transnationality: Locating feminist rhetorics. *College English, 70*(5) 461-470.

Jaffe, A. (1993). Involvement, detachment, and representation on Corsica. In C.B. Brettell (Ed.), *When they read what we write: The politics of ethnography* (pp. 51-66). Westport, CT: Bergin & Garvey.

Keller, C. (2004). Unsituating the subject: "Locating" composition and ethnography in mobile worlds. In S.G. Brown & S. Dobrin (Eds.), *Ethnography unbound: From theory shock to critical praxis* (pp. 201-218). Albany: State University of New York Press.

Lam, W.S.E. (2004). Border discourses and identities in transnational youth culture. In J. Mahiri (Ed.), *What they don't learn in school: Literacy in the lives of urban youth* (pp. 79-98). New York: Lang.

Latour, B. (2005). *Reassembling the social: An introduction to actor-network-theory.* Oxford: Oxford University Press.

Lovett, M., & Squier, J. (2009). Writing with video. In B. Cope & M. Kalantzis (Eds.), *Ubiquitous learning* (pp. 242-253). Urbana: University of Illinois Press.

Luke, C. (2001). *Globalization and women in academia: North-west/south-east*. Mahwah, NJ: Erlbaum.

Luke, C. (2006). Eduscapes: Knowledge, capital and cultures. *Studies in Language and Capitalism, 1*, 97-120.

Luke, C., & Luke, A. (2000). A situated perspective on globalization. In N. Burbules & C.A. Torres (Eds.), *Globalization and education: Critical perspectives* (pp. 275-298). New York: Routledge.

MacGillivray, A. (2006). *Globalization*. New York: Carroll & Graf.

Martinez-Leon, N., & Smith, P.H. (2003). Educating for bilingualism in Mexican transnational communities. *NABE Journal of Research and Practice, 1*(1), 138-148.

Matsuda, P.K. (2006). The myth of linguistic homogeneity in U.S. college composition. *College English, 68*, 637-651.

Prieto, M.J., & Youn E.S. (2004). Interview with Bruno Latour: Decoding the collective experiment. Agglutinations.com. Retrieved August 8, 2008.

Queen, M. (2008). Transnational feminist rhetorics in a digital world. *College English, 70*, 471-489.

Reynolds, N. (2004). *Geographies of writing: Inhabiting places and encountering difference*. Carbondale: Southern Illinois University Press.

Richardson, L. (2000). Skirting a pleated text: De-disciplining an academic life. In E. St. Pierre & W. Pillow (Eds.), *Working the ruins: Feminist poststructural theory and methods in education* (pp. 153-163). New York: Routledge.

Selfe, C.L., & Hawisher, G.E. (2004). *Literate lives in the information age: Narratives of literacy from the United States*. Mahwah, NJ: Erlbaum.

Selfe, C.L., & Hawisher, G.E., with Lashore, O., & Song, P. (2006). Literacies and the complexity of the global digital divide. In L. Van Waes, M. Leyten, & C. Neuwirth (Eds.), *Writing and digital media* (pp. 253-285). Amsterdam: Elsevier.

Young, M. (2004). *Minor re/visions: Asian American literacy narratives as a rhetoric of citizenship*. Carbondale: Southern Illinois University Press.

EPILOGUE

The Challenges of Conducting Ethically Responsible Research

Gesa E. Kirsch

Reading this wonderful book, I am struck by how much, how far, and how deeply research methods and methodologies have evolved during the last few decades, and how challenging, perplexing, and difficult it is to figure out what it means to conduct ethically responsible research. Writing studies scholars now regularly study extracurricular sites of literacy, a term used by Anne Ruggles Gere (1994) to describe the range of rhetorical activities used by ordinary people in everyday life outside of formal institutions. The most interesting and unusual research of this kind includes studies of rhetorical activities among small-town rural women (e.g., Hogg, 2006); the writing of homeless people as represented in street newspapers (e.g., Mathieu, 2005); rhetorical activities of Japanese Americans imprisoned in Internment camps during World War II (e.g., Okawa, 2008); activist rhetorics created by educators teaching working-class students (e.g., Kates, 2001); women's political organizations after suffrage (e.g., Sharer, 2004); women's use of the Internet to share birth plans and challenge medical authority (e.g., Owens, 2009, 2010); and literacy and social change among African American women (e.g., Royster, 2000). Each of these studies faces its own ethical and methodological challenges—how to represent family members and one's own memories in studying rural women (e.g., Hogg, 2006); how to think about social responsibility when the homeless become our research participants (e.g., Mathieu, 2005); how to represent the writings, government documents, and photos of formerly imprisoned, now deceased members of the Japanese Hawaiian community (e.g., Okawa, 2008), and so on.

Examples in this volume are equally fascinating in terms of the methodological and ethical questions they raise: They include research on prison art as a

form of resistance to highly regulated, strongly restricted, institutional environments; an examination of the body as a site of rhetorical activity as expressed by a lesbian performance artist; research on transnational students' use of digital technologies in maintaining social networks across different languages, cultures, and continents; an exploration of end-of-life decisions as negotiated by family members, caregivers, and doctors; and a report on methodological dilemmas that arise when confidentiality requirements do not allow note-keeping, audio-recording, or access to written documents. What is striking about this new work is that as it covers a wider range of rhetorical activities, different cultural contexts, and more diverse populations, it also rapidly increases the number of ethical challenges researchers face.

Editors Katrina Powell and Pamela Takayoshi suggest in their thoughtful introduction that evolving research methods and methodologies provide us with a vision of "research practice as a site of collaborative knowledge making where rhetorician-critics or local intellectuals are learning but also teaching, [where they] build more reciprocal and balanced relationships with participants, [and] design work where authority and knowledge circulate more or less evenly throughout the research relationship" (p. 13). How to achieve and implement this vision of ethically and socially responsible research remains an important challenge for scholars in the field. Importantly, Powell and Takayoshi include critical voices up front in this collection, in particular those of Ellen Barton and Richard Marback, scholars who raise doubts about whether socially progressive research might even be possible or desirable.

Barton and Marback raise serious counterpoints to many methodological claims made here—what might ethically responsible research look like, who decides, how do we know? Are we deluding ourselves when we set out to conduct research with socially progressive aims, even with the best intentions? How do we know what is socially progressive? Does social progress still look like "progress" a decade or two later? A century later? These questions are daunting, enduring questions that researchers and participants, scholars and teachers, community members and activists need to confront as they pursue their work in the ever-expanding field of rhetoric, composition, and literacy studies. By starting the volume with critical challenges to ethics, social responsibility, and researchers' intentions, Powell and Takayoshi allow readers to read the essays collected here against the grain, to entertain multiple perspectives, consider alternative interpretations, and realize that ethical and methodological questions will continue to shape and challenge writing studies research.

In many ways, this volume reflects the richness, the texture, and the layers of discussion which were present in the place where this volume originated—a working symposium for feminist scholars organized by Powell and Takayoshi at Virginia Technological and State University. I was fortunate to be among the participants and remember vividly how scholars at the symposium, much like the authors of these chapters, felt free to challenge each other; reconsider and try out new ideas; and to work through, around and beyond ethical, methodological,

and representational challenges. The inquiry process itself became an important part of the symposium—and of this volume—as we shared work in progress, explored ideas, disagreed with one another, and pushed each other further in our thinking, understanding, and growing knowledge of the many challenges involved in reflexive and ethically responsible research. The symposium was a powerful, lived experience that continues to unfold for me in many conversations, friendships, and collaborations with colleagues across the country—and in the provocative discussions taken up in the pages of this book.

Several authors in this volume also foreground how lived experience shapes their understanding of writing studies. For instance, Joann Addison reports on the disturbing tale of neglect and abuse her foster son experienced and reflects on the power that narrative inquiry has in shaping his future life. She notes that ethically responsible research takes on a whole new meaning when one is dealing with an infant whose life hangs by a thread, and whose future depends on the power of narrative—the stories told by social workers investigating his case, by newspapers reporting his story, by doctors and nurses treating his injuries, and by parental rights inscribed into law. Addison argues that we need to pay attention to the outcomes and consequences of these different narratives, and that narrative inquiry becomes a particularly powerful tool when it produces cumulative stories which reveal a broader reality that can be named and pursued in a court of law (e.g., domestic violence or child abuse). Addison suggests that narrative inquiry can and does change what actions are available to us; what stories can be told—and will be heard—as we seek legal protections for vulnerable populations.

K.J. Rawson provides an equally striking example of the power of narrative inquiry, although that is not her explicit focus. In "Queering the Archives," Rawson examines how the lesbian, gay, bisexual, transgendered (LGBT) populations are often and easily erased from history and cultural memory because they lack legal protections enjoyed by other citizens, because hate crime violence is not always reported and recorded, and because much of the LGBT culture continues to unfold on the margins of society. Rawson challenges us to consider several intriguing ethical dilemmas: how to deal with "embodied archives" (i.e., when the body becomes the text) and how to deal with "fictional archives" (i.e., when the only recourse to an absent history of a marginalized people is to imagine it, based on what we know about the time period, culture, and people).

Rawson introduces the work of performance artist Mary Coble who records the names of hate crime victims on her body with ink-less tattoo needles, then presses a tissue on these tattoos to record the names in her own blood, and produces an exhibit that displays both the blood-soaked pieces of tissue and her own body. The ink-less tattoo needles leave scars on Coble's body for several weeks but eventually fade. Coble's point is to show that cultural memory also fades, leaving no permanent record of the many hate crimes experienced by the LGBT community. This fascinating chapter challenges our most basic assumptions about archival research—what it does, how it works, what is collectable,

what can be preserved—and not. Rawson notes that because archives reflect social and cultural values, they function as "status" markers and tend to record only official, public histories. They also privilege written documents, not ephemeral moments like this artist's performance, or the hate speech and violence directed toward the LGBT community.

Rawson introduces a second ethical dilemma when she provides the example of a "fictional archive," a video documentary produced by Cheryl Dunye, that traces the fictional history of a Black lesbian actress in the 1930s. The video artist creates an authentic looking and sounding documentary of a character she imagines to have inhabited this world. Dunye's fictional documentary functions as a response to a world that does not document the lives of those who find themselves at the margins of society. Perhaps ironically, this material is now collected in the Lesbian Herstory Archives in Brooklyn, New York, alongside actual historical materials. Rawson presents serious ethical questions: how do we recover the stories, lives, and histories of marginalized peoples when their voices have rarely been heard, their histories have not been fully documented, and their status has not been in the purview of archival collectors?

Jacqueline Jones Royster (2000) begins to address this question in another context in her important book, *Traces of a Stream*, when she introduces the concept "critical imagination." Royster invites researchers to imagine what might be missing from official historical materials, what might be cast in shadow, what might have been, given what else we know. Royster proposes that once we employ critical imagination in our work, we will push further with historical research, look in places we might not have looked before, examine sources we might have neglected, and notice the rhetorical activities of populations previously overlooked.

The impact of Royster's call for employing "critical imagination" can be seen already in recent work that provides us with alternative—although *not* fictional—histories. For instance, scholars like Shirley Wilson Logan (2008), Jessica Enoch (2008), and Katrina Powell (2007a, 2007b) have helped us to see, for the first time, many rich alternative sites of rhetorical education and activism. In her important book, *Liberating Language*, Logan (2008) provides insight into rhetorical education in 19th-century Black America by researching places of worship, military camps, African American literary societies, sewing circles, and the Black press; in *Refiguring Rhetorical Education*, Enoch (2008) uncovers resistant pedagogies developed by 19th-century women teachers of African American, Native American, and Chicano/a students; and in *The Anguish of Displacement*, Powell (2007a) offers a rich portrait of rhetorical activities by Virginia mountain women, a group often portrayed as illiterate, uneducated, poor, dependent, and possessing few or no moral values.

Another ongoing challenge that researchers face, especially when aiming to conduct ethically responsible research, concerns questions of power and authority. As Powell and Takayoshi note so aptly in their introduction, the issue is this: [how do we] "design work where authority and knowledge circulate more or less

evenly throughout the research relationship" (p. 13)? Researchers have found many creative ways of sharing power and authority with participants—by inviting them to collaborate, to interpret research data, to analyze emerging themes, and to share research presentations and publications. It is much more common now to hear the voices, words, and texts of research participants, to read their own interpretation and analysis of data, and to see their self-representation of rhetorical activities in written texts or audio- and visual recordings. Yet questions about how even-handed research can be, and how evenly power and authority can circulate, remain critical challenges for any researcher.

Take, for example, the collaborative work of Cindy Selfe and Gail Hawisher with student contributors Patrick Berry, Shafinaz Ahmed, and Vanessa Rouillon from the University of Illinois, Urbana Champaign, and Gorjana Kisa and Mirza Nurdic from the University of New South Wales, Australia. Here we have an example of a rich study that uses digital media, blends different research methods, and combines roles of researchers and participants. Selfe and Hawisher invited participants to video record their writing and reading processes in their home and work settings, to interpret and discuss their experiences in co-authored research, and link video recordings to print publications, thereby enriching readers' experiences. Selfe and her colleagues remind us of the importance of studying the local within a global context, to attend to different forms of digital communication (e.g., Skype, texting, email, video, etc.), and to observe closely the transnational contexts in which literate lives take place. Yet ethical challenges remain central, even under conditions that are collaborative, interactive, and transnational in nature: when Selfe and Hawisher invited their participant-colleagues to take control of representations of literacy processes—in settings and times of their choosing, on subject matters of interest to them—they still intruded into their lives, requiring explanations, and at times translations, especially when working with transnational students displaced from their countries because of threat of violence, or lack of educational or economic opportunities.

The examples presented in this fine volume—both contemporary and historical—make clear that we will continue to face many ethical challenges as we continue to study new sites of rhetorical education and activism. Although I share many of the concerns raised by Barton and Marback in their provocative discussion about the possibilities and limits of socially progressive research, I remain optimistic that as we continue to reflect on our methodological practices, as we attend closely to questions of power and authority, as we attempt to develop "an ethos of humility, respect and care" (Royster & Kirsch, 2012), we are more likely to approximate the possibility of ethically and socially responsible research. I am intrigued by how new research methods and methodologies will unfold over time, in our field, and in related disciplines. This book offers exciting glimpses into this new work.

REFERENCES

Enoch, J. (2008). *Refiguring rhetorical education: Women teaching African American, Native American, and Chicano/a students, 1865-1911*. Carbondale: Southern Illinois University Press.

Gere, A.R. (1994). Kitchen tables and rented rooms: The extracurriculum of composition. *College Composition and Communication, 45*(1), 75-92.

Hogg, C. (2006). *From the garden club: Rural women writing community*. Lincoln: University of Nebraska Press.

Kates, S. (2001). *Activist rhetorics and higher education*. Carbondale: Southern Illinois University Press.

Logan, S.W. (2008). *Liberating language: Sites of rhetorical education in nineteenth-century Black America*. Carbondale: Southern Illinois University Press.

Mathieu, P. (2005). *Tactics of hope: The public turn in English composition*. Portsmouth, NH: Boynton Cook/Heinemann.

Okawa, G.Y. (2008). Unbundling: Archival research and Japanese American communal memory of U.S. Justice Department Internment, 1941-45. In G.E. Kirsch & L. Rohan (Eds.), *Beyond the archives: Research as a lived process* (pp. 93-106). Carbondale: Southern Illinois University Press.

Owens, K.H. (2009). Confronting rhetorical disability: A critical analysis of women's birth plans. *Written Communication, 26*(3), 247-272.

Owens, K.H. (2010). Revelations and representations: Birth stories and motherhood on the Internet. In E. Podnieks & A. O'Reilly (Eds.), *Textual mothers, maternal texts: Representations of mothering in contemporary women's literatures* (pp. 351-366). West Waterloo, ON: Wilfred Laurier University Press.

Powell, K.M. (2007a). *The anguish of displacement: The politics of literacy in the letters of mountain families in Shenandoah National Park*. Charlottesville: University of Virginia Press.

Powell, K.M. (2007b). Virginia mountain women writing to government officials: Letters of request as social participation. In B. Daniell & P.L. Mortensen (Eds.),. *Women and literacy: Local and global inquiries for a new century* (pp. 71-90). Mahwah, NJ: Erlbaum.

Royster, J.J. (2000). *Traces of a stream: Literacy and social change among African American women*. Pittsburgh: University of Pittsburgh Press.

Royster, J.J., & Kirsch, G.E. (2012). *Feminist rhetorical practice: New horizons for rhetoric, composition and literacy studies*. Carbondale: Southern Illinois University Press.

Sharer, W. (2004). *Vote and voice: Women's organizations and political literacy, 1915-1930*. Carbondale: Southern Illinois University Press.

ABOUT THE EDITORS AND CONTRIBUTORS

EDITORS

Katrina M. Powell is Associate Professor of English and Director of Women's and Gender Studies at Virginia Tech. She is the author of *The Anguish of Displacement* (UVA Press, 2007) and editor of *'Answer at Once': Letters of Mountain Families in Shenandoah National Park, 1934-1938* (UVA Press, 2009). Her work focuses on research methodology, displacement narratives, and performative identities and has appeared in *College English*, *College Composition and Communication*, *Prose Studies*, *Biography*, and *Women's Studies*.

Pamela Takayoshi is Associate Professor in the Department of English at Kent State University. Her work includes: *Teaching Writing with Computers* (co-edited with Brian Huot), which was the recipient of the *Computers and Composition: An International Journal for Teachers of Writing* 2003 Distinguished Book Award; and *Labor, Writing Technologies, and the Shaping of Composition in the Academy* (co-edited with Patricia Sullivan). Additionally, her writing has appeared in *College Composition and Communication*, *Computers and Composition*, *Research in the Teaching of English*, *Journal of Business and Technical Communication*, and numerous edited collections.

CONTRIBUTORS

Joanne Addison is an Associate Professor in the Department of English at the University of Colorado Denver. Her work focuses on methodological matters in literacy research and she is currently using experience sampling methods to study the lived experience of college students.

Ellen Barton and **Richard Marback** are both Professors in the Composition/ Rhetoric Program in the English Department of Wayne State University. Their collaborative work on ethics as interactional and rhetorical also appears in *The Rhetoric of Healthcare: Essays Toward a New Disciplinary Inquiry* (Heifferon & Brown, 2008). They have presented their work at the Conference on College Composition and Communication and the Rhetoric Society of America.

Kelly Belanger is Associate Professor of English and Director of the Center for the Study of Rhetoric in Society at Virginia Tech, where she teaches courses in rhetoric and writing, At the University of Wyoming, she was Director of Composition and founding director of the Synergy Program. With Linda Strom, she published *Second Shift: Teaching Writing to Working Adults* (1999) and has written articles and chapters on composition, writing program administration, and professional writing. Her current work focuses on the rhetoric of social change, Title IX, and higher education athletics.

Stuart Blythe is an Associate Professor at Michigan State University. Through a series of individual and collaborative projects, he has theorized and studied ways that individuals find agency in complex organizations and technologically medi- ated situations. His work has appeared in such journals as *College Composition and Communication*, *Computers and Composition*, the *Journal of Business and Technical Communication*, *Works & Days*, and various edited collections.

Kerrie R. H. Farkas is Associate Professor of English and Director of the Center for Public Scholarship & Social Change at Millersville University. Her research focuses on civic discourse and citizen involvement in local government and on student preparation for informed and engaged public discourse.

Gwen Gorzelsky is Associate Professor and Director of Composition at Wayne State University. She has published articles in *College Composition and Communication*, *College English*, *JAC*, *Reflections*, and other venues. Her book, The *Language of Experience: Literate Practices and Social Change* (University of Pittsburgh Press, 2005), examines the relationship between literacy and change, both personal and social, through three examples of collective projects that use literacy to promote change.

Christina Haas is Professor of Writing Studies at the University of Minnesota. Her scholarship rests at the intersection of writing theories, digital technologies, and embodied practices. She is the author of *Writing Technology: Studies on the Materiality of Literacy* and her current project (*The Writing Hand*) examines the human hand as a productive site of interface between human cognition, embodiment, and writing technology. She is also editor of *Written Communication: An International Quarterly of Research, Theory, and Application.*

Annette Harris Powell is an Assistant Professor of English at Bellarmine University where she teaches courses in writing, Advanced Writing, and Caribbean literature. Her research interests include identity, writing and place, discourses of cultural preservation and community-based conservation, as well as Caribbean rhetoric and gendered perspectives in literature. Powell's current project examines identity, memory, and place in relation to the lived life and culture of the Gullah-Geechee communities of the Sea Islands.

Gail E. Hawisher is University Distinguished Teacher/Scholar and Professor Emeritus at the University of Illinois, Urbana-Champaign. Her work probes the many connections between literate activity and digital media as reflected in her coauthored books with Cynthia Selfe, *Literate Lives in the Information Age* (2004) and, with Selfe and Patrick W. Berry, *Transnational Literate Lives in Digital Times* (2012), a multimodal, born-digital study of how people from across the world take up literacy and digital media. She is proud to have been the co-editor of three different series with NCTE, Ablex, and Hampton Press, which have contributed to the field since 1989 over 35 scholarly books on historical, cultural, and educational influences of digital media on our literacies and lives. She and Selfe are also founding editors of Computers and Composition Digital Press, an open access, peer reviewed, online book series. Her university has awarded her the Campuswide Award for Excellence in Undergraduate Teaching and the Lynn M. Martin Award for Distinguished Women Faculty.

April Heaney directs the Learning Resource Networks at the University of Wyoming, where she teaches writing courses for the English Department. Heaney also directs the Synergy Program, a learning community for at-risk students that won the Conference on Basic Writing Award for Innovation and the Theodore M. Hesburgh Award for Excellence in Undergraduate Teaching and Learning (to learn more about the program, please visit http://uwyo.edu/SYNER-GY/). She has published articles in *IEEE: Professional Transactions, Journal of the Scholarship of Teaching and Learning,* and the *Journal of Basic Writing,* as well as several nonfiction journals and edited collections.

Wendy Wolters Hinshaw is an Assistant Professor in the Department of English at Florida Atlantic University. Her articles on the rhetoric of trauma, teaching testimonial literature, and pedagogical approaches to student resistance have

appeared in *JAC* and *Transformations*, as well as the collection *Silence and Listening as Rhetorical Acts*. Her current project, "Incarcerating Rhetorics, Publics, and Pedagogies," investigates how art and writing empower prisoners to counter reductive representations of criminality, and how activists mobilize prisoners' creative work to both humanize the incarcerated and re-educate the public about incarceration practices in the United States.

Brian Huot is Professor of English at Kent State University where he teaches undergraduate courses in writing and graduate courses, including courses on research in writing studies. In addition to contributing over fifty articles and book chapters, he has co-edited five collections, coauthored one book, and published the monograph, *(Re)Articulating Writing Assessment for Teaching and Learning*.

Gloria E. Jacobs is an Assistant Professor of literacy in the School of Education at St. John Fisher College in Rochester, New York. She researches adolescent literacies with particular attention to the implications of digital technologies for literacy learning and acquisition. She completed her doctorate at the University of Rochester, NY, and has published her work in the *Journal of Literacy Research*, *Reading Research Quarterly*, and *Journal of Adolescent and Adult Literacy*.

Gesa E. Kirsch is Professor of English at Bentley University in Waltham, MA. Her research interests include feminism and composition, ethics and representation, qualitative and archival research methods, and women's education in the progressive era. She has published numerous books, most recently a coauthored volume with Jacqueline Jones Royster, *Feminist Rhetorical Practices: New Horizons for Rhetoric, Composition, and Literacy*.

Sharon James McGee is an Associate Professor of English at Southern Illinois University Edwardsville. With Joanne Addison, she co-edited *Feminist Empirical Research: Emerging Perspectives on Qualitative and Teacher Research*. Most recently, Addison and McGee have conducted a national survey of writing instruction and secondary and postsecondary institutions, work which was published in *College Composition and Communication*.

Jeffrey Perry is an Assistant Professor of English and the director of composition at Southern Utah University. His research investigates and critiques institutional writing assessments through critical theories of reproduction, and he explores the pedagogical role of writing assessment in the composition classroom. His book, with coauthor Brian Huot, *The Role of Writing Assessment in the Classroom*, will be published by Utah State University Press in 2013.

Margaret Price is an Associate Professor of writing at Spelman College. Her book, *Mad at School: Rhetorics of Mental Disability and Academic Life* (2011), is part

of the "Corporealities" series from the University of Michigan Press. Other work has appeared in *College Composition and Communication, Disability Studies Quarterly, Across the Disciplines*, and *Bitch: Feminist Response to Pop Culture*.

Ruth Ray is Professor of English at Wayne State University. She has conducted qualitative research, including community ethnographies, classroom-based studies, interviews, oral histories, and case studies for nearly 30 years. Most recently she has been conducting archival research and writing biographies and auto/biographies.

K.J. Rawson is an Assistant Professor in the Department of English at the College of the Holy Cross. At the intersections of queer, feminist, and rhetorical studies, his scholarship focuses on the rhetorical dimensions of queer and transgender archiving in both traditional and digital collections. With Eileen E. Schell, he co-edited *Rhetorica in Motion: Feminist Rhetorical Methods and Methodologies* (University of Pittsburgh Press, 2010) and his scholarship has also appeared in *Archivaria* and several edited collections.

Eileen E. Schell is Associate Professor of Writing and Chair and Director of the Writing Program at Syracuse University. Her research interests are labor histories and practices in writing and higher education, feminist rhetorics and composition studies, and environmental and agrarian rhetorics. She is the author of *Gypsy Academics and Mother-teachers: Gender, Contingent Labor, and Writing Instruction* (Heinemann-Boynton/Cook, 1997), coauthor of *Rural Literacies* (SIUP, 2007) with Kim Donehower and Charlotte Hogg, coeditor with Patricia Stock of *Moving a Mountain: Transforming the Role of Contingent Faculty in Composition Studies and Higher Education* (2001, NCTE), and also co-editor with KJ Rawson of *Rhetorica in Motion: Feminist Rhetorical Methods and Methodologies* (University of Pittsburgh Press, 2010).

Cynthia Selfe is Humanities Distinguished Professor in the Department of English at The Ohio State University. She is co-founder and Executive Editor of Computers and Composition Digital Press/Utah State University Press (with Gail Hawisher) and the co-Founder and co-Director of the Digital Archive of Literacy Narratives (with H. Lewis Ulman). In 1996, Selfe was recognized as an EDUCOM Medal award winner for innovative computer use in higher education—the first woman and the first English teacher ever to receive this award. In 2000, Selfe, along with long-time collaborator Gail Hawisher, was presented with the Outstanding Technology Innovator award by the CCCC Committee on Computers. Selfe has served as the Chair of the Conference on College Composition and Communication and the Chair of the College Section of the National Council of Teachers of English.

Christa Teston is an Assistant Professor of Technical Communication at the University of Idaho. In addition to her work on research methodology, she has published research on deliberative rhetoric, visualization practices, and pharmaceutical policymaking in *Written Communication*, *Technical Communication Quarterly*, and The *Journal of Medical Humanities*.

Elizabeth Tomlinson is a teaching Assistant Professor in the Marketing Department at West Virginia University where she teaches business communication and introduction to business and directs the Business Communications Center. Her recent research deals with audience and invention and digital identity construction. Her scholarship has been published in *Community Literacy Journal*, *Teaching English in the Two Year College*, and others.

Michael M. Williamson is Professor of English at Indiana University of Pennsylvania where he has held numerous administrative posts and taught undergraduate courses in reading and writing. In addition, Williamson has been teaching graduate courses in writing studies, including research in writing for almost 30 years. His published research has appeared in various journals and collections including *Research in Teaching English* and three contributions (the most of any individual) in the recently published collection *Assessing Writing: A Critical Sourcebook*.

AUTHOR INDEX

Addison, J., 4, 5, 9, 10, 26, 380, *382*
Adorno, T., 125, *139*
AERA/APA/NCME, 191-192, *209*
Airress, C.A., 296, *305*
Aldridge, M., 62, 63, 63(n1), 68(n3), 70, 72, 77, 78
Althusser, L., 190(n3), *209*
Alvesson, M., 326-327, *328*
American Bible Society, 300, 301, 302, 303, 304, *305*
American Medical Association (AMA), 63, 64, 65, 77
Anderson, B., 297, *305*
Anderson, L., 333, 342, *345*
Anderson, P., 144, 144(n1), *156*
Anspach, R., 63, 78
Appadurai, A., 299, *305*, 403, *407*
Apple, M., 196-197, *209*
Applebee, A., 200, *210*
Arendt, H., 91, *94*
Art for a Child's Safe America Foundation, 256, 257, 264, 265, *271*
Asch, A., 164, *182*
Associated Press, 303, *305*
Atkinson, P., 309, *328*

Baldwin, C.S., 36, *55*
Ball, A.F., 47, *55*, 357, *370*
Barad, K., 3, 4, *26*
Barnes, C., 168, *182*, *183*
Barton, D., 334, *345*
Barton, E., 60, 61, 62, 63, 63(n1), 65, 65(n2), 68(n3), 70, 71, 72, 77, 78, 163, *183*, 285, 289, 307, 309, *328*, *329*
Barton, L., 168, *183*
Bateson, G., 93, *94*
Bazerman, C., 104, *120*, 307, *329*
Bean, J., 227, *234*
Beauchamp, T., 60, 62, 65, *78*
Becker, A.L., 103, 104, *121*
Benhabib, S., 91, *94*
Beresford, P., 164, 175, *186*
Berlak, H., 193, *209*
Berlin, J.A., 33, 34, 35, 36, 46, 47, *55*, 124, 126, 131, 136, *138*, *140*
Berliner, D., 198, 200, *210*
Berry, P., 394, *407*
Bizzell, P., 40, *55*, 126, 128, *138*
Blakeslee, A., 97, 99, 99(n1), 100, 100(n2), *120*, 359, 360, 362, 363, *370*
Bloome, D., 334, *346*

Blythe, S., 21, *26*, 199, *211*, 276, 285(n6), *289*, *290*

Bochner, A., 333, 342, *346*

Booth, B., 246, *248*

Booth, T., 166, 167, *183*

Boscolo, P., 357, *370*

Bourdieu, P., 299, *305*

Bousquet, M., 132, 135, 136, *138*

Bracewell, R., 307, *329*

Bracey, G.W., 42, *55*, 199, *209*

Bracher, M., 91, *94*

Brackett, S., 67, 79

Braddock, R., 31, *55*

Brandt, D., 40, *55*, 300, 301, *305*, 349, *370*, 381, *382*

Brettell, C.B., 387, *407*

Brewer, J.D., 112, *120*

Brookfield, S., 197(n8), *209*

Bruce, B.C., 401(n4), *407*

Brueggemann, B.J., 160(n3), 166, 166(n5), 167, 172, 173, 175, 175(n9), *183*

Bruner, E.M., 148, *156*

Brunner, B., 143, *156*

Buchanan, L., 130, *138*

Buck, A., 394, *407*

Burbules, L.D., 148, *156*

Burch, S., 168(n7), *183*

Burke, K., 167, *183*, 254-255, 259, *271*

Burns, J., 67, 79

Burton, A., 239, *248*

Burton, V.T., 350, *370*

Butler, J., 263, *271*

Byrd, A., 295, *305*

Caiti, T., 259, *271*

Cameron, D., 5, *26*

Camp, R., 190, 200-201, 206, *209*

Canagarajah, S.A., 303-304, *306*, 389, 403, *407*

Canning, K., 6, *26*

Carnap, R., 33, 43, 43(n6), 44, 46, 51, 53, *55*

Carter, P., 402, *407*

Carter, S.P., 334, *346*

Casanave, C.P., 401, *407*

Cassell, J., 63, 63(n1), *78*

Castellano, M., 99, *120*

Chadwick, B., 202, 203, 205, *209*

Charleton, J.I., 168(n7), *183*

Charney, D., 32, *55*

Chenoweth, L., 166, *184*

Chepesiuk, R., 302, *306*

Cherry, R., 192, 199, 204, 206, *209*

Cherryholmes, C.H., 36, *55*

Chesney-Lind, M., 261, *271*, 272

Childress, R., 60, 62, 65, *78*

Chinn, S.E., 247, *249*

Chiseri-Strater, E., 358, 360, *370*

Christakis, N., 63, *78*

Christian, B.M., 334, *346*

Cist, A., 67, 79

Clandinen, D.J., 381, *382*

Clare, E., 160, 164, 178, *183*

Clifford, J., 321, 327, *329*

Cochran, C., 100, *120*

Cochran-Smith, M., 160, *183*

Coffield, K., 388, *407*

Cole, C.M., 359, 360, 362, 363, *370*

Cole, M., 349, 371

Collins, T., 172, *183*

Collins, V.T., 129, *138*

Combs, P., 221, *234*

Conefrey, T., 359, 360, 362, 363, *370*

Connor, U., 62, *78*

Connors, R.J., 31, 38, *55*, 124, 131, 132, *139*

Cook, J., 2, 9, 16, *26*, 104, *120*

Coombs, W.E., 38, 47, 51, 53, *57*

Corbin, J., 50, 52, *55*, 82-83, 6, 89, 90, 91, 95, 113, 116, *120*, 341, *347*

Corker, M., 164, 166(n5), *183*

Couser, G.T., 175, *183*

Creswell, J.W., 38, *55*

Cronbach, L.J., 197, 199, 204, 206, *209*

Crowley, S., 124, 127, 128, 132, *139*, *140*

Curley, M., 67, 79

Curtis, J.R., 63, *78*

Curtis, M., 349, *370*

Cushman, E., 7, 14, *26*, 68, *78*, 275, 279-280, 282, 283, 284, 285, 286, *290*, 358, 359, 360, 361, 363, 366, 368, *370*

Cvetkovich, A., 241, 243, *249*

Daniell, B., 5-6, *26*, 350, 351, 354-355, 356-357, 364, *370*

Danis, M., 67, 79

Dash, J., 293, *306*
Dautermann, J., 309, *329*
Davidman, L., 104, *121*
Davis, L.J., 160, 163, 164, 166(n5), 172, *183*
Dawson, J., 240, 241, *249*
De Bruin, D., 149, 150, *156*
De Certeau, M., 255, 257, *271*
De Vries, R., 149, 150, *156*
Demartini, A., 252, *271*
Denkler, A.E., 204, *306*
Derrida, J., 91, *94*
DeVoss, D.N., 16(n7), *27*
Dewey, J., 87, *94*
Diamond, L., 11-12, *26*
Dobrin, D., 40, *55*
Dolmage, J., 165-166, 167, 177, 181, *183*
Dougherty, D.S., 145(n3), 146, 147-148, 149, *156*
Doyle, R., 253, *271*
Duffy, J., 389, 403, *407*
Dunn, P.A., 177, *183*
Dunye, C., 243, *249*
Durst, R.K., 200, *209*, 367, *370*

Ebert, T., 125, *139*
Ede, L., 71, *78*
Egan, J., 166, *184*
Elbow, P., 92, *94*
Ellingson, L., 309, *329*
Elliot, N., 188, 190, 191, 193, *209*
Ellis, C., 333, 339, 342, *346*
El-Wakil, S., 388, *407*
Emerson, R.M., 315, *329*, 362, *370*
Emig, J., 104, *120*
Engel, D.M., 166, *184*
Enoch, J., 412, *414*
Enos, R., 317, 327, *329*

Faber, B., 282, *290*
Facione, P.A., 222, 223, *234*
Faigley, L., 35, 40, *55*
Fairclough, N., 163, 180, *184*, 195, *209*
Fals Borda, O., 275, *290*
Farkas, K.R.H., 85, 88, 90, *94*
Farmer, J.D., 342, *346*
Federal Bureau of Investigation, 254, *271*
Ferreira-Buckley, L., 238-239, *249*

Finders, M., 332, *346*
Fine, M., 1, 2, *26*, 104, *120*, 164, 175-176, 181, *182*, *184*, 333, 336, 337, 338, 341, *346*
Finkin, M., 148, *156*
Fishman, S.M., 360, 371
Fleischer, C., 97, 99, 99(n1), 100, 100(n2), *120*
Flower, L., 275, 279, 280, 282, 283, 284, 285, *290*
Flynn, E., 35, *55*
Fonow, M.M., 2, 9, 16, *26*, 104, *120*
Forester, J., 75, *78*
Foucault, M., 197(n9), *209*, 254, *271*
Franklin, H.B., 267, *271*
Fraser, K.L., 99, *120*
Fraser, N., 91, *94*
Freedman, A., 200, *209*, 211
Fretz, R.I., 315, *329*, 362, *370*
Fritsch, E., 259, *271*
Froelicher, E., 145(n3), 150, *157*

Gaillet, L.L., 237, *249*
Gale, X.L., 239(n2), *249*
Gallagher, C., 192, *209*
Garland-Thomson, R., 168, 172, *184*
Gee, J.P., 334, 336, *346*, 361, *370*
Geertz, C., 213, 321, 327, *329*
George, A., 213, *234*
Gere, A.R., 409, *414*
Gerretson, H., 342, *346*
Giddens, A., 403, *407*
Gilbert, D., 217, 221, *234*
Gladwell, M., 160, *184*
Glaser, B., 81, 82, 83, 84, 85, 86, 87, 90, 91, *94*, 315, 326, *329*
Glenn, C., 128, *139*, 239(n2), *249*, 262, 264, *271*
Goffman, E., 253, 254, 255, 259, *272*
Goggin, M.D., 131, *139*
Goldberg, J.P., 148, *156*
Golombisky, K., 9, *26*
Goodgame, A., 149, 150, *156*
Goswami, D., 161, *185*
Gould, S., 188, 191, 193, 193(n5), *210*
Grabill, J., 11, 21, *26*, 199, *211*, 276, 275, 279, 280, 282, 283, 284, 285, 285(n6), *289*, *290*, *291*

Graham, S.S., 12, *26*
Graves, W., 220, *234*
Green, B., 341, *347*
Greenough, W.T., 148, *156*
Grosz, E., 127, 128, *139*
Guba, E., 35, *56*
Gump, S.E., 394, *407*
Gunsalus, C.K., 148, 150, 153, *156*
Guo, Y-H., 388, 389, *407*

Haas, C., 82, 89, 91, *94*, 307, *329*
Habermas, J., 91, *94*
Hadjuk, T., 100, *120*
Halberstam, J., 243, *249*
Hames-Garcia, M., 253, 272
Hamilton, H., 60, 62, *78*, 79
Hamilton, M., 334, *345*
Hanson, A., 193, 197(n9), *210*
Haraway, D., 81, *94*, 171, *184*, 336, 337, 344, *346*
Harding, S., 1, 2, 16, *26*, 334, 336, 337, 344, *346*, 373, *382*
Harris, R., 91, *94*
Harrison, T.M., 279, 282, 284, 298, *290*
Hastings, P., 253, 272
Haswell, R., 3, *27*, 32, 40, 51, 53, *56*, 112, *120*, 199, *210*
Hawisher, G.E., 387, 388, 389, 394, *407*, 408
Hayes, J.R., 100, *120*
Heath, S.B., 197, 198, *210*, 275, 280, 282, 284, *290*, 349, *370*
Henderson, D., 62, *79*
Hennessey, R., 125, *139*
Herndl, C., 281, 285, *290*
Herrington, A.J., 161, *185*, 349, *370*
Hertsgaard, M., 221, 228, *234*
Hesford, W.S., *138*(n1), *139*, 296, *306*, 385, 386(n1), *407*
Heyes, C., 5, *26*
Hidi, S., 357, *370*
Hillocks, G., 31, 38, 45(n8), 50, 52, *56*, 197, 200, *210*
Hirsch, E., 379, *382*
Hogg, C., 409, *414*
Holbrook, S.E., 131, 132, *139*
Holding, L.H., 394, *407*
Holewa, H., 62, 79

Holmes, K.E., 300, *306*
Holmstrom, N., 136, *139*
Horkheimer, M., 125, *139*
Horner, B., 15(n4), 27, 127, 132, *139*
Huberman, A.M., 316, *329*
Hudson, R., 51, 53, *56*
Hull, G., 99, *120*, 334, 337, *346*
Hunter, A., 112, *120*
Huntley, D., 302-303, *306*
Huot, B., 41, 42, *56*, 190, 191, 192, 193, 194, 195, 206, *210*

Information, Please, 145, *157*
Ingraham, C., 2, *27*
Institute on Women and Criminal Justice, 258, 272
Ivanic, R., 334, *345*

Jacobi, T., 253, 272
Jacobs, G., 331, 332, *346*
Jaffe, A., 387, *407*
Jarratt, S.C., 239(n2), *249*
Joe, K., 261, 272
Johnson, N., 130, *139*
Johnson, P., 253, 268-269, 272
Johnstone, B., 62, *78*
Jones, L., 221, *234*
Jonson, A., 60, 63, *78*
Joyappa, V., 342, *346*
Joyner, C., 293, *306*

Kates, S., 409, *414*
Katz, J., 221, *234*, 246, *249*
Kaufman, S., 63, *78*
Kehl, K., 67, 79
Keller, C., 385, 388, 403, *407*
Kelsh, D., 125, 133, 134, 136, *139*
Kemmis, S., 336, 342, *346*
Kennedy, G.A., 36, *56*
Kerr, T., 253, 272
Kessler, S., 5, *27*
King, R., 257, 272
Kirchoff, K., 67, 79
Kirsch, G.E., 5, 7-8, 10, 15(n4), *27*, 35, *56*, 101-102, 104, 109, 113, *120*, *121*, 153, *157*, 172, *184*, 237, *249*, 413, *414*
Knobel, M., 334, *346*
Kornfield, P., 255, 272

Kramer, M.W., 145(n3), 146, 147-148, 149, *156*
Kroeger, S., 172, *183*
Kroll, B., 106-107, 109, *120*

L'Eplattenier, B., 237, *249*
Labov, W., 374, 375-376, *382*
Ladson-Billings, G., 342, *346*
Lam. W.S.E., 386, *407*
Lamb, W., 266, *272*
Langer, J.A., 200, *210*
Lankshear, C., 334, 341, *346, 347*
Lareau, A., 225, *234*
Lashore, O., 388, *408*
Lassak, M., 342, *346*
Last Acts Coalition, 63, 79
Lather, P., 8, 27, 104, *120*, 167, *184*
Latour, B., 104, *120*, 401, *407*
Lauer, J., 317, 327, *329*
Lawson, C., 270, *272*
Lay, M., 35, *56*
LeBlanc, A.N., 221, *234*
Lee, A., 169, 176, *184*
Lehmann, N., 188, *210*
Leonard, Z., 243, *249*
Leonhardt, D., 216, *234*
Lewiecki-Wilson, C., 173(n8), 176, *184*
Lewis, B.E., 175, *184*
Lincoln, Y., 148, *157*
Lindemann, E., 281, *290*
Lindquist, J., 350, 371
Linton, S., 163-164, 171, 172, 174, 178, *184*
Lipson, M.Y., 166, *184*
Liu, L., 388, 389, *407*
Lloyd-Jones, R., 31, *55*
Loffreda, B., 216(n1), 221, *234*
Logan, S.W., 412, *414*
Longmore, P.K., 168(n7), *184*
Lovett, M., 394, 408
Lu, M., 15(n4), 27
Lubrano, A., 216, 230-31, *234*
Ludlow, R., 252, *272*
Luke, A., 334, 337, *347*, 389, 403, 408
Luke, C., 389, 403, 408
Lunsford, A., 71, *78*
Lytle, S.L., 160, *183*

MacClean, M., 100, *120*
MacGillivray, A., 386, 408
MacNealy, M.S., 100, 104, *121*
Madaus, G., 191, 194-194, *210*
Mahiri, J., 349, 371
Malone, R.E., 145(n3), 150, *157*
Marback, R., 61, *78*
Martin, D.J., 342, *346*
Martinez-Leon, N., 386, 408
Marx, K., 125, *139*
Mastrangelo, L., 237, *249*, 253, 272
Matchett, M.L., 100, *120*
Mathieu, P., 409, *414*
Matsuda, P.K., 386, 389, 403, 408
Mattingly, C., 130, *139*
Mauer, M., 257, 272
Mbembe, A., 238, *249*
McAuliffe, D., 166, *184*
McCabe, M., 100, *120*
McCaffrey, M., 100, *120*
McCarthy, L.P., 309, *329*, 360, 371
McComas, K.A., 279, *290*
McCurdy, D.W., 230, *235*
McDonald, S.P., 38, *56*
McGrath, P., 62, 79
McGruder, C., 145(n3), 150, *157*
McKee, H.A., 16(n7), 27, 146, *157*
McKenna, W., 5, 27
McRuer, R., 175(n9), *184*
McTaggert, R., 336, 342, *346*
Medway, P., 307, *329*
Mercer, G., 167, *184*
Messick, S., 188, 188(n1), 192, 195, 197, 198, 206, *210*
Middleman, R., 244, 245, *249*
Miles, L., 199, *211*
Miles, M., 316, *329*
Miller, S., 131, 132, *139*
Mishler, E., 65, 79
Mitchell, D.T., 160, *184*
Mitchell, J., 36, *56*
Mitchell, W.J.T., 172, *184*
Mohr, M., 100, *120*
Moje, E., 332, *347*
Mollow, A., 164, 180, *185*
Monberg, T.G., 7, *26*
Morrison, J., 253, *272*
Mortensen, P., 5, 27, 101-102, 109, *121*

Moss, P., 192-193, 199, 206, *210*
Mountford, R., 130, *139*
Munger, F.W., 166, *184*
Murphy, J.J., 36, *56*
Murphy, T., 144, 145, *157*
Murray, D., 92, *94*

Nadeau, J-P., 35, *57*
Nahrwold, C., 281, 285, *290*
Naples, N., 97, 98, 101(n4), *121*
Nash, R., 379, 380, *383*
National Park Service, 299, *306*
Neal, M., 190, 191, *210*
Neff, J.M., 85, *94*
Nellis, A., 257, *272*
Nelson, C., 145(n3), *157*
New London Group, 334, *347*
Newman, L., 221, *234*
Nichols, S., 198, 200, *210*
Noddings, N., 220, *234*, 344, *347*
Nuland, S., 70, *79*
Nystand, M., 191, *210*

O'Connor, P., 253, 263, *272*
O'Sullivan, M., 240, 241, *249*
Odell, L., 161, *185*, 200, *211*
Office of Human Subjects Research, 145(n2), *157*
Office of Juvenile Justice and Delinquency Prevention, 252, *272*
Okawa, G.Y., 409, *414*
Olbrechts-Tyteca, L., 103, *121*
Oliver, M., 164, 168, *183*, *185*
Olson, C., 394, *407*
Olson, D., 91, *94*
Olson, G., 379, *382*
Otto, S., 334, *346*
Owens, K.H., 409, *414*

Padden, C.A., 166(n5), *185*,
Pajares, F., 357, 371
Parascandola, L., 132, 135, 136, *138*
Pari, C., 213, *235*
Parks, S., 14(n3), *27*
Patrick, D., 63, *78*
Penrose, A.M., 200, *211*
Peräkylä, A., 63, *79*
Perelman, C., 103, *121*
Perkel, D., 340, *347*

Peskin, A., 333, *347*
Peterson, A., 164, *185*
Phelps, L.W., 187, 188-189, *211*, 377-378, *383*
Pike, K., 103, 104, *121*
Pompa, L., 253, *272*
Porter, J., 16, *27*, 68, 73, 74, 75, 79, 97, 98, *121*, 187, 188, 199, *211*, 275, *291*
Powell, K.M., 13-14, *27*, 275, 282, 283, 285, *290*, 412, *414*
Pratt, M., 252-253, *272*
Pratt, M.L., 160, 165, 165(n4), *185*
Prendergast, C., 173(n8), *185*
Presser, L., 1, 2, *27*
Price, M., 161, 163, 173(n8), 175(n9), *185*
Prieto, M.J., 401, *408*
Pringle, I., 200, *209*, *211*
Prior, P., 307, *329*, 394, *407*

Queen, M., 386-387, *408*

Raimon, M., 268-269, *272*
Ramsay, A.E., 237, *249*
Ratcliffe, K., 98, *121*, 124, 125, *139*
Rawson, K.J., 8, 21, *27*
Ray, R., 10, *27*
Readings, B., 196, 198, *211*
Reed-Danahay, D.E., 333, 342, *347*
Reinharz, S., 104, *121*
Reynolds, N., 388, *408*
Reynolds, T., 268-269, *272*
Richardson, L., 11, *27*, 102, 104, *121*, 388, *408*
Ricouer, P., 381-*382*, *383*
Riesenweber, J., 296, *306*
Riley, K., 21, *26*, 276, 285(n6), *289*
Rittel, H., 277, *290*
Roach, J., 278, *290*, 296, 302, *306*
Roberts, C., 62, *79*
Rodriguez, D., 253, *272*
Rogers, L., 253, *272*
Rogers, R., 175, *185*, 195(n7), *211*
Rohan, L., 8, *27*, 131, *139*, 237, *249*
Rorty, R.M., 32-33, *56*
Rose, M., 99, *120*, 216, *234*
Rosiek, J., 381, *382*
Ross, J., 278, *290*

Royster, J.J., 7-8, 15(n4), 27, 409, 412, 413, *414*
Rubin, B.C., 216, *235*
Rupp. L., 2, 9, 9(n2), *28*

Sacks, P., 193, *211*
Samuels, E., 175(n9), *185*
Sanneh, L., 302, *306*
Sarangi, S., 62, 79
Sauer, B., 307, 317, 323, 325, *329*
Sauer, C.O., 295, *306*
Sawhill, I., 221, *235*
Schell, E.E., 8, 21, 27, 131, 132, 135, *138*(n1), *139*, *140*, 386(n1), *407*
Schiffrin, D., 62, 79
Schneider, C., 60, 65, 79
Schneider, M., 172, *183*
Schoer, L., 31, *55*
Schön, D., 14, 27, 34, 37, *56*, 73, 79, 101, *121*, 197(n8), *211*
Schultz, K., 334, 337, *346*
Scott, J.B., 12-13, 27, 282, *290*, *291*
Scott, R., 317, *329*
Scott, T., 132, 135, 136, *138*
Scribner, S., 349, 371
Segal, J., 65, 79, 309, *329*
Seitz, D., 350, 351, 352, 353, 354, 357, 371
Selfe, C.L., 14, *27*, 387, 388, 389, *407*, 408
Selzer, J., 125, 125, 127, *139*
Shakespeare, T., 166(n5), *183*
Shapiro, J.P., 168(n7), *185*
Sharer, W., 409, *414*
Sharer, W.B., 237, *249*
Shaughnessy, M., 177, *185*
Shaw, B., 168(n7), *185*
Shaw, L.L., 315, *329*, 362, *370*
Sheldon, R., 261, *271*
Shermer, M., 222, *235*
Shohany, E., 193, *211*
Shor, I., 213, 222, 223, 233, *235*
Shuart-Faris, N., 334, *346*
Siebers, T., 164, 169, 172, 175(n9), *185*
Siegler, M., 60, 63, 78
Simmons, W.M., 275, 279, 282, 283, 284, 285, *291*
Simon, S., 303, *306*

Skoldberg, K., 326-327, *328*
Smagorinsky, P., 40, 44, *56*, 103(n8), 106, 110, 111, *121*, 361(n3), 362, 366(n5), 371
Smith, J., 367, 371
Smith, J.K., 35, *56*
Smith, P.H., 386, 408
Smith, W.L., 38, 43, 47, 51, 53, *56-57*
Smithies, C., 8, 27
Snyder, I., 341, *347*
Snyder, S.L., 160, *184*
Society of American Archivists, The, 238, 249, 297, *306*
Solberg, J., 394, *407*
Solinger, R., 268-269, 272
Solomon, M., 60, 79
Song, M., 67, 79
Song, P., 388, 408
Southwest Educational Development Laboratory, 218, *235*
Spinuzzi, C., 307, *329*
Spradley, J.P., 230, *235*
Squier, J., 394, 408
Stamps, J., 380-381, *383*
Steedman, P., 315, *329*
Stewart, K., 296, *306*
Stone, E., 160, 165, 171, *185*
Strauss, A., 50, 52, *55*, 82, 82-83, 84, 85. 86, 87, 88, 89, 90, 91, *94*, *95*, 113, 116, *120*, 315, 326, 327, *329*, *330*, 341, *347*
Street, B.V. 34(n2), *57*, 200(n10), *211*, 303, *306*, 334, 336, 337, *347*, 349, *371*
Strickland, D., 124, 132, 133, 135, 136, *140*
Stuart, O.W., 164, *185*
Sullivan, P.A., 16, 27, 35, *57*, 68, 73, 74, 75, 79, 97, 98, *121*, 187, 188, 199, *211*, 275, *291*, 359, 360, *371*
Sunstein, B.S., 360, *371*
SUPPORT Principal Investigators, 63, 79
Swartz, O., 143, 149, *157*
Symposium Collective, 5, 7, 27

Takayoshi, P., 13-14, 27, 275, 282, 283, 285, *290*
Tannen, D., 62, 79
Tapia, R., 268-269, 272

Tashakkori, A., 82, *95*
Taylor, V., 2, 9, 9(n2), *28*
Teddlie, C., 82, *95*
Thompson, W.M., 172, *186*
Tierney, W.J., 148, *157*
Tinberg, H., 35, *57*
Toulmin, S., 103, *121*
Trainor, J.S., 350, 351, 352, 352(n1), 357, 367, *371*
Trimble, T., 62, 63, 65(n8), *78*
Trimbur, J., 126, 136, *140*
Truog, R., 67, *79*
Turnbull, N., 37, *57*

U.S. Census Bureau, 252(n2), *272*
U.S. Department of Health and Human Services, 153, *157*
Upton, T., 62, *78*
Urrea, L., 221, *235*

Valiante, G., 357, *371*
Vidovic, J., 62, 63, 65(n8), *78*
Villanueva, V., 123, 134-135, 136, *140*

Waletsky, J., 374, 375, *382*
Walmsley, J., 166, 168, *186*
Watts, S., 145(n3), *157*
Webber, M.M., 277, *290*
Weis, L., 175-176, 181, *184*

Wendell, S., 164, 172, *186*
Weseen, S., 175-176, 181, *184*
Whalen, B., 12, *26*
White, E.M., 190, *211*
White, R.F., 144(n1), 146, 148, 150, 151, *157*
Williamson, M.M., 190, 192, *211*
Wilson, A., 164, 175, *186*
Winslade, W., 60, 63, *78*
Winsor, D., 307, *330*
Witte, S.P., 192, 199, 204, 206, *209*, 307, *329*
Wixson, K.K., 166, *184*
Wong, L., 175-176, 181, *184*
Wrigley, O., 166(n5), *186*

X, M., 266, *272*

Yancey, K.B., 190, *211*
Yerger, V.B., 145(n3), 150, *157*
Yin, R., 378, *383*
Youn, E.S., 401, *408*
Young, M., 257, 272, 389, 403, *408*
Young, R., 100, *120*
Young, R.E., 97, 98, 100, 100(n3), 103, 104, 113, *121*

Zappen, J.T., 279, 282, 284, 298, *290*
Zussman, R., 63, *79*

SUBJECT INDEX

Activism, 11, 13, 159, 168-171, 187, 206, 237-250, 275-292

Analysis, data, 1, 5, 9, 12-15, 32, 39, 40, 50, 51-52, 53, 59-80, 82, 83-84, 90, 98, 99, 107, 112-114, 115-116, 118, 124, 126, 128-131, 136-138, 148, 160, 163, 195, 215, 253, 315, 316, 317-318, 324-325, 337, 339, 351, 361, 363, 377-378, 386, 413; *see also* Research Practices

 Constant comparison, 82, 83, 86, 91, 163

 Discourse Analysis, 61-63, 68, 70, 71, 163, 195, 207, 253, 309, 313, 333

Grounded theory, 39, 81-96, 307-330

Archive/archival, 8, 16, 294-295, 378

Art, 106, 237-250, 251-272, 294-295

Assessment, 42, 43, 70, 71, 72, 187-212

Class, viii, 97, 100, 103, 115, 123, 124, 126, 128, 131-136, 151, 153, 172, 191, 199, 201, 205, 207, 213-236, 242, 332, 350, 353, 389, 393, 404, 409

Cognitive dissonance, 100, 104, 107

Collaboration/collaborative, 8, 9, 12, 13, 15, 39, 83, 110-111, 114, 119, 152, 154, 155, 176, 193, 222, 275, 282,

285, 307-308, 317, 325, 339-341, 342, 388, 411, 413

Composition, viii, 10, 14, 31, 32, 40, 43, 51, 53, 60, 68, 71

Confidentiality, 307 -308

Contact zones, 252-253

Convergence, 15, 68

Data collection, 2, 3, 12, 14, 15, 50, 52, 53, 54, 77, 82-85, 99, 111, 118, 144, 149, 162, 167, 215, 238-239, 242, 280, 282, 296, 307-330, 331-348, 351, 362, 363, 364-368, 378 -379

Data analysis, 52, 98, 107, 112-113, 118, 160, 163, 215, 351, 361, 363, 413

Descriptive analysis: 59, 60, 61, 67, 71, 77

Diffractive/diffraction, 3, 4, 7, 8, 11, 12, 16

Dilemma, 59, 60, 61, 68, 71, 77

Embodiment: 125, 127-128, 137, 164, 239-242, 320, 365

Empirical, 2, 4, 6, 11, 16, 31, 32, 34, 37, 38, 40, 43, 44, 46, 48, 50, 51, 52, 53, 54, 60, 62, 67, 73, 74, 75

Empower/empowering, 9, 10, 74, 75

Epistemology(ies), 1, 2, 4, 5, 10, 11, 14, 15, 16, 32, 35-37, 38, 40, 44, 45, 46,

47, 48, 50, 51, 52, 53, 54, 59, 97, 98, 100, 108, 111, 113, 118, 146, 148, 149, 152, 164, 186
Ethics/ethical, vii, 1, 3, 4, 10, 11, 14, 15, 16, 59, 60, 61, 62-77

Globalization: viii, 24, 136 -137
Grounded theory, *see* Analysis, Data

Heuristics for researchers, 7, 22-23, 45, 51, 53, 59, 60, 103, 114-115, 287, 316, 317-321

Ideologies, 1, 2, 6, 33, 34, 36, 37, 46, 47, 50, 52, 54, 148 -149.
Institutions, institutional critique, 42, 62, 68, 124, 129, 135, 138, 165, 183, 189-190, 198-199, 214, 237-238, 239, 251-272
Interpretation, 82-83, 101, 107, 112

Linguistics, 59, 60, 61, 62, 63, 71, 72, 77
LGBT identity (sexual orientation, gay or queer identity), 2, 12, 97, 100, 103, 115, 123, 135, 152, 174, 179, 182, 216, 221, 237-250, 238, 261 -262,
Literacy(ies), vii, 5, 6, 14, 15, 16, 32, 40, 47, 49, 50, 52, 54
 Community, 283, 368
 Digital, 332
 School-based literacies, 105, 106-107
 Theories of, 194, 200, 349
 Workplace literacies, 85, 307

Material conditions, 4, 16, 124-125, 128-129, 135
Memory, 296
Methods, 1, 37-40, 109-111
 Autoethnography: 333, 365-367
 Data collection, *see* Data Collection
 Data analysis, *see* Data Analysis
 Ethnographic, 9, 16, 32, 37, 39, 43, 51, 53, 335
 Facilitated communication, 176
 Field notes, 83, 87, 92, 220, 312-314, 316, 318, 321, 331, 333, 335, 338, 344, 361-363, 365-366, 367, 368, 370
 Historical, 6, 8, 123-126, 130-132, 191, 237-250, 293-306

Interviews: 12, 43, 87, 90, 103, 117, 119, 137, 147, 151, 153, 161, 166-167, 170-171, 214, 215, 217, 220, 229-230, 259, 269-270, 277, 289, 337-339, 342, 344, 365, 378, 386-387
 Mapping, 50, 86, 91-92, 280, 318
 Observation, 87-89, 321-324, 335, 367 -368
Multimodal composing, 106, 125, 334

Narrative (narrative theory), 4, 6, 7, 8, 9, 10, 12, 13, 14, 15, 16, 39, 45, 59-80, 373-384
NCTE, 13, 40, 106, 132

Orality, 131-132, 294, 303, 307-309, 312, 319, 327, 374-375, 390

Participant: 1, 2, 6, 7, 8, 9, 10, 11, 12, 13, 14, 15, 16, 39, 45
Participatory research, 9, 16, 39, 336
Pedagogy, 47, 110, 128, 131-134, 147, 159, 160-164, 169
 and assessment, 190, 197, 202-203
 critical pedagogy, 10, 126, 213-236, 350-353, 367
 writing pedagogy
Positionality, 2, 5
Preservation, 237-250, 293-306
Process, vii, viii, 1, 2, 4, 6, 9, 10, 11, 12, 14, 15, 16, 31, 34, 37, 42, 46, 50, 52, 53, 63, 65, 66, 73, 74
Promotion, 11, 13
Publication, 11, 13
Public, 11, 50, 52, 62

Race and ethnicity: 14, 47, 97, 100, 103, 115, 124, 128, 134-135, 136, 151, 199, 201, 203, 216, 222, 225, 242-243, 283, 332, 336, 350, 351-352, 353-354, 354, 389
Reflection
 Reflection in action, 73
 Reflective practice, 15, 16, 34, 42, 74, 75, 101, 183, 188, 193, 213, 326-327
Reflection on ourselves as researchers (self reflexivity), vii, 2-4, 7-8, 104-106, 112-113, 159, 168, 171-172, 358-360

Reliability, 39, 108
Representation, 2, 3, 4, 5, 6, 7, 8, 9, 12, 14,
 15, 32, 38, 41-45, 46, 48, 49, 50, 51,
 52, 53, 54
Research practices
 Data collection, *see* Data collection
 Data analysis, *see* Analysis, data
 Feminist
 Informed consent, 98, 144, 145-147,
 153, 161, 215, 289, 338
 Institutional Review Boards, 123-140,
 289, 314, 333
 Qualitative, 12, 31, 32, 34, 37, 39, 40,
 43, 47, 50, 51, 52, 53, 149, 154, 163,
 166
 Quantitative, 31, 32, 34, 37, 39, 47, 50,
 51, 52, 53
 Research questions, 81-96, 314
 Writing as a research practice, 92, 113,
 115-116, 168, 174, 241, 361-363
 See also Methods; Analysis, data
Research Participants, 85, 90, 152, 166,
 176
 participant researcher relationship, 8,
 12, 13, 113, 164, 175, 180-181, 331,
 332-333, 361
 reciprocity in research relationship, 12,
 13, 275-276, 278-279, 283, 284,
 285, 287-288, 338, 339, 351, 358-
 360, 363, 366-367, 368-369

Researcher subjectivity, 97-98, 101-102,
 109, 112
Researcher reflection, 102

Sexual identity, 11, 152, 237-250
Socially progressive, 4, 14, 15, 16, 40, 46,
 47, 60, 67, 68, 71, 72
Spirituality, 5, 129-130, 262, 349-351, 353
 -357, 364, 366, 367, 368
Sustainability/Sustainable, 15

Technologies: 14, 97, 105, 169, 187, 190-
 191, 194-195, 313, 332, 335, 386
Tenure, 11, 13
Theory
 Disability studies: 19, 143-158
 Feminist, 1, 5-15, 35, 90, 104, 113,
 128-129
 Literacy, 334
 Marxist, 124-127, 134-135
 Materialism, 124-128
 Queer, 237-250, 331-348
 Rhetoric(al), 42, 59, 60, 61, 65, 68, 71,
 72, 73, 74, 75, 76, 77, 110, 127-131,
 254
 Social construction, 5, 73, 65, 76, 77,
 126, 148, 164
 Transnational, viii, 16
Transparency, 5, 44

Validity, 39, 36, 187-212

634356

CPSIA information can be obtained at www.ICGtesting.com
Printed in the USA
LVOW10s1053300713

345337LV00001B/25/P

9 781612 890890